# A Sweeper-Up After Artists

## A MEMOIR

and Irving Sandler continues to be the balayeur des artistes
and so do I (sometimes I think I'm "in love" with painting)

<div align="right">—Frank O'Hara</div>

# A Sweeper-Up After Artists

## A MEMOIR

### Irving Sandler

**Thames & Hudson**

First published in hardcover in the United States of America in 2003 by Thames & Hudson Inc., 500 Fifth Avenue, New York, New York 10110

thamesandhudsonusa.com

Library of Congress Catalog Card Number 2003103229

ISBN 0-500-23813-8

Designed by Liz Trovato

Printed and bound in the United States of America

# Contents

# PREFACE
## Reminiscences and Speculations

**WHY DID I WANT TO WRITE**

Why did I want to write my memoirs, or think that anyone would want to read them? Simply, because the art and ideas of many of my avant-garde artist and critic friends and acquaintances, which I had been tracking for more than four decades, continue to engage the art world. As for my personal life, apart from my life in art, it has been unexceptional, no traumatic physical or psychological sicknesses, addictions, childhood abuse, incest, extramarital affairs, etc., worth recounting. But framed as a kind of art-world autobiography, my memoirs might be interesting to others. I thought it was worth the try. For an audience that wants first-hand testimony about the development of American avant-garde art and its art world, I can attest that I was there, a participant in and witness to art history.

I have relied on my memory, of course, but even more on notes jotted down on the spot—in studios, at artists' meeting places, such as The Club, sitting at the bar of the Cedar Street Tavern, at exhibition openings, and during innumerable interviews, panel discussions, and lectures. Indeed, my incessant note-taking got me a reputation as an art-world character. One critic dubbed me "a kind of Boswell of the New York art scene." In one of his poems, Frank O'Hara called me "the balayeur des artistes," the sweeper-up after artists. He added that he was one too: "Sometimes I think I'm 'in love' with painting."

My notes became the source for a four-volume history of avant-garde art since World War II (with the emphasis on New York school painting and sculpture), the first volume appearing in 1970 and the final one in 1996. But in reviewing the notes, as well as a mass of my published and unpublished articles, reviews, and lectures, it occurred to me that there was to be found in this material valuable data, insights, ideas, and speculations that I had not incorporated into my books. Moreover, I had framed my surveys with an art-world consensus in mind. Consequently, I had curbed my own point of view. Perhaps there was another narrative to be written, an intimate history seen through the prism of my personal experience.

In order to put my picture of the art world in context, I felt the need to write something about myself, to indicate, if only cursorily, how I became the art critic-historian that I am. After all, interpretation depends on who is doing the interpreting, as well as when and where. I discovered that my recollections were unavoidably shaped by my imagination, perhaps as much as by fact. I also confess that in presenting them, I have engaged in self-theatricalization, more than I would like to admit, but less, I think, than most memoirs, for mine aimed to be more about the art world than about me. No, not exactly theatricalization, perhaps more an unavoidable emphasis on what Virginia Woolf, in her autobiographical essay "A Sketch of the Past," called "moments of being." We recall these moments with great vividness and at the same time we disregard "the nondescript cotton wool" of "non-being" of which most of our lives consist.

But then history, as it is usually written, tends to focus on extraordinary moments, and I mean my memoir to be history—narrative history in the first person. And in story form, I mean it to be an antidote to the unreadable jargon-ridden and statistics-binging prose of ideology-prone or overspecialized historians. Consequently, I will not speculate about impersonal historical forces but will focus on the story of art-world people with conscious and unconscious motives and aspirations who interact with each other with the aim of advancing the art they create or believe in.

# Stumbling Upon A Vocation

In the early 1950s, I was a graduate student in American history at Columbia University. I was suffering through what Ortega y Gasset called a "shipwreck" period. My first marriage was breaking apart. I was impoverished and found the cheapest place to live, a small sunless room with a window on a dark airshaft in a shabby apartment house. I could just about meet the rent of $6.50 a week with money earned in low-paying, part-time jobs. These were hard to find since I was informed repeatedly that I was "overqualified." I was so destitute that to supplement my meager earnings I attended church dinners and lectures at the college for the refreshments that were served afterwards. I did enjoy the lectures and symposia, the start of a lifelong habit.

Life was not totally unpleasant at Columbia. There was schoolwork and research; interesting people; extracurricular lectures and activities, such as playing bridge; concerts at Juilliard; jazz in Harlem; plays at the Berghof School; and all sorts of other events and entertainments, most free and some that I could even afford to pay for, such as a Merce Cunningham dance concert, which I found thrilling. I couldn't understand why people in the audience hissed and stomped out. And there were library books to read—among them Ortega y Gasset's— which often spoke to my situation at the time and provided consolation of sorts. I had a membership card to the Museum of Modern Art that admitted me free, a legacy from my failed marriage. The museum garden became a kind of oasis. And then, of course, there were MoMA's movies—and the painting and sculpture galleries that I wandered through with growing frequency.

I had begun to lose interest in American history. And I was finding it increasingly tiresome to work on my dissertation, the topic of which was the history of the National Association of Manufacturers. I was goaded on by Henry Steele Commager, who was my most impressive professor. I was in awe of his command of American history and his zest for the subject, but I recognized that I could never attain his knowledge or his enthusiasm, not in the field of American history. Nor could I use the terms *democracy* or *fourteenth amendment* with the resonance and conviction of such historians as Charles and Mary Beard or Vernon Parrington. I knew that I could not make a significant contribution to American history. Nevertheless, I kept at it for want of anything more interesting—and

because I knew what I did not want to do, namely work at some nine-to-five job performing meaningless tasks day after day, like Sisyphus.

If writing American history was not to be my mission, I still needed one. Through my late twenties, my major life problem was to find challenging work to which I could give myself wholeheartedly and in which I could excel, achieve distinction, make my life count. I even had a sense of destiny, a hope that something I produced would be of such worth that it would live beyond my death. I was not conscious at the time of my need, but as I look back, I believe that the search for a "calling" informed all of my undertakings.

In 1952, while walking through the galleries of the Museum of Modern Art, I was dumbstruck by a black-and-white picture. The label informed me that the canvas was titled *Chief* and was painted by a Franz Kline in 1950. It was the first work of art I really saw, and it changed my life, somewhat like Saul jumping into Paul, as Elaine de Kooning wrote of Kline's own leap from figuration to abstraction. My conversion was less dramatic, of course, but my life would never be the same. Or, put another way, *Chief* began my life-in-art, the life that has really counted for me.

Art had not particularly interested me previously. As a boy I had visited the Philadelphia Museum of Art occasionally and I recall lingering in front of Thomas Eakins's paintings. But there were no books on art at home and only one reproduction, a conventional landscape that I bought framed for $1.99 (or was it $2.99?). As a teenager, I had known a few artists, one of whom was painting views of New York's Sylvan Lake from a hill high above, and another, a well-known sculptor, Minna Harkavy. In college, I was taught nothing about art history and little about the intellectual and cultural context of art, except for a course in aesthetics in which no works of art were mentioned or slides screened.

What was it, then, in Kline's *Chief* that stunned and moved me? The painting did not provide any particular pleasure or delight. Nor did I "understand" it. I responded in another way—with my "gut," as it were. The painting had a sense of urgency that gripped me. I sensed Kline's need to create something deeply felt. That spoke to my own need. Moreover, *Chief* had a disturbing edge, a certain rawness, disorientation, lack of balance that reflected my predicament (and later, I would think, that of humankind). It was at once surprising, familiar, and imposing. And it challenged me to find out more about it and my experience of it.

*Chief* revealed to me the power of the visual in my being. It was like releasing the floodgates of seeing. But my seeing would be almost exclusively focused on art—and, somewhat later, architecture. I looked to art for revelation. But of what? Sensuous pleasure? Yes, I delighted in it whenever I found it—in a Hans Hofmann or Joan Mitchell. But more, much more, I looked to art for meaning, for the illumination of my life—and by extension, of my society. Art became the content of

my life, to paraphrase Malevich, and even a kind of surrogate religion: its gospel, art history; its church, the museum. Isaiah Berlin was right when he asserted that "those who have never been under the spell of [some such] illusion, even for a short while, have not known true intellectual (or creative) happiness."

Rethinking the appeal of the Kline and subsequent works of art that elicited a profound emotional and/or intellectual response, I later wrote that each has magical powers, like a fetish, icon, or reliquary, whether it be an image of a deity, a shrunken head, or a shell. The art object can literally bewitch the viewer. Casting a spell, it can transform him or her—that is, summon up a fresh perception of art, life, and the world, and even cause the viewer to feel, think, imagine, and act in new ways—and desire profoundly to reexperience the magic.

But I have run ahead of my story. I had to know more about Kline and his painting, but how to proceed? Then there occurred a series of chance incidents that brought me face to face with Kline and his colleagues and revealed to me my future work. Much of what happened to me at that time was a matter of luck. But how much in life is luck and how much is the readiness to take advantage of seemingly random events? Would what followed have come about anyway? Perhaps, but I am convinced that sheer luck played a crucial role.

In the spring of 1953, a fellow student at Columbia went west for an archaeological dig on an Indian site and lent me his apartment. Then a student at Harvard, who was an acquaintance of my girlfriend, Mary, came to New York for the summer to do research, and offered to trade his automobile for the apartment. With my archaeologist friend's consent, I did. In July, Mary and I decided to drive to Provincetown, Mass. I don't recall why we chose Provincetown, but it was not because it had attracted generations of artists. Our plan was to camp out on the dunes in a tent we found in the trunk of the car. One night of nature was all I could bear. The next day I found a job as a dishwasher at the Summit Restaurant, run by disciples of Gurdjieffi and Krishnamurti, and Mary and I rented a room on a back street in Provincetown.

I later relocated my dishwashing to the Moors, a superior Portugese restaurant. There I met the artist Angelo Ippolito, who happened to be a waiter. We became friends. Ippolito knew Kline and his abstract expressionist associates and began to "teach" me about their painting with good humor and engaging wit. I would ask dumb questions: "Aren't abstract paintings an escape from reality? Do people buy them?" Angelo would answer patiently, "I'm not running away from anything. I want to paint this way, so I do. If people don't want to buy my work, it doesn't bother me, except that it's not easy to eat, but I go on painting. They leave me alone, I leave them alone. Sometimes, when I get asked 'What does it mean?,' I say, 'It may not be for you.'"

At an art opening that summer, I chatted with a poet, Joel Oppenheimer, who

had been a student at Black Mountain College when Kline had been a visiting professor there, and we became friends. Joel and his wife were going through a rocky period. She liked Mary and me, and the four of us often met. Like Angelo, Joel taught me about avant-garde art. He also introduced me to the poetry of Charles Olson, Robert Creeley, and other Black Mountain poets who were friends of the abstract expressionists, and whom I soon met. I quickly learned where young artists gathered in Provincetown, joined them on the beach and at their parties, and listened closely to their incessant art-talk.

After my return to New York, Angelo found me a job managing the Tanager Gallery, an artists' cooperative on Tenth Street of which he was a member. Joel took me to the Cedar Street Tavern on University Place, the favorite hangout of the New York school. He sat me down in a booth across the table from Kline. I was too shy to say anything, but I didn't have to since Kline was an irrepressible raconteur.

I began to frequent the Cedar, showing up late every night, nursing a 15-cent beer, and eavesdropping on the artists' conversations. As I came to know the habitués, they invited me to their studios. I was soon taken to The Club, which the abstract expressionists had founded in 1949, and I became a regular guest— getting myself invited every Friday night.

Within easy walking distance of the Cedar, Tenth Street between Third and Fourth avenues, where the Tanager Gallery was located, was the geographic hub of the international avant-garde, or so the artists who lived, exhibited, and congregated there had the self-assurance to believe. On the one block were to be found the studios of a number of leading abstract expressionists, among them de Kooning, Philip Guston, Esteban Vicente, and Milton Resnick, as well as sculptors Phillip Pavia and James Rosati. It was also the location of five artist-run galleries; three others were in neighboring streets.

Geographic proximity fostered camaraderie. Artists could readily find friends with whom to share their intentions, aspirations, and dreams. Although the artists were competitive, they celebrated each other's achievements. The main activity at any social occasion was art-talk, ceaseless art-talk. I delighted in the conversation and never tired of it.

The artists had careerist hopes but kept their desire for fame and money to themselves. They insisted that all that counted was art and making art, and that everything else was secondary, if that. Creating art was all-important, to be sure, but it was not just a matter of doing one's own thing. It also meant drawing from and contributing to the avant-garde culture of art—that is, using the visual and verbal information provided by the art world to shape one's production and ideas, and adding one's perceptions to the art world's aesthetic and intellectual stew. Otherwise, one's art would end up naive and irrelevant.

Young artists organized cooperative galleries because there were too few commercial venues that would show their work. The Tanager was the first on Tenth Street and we thought of it as the premier gallery. We also hoped that it would determine art-world taste. I echoed this attitude in a statement I wrote in 1959 on the mission of the Tanager. I called it "the public extension of the artist's studio. Its shows have reflected the intimate artistic problems that painters and sculptors face and have proved a means of defining, clarifying, and evaluating them." I concluded by dubbing the Tanager "the barometer of the New York art scene."

At the Tanager I came into daily contact with artists such as Ippolito, Alex Katz, and Philip Pearlstein, who became close friends, as well as Charles Cajori, Lois Dodd, Nicholas Marsicano, Sidney Geist, and Sally Hazelet. I also became friendly with members of the Brata Gallery across Tenth Street, notably Al Held, George Sugarman, and Ronald Bladen. While at the Tanager I frequently met de Kooning and Resnick, whose studios were next door to the gallery, Guston, who worked down the street, and any number of other artists in the vicinity who, taking a break from their work, would drop into the gallery. Consequently, I was New York schooled, receiving my art education at artists' lofts, the Tanager and other Tenth Street cooperatives, the Cedar Street Tavern, and The Club.

The Tanager was often visited by museum directors and curators, Alfred Barr and Dorothy Miller of the Museum of Modern Art, and Lloyd Goodrich and John Baur of the Whitney Museum; critics Harold Rosenberg and Thomas Hess; painter-critic Fairfield Porter; and poet-critics, Frank O'Hara, James Schuyler, and Barbara Guest. A few collectors would occasionally stop by as well, notably the taxi king, Robert Scull, who was just beginning to buy work.

In 1955 I found a small railroad flat with the bathtub in the kitchen and toilet in the hall on Seventeenth Street off Third Avenue. The rent was $17 a month. A now-forgotten painter, Giuseppe Napoli, lived across the hall. He painted still lifes in the style of Giorgio Morandi but in darker colors. One summer, while I was in Provincetown, he suddenly received a Fulbright Fellowship to Italy to study near his mentor and asked me if he could store a few of his pictures in my apartment. When I returned, I found wall-to-wall Napolis. He had one set of collectors that I knew of, Herbert and Dorothy Vogel, who owned many of his works and had Napoli's permission to choose what they wanted from my apartment. They were tiny people, he a post-office worker, she a librarian, who would spend hours studying Napoli's canvases and debating whether the "passages" worked—often with me looking on or trying to get on with my life. They later become major collectors of avant-garde art on their modest salaries. Their enormous collection, which they stored in their tiny apartment, ended up in Washington's National Gallery of Art.

My position at the Tanager Gallery enabled me to enter fully into the art

world. More than that, the art world became my world, more accurately, my village, and I got to know most of its few-hundred inhabitants. It was a "community" that I committed myself to utterly, in both my work—whether writing, or organizational activities, or teaching—and in my play. I identified with bohemian artists who were living the life of art "on air," partly because they were poor, as I was, and partly because they rejected materialism and mass culture and had high aspirations. Ippolito taught me how to subsist with elegance on no discernible income. His studio, which was furnished with junk he had picked up in the gutter, was among the handsomest I knew.

And my "community" was in New York City. I had always been an urban person. Duke Ellington spoke for me when he asked, "Grass? Grass? Isn't that what grows on graves?" And Frank O'Hara, when he wrote, "One need never leave the confines of New York to get all the greenery one wishes—I can't even enjoy a blade of grass unless I know there's a subway handy, or a record store or some other sign that people do not totally regret life."

Becoming the "Manager of the Tanager," as Ippolito dubbed me, was a start. I soon volunteered to do more, this enabling me to enter more fully into the art world. By 1956, The Club was in decline. The older members who had founded it in 1949 were not attending as frequently as they had, although many continued to pay dues. They no longer felt the need to talk or socialize in public. The demands of wives and children inhibited late-at-night hanging out. In 1956, a meeting, to which I was invited, was called to disband The Club. After some desultory discussion, Elaine de Kooning suggested that The Club could continue if someone would offer to run it. Silence. Then I spoke up, saying I would take it on.

I continued to attend Columbia University, though I found it far more stimulating, indeed elating, to listen to artists than to professors and graduate students. And I was spending more and more time visiting galleries and museums. But I was not quite ready to abandon my academic career. I could at least take my oral examination. Henry Steele Commager asked me to account for the success of the colonists in the Revolutionary War. I answered that George Washington made the difference. He was a military loser and yet, through the force of his character, the "self" that he made, that he willed, he kept his pitiful army together until he won. My professors were not impressed by my Great Man thesis. (Later it occurred to me that I was viewing Washington as a kind of existential hero, like Kline and de Kooning and other artists I was getting to know.) Evaluating my performance, Professor William Leuchtenberg, my advisor, recommended that I quit Columbia, and I did so with little sense of regret. (However, my academic failure rankled, and some two decades later I did earn a Ph.D., but in art history. After I had achieved

some eminence, Leuchtenberg and I happened to be invited to deliver lectures at the Whitney Museum of American Art. He looked at me as if he had seen me before but could not place me, and I did not provide him with the information; I viewed our being on the same program, ironically, as a minor academic victory.)

In the summers from 1955 to 1958 my Tenth Street was Provincetown. I socialized primarily with avant-garde artists, but I also became friendly with veteran regionalist and social realist painters, such as Philip Malicoat and Irving Marantz. I was also inducted into an artists' club, the Beachcombers, most of whose members were oldtimers and whose primary activities were once-a-week dinners prepared by different members. The main dish of the meal I cooked was baked ham. It proved to be an embarrassment because one of the guests turned out to be a distinguished rabbi who had given one of the prayers at President Harry Truman's inaugural ceremony.

Years later, in 1981, I was asked by the Provincetown Art Association and Museum to write the catalog introduction for an exhibition about the Sun Gallery, an artist-run gallery of the 1950s that had achieved a certain historic interest. I began by remarking that "My P-town is of the fifties—part oasis, part mirage," existing only in my memory, not "revised by anything that happened to it since. What I recall most strongly is the awareness of potential, of promise, of the clear and present possibility of future greatness." And there were living in Provincetown artists who appeared well on their way to achieving it—a number already had, for example, Milton Avery, Franz Kline, Adolph Gottlieb, Robert Motherwell, and Hans Hofmann. They made visions of glory seem attainable to younger artists.

Provincetown itself enhanced these visions. With its dunes, ocean, and sun, and its light—as Motherwell wrote, "exactly the same kind of light that Matisse loved or Miró loved, or the Greek sculptors loved"—it was just the place to believe in unlimited horizons and a lustrous future. It was far enough removed from the "real" world for a young person to invent his or her identity in "life" and, if serious, to aspire to it in art.

And there was a great deal of free time to do what one wished—even nothing. Those who had to earn their keep could do so easily by working part time. During my second summer in Provincetown, I managed by washing the kitchen floor every night after closing and the refrigerator once a week at the newly opened Ciro and Sal's Restaurant. For this I was fed and paid $15 a week. I also sat at the HCE Gallery for an hour daily to relieve Ivan Karp (later the owner of the O.K. Harris Gallery), who worked there full time, while he had lunch, and received one dollar a day. As a reward for my faithful service, Nat Halper, who owned the gallery and was also a James Joyce expert, gave me the cheapest print on sale

(price tag $15), a Milton Avery woodcut of an owl that I still treasure. My total work week was under fifteen hours. The following summer, I shared the cellar of a house on the bay with a painter and a writer. We each paid $33.33 for the summer's rent. Our landlord, Captain Russell, was a fisherman who, in his spare time, was a self-taught sculptor. He boasted that a *New York Times* critic told him that many artists study for years to be "primitive," but the captain was "a natural."

My haven was Ciro and Sal's Restaurant, where I was to be found most every night in the company of artists, who ate there because its owners were painters who gave a cordial welcome and special prices to fellow artists. The cuisine was fine, although occasionally the spaghetti would be gummy and the sauce, over-salted or burnt, but the atmosphere was familial. We all doted on Sal's dignified and quiet father, Romolo, who made imaginative artifacts out of imported olive oil tin cans, and reminisced about the beauties of Ischia.

It was in Provincetown that I began to amass notes for my intended history of abstract expressionism. I interviewed Avery, Motherwell, Gottlieb, Louise Nevelson, Jack Tworkov, George McNeil, and Fritz Bultman. Nevelson became a friend. I have always had a weakness for *grandes dames*, and they didn't come grander than Louise. Once while wandering through Provincetown's art galleries, I was struck by one of Louise's black boxes and thought, I'd like to own one of those. The wall label read $100. I figured that minus the 33 1/3 percent gallery commission, I could just about afford to buy it—on time. Would Louise sell one to me for $66.67, and in installments? I asked and she agreed. We arranged to meet at her studio in New York. Black sculptures, hung on walls and suspended from the ceiling, hovered over black junk wood, scraps of furniture, and mill ends, which were scattered on the floor. Louise produced a number of boxes and I chose one. I asked her about how I would pay, and she replied, "You need the money more than I do. It's yours."

Most of the young artists I knew in Provincetown were studying or had studied with Hans Hofmann. Everybody knew that he was the greatest teacher any-where (and they were right). I found that out at first hand by sneaking into the Friday critiques that he gave at his school. These were my first "formal" lessons in art. In his idiosyncratic mix of German and English, Hofmann began one session by fulminating against hypersensitivity and preciousness, urging students not to be tame and fearful. He would accentuate every comment with "nikker" (*nicht wahr*). His eye was always on color, how to make it luminous and keep it from being "mono-tone-eous," as he put it; how to make it "cree-yay-teef" and "mod-ern"; and how to make it simultaneously flat and volumetric.

Hofmann repeatedly invoked Matisse, who he claimed "is a fantastic compos-er because his flat color areas never look flat. He does not dig holes in the picture. Matisse understands the difference between naturalistic depth and pictorial

depth which respects the wall. He aims toward nature but never imitates." Naturalistic painting was bad, but worse still were "surrealist tricks" that disguised the painting medium. Hofmann stopped in front of one student's work and said: "It's too beautiful. You must suppress conventional beauty in order to create a new beauty." To another, he said: "Simplification need not mean poverty." And to still another: "Be more direct. Your feeling for space has to be revealed on the surface." Hofmann's students, even those who aped him, the Hofmannerists (as Leo Steinberg dubbed them), believed they would be the painters and sculptors to succeed the first-generation abstract expressionists, and a few turned out to be.

The Sun Gallery was the showplace of the bohemian young. Like the artists who exhibited there, it existed on a proverbial shoestring, largely funded with the earnings of its founders, Dominic Falcone, who, among other jobs, washed dishes at the Moors restaurant (but not when I did), and Yvonne Andersen, who worked as a salesperson at the Studio Shop. The gallery would have nothing to do with the "establishment." As Falcone proclaimed in its credo in 1955, "The Sun is open to all the new voices, always listening for the new sounds, lifting them from the darkness into the light." Even abstract expressionism was suspect as being too entrenched.

Lester Johnson, Jan Muller, and Alex Katz were given multiple one-person shows at the Sun Gallery between 1955 and 1959. Johnson and Muller were turning away from abstraction toward figuration, and Katz was moving toward literal portraiture, a shocking move at the time. A number of artists who exhibited at the Sun Gallery were venturing in the radical direction of happenings, a label coined by Allan Kaprow, who was himself given a one-person show at the gallery in 1957. Red Grooms, who had met Falcone when they were fellow dishwashers at the Moors, presented one early theater piece, titled *A Play Called Fire*, at the Sun in 1958.

The personalities of the artists who showed at the Sun were as singular as their styles. Of the artists I knew best, I recall Ippolito's elegant wit; Katz's fast one-liners about art, as coolly incisive as they were provocative; Kaprow's iconoclasm in making art and his logic in talking about it; and Grooms's exuberance and charisma. (When he turned his out-of-the-way studio on Delancey Street in lower Manhattan into a "museum," the art world trekked to visit it.)

The epigraph to the Sun Gallery catalog was a quote of Wordsworth's: "Bliss was it in that dawn to be alive,/ But to be young was very heaven!" And so it had become for me, since by the end of 1956, I had become an integral part of the New York art world.

But what would I do or be? A painter, or—what? Perhaps a writer on art? On Kline's kind of art? I recognized that my aesthetic experience was both sensuous and intellectual. But I found myself drawn increasingly to conceptualize it intel-

lectually, or at least to translate my experience verbally. Thus, I would write about it, perhaps a history. Hadn't I been trained to do that? I had already begun to take notes of what artists said in order to help me comprehend the work that so moved me. Now they would become the primary source of my survey.

How did I become an art critic? In November 1956, I received a phone call from Thomas Hess, the executive editor of *Art News*. He said that artist acquaintances had informed him that I had been hanging around for several years, that I was not an artist but some kind of historian, that I had made a film on de Kooning (more of which later), and that I seemed to know something about contemporary art. Would I like to write art criticism? That had not occurred to me, so I begged off. Like my artist friends I was disdainful of art critics, and in the arrogance of my innocence, I considered *Art News* the establishment. I said that to Hess, and he laughed and invited me to lunch. I accepted. I had heard a lot about him and wanted to meet him. Besides, in those lean days how could I refuse a meal?

Hess took me to Larre's, a French restaurant on West Fifty-sixth Street, inexpensive but way beyond what I could afford. After his second martini, he proposed that I undertake a few trial reviews to see how I liked it, and then we would discuss them. I agreed; why not? In the mail I soon received a list of twenty galleries (which I later discovered was a full monthly complement). That was more than I expected, but I wrote them up. When I picked up the next issue of *Art News*, all of the reviews were there. I phoned Hess and said that I thought we had agreed just to discuss them. He said that they were O.K., wouldn't go down in history, but O.K. "Would you like more?" "You bet!" I replied.

Apart from managing the Tanager Gallery and The Club and entertaining the idea of writing the history of abstract expressionism, it was not clear to me what role I might play in the art world. Hess settled that. He not only "tricked" me into reviewing, but gave me the confidence to believe that someone might want to read my copy. It was suddenly clear to me that writing about art was far more engrossing than anything else I had been doing. I had found my vocation.

Moreover, in my impoverished state the money I earned reviewing shows was welcome. Critics were paid $3 a review for 100 words or less and a penny a word for anything over, plus carfare, and $75 for an article. I frequently spent a morning previewing a show in an artist's loft or gallery and the rest of the day—and sometimes longer—writing and rewriting a review that was rarely longer than 100 words. I earned roughly $80 a month. I would soon supplement my income, as most critics did, by teaching and lecturing, curating and writing catalogs, and jurying shows.

It may be that art criticism engaged me in part because it provided a way of proving my intellectual worth to myself. Early in my life I had come to believe

that I was not as clever as some other kids who were my friends. And yet I knew even then that I wanted to do something of an intellectual nature, and excel at it. I also realized that if I was going to succeed at all, it would be through hard work.

Having found my vocation, I began to work harder than ever before if only because little else that I could imagine was as pleasurable and stimulating, or perhaps I should say, less tedious. Spending more time writing, I had less time to hang out. I still frequented the Cedar Street Tavern late at night, saw as many shows and visited as many artists' lofts as I could, but with a new purpose: to further my knowledge of contemporary art, knowledge I needed for my work.

Writing about art was what I did when I got up in the morning, freely and spontaneously. It seemed more like recreation than labor. Leisure activities not related to my work bored—and bothered—me. I would be nagged by the thought that there was something else I had to do: some deadline to meet, some show to see, some artist to interview. Every now and then writing would oppress me, particularly in the final stages of a text, when all that kept me going was willpower. At such times, I would look back at my growing body of work—and the effort it had taken—and how much of my life it had consumed. With a twinge of self-pity, I would sometimes be reminded of Czeslaw Milosz's lament, "Here is an oeuvre accomplished. If only they knew at what price. Would they not turn away in horror?" Then, I would remember that for me the price was anything but horrific. And despite the difficulty I had writing (it has never gotten easier), I found it absorbing and enjoyable and a source of pride. Barbara Rose once remarked that I would end up as an inch in a library's card catalog (or its equivalent in cyberspace). The thought both depressed and pleased me.

I not only found my work after 1956 but a woman to love, Lucy Freeman. Fran Greenberg, the girlfriend (and later wife) of John Krushenick, a Tenth Street artist acquaintance of mine, introduced me to Lucy, her oldest friend. Lucy later told me that I attracted her because I was supposed to be an intellectual, and when we met, I was carrying a Masoretic Bible. I found her appealing because she was affable, intelligent, knew a great deal about art, and had great blond hair and a round bottom. We became an "item." Lucy was a graduate student studying English fourteenth-century illuminated manuscripts at the Institute of Fine Arts of New York University. We were both poor, living on part-time wages. When she received her Ph.D., H. W. Janson, the chair of undergraduate art history at New York University, hired her to assist him in editing the *Art Bulletin* and to teach.

Janson shrewdly recognized that if he engaged exceptional women art historians who needed or wanted to live in New York City for one reason or another, he could assemble a first-rate faculty at less cost than if he appointed men. His undergraduate Department of Art History became the foremost in the United States. When Janson retired, Lucy became chair, the first woman elevated to that

position at New York University. To most feminists, Janson was a sexist because he did not include a single female artist in his monumental *History of Art.* To those to whom he gave jobs he was something of a hero. Lucy went on to a distinguished career as a scholar and teacher, becoming at one point the president of the College Art Association.

Lucy and I married in 1958. We had a rowdy party made up largely of artists. I made the punch, refilling it with vodka until there was nothing in it but vodka. I was told that I got roaring drunk and took off down Second Avenue chased by guests trying to recapture me. I woke up late the next morning with a horrendous hangover and discovered that we were the proud possessors of dozens of works of art—wedding gifts. My artist friends had no money but stacks-full of unsalable art. Overnight, we became major "collectors." The art on our walls would raise ethical questions for me as a critic. Lucy and I justified our owning art by vowing never to sell any work given us. Our collection would become a conduit from the artists' studios to museums—as we have bequeathed works to the Museum of Modern Art, the Whitney Museum, and the Brooklyn Museum.

Lucy and I stayed married. How did we manage it? The French love song, the most beautiful ever written, says it best:

My love loves me.
How else can such beauty be?
A rainbow shines in my window.
My love loves me.

I admit that I don't know what love is, but after forty years, I still look at Lucy with delight. It helped our marriage that she had a career of her own that "called" her as strongly as mine called me. I could never envision myself coupled to a homemaker whose life would be spent cooking, cleaning, caring for the kids, etc., etc. It makes me shudder just to think of it. Nonetheless, Lucy provided me with a stable life that allowed me to concentrate on my art criticism and history. She became my first and primary reader, as aggressive in her editing as she was otherwise agreeable. The bohemian existence is unavoidable when one is too poor to live otherwise, but with regard to work, it is more often than not counterproductive. Flaubert once wrote: "One must live like a bourgeois and think like a demigod," or try to. I can't tell whether my thinking would meet Flaubert's standards, but I was able to spend a good deal of time looking at art and writing about it.

# The Art World of the 1950s

In 1959, I counted all of the artists who might conceivably have been included in the New York school, and the total was short of 250, a relatively small number considering the international recognition of the new American painting. I had met nearly every one of them, had seen their work, had visited their studios or encountered them at gallery openings or at The Club, or had shared beers with them at the Cedar Street Tavern.

Looking back on our lives in the fifties, I think of my friends in the Tanager Gallery on Tenth Street—Charles Cajori, Lois Dodd, Sally Hazelet, Angelo Ippolito, Alex Katz, Nicholas Marsicano, and Philip Pearlstein—or in the Brata Gallery across the street—Ronald Bladen, Al Held, and George Sugarman. Most of their time was spent in the privacy of their lofts making art and trying to earn enough to support it, mainly through part-time menial jobs.

On the whole, our day-to-day lives were ordinary. When I set my mind to it, I recall memorable snippets of talk, fleeting but recurring images of socializing at openings, parties, and dinners. I also think of the sense of community that my artist friends and I shared and my awareness that they were creating significant, possibly great, art, realizing what Franz Kline called "the dream." If I were sentimental, recollections of the "dream" and the camaraderie would make me misty-eyed. Those years from roughly 1955 to 1962 were the best in my life.

We were all poor, but that did not concern us much; it was assumed that if you wanted to be in the avant-garde you had to take a vow of poverty. But living was incredibly cheap: lofts could be had for as little as $30 or $40 dollars a month. Part-time work paid a dollar an hour, which meant that an artist could earn the rent in thirty hours. Living and working spaces were largely furnished with junk recycled from the city streets. The downtown neighborhood we lived in was run-down, drab but not a slum, and it was safe. Though no one went hungry, artists did suffer—from lack of recognition, and because, as Landes Lewitin once quipped: "It is difficult to be a great artist." The goal was to create masterpieces, even when the art transgressed conventions, and it often did.

Sales of artworks were nonexistent for most and rare for the few. No one expected commercial success, and some took pride in their "purity." The pressures of money, fame, and art-world power did not weigh as heavily as they would

later. There were few big "winners" to foment envy and resentment in the "losers." However, the economic situation did pick up slowly during the 1950s, as teaching jobs became increasingly available and the art market expanded, but there was no substantial improvement until after 1958.

What kept us going? Frank O'Hara recalled: "Then there was great respect for anyone who did something marvellous: when Larry [Rivers] introduced me to de Kooning I nearly got sick. [Besides] there was then a sense of genius." The support of one's colleagues and friends, like O'Hara, meant a lot. As composer Morton Feldman wrote: "What really matters is to have someone like Frank standing behind you. That's what keeps you going. Without that your life in art is not worth a damn." There were, however, rewards apart from doing your own thing and the esteem of your fellow artists: You might have a work in a Whitney Annual, a reproduction or an article in *Art News*. And the future might provide a retrospective in a museum, a chapter in an art book—or a footnote—or even a mention in a text that included Giotto, Piero, Michelangelo, Rembrandt, or Velazquez.

We spurned conventional American society, which was in thrall to mass culture and which rejected avant-garde art. But our venom was aimed primarily at middle-brow art. We resented the neglect of abstract expressionist painting by the public at large but were sufficiently optimistic to believe that there were sympathetic people out there, a few rich enough to buy art, and felt that their number would grow, and it did.

Caught up in a milieu of creative energy, my artist friends spent long hours in their studios. They considered themselves countercultural bohemians alienated from the American way of life, but nonetheless they retained its bourgeois work ethic. They achieved personal fulfillment in their art paradoxically through self-discipline and hard work in the American grain. They proclaimed that they were free, and in their art they were, but as artists they were chained to their brushes. The freedom they valued was the nonfreedom that drove them to make art.

It was not all work. We socialized, generally late at night, and when we did, we talked about art—incessantly, and with utter seriousness. We did discuss sports, sex, movies, and books, but not politics, although most of us were liberal or leftist and voted the Democratic line, if we bothered to vote at all. Politics were evaded because they were identified with social realism, which the avant-garde had rejected as retarded. Talking about art was our primary recreation. What little money artists had went for paint and canvas. Nevertheless, life was not solemn. We did have fun—smoking and drinking (mainly beer) at the Cedar Street Tavern or the Five Spot, a jazz joint, and at The Club (whiskey and coffee); dancing at The Club (after the panels or lectures, which were the main events), and Bring-Your-Own-Bottle loft parties. Why did avant-garde artists need to congregate and to establish a community? Primarily, to avoid loneliness after long hours in the studio; to

socialize with kindred spirits; or to receive the assurance of fellow avant-garde artists that their moves into the unknown were not insane. But was there more? What if de Kooning had not met Gorky or Pollock? What if Still, Rothko, Gottlieb, Newman, and Reinhardt had not become friends? Would abstract expressionism have come into being, or how would it have been different? I wonder.

The Cedar Street Tavern was *the* bar of the New York school. For most downtown artists it was within walking distance of their lofts. I went to the Cedar nearly every night from 1953 until it closed in 1963. Generally I showed up around ten o'clock, when my artist friends did, and nursed a beer until two or so in the morning. Having decided to run The Club and beginning to work on my history of abstract expressionism, I began to research earlier artists' meeting places. From scattered remarks of its old-time habitués, I was able to piece together the Cedar's early history as well as that of other artists' venues in the 1930s and 1940s.

Most of the older abstract expressionists first met each other during the Great Depression, either while on the Federal Art Project, or at gatherings of the Artists Union, or in such restaurants as Romany Marie, the San Remo, or the Stewart Cafeterias on Twenty-third Street off Seventh Avenue and on Sheridan Square. During World War II, the Waldorf Cafeteria on Sixth Avenue off Eighth Street became the favorite hangout for downtown painters and sculptors. However, they were not comfortable there; when the weather permitted, they assembled in nearby Washington Square Park. The cafeteria was a gloomy and cruddy place, full of Greenwich Village bums, delinquents, and cops. The management did not want the artists; they just drank coffee, and were often too poor to buy even a cup. What was worse, since hot water was free, some artists would bring their own tea bags, or use the ketchup on the tables to concoct tomato soup. To harass them, the Waldorf managers allowed only four persons to sit at a table, forbade smoking, and, for a time, even locked the toilet. In reaction, the artists began to frequent the Cedar and to think about forming their own club.

The Cedar Street Tavern was located on University Place between Eighth and Ninth Streets. Its name came from the sign of a defunct bar. In 1955, John Bodner, a former army master-sergeant and butcher, and Sam Diliberto, a former window-washer, bought the place. By then it had become the living room of the New York school. We liked the owners, and the affection was reciprocated. In Bodner's obituary, Black Mountain poet Joel Oppenheimer wrote: "Somehow we all became John's bums. Three a.m. Sunday morning ... we'd go off to Rikers [a nearby coffee shop] for some eggs. More often than not he'd drop us off on the way home, too. And if you needed 10, you had it. [He] always knew when you were hurting, and he was there when you needed someone to share good news with." The owners gave us credit, took messages, and held mail. Most of us were fans of baseball

and boxing; the only time a TV set was allowed was during the World Series. In 1956, during the Dodger-Yankee series, John bet his share of the Cedar against Kline's studio. John won, but he settled for a painting.

The Cedar was a nondescript place—in the front, a bar; in the rear, booths and tables. It was no different in appearance from thousands of lower-middle-class American taverns, except that there were English sporting prints on the walls, but no other art. At one point in the late fifties, Bodner decided to upgrade the bar's decor; we objected, and he yielded to our wishes. But we allowed him to repaint the walls—from a drab green to an equally nondescript gray.

We liked the Cedar's anonymity, and it served a purpose. Its lack of arty decorations—chianti bottles, driftwood, travel posters—kept away the local bohemians who lived the life of art without creating any—the "creative-livers," as we called them. And its lack of television discouraged neighborhood folk from coming.

Colorlessness became protective coloration. It shielded us not only from the artists manqué, but also from Madison Avenue types who posed as bohemians after five o'clock, the chic of all varieties who came slumming, and tourists from Brooklyn and the Bronx who came to gape at the way-out Village characters. To further deter these interlopers, we tended to dress soberly, as every photograph taken at the time indicates. Most artists wore corduroy jackets and knit ties (black for formal occasions). This uniform made me think of Degas's remark to the flamboyant Whistler, "You dress as if you have no talent." Indeed, the Cedar typified a "no-environment," de Kooning's term for the milieu of the contemporary artist—no picturesqueness, no romance, no nostalgia.

It seemed fitting for artists to meet at a tavern located on University Place but named—or rather misnamed—Cedar Street. An establishment that could not even get its own name straight must be the right place for artists who refused to accept fixed categories. Indeed, they refused to be labeled or classified, rejecting the idea that they were abstract expressionists, abstract impressionists, action painters, or what have you. They couldn't even agree on a name for their club.

Meetings at the Cedar tended to be impromptu; you never knew whom you might meet. Social life was very free; you were neither host nor guest and you could come and go as you pleased. Old and young artists interacted freely. The tavern was, as Elaine de Kooning commented, a place of accessibility. Out-of-town artists would arrive looking for contacts and information. The Cedar was used by newcomers as a way of getting known. Habitués who could not show up would phone to have *themselves* paged. John Krushenick was once paged when he was at the bar. He said, "It can't be for me. I'm here."

As at the Waldorf Cafeteria, the primary activity at the Cedar was arguing about art. Indeed, artists came to the bar just to talk. That was more important than drinking, at least in the early days. In retrospect, the move from the Waldorf

Cafeteria to the Cedar marked the switch from coffee to beer and then to whiskey, even for artists who could not afford it, since their temporarily more affluent friends would stand drinks. At first, no one had enough money for serious boozing. Elaine de Kooning said that in the forties, artists never had hangovers. But with growing affluence many soon did; and for some of them monetary success turned out to be disastrous. However, I was not affected. I was a one-drink drunk—and a happy one—who rarely consumed enough alcohol to have any next-morning miseries.

Pollock would show up one night a week—Monday, if memory holds—after seeing his therapist and already drunk. Stories about his visits abound, particularly about him and Kline, whom he sought out. On one occasion, while Kline was making a phone call, Pollock rocked the booth until he tore it from the wall. Another night, Pollock picked a fight with Kline, knowing from past encounters that his friend would not hurt him, but just this once Kline hauled off and whacked Pollock. Pollock grasped Kline in a clinch and was heard to whisper, "Not so hard, Franz." There was also the time that Pollock ripped the door of the men's toilet off its hinges and Bodner banished him from the bar but relented when he saw Pollock standing forlornly outside, looking in through the window.

As part of my art education and then my research, I often jotted down the conversation of artists at the Cedar. The following is culled from notes taken on a typical night, this one in 1957. Among the participants were Paul Brach, Herman Cherry, Philip Guston, Morris Kantor, Nicholas Marsicano, and Mercedes Matter. They began by discussing the show of 1930s art at the Poindexter Gallery—who was included and who was left out (Guston, Kantor) and why. Aristodemos Kaldis came in with the newly published Poindexter catalog and passed it around. The page with a 1930s painting by Gorky was held up, and the discussion shifted to how closely he copied Picasso and whether his 1930s pigment-laden pictures were painted in thin layers or piled on thickly. Guston recalled a visit to de Kooning's studio in 1938 where he was shown a painting of a man; de Kooning had been working on the man's eye for several weeks. That prompted Matter to talk about how she and de Kooning assisted Fernand Leger on a mural for the French Line pier in 1936. Marsicano said that the Depression thirties were a bad time for artists. Kantor agreed but added that he had painted some good pictures.

Guston changed the topic to the *Nature* show at the Whitney Museum, telling of the exchange of letters between himself and its director, Lloyd Goodrich. He agreed to allow Goodrich to exhibit his picture, but only if the catalog included his denial that his work had anything to do with nature. Inspired by Guston's letter writing, Cherry spoke of the beauty of artists' letters, particularly those of Pissarro, Cézanne, van Gogh, and Gauguin. The conversation then switched to Phillip Pavia's idea for a magazine (it would be called *It Is*) and what kind of art it would be for and against. Cherry said it would be against middle-class art. Someone

asked, "What is middle-class art, and how does it differ from academic art?" Guston answered, "Art that continues in a manner past its prime is academic." Brach interjected that according to that definition, followers of de Kooning could be considered academic. Cherry disagreed. Other topics were the suitability of flowers as the subjects of painting; Larry Rivers and the $64,000 television quiz program in which he was a contestant; the Picasso opening; who *Art News* had overlooked in the early 1940s; and where people were going for the summer.

The Cedar Street Tavern closed in 1963. The entire block on which it was located was torn down to make way for a new apartment building. After that, some artists began to frequent Dillon's bar, three blocks to the north on University Place. By then, most of the earlier habitués had already stopped coming regularly—and so had I.

In the process of looking into the early meeting places of avant-garde artists, I talked to Robert Motherwell and Mark Rothko about a school that they, along with William Baziotes and David Hare, founded in the fall of 1949. Rothko said that it was Clyfford Still's idea, proposed when they drove in Still's Jaguar to visit Motherwell in East Hampton. Still participated in the initial planning but did not teach; Barnett Newman joined the faculty somewhat later. Named the Subjects of the Artist School, its prospectus stated that there would be no formal courses but that the teachers would conduct "a spontaneous investigation into the subjects of the modern artist—what [they] are, how they are arrived at, methods of inspiration and transformation, moral attitudes, possibilities for further explorations, what is being done now and what might be done, and so on." The purpose of the school was not to teach techniques or the components of styles but to focus on varieties of content.

To broaden the education of its students, the faculty invited avant-garde artists to speak at a series of Friday evening lectures. The talks were open to the public (admission for nonstudents was 75 cents). The early speakers were invited by Motherwell. After four sessions, he asked Newman to take over, and Newman arranged the remaining programs, occasionally in collaboration with Motherwell and with the assistance of Robert Goodnough. For their efforts, speakers received a bottle of whiskey, dinner with Motherwell and Newman, and the gate, minus the cost of chair rental. The audience numbered from 85 to 115 or so (the largest turnout was for Jean Arp). The School closed after one semester, but the programs were continued by a group of New York University professors who, in order to provide working space for their students, rented the loft and renamed it Studio 35.

Newman recalled that at the beginning, "We were all timid. None of us had talked in public before." But the artists gained confidence, and soon public speaking would become a common activity. Beginning in 1949, the artists who

delivered talks on their own work were Rothko, Peter Busa, Robert Jay Wolff, Arp (interpreted by Frederick Kiesler), and Fritz Glarner. Joseph Cornell showed his own films on one occasion and, on another, rare early fantasy movies that he had collected. Other lectures were by Newman on the prehistoric Indian Mounds in Ohio, Richard Huelsenbeck on "Dada Days," Willem de Kooning "On the Desperate View" (his paper was read by Motherwell), Harold Rosenberg on "The Furies," Gottlieb on the "Abstract Image," and Ad Reinhardt on "Abstraction."

Julian Levy also spoke "On Surrealism in America." He was a replacement for Arshile Gorky, who had recently died. On Newman's insistence, he recounted the story of his personal involvement with surrealism. There was also a panel discussion on the topic, "What Has Happened in American Painting in the Last Two Years." The participants were Baziotes, de Kooning, Harry Holtzman, Motherwell, and Reinhardt. The final activity of Studio 35 was a three-day closed conference, April 21–23, 1950. The proceedings were stenographically recorded, edited by Motherwell, Reinhardt, and Goodnough, and published in *Modern Artists in America* (1951). In the introduction to this publication, the reason for the decline of Studio 35 is given: "These meetings . . . tended to become repetitive at the end, partly because of the public asking the same questions at each meeting." The Club was to avoid this problem by making it somewhat difficult for non-members to gain entry.

In a conversation with me, Motherwell summed up the goals of the School. "It had three," he said: "One, to make a little money for the teachers; two, to enable students to interact with a variety of avant-garde artists; and three, to provide a meeting place for the avant-garde and its audience." "What was its track record?" I asked. He replied: "The School failed in the first two of its aims and succeeded in the third. A modern art school was turned into a modern art forum."

Many of the founding members of The Club attended the lectures at the Subjects of the Artist School and a few spoke there. However, the School was not The Club's parent body, as was often claimed. The two were formed independently. The teachers at the School were "uptown" artists. The charter members of The Club, lived "downtown" and constituted a different social group. In the late fall of 1949 they met informally at Ibram Lassaw's studio for the purpose of finding a meeting place.

As administrator of The Club and aware of its importance in the history of the New York school, I set out to learn as much as I could about it. One obstacle was the myth that had been woven about its evolution, even as early as the middle 1950s. It took some hard digging to get to the truth. The artists who met at Lassaw's studio included Giorgio Cavallon, Peter Grippe, Franz Kline, Willem de Kooning, Landes Lewitin, Conrad Marca-Relli, Phillip Pavia, Milton Resnick, Ad

Reinhardt, James Rosati, Ludwig Sander, Joop Sanders, and Jack Tworkov (and the dealer Charles Egan). Elaine de Kooning and Mercedes Matter also attended but were not considered charter members because they were women; such was the masculine ethos at the time. The founding members rented a loft at 39 East Eighth Street and fixed it up.

Why did they decide to organize a club? The initial reason was that they found the Waldorf Cafeteria unpleasant and wanted a comfortable space where they could talk and have coffee. But there was another compelling, though not always conscious, reason to get together: the need for mutual support. In the face of art-world and public hostility, indifference, and ignorance, vanguard artists created their own art world, composed mostly of other artists. They had long traded studio visits and discussed each other's work for hours with great frankness. The Club was a semipublic outgrowth of these private meetings.

The abstract expressionists would not have been motivated to organize a club had they not achieved a sense of confidence in the worth of their art and a concomitant anger at its neglect. Emboldening them were a series of impressive one-person shows at the galleries of Peggy Guggenheim, Betty Parsons, Samuel Kootz, and Charles Egan, which revealed to the artists the significance of what they had created and generated a sense of collective excitement. Gallery owners are often denigrated as money-grubbing exploiters of artists, but not the audacious and discerning dealers of avant-garde painting and sculpture who first risked showing it. At the same time, critics such as Clement Greenberg, Manny Farber, Thomas Hess, and Robert Goldwater directed public attention to the new American painting, and proclaimed that it was more vital, radical, and original than any being produced elsewhere.

The growing recognition of vanguard artists provoked them to speak out against art-world rejection. In 1948, a meeting called by artists at the Museum of Modern Art censured hidebound critics in general and the statement attacking modernism issued by the Boston Institute of Contemporary Art. In 1950, at the end of a three-day conference of avant-garde artists at Studio 35, Adolph Gottlieb suggested that the jury that had selected works for a major show entitled *American Painting Today*, 1950 at the Metropolitan Museum be repudiated as hostile to modern art. Gottlieb proposed sending a public letter to the president of the museum, and drafted it in consultation with Newman, Motherwell, and Reinhardt. The letter denounced the conservatism of the five regional juries, the national jury, and the jury of awards. It stated that the "choice of jurors . . . does not warrant any hope that a just proportion of advanced art will be included." Consequently, the signatories would boycott this "monster" show. The letter was signed by eighteen painters and supported by ten sculptors.

Newman hand-delivered the letter to *The New York Times* and it ran as a front-page story on the following day under the heading: "18 Painters Boycott

Metropolitan: Charge 'Hostility to Advanced Art.'" *The New York Herald Tribune* also published an editorial titled "The Irascible Eighteen" (giving the artists a label). Other newspapers, magazines, and even national publications featured the controversy. The report in *Time* was accompanied by reproductions of paintings by Baziotes, Reinhardt, and Hans Hofmann. *Life* not only covered the story but in 1951 published a group portrait of the dissident painters. Pollock, Pousette-Dart, and Still objected to posing for a mass-media magazine, but they all showed up. The photo in *Life* was the most dramatic sign of the abstract expressionists' public acceptance. This collective portrait has been reproduced so often and disseminated so widely that it has become the iconic image of these artists who achieved the triumph of American painting.

The "Irascibles" controversy was a key event not only because the abstract expressionists as a group had broken through to the general public for the first time but because it was a sign of a new collective consciousness. However, it is difficult to specify what the basis of that consciousness was, since the artists worked in diverse styles, never issued a manifesto, and strongly resisted the notion that they were a group. At the three-day conference at Studio 35, Alfred H. Barr, Jr., the founding director of the Museum of Modern Art, suggested that the artists should decide on "the most acceptable name" for themselves before others did. Barr went on to say that their work had been labeled "abstract-expressionist, abstract-symbolist, intra-subjectivist, etc." Willem de Kooning countered, "It is disastrous to name ourselves," and he spoke for the assembled painters as a whole. However, the abstract expressionists knew what they were against, namely outworn styles and discrimination by art officialdom.

The abstract expressionists continued to feel embattled, but their art was receiving growing recognition. In 1950, New York's Museum of Modern Art, the Whitney Museum of American Art, and Boston's Institute of Contemporary Art issued a collective policy statement which proclaimed "the continuing validity ... of modern art"—that is, "art which is esthetically an innovation,"—and promised that in the future they would treat advanced art fairly. A significant sector of the art establishment had begun to make friendly overtures to the American avant-garde. Indeed, it appears that in 1950 it suddenly became intellectually disreputable to dismiss avant-garde art out of hand or ridicule it as a lunatic or infantile aberration. If the wider public remained hostile to the abstract expressionists, the art world was beginning to become friendly. The proceedings at The Club should be viewed from this perspective. It provided a platform for an underground movement that was coming out into the open. That is, it served to call the art world's attention to the artistic achievement and ideas of the New York school.

The Club was governed by a voting committee, which consisted of those charter members who remained active and others it elected. By the end of 1952, some

twenty more were added to the voting committee, including Leo Castelli, Herman Cherry, John Ferren, Philip Guston, Harry Holtzman, Elaine de Kooning, Nicholas Marsicano, Mercedes Matter, and Harold Rosenberg. All Club policies were determined by the voting committee without recourse to the membership. No rule established at one meeting was deemed to limit the actions at subsequent meetings and minutes were rarely kept. In fact, no one seemed to remember just what decisions had been made from month to month. For example, as late as 1955, a subcommittee was appointed to identify who the charter members were. However, the dominant force in Club affairs was Phillip Pavia, who arranged the programs, made up any financial deficit, and ran most everything—his way.

There were certain established practices. To become a member, one had to be sponsored by a voting member and approved by the committee. A black-ball method was used—two negative votes (it had to be two because Lewitin generally voted no) and a candidate was rejected—but this was occasionally ignored. New members were selected because of their compatibility and not because of the style they worked in. I began to attend Friday sessions regularly in 1954, as a guest of Angelo Ippolito and other artists I had gotten to know. I was proposed for membership in 1955 and sponsored by Pavia and Lewitin (one of the rare times he backed anyone).

In the beginning, new members were charged an initiation fee of $10 (sometimes waived for poorer artists), presumably to buy a chair, and monthly dues of $3; later the dues were lowered to $10 or $12 annually. Membership jumped quickly. By the summer of 1950, the original twenty or so had tripled. An entry in the minutes a year later reads, "77 members + 11 deadheads." Most of the abstract expressionists, even the ones uptown, such as Motherwell, Gottlieb, Baziotes, and Newman, soon joined. However, Pollock, Rothko, and Still never did. Frequent attendance, however, was another matter. The regulars tended to be those who had congregated at the Waldorf and their friends who lived south of Twenty-third Street. In 1955, the voting committee limited total Club membership to 150. It was later raised to 200.

The Club was meant to be private and informal. At first, every member had a key and came when he or she pleased. Meetings were generally prearranged by phone on the spur of the moment. But The Club soon took on a more public and formal character—against the wishes of many of its members—first by inviting speakers (prompted by the Studio 35 sessions), and then by arranging panels. In order to be both private and public, free-wheeling roundtable discussions, limited to members, were held on Wednesdays (until 1954); on Fridays, lectures, symposiums, and concerts were presented.

Each Club member in good standing was permitted to bring guests or to write them notes of admission. But few nonmembers, if persistent, were denied entry; it was usually sufficient to announce the name of the member who was supposed to have invited one. At first, guests came in free; later, there was a 50-cent charge,

presumably paid by the member, not the guest, to emphasize the private nature of The Club. The guests tended to be critics, historians, curators, collectors, dealers, and avant-garde allies in the other arts.

Initially, only coffee was served at The Club. Subsequently, a bottle of whiskey was provided to oil up the panelists, and still later, whiskey was served after the programs, the costs defrayed by passing a basket. Those who happened to have money at that moment pitched it in, those without were excused. The Club was a social meeting place as well as a forum. All of its members recall fondly the camaraderie, the drinking, the fun, and above all, the dancing, at times until daybreak, to a broken-down record player that painter Giorgio Cavallon was often called upon to fix. The first location had a fireplace and artists would pick up wood crates on their way. Sculptor James Rosati recalled, "The first New Years party consisted of myself, de Kooning, Kline, Lewitin, Cavallon, and Ludwig Sander. A fire was lit and we decorated the place with Christmas stuff we found on the street. Each of us had a section of wall, and we created a tremendous collage made up of junk materials. It was a beautiful thing. We all bought bottles of booze and stayed up all night. It was one of the warmest evenings in my memory. We repeated it the next year."

The major innovators of abstract expressionism, namely Pollock, Still, and de Kooning, had achieved their radical "breakthroughs" to their mature styles a year or two before the founding of The Club. But their work and its rationales—and that of their colleagues—continued to be problematic until well into the 1950s, and required more elucidation and interpretation. Moreover, there were many new issues confronting avant-garde artists as well as some old ones that needed to be jettisoned. As Milton Resnick said: "The function of The Club was oral waste disposal." The need to talk was urgent enough to keep "these highly individualistic artists together, their ideas criss-crossing and overlapping in a conflict that would tear apart any other togetherness," as Pavia put it. "They faced each other with curses mixed with affection, smiling and evil-eyed each week for years." Reinhardt was less generous in his appraisal. In a postcard to me shortly after my article on The Club appeared in *Artforum* in 1965, he derided the idea of The Club as "the good old days." "What to add to your 'facts' of The Club? The 'fantasies'! . . . The realities, the real story of the Club from week to weak were in the fantasies which were really fantastic, the real fantasies, inner, outer, uptown successes, downtown failures, conspiratorial consensuses, fake camaradaries, artists' inhumanities to artists, the 'love' of 'life' was the kiss of death."

Much of the informal talk at The Club was about mundane matters: tips on where to buy cheap art materials (a perpetual topic), sports, gossip, personal problems, but not politics, at least, not when Pavia or Lewitin were around. As Resnick said, "One of The Club rules—no politics." It must be stressed that The Club never had a collective mission or promoted an aesthetic program. In fact, its

members, passionately individualistic, abhorred ideologies and categories—anything fixed that might curb expressive possibilities. "We agree only to disagree" was the unwritten motto. Therefore, no manifestoes, no exhibitions, no pictures on the walls (size and placement might indicate a hierarchy), and as much as possible, no names of contemporaries, lest, through iteration, some be made heroes and, as Goldwater quipped, to prevent riots.

Despite the openness of discourse at The Club, the majority of its members worked in abstract styles, but they were a diverse group with positions as irreconcilable as de Kooning's and Reinhardt's. And most of the abstract artists were disposed to expressionism, central to which was de Kooning's, Kline's, and Guston's gesture painting. Gesture painting, as I dubbed it, or action painting, Harold Rosenberg's label, naturally became the main topic of discussion, particularly because each member insisted on talking about his own work and experience—a novel turn in New York art-talk, which in the past had focused on French art. Jack Tworkov recalled: "Suddenly we realized that we were looking at each other's work and talking about that and not about Picasso and Braque. We had created for the first time a milieu in which American artists could talk to American artists about their art and consider what they said *important.*"

The programs at The Club were organized by Pavia from its beginnings until the spring of 1955. By then its makeup had changed. Older members, Pavia's "boys," began to attend less often and younger artists replaced them. John Ferren took over from Pavia for a year. In 1956, I assumed Pavia's and Ferren's role, but my "boys" were not of the first generation of the New York school but of the second, my generation. I ran The Club until near its end in the spring of 1962.

My first step was to see that new members were added to the voting committee that was in charge of The Club. Younger artists were invited, and they soon took over leadership. My chief function was to organize the panels, lectures, and other activities, with the advice of a program committee, which I took only occasionally. The painter William Littlefield offered to help by making coffee, and the photographer Fred McDarrah became the doorman (which enabled him to take photographs—the only one allowed to—thus launching his career as the visual chronicler of the avant-garde).

The early lectures at The Club covered many facets of modern culture. Among the speakers were philosophers William Barrett, Hannah Arendt, and Heinrich Bluecher, composers Edgard Varèse and John Cage, artist Kurt Seligmann, social critic Paul Goodman, cultural anthropologist Joseph Campbell, museum director Lloyd Goodrich, and art critics Harold Rosenberg, Thomas Hess, and Nicolas Calas. There were also concerts by the Juilliard String Quartet and David Tudor, and parties held in honor of Alexander Calder, Marino Marini, and Dylan Thomas.

A selection of events from the fall of 1951 to the spring of 1952 indicates the

range of artists' interests and aesthetic positions. On different nights, there were talks by Max Ernst on his work, Lionel Abel on modernity, Peter Blake on the collaboration of art and architecture, Hubert Kappel on Heidegger, John Cage on contemporary music, and Dr. Frederick Perls on creativity in art and neurosis (one of the few talks at The Club that dealt with psychology). There were also four symposiums on abstract expressionism, prompted by the publication of Thomas Hess's *Abstract Painting*. Among the participants were William Baziotes, Elaine and Willem de Kooning, Burgoyne Diller, John Ferren, Robert Goldwater, Adolph Gottlieb, Philip Guston, Thomas Hess, Franz Kline, George McNeil, Ad Reinhardt, Harold Rosenberg, Kurt Seligmann, and Jack Tworkov. The discussion on abstract expressionism was continued by a group of younger artists and critics: Jane Freilicher, Grace Hartigan, Alfred Leslie, Joan Mitchell, Frank O'Hara, and Larry Rivers. Other panels were on purist ideas in art, the image in poetry and painting, and new poets (with John Ashbery, Barbara Guest, O'Hara, and James Schuyler).

Of all the subjects discussed at The Club, the one that recurred most often and gave rise to the hottest controversy was the problem of community, of defining shared ideas, interests, and inclinations, and how they might be changing. Much as the abstract expressionists hated the thought of a collective style, its possible existence concerned them. The issue of group identity was also raised earlier, at the Studio 35 sessions in April 1950. Gottlieb said: "I think, despite any individual differences, there is a basis of getting together on mutual respect and the feeling that painters here are not academic." Newman picked up this point. "Do we artists really have a community?"

This question was central to symposiums on "Abstract Expressionism" at The Club in 1952. Even the label was in dispute; Pavia called it "The Unwanted Title." Eight panels in April and May 1954 were entitled "Has the Situation Changed?" I arranged another series with the same heading in January 1958 and February 1959, followed by four panels on "What Is the New Academy?" in the spring of 1959, which were continued in seventeen statements by artists published in *Art News*, summer and September, 1959. However, no consensus was ever arrived at.

The conversational style at The Club was confessional. You talked about your own art and ideas. If you quoted anyone else or, what was worse, books you had read, Milton Resnick would brand you a German professor. It was not always easy to follow the discourse. Artists refused to begin with formal analysis, pictorial facts, or the look of works. This approach might have implied that the abstract expressionists were fabricating pictures in predictable and established styles whose attributes could be identified. The artists vehemently denied that this was the case. They supposed that their peers understood how a picture "worked" in formal terms. Therefore, they tended to talk about how and why they involved themselves in painting, the purpose of art, and the nature of the artist's moral commitment and

existential role (but with very little reference to Sartre or Camus). In sum, they tried to translate into words their creative experience rather than the art object.

Conversation was treated as the verbal counterpart of their art-making activity, and artists tried to convey what they really felt in both. This created frustrating difficulties, because such ideas can rarely be checked against specific works. As Goldwater wrote,

> The proceedings always had a curious air of unreality.... The assumption was that everyone knew what everyone else meant, but it was never put to the test; no one ever pointed to an object and said, see, that's what I'm talking about (and like or don't like). Communication was always entirely verbal. For artists, whose first (if not final) concern is with the visible and the tangible, this custom assumed the proportions of an enormous hole at the center.

Self-confession did lead artists to take liberties with and to strain language and logic, but there were compensations. What they had to say they said directly, personally, and passionately. It could result in incoherent and egotistical bombast and often did, but it also yielded original, trenchant, and provocative insights. For example, in 1959 George McNeil spoke of the grayness of his life as a painter and how that bothered him:

> I wish I could relax and sit in the park. I want an art that has life in it—its sweat, its shit, its joy—everything. That's why I hate Newman. He stands outside of life. Mondrian is different; his facade covers a rich living being. Mondrian's surfaces are rich; Newman's are impoverished. Van Gogh is the painting counterpart of Kierkegaard and his life justifies mine and that of other artists today. An artist first creates and then makes up ideas about what he has done. Painting ideas is the death of art. I simply do not know how to *make* a painting.

Speaking in the first person, from the gut, as it were, made the conversation at The Club intense and exciting. As Goldwater remarked: "The consciousness of being on the frontier, of being ahead rather than behind, of having absolutely no models however immediate or illustrious, of being entirely and completely on one's own—this was a new and heady atmosphere." But the atmosphere was also fraught with anxiety. Without models to fall back on, how would one know whether one succeeded or failed? Talking it out helped reassure artists that their essays into uncharted areas were not delusional. As Alex Katz commented, "The Club was a place where artists revealed their insecurities, defended and promoted their ideas, pled for understanding—before an audience of equals. It could be pathetic; it was necessary."

The verbal style of The Club also generated bitter personality conflicts, for, as Goldwater remarked, "Since the artist identified with his work, intention and

result were fused, and he who questioned the work in however humble a fashion, was taken to be doubting the man." Reinhardt made it a practice of doing both— and got away with it—which says something about the openness of The Club. He tut-tutted all assertions of the anguish of creation, the risk, the suffering, and he chastised art that was alleged to embody angst.

Art-talk at The Club was often elating. I found it so, as did Jack Tworkov. He caught some of upbeat spirit of The Club in an entry in his journal of April 26, 1952.

> The Club is a phenomenon—I was at first timid in admitting that I like it. . . . There was the prospect that the Club would be regarded either as bohemian or as a self-aggrandizing clique. But now I'm consciously happy when I'm there. I enjoy the talk, the enthusiasm, the laughter, the dancing after the discussion. There is a strong sense of identification. . . . Here I understand everybody, however inarticulate they are. Here I forgive everyone their vices, and I'm learning to admire their virtues. How dull people are elsewhere by comparison. I think that 39 East 8th is an unexcelled university for an artist.

However, there was also constant gossiping, backbiting, and bickering, which is not surprising in an art world as small as the New York school. Little of this bad-mouthing is remembered or recorded, but in 1957, I jotted down one such session between two founding members of The Club—Milton Resnick and Landes Lewitin. The topic was the conflicting attitudes of New York painters to the school of Paris. Resnick, pointing a finger at Lewitin: "You poisoned our atmosphere by saying everything good came from France." Lewitin responded: "There is more talent in the United States than in the whole of Europe, but the question is what comes out. I'm talking about false values." Resnick, emphatically: "Let's talk about America. You have dislocated part of your brain which is in France, not America. The only thing about Paris that was meaningful was that at one time it was the center of art. This was important to us, because we were provincial." Lewitin disagreed: "Paris still is the center." "No longer," countered Resnick: "Now it's provincial. Why was it when twenty of us sat around in the Waldorf, good and strong artists, you made up a list of Parisian artists that made us look like a bunch of weak sisters." Lewitin asserted: "You still are. De Kooning is America's greatest artist, and he's shitty."

Resnick, with a snort: "France. Why does Grant Wood appeal to the French, who think of it as American art?" Lewitin added: "It's the same French that hate Matisse." Resnick said: "The French don't consider Matisse's art French. Just something to be exported to America. Picasso's art is also not considered French." Lewitin then said: "Phillip Pavia brought a copy of Hess's book [*Abstract Painting*] to the old Club. De Kooning staggered in and sat down. Then Pollock staggered in. He said to me, 'Did you see my show?' I answered, 'You used to be a good painter. Why did you give it up?' He laughed. Then he said to Bill, 'Did you write this

book? Are you a better painter than I am? You can't paint. Who wrote this book? Your wife?'"

I asked Lewitin: "Is there anyone on your list of artists who's any good?" Resnick spoke up sadly: "There's something bad in the atmosphere. All we seem to be able to talk about is what we don't like." Lewitin said: "When they roll out the red carpet, the guy who straightens the corners will pull it." Resnick responded: "De Kooning called you a carpet puller."

Among the many characters who frequented The Club, Lewitin and Aristodemos Kaldis stand out. Lewitin was stout and sallow in complexion. Soberly dressed in a black suit and a narrow black tie, he looked like a prototypical bourgeois, although when outdoors, his black beret tagged him as an artist. Lewitin despised the abstract expressionists and at every opportunity savaged them with humorless wit. His primary hate was Kaldis, a prototypical bohemian. Kaldis was not a member of The Club but attended regularly, and had the last say at every panel he attended, booming his opinions at great length with a heavy Greek accent, stopping only when he sensed that the assembled audience, waiting impatiently for the drinking and dancing, would physically throttle him.

At an opposite extreme, Ludwig Sander, short and rotund, punctilious in appearance and speech, with total recall, recounted everything in great detail in a flat monotone. Over it all, Phillip Pavia presided, assuming in a raspy voice the role of spokesman for "the boys"—that is, de Kooning, Kline, and their cohorts. Indeed, The Club was frequently referred to as de Kooning's club,—with some justification. Tworkov recalled that until the mid-fifties, when de Kooning began to drink heavily, he was the most influential of downtown artists. He was a blunt but captivating conversationalist and attracted people to him. He set The Club style.

Younger artists began to frequent The Club in the early 1950s. Larry Rivers recalled: "The Club was a place to go Friday nights to see and be seen… The artists all seemed serious. [Some] had personal memories of Mondrian, Grosz, Léger, and the surrealists and dadaists who came to this country fleeing Europe before and during World War II. [The older artists] were like parents; they seemed powerful, and you got a lot from them." The talk at The Club "made me feel that art had an intellectual as well as an emotional content." Rivers concluded that "The club gave me a feeling of importance about being an artist and a part of something."

Almost from the start, avant-garde artists in the other arts were invited to lecture and participate on Club panels. They also began to attend the sessions and interact with its members. One reason for this coming together was that the some 250 artists in the New York school constituted the core audience for the other avant-gardes—in many cases the only audience. John Cage once remarked to me that artists really did not like his work. But they all came to his concerts, I pointed out. He replied: "Well, if they didn't, there'd be nobody there." He simply

assumed that one vanguard would support another, admire the work or not. The artists in attendance all knew each other. At one Cage-Cunningham concert, Harold Rosenberg was alleged to have quipped: "Here it is almost curtain time and the Lassaws aren't here yet. . . . There's a stranger in the third row. Throw him out." Among frequent visitors at The Club were composers Cage, Morton Feldman, and Lucia Dlugoszewski; dancers Merle Marsicano and Erick Hawkins; poets Edwin Denby, Frank O'Hara, and James Schuyler. Art critics Thomas Hess and Harold Rosenberg, and museum directors and curators Alfred Barr, Dorothy Miller, and Holger Cahill also attended. Getting to know the artists encouraged art professionals to pay growing attention to the New York school.

The beat poets occasionally visited the Cedar Street Tavern and attended artists' parties, but they were not part of the artists' scene. They did pal around with a few artists—Alfred Leslie, for one, who made the movie *Pull My Daisy* starring Jack Kerouac. I was with Kerouac at one party. He sprawled in the bedroom most of the night talking on the phone. I invited Allen Ginsberg to participate with curator and art historian Peter Selz and others on a panel at The Club. Ginsberg brought Gregory Corso, who perched himself on a high radiator above the audience. I don't remember much of what was said. At one point Corso began to chant "Death, Death" and Ginsberg answered with "Life, Life." At the end of the panel, Ginsberg jumped on Selz and began choking him, because of some policy disagreement about *Big Table* magazine. Years later I met Ginsberg at a reception and recalled that event. He smiled and said: "That was not one of my better nights."

We all read beat fiction and poetry. We thought that their conception of spontaneous prose was influenced by gesture painting, but we had little sympathy for the beats' "crazy credentials" or bad-boy Buddhism. By 1959, the beats had been coopted by mass culture. One could Rent-a-Beatnik, make Ginsburgers from *The Beat Generation Cookbook*, or slaver over a beat Playmate in *Playboy*.

In 1961, Elaine de Kooning said to me: "The Club has 200 members and none of them is black. Why?" Concerned, I asked Hale Woodruff, a colleague of mine at New York University: "Why aren't you in The Club?" He laughed and said: "I was asked to join but I had been around too long for that." "But," I said: "I find it hard to believe we're racist. Why do you think there are no black artists in The Club?" He replied: "Count them." I said: "Romare Bearden, Norman Lewis, Charles Alston, Bob Thompson, Ted Joans." And I stopped. "Well that's it," he said. I asked: "Why so few?" He shrugged and said: "I've often wondered about that. It may be that poor ghetto youths don't want to enter another life of poverty."

I asked Romare Bearden whether there was racism in the New York art world. His response was, not overt, but black artists were rarely invited to dinners and parties of collectors and other art-world powers, where careers were made. When I posed the same question to Norman Lewis, he replied bitterly: "You know that

famous photograph of the conference at Studio 35." "Yes," I said. "Well, I'm the only black face there and the only one who has gotten absolutely no recognition. Do you think that the one thing is related to the other?" He had a point, even though there were other artists in the photograph who were also overlooked.

African-American artists began to enter the art world in considerable numbers in 1963. In that year, Romare Bearden and Hale Woodruff formed an organization of African-American artists interested in civil rights, including my students Emma Amos and Alvin Hollingshead. They named it the Spiral Group, the title symbolizing an ever-broadening and upward movement. At their meetings, the discussions soon involved a critique of each other's works, the problems of African-American artists and their role in the art world, preparation for a group show, and debates over the possible existence of a "black" aesthetic or "Negro image," an issue that was never resolved.

The idea of mounting an exhibition of the works of Club members—like a big salon—was broached many times but was vetoed because it might indicate a trend or position and curb the open character of The Club. De Kooning believed strongly that anonymity was vital, and he was heeded. However, in 1951, Resnick began promoting the idea of an exhibition. Kline, Marca-Relli, Ferren, and Cavallon were enthusiastic, and de Kooning changed his mind. It then was decided to have a show, but not under the direct auspices of The Club. With the help of Leo Castelli, a group of charter members leased an empty store at 60 East Ninth Street (next door to the studios of Kline, Marca-Relli, and Ferren) for $70, and drew up an initial list of participants. Castelli recalled in 1957:

> The store was in terrible shape, but we all pitched in to clean it up. Kline designed the announcement. I footed the bill, although everyone was supposed to contribute. However, some of the artists, de Kooning, for example, gave me a drawing. Technically, inclusion was by invitation, but almost anyone who wanted in could get in. Pollock wasn't too interested but he did send a painting which was hung vertically instead of horizontally. It took about three days to install the show because artists came in and complained about the placement of their works. The show had a big sign on canvas which covered the whole front of the building. The opening was on a warm May day. There was a great crowd. Alfred Barr attended and was very surprised and excited. He wanted to know how the show came about and I went with him to the Cedar Street Tavern and we talked for a long time. The show was well attended; it closed on June 10.

The sixty-one artists listed on the announcement of the exhibition read like a Who's Who of the New York school's downtown component. However, with the exception of Motherwell, uptown painters who had been connected with, or close

to, the Subjects of the Artist School (Baziotes, Gottlieb, Newman, Rothko, and Still) did not contribute canvases. What was the upshot of the show? Castelli said: "The participating artists were elated. It proved that their art was new and important— and better than what was being made in Paris." Encouraged by the success of the *9th Street Show*, participating artists decided to organize further group exhibitions that they themselves would select. Eleanor Ward of the Stable Gallery offered her space, and the Stable Annuals, as they came to be known, were mounted from 1953 to 1957.

I did not begin to record Club proceedings in earnest until 1954. In the spring of that year, I jotted down questions posed by Belle Krasne during a panel titled "Ideas in the Art of the Past Decade." They were: "What are the distinguishing characteristics of the new artistic trends? To what extent do they follow from movements which arose earlier in the century? To what extent— or in what respects—are they different? What are their essential ideas? techniques? materials? Are there differences between the trends here and abroad? Are there similarities?" These issues were debated repeatedly during the next half-dozen years.

A panel titled "Germinal Sculpture" that took place at The Club in the spring of 1955 was a more or less typical Club session. Clement Greenberg began: "The renaissance tradition of sculpture was challeged by construction sculpture whose source was in cubist collage. This was new, newer than abstract painting. Construction sculpture did not look like art, but this did not frighten its innovators. It does their followers who have regressed to biomorphic forms—plant, bone, muscle. As a result their work has become decorative." Ibram Lassaw objected: "We did it to extend the range of sculptural form."

Greenberg then said: "Picasso was the font of construction sculpture." Frederick Kiesler protested: "He was not the only innovator. There were others, Archipenko, for example. There are broader social and cultural conditions that affect many artists." "True," Greenberg responded, "but the strongest line extended from Picasso to Gonzales and Giacometti." Sidney Geist agreed: "We did it because Picasso did it." A chorus of noes from the floor. Sidney Gordin called out: "We did it first. Then we found out Picasso did it." "Be honest," exclaimed Geist: "Where did you get it?" Gordin answered: "I swear I got the idea first." Al Newbill addressed Geist from the floor: "There are ideas that travel deeper than the level you are trying to keep things on." "No," said Geist: "I can't accept the zeitgeist idea." Richard Stankiewicz interjected: "If Picasso had done what he did fifty years earlier, would anyone have paid attention?"

Lassaw then said: "Let's keep in mind the influence of the Eiffel Tower on sculpture. Also Spanish iron works." Kiesler added: "The Crystal Palace in London." Lassaw continued: "The development of technology—welding, new materials—anticipated construction sculpture. Would the ancients have used

stone and bronze if they had welding and steel?" Willem de Kooning interposed: "I don't understand this line of reasoning. What's wrong with modeling and casting? If you like new mediums, that's one thing, but it isn't necessary that we use them. Fantastic things are being done with casting. You are putting an aura around an open shape that is supposed to make it good." Newbill added: "What Bill is trying to say is that technique is irrelevant to art." Kiesler disagreed: "The next material for sculptors will be plastics. Metals are old hat."

Geist asked: "What are the political or social influences on our work? Are there any? I think art has a social responsibility, an idea I picked up in the 1930s. Artists owe something to society." Stankiewicz asked: "How much does society support artists?" There was an awkward silence. De Kooning concluded the panel: "We always duck social issues."

There was so much art-talk in studios, the Cedar Street Tavern, and The Club that in the spring of 1957 I decided to make the very discourse itself the topic of a panel I titled "The Painter as His Own Poet." Harold Rosenberg began by saying: "Artists have been talking at these sessions for almost ten years, but the most popular speech has been that they shouldn't. Eloquent artists have been going on for hours about how they should keep silent. So the denial itself has become a subject. But there is another question: To whom should the artist speak? Should he talk to anyone or be careful to whom he talks?" Nicholas Marsicano responded, "Perhaps the issue is how to shut artists up. The best words don't make the best paintings. Yet there is a compulsion to babble." Frank O'Hara stood and said slyly:

When they talk, painters immediately declare that they are inarticulate. That's charming. Many painters talk in paradoxes, and this too is nice. Poets are just as inarticulate as painters when they talk about how it is done. Poets who have distinguished themselves as critics—Baudelaire, Apollinaire— talked it over with the painters first and made a work of it. It was not just jotting things down. It was work. Baudelaire was critical. Apollinaire wrote prose poems. To whom should artists talk? You can talk to a wrong person, but it doesn't matter. What's important is what the artist didn't say. Everyone knows this. The rest is propaganda. We can't be afraid of unfriendly people. It is necessary to verbalize if anyone is interested, because it places you in society. You are free not to believe.

O'Hara ended his comment plaintively: "Today art does not need explaining. Everyone goes to galleries. No one reads poetry. Who needs poets?"

David Hare then asked:

Why should an artist speak at all? Painting is communication. Why use another medium? Is it because we are more familiar with the ear than the eye? Another issue is, can the artist write or speak? If he can't, then he shouldn't.

Let the critic do the speaking. The ideal thing would be for the artist to have someone who could speak for him in a kind of symbiotic relationship and tell the public exactly what he means better than he could, just as Baudelaire presented the painting of Delacroix.

Rosenberg said: "History shows that artists have made excellent writers, yet an idea has taken hold that artists ought to be primitive." Speaking from the audience, Jack Tworkov, with a bitter edge to his voice, picked up on Rosenberg's comment: "The worst praise an artist can get is that he is articulate. If a guy can't talk he is supposed to be a great painter. He may just be stupid." Paul Brach stood and concluded the panel: "I won't rhapsodize but I found this the most intelligent and mature meeting The Club has had this year." Rosenberg waved his hand: "We are happy to have your testimonial."

Recalling a decade's worth of panels and lectures at The Club, three come to mind vividly. In the fall of 1954, the Japanese painter Sabro Hasegawa, dressed as a Zen monk and sitting cross-legged on the table, told four Zen stories over and over for four hours. No one left. Many artists were curious about Zen and read books on it by Suzuki, Watts, etc., but apart from Lassaw and Cage, who embraced Zen, it did not give rise to much discussion at The Club.

In March 1961, David Sylvester read his book on Giacometti at The Club. (It was not published until 1994.) He began at 10 P.M. and finished at 2 A.M. Afterwards, he came to our apartment, stayed until seven, and devoured all the food in the house, including, happily, a pound of prune-filled cakes my stepmother, a terrible cook, had made. He insisted that we list the ten great painters of the twentieth century. Bonnard headed his list. My first four were Matisse, Picasso, Mondrian, and Miró, with Bonnard eighth or ninth. I told him that I thought most New York school artists and art professionals would agree. Sylvester said that if he asked for a listing in Europe, and someone did not put Bonnard first, he would leave because that person would not be worth knowing, but in America? Well, we were barbarians, which was why our art was so good. In a lecture at the Tate Gallery in the summer of 1996, Sylvester said that his visit to us in New York was very important to him, because it made him reconsider his selection and eventually to accept my list. Every time I met Sylvester we played the game of making lists. I was charmed by his passion for the artists he chose, no matter how often he changed them.

The most amusing incident at The Club occurred during a panel on which Marisol was a participant. She was notorious for her silences and one-word responses to any question—it was either yes or no. She came to The Club wearing a mask and as usual said nothing. At one point, someone called out, "Take it off, Marisol!" and the entire audience began to chant, "Take it off!" When the assembled artists became rambunctious, hooting and stamping their feet, she

removed the mask and revealed another mask that she was wearing under it. Shock, then uncontrollable laughter!

———

Along with The Club and the Cedar Street Tavern, the artist-run galleries on East Tenth Street between Third and Fourth avenues became the meeting places of the New York school. Near the middle of the block was the Tanager Gallery, founded in 1952, the gallery I "managed" from 1956 to 1959. It was the first of eight cooperative galleries—that is, showplaces founded, underwritten, and operated by artists—on and around Tenth Street; the others were the Hansa (founded in 1952), the James (1954), the Camino (1956), the March and the Brata (1957), and the Phoenix and the Area (1958). The Reuben Gallery, opened in 1959, was privately owned and therefore not technically a cooperative, but it functioned like one. The dues-paying members of the Tenth Street galleries, who numbered about 200, not only exhibited their own work but invited their friends, most of whom lived nearby, to show in their spaces.

The liveliest galleries were the Tanager, Brata, March, and Reuben. The founding members of the Tanager were Charles Cajori, Lois Dodd, Angelo Ippolito, William King, and Fred Mitchell. Other members were Alex Katz, Philip Pearlstein, and Tom Wesselmann. Among the nonmember artists who had one-person shows at the Tanager were Alfred Jensen, Rudy Burckhardt, and Gabriel Kohn. The Brata Gallery was founded by painters Nicholas and John Krushenick, who operated a frame shop behind the exhibition space to support themselves. Among Brata's members were Ronald Bladen, Al Held, and George Sugarman. The March had di Suvero. The owners of the Reuben Gallery took the advice of artists, notably Allan Kaprow, and turned it into a primary venue for environment and happening art. For example, its *Below Zero* show included, Jim Dine, Red Grooms, Allan Kaprow, Claes Oldenburg, Robert Rauschenberg, George Segal, and Richard Stankiewicz. I still have a vivid memory of Kaprow's mountain assembled from crumpled newspaper, Segal's plaster figure on a bicycle, and Rauschenberg's *Coca-Cola Plan*, in which were juxtaposed Coke bottles, an eagle, and a blueprint.

Why did artists believe it was important to exhibit on Tenth Street? Primarily, to show other artists what they had created. There were very few sales. As the Tanager "manager" I was not expected to sell work, although it was assumed that I would try, and I did. In my three years in the job I succeeded in making only one sale. It was during our Christmas group show, which included some 100 small paintings and sculptures. A woman came in and wandered about. I was writing a review for *Art News* and took no notice of her until she approached the desk and announced that she would like to purchase a work. We walked over to an abstract welded construction of a bull. The conversation went somewhat as follows.

"How much is it?"

"One hundred and twenty-five dollars."

Pause.

I thought, it's too much.

"But I know that the artist needs the money. I'll let you have it for eighty."

"If the artist is in need, I'll pay the full amount."

My mind by then was jelly.

"Will you leave a deposit?"

"I'll write a check for the entire amount."

"Can we keep it for the duration of the show?"

"Of course."

"And when the show comes down, where shall we deliver it?"

"To the Museum of Modern Art."

"Oh, and what's your name?"

"Mrs. Mellon."

"How do you spell that?"

At that instant I knew I would never become a dealer (and that's the only job in the art world I never held). The check was drawn on the Mellon bank in Pittsburgh. In retrospect I think, how innocent I was.

In looking back on the shows mounted in the cooperative galleries I am struck by their diversity. And yet Clement Greenberg later claimed that the painting on view had a "Tenth Street touch." If by "touch" Greenberg meant that most of the work, whether abstract or figurative, was gestural, then it was. But what he really meant was that artists on Tenth Street aped de Kooning, whose work he had come to dislike. De Kooning was certainly a hero to most Tenth Street artists, and a considerable number were influenced by him, as were young artists who showed uptown, such as Joan Mitchell, Grace Hartigan, Alfred Leslie, and Michael Goldberg. But the most interesting young artists who exhibited on Tenth Street, such as Katz, Pearlstein, and Held, were beginning to react against gesture painting. To put it directly, painting downtown was too varied to be identified by some "Tenth Street touch." Inventing one, Greenberg was able to put down both de Kooning and younger artists whom he thought were in competition with the stained color-field painters he was beginning to champion, none of whom showed downtown. Greenberg's sly comment was made in bad faith, and I think he knew it.

By the end of the fifties the downtown art scene centered on The Club, the Cedar Street Tavern, and Tenth Street was in decline. By this I mean that artists no longer felt the need to frequent the galleries or the scene there, certainly not an upcoming generation. The death knell was heralded in 1959 in an *Esquire* article titled "10th St.: Main Street of the Art World." Beneath the heading was a photo of an opening at the Tanager Gallery whose caption announced that "New York's

Tenth Street is to the twentieth century what Paris was to the nineteenth: the art center of the world." The article went on to say that the artists "live together in a close, structured community, where they form their own galleries, criticize one another's paintings, where approbation and judgment come from contemporary artists instead of critics and the public, where social position itself is determined not by how much money you've earned from your painting or where you've studied, but rather in terms of just how good an artist . . . you are." But what the article described was no longer what-was-happening but what-had-happened. The article did predict that Tenth Street would end up a "staid, conservative art academy"—but not yet. However, it already had.

# My Pantheon:
## Willem de Kooning, Franz Kline, Philip Guston, Mark Rothko, Ad Reinhardt, David Smith

## THE PAINTINGS OF WILLEM

The paintings of Willem de Kooning, Franz Kline, Philip Guston, Mark Rothko, and Ad Reinhardt, and the welded constructions of David Smith remain as vivid for me now as when I first saw them in the 1950s. The artists themselves became my heroes, and my friends, though not pals, since they were older and I had put them on pedestals. From my first encounter, I also was stirred by the painting of Arshile Gorky and Jackson Pollock, but I did not know them personally.

As I look back, I think that what initially moved me in the works of de Kooning, Gorky, Kline, Guston, Rothko, and Pollock—even before I recognized their originality and individuality—was a pervasive sense of anxiety. This mood pervaded American society in the 1940s—the decade of World War II and the atomic bombing of Japan that terminated it; the revelations of the Holocaust; and the early years of the Cold War. Stunned by the Japanese sneak attack on Pearl Harbor on December 7, 1941, which brought us into the global conflict—and me into the United States Marine Corps—a small group of avant-garde artists underwent a drastic and irrevocable change of outlook. This new vanguard, which included Gorky, William Baziotes, Robert Motherwell, Rothko, Adolph Gottlieb, Pollock, and de Kooning, felt that their art was in crisis. In the face of a cataclysmic war, what could they paint? They had already rejected social realism and regionalism as backward-looking and academic. The then avant-garde art, namely geometric abstraction, also seemed irrelevant in this traumatic time. Everything it stood for—rationalism, art-for-art's-sake, a brave new machine age, the explicit or implicit futuristic vision of man and society as perfectible—ceased to be believable.

The new avant-garde supported America's cause, but the war's violence, destruction, bestiality, and suffering gave rise to an "imagination of disaster," to borrow a phrase from Henry James, a fearful and anxious state of mind. The hot war brought into sharp relief the irrational side of humankind, a side that had to be addressed in any art that aspired to be relevant. The Cold War, with its threat of nuclear devastation, perpetuated and aggravated the disquieting consciousness of humankind's vulnerability and tragic condition.

After the war ended, the attitude of vanguard artists (and myself) was informed by the existentialism of Jean-Paul Sartre and Albert Camus, which, like abstract expressionism, had developed in the throes of world-wide conflict. Both

artists and philosophers suffered "alienation and estrangement" and believed that central to their being was, as philosopher William Barrett, an acquaintance of many of the artists, wrote, "a sense of the basic fragility and contingency of human life; the impotence of reason confronted with the depths of existence; the threat of Nothingness, and the solitary and unsheltered condition of the individual before this threat." I once asked de Kooning about the influence of existentialism. He replied: "It was in the air. Without knowing too much about it, we were in touch with the mood. I read the books but if I hadn't I would probably be the same kind of painter. I live in my world."

The sensibility of a time is very transient, and it is difficult to imagine what it was like to have been alive at any earlier period. Motherwell evoked the temper of the forties when he said to me in conversation: "I think that my generation is the most tragic that has ever existed. American painting is really after a sense of the tragic. If it is really tragic, then it may be great. If not, then it is of no consequence." To be sure, many artists—all but one or two of whom are now forgotten—have glossed over this dreadful decade in high-flown, optimistic rhetoric. De Kooning was not taken in. When I asked him what living in the forties was like, he recalled, "The Greek mythological business of Kaldis and Lewitin gave me a pain. How could you be Apollonian in the 1940s; you could only be pathetic." De Kooning's alienation was fueled not only by the war and its aftermath but by the hostility of the American public to avant-garde art. But he also said: "Nobody owes the artist anything. I don't have to be an artist. I chose to be one." Still, he wished for art-world and public recognition, since that would provide validation for his painting.

De Kooning—or Bill, as we called him—was the artist I most admired. Luckily for me, he lived and worked next door to the Tanager Gallery while I was employed there. To take a breather from painting he would drop into the gallery almost daily and chat with me. I found his insights on art incisive and provocative, and so did everyone I knew. However, when a know-nothing would ask belligerently: "What is that picture supposed to mean?" or some such question, Bill, who spoke with a Dutch accent that he never lost, suddenly wouldn't understand English or would answer thickly something like: "I dunno. Rich ladies like it." He was often funny in a blunt way. When invited to dinner by Nelson and Happy Rockefeller, he greeted his hostess, "Gee, Mrs. Rockefeller, you look like a million bucks." Composer Morton Feldman recounts that once when Bill was asked for his opinion of an abstract picture, he replied that it was awful. But then, told that it had been painted by a monkey, he said: "That's different. For a monkey, it's terrific."

Bill was a binge drinker who would be sober for lengthy periods of time, at least when I saw him regularly in the middle and late 1950s and early 1960s. Drunk, he could be abusive. Whenever I encountered him plastered at the Cedar

Street Tavern, I would wheel around and walk across the street to the Chuckwagon, a greasy-spoon cafeteria, where I would sit with Landes Lewitin, who presided there, and nurse a coffee, instead of a beer, through much of the night.

Drunk or sober, Bill was *the* painter of the New York school in the 1950s. Indeed, he was so revered by downtown artists that their conversations were boastfully studded with "me and Bill." A few sported a Dutch sailor cap because he did, and cultivated a Dutch accent. Even avant-garde artists outside of Bill's circle who had no use for his painterly drawing recognized his premier position. One such artist was Barnett Newman. Once in 1961, Bill and Barney met at our apartment to write a letter of protest to *The New York Times* against its art critic, John Canaday. Instead, they got to reminiscing about old times. The stories they exchanged were spellbinding, but the interpersonal dynamics were equally fascinating. In any social situation among artists, a kind of pecking order is established. Even Barney, who was one of the most self-aggrandizing painters I knew, deferred to Bill.

What was it about Bill's work that gripped so many artists—and me? His painting, as sheer *painting*, was unmatched by any of his contemporaries. He once said to art critic Peter Plagens that "a painter is great from the elbow down." Plagens added that Bill had that greatness. Bill's painting was based on drawing with the loaded brush. As such, it was not radically new—Chaim Soutine had done it earlier—but Bill's painting was often abstract, and Soutine's never was. Even when figurative, Bill's pictures looked nothing like those of his predecessor. Moreover, unlike Soutine's work, Bill's had a synthetic cubist infrastructure, but it did not resemble the composition of the current imitators of Picasso, Braque, or Mondrian, in which forms were outlined and filled in. Their kind of picture-making had been practiced by most modernist artists for more than a quarter of a century and had not only come to look outworn and stale, but could no longer express contemporary feeling.

Bill said that he would not base his work "on paintings in whose ideas [I] no longer believe." Much as he was influenced by synthetic cubism, he also reevaluated and revised it with reference to his (our) "way of living today." He rejected its clarity, fixity, and stability. All that remained of cubist flat-patterning were its shreds, which underpinned, but barely, his painting. Bill destabilized synthetic cubist design, and instead composed his pictures of ceaselessly shifting and interpenetrating forms. The images seemed to embody his life-style. He was too "nervous," too anxious, to feel at ease in any fixed situation. Consequently, the space he painted was disordered, disrupted, and dislocated. As painter Wayne Thiebaud remarked: "Bill structured chaos."

Bill once said that in the middle and late 1940s, when he reflected on art, he

found himself "always thinking of that part which is connected to the Renaissance. It is the vulgarity and fleshy part of it . . . the stuff people were made of." He also thought of the space the Renaissance painter measured out for himself—a "large marvelous floor that he worked on." However, he would not accept the full-blown Renaissance figure and its ordered surround, and he kept dismembering both, piecing them together and disassembling them again, creating what Plagens called "torn-meat abstractions."

In taking the familiar human image and classicizing cubist structure and melting both down, Bill expressed the anxiety of living in the nuclear world. It was this above all that spoke to me. Morton Feldman once wrote, "Byrd without Catholicism, Bach without Protestantism, and Beethoven without the Napoleonic ideal, would be minor figures. It is precisely this element of 'propaganda'—precisely this reflection of a *zeitgeist*—that gives the work of these men its myth-like stature." To Feldman's list I would add de Kooning without World War II and the Cold War.

Bill's experience of New York City contributed to his nervousness—as it did mine—although he loved the city—as I did. His pictures of the late forties convey the complexity, claustrophobic space, hectic tempo, and peculiar agitation of the city. The *Women* of the early 1950s are city-bred pinup "girlies." They, and the abstractions that followed, are clogged with raw and paroxysmal paint-laden forms which evoke the squalor, violence, and restlessness of street life.

Charles Cajori was chatting with Bill on Tenth Street when a drunk panhandler approached them and asked for a handout. Bill gave him some coins, and they watched as the drunk stumbled off across Third Avenue, zig-zagging to miss cars and barely doing so. Bill said, "There's a man who understands space."

Bill's painting was admired because it conveyed the mood of hot- and cold-war America and New York City, because it deflected Western painting in a new direction, and because it provided other artists with manifold pictorial possibilities, both avant-garde and traditional. And he was accessible to New York school artists who, like him, lived and worked in downtown Manhattan. Pollock (who lived out of town), whom we considered his rival, was more famous, but Bill's followers believed that if they "dripped" pigment, they would only produce secondhand Pollocks. As they saw it, Pollock had a "gimmick," whereas Bill painted in the grand manner. Though they were mistaken about Pollock, Bill's pictures had a greater scope, demonstrating that improvisation with the loaded brush could yield a richer variety of forms. He showed that painterly drawing could be both ambiguous and clear; abstract and figurative; flat and deep; refer to past art and react against it. Most important, Bill's pictures could conflate cubist-inspired design with open fields, as in *Excavation* and *Attic*.

As Al Held summed it up, Bill invented a wide-ranging visual "language" with

which other artists, once they learned it, could write their own "sentences." And many did. When Chuck Close met Bill, he told him he was pleased to meet the man who had painted more de Koonings than he had. Robert Storr said, "You could learn how to paint by doing bad imitations of de Kooning's paintings." But most of his followers wrote in Bill's hand, unfortunately for them. Much as he enjoyed his influence, he could also be quizzical about it. He remarked to Cajori about an imitator's work, "He's done it better than I did." It was said about another copyist that he didn't ape Bill, he illustrated him. Bill told Robert Rauschenberg that "he didn't worry [about his imitators] because they couldn't do the ones that don't work." The followers could ape Bill's style but not his attitude. As Wayne Thiebaud summed it up: "Bill was an intellectual greased pig. He embraced contradictions. He never had an answer."

Elaine de Kooning characterized the anxiety in her husband's process. "Bill was very irritated with his facility and he was constantly struggling against it, going against grain. He didn't like things to come easy. He wanted to have his image evolve out of a sense of conflict. In fact, it wasn't so much that he wanted it to come out of a sense of conflict as that he was born with divine discontent. I don't know where the term 'divine discontent' came from, but Bill had it." Hartigan said that de Kooning's process was "do it and deny it over and over again, looking for something more honest, more true, for the picture . . . to tell him 'Here I am.'"

The circle of which I was a part admired Bill's "ambition." I once asked Robert Goldwater to characterize it. He responded, "Bill faced the same difficulties that Cézanne had, that is, to achieve a tightness of surface with open painting. But Bill's problem was more formidable. Cézanne referred to objects, but Bill didn't. He tried to reconcile tightness of surface with sweep and energy. He wanted to preserve the clarity of cubist painting and at the same time treat the surface as a continuum of energy."

I often visited Bill in his studio in the fifties, and on two occasions, once in 1957 and again 1959, held lengthy interviews with him. In the first, he began by recalling the Great Depression and how poor he and his friends had been. Then he added that they accepted poverty as their lot because they had a mission. "We worried only about the work. We talked only about art. It was all artistic ideas."

Bill remarked that the Federal Art Project kept artists alive by providing them with a monthly stipend to make art. Smiling, he recalled that artists were paid as much as house painters because their union insisted on it. What if fine artists had started painting apartments? The union leaders evidently thought that they had to protect artists to protect their own. Bill concluded ironically that at last artists were considered on a par with wage laborers. He went on to say: "The Project was terribly important. It gave us enough to live on and we could paint what we wanted. It was terrific largely because of its director, Burgoyne Diller. I had to resign after a

year because I was an alien, but even in that short time, I changed my attitude toward being an artist. Instead of doing odd jobs and painting on the side, I painted and did odd jobs on the side. My life was the same, but I had a different view of it. I gave up the idea of first making a fortune and then painting in my old age."

The Project brought artists together and gave rise to an aesthetic ferment that was vital to the development of American art. Bill said, "There was a terrific amount of activity going on in the thirties. It was not a dead period. You don't have to like the art to appreciate the excitement. But many of the people were good artists—[John] Graham, [Stuart] Davis, Gorky. We knew each other. But we also respected American scene and social realist artists. Gorky and Raphael Soyer were good friends. I wasn't a member of the American Abstract Artists, but I was with them. I disagreed with their narrowness, their telling me *not* to paint something. We fooled around with all kinds of things and changed from style to style a lot. It was a great big hodge-podge."

However, Bill and his friends "fooled" around with Picasso more than with other artists. In his late teens, while still in Holland, he had seen his first picture by Picasso—in the window of a gallery—and felt physically shaken. He remarked that his younger friends could no longer respond to Picasso the way he had that first time. But that, I thought, was how many of them seem to have been affected by de Kooning, and I, by Kline. On another occasion Bill, in 1958, said: "There was this Picasso—yellow on the right, dotted floor—that had a certain 'lift.' I decided I had to get it in my own pictures. I thought if I couldn't, I ought to give up painting." Then he began to talk about something else. I interrupted, "Did you get the 'lift,' Bill?" He looked away and murmured, "Something else happened," and changed the topic. Later, he had equally strong feelings about Soutine. "People always talk about Picasso; what about Soutine?"

Bill was a member of an informal group of artists that included Stuart Davis, John Graham, Arshile Gorky, and David Smith, which met often in various Greenwich Village restaurants and bars. Though sympathetic toward geometric abstraction and expressionism, they were not particularly interested in working either way. Instead, they emulated synthetic cubist styles with recognizable images (among which they included Miró's), and above all, Picasso's. Indeed, they idolized Picasso; Graham hailed him as the greatest artist of the past, present, and most likely future (although he would later turn against Picasso with the passion he had once embraced him). Davis was the best-known artist of this group, but Graham was the more knowledgeable since he visited Paris regularly and was able to follow modernist art there. He kept his friends informed of artistic developments in France.

Like most artists during the Great Depression, Bill participated in leftist political activities. For one May Day demonstration, he and Gorky were asked to make

a float saluting the Abraham Lincoln Brigade, which was fighting fascism in Spain. Bill was supposed to paint the head of Lincoln but didn't know what he looked like. He asked Harry Holtzman, who handed him a penny. Much as he favored leftist causes, Bill stood opposed to Communism. He told Barnett Newman that in the 1930s he was the only "American"; everyone else hated the United States. He remarked to Peter Schjeldahl that soon after jumping ship from Holland in 1926 he wandered into the Hoboken train and ferry terminal.

> It was early in the morning and a thousand guys in hats ran in. You know, commuters. A guy at the diner counter had all these coffee cups lined up. He had a big coffee pot, like a barrel, and he poured without lifting it, one end of the counter to the other in the cups. Like this: one pour! . . . I thought, What a great country! I always remembered that guy with the coffee when my Communist friends in Greenwich Village used to say this is a lousy country. I told them they were nuts.

In 1959, Thomas Hess phoned me to say that he had an interesting idea for an article. Bill had mentioned that in 1936 Burgoyne Diller arranged to have murals painted for the new French Line Pier by Fernand Léger and a group of young Americans on the Federal Art Project, including Bill. It never was completed. What was the story? Did I want the assignment? A mural that never was; odd, but worth investigating.

I spoke to Diller, who recalled the difficulty of finding commissions for modernist artists on the Federal Art Project. When the French Line Pier was nearing completion, he saw a chance to "get some of our boys jobs," since the pier was a municipal property. Léger happened to be in New York, and Diller enlisted him as director of the project, hoping that his reputation would favorably impress the French Line executives. Léger badly wanted to paint a mural in the United States but couldn't enroll in the Project because he wasn't a citizen. However, he was willing to participate without pay, just for his own satisfaction. Among the other American assistants were Balcomb Greene, Mercedes Matter, and George McNeil. Léger was recognized as a modern master in modernist circles. As Bill said, "It was like meeting God. He looked like a longshoreman—a big man. His collar was frayed but clean. He didn't look like a great artist; there was nothing artistic about him."

According to Bill, Léger had no authority over the Americans except his good will.

> Léger was surprised to find so many New York artists—more than in Paris— who were aware of his painting, understood it, and were able to work with him. . . . We all worked in the same room at Thirty-ninth Street and Fifth Avenue. It was like a shop. Léger took us to the French Line pier. He decided

to do the outside, where there was ironwork, and we would do the inside rooms, each of us was to have one panel. He sent us to the Museum of Natural History to get ideas about the sea and to draw undersea objects—ordinary objects. We were to do our own designs and he would criticize them and unify them. We really wouldn't be like assistants; he was very nice about this. He talked to us as if we were professionals. But he did seem a little bored with our sketches.

Bill went on to say that "Léger had a fantastically original way of looking at the world. He was like a builder. He would draw an anchor, a French flag, and an American flag and fill them in. He worked like a commercial sign painter." When I interjected that Bill's comment could be taken as a putdown, he seemed to be taken aback. Shaking his head he responded that

Léger was a great painter. He made lots of sketches, threw them around on the floor, and picked one out. The one he picked always clicked. Then he squared it off [to transfer it onto the wall], like a renaissance painter. Léger worked a slow line, which is so marvelous. At times he would use pigment right out of the tube; outline a figure in black and paint it yellow. He would shade flat, just like a child. It was a very direct way of painting. There was no mystery in how he did it. Yet, when you saw it finished, you wondered why it worked so terrifically. He would look at his work in a very relaxed way and say, "bon."

Bill accompanied Léger to the Museum of Modern Art. They paused in a gallery in which both his and Picasso's pictures of three musicians were displayed. Léger looked at the Picasso and his own painting, back and forth, and muttered, "pauvre Picasso." Bill concluded, "You got the feeling from Léger that to be an artist was as good as being anything else. This was a very healthy feeling. He gave me a feeling of confidence; he does his painting, I do mine."

Diller recalled that a few weeks after the French Line Pier project was underway, he and Léger presented preparatory sketches for the murals to the president of the French Line. He was horrified that they were semi-abstract, and in a rage called Léger a Communist and ordered him and his assistants off the pier. In return, Léger himself got furious, and he and Diller were thrown out of the office almost bodily. Léger gave his drawings to Diller and they were preserved; those of his American assistants were later sold as junk by federal bureaucrats.

Diller was struck by Bill's talent. After Bill was forced to leave the Project, Diller tried to find him commissions. At the time of the 1939 World's Fair, a mural was planned for the Hall of Pharmacy Building. Diller recommended Bill and asked him to draw up some sketches. They were too abstract for the committee, which rejected them because Bill couldn't draw, so they told Diller. Diller got the bright idea of asking Bill to submit the kind of drawings he had made while a stu-

dent at the Rotterdam Academy, drawings in which the charcoal was sharpened to a needle's point and just tickled onto the paper. He got the commission.

Once, while having lunch with Bill, I asked whether he thought of his *Women* as primarily figurative or abstract. He bridled at the question. "They are images of women. If I wanted to paint abstractly, I would have." I should have remembered that the black paintings of the late 1940s that preceded the *Women* are abstract but have figurative references. I even called them "anatomical abstractions" in my history of abstract expressionism. Grace Hartigan visited Bill several times while he was painting *Excavation*, his greatest work. She spotted the image of a skylight in the center on the upper edge. She hesitated to mention it but finally pointed it out to Bill. He said that he would paint it out eventually but needed it to indicate the scale of the other elements in the picture. As Hartigan viewed it, *Excavation* was an interior with figures. I then said that if that was so then he had melted them all down, and *that* fascinated me.

In 1955, a writer friend, a filmmaker, and I decided to make a series of films about living artists. We would film their one-person exhibitions, interview them, and if possible show them at work. Our idea was to produce three ten-minute segments a month and make them available to museums and schools for educational purposes, and in the process create a record of current art in New York. We arranged with Bill to use him as the subject of our pilot film. After filming his work in the Sidney Janis Gallery, we went on to his studio, arriving late at night with our rented cameras, cans of film, lights, tripods, wiring, etc., lugged them up three flights, set everything up laboriously, and when ready, I said, "O.K. Bill, paint!" He had a stunning picture in progress, and he painted on it in a Pollock-like-according-to-Namuth's-film "action" manner. Our camera followed the flailing brush and dancing feet. It couldn't have been better as film.

A few days later I met Bill on Tenth Street and asked him how the painting was progressing. He said that he had junked it the moment we left. I asked why? "I lost it," he said. "I don't paint that way." Then why the charade? He answered: "You saw that chair in the back of the studio. Well, I spend most of the time sitting there, studying the picture, and trying to figure out what to do next. You nice guys bring up all that equipment, what was I supposed to do, sit in a chair all night?" "But Bill," I said, "in the future, they'll look at our film and think that's how you painted." He laughed.

At a small party at Bill's studio, Salvador Dali and his wife, Gala, walked in. Bill greeted them, but his artist friends paid them no attention. Dali joined a group of guests and was soon engaged in relaxed conversation. At one point, Gala said something in Spanish to Dali and they left. I asked Esteban Vicente, who was

standing next to me, "What did she say?" He replied: "There's no money to be made here. Let's leave." I raised an eyebrow at Vicente. He laughed. Dali had supported Franco, and it may have been the anti-Francoism of Vicente, who had been the Republican Consul in New York during the Spanish Civil War, speaking.

In my two interviews with Bill, he talked at length about Clyfford Still. I sensed that Still was on his mind because he had become a more formidable competitor than Pollock. He once remarked to Grace Hartigan that Still was the most "original" artist in the United States. She added that by the tone of his voice, she wasn't sure that was so good.

Still's stance as an "American," like Pollock's, had intrigued Bill, who was always aware that he was an immigrant. Unlike Still, who aggressively promoted himself as the artist of the New World, Bill could never forget his roots in the Old Country. He equated Still's nationalistic claims with Still's antitraditionalism. In our conversation of 1957, Bill said that he was different because he tipped his brush to his European "fathers," both old masters (Rembrandt and Rubens) and modern ones (Picasso, Miró, and Soutine). He was a "conservative," but he was quick to add that he was "grappling for a way to say something new. . . . I have this point of reference—my environment—that I have to do something about. But the Metropolitan Museum is also part of my environment. . . . I change the past." He then added that Graham (né Ivan Dabrowski), Gorky (né Vosdanig Adoian), and Hofmann were also conservatives (and, like Bill, immigrants). In particular, as Bill said to Barney Newman, he marveled at "Gorky's amazing eye, how this Eastern outsider could know so much about Western art and hit the point so well."

In my 1959 interview, Bill stressed even more strongly the dissimilarities between his painting and that of Still—and Pollock, whose name he coupled with Still's: "They eat John Brown's body. They stand all alone in the wilderness—breast bared. This is an American idea. . . . I am a foreigner after all. I am different from them because I am interested in all of art. I feel myself more in tradition." Elsewhere, Bill said, "It's a certain burden, this Americanness. If you come from a small nation, you don't have that. [An] American artist must feel like a baseball player or something—a member of a team writing American history."

Bill was broke until the end of the 1950s. I admired his sense of mission, in part because I too was hard-up and had a calling. As an avant-garde artist, he had chosen art for its own sake, and knowing that the "philistines" would never accept it, had chosen a life of poverty. Then, in 1959, his show sold out (to the "philistines"), which was the beginning of his monetary success. He had great difficulty coming to terms with his new riches. Once, in the early 1960s, he said to me with some bitterness, "I didn't paint today. It cost me $10,000." When he first made a lot of

money, he tried to spend it as quickly as he could. One way to purge himself of cash was to build a white elephant of a house and studio in East Hampton. No component was standard size; everything was custom-made. He had the building pieced together improvisationally, just like he painted. One day he would order the workmen to put up a wall; the next day he would tell them to tear it down.

I don't believe Bill ever came to terms with his wealth. Lee Eastman, his accountant, told me of the time Bill received a letter from the phone company which he assumed to be a "bill" for the exorbitant sum of $6,000. He called Eastman in a rage, demanding to know how it could be, everyone knew that he rarely used the phone, and he even packed it with cotton batting so that he would not hear it ring. Eastman calmed him down, saying, "That's not your bill, it's your dividend."

Bill was unable to "sit in style." It made him uncomfortable. From the start of his career, his work was distinguished by sharp shifts from figuration to abstraction and back, from compacted forms that are suggestive of the city to open forms suggestive of landscape. After his "black" abstractions of the late forties, Bill painted a series of female figures—big-busted with teeth bared, both violent and voluptuous. His wife, Elaine, said that he started to paint women after he met her. "His earlier pictures were of men, quiet, reflective, and contained. The *Women* were explosive. I think they were affected by me and also by his mother"—both formidable figures. Elaine was one of my favorite people. She was a fine artist in her own right, and besides was both beautiful and brilliant; some of the most incisive art writing of the decade was by her. As Frank O'Hara said, "[She] knew everything, told little of it though she talked a lot, and we all adored (and adore) her."

Elaine's relationship with Bill was too complicated for me to fathom. It did seem to be perpetually on and off. Bill was very attractive to women and had many affairs. Tom Hess told me that when he was writing his book on Bill, there were many works that were undated. Bill was of no help except that he remembered with whom he was sleeping when he painted a work. To complete his research, Tom had to phone his former women friends.

In the late fifties, Bill opened up his images into landscapes. In retrospect, his paintings from 1947 to 1960 were his best; his last great picture was the Whitney Museum's *Door to the River* (1960). Nonetheless, such is Bill's genius that his subsequent paintings are compelling and challenging, at least until 1987.

In the late-1960s, Bill introduced new female subjects into his painting. Squatting like animals, thighs or haunches spread, pudenda brazenly exposed, defiantly, mockingly, they invite sex, or perhaps they defecate. Indeed, they refused to be potty-trained. They are seductive and repellent, sometimes funny, but so revealing—of Bill's attitudes, appetites, and hangups—that they leave the viewer more embarrassed than amused. They continue the countertradition of figure painting

in Western art in our time (as Cézanne's or Picasso's nudes had in theirs). Indeed, they are the antithesis of classical Eves, goddesses, or nymphs. Even Soutine's deformed figures, which Bill's most resemble, seem benign in comparison. (Cindy Sherman's grotesque sex-mates would later top Bill's women in lewdness.)

In the mid-1970s, Bill transformed the figures into abstract landscapes—another radical turn in his work. Most art critics viewed the new paintings as lyrical, indeed bucolic, a change they attributed to his move from New York City to eastern Long Island. According to this interpretation, gone was the old Bill, the Tenth Street Bill, who had painted pictures so raw, energetic, and packed with unexpected, multilayered, and often contradictory meanings that one was kept perpetually anxious and off-balance (as one imagined Bill himself had been while painting), much as one marveled at his virtuosity in juggling manifold variables.

I disagreed. In a review, I wrote that despite the sensuousness of the new abstract landscapes, "I remain uneasy, nagged by an edge of rawness or is it messiness, by a certain laxness that may be self-indulgent. Or is it the issue of the risks de Kooning takes? Does the old de Kooning continue to lurk beneath the sumptuous and seemingly slack surfaces? I believe he does." What were these risks? Bill had ripped out the infrastructure—the backbone or muscle—for which his earlier paintings were justly famous and let the areas of pigment flop about, holding them in tension at the edge of pictorial chaos.

Like everyone else in the art world I was perplexed by Bill's painting of the last two decades of his life, during which he was suffering from Alzheimer's disease. Did these late pictures reveal that they were painted by a mentally diminished artist? Chuck Close visited Bill in East Hampton in the mid-1980s. Bill was slumped in a chair and did not recognize Close. When they went into the studio, Bill straightened up. He still did not remember who Close was, but he knew where he was and why he was there. When they left the studio, Bill went back into his slump.

Whatever the nature of his sickness, many of the late pictures that were exhibited are exceptional, such is the bite and refinement of the drawing and the skill with which Bill thickened and thinned lines, varying their velocities and the shallow depths they create. The ghost of Ingres, one of Bill's favorite painters, hovers in the drawing. The colors and the rubbed and scraped transitions from one hue to another are subtly modulated. The surfaces emanate an airy, lambent light. It was all painted with the utmost concentration and purposefulness. In these pictures Bill seemed to have condensed his own artistic history—that is, he abstracted his artistic identity. Like all of his mature work, the late pictures are based on painterly drawing which often refers to the human anatomy. Almost everywhere that one looks, there are "glimpses" of the female body. The canvas

with its painted skin becomes a substitute for the human skin, and it is lovingly caressed. Tracking the 1980s pictures year by year, indeed canvas by canvas, one can see the visual logic at work, the way in which Bill distilled what made de Kooning de Kooning. Indeed, whatever he painted was unmistakably his. Robert Storr said that Bill's last works are "old man's painting. Bill made something fresh of what he had. . . . Merce Cunningham can hardly move but what he does makes more athletic dancing look shallow."

When Bill's work entered the 1980s its content changed. Suppressed was the anxiety that had distinguished the work of the late 1940s and 1950s. I hasten to add, however, that the risk is still there. Reducing his painterly drawing as extremely as he had meant that any lapse in the intensity of a line would be readily apparent. That is the same kind of risk Matisse took in *The Dance*. Still, Bill replaced anxiety and turmoil with a kind of serenity and quiet.

When Bill died, I was unable to attend his funeral in East Hampton. I mourned in private. I was appalled by the obituaries. Most dealt not with his art but with the man or rather the dirt about his life, his drinking, womanizing, and Alzheimer's disease. When Elizabeth Baker asked me to write his obituary for *Art in America*, I was able to rectify matters by attempting to explain why Master Bill, as his friend Gorky dubbed him, was one of the greatest painters of our time. It felt good in this small way to repay Bill for all that his painting and conversation had meant to me.

---

Franz Kline held court at the Cedar Street Tavern almost every night after ten. He would talk to anyone and consequently was the most accessible of his peers to young artists—and to me. Franz was the most amiable of the older abstract expressionists. As one admirer recalled:

> He liked beer at the Cedar Bar and English tea in the studio. He could play the dandy or the clown, act like Ted Lewis, Wallace Beery, or Mae West, talk about rugs, vintage cars, Gericault's horses, baseball, and Baron Gros. He loved jazz and Wagner. He was a confirmed New Yorker, but had roots that he never forgot in the gritty coal country of eastern Pennsylvania. . . . He could juggle life until it came up fun.

Franz loved to tell "shaggy-dog" stories. One I remember was about some guys drinking at a bar. Tom goes to the men's room. When he does not appear for some time, Jim goes looking for him. Tom is not in the men's room. Across the corridor is an open elevator shaft. Jim looks down and there's Tom. Tom looks up, sees Jim, and pleads: "No, no, don't flush it." It occurred to me that Franz's love of shaggy-

dog stories related to his painting; both their verbal punchlines and his teetering visual structures jolted expectations.

Every now and then Franz would grow silent, his eyes distant, and he would appear overcome with loneliness—even in the company of friends—a look that is often caught in photographs of him. I often wondered how much of this sadness was caused by the plight of his wife, Elizabeth, a former ballet dancer. From 1948 to 1960, she was committed to a mental institution where Franz visited her periodically. In 1950, he painted two pictures of the dancer Nijinsky, who had just died, one a portrait, the other an abstraction. I think that for Franz, Nijinsky as a tragic figure became a kind of surrogate for his wife, and, in the costume of Petrouchka, the clown who had lost the woman he loved, the image of himself.

Franz arrived at abstraction by simplifying and enlarging the contours of his figural images. Elaine de Kooning recalled that Bill was lent a bell-optican projector and Kline, who happened to be visiting, inserted one of his drawings, and was stunned at the power of the magnified image.

Soon after Franz's death, I happened to be at the Archives of American Art when his papers, books, and other materials arrived, and was allowed to look through them. I discovered some little-known facts about his roots in the Pennsylvania coal country. He was the artist for the Lehighton High School newspaper, *The Leni-Lenapian*, drawing satirical cartoons in the style of Julius Held. He won a varsity letter playing football (he was elected captain in 1929) and saved the newspaper clippings. He also kept a photograph of Virginia Woolf scissored from the *The New York Times* in 1929, and an obituary, also from the *Times*, of Jim Thorpe, the great Indian athlete whose medals were later taken away. In 1928 and again in 1930, Franz took courses in coastal artillery at Fort Monroe, Virginia. Among the books that he acquired was one of the drawings of Charles Keene and Phil May (two volumes); a 1938 edition of Art Young's *Thomas Rowlandson*, as well as prints by Sotatsu, and a batch of newspaper cartoons by Low. (Did Low's heavy contours influence Franz's later painting?) He also owned models of Lehigh Valley Railroad trains.

Franz studied art in England from 1935 to 1938. He had a letter of introduction signed by Cordell Hull, the Secretary of State, at the request of Pennsylvania Representative Francis E. Walter. According to a British Certificate of Registration, his name was Franz Rowe Kline. In 1935, he changed the Rowe to Joseph. Four years earlier he had drawn a portrait in pencil of Emperor Franz Joseph of Austria. I wondered why, and whether Franz's people had emigrated from Austria. So did the Hollywood star Hedy Lamarr, who in 1959 wrote him a fan letter in which she remarked that she so admired his pictures that she had bought one, and then asked whether he was of Austrian descent since she was.

The paintings for which Franz is best known are black and white. For my gen-

eration it was difficult to think of these "colors" without involuntarily thinking of Franz, although many of his associates—Gorky, de Kooning, Motherwell, Clyfford Still, Newman, and Bradley Walker Tomlin—also painted black-and-white series. Franz's abstractions call to mind locomotives, railway trestles, and other industrial structures, remembered from his youth perhaps, as well as partly demolished or constructed sections of skyscrapers and bridges. Indeed, his dynamic black–and–white swaths retain "the bulk and the force and momentum of the old-fashioned engines that used to roar through the town where he was born," as Elaine de Kooning wrote.

Franz invited the de Koonings to help him title the pictures in his first show. They all had to agree. Franz decided to call one work *Chief,* named after a Lehighton locomotive, but Elaine persuaded him that the name would go better with the canvas that now bears the title. That was the painting that was responsible for my first epiphany in art.

Like de Kooning, Franz loved New York City. With Newman's professed transcendentalism in mind, he once said: "Hell, half the world wants to be like Thoreau at Walden worrying about the noise of traffic on the way to Boston; the other half use up their lives being part of that noise. I like the second half. Right?" Like de Kooning's painterly drawing, Franz's caught the beat of the city, but whereas de Kooning's images are compacted, ambiguous, and anxious, Franz's are bold, expansive, and exuberant. Yet they also have a sense of disequilibrium, even violent upheaval and destruction. Their pictorial armatures are unstable and ruptured. Franz himself tried to account for the deconstructive aspects of his painting, commenting, "To think of ways of disorganizing can be a form of organization." Consequently, his images convey a mood of malaise, a mood evoked by the most relevant abstract expressionist paintings.

Franz was verbally quick and so adept at word play that he was the only artist whose conversation I was unable to jot down. Indeed, for him talking was a kind of verbal game. He was easy to understand, but I could not follow the flow of his words and take notes at the same time. Frank O'Hara did manage to pin him down in his "interview," titled "Franz Kline Talking," but only by later reimagining his responses and manner of speaking. Indeed, only a poet with O'Hara's gift for language could have invented Franz's monologues so accurately.

Once, at the Cedar Street Tavern, Franz remarked on the difficulty—indeed, the impossibility—of being an artist, and in the face of that predicament, his sympathy for all artists, even those who were generally ridiculed by his peers. Pollock was put down by de Kooning and his pals, but Franz always rose to Pollock's defense. In a conversation with Philip Guston, he said that Pollock could never accept anything as it was—in life and in art—particularly anything conventional.

Compulsively, he had to change it. Newman was also patronized in our circle as "the little guy in the corner with the monocle." One night at the Cedar, a young artist complained to Franz how simple-minded the pictures he had just seen by a certain Barnett Newman were—just one flat color painted like a house painter, with a couple of lines through them. Franz said: "Simple? Were they all the same color?" "No, different colors." "Were they all the same size?" "No, different sizes." "Were the stripes the same?" "Color?" "Width?" "Placement?" "No, different." "Different." "Different." Franz concluded: "Sounds awfully complicated to me."

Drawing obsessed Franz. A young artist at the Cedar challenged him with: "What about Monet?" He retorted: "What about Manet?" As he saw it, neither he himself nor any of his contemporaries could draw. But then, he claimed, no artist in the entire history of art could either. He paused. "Well, maybe Picasso. But Picasso knew he couldn't draw, but he thought that maybe Cézanne could. But Cézanne knew he couldn't, but maybe Ingres. Ingres thought maybe Raphael." And so on and on, ending up with the cave painters. I once said to Franz at the Cedar that his approach to drawing brought to mind an anecdote about a chance meeting between Blake and Constable on Hampstead Heath. Constable was sketching. Looking over his shoulder Blake said, "That's not drawing, that's sheer inspiration." Constable retorted drily, "I had meant it to be drawing. You want to have it both ways, Franz, don't you?" He looked over to the bartender: "Give this guy another beer." The painter Joe Stefanelli once remarked to Franz that his abstractions had no reference to past art. "Hell they don't," said Franz, "I drew and copied for years and I was good but never as good as the old guys. I sort of snuck in when no one was looking."

Drawing was so central to Franz's art that his painting was primarily a rendering of his drawing. That is, he would make quick sketches on paper, choose one, and transpose it into painting. Franz was often dubbed an "action painter," but the improvisation in his work was primarily in his preliminary sketches, not in his painted canvases. Moreover, as he said to David Sylvester: "Painting is a form of drawing, and the painting that I like has a form of drawing to it."

Kline was famous both for the stories he told and those told about him. When his dealer, Charles Egan, sold one of his paintings, he rushed uptown to claim his share of the money before Egan guzzled it away. To celebrate the sale, Egan took Franz out to the Schrafft's restaurant around the corner and dealer and artist proceeded to get drunk. But not sloshed enough for Franz to have forgotten his purpose, and he asked for his share. Egan replied sadly that they had just spent it. Such were the profits to be made on abstract expressionist paintings through most of the fifties.

Franz painted his earlier black-and-white pictures with house paint. He con-

tinued to use it even when he could afford better because he liked the artless look. I had heard that in the mid-1950s, his dealer, Sidney Janis, broke into and entered Franz's studio, cleared out all of the house paint, and left tubes of Windsor Newton in its place. I once asked Janis if this were true. His answer was to smile.

Howard Kanovitz, a private student of Franz's, brought one of his pictures for him to criticize. Franz examined it and said: "I think your image would work better in a larger format." Kanovitz painstakingly enlarged his painting and brought it back to Franz. Again he studied it and said: "Well, now we can see it."

Grace Hartigan recounted that Franz would not accept that she was of Scotch-Irish stock because she was taller than he was. He kidded that she was Swedish and that her parents were skiing champions. He visited her studio once when she was in the middle of a painting and was very unsure about how to proceed. They looked at it a long time, and he said: "You're not going to finish it, are you?" That finished it; she titled it *Sweden.*

When confronted with a collector who wanted his opinion about some painting, Franz said: "Well, you wouldn't see that in Coney Island."

---

I admired Philip Guston's abstractions from the time I first saw them around 1953. Composed of spare paint marks in airy fields of white canvas, these works of the early fifties seem to be lyrical. But only seemingly, because they are pervaded by anxiety. Every move is tentative to the extreme, offset by a countermove. The short brushstrokes are partly erased, their ghosts remaining as details of the images, as if Philip lacked the confidence to let them stand unmodified. The touches of pigment and the areas they form are tremulous, seemingly about to shift. The colors are grayed, suggesting that once Philip asserted a hue he nervously toned it down. The color areas huddle near the centers of the pictures and thin out toward the borders. Although the brushmarks are fleshy and assert the surface, the painterly nuances and halftones produced by the modulated colors and erasures generate a brooding atmosphere. In sum, Philip's seemingly indecisive painting conveys the difficulty of choosing among mutable alternatives, a central existential dilemma in contemporary life.

In the 1950s, Philip's abstractions were increasingly acclaimed for their lyrical quality and poetic references to nature. He himself vehemently rejected these interpretations—to no avail. Growing numbers of young artists saw in Philip's abstract impressionism, as they labeled it, a viable alternative to the abstract expressionism of de Kooning and Kline. By 1956, Philip's influence rivaled that of his two fellow artists. Shortly after becoming a critic for *Art News* in 1956 I asked Thomas Hess if I could write an article on Philip's work. He agreed but sat on the completed copy for two years. I knew why. Philip had become too influential and

Hess, a de Kooning fan, didn't want to help the competition. Such were art-world politics. The article finally appeared in 1959.

In the process of writing the essay, Philip and I became friends. He was, or acted as if he was, the most existential of the abstract expressionists. Every step that he took in life seemed to involve an agonizing choice, just like the moves in his painting. Even having lunch with him was nerve-wracking. What to eat? He would pore over the menu and change the order repeatedly. Philip's rhetoric was also existential, and it strongly influenced my thinking. He said: "I do not think of modern art as Modern Art. The question is: Can there be art at all?" What he had in mind was the butchery in the two World Wars and the Holocaust. What could an artist do? Be as honest as he or she could. To be valid, he said, modern art had to expose the artist's true state of feeling "no matter how perverse and contrary it may be to conventional and known attitudes." That called for the artist's "willful nonacceptance of limits."

Philip often spoke of his process of painting and its meaning to him. He said, "I must live my forms." What engaged him primarily were "the paradoxes of painting [that is] depth and flatness—stillness and motion—paint and image." In another conversation he added to the contradictions, "the moment and the pull of memory." He worked "in a tension provoked by [these] contradictions." "I paint from part to part, relating part to part, for weeks, like a carpenter, overlaying painting on painting, scraping out good intentions, preconceived thoughts, conscious choices—all that boring stuff, until in a fevered instant of vision, all of the parts miraculously interpenetrate, each keeping its identity and charging the others. The paradoxes vanish." That was Philip's "moment of truth," and it came as a surprise. He explained, paraphrasing W. H. Auden: "With a so-so poem you say, 'Yes that expresses exactly how I feel,' but with great poetry, thrilling poetry, you say, 'I never knew I felt like that.'" The momentary resolution of contradictions was an epiphany that Philip was driven to repeat.

Philip said, "If a painting can fix forms in an order, even on the fictive picture plane, for an instant, this is optimistic, but it must always be with an awareness of the tragic." Humor could also be tragic. Philip admired Herriman's Krazy Kat comics. "What makes it great is that you don't know whether to laugh or to cry."

Philip would say again and again—as if he had never said it before—that everything in a work of his had to be "felt"; nothing could be "gratuitous." "Otherwise the abstract picture would be a ridiculous doodle." Consequently, painting was an "ethical" rather than an "aesthetic"—that is, formal—act. But, I asked, was an ethical picture necessarily good? He scoffed:

What is good? Morty Feldman, a friend of Morty, and I once left a Zino Francescatti concert. The friend asked Morty what he thought of the performance. Morty replied that it was sublime. 'Are you sure?' said his friend.

Morty grabbed him by the collar and answered: 'Sure? Of course I'm not sure, but I'll stake my life on it.' That kind of risk has nothing to do with formal designing. You know, fifty years from now, our painting will be looked upon as great formalist art, but those of us who set out with formalist intentions will be forgotten. That's a paradox.

But Philip knew good from bad. During a visit to his home in Woodstock, Lucy and I wandered through the woods behind his house and came across a ravine at the bottom of which we saw dead canvases that he had hurled down in rituals of aesthetic burial.

Feldman was one of Philip's closest friends, so close that many of the lima-bean heads that populate his late paintings are to my eye "portraits" of Feldman, not self-portraits of Philip, as critics have written. When I heard Feldman's composition *For Frank O'Hara* at a concert, with its insistent but muted flow of sounds, like aural dabs of the brush, I remarked to Lucy, "It's Guston 1953 in music."

During a visit to Woodstock, after dinner one night, Philip produced a sheaf of reproductions of Piero's frescos in Arezzo and began to talk about them. He had studied these works so thoroughly that he could point out the parts Piero had painted day by day. But what Philip really tried to convey was how Piero's forms interacted "mysteriously." He kept Lucy and me captivated until three in the morning.

In Philip's works of the late fifties the shapes began to suggest objects and figures in obscure space; the gestures became rougher, the surfaces more atmospheric, and the colors increasingly grayed. He said that he wanted to create an art that would reveal to people just how miserable their lives were. These bleak pictures were exhibited at the Jewish Museum in 1964. A few weeks before the opening, Philip invited me to preview them at his warehouse. Dozens of the paintings, stretcher to stretcher, propped against the walls, generated a palpable atmosphere of gloom. Philip asked me if I thought the show would be well received in the art world. I shook my head in the negative.

Trying to soften my dire prediction, I reminded him of his roller-coaster career. "You were the golden boy of realism, win top prize for painting at the Carnegie Institute in 1945, get a Guggenheim Fellowship the next year. Then, you go abstract and get dumped by the realist establishment and brushed off as a Johnny-come-lately by the abstract expressionists. They pay you back for your early success. But, by 1956, you're top of the heap again as the abstract impressionist, much as you hate the label. Dozens of younger painters swear by you." Then I paused and added, "Philip, you've had to tough it out in the past, you'll have to again. You are about to be savaged. This is Warhol's moment and Stella's. This melancholy gray brushiness, this illusionistic space, will be utterly unacceptable." Philip nodded in agreement. But that did not prevent him from being devastated by the critical

reception of his work, and he more or less abandoned the art world. I saw Philip only once in the next four years. He bad-mouthed abstraction and spoke of a yearning for realism, like that of Soutine who had turned paint into flesh.

With his Jewish Museum show, Philip's reputation plummeted. He was literally forgotten. In 1968, I taught two graduate painting seminars at Pratt Institute. Philip was scheduled to deliver a talk on one of my teaching days, and I strongly recommended to the first group of students I met that they attend. I got a classroom of blank looks. Surprised I asked, "Who here has never even heard the name Philip Guston, raise your hand." Half the students did. This was repeated in the second class.

In 1969, with a show of figurative painting, Philip again became the focus of art-world attention. His work had changed radically, and I was totally unprepared for it. At the opening, he walked over and asked what I thought. Flustered, I told him that I had only begun to grapple with the imagery. I could see how it developed formally from his earlier work. But I needed more time. I was more receptive to his new painting than most of Philip's friends, who were appalled by its references to cartoons. Philip was disappointed by my response, however, and he was cool when we next met.

Looking back, I should not have been as shocked as I was. My article on Philip of 1959 was aptly titled by Hess, "Guston: A Long Voyage Home," implying that Philip had started with figuration, then had moved to abstraction, and now had begun to circle back to figuration. I had juxtaposed illustrations of two of his paintings, the realist *Martial Memory* (1941) and the abstract *Fable* (1957), and pointed to "significant resemblances in the massing of shapes and the treatment of space." I noted that "the palpability of recent work [evokes] the substance of man." In notes jotted down in the spring of 1957, I commented that Guston had alluded to the relationship of *Fable* (which he had just finished) to his earlier figurative picture. He said: "Years of painting representationally equipped me for the atmosphere I use. Although I don't paint a room or a landscape, this is the space that I live in." In another conversation, he observed: "A painter goes around in a circle. I want to work in greater depth, in and out, and this means using forms. They are coming out of me in an internal way." But I did not pick up on Guston's comments. I would not recognize that the shapes suggested figures huddled in the center of the canvas. Why had I overlooked them? Because it had not occurred to me that *Fable* was anything other than nonobjective. I had expected the painting to be abstract and I simply would not view it any other way. Looking at the painting now, the vestigial figures are inescapable. In Guston's subsequent work of the late 1960s they had fully materialized.

If Philip's peers could not accept his figurative paintings, young artists in the

1970s—looking for an alternative to pop art, the new realism, photorealism, minimalism, and postminimalism—admired and emulated them. They realized that his mixture of recognizable images and seemingly crude paint handling opened up new possibilities. Indeed, Philip became so influential that Peter Schjeldahl could report that 'Gustonesque' now recommends itself, like 'Kafkaesque,' as a term in the lexicon of perversely poetic 20th-century feelings."

---

I met Mark Rothko around 1956, somewhat later than de Kooning, Kline, and Guston. He was often to be found in the garden of the Museum of Modern Art. I would run into him there, and we'd have coffee, or go out for a bite to a nearby Chinese restaurant. He was not always easy to talk to about his work. He would keep turning the conversation back to me. What did I feel and think about his work? *Really* feel and think. He could suddenly turn distant, seeming to be lost in some private reverie. At other times, he was very convivial, for example, flirting in an avuncular fashion with Lucy, whom he called "Blondie."

Mark's appearance amused me. Avant-garde artists were supposed to be wild looking. None of my downtown friends were, but at least they were somewhat rumpled. Mark was always soberly dressed, looking, acting, and speaking like a middle-class intellectual. His early collaborator, Adolph Gottlieb, was even more bourgeois in appearance. Outfitted like a dapper businessman, Gottlieb talked like one—very direct without verbal flourishes. Once he achieved success, he would go sailing in the summer dressed in natty yachting fashion. I believe that Mark and Adolph performed in public as "squares" to counter the popular caricature of "the crazed artist." They considered themselves outcasts of society, but too seriously alienated to affect bohemian poses.

I first saw Mark's paintings around 1954 and was immediately gripped by them. They still produce in me a *frisson*—is there an equivalent English noun?—even though I have seen Mark's work more often than that of any other abstract expressionist. Every summer for some three decades, I have worked in the library of London's Tate Gallery and at the end of most days, I have visited the room with the murals Mark had painted for the Four Seasons restaurant in the Seagram Building—all brackish reds and grays, emitting an atmosphere that turned the space into a shrouded and haunting environment, pervaded by intimations of death. They were genuinely tragic—and yet somehow exalted. These murals were culled from some dark stratum in Mark's psyche and touched some dark stratum in mine.

I interviewed Mark about a half-dozen times from 1957 to shortly before his death in 1970, in the hope that he would let me write a book on his work, or to

put it another way, promise permission to reproduce his paintings. But he kept putting me off. "Write it," he would say, "and then, we'll see."

Mark said that in the 1930s, he and Adolph had sat at the feet of Milton Avery, meeting him almost daily. They often talked about Matisse. Mark said: "Matisse was the greatest revolutionary. I was influenced most by his frontality, but my surfaces were closer to Avery's. But Matisse is the man."

Mark and Adolph spoke of the impact of America's entry into war on themselves and on Pollock, William Baziotes, and other avant-garde painters labeled by Mark "the mythmakers." Mark said that for him and Adolph none of the current painting styles made sense. They agreed that if there was to be any art at all, they would have to reject what had been, above all their own Avery-inspired figuration, and begin anew. In this respect, they were different from Gorky and de Kooning, who still had faith in the tradition of Western painting. "But," I said, "the war also affected them—in different ways." Mark agreed: "How could it not?"

Within months after Pearl Harbor, Mark and Adolph decided to collaborate in the development of mythic and primitivistic subjects they believed were relevant to a war-torn world. The two painters made their new approach known in 1943 in a letter to *The New York Times*, their "manifesto," as Mark called it. Mark was responsible for the sentence "Only that subject matter is valid which is tragic and timeless." This now sounds trite, but he believed it passionately then and to the end of his life.

The cheerless aspect of existentialism was very much in the air in the 1950s. Indeed, the consummate existentialist mise-en-scène would be a Rothko painting being contemplated by a Giacometti sculpture to the accompaniment of the tape of a Beckett play. Paul Brach viewed a Rothko painting as the visual counterpart of God in *Waiting for Godot*. He said, "It's a kind of visual Torah. You stand before it in reverent contemplation and it intones: 'Come back tomorrow and I'll reveal the secret of life and its mysterious import, and utter the unutterable name of God.' You come back the next day and hear the same message."

During the forties, Mark published occasional statements about his painting. In 1949, he stopped, but in 1958, he felt that his work was so misunderstood that he had to speak up. The goad was an article in the *Art News Annual* by Elaine de Kooning which coupled him with Franz Kline and treated him as a kind of gesture painter. He then wrote a letter to the editor rejecting her thesis, and to further make his point, delivered a talk at Pratt Institute which was widely publicized. He strongly denied any concern with "self-expression" and insisted instead that he had a "message" about the human condition to communicate. His painting, he said, contained seven ingredients which he "measured very carefully." Above all, it had to possess "intimations of mortality." Next in order (of quantity) was "sensuality . . . a lustful relation to things that exist." Three: tension. Four: irony, "a modern ingredient—the self-effacement necessary for an instant to go

on to something else." And to make the consciousness of death endurable, five, wit and play; six, the ephemeral and chance; and seven, hope, 10 percent worth. He added that he mixed these ingredients with craft—he dwelt on this—and with craftiness or, to use his own word, "shrewdness." Mark meant this listing to be taken seriously, but it was also an ironic gloss on formalist analysis. He enumerated elements of human nature as if they were measurable quantities, just as line, form, and color were supposed to be.

In his talk at Pratt, Mark presented his self-image as an artist. His function was not that of a formalist problem-solver or a self-revealing expressionist but that of a contemporary seer who, on the authority of an inner voice, envisions and reveals truths about the human drama. "I want to mention a marvelous book, Kierkegaard's *Fear and Trembling/The Sickness Unto Death*, which deals with the sacrifice of Isaac by Abraham. Abraham's act was absolutely unique. There are other examples of sacrifice but what Abraham was prepared to do was beyond comprehension. There was no universal that condoned such an act. This is like the role of the artist."

When I met Mark next I told him that Franz Kafka had posed a related question. Kafka asked, What if Abraham got the message wrong? An Abraham who comes unsummoned! It is as if the best student were solemnly to receive a prize at the end of the year, and the worst student, because he has misheard, comes forward from his dirty back bench and the whole class roars with laughter. An Abraham who misheard God and ended up killing his son. How grotesque. Mark nodded and said, "Yes, isn't that the risk?"

If Mark was unshaken in his conviction that painting could bear the burden of profound meanings, he was of mixed mind as to whether these meanings were being grasped by anyone. On the one hand, he remarked, there seemed to be an audience waiting for a voice like his to speak to them. On the other hand, he could not understand why. He was so curious about the response of visitors to his retrospective at the Museum of Modern Art in 1961 that he would follow them around, eavesdropping on their conversations.

Rothko's doubts were on my mind when I took an NYU adult education class to the retrospective. Pausing in front of the Albright-Knox's orange-yellow painting, one of Mark's most "beautiful," I asked my students, all of them affluent women: "Which of you would like to own this?" No one responded—to my surprise—for they were fairly sophisticated and sympathetic. "Most of you can afford to buy it, but in case money is a consideration, you can have the painting free." No takers. I began to press the point. "Think of your living rooms and imagine this picture on a wall instead of your wallpaper. Think of it as decor." Silence. "How about redesigning the room around the picture?" No one would. I asked why? Members of the class answered that the picture was unnerving, upsetting.

It made them uneasy. I then said: "Rothko would be delighted that none of you would accept his works, even this one, as decoration." When I told him this story, he was. However: I said, "If the painting is not decorative, it is beautiful." He nodded. Later, I encountered a sentence of Nietzsche's: "There are no beautiful surfaces without a terrible depth," and I mailed it to Mark.

Mark, Still, and Newman had been close friends in the 1940s, but early in the following decade, they had a falling out. Newman and Still bad-mouthed each other verbally and in print. Still also attacked Mark in a nasty letter which was widely circulated, but Mark did not respond. Mark no longer saw Still—he said he would if Still called him first—but that did not stop him from admiring his former friend. One day I encountered Mark and Al Held sitting at a table in the Museum of Modern Art garden. I sat down with them and the three of us were soon joined by Clement Greenberg. The conversation turned to Still, and Greenberg asserted that if Still chopped off a foot or two from each side of his large horizontal pictures they would be greatly improved. We were shocked at Greenberg's presumption, most of all Mark, who blubbered: "But Clem, you are talking about a very great painter." This was the only time I saw Mark at a loss for words.

When Greenberg was on the payroll of the French and Company Gallery and arranged a show of Newman's work there, he decided that Mark had been influenced by Newman and had arrived at his mature style by turning Newman's vertical line on its side. This was simply bad faith. Greenberg may have forgotten the horizontal rectangles in the backgrounds of Mark's earlier calligraphic pictures, but really, he knew better. However, was it the other way around? Was Newman influenced by Rothko? Possibly. I also wonder whether Newman arrived at his vertical zips by damping down Still's "flames" or by turning a spare Avery landscape he owned on its side.

One day in the fall of 1959, I met Mark on Tenth Street and he told me that he had just completed murals for the fashionable Four Seasons restaurant. He invited me to see them, and we walked over to his studio on the Bowery. It was a cavernous space in which he had built a mock-up of the restaurant in order to paint the murals in situ, as it were. We sat silent in the midst of these somber paintings. At one point he said: "Can you imagine rich people eating dinner surrounded by this work?" I envisaged businessmen glancing at the decor between sips of their three martinis and pauses in their deal-making. It was depressing to contemplate. But Rothko had agreed to accept this commission in "the most expensive restaurant ever built," according to its PR. I hesitated in answering but then allowed that I could not imagine the mural in the Four Seasons. He said: "Neither can I. I just sent their advance back to them." It was a considerable sum, and I knew it hurt Mark to part with it.

On April 19, 1968, Mark had an aneurism and felt the approach of death. Not trusting his doctors, he consulted his close friend, sculptor Herbert Ferber, a former dentist whom Mark thought ought to be expert in medical matters. I was visiting Ferber when Mark phoned. Ferber spent a long time calming and reassuring him that his condition was not necessarily life-threatening but that he would have to take care of himself—stop smoking and drinking. Mark did just the opposite. He seemed to fall apart as a person, at least when he was drunk, which he often was. But still, he continued to paint.

Shortly before Mark died, I was in the Marlborough Gallery looking at one of Motherwell's "open" or "window" paintings, each consisting of a simple rectilinear "drawing" on a single color ground, when a voice behind me asked: "What do you think?" It was Mark. I answered: "I think I see what he's done. With an eye to minimalism, he's 'compressed' his imagery, but I'm not sure it's felt." Mark said simply: "It's felt." He then asked if I would like to come with him to his studio. I went, although in doing so, I was breaking an appointment, the details of which I've forgotten. Mark had a series of "landscapes" on paper on one wall and an unfinished oil painting on an easel. Each of the pictures consisted of a horizon line that divided in two a ground of subtly varied grays. What did I think? I was very moved and told him so. "The pictures are without hope," I said. He asked about the bands of white that framed the images. I replied that I hadn't noticed them. "Aren't they just borders?" That upset him. I immediately understood why; he needed the flat white of the paper to counteract the atmosphere in the pictures.

He then asked what younger artists would think of this work. Had it kept up with the times? It occurred to me that he might be relating its simplification to minimal art, as I suggested Motherwell's "windows" had. I said that the newcomers were too cool to like it at all; the unabashed tragic cast and illusionism would put them off. He nodded and smiled his crooked smile but seemed to accept my comment. Friends of Mark later said that he committed suicide because he was depressed over his lack of recognition by younger artists. This explanation struck me as superficial. In a remark to Katharine Kuh circa 1961, Mark said: "I curse God daily, because men are born to die." Knowing this, his suicide nine years later did not surprise me as much as it would have otherwise.

I never trusted Motherwell's comments about fellow artists. He was reluctant to praise a living contemporary lest it lower his own standing. But he made an exception of Mark. In 1957, he said to me: "In his seriousness and utter devotion to art, Rothko is a latter-day counterpart of Mondrian. He is able to internalize whatever he finds illuminating in modern art more completely and originally than any of his fellow artists." Motherwell concluded that "Mark is the most profound human being of any American painter living or dead."

If he were alive, Ad Reinhardt (né Adolph Frederick) would chide me for linking him with the likes of de Kooning, Kline, Guston, and Rothko. He once begged me to stop admiring either their work or his. "Choose," he said, with a grin. Ad liked to tell one of President Franklin Roosevelt's stories. A Sunday school teacher asked her class, Who would like to go to heaven? All hands went up but Johnny's. "Don't you want to go to heaven, Johnny?" Yes, teacher, but not with dem guys. However, much as Ad spurned the abstract expressionists, he was always to be found in their company because he believed that if they didn't form a community and speak for themselves, critics and their ilk would. Besides: "With whom else am I supposed to hang out?" he asked. "Ben Shahn?"

Ad was a purist who stood for "art-as-art," that is, art-for-art's-sake, and he wrote a lot about it, to the extent that he could be treated as an art critic as well as a painter. Ad's purist esthetic is related to Clement Greenberg's formalism. They should have been allies, but they despised each other. Greenberg rejected Ad because he refused to paint according to Greenberg's dicta. In the middle of a lecture on Duchamp at the Metropolitan Museum in 1970, Greenberg suddenly inserted an attack on Ad's so-called black paintings, proclaiming that they were made by fiat and consequently were inferior. Ad ridiculed Greenberg publicly for his role as advisor to collectors and dealers, in other words, as a "businessman." Ad's remarks, which appeared in *Artforum*, so enraged Greenberg that he threatened to sue the magazine. Ad was as sure of himself as Greenberg, but unlike the critic, he had a wicked sense of irony and was often funny.

Ad insisted that artists had to deal solely with what painting needed to become art-as-art—that is, to purge everything else, and the operative word is purge. As a champion of "art-as-art," he pitted it against "life-as-art." He insisted that painting had to be painting, pure and simple. Artists had to ask humbly of painting what it required, or rather what it no longer required, in order to be art-as-art. What artists wanted to express—their dreams, visions, experiences, politics, etc.—was of no account. Ad insisted repeatedly that "Art progresses by negation, leaving things out. Anyone who makes a positive statement is disreputable." He was, as he quipped, "positively for a negative art."

In his own so-called black paintings, Ad systematically wiped out the traces of the artist's creative process, presence, and temperament. He eliminated signs of his hand; motile, organic shapes; and varied, vivid colors—all of which were signifiers of life-as-art. Ad said that his black painting was "the ultimate painting," but then he produced a series which he numbered: Ultimate painting, fifty-two, Ultimate painting, fifty-three. Was he being arrogant, ironic, or funny? Ad said, "Parody is always implicit. Painting is always a private joke. I sense the parody in everything I do." At the same time, he believed passionately in the purism he espoused.

Ad maintained that the proper site for art was the museum because it was divorced (or should be) from the "real" world. As a thing apart, art belonged in its own exclusive realm. He said: "I like the academy-cloister-ivory-tower-museum isolation of art. . . . A museum should be a tomb, not an amusement center." Ad endorsed Malraux's idea of a museum without walls, because it promoted the idea that art comes from art and ought to be perceived as art-as-art.

There is something Kierkegaardian in Ad's veneration of art. Just as the philosopher wondered whether Christianity was too elevated for anyone to call himself or herself a Christian, the painter questioned whether he or anyone else could call himself or herself an artist. At times, the most that Ad seemed able to claim was that he was a craftsman, like the anonymous Moslem stone cutters who took generations to complete the magnificent huge screens they fashioned for their mosques.

Ad rejected all claims for art-as-spirit. As he said: "There has been no possessed or visionary artist in the entire history of art. Blake was a crazy poet. I'm on Reynolds' side. No artist talked to God." As a student at Columbia University, Ad had become friendly with Thomas Merton, who later became a Trappist monk and a noted spokesperson for the order, in which talking was forbidden. Ad would occasionally visit Merton's monastery in upstate New York. I met him once soon after his return and asked: "Are the Trappists pure enough for you, Ad?" He replied with a shrug: "They're in the butter and egg business."

Ad hated everything the abstract expressionists painted and professed, and he said so loud and clear. As he saw it: "Abstract expressionism is merely *old* moody German expressionism in a *neo* guise. Heat, passion, life, emotion, warmth— these are the phony words that have called in the crap all through this century. There should be penalties for expressionist debauchery." Then why did so many artists become abstract expressionists? He answered: "Psychoanalysis and progressive education. They both preached self-expression." Ad once asked an audience at The Club: "What's wrong with Larry Rivers painting a portrait of an assistant curator without his pants on—if he feels like it?" Ad insisted that his fellow artists were not only misguided in painting as they did, but were immoral as well. He denounced them all equally, but perhaps Robert Motherwell a little more, because of his surrealist rhetoric.

Although Ad was scornful of impure painting, at least it was painting. In contrast, sculpture was beneath contempt. He referred to it as "sculpture-and-pottery." "Sculpture," he said, "that's what you back into while looking at painting." Or, "where you park your ashtray."

Ad was often found at The Club and participated on many panels there. In 1960, he said that a lot of corrupt artists complain about corruption. He then listed artists' errors, among them, "to say there is no right or wrong in art, to make believe that artists don't know what they're doing when everyone else knows, to

consort with poets and musicians, to believe that there is no difference between abstraction and representation." Ad concluded: "I think I'll attack Motherwell."

In contrast to Ad's statement, Kline, speaking for the abstract expressionists, said: "To be right is the most terrific personal state that nobody is interested in." Ad shared his desire to be right with Josef Albers, an artist whose ideas and painting he admired. Albers told sculptor George Rickey that as a young man on vacation, he had met a psychoanalyst who, when he heard that he was an artist, asked to see some of his work. Albers lent him a portfolio of his nonobjective drawings. Several days later, the psychoanalyst returned them and proceeded to tell Albers in clinical detail that he had a problem with his father but loved his mother and so on. Albers stopped and with a smile said: "You see, George, you can't be too careful."

Ad ridiculed his colleagues at every opportunity. When asked in 1958 to write a statement for *It Is*, the in-house journal of the New York school, he submitted "44 Titles for Articles for Artists under 45." Among the entries were:

> "I am nature. I am history. I am fate. I sell my art."
> "Artists who get 'the call.' Call-artists."
> "Who's better? Lawyers who paint or doctors who paint?"

I was amused by these entries but troubled by the following one, suggesting that abstract expressionism had become academic. Ad spoofed "'Divine madness' in the third abstract-expressionist generation." I was also troubled by Ad's answer to the question, How did art become prostituted? "It was first done for love, then for others, and finally for money."

Ad would ridicule his contemporaries by name in print. He once juxtaposed comments by artists with his own gloss. Gottlieb and Rothko had said: "There is no such thing as a good painting about nothing." Ad's comment was: "There is no such thing as a good painting about something." De Kooning had said: "Art never seems to make me peaceful or pure." Ad's gloss: "Art never seems to make me vulgar or violent." Baziotes had said: "I looked at Picasso until I could smell his armpits." Ad responded: "Study the old masters. Look at nature. Watch out for armpits."

The abstract expressionists countered Ad's ridicule by razzing him in turn. Elaine de Kooning spoofed him in an article titled "Pure Paints a Picture." She wrote: "'If any paint remains on the picture-surface at the end of a day's work, I have failed,' states Adolph M. Pure, noted Anti-Post-Abstract-Impressionist. 'And to fail,' continues the enigmatic painter, 'should be the highest aspiration of the fine artist.... *The more pure your art is, the more you can give less.*'" Elaine had Pure paint by injecting a black fluid into foam rubber. "'I prefer to work in the dark ... figuratively and otherwise ... You can't be an artist *and* a success. You've got to take your choice.'" But Elaine admired Ad, listing him among her "pin up boys ... for his originability under difficult circumstances." Like Elaine, many abstract expressionists respect-

ed Ad's painting, much as they tried to dismiss his pronouncements.

In 1960, I witnessed a confrontation between Ad and his "enemies," Philip Guston, Robert Motherwell, and Jack Tworkov. It took place at a panel moderated by another of Ad's "enemies", art critic Harold Rosenberg, at the Philadelphia Museum of Art. Chagrined by abstract expressionist claims that purist art had no meaning, Ad countered that it had given rise to a new kind of content, one that embodied reason, consciousness, idealism, perfection, and tradition. Ad then announced that he stood for abstraction and was prepared to attack almost everything else. He said that any attempt to mix art with life, love, faith, society, the atom bomb, etc., is intellectually offensive. It results in dilution, compromise, vulgarization, and popularization. Ad went on to say that "it is wrong for artists to make believe that abstraction versus representation is no issue. As early as 1913, Clive Bell wrote that representation was a sign of weakness in the artist. Bell's statement that 'Every sacrifice made to representation is something stolen from art,' had been true for these forty-seven years." Ad then berated "impure" modern artists who passed themselves off as prophets, professors, primitives, bumpkins, ordinary chaps, personalities, or seismographs of the *zeitgeist.*

Directly addressing the other painters, Ad said: "It is not right for artists to encourage critics to think . . . that wiggly lines represent emotion." Tworkov rebutted Ad by asking: "Where is the artist to be found when you get through with all of your don'ts? Where is the man and where is the art? What makes art pure or impure? I don't know exactly where life enters into art. . . . Why would you want to keep it out?" Ad responded: "Art is always dead, and a 'living' art is a deception." He repeated: "Above all, I would exclude wiggly lines." Tworkov retorted: "What's the point? Until I saw the wiggly lines, I wouldn't be sure whether I liked them or didn't like them." Guston added: "I would like to know, who makes the wiggly lines and who sees them?"

In summing up, Harold Rosenberg said that Ad's "wiggly line" raised a perennial question: "To what degree ought art be separated from life?" Then Motherwell jumped to the defense of Ad's nay-saying: "When one excludes the misuses of painting, one is left with its proper uses. Ad's despair at sleazy popular responses is essentially constructive." Ad winced—at the thought of Motherwell as an ally, I presumed.

Ad was Jack Tworkov's pet peeve. Jack said:

> I am against dictation in art as I am in politics. I don't like rigidity in art. Bill de Kooning once said that you don't have to strive for rigidity; it overtakes you. Reinhardt wants to eliminate the artist from his painting. But his artistic image is there—in hiding. That's his real content. It makes us intuit what kind of a man would paint such pictures.
>
> Reinhardt takes a "moral" position which excludes every artist but him-

self. But, no great artist arises in a place where there are no other great artists, that is, in isolation. If Reinhardt's criticism of contemporary art is true, then the whole period isn't worth two cents, and that includes Reinhardt. Yet, what he does is interesting, but other things are equally interesting.

Much as Tworkov and his abstract expressionist colleagues rejected Reinhardt's dicta, his main point hit a nerve, and he never eased the pressure. He challenged them with, "You may need art to express your feelings, dreams, visions, whatever, but does art need you?"

Looking back, I now think that Ad's painting was closer in spirit and mood to that of the abstract expressionists than he would allow. In a show of thousands of paintings, his would be immediately recognizable. What could be more individual? And despite his desire to remove color from color in his pictures, the ghosts of color remain. He is revealed as a virtuoso colorist who preferred a dark palette. But, is the shadowy atmosphere emanated by his pictures also depressing? And what does it signify? Commenting on his "color symbolism," Ad wrote ironically that black symbolized "heroism, patriotism," and then added (without irony in my opinion), "death, doom, darkness." But Ad insisted: "I'm not involved with bitterness, black bile, or depression, like some critic once said. There is no reason to read darkness as gloom. However, I am for dullness, monotony, and deadness. My paintings are dark gray, not black. Sometimes they are light, not dense." Nevertheless, could not their blackness be viewed as romantic—even tragic— and link him to Rothko? Ad would have denied this strongly, of course. However, he did allow that, as he said, "the most personal gesture an artist can make in a romantic age is to paint like a classicist. What prevents this art from being eccentric is the context in which it is being presented, that is, within the romantic group. Its aim is to call attention to its hostile context."

Much as Ad's painting was preplanned, he told me that he was freer than the abstract expressionists, who made a virtue of their freedom. "I'm free because I know exactly what I'm going to paint, and I'm going to paint it over and over." Ad went on: "When you do the same thing over and over again you can be spontaneous. I have a rigid formal process yet it is most spontaneous, more spontaneous than Pollock. De Kooning paints his ass off. I only paint when the spirit moves me. It's gentleman painting."

The surfaces of Ad's paintings were often mauled by hostile viewers and he would have to repair them. He resigned himself to that. He would send his pure paintings out into the world where they would be defiled. They would then return to his studio to be purified again. The Museum of Modern Art's black Reinhardt was damaged and the curator phoned Ad and asked him to repair it. Ad told him to ship it down to his studio and he would send another one up. The

curator demurred: "But ours is *the* Museum of Modern Art's picture." Ad replied: "I don't know what you're fussing about. I've got paintings here that look more like that painting than that painting does."

Much as Ad believed that his purist abstraction had advanced painting to a new stage, he maintained that earlier styles in their own time were valid. Not only did he admire the old and modern masters but he studied them as well. He traveled throughout the world taking superb photos of works of art—of every and any kind—which he later made into slides. He used the camera both to help him see and to record what he saw. Every April Fool's Day, Ad would screen his slides at The Club in what turned out to be both an homage to and a parody of art history. He would project each for about five seconds, refuse to identify any, or to slow up. "Look at the art as art," he would say: "That's all you have to see, nothing more." The audience would grow frustrated—and often rowdy, but Ad would not relent. He was occasionally witty, however, showing dozens of slides of one subject—the naked buttock through the ages, or the elbow.

As Ad saw it, his aesthetics were his ethics. The purist artist was a moral person, or aspired to be. By this standard, impure artists as people were corrupt. Ad would insist that "an artist has a moral force which he has to preserve. An artist has to be better—like a priest or a teacher. A priest with money is no easier to take than an artist with money. If an artist becomes a businessman he loses his moral force. The assault on me for being successful is justified to a degree." Referring to the growing affluence of the abstract expressionists, Ad spoofed them as the "Kootz-and-Janis Kids," punning the names of galleries that represented the artists and the well-known comic strip. Again with Newman, Gottlieb, and Rothko in mind, he said that "Looking for church jobs is scandalous. It's Chagallerie."

Ad agonized over his own ethics. He was against commercial galleries but once had shows in three galleries simultaneously. Eyebrows were raised but that did not curb his moralizing. One night, I sat across from him at the Chuck Wagon, a downscale eatery across the street from the Cedar Street Tavern, while he chewed over whether to accept a $1,000 prize he had just won. He said: "I'm against awarding prizes for art." I responded: "Then turn it down." "But the publicity that my refusal will generate can be considered careerist. Look at the mileage Barney Newman got out of that ploy. Is refusing more immoral than accepting?" Ad ended his long deliberation by opting for the prize. Another time, a prominent collector (and big-time lawyer, no less), Ralph Colin, wrote an article calling Ad a fraud. Colin had been a prime mover in organizing the Art Dealers Association, whose principal aim was to promote the ethical standards of its members. I said to Ad: "He should know better. He's slandered you. You ought to sue." I had forgotten for a moment that Ad himself had been the defen-

dant in a frivolous libel suit brought by Newman. Ad answered flatly: "Artists don't sue."

In the evening, after a day's work, Ad would have a few drinks and write postcards to his friends and enemies in an elegant and distinctive script. I received about a dozen. The one I like the best arrived in March 1962. Ad had received the announcement of a young artist's show with a note at the bottom from the dealer saying that this young artist was given ten one-person shows in the last year and would Ad come to the opening to lend his moral support. Ad answered that he would attend; any artist that successful needed his moral support.

In a postcard dated April 4, 1962, Ad reported that he had given a lecture to architects on "ugliness," and the *New York Post* columnist "Murray Kempton was there—where were you? He's in a position to outscoop you on ugliness." But I had heard Ad's views earlier at The Club. The subject of his 1961 April Fool's Day talk at The Club was, "Who is Responsible for Ugliness?" His answers were: "Artists are responsible for ugliness. . . .The ugliest thing is art-as-commodity. . . .The artist as businessman is uglier than the businessman as artist. . . "Ugly geometric art is uglier than ugly expressionist art." Ad concluded: "Art is too serious to be treated seriously."

In the summer of 1967, just after our daughter, Cathy, was born, Ad sent a postcard to Lucy on which there was a picture of a rabbit by a sixteenth-century artist named Hans Hoffmann (spelled with two *f*s, unlike our Hofmann, who has only one). "If the rest of your (new) family don't want this nice bunny, give it to Irving for his files on the first generation. This document now in the Palazzo Barberini, not a gift of [dealer] S. Kootz or [art historian] P. Selz, see the expression(ism) in the Bunny's eye, and the bee almost in his bonnet, was macht das aus, was meint das iconologically?"

I have a Xerox copy of an undated letter Ad wrote to Tom Hess in which he asks Hess to publish a piece of his—quickly. "If you don't print my piece soon I won't get any credit for killing N.Y. Schesstractexpressionism before it dies of its own accord." Then Ad presented a long list of all "the people and stuff on your side," that is, against Ad's, which included just about everyone, including Hess, plus "mass-media, mass-appeal, Newsweek . . . Yale Art Department . . . modern museum's lending service . . . Life, Time, Fortune, money, status, power, mass-persuasion . . . fake comaraderie, togetherness, popularity, fun, openings," etc., etc. He went on to say that his side had a very few supporters. They included Hess (again), Lucy and me, "art, right, fate, history, and the future." He concluded, "What you got to lose?"

I asked Ad if I could buy one of his paintings and pay for it in installments. He agreed. But nothing happened for a few years we kidded about it on and off, but I

would not press the point and he took no action. Once when we were strolling near his studio on Broadway and Eighth Street, the subject came up and Ad said: "Yes, let's do it. We'll go the studio and choose a painting." As we walked on, I asked: "How will I pay?" He said, "Are you carrying a check?" I nodded. "Then write it for just that amount that'll hurt and not a penny more." I answered sharply, one of the few times I raised my voice to a revered artist: "But Ad, that's ridiculous. You know me and how hard-up I am. I insist on paying on time." He said: "I'm not a dealer or a collection agency. If you want a picture, you'll have to do it my way." I wrote a check for $100—and it did hurt—and gave it to him. We went to the studio, and Ad pulled out a 20-foot red canvas (now owned by the Hirshhorn Museum, I think) and said: "How would you like this one?" I asked, shamefacedly: "Ad, did you look at my check?" He answered: "Our business is finished. You can have anything here you like." I said: "Let me have the smallest black painting you have." Lucy and I hung it over our bed above a de Kooning lithograph we bought. That wall became our shrine.

In 1960, I savaged Frank Stella's black-stripe paintings in an article I wrote for *Art International*. To indicate how awful Stella's works were, I compared them unfavorably to Ad's black paintings. I met Ad soon afterwards and he objected to my using his work to trash that of the young painter. That took me aback. Ad would never have protested if I had attacked Motherwell in this manner. It occurred to me that Ad approved of Stella's painting. I bumped into Henry Geldzahler, the curator at the Metropolitan Museum, soon after, and he told me that Stella admired Ad, and that the two had not yet met. I then invited Ad to show his slides to Stella in a private viewing at my apartment, and he agreed. Stella evidently forgave me for my review because he came and brought Geldzahler with him. Lucy and architectural historian Richard Pommer, a fellow student of Lucy at NYU's Institute of Fine Arts, were also present. Stella and Ad hit it off famously, and the evening was a great success. Stella would become the most influential artist of his generation and was able, more than anyone else, to establish Ad as a major artist and to demonstrate that he did not close off art but opened it up. When Ad died, Stella wrote: "He can't play the game anymore. But nobody can get around the paintings anymore either. If you don't know what they're about you don't know what painting is about."

––––––––

From the first, I was struck by the ruggedness and strut of David Smith's welded constructions. They were my idea of what modern sculpture ought to be and became my measure of quality. Only the sculpture of Isamu Noguchi, Mark di Suvero, and Richard Serra could stand up to David's work. Di Suvero called David

the "blacksmith artist who changed sculpture from an objet d'art type of thing to something that is really strong, American industrial art." There was indeed something peculiarly American about David's work—and about David. He was sophisticated enough to hobnob in New York art circles, where he was often to be found. And yet there was something about him that was not citified, a bigness and openness about the man—and his laugh—that seemed more at home in the wide American out-of-doors. Not surprisingly, David preferred to live and work in upstate New York.

In 1998, I was asked by the Storm King Art Center to write a memoir on David for the catalog of a major show there in which I describe how I met David in 1956, and how we saw each other on and off until his death in 1965. I was always puzzled as to how, having grown up in Indiana and Ohio without art, he could have developed an avid receptiveness to avant-garde culture. He arrived in New York City in 1926 at age 19 and soon encountered the modern arts. Even three decades later, he still conveyed the excitement of attending a production of Stravinsky's *Firebird Suite* or seeing cubist paintings and collages. He also read James Joyce's novels—for the first of many times.

David enrolled at the Art Students League soon after arriving in New York. From 1927 to 1931, he studied painting with Jan Matulka. Matulka taught him about cubist picture-making and also introduced him to the nonobjective painting of Mondrian and Kandinsky. David said that after listening to Matulka one could never take abstract art lightly. Above all, he was inspired by his mentor's independence and courage since he sensed that Matulka's teaching, which was strongly opposed by hidebound colleagues, would probably lead to his dismissal from the League. It did.

After he was fired from the Art Students League, Matulka became something of a recluse. He continued to paint but did not exhibit. David maintained contact with his former teacher and tried to have his paintings shown. He urged Clement Greenberg and me to see them, and once in the late 1950s, he shepherded us personally to Matulka's apartment. We looked at the paintings in his living room. Lacking space, Matulka had tacked multiple canvases onto stretchers and flipped them like fabric samples. His work had not deviated much from his synthetic cubism of the 1930s, but it remained highly accomplished. Greenberg and I were impressed with what we saw, but we could not think of a gallery to suggest.

In the 1930s, David gravitated to avant-garde artists and joined the group that included Stuart Davis, John Graham, Gorky, and de Kooning. He said that he felt like a student, but they treated him as an equal. He added that he was lucky to have been accepted into this cosmopolitan circle. Like his friends, he greatly admired Picasso but experimented with every other style. In 1938, David joined the American Abstract Artists, most of whose members were doggedly nonobjec-

tive, and he exhibited abstract sculptures in their shows, while at the same time modeling his figurative *Medals of Dishonor.*

David kept up with innovative art in Paris by listening to John Graham, who made frequent trips there, and, like most modernist artists in New York, by reading or looking at *Cahiers d'Art.* David began to think of changing from painting to sculpture after he saw illustrations of Picasso's metal constructions in *Cahiers d'Art* in 1929. It occurred to him then that iron sculpture could be his forte. He had worked on the assembly line at the Studebaker automobile factory in South Bend, Indiana, and was generally familiar with metalwork. In the early thirties, *Cahiers d'Art* also published illustrations of Lipchitz's "transparencies," Giacometti's *Palace at Three A.M.* and other sculptures, Pablo Gargallo's forged sculptures (they had been exhibited at New York's Brummer Gallery, a show David had seen), and Gonzalez's iron constructions (Graham gave Smith one in 1934).

David often spoke of his passion for cubism, although he once said (with a smile) that he might still have arrived at his welded construction even if he had not encountered Picasso's work, since he had read James Joyce's *Ulysses,* so his "verbal knowing" would have sufficed. David also taught himself about surrealism by studying illustrations in *Cahiers d'Art* and by reading such magazines as *Transition* and *This Quarter,* whose Surrealist number (September 1932) he never forgot.

Like many of his friends during the Great Depression, David was socially conscious. In his *Medals of Dishonor,* he derided munition-making, gas and germ warfare, aerial bombardment, and other social outrages. He also attributed social meaning to welded construction, maintaining that iron and steel were the modernist sculptural mediums. "The metal itself possesses little art history. What associations it possesses are those of this century: power, structure, movement, progress, suspension, destruction, brutality." David's nouns—power, movement, progress—have a peculiar American resonance.

I once asked David whether his sculpture-making was essentially drawing. He nodded. I recalled that he had written: "I make my constructions like drawings. If you could draw on paper, you could make it with steel rods. A construction was a drawn object you could pick up." David then turned the conversation to music. He said that single instrumental pieces resemble line drawings, and he particularly liked unaccompanied cello and clarinet pieces.

The process of welding was vital to David. He equated its directness with honesty. As the art critic for the *New York Post* in the early 1960s, I once chanced upon him on my rounds. He asked if I intended to review the bronze casts of Julio Gonzalez's iron constructions then on view. Before I could answer he urged me not to. He scoffed: "They're not welded, like the originals. They're only casts."

David did not confine himself to sculpture. Indeed, his body of work is distinguished by its variety. One series that numbered in the hundreds consisted of

spatter pictures. He would place pieces of paper and/or objects onto papers painted white and spray the surfaces with industrial pigments. Once the papers and/or objects were removed, the white images that emerged looked like the ghosts of his constructions.

In 1959, he exhibited these pictures at the French and Company Gallery. I covered the show for *Art News* and was unstinting in my praise. I met David soon after the review appeared. He thanked me for it and remarked that it was the only wholeheartedly favorable one that the show had received. I said that I liked the pictures so much I would like to buy one—paying for it in installments, of course. He said: "I ought to give you one, but I won't. I'm a professional artist. Do you have five dollars?" I said I did. "It's five dollars down and five on delivery."

In August 1964, Lucy and I went to visit David in Bolton Landing, at his "sculpture-farm," as he called it, to collect our picture. He took us for a tour of the fully equipped factory that he had built there—he had named it the Terminal Iron Works—and the bucolic landscape with its idyllic views of woods, meadows, hills, and lake, in which the workshop was situated. Outdoors, he had sited some six dozen large pieces, which stood like sentinels, a title he would use for a number of welded constructions begun in 1956. I was struck by how well the works fit into their natural surroundings, how they mutually enhanced each other. Indeed, the landscape of upstate New York is their natural habitat. David told Hess that he designed many of his constructions for outdoors and that he preferred stainless steel: "I polished [the surfaces] in such a way that on a dull day, they take on the dull blue, or the color of the sky in the afternoon sun, the glow, golden like the rays, the colors of nature. . . . They are colored by the sky and surroundings, the green or blue of water."

Although David's fabrication was machine-shop, his subject matter was rarely machine-age, despite his use of iron and steel. His images generally referred to the human figure and the environment. David himself recognized the connection between his work, visual reality, and his life. He told David Sylvester: "My sculpture is part of my world; it's part of my everyday living; it reflects my studio, my house, my trees, the nature of the world I live in."

A number of pieces outdoors were painted either in color or white. As David said to Hess: "I've been painting sculpture all my life. . . . Painting and sculpture both, beats either one. . . . Sometimes you deny the structure of steel. And sometimes you make it appear with all its force in whatever shape it is. No rules." He pointed to an all-white piece and remarked that he had put seventeen coats of white on it before he got the color right. In my 1959 review of his spray pictures, I noted that the white images resembled his sculptures. I also related the spattered backgrounds to "the unspoiled Lake George settings against which he likes to place his sculptures." In the actual landscape, I saw clearly how closely linked the pictures and the welded constructions were.

David's studio-factory was crowded with sculpture in progress, but such was his productivity, there was work everywhere in the house as well. One room was filled with drawings, both abstract and figurative; another, with ceramic plates; and still another with spattered pictures. While looking through some of his drawings with us, David commented that as a "professional" artist he tried to complete one drawing a day, no matter what. He put Lucy and me in the room of spattered pictures—on tables and in drawers—told us to choose one, and left. We selected about a dozen and were trying to make our final choice when David returned. Studying his work with us, he asked if we didn't mind his holding out two or three. He said that he could use them as "seed" for sculpture.

At one point while we were in the fields looking at his work, we saw a mammoth earthmover wend its way up the mountain toward David's place. We walked to the gate to meet it. The foreman greeted David and told him that a metal part had broken and would he please weld it. David asked whether he had the forms authorizing payment for his labor. The foreman shrugged and said dejectedly that he would have to write them up in triplicate and present them for approval to the town authorities. They both looked at each other for a prolonged moment, and the foreman said: "All right, David, what do you want?" "A shed right there," pointing to where materials already had been laid out. "O.K. boys," he said to his crew, "give him his shed." I was touched by the familiarity in their bantering. David felt very much a part of the Lake George community. He took us to a dinner at a local Italian restaurant. As we entered he was greeted by name by his fellow townspeople. His delight and pride in that recognition showed. The Lake George area was more than a place in which to live and work. It was a place with which to identify. The people there had become his people. David's community encompassed both metropolitan and rural America.

Did David's work reveal his American roots? Perhaps in his tinkering and choice of machine-shop fabrication. He was a modernist, intent on making new art. Was there any relation between his American identity and modernism? The eighteenth-century traveler Crèvecoeur (writing as Hector St. John) defined the American as "a new man who acts on new principles; he must therefore entertain new ideas and form new opinions." David's decision to locate his factory-studio in the pastoral Adirondack mountains strikes me as peculiarly American. It was as if he tried to reconcile the two antithetical visions that Leo Marx defined in his book, *The Machine in the Garden*: on the one hand, the idealized image of America as a New Eden in which its inhabitants would lead a simpler life, closer to nature (as evoked by the writings of Cooper, Thoreau, Melville, Frost, and Hemingway), and on the other hand, a regard for industrial might, which has had an equally powerful hold on the American consciousness.

In 1977, Beth Rowe, the director of the Lake George Arts Project, invited me to curate a show on Prospect Mountain in the town of Lake George overlooking David's spread at Bolton Landing. The mountain has spectacular views of the lake. I suggested that we exhibit welded construction as an homage to David, who had died in 1965. It made sense because, as I commented at the time to a local reporter, "when artists think of this area . . . Bolton Landing does not mean a tourist's world. It means Smith's world." Or as John Ashbery wrote, just as Monet made Giverny famous, so Smith had made Bolton Landing. Moreover, the sculpture would be sited in the Adirondack landscape, just as David's was.

Rowe wrote a grant proposal to the New York State Council for the Arts and was rejected. She phoned to say that our show was off. I was furious and told her to fight: talk to your mayor, state legislators, congressmen. Get them to tell those Council bureaucrats that they are discriminating against upstate New York. Demand that some of the goodies they give to Manhattan go to Lake George. It succeeded, of course, and we were on.

I selected eighteen sculptors ranging from established artists, such as di Suvero and Willam Tucker, to little-known figures, such as Brower Hatcher, Lee Tribe, and John von Bergen. David was featured with two major works. Procuring them presented problems. Clement Greenberg, the executor of David's estate, demanded that we post guards around the clock. Our funds were tight, but we managed by hiring somewhat dotty unemployables. Greenberg never found out.

Prospect Mountain was a perfect venue for a show of sculpture in landscape. It had one road that stretched for five and a half miles up the mountain. Most visitors ascended by automobile. The work was highly visible and easily accessible to people, who could park their cars at various places, get out, walk around, and look. We also published a booklet containing an essay by me on abstract metal construction, which was presented to everyone who visited the park. David would have approved. He was strongly supportive of the Federal Art Project in the 1930s because it had "stimulated an interest in [exhibiting] art where art had never been shown before."

The show changed the perception of art by the local builder's crew we hired to help install the work. That would have touched David. He had been a worker himself—on an automobile assembly line, as a telephone lineman, a cab driver, and a welder of tanks and locomotives during World War II. In 1942, he had joined the United Steelworkers of America, Local 2054, and was proud of his membership. At first, the Lake George crew looked upon the artists as weirdos, but as they worked together, the workers recognized that the artists knew their craft and relations became very warm. The workers and artists not only came to respect each other but to like each other; one of the workers actually took a day of personal leave to help a sculptor set up his piece.

The most dramatic moment of collaboration was the installation of Isaac Witkin's huge metal construction. It had been mangled in transport to Lake George and Witkin dejectedly told us to remove it from the show. Examining the piece, the foreman said that he saw how it might be fixed. Witkin shook his head but agreed to the foreman's proposal that we give it a try. We met on site at daybreak, hours before the opening. The foreman had his man on the crane lift the piece weighing tons as high as it could go and let it drop. As it hit the ground with a heart-stopping crash, two workers wielding sledgehammers banged it into shape while Witkin and his assistant bolted it together. It succeeded, but Isaac's nerves were so jangled that he left immediately, leaving Beth Rowe to repaint the sculpture as best she could. As we were leaving, we saw two workmen turn their car to drive back up the mountain. I shouted to one: "Where are you going?" He called back: "To take another look at the art."

David would have approved of *The Prospect Mountain Sculpture Show* for still another reason, namely its inadvertent influence on New York State's funding of the arts. David was grateful for the Federal aid that he and other artists had received during the Great Depression. It had enabled them to survive as artists. Moreover, as he said, the Project gave artists the feeling that "for the first time, [we] belonged . . . to society. [We] had recognition from our own government that we existed."

Soon after the show opened in the summer of 1979, the New York State Council on the Arts was undergoing its annual crisis. The state legislature in Albany, prodded by upstate lawmakers, who thought too much money was being allotted to New York City, resisted funding the Council. Prospect Mountain was an hour's drive from Albany, and the local newpapers gave the exhibition considerable coverage. The New York art world also took notice. Many of its constituents followed the advice of John Ashbery, who wrote in *New York* that the show was not to be missed because "work of these proportions doesn't often make it to New York galleries." State legislators too made the trip to Lake George and were impressed that a major show heavily funded by the Arts Council had been mounted in the hinterlands and had received favorable media attention not only locally but nationally as well. Our exhibition contributed to the passage of the legislation to continue to fund the Council.

The show had another spinoff. State legislators who visited Prospect Mountain were guided through it by Beth Rowe. In due course, she became the Executive Director of the New York State Senate Cultural Committee. Beth became a close friend of Lucy's and mine, as did her soon-to-be husband, Brower Hatcher, who was one of the exhibiting sculptors. I was so taken with the new work Hatcher exhibited on Prospect Mountain that I began to follow his work. In 1991, I curated a major show of it at the Center for International Contemporary Art in New York City.

Much as David and I were friends, I sensed that he was suspicious of my role as art critic. Once sitting together in Bradley's Bar, in response to a remark he made, I said: "But David, that doesn't make sense." He responded smiling: "What can a critic know?" Later, looking over his 1954 notebook in the Archives of American Art, I came across the following comment jotted down in longhand. "The secret . . . inner identity [of the artist] is seldom talked about and should be always secret. Words lead us into clichés not involved with the order of art making or the visions which are the artist's references. Art comes from dreams and visions and not [from] verbal philosophies."

# More First Generation Artists Who Inspired Me:
## Hans Hofmann, Josef Albers, Milton Avery, Jackson Pollock, Clyfford Still, Tony Smith

There were other older artists whose diverse work and/or ideas were very significant to me, although not as much as that of my artist heroes. I was strongly influenced by the ways in which Hans Hofmann, Josef Albers, and Milton Avery approached color. I met Hofmann socially several times, occasionally at openings in Provincetown and New York, once at a small dinner party days before his death in 1966, and twice while previewing his shows at the Samuel Kootz Gallery for *Art News* and the *New York Post*. Hans was there to supervise both hangings of his work and we were able to talk at length. He was supposed to be deaf and wore a hearing aid, but I imagined that he used it to avoid useless and boring conversations. At one installation, I quietly suggested to Kootz that two pictures would look better if they were switched. Hans was three rooms away but he called out: "What did he say?" and came right over. They made the change. My reviews were very laudatory. Once when we met, Hans thanked me and offered to give me a painting, but I was too shy to collect it.

Hans was more than four decades older than I was and an eminent artist and teacher. Nevertheless, at one and the same time, he was able to act the modern master and to treat me cordially. He was robust and warm, enthusiastic, expansive, and assured. But because of his age and the aura of history that he emanated he was also somewhat imposing. Hans had lived in Paris from 1904 to 1914—the heroic decade of twentieth-century art—and had been a friend or acquaintance of the innovators of fauvism and cubism, learning their ideas at first hand, possibly even contributing some of his own. As early as 1915, he had opened a school in Munich. It would become world famous and earn him the reputation as the greatest teacher of modernist art in the twentieth century. Devoting himself to teaching, he abandoned painting from roughly 1915 to 1937.

Hans was teaching in the United States when the Nazis took power in Germany, and his wife told him not to return. He loved the United States. In 1949, he spoke at Forum 49 in Provincetown on the topic of "What is an Artist?" and concluded his talk by hailing the American Constitution as a great work of art. "Long live the arts and the artist in a free future."

Hans opened his own schools in Provincetown and New York and was responsible for teaching modern art to half of the avant-garde in the 1930s and a

sizable segment of the New York school in the 1950s—but not the pioneer abstract expressionists of the 1940s, with whom he himself was associated as a painter.

When Larry Rivers was asked what made Hans a great teacher, he replied: "His charisma. When he came around to look at the work he was relaxed enough to beef up the timid hearts and pompous, blustering and egocentric enough to make every fiber of the delusions of grandeur puff and puff and puff up until you saw your name clearly in the long line from Michelangelo to Matisse . . . to Hofmann himself. [He] had a way of making art seem *glamourous* and meaningful and what is there in life that can compare with its glories etc. etc." Mercedes Matter said: "He had tremendous energy, and ultimately, that is what every great teacher has. He poured it into you. He had very specific things to say and was very definite. He made things simple. . . . He also knew how to let you alone. His down side was his dogmatism. He was so dynamic and positive that he could create dependency. Many students had to break drastically."

So many of my acquaintances were students or former students of Hans that I was able to learn about his aesthetics from them. What did he teach? To put it briefly, an artist had to take into account at one and the same time three interacting factors: the three-dimensionality of nature; the two-dimensionality of the canvas; and the artist's own intuitive and imaginative "feeling into" both nature and painting. The artist was supposed to begin with some reference to visual reality, then translate the volumes and voids of things seen into planes of color in accord with the flat nature of the picture surface. And then the crucial action was to compose these flat areas into complexes, every element of which was to be reinvested with a sense of space, that is, depth or volume, without sacrificing the physical flatness of the picture plane. To achieve this simultaneous two- and three-dimensionality or "plasticity," Hans devised the technique of "push and pull"—an improvisational orchestration of areas of color.

The strength of Hans's teaching was his ability to demonstrate his ideas by referring directly to the paintings of each of his students. When I observed him in his classes—I would sneak in—he would reach into a ream of construction paper he carried, ruffle through it to the color he desired, tear off a piece, and affix it to the surface of a student's work. The picture would take on a new life. All of the colors would become more volumetric and vivid. His students could see the improvement.

I always admired Hans's painting and believe that certain of his pictures— *Lava* and *Agrigento* come to mind—must be numbered among the greatest of abstract expressionist canvases. Other critics—Clement Greenberg, Harold Rosenberg, William Seitz, and Thomas Hess—also valued Hans's work. However, our favorable opinion was not shared by most of Hans's fellow artists or his for-

mer students. It may be that critics perceived Hans differently than artists because we focused on his great paintings. His detractors seemed to judge him by his weaker pictures. Hess, in his obituary of Hans, wrote that "They see table-pounding insensitivity [in his painting]. It seems numbing, overdesigned. . . . too athletic a display of pictorial musculature—almost like a weightlifter flexing his 'delts.'" They also maintained that because Hans worked in a variety of directions at the same time, his pictures were facile exercises in problem solving and lacked singleness of vision, purpose, and conviction.

Hans was downgraded for another, more significant reason. Apart from his works' alleged lack of quality, its content was different from that of de Kooning, Kline, Guston, Pollock, and Rothko. Their painting, as Jack Kroll, *Newsweek's* art critic, wrote, "appears to be a cardiographic report from the Age of Anxiety." In contrast, Hans's canvases were unabashedly hedonistic and evoked nature at its most luxuriant. Seitz observed, "One would be hard-pressed to find a stroke . . . that is melancholy, bitter, ironic, or disenchanted" in his pictures. That may sound commendable, but in the hot and cold war 1940s and 1950s, it was not. As Philip Guston said to me, "There is no torture in Hofmann's pictures. They are Teutonic gymnastics, a kind of health faddism." Hess concluded: "No wonder he eludes so many of us in an age which rejects solutions and, most of all, happy endings."

Hans openly revealed his roots in French modernism that his colleagues rejected or tried to bypass. Throughout his long career, he was intent on fusing cubism and fauvism—the compacted drawing and design of the one and the explosive color and texture of the other. Because of his ties to his youth, Hans continued to proclaim the hegemony of Paris over New York, at a time when his abstract expressionist colleagues were asserting their artistic independence, and this was held against him.

In the 1960s, Hans's painting was reevaluated by young painters who were commanding growing art-world attention. For example, Frank Stella dubbed him "The Artist of the Century." Why the upgrading? In his obituary, Hess expressed the hope that a more peaceful generation would recognize Hans's desire to create joy. In the 1950s, Greenberg was able to turn the attention of the stained color-field painters who followed his lead away from social pressures to purely aesthetic ones, demanding that they cultivate hedonistic decoration as a reaction against abstract expressionist angst. The extravagant physicality of Hans's painting, expressed by his energetic brush and bold palette, and his obvious delight in the orchestration of high-keyed colors, fit Greenberg's bill. As I see it now, the embrace of *joie de vivre* was an attempt to forget the calamities of World War II, the Cold War, and Korea, and to ignore the horrors of Vietnam. I could not overlook these wars, and much as I relished Hans's painting, I could never wholeheartedly accept it.

If Hans had any competitor as the foremost teacher of modern art, it was Josef Albers. A refugee from Nazi Germany, like Hans, Albers had been a professor at the Bauhaus and later, the head of painting at Yale. As I was learning about Hans's approach to color, I met Albers's former students, who shared with me what their teacher had to say. However, I did not meet Albers himself until the late 1950s, at openings at the Sidney Janis Gallery, and again in 1962 when I interviewed him on the Casper Citron radio show. He was too formidable for me to call him Josef and, indeed, spoke to me as if he was patting a child on the head. Perhaps he had the right; after all, like Hans, he was a historic figure. But Albers assumed the high-and-mighty role of professor—and German at that—addressing an insignificant student—it was infantilizing—whereas Hans was the *gemütlich* mentor.

While curating a show of Yale Art School graduates in 1979, I was told by the participating artists who had studied with Albers that his goal, as he had said, was to open eyes; that he was extraordinarily sensitive to materials; that he insisted on clarity, control, and economy; and that he disdained self-expression and artistic fashions, what he called the "bandwagon." He urged his students to "sit on your own behinds." They all recalled the rigors of his famous color course, which taught them to see color, or rather, colors in interaction. Several shuddered as they relived the agony of solving the problems Albers set for them, for example, to relate two colors so that they produce the effect of a third: $1 + 1 = 3$.

Albers and his disciples had indoctrinated colleagues of mine at SUNY Purchase, whose faculty consisted largely of Yale MFAs. His teaching often came up for discussion, and when there were Hofmann alumni in the company, comparisons were made between the approaches of the two masters, namely, which was better. Hofmann and Albers had disliked each other's painting. Hofmann was suspicious of Albers's "designing," and Albers mistrusted what he took to be Hofmann's self-indulgent expressionism. When the former students of both men retained the prejudices of their teachers, the conversation could grow heated.

However, both artist-teachers were alike in that they were totally committed to art and insisted on the primacy of seeing and doing. They had different things to teach. Albers was intent on demonstrating how colors in interaction changed colors, that is, how colors functioned "optically." Hofmann was more concerned with how material planes of colors could be juxtaposed in order to create a sense of immaterial volume and depth. The methods of both were improvisational, but whereas Hofmann preferred abstract expressionist messiness, Albers opted for Bauhaus cleanliness. Albers stood opposed to the New York school, but he recognized the vitality of the leading artists—they "tickled" him—and he invited them to lecture at Yale, though after they left he would challenge what they had said.

Both Albers and Hofmann strove to evoke the transmaterial—that is, "the

spiritual"—in art: for Albers, the disembodied *effect* of a third color engendered by two, and for Hofmann, the equally intangible *suggestion* of a third dimension. The evocation of "the spiritual" was so vital to Hofmann and Albers that it took on a quasi-religious import or, if not quite that, it reflected a Hegelian metaphysic, perhaps a carryover of their German schooling.

---

At roughly the same time that I was introduced to Hofmann's "plastic" color and Albers's "optical" color, I learned about Milton Avery's "field" color. I met Avery a few times at openings, visited him and his wife, Sally, in Provincetown in the summer of 1957, and had dinner with him once at their home. Milton was very genial, smiling gently most of the time, but sat quietly and said very little. When I asked him a question, Sally answered. "Milton showed Rothko, Gottlieb, Newman, and other young artists how to use large areas of color, and that set them off in a new direction, but he never taught anyone formally. He was a modernist at a time when social realism was the dominant style, and the young artists took courage from him." Avery interjected: "I wasn't conscious of that. My relation to the younger painters was primarily a social one and we looked at each other's work."

Avery was inspired by Matisse and, in the 1930s, transmitted his ideas to his young friends. Like Matisse, Avery sought for expression through color. To enable color to attain visual and emotional fullness, both painters suppressed pictorial elements that Gauguin termed "alien" to color: complicated drawing and heavy textures that distracted attention from color, and particularly modeling from light to dark that dulled color. Like Matisse, Avery was a color magician, but his painting was more sober and brooding, akin to that of Albert P. Ryder and Marsden Hartley. Avery's subjects are also different in setting from those of Matisse. As Rothko observed, he painted "his living room, Central Park, his wife Sally, his daughter March, the beaches and mountains where they summered; cows, fish heads, the flight of birds; his friends and whatever world strayed through his studio: a domestic, unheroic cast," and Rothko might have added, an American one. However, it was Avery's use of color that most impressed Rothko—and Avery as a man, who emanated an aura of calm conviction in his work.

---

I also met Robert Motherwell while summering in Provincetown in 1957, and interviewed him five times. That began an acquaintanceship that lasted until the early 1970s, when he moved away from New York City. As a painter Bob was insecure. "Guston," he said, "is a more natural painter than I am. So is de Kooning." But Bob was convinced that he was smarter than his abstract expressionist colleagues, and put

himself forward as their spokesman, not without irate objections from them. I had read much of what Bob had written even before I met him and had to admit that in providing gesture painting with conceptual cachet he was quite a good mouthpiece.

Bob was as romantic as he was intellectual—using his way with words to flesh out an image of the artist as existential tragedian. He spoke of the abstract expressionist artist as "a solitary individual in the Kierkegaardian sense," overcome with existential despair, exacerbated by "the belief that no painter would get recognition."

"Does beauty count?" I naively asked Bob in an early conversation. He replied patiently, "If you go directly after beauty, you'll end up with something like *Harper's Bazaar*. Then beauty must be a byproduct of some other intention.... For me those painters who have the most intense sense of existence seem to be the most beautiful painters, I think of Guston, Rothko, and Kline." Elsewhere he said that he and his associates had "a horror of anything contrived. The only alternatives to contrivance are inspired moments of existence."

Bob was well versed in modernism but came to painting late, after studying philosophy. Matta, a young surrealist painter whom he met in 1941, was his primary influence. Matta, as Bob put it, was the most energetic, poetic, charming, brilliant, and enthusiastic artist that he had ever met. In the three summer months of 1941, Matta gave him a "ten-year education in surrealism." They also went to Mexico where Matta introduced Bob to Wolfgang Paalen. Bob and his wife settled near Paalen and lived there until just before Christmas. Bob said that he received his "post-graduate education in surrealism, so to speak." However, when in the *Triumph* I wrote that Bob had studied with Paalen, he denied that he had and, instead, claimed to have been a colleague.

Bob spoke often about the surrealist émigrés. He recalled nostalgically the excitement they created in New York. They formed "a kind of brotherhood" which met three times a week at Larre, the inexpensive French restaurant on West Fifty-sixth Street. There were internal struggles, however, in the early 1940s. Matta had a perverse love-hate attitude toward André Breton and his coterie. Bob recalled: "Matta wanted to show them up as middle-aged, gray-haired men who weren't zeroed into contemporary reality." If, as André Breton said, "psychic automatism," or spontaneous drawing and painting, was central to surrealist practice, then, according to Matta, the émigrés were employing it too timidly.

Matta then tried to put together a group of young artists who would be daring in their exploration of automatism and whose radical new paintings would create a revolution that could renew surrealism. At first he enlisted Esteban Francis, Gordon Onslow-Ford, and Bob. But he wanted more New Yorkers in his group, and he asked Baziotes, whom he had recently met, to recommend artists he knew on the Federal Art Project. Baziotes suggested Pollock, de Kooning, Peter Busa, and

Gerome Kamrowski. Baziotes and Bob visited them, and Bob "taught" them the theory of automatism, or so he claimed. De Kooning was not interested in the surrealist "adventure," but Pollock, who drank through the meeting, liked the idea, although he would not join a group. Then Matta capriciously gave the whole thing up. Only Gorky was accepted into the surrealist inner circle.

On the whole, the émigrés did not interact easily with the New Yorkers. Bob said: "To the Europeans, to be an artist was to act like an aristocrat. This was upsetting to our young working-class or middle-class artists who had been on the WPA." Jimmy Ernst once told me that he thought that as the son of Max he might bring the Parisians and New Yorkers together. He invited both groups to a party in his studio. The French congregated on one side of the loft, the Americans on the other. At one point, Max sought out Jimmy and, pointing to the Americans, asked: "Who are these people, your wife's relatives?"

Bob did have his differences with Matta. Matta believed, as Bob said, that "there is something essentially vulgar about being a good painter. It was part of the surrealist ethic. Even Miró was suspect. Max Ernst called Picasso a pastry chef. Duchamp also believed this." Bob accepted that automatism was surrealism's most liberating and revolutionary contribution, but he refused to surrender artistic decision-making and the quest for quality. Nor would he deny the influence of his beloved Picasso, Miró, and Matisse. Consequently, he replaced the surrealist term "psychic automatism" with "plastic automatism," an improvisational method that would enable artists to invent unexpected forms and take into account formal and aesthetic considerations.

Although I learned a great deal from Bob, I looked critically at everything he proposed because much of it seemed self-serving. Bob sought to rewrite the history of abstract expressionism—with himself as the seminal figure. For example, he dismissed the 1930s as a fruitless, dismal, and insignificant decade in American art— naturally, because he was not around then. He claimed to have introduced Gorky to automatism at a party where they met and talked. According to Bob, Gorky kept saying: "Tell me more." Harold Rosenberg, a bystander, later recounted this conversation to de Kooning, who laughed and said that Gorky was being ironic. De Kooning went on to say that when he saw his first painting by Soutine, he ran into Gorky and Stuart Davis, and reported his find with great enthusiasm. Davis shrugged and said: "Who's Soutine?" But Gorky said, "Tell me more." And de Kooning responded: "You already know all about him." Despite the protestations of Rosenberg and others, such as David Hare, Bob kept on claiming that he influenced Gorky.

Bob was the most history-minded of the abstract expressionists, but if it served to aggrandize his historic position he would shrewdly diddle the facts. For example, he presented himself as a protégé of the revered Meyer Schapiro, striving for a kind of brilliance by association. Schapiro told me with a curl of his lip that Bob

enrolled in a course of his at Columbia but did not complete it. "He later came on as a philosopher to impress the surrealists." Schapiro's attitude toward Bob was shared by many artists, who disliked his intellectual snobbery and attempts at self-promotion, often at the expense of his colleagues. Bob dismissed de Kooning as a "newcomer," in comparison to himself, conveniently overlooking the fact that he had had his first show in 1944 after only three years or so of painting, whereas de Kooning years before that had achieved a considerable underground reputation in the community of avant-garde artists. No wonder de Kooning called him "the baby-faced killer." Bob would bemoan the "misunderstandings with the de Kooning group. Why do they put me down as a French painter? It's so unfair." Was it unfair? I asked Schapiro. He replied: "Well, Motherwell was always in love with the school of Paris, and his pictures possess the elegance identified with it." That was bad enough, but artists in my circle thought that Bob was not much of a painter and didn't deserve the attention he was getting.

Tucked away in Bob's statement on Bradley Walker Tomlin in the catalog of Tomlin's retrospective at the Whitney Museum was a mini-history of the influence of the European surrealists on the American abstract expressionists "with Joseph Cornell, David Hare, Noguchi, myself, and a little later, Gorky, as transmission agents." That "a little later" was written in bad faith. So was Bob's dismissal of his "friend" Tomlin as a "dilettante," and in 1978, bitchily, as a "groupie," and this about a remarkable artist who as early as 1948 had achieved an independent abstract expressionist style. These were cheap shots which made my art-historical blood boil. The "groupie" remark appeared in an obscure English magazine. But Bob knew that "information" planted in out-of-the-way publications would be ferreted out by zealous young scholars, such is the nature of academic research. Bob achieved some of the success that he did because he outlived most of his colleagues and kept himself available to young historians, indeed, cultivating them.

When I first met Jackson Pollock around 1954 he had been a household name since the notorious 1949 article on him in *Life*. My artist-friends and I recognized his innovative role and admired his paintings, but we did not put Jackson in the class of de Kooning or, for that matter, Kline or Guston. In person, we knew Jackson as a drunk who would show up late on Monday nights at the Cedar Street Tavern and do a Pollock number, picking fights and breaking stuff. One night I sat with Jackson at a table at the Cedar and watched him shatter a beer glass, mix the shards with cigarette ashes, and, using his bare hands, compose a "picture" on the tabletop. At a loft party another night, he went from window to window smashing each one in turn. Did he do this out of a compulsive need to recreate everything—

as Kline said—or was he just sloshed? I thought his behavior was just a drunken act. But when he peed in Peggy Guggenheim's fireplace during a dinner party at her apartment, she told Burgoyne Diller that only a genius would do that. She was right about his genius. When I stood transfixed before *Autumn Rhythm* at the Metropolitan or *One* at the Modern, Jackson the drunken boor was forgotten. I would vow never to confuse what I knew of an artist's life with his or her art.

But was the Jackson I encountered at the Cedar the "real" Pollock? For example, when drunk he could hardly put two intelligible words together, and he got the reputation of being tongue-tied even when sober. Was this great artist always that way? Or was he some kind of Dr. Jekyll and Mr. Hyde? What was he like when he was on the wagon or at ease in a social situation? I decided to ask people who knew him. In an interview with me in 1966, Theodoros Stamos recalled that when "Pollock was sober he was marvelous. He couldn't have been nicer and more charming. When he was drunk he was terrible." I interjected that Rothko had told me that he was very smart. Stamos agreed and added, "and he could talk."

One night in 1958, at the Cedar Street Tavern, Tony Smith reminisced about Jackson: "Pollock's house was jam-full of art magazines and books. He really knew what was going on. Pollock's inarticulate nature was social not intellectual. He couldn't act or talk to people in a social situation, but those he felt comfortable with were astounded by the acuteness of his eye and insights into painting." In a later interview, Smith reiterated: "Jackson was very aware of European painting—Miró, Arp, Masson. When I asked him how he had come to drip, he showed me an automatic drawing by Arp in the catalog of *Fantastic Art Dada Surrealism* at the Museum of Modern Art in 1936. But Pollock always transformed what he took."

In 1958, I interviewed Lee Krasner, a first-rate painter and art-savvy intellectual, about her husband. She had encountered his work in 1942 at a group show that John Graham had organized at the MacMillan Gallery in which she was also included. Jackson's work stunned her; he had taken "some jump" beyond her and everyone else she knew. She looked him up and became his lover. He told her that surrealism was good because it shook up the geometric abstraction favored by members of the American Abstract Artists, and recommended that she ditch them. Soon after she met Jackson, Lee brought him to Hofmann's studio. Hofmann said to him that artists had to abstract from nature. Jackson responded that he didn't. Hofmann said: "But you will repeat yourself." Jackson countered: "I am nature."

What did Jackson's painting signify? Lee replied: "Boundlessness. He believed that painting ought to be boundless," like the endlessness in jazz, which he loved. She went on to say that "Jackson felt affinities between his allover imagery and that of Still, Rothko, and Newman." Jackson said that because of its limitlessness, his and their painting was not French and was therefore American.

What was Jackson's influence on other artists? James Brooks, his friend, replied: "His technique 'released' me from the inhibiting tightness, rationality, and coolness of cubism." Charles Cajori, a younger painter, said that it was not the "drip" that made Jackson important to him but the "new" space he had created, the open, flowing, unending space without climaxes. "This space was to our time what perspectival space was to the renaissance." Moreover, Jackson's poured paintings are metaphors for spontaneity, directness, and freedom. His chance "drips" are also signs of the absurd fortuitousness of the human situation. But then he did control and order the accidents, simultaneously chancing and forming.

Jackson was convinced that he was a great artist and at the same time was plagued by the fear that his painting was trash. Was he just a weirdo "Jack the Dripper," as *Time* dubbed him? Peter Busa remarked that "Pollock went the furthest. He believed in what he was doing, but he had tremendous doubts." Nicholas Carone agreed, but added that despite Jackson's doubts, "He dared to RISK! To choose to paint on the floor with Picasso on your back. Jackson said, to hell with everyone. To hell with the dollar sign. This has got to pour out of me because an inner image needs to be expressed, and I'm going to die if I cannot be myself."

The more I saw of Jackson's paintings, both myth-making and poured, the more awed I was by their greatness. They would hold their own against any work in the history of art. Sadly, the 2001 movie *Pollock* made little sense of why Jackson became the artist that he was or what his painting was about. Instead, it pandered to the vulgar image—still widely held by the public—of the artist as nutcase. Jackson was presented as a pathetic drunk, psycho, and boor. I half expected to see him cut off his ear. The tawdry portrayal of Pollock was bad enough, but the film compounded it by presenting Lee Krasner as a shrew and ignoring her role as a painter and intellectual in her own right. And Clem was little more than a fat slob who grunted, "Paint." De Kooning was the most ludicrous of the cast of characters, and when he acted his wimplike bit, Lucy and I laughed out loud in an otherwise silent theater. But the movie had one truly funny line. When Lee first sees Jackson's poured paintings, she says: "You done it, Pollock, you cracked it wide open." I was determined to use that phrase in one of my studio visits, but I knew of no artist who would be amused.

---

Pollock was one of the three pioneers of abstract expressionism. The other two were Clyfford Still and Willem de Kooning. Still and Pollock recognized each other as kindred spirits and became friends. Pollock respected de Kooning; Still did not. In the de Kooning circle, we regarded Still—as we did Pollock—as an innovator, but not as a "painter." Still did have a coterie of devotees who would carp at de Kooning as a traditionalist and declare that Still was a genuine rebel.

Still believed that painting was a moral act. As an artist, he waged a constant war between good and evil, God and the devil. The battleground was within himself and the art world. He was convinced that he had won. As a sign of his goodness, he lived a Puritan life in order to concentrate on his work. To remain righteous, Still would not be beholden to anyone. Keeping clear of all artistic and social indebtedness became a major aim for him in life and in art. Still's former student and friend, Jon Schueler, told me that Still was constantly embattled. He believed that the enemy might pop up at any moment. It might be you and you never knew why.

Whenever Still felt a threat to his creative being, he took action, often brutally, particularly as the fifties progressed. With growing zeal, he denounced the devils—that is, artists who valued commercial success, who had sold out, and whose depravity was evident in their work. As he said to Ti-Grace Sharpless, with New York artists in mind: "And the artist today, who is he? A lower-middle class Christ who can sub in a pinch as baubled court jester? An intuitive boob? . . . A mystic slob, perhaps vomiting on a bed for the benefit of a dinner party? Or is he a spaniel for old ladies?" In his reference to vomiting in this statement, Still's venom was aimed primarily at his dead friend Pollock, although his pet hate was Newman. At one time or another Still cut off his art-world friends—and even his devoted students—and arrogantly attacked them for imagined moral lapses. I imagined Still to be the kind of man who scanned the index of the *Bible* to see how he was listed.

Still played the Old Testament prophet thunderously and pompously. Artists naturally resented his fulminations. One February night in 1958 at the Cedar Street Tavern, he came up for discussion. The participants were Herman Cherry, Erle Loran and his wife, George McNeil, Robert Richenberg, and George Spaventa. They trashed Still—but not without awe touched with envy for his nerve. I didn't jot down who said what, but the conversation went more or less as follows: Why do collectors let him push them around? . . . They buy his myth. You know, when Still sells a picture there are conditions attached. He chooses the picture and sets his own price. He requires that it be hung in a certain way with no other work in the room. . . . He tells collectors that what they buy is the loan of a picture, like renting a postage meter. . . . When Still heard that Ossorio had sold his Pollock, he demanded his painting back claiming that he did not want a "dealer" to own it. He and a woman friend went to Ossorio's house and while Ossorio was out of the room, distracted by the woman, Still cut his canvas out of the frame, rolled it up, and carted it away . . . What a rotten thing to do. Ossorio bought that work early. And he was Still's friend . . . Why does Still act that way? Is it because of innocence, conscious scheming, or neuroticism? . . . It's just smart self-promotion. . . . Well, it certainly works. At one point Cherry said: "I lived next to Still for four years. We never said a word to each other except twice, when Still knocked on my

door and invited me for a drink. Both times, he told me about his boyhood. Every Christmas, he left a bottle of wine at my door."

My Basel experience with Still's painting and the praise of his enthusiasts made me want to meet the artist, despite his awful reputation. I asked Jon Schueler to talk to his former teacher about me, and he did, but nothing came of it. As a New York critic identified with the New York school, I was evidently corrupt in Still's eyes, but I saw a chance of meeting him in 1963, when a retrospective of his paintings opened at the Institute of Contemporary Art at the University of Pennsylvania. Still had made sure that no New Yorker was invited, but I was a friend of Ti-Grace Sharpless, the curator of the show. I asked her to please let me attend. Aware of how much I wanted to meet Still, she invited me not only to the opening but to the dinner in his honor at the University of Pennsylvania Museum. More than that, she sat me right next to Still. But at the dinner, I sat next to an empty chair, on the one hand and on the other, a rotund man—he was, I think, a Philadelphia Biddle—who was the spitting image of Ingres' Monsieur Bertin and said things like "That Still ought to be spanked." I asked Ti-Grace whether Still didn't attend the opening and the dinner because of his arrogance. She said no; it was because of his shyness. Her introduction to the catalog was a shameless panegyric to Still-the-macho-master, understandably because he would probably have canceled the show if it had been otherwise. I reviewed the show for *The New York Times*, very favorably I thought. Still apparently didn't like it, however, because mention of the review—and everything else I later wrote—was excluded from his bibliographies. After he died, I was rehabilitated in newer catalogs and books on him.

Still invented himself as a mythic figure, but many of the claims he made to back up the myth were questionable. For example, he said that he enrolled in the Art Students League, but after an hour spent there he walked out because he decided he had nothing to learn. However, a biography of 1940 reveals that he studied for at least six months at the League with Worth D. Griffin and Vaclav Vytlacil. Still vehemently denied that his later abstractions had any reference to the Western landscape. Yet in March 1948, there appeared in the *Magazine of Art* a short text most likely dictated by him that read: "Still feels that his fluid, often flame-like vertical shapes have been influenced by the flatness of the Dakota plains; they are living forms springing from the ground." The fabled self-image that Still worked on hardest was that of the rugged individual in a virgin land. Paradoxically, he used avant-garde art to "break through" to a nineteenth-century vision of American frontiersmanship.

As a de Kooning man, it took me time to appreciate Still's innovation. It was as radical as Pollock's, and there are striking affinities in their work. Both artists eliminated from their painting recognizable images and symbols, which could be

identified with surrealism, arriving at nonobjectivity. They also suppressed all vestiges of cubist design, whether in the manner of Picasso or Mondrian—that is, residues of tightly knit composition of varied, clearly defined shapes deliberately interrelated and contained within the canvas rectangle.

Still and Pollock formulated a new conception of an abstract picture as an allover, open field. But instead of weaving an expansive linear mesh, as Pollock did, Still created an equally expansive field of color areas. Both kinds of field organization are free of cubist restraints. They engage the viewer with immediacy—that is, suddenly, all at once—in a way very unlike cubist relational composition, which induces the viewer to experience a picture slowly from part to part to whole. Cubist picture-making had been central to modernist art of the preceding four decades. In rejecting it Pollock and Still introduced the most original and radical formal invention of abstract expressionism.

Still showed Rothko and Newman the way to color-field abstraction. The three painters had been close friends in the late 1940s, but in the 1950s they had a falling out. Still broke with Rothko when he wouldn't join him in a campaign against the market mentality in the art world. He then accused Rothko of being a "seductive" painter. Still and Newman stopped seeing each other when they began an unseemly squabble over who did what first. While both painters were alive, critics and historians refrained from taking sides. It might have led to a lawsuit. But it is clear to me that Still was the seminal influence. The stylistic antecedents of the fully abstract paintings begun in 1947 are evident in pictures with recognizable images he exhibited in 1943. Rothko and Newman knew these pictures and used their formal innovations to realize their own individual visions. In the case of Rothko, from roughly 1947 to 1951, prior to his "mature" abstractions, he painted so-called "multiform pictures" in which Still's influence was obvious. By 1947, Still's pictorial innovations were also imprinted on Newman's mind. They met in 1946 and became friends. Barney said: "I saw Still's paintings before his first show—Hofmann was with me. They were composed of close-valued color areas. I thought he was doing *something*." The first painting in the style for which Newman is best known is a small painting titled *Onement 1*. According to Newman, it was executed in 1948, although it may have been painted somewhat later. He said that it was "the first painting . . . where I felt I had moved into an area . . . that was completely me." Newman's color-fields were first exhibited in 1950, well after the shows of Still and Rothko.

The arm-wrestling over priority between Still and Newman became so sweaty that both began to push back the dates of their works. Still began to date paintings from the inception of the idea. Newman was as brazen. Late in 1949, *Tiger's Eye* reproduced his *The Break*, dated 1948. The picture is composed of three gesturally painted vertical columns and a sun moon. The reproduction was obviously

dated by him since he was an editor of the magazine. He later painted "1946" onto its surface. Reinhardt found Still's and Newman's date-rape funny; when I asked him for a photograph of his work, I received one on the back of which he had penciled 1950 crossed out, below it, 1949 crossed out, below it 1948 crossed out, and so on. What was a historian to believe?

I do not mean to imply that Newman was dishonest in claiming that his works anticipated Still's. I imagine that in painting *Onement 1*, he experienced a revelation. As he saw it, his style was so different as to be original—and even first. If not that, then he claimed that he had the idea of his field abstractions prior to seeing Still's paintings, and it was the idea that counted, not the date of its execution. Whatever his justifications, Newman certainly believed that any reference to Still's or Rothko's influence on his development demeaned his original contribution, his absolute vision, and in the end, his identity as an artist and even as a man. Consequently, Newman felt impelled to declare the autonomy of his vision and defend it doggedly. Contributing to his zeal was the unfavorable art-world response to his shows of 1950 and 1951, and subsequently, Still's rejection of his work and Rothko's success. There was something macho in Barney's and Still's stance—shared by most abstract expressionists. They seemed to think that their manhood was vested in their paintings. As Goldwater commented, questioning the art meant questioning the man—and that was intolerable.

If Still was the great innovator of abstract expressionism that I make him out to be, equaled only by Pollock, why did his reputation go into an eclipse? Struck by his originality, he may have thought that he had the right to act like a champ and ended up a chump. Be that as it may, Still's moral and prophetic posturing unquestionably worked against his reputation. His pretentious self-aggrandizing—as boundless as the space in his painting—was over-the-top. It hurt—and continues to hurt—his status as an artist, and his standing has been eclipsed by Rothko's and Newman's. Still himself was largely to blame for his relative neglect. Aside from his offputtingly bombastic and arrogant statements, he (and, after his death, his wife) allowed his work to be shown and reproduced only rarely and then often to poor advantage, that is, by concentrating on his post-1960 overblown abstractions, as he did at the retrospective of his work at the Metropolitan Museum of Art.

———

Newman and Rothko told me that I had to talk to Tony Smith about "the early days," but I didn't get around to it until 1966, when I visited him at his home in South Orange, New Jersey. Tony was drinking heavily at the time, but on the day of our interview he had just seen his doctor, who had frightened him into sobriety, at least until dinner, to which I had been invited.

Before becoming a major sculptor in his own right, Tony was known primarily as a trusted friend of artists, and his role in their lives was vital. Peter Busa spoke of Tony's wholehearted enthusiasm and his ability to see; "he had a tremendous eye." Motherwell said: "Tony was the first to understand the new art and was an incredible inspiration." He also had a fine mind and was adept at talking about art. In sum, he was a primary audience of one for the painters he was close to, notably the leading artists in the Betty Parsons Gallery: Pollock, Still, Rothko, and Newman. In fact, as Newman said to me, Tony proposed a show of the four artists in 1949. Tony said: "There was a marvelous spirit at Betty's. I was a kind of carpenter. I helped hang shows. There was a tendency to think of problems as group problems—that is, before 1953. Then the big four demanded that Parsons focus all of her attention on them and drop most of the other artists she represented. When she refused on the grounds that this infringed on her right as a dealer, Pollock left and then the others."

Tony then changed the topic to the *Bloodflames* show at the Hugo Gallery in 1947, a show that included Gorky, Matta, Hare, Noguchi, and Kiesler, and was the last manifestation of surrealism to interest the American vanguard. He said: "At the time I wouldn't have been able to predict the visionary direction American painters would take." But in that year Pollock and Still made radical moves. I asked what made them visionary. Tony replied:

> Their paintings were allover. There was no distinction between figure and ground. And they seemed untouched by human hand—no autograph, no handwork. Pollock got away from the manipulation of paint with the drip, Rothko, with washes, and Still, with the palette knife. All of this led to a transcendental image.

As Tony saw it, signs of the hand called attention to the artist's self—that is, to the personal. By suppressing touch, artists could evoke the suprapersonal. He went on to say: "We thought about American-ness. We were against Culture with a capital C because it was suffocating. We judged art not on the basis of tradition but of our experience. The Europeans considered us barbarous. We said to hell with them. We were going to be what we were, and if it was American, O.K." I asked Tony if 1942 to 1952 could be considered the decade of the first generation of the New York school. He replied, "Pollock said 1943 to 1953" and added, "We did *something* in those ten years."

---

I first met Friedel Dzubas at the Cedar Street Tavern. He was passionate about his painting, and I admired his commitment. I found his works (he gave me one) interesting, but to say that is to downgrade them. However, we enjoyed talking to

each other and became friends. Born in 1915, Friedel was younger than most first-generation abstract expressionists and older than the second. Consequently, he was of an age to be on intimate terms with his elders but sufficiently their junior not to be involved in their jockeying for status. Thus, I found him a valuable source of information, especially because he tried to be objective and was fair-minded. I interviewed him formally twice in 1957. Friedel said:

> Bill de Kooning is a very proud man, and he is not really touched by criticism. Except when Jackson told him that his last paintings stank. Bill really got sore, and Jackson then got very miserable—physically ill for several days—because he had hurt Bill.
>
> Jackson was the opposite in temperament to Bill. He was an extremely vulnerable man. This big, loud, and socially obscene man had a softness that Bill doesn't have. Jackson would try to get into fights, and Bill would pull him away. Jackson was really afraid to fight, but Bill was not.
>
> Jackson was very chauvinistic about American painting. He had a great pride and felt that what we had to offer was much more pertinent than Europe.
>
> In the early days the artists had no acceptance. They were like conspirators, banded together by their loneliness. Only when a public was slowly created did they indulge in the luxury of splitting up. Elaine de Kooning and Lee
>
> Krasner Pollock went out for votes. Elaine directed the campaign for Bill; she was a very powerful woman. She pulled in Tom Hess and young poets, like Frank O'Hara. Lee played politics with the elite, I mean Rothko, Still, Ossorio, Clem.

I don't recall when I first met Aristodemos Kaldis. He seemed to be everywhere—at the Cedar Street Tavern, The Club, and the Tenth Street artist cooperative galleries. He loomed so large that he seemed to be imprinted in my memory from my earliest days in the art world. Kaldis was the exemplary bohemian. He was a bulk of a man with a full head of unkempt black hair and a growth of hair on his nose, wearing a rumpled dark suit or great black coat and a flowing red scarf. A portrait of Kaldis by Paul Georges in the collection of the Neuberger Museum captures him to perfection. A nonstop talker, Kaldis's booming Greek-accented voice filled any space, indoors or outdoors. You might encounter him anywhere: On our first trip to Greece in 1965, Lucy and I checked into our hotel and eagerly made our way to Constitution Square, to be met by Kaldis's bellow: "Ah, the Sandlers, rich enough to visit Athens." He took us on the rounds of Bazooki joints. Naturally, I paid the bills.

In 1954, Kaldis invited me and a woman friend to a Greek dinner which he cooked in his tiny apartment. He had an eye (and hands) for the "ladies," and I think he was interested more in my companion than in me. The other guest was Charles

Olson, the Black Mountain poet, who was equally large and boisterous. The conversation was serious, though drunken in its later stages. It was mostly about Greek mythology in painting and poetry, and both men knew their subject well.

It was hard to imagine Kaldis as any kind of a scholar, loud and ribald as he was, but he was knowledgeable in classical Greek mythology, philosophy, and culture. His conversation was studded with quotes from the ancients, delivered first in Greek and then translated into English. He was proud of his erudition and was not shy about displaying it. He often boasted about a series of lectures on the keys to modern art he had given in 1945 at Carnegie Hall. "All of the artists were there and they learned from me." He was also proud of the fact that a painting of his was purchased by Albert Barnes for his foundation.

I invited Kaldis to do two solo lectures at The Club. The first was titled "The American Artist as Magician, Healer, Outcast, Redeemer, and Savior," and the second, "Mona Lisa: Her Ancestors and Granddaughters." Kaldis was at The Club most every Friday night and was generally the last to speak after a panel, evaluating what everyone had said at length and adding a metaphysical dimension to it. He could also swear metaphysically; he once called the critic Nicolas Calas an "epicuros," which I took to mean that Calas had "sold out" to the "establishment," and I never heard a curse sound so scornful.

If there was something bigger than life about Kaldis, his paintings tended to be smallish in size and delicate, the subject the remembered panoramic landscape of the Aegean coast, and the light, above all, the penetrating light that sharply defines everything, a light that I identify with Greece.

---

I met John Ferren in 1954 at The Club. He loved the talk there and had volunteered to arrange the panels in 1955. I replaced him as program chairman the following year, but he remained active in Club affairs, one of the few senior artists who did.

Puffing comfortably at his ever-present pipe, John was at ease with himself and our world. Although he had a decades-long reputation as a painter and teacher, he made himself available to young artists. Only Kline was more convivial. But he never let his geniality get in the way of his intellect. His fellow artists scorned conventional society and its stifling mores in the Eisenhower era and in this sense were rebels. Within this group, John was a gadfly, quick to point out hypocrisies. For example, he twitted his colleagues on their boastful claims to being avant-garde, pointing out that abstract expressionism had become "established"—and he was one of the first to recognize that it had. But he always had an even-tempered, soft-spoken manner. Indeed, he looked like anything but a maverick, more like a professor (and he was that as well as an artist)—jacket and tie, clean-shaven, with his mustache neatly trimmed.

John would particularly needle friends who claimed to have some privileged insight into art's purpose and destiny. He humorously recalled that on two occasions he had come close to discovering The Key to modern art. On his first trip to Paris, where he lived from 1931 to 1938, he encountered Picasso and Braque in a café in one of their rare meetings. Now, he thought, he would get The Word. He sat down at a table near them and overheard Picasso say: "Now Georges, that's not the way to put in plumbing." At another time, John recalled: "I dreamt that I had solved painting. I forced myself to wake up, found a pencil, and wrote my dream on the wall. In the morning I remembered what I had done and found the spot on the wall. It read, 'Dream 76. Green.'"

John said that for him making art was a kind of "pilgrim's progress" in search of "a personal truth which can be more than personal," and that truth could only be found in the intuitive process of painting. Most of his colleagues in the New York school shared that belief, but many spurned the role of the mind, which they suspected would get in the way of feeling. John strongly rejected the idea that "brains hamper a real artist." He was convinced that unbridled spontaneity was yielding painting that was familiar and academic. This led him in 1956, at a time when it was unfashionable, to introduce a conceptual component—a contained, symmetrical, geometric infrastructure—into his impulsive action painting. In a 1958 review of his paintings whose images suggested vases, I wrote that the "controlled and intellectual [and the] spontaneous and emotive are the components of a dialectic—an attempt to synthesize a classical ideal with a romantic quest." The next time we met, John said, smiling: "Well yes, I guess I am a Zen Methodist."

Cherishing ideas, John stood opposed to the often anti-intellectual tenor of Club discourse. He said that too much of the conversation was "ambiguous, the unfinished phrase, the shrug of a shoulder. De Kooning was a master at this. Resnick was the vaguest." One of the most damning epithets that could be hurled at an opponent was that he or she sounded like a professor. As if in reaction to this, John once invited several philosophy professors to speak at The Club. He introduced them and moderated the discussion. One of the participants, Arthur Danto (later a working art critic), tacked on the wall a drawing composed only of a horizontal line in its center and proceeded to detail the diverse ways in which the diagram could be interpreted. This was not the kind of art talk expected at The Club, and the audience listened in stunned silence. It exploded when the discussion turned to what the color red might signify metaphysically, and the panelists were furiously denounced for their academic approach. John expected this, of course, and always benign, puffing on his pipe, kept the peace. But it was clear to those who knew him that he was making a point and that he relished the hubbub. After the shout fest subsided, Angelo Ippolito quipped, "Except for you, John, everyone won a good-conduct medal this year."

John was always supportive of his colleagues, and they—and I—appreciated it. In 1960, I received a travel grant to Europe because of his letter of recommendation. As a member of the OSS during World War II, John had entered Paris in advance of the Allied armies. The first thing he did, at considerable peril to himself, was to make his way to Picasso's studio to make sure he was safe.

———————

In 1958, I arranged to interview Burgoyne Diller at his home in Highland Park, New Jersey. I had already recognized him as one of the finest American artists to have emerged in the 1930s—on a par with Milton Avery and Stuart Davis. Diller was an imposing man and handsome, although ravaged by alcohol. He first took me down to his cellar studio. Nonobjective works of art, many on paper, were strewn on the floor. At one point I said to him: "Mr. Diller, it's damp down here and your works will be destroyed." He said: "Nobody wants them and besides, they're no good. I'll toss out most of them anyway." "But Mr. Diller, they're terrific, and many look as if they're from the 1930s. You mustn't scrap these pictures." Diller got angry. "Don't tell me what I can do with my own work." It made me uncomfortable to argue with a distinguished artist, but I wouldn't back down. "You have no right in 1958 to destroy work you did decades earlier. You put yourself in the role of art historian." He shouted: "How dare you!" But he quickly calmed down and we went for a ride in his car, hitting about eight different bars. He had a double shot of whisky and a small beer chaser in every one but with no visible effect. He remained lucid throughout our entire conversation.

Diller recalled how he—and other of his avant-garde colleagues—found their way to abstraction. "It was a logical sequence from academic painting to impressionism to Cézanne to cubism to Russian constructivism to Doesburg and Mondrian. I was not interested in the social rationales presented by the constructivists and neo-plasticists." Diller was a zealous champion of abstract art, as were his friends in the American Abstract Artists. When one of its members, Alice Trumbull Mason, heard that her daughter, Emily, had decided to marry Wolf Kahn, a figurative painter, she told her: "Keep your head. Art first."

Diller said that he accepted the position of head of the mural section of the WPA because artists of prodigious talent were living like swine. His efforts were critical to the survival of many avant-garde artists. He became, as Mercedes Matter said of him, "an idealist who sacrificed his own painting to become a crusader for living artists."

As an abstract artist himself, Diller was sensitive to the problems of avant-garde artists and tried to find mural commissions for them, particularly because they were discriminated against in the easel division. This proved difficult. Powerful politicos were hostile. In order to publicize the mural project, he organized a show of mural sketches which Mayor Fiorello LaGuardia visited. Looking at

one of Gorky's drawings, he said: "If that's art, then I'm a Tammany politician." Diller also encountered resistance within the Project; he was advised to be conservative in order to win friends for public assistance. Frustrated beyond endurance at times, he said to his superiors: "If you don't like my policies, fire me."

Diller was also up against bureaucrats responsible for public buildings. They had to agree to have murals painted and then to allot money for materials. He said: "I had to scheme to get work for abstract artists. I succeeded some of the time, like getting Gorky transferred from the easel project to my mural project and obtaining for him a commission to paint walls at Newark Airport. In negotiating for the work I had to agree that it would not be abstract. Diller then remarked that Gorky's work in Newark had been destroyed, but pausing, added that they might still be on the walls, under coats of house paint. I told Ruth Bowman, the curator of the art collection at New York University, about Gorky's murals and urged her to investigate. She did, and she found them.

Diller not only had politicians and bureaucrats to contend with but also Communists, who were well organized and exerted a pervasive influence in Project affairs and in the Artists Union. In positions of power, they could have artists who resisted them too strongly thrown off the Project and probably did, although they were not in the open, so one didn't know. The Communists promoted social realism and reviled avant-garde artists as "ivory-tower escapists" and worse. Recalling their role, Diller fumed: "They condemned me for avoiding social responsibility. Me, with my social viewpoint! My answer to them was that if you made pictures on old brick walls, I might join you, but so long as you make works to be shown in Fifty-seventh Street galleries and sold to the Rockefellers, you are full of crap."

Diller had a serious drinking problem. A number of his friends in the 1930s remained loyal to him, notably Ad Reinhardt, who in Diller's most wretched days saw to it that he continued to teach at Brooklyn College and covered for him when necessary. Shortly before he died, the owners of the Chalette Gallery took Diller in hand, saved his work, and exhibited it. I encountered Diller near the end. He was then emaciated but he shook my hand warmly, smiled wanly, and recalled our conversation.

———

I had met Isamu Noguchi casually a few times at The Club and the Cedar Street Tavern, and gallery openings, and we had exchanged pleasantries, little more. I had always admired his sculptures and once thought it would be a terrific idea to install three of them on the plaza in front of the Seagram Building, one on top of each of the two fountains and one in the middle. I approached the powers that be at Seagrams and the Pace Gallery and they supported my proposal, as did Noguchi, but the project fell through.

Through a chance encounter, Lucy and I were able to spend a day and part of another with Noguchi. We were on an early-morning train to Giverny to meet Ora Lerman, an artist-in-residence at Monet's Japanese gardens, whose restoration was funded by *Readers Digest*. As a member of the jury that chose her and two other artists as well as a board member of the College Art Association that selected the jury, I decided to see how things had been working out and to visit the garden as well. Ora had offered to meet us at the station with her automobile.

The train was so crowded that Lucy and I had to sit in different sections of the car. Lucy passed a note to me suggesting that the man in the seat in front of me was Noguchi. It was. At the Giverny station we saw him looking for a taxi. There was none. I approached Noguchi and a beautiful woman he was with and, correctly assuming that they were visiting Monet's Japanese garden, offered them a ride with us. He recognized me—I was very touched by that—and accepted. While waiting for our car, Noguchi commented on the Seagrams project and on how sorry he was that we hadn't been able to carry it off.

As we wandered around the garden I asked Noguchi if he had any special reason for his visit. He said he did. He was to meet Japanese television the next day in his own Japanese garden at the UNESCO building in Paris, and he was sure he would be asked what he thought of Monet's garden, so he had better take a look. I asked him whether there were any gardens in Japan like Monet's. He thought for a minute or so and responded that yes, there was one that looked a little bit like this one. When we came to the famous bridge, Lerman took a photograph of Noguchi, Lucy, and me on it.

Noguchi offered to meet us the following morning at UNESCO, and we jumped at the chance. As we walked through his garden, he remarked that in order to get the space he needed he had a large sculpture by Calder moved to another, less prominent, site. He then said with a smile—was it a guilty smile?—that he couldn't understand why Calder had been peeved with him. Lucy and I were awestruck by the beauty of Noguchi's garden and the artistry with which he intermixed natural phenomena of his design and his own sculptures. A masterpiece, and yet so little known.

---

I looked up William Baziotes in 1964. He was a loner. He not only lived apart from other artists, in a middle-class housing project on 125th Street near Broadway, but he was rarely to be seen in art-world venues, at least in my time. We met at Bill's apartment, where he had his studio. He introduced me to his wife, Ethel. They seemed inseparable, and I later learned that they were.

Bill looked like a mix between a boxer and a gambler, or as Rothko described him, "a gangster—primitive, tough, and innocent." Ethel told me that Bill loved

things American: boxing, detective stories, burlesque, bars, and cafeterias. He found Americans strange, the strangeness of what Baudelaire called "men from the multitude."

I found it hard to imagine Bill, born and bred in working-class Reading, Pennsylvania, in sophisticated surrealist circles. He told me that he met Matta in the spring of 1940 and they became friends. Bill recalled: "Matta was a shrewd analyst of paintings. But I didn't understand much of what he was talking about. He once told me he was a corpse over which flies crawl. What in hell does that mean?" Bill and Matta differed in critical ways. Bill said that "Matta called Picasso a carpenter. He once told me that I painted too well. He was interested in living. I felt closer to being a carpenter."

Bill said that the four artists he had met that most impressed him were Mondrian because of his dedication to art, Miró because of his particular poetry, and Duchamp and Ernst because of their courtliness. "I didn't talk to them about art, but I watched them. . . . Artists like Mondrian made modern art real for me. Before then it was like a California cult." Bill added: "They brought Paris over here. I never reacted against Paris. How can you react against Braque? That's silly. A good artist doesn't react to anything consciously. You go out on your own. If you are involved with your father too much, there's something wrong with you. If you are healthy, you just move away without even knowing it."

In our conversation Bill related his painting to boxing. He read to me a comment by the heavyweight champion Gene Tunney that he had copied and that I jotted down: "If there's any extreme form of individualism, it's ring fighting. You wage your own battle all by yourself. No partners, no comrades in there with you. . . . Like dying, you fight alone. So consider the prize-fighter as a spiritualist, individualist, a solitary soul in travail." He concluded: "American painting is different from the French. It's about loneliness and violence."

———————

Alfred Jensen was a small round man with a squarish face. His studio on East Tenth Street was near the Tanager Gallery, and he would often visit when I was sitting there. The studio was tiny, but he managed to paint huge pictures in it. Close in age to Rothko, and a friend of his, he remained part of the downtown scene, although he was essentially a loner. The first works I saw were high-keyed expressionist abstractions, which were shown at the Tanager. Then in 1957 his work changed; he began to paint checkerboard configurations in black and white and high-keyed, prismatic blue, yellow, purple, and red, their arrangement dictated by number systems he drew from pre-Columbian and Buddhist architecture, diagrams, and other ancient sources. I lent him my book on Kabbalah, which he never returned, but I understood why. In their preconception and geometric clarity, Alfred's pictures ran counter to the prevailing gesture painting, but a few Tenth Street artists,

notably Al Held, George Sugarman, and Ronald Bladen, greatly admired them.

Alfred had been the advisor of collector Sadie May. When she died, she left him a sum of money which he was able to live on until the end of the 1950s. When the money ran out, he stopped by the Tanager. Crestfallen, he told me that he was on the way to Western Union to try to get a job as a messenger boy, the only job he felt qualified to do. That weekend, Alfred sold some tens of thousands of dollars of work—a true Cinderella story.

Alfred was obsessed with the "science" of the ancients, but would occasionally cheat in his paintings, changing a color or so if the picture needed it. Visually, Alfred was extraordinarily sophisticated. In other ways, his thinking was primitive. He was a primitive abstractionist. Whenever I met him, he would immediately begin to talk on and on about the number system of his latest series of pictures. Once he told me of a new group based on the solar year of 360 days and a lunar year of 260 days. I said that I had not heard of a lunar year but I knew about a solar year; it had 365 days. What happened to the five days? Alfred's face flushed with anger. "Don't you think the ancients knew that? They hid in caves for five days."

As I look back on the New York school, what stands out is how diverse it was. Many artists achieved recognition at one point in their lives and then were forgotten, in many cases undeservedly. Paul Burlin was one. He was the consummate curmudgeon, a tough-guy who hated gentility, complacency, and conformism, and aimed, as he said, to "thump" people into rejecting the status quo.

Paul was a historic modernist painter. He was invited by William Glackens to exhibit in the Armory Show of 1913. In 1921, he had a show at the Pennsylvania Academy of Fine Art. His work was slandered by a local art critic, and when he threatened to sue, the newspaper apologized. As a consequence of the controversy, a symposium of Philadelphia physicians diagnosed modern art as insane. Disgusted, Paul moved to Paris, where he got to know Roger Fry, Léger, Braque (with whom he played handball), Picasso, Matisse, and Miró.

Toward the end of the 1920s, Paul felt increasingly alienated in Paris, and in 1932, he returned to the United States. He adopted a social realist manner but eventually rejected it because it had too little to do with painting.

He then turned to Kandinsky, who had long been a hero to him. Like Kandinsky, Paul carried expressionism into abstraction. Indeed, he was one of the few painters in New York to whom the label abstract expressionist applied. Once, in his studio, when the two of us were looking at his abstractions, composed of shattered fragments in agitated, acid-colored flux, he said that he was after a "quality of feeling that says to hell with everything but this, with all reasonableness but this." He hoped that his work would reflect "an age of treacherous, har-

rowing notions of mutability, death, and decay. All the old realities have dissolved … All rigidity of form disappears and enters into a metamorphosis." Paul thought that abstract expressionist painting was different from that in Europe. "The American's fly is open and he doesn't give a damn."

In 1948, Paul and Bradley Walker Tomlin organized a protest meeting at the Museum of Modern Art. The catalyst was a statement issued by the Boston Institute of Modern Art that denounced modern art for being "a cult of bewilderment [which rested] on the hazardous foundations of obscurity and negation, and utilized a private, often secret, language." The statement went on to demand that artists "forge closer ties with an evergrowing public in terms of common understanding." In his talk, Burlin called for resistance to "the morticians of the hinterland" in Boston who would dictate to modern painters as well as "the hardworking burros of the press who dig strangely and ineffectively amongst the debris." Burlin concluded that modern art "is the bulwark of individual creative expression, aloof from the political left and its blood brother, the right [which] would destroy the artist." The most memorable talk was by Stuart Davis, who compared the assaults on modern art by Sanity-in-Art Action Committees to the practices of the Un-American Activities Committee and the Moscow art purges. He got so agitated that his friends thought he might have a heart attack.

---

I met Nicholas Marsicano in 1955. He was an older artist, but he preferred to socialize with younger artists on Tenth Street, and joined the Tanager Gallery. When I began to write art criticism, he became a kind of mentor. Nick once spoke about his studies at the Barnes Foundation. Surrounded by dozens of paintings by Renoir, Cézanne, Seurat, Matisse, it seemed to him that the whole vast history of art—and not external reality—was "nature" to the artist. Consequently, he decided to take art-as-nature as his subject. Nick improvised images of women. When I once asked him what they represented, he replied "mythic figures of art" and added, "They have nothing to do with women strolling down Fourteenth Street." But the "mythic" women he depicted were "real" to him, and troublesome. "They are always trying to get into the act, poking their noses out of the canvas. I've got to lure them back on the picture plane and trap them there."

Nick had very original and imaginative approaches to art and art history. For example, he thought that painting could be classified under three "concepts": landscape, figure, and still-life. Each had its own criteria. Figure painting required concentration and precision. Consequently, Chardin's still-lifes, Courbet's trees, and Mondrian's neoplasticist abstractions were "portraits." But categories could get complicated. There could be portraits of still lifes or landscapes of portraits. It was not always easy to follow Nick's reasoning, but it always made you think about issues

afresh. I once asked Tom Wesselmann who was the most inspired teacher he ever had. He said, "Nick." Then I asked whether he understood a word that Nick spoke. He said, "no," but at the end of a class he wanted to go into his studio and work.

———

Gabriel Kohn was a decade or so older than most of us on Tenth Street. Pudgy, with dark bags under his eyes, he had something of a hang-dog look about him. Kohn was a sculptor who should also have been an architect. Both as a sculptor and as a would-be architect, he was ahead of his time. He laminated pieces of found wood into bulky shapes at a time when open welded constructions were in vogue. The pieces were not large, but when Kohn conceived them he had architecture in mind. Not international style architecture, however, since he avoided the horizontal and vertical and preferred the diagonal and organic forms, particularly the U. His main concern was to shape interesting volumes, but he thought of them as scale models for huge works, hopefully buildings. If great architecture was the grandest form of sculpture, as he believed, why not make sculpture into architecture. Kohn anticipated Frank Gehry and his followers, but his name will never be inscribed in the annals of architecture. He had his moment in the limelight when Henry Geldzahler included him in his prestigious show at the Metropolitan Museum, *New York Painting and Sculpture: 1940-1970*, in 1970, but he was soon relegated to the art world's limbo.

———

The fifties are viewed today as the decade of abstract expressionism, and they were. But, as I commented, they were also a time in which diverse artistic styles flourished—and crossfertilized each other as they competed for art-world attention. New York school art ranged from realism to nonobjectivity, from purist art-as-art to expressionist life-as-art, from traditional painting and sculpture to iconoclastic environment and happenings. At once inspired and challenged by this rich stew of styles and ideas, ambitious artists could recognize what was fresh or stale in the art around them while realizing their own individual visions. New art could not have been created in any other milieu.

# Art Criticism: Apprentice Years

THE HALF-DOZEN YEARS I

The half-dozen years I reviewed for *Art News* (from 1956 to 1962) was my period of apprenticeship. I wondered about the definition of art, of course, but not overly much. Was art supposed to be beautiful? Kline's *Chief* wasn't, in my opinion, but encountering it, I had had an eye-opening revelation to which I could give no name. Art then was something that engaged me emotionally and mentally. That was definition enough, and it took care of all the theory I needed to know. If a work stirred me, it had aesthetic quality, and it was great if it lifted me out of my ordinary self into some other realm in which my being expanded. Or perhaps, transcended? I didn't force the issue.

My experience with Kline's *Chief* decisively shaped the kind of criticism I would write. Since the impact of the painting was existential, my approach would be subjective and personal. My criticism would be a record of my singular encounter with art in as lucid, and hopefully vivid, prose as I could manage. This was the approach of the art critics to whom I felt closest, namely poets, often referred to as the New York school of poets: Frank O'Hara, James Schuyler, and Barbara Guest, and their younger associates Bill Berkson, Carter Ratcliff, and Peter Schjeldahl.

Unlike them, however, I did not have a personal literary style. Consequently, I decided that the only way for me to write was clearly, which may have yielded its own kind of style; at least, so I hoped. Moreover, I believed that I owed it to artists to be clear. They were, often, mystified by reviews of their work. They simply could not understand the relationship between most art writing and their art. (Later, when I read incomprehensible, slipshod reviews of my own books, I sympathized with artists even more. If I couldn't comprehend words about words, how much more bizarre words about forms and colors must have appeared to them.)

I would not restrict my criticism to formal considerations, as Clement Greenberg urged art critics to do. Nor would I make it a primary goal to tell good from bad. Greenberg claimed that a critic had to declare his or her likes and dislikes in order to establish his or her credentials. Standoffishly giving grades to art, as it were, went against my nature, which was to be an enthusiast. I wanted to expose myself to new art and try to understand it—and my response to it.

I had other intentions as well. I wanted to win recognition for avant-garde art. I would be of service to the artists of the New York school by giving their art a voice. I also wanted to interpret new art for the public. Linda Nochlin once commented that the great nineteenth-century critics—Ruskin, Baudelaire, and Zola—made it their mission to defend "what was new to an audience which liked what it was familiar with, and that they were there to persuade that audience to abandon habitual attitudes towards works of art: to cure the middle class not merely of its blindness but of its skittishness in the presence of the new." I would continue their enterprise.

I also wished to convey the intentions of the artists I admired. "The world is fond of them, and turns their heads with applause. They seem to be superior to real artists, who are objected to on the grounds of their alleged egoism, bad manners, and rebellion against the rules of society. This is because great men belong to their work." If the real artists were eclipsed by the demi-artists, it was not for long. Many of the artists I knew were personable and significant. We knew who was who.

When I began to write about art, critics associated with the New York school were looked down upon by the artists they looked up to. I did not mind my inferior status since I considered it a privilege to hang out with artists I admired. Nonetheless, I was ambitious in my lowly calling to write something that truly illuminated the art I believed to be for the ages. I hoped that my prose might be important, and like the art, live on.

Not all critics shared my opinion that criticism was secondary to art. Greenberg thought he was smarter and knew better than artists, even David Smith, whose sculptures after his death, Greenberg "improved" by removing paint from a few. In the 1980s, art theoreticians, parroting Barthes, heralded the death of the artist and the birth of the spectator, by which they meant themselves. What counted was interpretation not creation. I found this attitude self-aggrandizing. To be sure, such self-promotion has had a long history, more so in literature than the visual arts. It was put over by critics who succeeded in setting themselves up as authorities of intellectual and cultural life. These writers focused on ideas about art rather than on actual works.

The art critic Donald Kuspit believed he was superior to the artists he wrote about because of his presumably greater understanding of philosophy, social issues, etc. He maintained that critics who explicate our age are extraordinarily creative. Their enterprise is so heroic that it ought to be independent and not submissive to any work of art. But would not this invented sense of our age become a bias with which to prejudge art (something Kuspit said he didn't want)?

As I saw it, art ought to determine a critic's sense of his or her time. If a critic won't submit to the art, then the critic is in the wrong field, and his or her criticism ought to be truly independent of art—that is, leave art out of it.

Kuspit and I had two verbal shootouts, the first at a meeting of the National Endowment for the Arts' Visual Arts Overview Committee in Washington, and the second, during a panel discussion at the Rhode Island School of Design museum. I challenged him: "Why deal with art at all? Why don't you confine yourself to the social sciences or philosophy and climb off the back of art? Doesn't the artist-as-genius take precedence over you as critic?" Kuspit scoffed at my use of the word "genius" and asked: "Why put yourself in a subservient position to the artist? Isn't that demeaning?" His question flustered me, I must admit, and all I could blurt was that works of art are privileged, and so were the artists who create them. Critics who can't accept that are guilty of the sin of envy. I then declared that certain works of art so awed me that I was left speechless, unable to adequately impart my feelings in my writing. How could I be anything but humble?

Philip Pearlstein abetted my humility. He cautioned me—and critics in general—against using art as the raw material for my own ends. "Don't assume," he said, "that artists are dumb and don't know what they are really doing and that the critics know better because they presumably have a fuller grasp of their time and therefore can presume that their primary purpose is to define what artists did." Pearlstein went on to say: "Don't suppose that your emotional and subjective response to the work is sufficient or reliable." Critics ought to try to find out what an artist's intentions are and why he or she chose to work in a certain way—and come to terms with that information.

The art that most appealed to me when I began to review was gesture or action painting. Above all, I admired the work of de Kooning, Kline, and Guston. I was moved by the way they arrived at their images in the process of painting—images that appeared to embody the drama of creation and that were raw and gritty and unabashedly emotional, free, and energetic. The gesture painters seemed to be engaged in a heroic struggle to discover (we used the existentialist term "encounter") their individual artistic identities. However, I was not an uncritical standard-bearer of the New York school. I did make value judgments. There were artists in my milieu who I believed were authentic and others who were bogus groupies, and I said so. Nonetheless, I became a true believer of abstract expressionism.

As a true believer, I felt utterly self-assured. But I was also embattled, because the new American painting provoked not only public scorn but art-world hostility as well. In the spring of 1953, forty-eight leading figurative artists, including

Edward Hopper and Milton Avery, issued a statement in a new quarterly titled *Reality*. It condemned abstract expressionism as an art of "mere textural novelty" that "encourages a contempt for the taste and intelligence of the public." Employing "a ritual jargon equally incomprehensible to artist and layman," it has produced "an atmosphere of irresponsibility, snobbery and ignorance." These latter-day humanists declared that as pernicious as abstract expressionist painting was the writing about it.

Now and then, I have reread my initial attempts at criticism for *Art News* with mild embarrassment. How little I knew then and how judgmental I was. In my second batch of reviews, published in February 1957, I broached an issue that would trouble me increasingly for the next five or six years, namely, the academicization of abstract expressionism. In a review of one painter, I wrote that he "belongs among a group of young abstractionists who have thoroughly assimilated the ideas which transformed American painting. . . . Control and restraint are replacing uninhibited experimentation, and the unresolved loose ends are disappearing." The upshot was painting that was "pat and sedate." The artist's gallery protested to Hess, but he stood by me.

I soon took aim at the School of Paris. On Gerhard Schneider's painting, I wrote that "The bold action is there, but not the guts." I did, however, praise Lanskoy, but only tepidly compared to my rave of Joan Mitchell, whom I hailed as "one of America's most brilliant Action-Painters." Tom Hess featured it—naturally.

By the summer of 1957, I had achieved sufficient status as an art critic to be asked to review art books for the *Saturday Review*. The following summer, I was commissioned to write an article on contemporary American sculpture for *Art d'Aujourd'hui*. When my article appeared, *Konstrevy*, a leading Swedish art magazine, asked to republish it. By 1959, I was invited to appear on panels and juries at prestigious venues with important art-world figures. In the spring of 1959, B. H. Friedman asked me to contribute a chapter on Joan Mitchell to a book he was editing on younger artists of the New York school. I also was engaged to teach the history of modern art for a semester at Pratt Institute. In 1960, I began to teach adults part time at New York University, and in 1963, I was employed full time at its School of Education.

In 1960, the voting committee of The Club honored me with a dinner at which I was presented a photograph with a citation conferring on me the "Off-Broadway Art Critics Award—for coolheaded judgments in a hotheaded field—picker of more winners from unknown stables without riding them than any other critic. These three plaques are given for outstanding service in an open field—especially for a muddy track—which includes the mares and stallions. *FOR IRVING SANDLER—THE 1960 ART MUDDER.*" The three plaques originally

had been awarded "in recognition of 25 years loyal service, Newton Falls Paper Mill," "Progess Trophy awarded by the Amateur Athletic Union of the United States," and the "North Carolina High School Music Contest Festivals."

---

In all my years in college, I had taken only one course in art, and that in aesthetics. It was taught by an antiquated philosopher who did not show a single illustration or slide; nor did he deal with any work of art. At first, my lack of art history didn't bother me. After all, it had nothing to do with my initial attraction to abstract expressionism. But when artists I admired referred knowledgeably to past art, I wanted to know why, and I looked it up. That led me to visit the Museum of Modern Art, the Whitney, Metropolitan, and Frick with growing frequency, to attend lectures and symposia, and to read books on art. But I began to study art history systematically only when I began to teach at Pratt, cramming in as much information as I could each week before meeting my class. By this time, too, I had met Lucy, who was a graduate student in art history. I learned a great deal from her, particularly from the way she looked at art, a kind of peripheral vision that enabled her to see telling aspects of a work that others generally overlooked.

Nonetheless, I continued to be troubled by my lack of an art historical background. I needed to know more, especially first-hand experience of earlier works that were not available in New York museums. That necessitated going to Europe and making "the grand tour," but we were too poor. In the spring of 1960, I applied to the Council for International Education for a travel grant. I informed its director, David Wodlinger, that I had written art criticism for some four years and needed to broaden my knowledge of past art. He responded sympathetically and asked for three letters of recommendation. Thomas Hess, Clement Greenberg, and John Ferren (who was an acquaintance of Wodlinger) wrote on my behalf, and I was awarded the Tona Shepherd Estate Grant of $1,000 to travel in Germany and Austria.

The art that Lucy and I saw was overwhelming. I was simply unprepared for it. Ten days in Vienna: Rubens, Caravaggio, and Velázquez at the Kunsthistorisches Museum; the drawings at the Albertina; the monastery at Melk, etc., etc. And for fun and games, Hapsburg Imperial architecture. Ten days in Munich: van der Weyden, Memling, and Dürer at the Alte Pinakothek; the antique sculpture at the Glyptothek; the Rococo churches—God's boudoirs—outside of Munich at Wieskirche, Ettal, and Rottenbuch, and the German moderns, the early Kandinskys at the Lembach Gallery. Speyer. Worms. Cologne. Frankfurt. etc., etc. Above all, Velázquez and van der Weyden.

Then Lucy and I cheated and snuck off to Italy and France, where we spent

most of the summer visiting the textbook monuments and museums. The trip had been illuminating, but it now also became nerve-racking. We were looking at too much, too fast. I was in art overload. What plagued me most of all was the problem of aesthetic quality. In every Italian museum, there was at least one fourteenth-century (Lucy's century) gallery filled with pictures of the Virgin and Child. Each work had the same subject, same content, and, more or less, the same form. Yet, some were masterpieces, some O.K., and some were awful. What made one better or best? It was enough to drive me off my rocker. But I soon decided that there were no criteria, at least, nothing one could point to. There was only taste. Mine, of course. But as a critic I asked, Why mine? Why anyone else's?

Lucy and I also took a side trip to Switzerland. In Zurich I met James Fitzsimmons, the publisher of *Art International*, who asked me to write a monthly letter for the magazine. I agreed. Basel provided me with an answer to a question that lurked in the back of my mind as we traveled through Europe. Confronting as much great art as I had, I wondered how my guys, the abstract expressionists, would hold up. In the Basel Museum, on the way to an exhibition of Greek classical art, we encountered a vast canvas by Clyfford Still installed in the stairwell, and it could have hung without embarrassment next to any painting we had seen, and I was not all that fond of Still's work.

I returned to Europe in 1961, this time assigned by Hess to review a large show of *French Painting from Delacroix to Picasso* in Wolfsburg, Germany, the company town of Volkswagen. VW organized the show and invited several dozen critics to see it. Although it was the seventh in a series of biennials, I thought the junket was timed to counteract the adverse publicity generated by the trial, in Israel, of the Nazi mass-murderer Adolf Eichmann. Consisting of 241 works by 40 artists borrowed from 64 museums and private collections in 13 countries, *French Painting* was an impressive survey but not much different from others of its kind. It did include some extraordinary works, notably Manet's *The Execution of the Emperor Maximilian of Mexico*, borrowed from the Mannheim Kunsthalle.

The city of Wolfsburg itself engaged me as much as the show. In 1937, it was a hamlet of 150 people. A quarter of a century later, its population had grown to 60,000, half of whom worked in VW. The construction of the Volkswagenwerk, Hitler's pet *Strength through Joy* project, began in 1938, but the first "people's cars" produced turned out to be military vehicles. At the end of World War II, the plant was a shambles; even the Russians did not want any part of it as reparations. By the time I visited, there were only 55 corporations larger than Volkswagen in the world. The company expected to produce over a million cars and trucks to be sold in 123 countries. The workers shared in its prosperity. They lived in barracks-like,

pastel-colored "modern" buildings, clustered along broad, well-lit avenues. Antiseptic and airy, they were livable but boring and joyless.

The company proudly announced that its workers were programmed to be cogs in "a living machine" devoted to the manufacture of automobiles. Never was a factory town (itself a common German phenomenon) more absolute. This was why VW's director-general Heinrich Nordhoff commissioned mega art shows in his company town. It had to make up for the monotony of the regimented existence of its workers. Indeed, VW was the only organization in Wolfsburg with the means to initiate exhibitions and concerts.

I was skeptical about the kinds of cultural affairs that Volkswagen chose to feature. There were almost no creative activities, such as art or music classes. All were spectator events. Art meant recreation, an adjunct to production. A Sunday trip to an exhibition was the kind of diversion that was expected to increase industrial efficiency on Monday. The company justified its lack of interest in fostering its employees' creative potential by pointing to the dangers of overly infringing on their private life. I wondered whether there was also a fear that making art might cause them to question the value of their mechanized life in Wolfsburg.

In writing my article, I could not help but think of the disparity between the romantic and expressionist cast of the art and the omnipresent, strait-jacketed factory environment. I also posed the question: How do people living overorganized lives look at messy, disruptive, and individualistic modern paintings and sculptures whose values call into question the lives they live? What meaning do they find in works that are heroic essays on the frontiers of sensibility and glorify the spirit of revolt?

---

Soon after I began to write for *Art News*, I jotted down a series of notes on art criticism. I asked whether there were universal values and standards that could be used to measure each and every work of art, whether these values and standards were exemplified in past art, or whether each age created its own, which it then used to revise judgments of earlier art. I decided that the art of my time, while it drew on the past, established its own values and standards, which it then applied in its evaluation of earlier art.

I also wrote that, for me, the telling mark of a great work was a rush of feeling that left me momentarily dumb. Writing about this rare sensation would be my greatest anguish. I aspired to make verbal language worthy of the art. Moreover, I wondered whether there might be a fundamental antagonism between art and criticism. It seemed to me that the critic tried to ensnare art in his or her interpretation while the artist tried to elude any single reading. Criticism all too often pinned the butterfly of art, which struggled to escape. And art, if it had any

import, succeeded. As Leonardo wrote, "Your pen will be worn out before you can fully describe what the painter can demonstrate forthwith . . . and your tongue will be parched with thirst and your body overcome by sleep and hunger before you can describe with words what a painter is able to show you in an instant." Art criticism then was a no-win vocation, but that's what I did.

The issue of morality or social consciousness in art did not concern me much when I first began to write, but it became a nagging question. Is there right or wrong in art? Should it make people better? Should it serve a social purpose? Any purpose? If art was not socially conscious, was it merely entertainment or decoration? I concluded that it was sufficient for art just to be expressive and inspired, but I continued to worry about the uses of art.

Didn't gesture painting have social significance? The artists themselves rejected any such claim. I attributed this to their dislike of social realism and regionalism and their political messages. It seemed to me that abstract expressionism was a radical critique of conformist society. The artists' political purpose was their commitment to individual creation in an America in which mass culture was mushrooming. The gesture painters personalized nonconformist dissent, as it were. "The more passionately self-expressive the art was, the more political." (I had anticipated a feminist slogan.)

My thinking about art criticism evolved in conversations with artists and fellow critics, many of whom participated on panels at The Club. One of the most useful of these panels, titled "The Role of the Critic in Contemporary Art," took place in 1956. The participants were painter John Ferren, who moderated, art historian Robert Goldwater, and art critics Clement Greenberg, Thomas Hess, and Stuart Preston of *The New York Times*.

> GREENBERG (opening the conversation): I like Delacroix's painting style better than Ingres', but finally, when I saw them side by side at the Louvre, I had to admit that Ingres was the better painter. Such confrontations are the drama of art criticism.
>
> HESS: I don't think it is informative or valuable for a critic to go to a show and pick out good from bad paintings. Here the critic becomes a buyer, trying to decide which painting he wants to own. The critic though can choose among styles and periods.
>
> GREENBERG: A critic has to say, This is what I like in art, and this is what I don't like. The difference between good and bad art is crucial. We should all behave like collectors when we look at paintings. The act of experiencing a painting is automatic. Then, you have to find out what you're experiencing. What, besides pleasure or kicks, is the point of art? And the verdict on kicks is do or don't we like it.

GOLDWATER: Then, why not choose Delacroix over Ingres, Clem? There's a contradiction in what you say. Why don't you say to hell with Ingres? Aren't you trying to be like St. Peter deciding who gets into heaven and who doesn't?

GREENBERG: Comparisons among paintings are not odious. You don't have to be Olympian, but you can voice comparative judgments. We make them anyway.

HESS: Can you make comparisons between Delacroix, Titian, and Tintoretto? What about comparisons between Giotto and Courbet?

GREENBERG: Yes, such comparisons can be made relevant. I would do it in this way: Giotto in Padua shows that he was a good painter and a lousy decorator. Then you can ask the same questions about Courbet. You'd have to set up categories. I don't think Courbet was as good a painter as Giotto.

GOLDWATER: You're not being historical, Clem. You are reducing paintings to a single standard. What Giotto did is one thing, and what Courbet did is another. They are psychologically different. The problem is to trace each different direction. Comparison is worthless, and that holds for today too.

GREENBERG: The time span is not that important. Let's not be too parochial. But maybe the gap between Giotto and Mondrian is too wide. Here, their different directions would be important.

GOLDWATER: Let's deal with the real problem for the critic. Does one's reaction just have to be a personal one? How can we make it more objective? Do we have the responsibility of finding out the artist's frame of reference, what he is working for? And what the audience is after?

HERMAN CHERRY (from the audience): Why are you critics? Why didn't you go into some other field?

HESS: We're just lucky.

Hess was being funny, of course, but in my case, he was right.

———

In 1955, I bought some tubes of oil paint and canvas board and wondered how to proceed. I decided to paint my self-portrait and executed it in an eccentric mix of neoimpressionism and expressionism—all in gloomy browns and ochers punctuated by pink-shot eyes. The picture may not have been "good," but it was an accurate representation of my depressed condition at the time. Next, I improvised on works of art by others: a postcard of Despiau's sculpture of a nude at the Museum of Modern Art, a reproduction of a landscape by Fattori. My Despiau was painted and repainted until its surface was heavy with layers of pigment. Unable to finish it, I decided to cut out the section I liked. I penciled guidelines for trimming it but they resolved the picture formally to my satisfaction. But I did trim the Fattori. I invited Angelo Ippolito to look at my efforts. He brushed them off as "buckeye"—

that is, unsophisticated—and advised me to quit. Guston, however, told me I had "talent" and should continue. David Sylvester praised my work extravagantly, but then, he told every artist he encountered that each was the best of his or her generation. Knowing that he did, they still admired his judgment. I took Ippolito's advice, but only because writing about art became more consuming than making it.

In the 1950s, critics could not make art without being considered dilettantes, although those (e.g., Fairfield Porter or Elaine de Kooning) who announced that they were artists could write criticism "on the side"—reams of it by the late fifties. I had declared myself as an art critic, so I could not paint. However, one day in 1958, I met Bill de Kooning on Tenth Street. He told me that he liked my reviews, but then he asked: "Have you ever painted?" I answered: "No, that is except, for a year on my own." "So, you've never been to art school." "No." Then, he said: "How can you write about what you have had no training in?" Because it was de Kooning talking, I took that comment very seriously. Besides, there was the idea then that artists were the best judges of art, and I was humble enough to agree, another reason for studying painting.

After my conversation with de Kooning, I asked Landes Lewitin if I could study with him. He replied that he had never taught, but he agreed to let me work beside him in his studio. Lewitin (we never called him Landes) was renowned for his knowledge of the craft of painting, the properties of pigments—he mixed his own—and when combined, their effect on each other. Artists respected Lewitin's know-how. De Kooning, whose own command of craft was formidable, once had trouble keeping his painting wet for as long as he needed. He turned for advice to Lewitin, who told him that he wasn't about to reveal techniques he had spent a lifetime investigating. At a party a short time later, de Kooning noticed that Lewitin was looking sickly. He helped him to his studio and made him comfortable. As de Kooning was about to leave, Lewitin beckoned him back and whispered, "oil of cloves."

Lewitin was the curmudgeon of the New York school. He had a huge opinion of himself and his art. Although he sold few of his paintings, he raised their prices every time Picasso did. At the same time, he bad-mouthed artists who used "painting as profiteering," in other words, who were successful. With squinty eyes, he looked down on his colleagues, above all de Kooning, Kline, and Motherwell, making witty but acidic remarks about them and their work. Lewitin wielded some kind of lens through which he looked at paintings and examined them by some secret standard known only to himself. Few passed his test.

Despite Lewitin's dislike of his fellow artists in the New York school, he was always to be found at The Club, of which he was a charter member and the gatekeeper. Soberly dressed in a black suit with a narrow black tie, he refused entry to as many guests as he could. Because he disapproved of drinking alcohol, he

presided most every night at the Chuck Wagon, a coffee shop across the street from the Cedar Street Tavern. He always came alone, never with his wife or daughter.

Lewitin believed in Art with a capital A, as art of "transcendence," "cosmic ecstasy," "exaltation," and "archetypes." He treasured the art of the past but insisted that "the truly traditional painter traduces tradition. Tradition does not imply a stale, slavish continuance but the drawing of sustenance from the spiritual sap ... of past art.... If the avant-garde is authentic it ... rapidly becomes part and parcel of the nature of art. Avant-garde just means that an arrow is pointed to an added vision." Lewitin allowed that the abstract expressionists had pointed painting in the right direction, but had nonetheless inaugurated a "reign of error." He accused them of "navel-viewing" and asked what had become of "star-gazing."

In my view, Lewitin's criticism was destructive. After all, he ridiculed the art that I admired. Nonetheless, I grappled with his ideas. Was there, as he claimed, a transcendent something in all great art? Underlying absolutes? A meta-art quality? Was it true that "The sensations are the same in all great art"? Not in my view. However, when Lewitin took me to the Metropolitan Museum and made me stand behind the head of the Har Khebet sarcophagus and grab it (when the guard wasn't looking) in order to feel the potency of the shape, I understood what he called its "wonderment." Much as I was intrigued by Lewitin's exalted vision of art I was not persuaded, because it refused to acknowledge the abject aspects of life.

I found Lewitin's "teaching" enjoyable, however. On our first session he asked me what I wanted to paint. I told him I didn't know, but a few years earlier I'd painted several pictures based on the Hebrew alphabet. "No good. You can't invent with letters. Look at the failure of Chagall and Ben Shahn." I had also painted some squares. "No good. The vocabulary is worn out. Besides, what do letters or squares mean to you?" I did paint the female nude. "Why not the male?" "The female is sexier." "No good. Eroticism fouls art." Lewitin began to sketch a male nude, showing me how all the parts of the body fit, but freely, inventing as he drew, letting anatomy suggest new forms.

For our next session, I brought in a free rendition of a Dürer drawing. Lewitin said: "It's very good. It can easily get you into a Tenth Street gallery. But for our purposes it's useless." He gave me a book by a Mrs. Merrifield titled *Light and Shade*, a manual of academic practice published in the middle of the nineteenth-century, and Manning Robertson's *Approach to Architecture*. Lewitin told me to study the geometric diagrams in the Merrifield and the passages on color in the Robertson. He then taught me to hold a crayon and draw with it; that was very important, he said. To prove his point, he had me fill in a form and then filled in another himself. I was surprised at how much more vivid his looked. As I left, Lewitin asked me to bring in cardboards from laundered shirts, a quarter-inch brush, and tubes of oil paint in black, white, and earth colors. Why only earth

colors? Why not cadmiums? He snorted: "Cadmiums. You'll need ten years of painting before you can use them."

At the beginning of our next session, Lewitin said: "Now let's consider the painting process." Sarcastically, "Process. Isn't that what your action-painting friends are always babbling about?" He then demonstrated how to dip a brush in paint and apply it to the canvas. He said: "Most painters abuse their pigment in the process of mixing and smearing it. You must *not* mix colors. Paint has to be used straight from the tube and applied a stroke at a time—with awareness and sensitivity and above all, with concentration and spontaneity. To paint properly an artist has to be in control, but he also has to be free." He added, with a tone of haughty irony: "You should be interested in freedom. Aren't all of your buddies always jabbering about that?" I spent the rest of the afternoon mastering the art of picking up paint.

Lewitin then promoted me to copying illustrations of cubes, cylinders, and cones from the Merrifield book, but instead of modeling them smoothly from light to dark, I had to draw the diagrams and fill in each section with a single color, a brushstroke at a time, in a kind of pointillist manner, with no overpainting or "correction." "Scrubbing" or "smudging" was forbidden; it made the painting murky, unclean, unclear, and destroyed the surface. I was amused by the wit of Lewitin's assignment. He made me find Cézanne's cube, cylinder, and cone, not in nature but in an academic handbook. And somewhat like Cézanne, I rendered these three-dimensional diagrams flat, in a modernist manner.

Having set up a paradoxical situation in which I had to be at once controlled and spontaneous, Lewitin whipsawed me back and forth. He would look up from his own painting, shake his head, and say: "You're getting sloppy, more control." Then: "You're getting too tight, be freer." Finally, I arrived at a moment when I had the brush poised, unable to move—a Zen-like moment of acute awareness.

I soon rebelled against earth colors, and one day brought in a tube of cadmium red and announced that I was going to use it. "Where?" demanded Lewitin. "That square right there," I responded, pointing to it. He took the tube from my hand, and brushed the area himself.

Lewitin gave me a thirty-three-page pamphlet by a Theodore L. Shaw titled *Art at a Price: The New Aesthetics*, the cost of which was 25 cents. On the cover was the claim, "You Can Be A Successful Artist." I was surprised at first by the choice of a drugstore paperback but then thought it was just like Lewitin to find wisdom in arcane publications. He had underlined a few passages. One near the end of the essay impressed me as it had him. The author recommended that artists imitate the art of others, if they were moved by it. I recalled that Lewitin lauded any attempt to "take a worn-out form and make of it something fresh, vital and original. To do so takes invention, and this is crucial. Michelangelo did

it with the figure. Picasso borrowed everything from the past and returned it with interest. Matisse was a great genius, but what would he have been without Gauguin?"

Lewitin's paintings are now forgotten. That's too bad. He invented his own visual alphabet—a mix of abstract hybrids composed of hieroglyphics, invented idols, figures, animals, birds, and plants—whose letters he lined up in horizontal rows, like writing. In the realization of his imaginative logos, he exercised an extraordinary command of the mechanics and culture of painting.

In 1995, I was asked to enter a picture in a show of *Critics as Artists* at the André Zarre Gallery. I submitted one of my Lewitin exercises. My colleagues were serious artists, and I was surprised that my entry held its own against its neighbors. In his review, Hilton Kramer singled it out as "a perfectly realized little picture." I thought he did so because I was the only true amateur in the show. But his praise inspired me to resume painting so that the world could have my messages of good will. After painting a dozen or so "masterpieces," I again found that I did not have enough time, and I quit.

What did I learn from my painting experience that helped me in my art criticism? Very little. I did become more sensitive to paint quality and "touch." However, "good" or "great" painting does not depend on craft, but on inspired leaps that transcend picture-making. As William James observed, the creative leap cannot be reimagined, even by the artist. Knowing how a painter produced a picture added little to my experience of what he or she accomplished.

Over the years I have posed the question: What is the function of art criticism? In the early 1990s, I wrote in the introduction to a book on art criticism that I never found the time to complete:

> I imagine that most critics would like to make art but find it more compelling to write about it. Just as artists create out of an inner need, so do critics write. Like artists, they would like to be written into history, as Baudelaire and Apollinaire have been.
>
> The critics I admire report on their experiences of the art. They try to fathom what the artist had in mind; to situate the art in a larger artistic context in order to specify what makes it unique and individual—if indeed it is. They also aim to reveal what its broader cultural relevance might be; and open up fresh perspectives on the work. My model is Meyer Schapiro's book on Cézanne. I was so stunned by his insights that I couldn't wait to get to the Metropolitan Museum to check them against my perceptions, that is, to see if I could see what he had. That's art criticism at its best.

As a young critic, I naturally grappled with the ideas of respected older writers

on art, mainly Alfred Barr, Harold Rosenberg, and Clement Greenberg, but also Meyer Schapiro and Robert Goldwater. Rosenberg and Greenberg influenced my art criticism more directly than Barr, but as the founding director of the Museum of Modern Art, Barr was the most influential American taste-maker in the visual arts. His writings, bolstered by the incomparable permanent collection he amassed for the museum, established the history of modern art, its ideology, and its standards of quality. They provided the aesthetic and intellectual foundation of my thinking and that of my acquaintances (and in time, the American art-conscious public). Indeed, we received our basic art education at MoMA. Barr's ideas became our *lingua franca*. He and his coterie elected the pantheon of modern art, architecture, and design (and much else in American culture).

I met Barr—a thin, austere figure—occasionally, but Mr. Barr, as I addressed him, was too reserved and exalted to talk with easily. I never told him how much I admired him, but years later, as an homage, I wrote an introduction to a book of his collected essays, which Amy Newman and I selected and edited.

Trained as an art historian, Barr viewed the history of art as a continuum in which each new avant-garde style was the latest stage to which art had advanced. This view was mapped out in Barr's movement-by-movement installation of MoMA's collection and the lucid books, catalogs, and brochures published by the museum. Although Barr devised a chronology, he did not believe (as Greenberg would) that art was progressing in one direction only and that its latest manifestation rendered all that came before obsolete. Barr did allow that at any moment a single style did seem more viable than others, but more viable relatively, not absolutely. To him, the history of art was a vast storehouse of ideas that living artists could use for new departures, depending on their vision, energy, and independence. Consequently, he was opposed to any preconceived dogma. As he summed it up: "Modern art is almost as varied and complex as modern life." Underlying his approach was the need to judge art on the grounds of aesthetic quality. Barr's eye was extraordinary. Walk into most any show of modern art, and look for the strongest work. More often than not, it belongs to the Museum of Modern Art.

I was sympathetic to Barr's ideas but with serious reservations. By historicizing and aestheticizing avant-garde art and playing down its radicalism, he tamed it. Unlike Barr, who tended to view modern art as a seamless progression of beget-beget-begets, I believed that avant-garde movements constituted radical breaks in the history of art. However, I also recognized that in time history assimilates even the most iconoclastic art into its flow. As Morton Feldman said: "To rebel against history is still to be part of it." Nonetheless, as Nicolas Calas once said: "What art deforms art history reforms." Moreover, although Barr acknowledged the social

and political context of art in his writing, his references were only cursory. I considered this context more important than he did.

Barr was a graduate of Harvard University, a White-Anglo-Saxon-Protestant, and a heterosexual—and sexual and religious orientations were significant. Many of his friends and associates were also Protestant and heterosexual, but a significant number were homosexual or bisexual, some of whom had what they themselves termed tactical marriages or token wives. Among the more prominent were architectual historian Henry-Russell Hitchcock, Jr.; A. Everett "Chick" Austin, the director of the Wadsworth Atheneum; and Jere Abbott, Barr's classmate at Harvard. Abbott traveled through Europe with Barr in the winter of 1928–29 and became associate director of MoMA. Younger gay Harvard graduates in Barr's circle were Philip Johnson, the founding director of MoMA's architecture department, and Lincoln Kirstein, a MoMA board member who curated a number of its shows. Other friends were composers Virgil Thomson, John Cage, and Aaron Copland, and painters Pavel Tchelitchew and Eugene Berman.

As Harvard graduates, Barr and his associates were an intellectual and cultural elite. Rich or well-to-do, sophisticated, charming, and good-mannered, they moved with ease in the salons of the rich and fashionable. They embraced modernist culture because it was urbane and trendy, and because it denied the conformist and stodgy appetites of the hated middle class—the "babbitry," as they labeled it—whose business was business, which President Calvin Coolidge proclaimed as America's national enterprise. They aspired to be aristocrats of up-to-date culture and taste, but they were also populists. Like good American patricians, they would minister to the culturally underprivileged.

Barr was a champion of "high" painting, sculpture, photography, and architecture. At the same time, he found artistic worth in the popular arts, such as Hollywood movies and applied art and design, and he made a place for them in his museum, to the chagrin of his elitist art-professional colleagues, who detested "kitsch." As Barr said, "Culture depended not upon taste in Persian miniatures or Sheraton highboys but upon discrimination in motor cars, the shape of steam radiators and ten-cent store crockery." Barr also organized shows of folk and outsider art, but a number of his powerful trustees opposed his interest in this direction. The last straws were two shows presented by Barr in 1943: a decorated shoestand by a New York folk artist named Joe Milone and an exhibition of primitive paintings of figures with two left feet by a retired Brooklyn slipper manufacturer, Morris Hirshfield. For these "sins," Barr was summarily fired, despite the fact that he was largely responsible for making the museum the great institution we now know it to be. Nevertheless, he con-

tinued to show up for work, and, in 1947, was made Director of Museum Collections.

The primary reason for Barr's ouster was the underlying conflict between the two roles of the museum, the one as a repository of time-proven art, and the other, as a showplace of new, often problematic and iconoclastic art and artifacts. Powerful anti-Barr trustees believed that MoMA's essays into popular culture and cutting-edge art demeaned its permanent collection and exhibitions of high and established art. The issue of what it is proper for a museum to exhibit continues to be controversial to our day. (Witness the debate over the recent exhibition of motorcycles and the designer rags of clothing merchants in our museums.)

The last time I saw Barr was during the Vietnam War, when, as president of the American section of the International Art Critics Association (IACA), I arranged for our members to meet with the radical Art Workers Coalition. To my surprise and dismay, Barr showed up. I was sure that the art workers would savage him as the running dog of Nelson Rockefeller, the president of the Museum of Modern Art, and a major supporter of the war. To their credit, however, they sensed that Barr was not well—he was becoming senile—and they treated him with sensitivity.

One of the reasons I admired Barr was because of the enemies he made, notably Lincoln Kirstein. Barr had been a tutor of Kirstein's at Harvard and later had brought the younger man into his company of friends and the inner circles of the Museum of Modern Art. I talked to Kirstein several times at MoMA events but learned most about him through reading. His views on culture struck me as mean-spirited. As an insider at MoMA, Kirstein attacked Barr and the museum for having "a sinister effect on art." Barr never forgave him for his vendetta against him and MoMA.

The more I discovered about Kirstein, the more I disliked his views. I could not admire or even take seriously anyone who believed that "Modern art . . . is nothing but a terrible inflation of a kind of cancerous self-indulgence, the great availability of the media, the terrible effects of behaviorism and of the idea of progressive education," and the lure of money. Only someone visually deprived could comment that Manet was "a lousy painter. . . . Clumsy, easy to look at, unfinished, no interest in psychology whatsoever—a simple French bourgeois hedonist who thought painting was good food and 'la peinture comestible.' You can eat it. And it appeals to people who really don't know anything about it," and on and on.

To his credit, Kirstein did bring Georges Balanchine to this country in 1934 and helped him found the School of American Ballet, and in 1948 the New York City Ballet. Even so, Kirstein's opinions, not only on modern dance, which he disfavored, but even on ballet offended me. He was obsessed with discipline and

hated freedom (Barr's passion) and individuality. He preferred ballet dancers over other artists because "they're not educated [and] don't have any ideas." Kirstein thought that his dancers should train much as storm troopers were made to goose-step. But I continued to enjoy both ballet and modern dance.

Of all the players in Barr's circle, Philip Johnson most intrigued me. Barr was his mentor, and their relationship was a passionate one. During a long interview with Johnson, I realized what his attraction must have been for Barr. Johnson's charm was palpable. He was also important to Barr because his wealth underwrote MoMA's Department of Architecture, of which he became the head. With Barr and Hitchcock, Johnson launched a campaign to sell modernist architecture to the American public. However, unlike the European innovators of the International Style, who called attention to its social usefulness, the Americans promoted it primarily because of its aesthetic qualities.

What baffled me about Johnson was his early espousal of Nazism. His reading of Nietzsche played a part in this. I could make sense of the appeal of the philosopher's hatred of the middle class and its sexual taboos, his celebration of manliness, his notion of the artist-superman, and even his anti-Semitism. But it was one thing to want to move "beyond" bourgeois conventions and to conceive of oneself as a cultural *übermensch*, and another to embrace Hitler.

Such was Johnson's commitment to fascism that in 1934 he resigned from MoMA and, with its assistant director, set out to found a Huey Long-like political party. He even devised a sexy silver-shirt uniform for the members. However, Johnson's political ventures soon collapsed, and when he asked to be re-accepted by the museum, Barr agreed (although he would not rehire his companion). Barr's decision was surprising since he was an implacable foe of totalitarianism, but friendship won out.

Johnson did not abandon the Nazi cause. In 1939, he traveled to Berlin as a correspondent for Father Coughlin's virulently anti-Semitic magazine, *Social Justice*. He entered Poland with the German invaders and witnessed the burning of Warsaw, which he found "a stirring spectacle." William L. Shirer, who had met Johnson in Poland, called him a Nazi spy. The FBI had its suspicions and, after the United States entered World War II, kept tabs on Johnson. Such was his allure, style, and wealth that in 1957 he was put on MoMA's board, after Mrs. John D. Rockefeller III spoke up on his behalf, saying "Every young man should be allowed to make one large mistake." I wonder whether Johnson's youthful "indiscretions" would have been forgiven by MoMA's trustees had he been a rabid Communist.

After battling the dead hand of Beaux Arts architecture and other revival styles on behalf of the International Style, both as a critic and as an architect in his own right, Johnson later turned against modernism. He began to champion

Frank Gehry, Peter Eisenman, and other postmodernist architects, a number of them Jews, with whom he had become friendly. Such was his charisma that they accepted him as a kind of elder statesman. Eisenman was quoted as calling Johnson the "most influential architect since Bernini." As if to atone for his racist sins, Johnson built a thirty-six-foot Lincoln Kirstein Tower as well as a "Ghost House" named for Gehry on his property in New Canaan. I am not persuaded by Johnson or his Jewish friends about his new-found tolerance.

My curiosity about Barr and his circle led me to track another upper-class, largely homosexual, WASP intelligentsia—not at Harvard but at Cambridge University in England, namely, the Apostles. The Apostles were a secret society whose members thought of themselves as a cultural elite. They were passionately committed to each other, so much so that they valued their comradeship more than England. Their model was E. M. Forster, who said that if he had to choose between betraying his country and his friend, he hoped he would have the guts to betray his country.

The Apostles, or at least those among them who were politically inclined, believed that the bourgeois society in which they had been reared was decadent and had to be overthrown. Disillusioned with feeble attempts by the British government to alleviate the Great Depression, they were convinced that the Soviet Union had all the answers. The future was there. They were also profoundly moved by the Spanish Civil War, which they viewed as a titanic battle between fascism and socialism. They felt that they were required to choose, and they did, gravitating into the orbit of the Communist Party. A couple, notably Guy Burgess, and Anthony Blunt, became Soviet spies.

Just as Johnson fascinated me, so did Blunt, a distinguished art historian who in 1945 was appointed Surveyor of the King's Pictures, a position he retained when Elizabeth became queen. Blunt's political convictions motivated him to spy, but his sexual orientation facilitated the move. As a homosexual and an Apostle he had been habituated to an undercover double life. When Blunt's cover was blown, he was not prosecuted, presumably because of his social status and his once-close connection with the royal family. But he was shunned, unlike Johnson, who rose higher and higher in the ranks of the culturati.

Why did the Cambridge Homintern turn to politics and the MoMA coterie to the arts? Perhaps one reason was that the Americans matured in the prosperous 1920s, the English in the economically depressed 1930s. England was much more threatened by Nazi Germany, and the shameless appeasement of Hitler by successive English governments disgusted the Apostles. Moreover, Soviet Communism was antifascist and appeared to offer solutions to the economic crisis in capitalist countries. Nonetheless, both the Harvard and Cambridge groups shared a patrician upbringing, a homoerotic bond, mutual admiration, wit and talent, a

hatred of middle-class conventionality in life and culture, and an unshakable belief in the rightness of their causes. They also possessed a sense of being beleaguered outsiders and, hence, an intense group loyalty. What modernist culture and aestheticism were to an American privileged, homosexual elite schooled at Harvard, Marxism, Soviet Communism, and for a number, espionage were to their Cambridge-educated counterparts in England.

# My Pals in the 1950s:
## Alex Katz, Philip Pearlstein, Al Held, Mark di Suvero

Of the some two hundred fifty artists who exhibited in the Tenth Street cooperatives in the second half of the 1950s, I became a close friend of six: Alex Katz, Philip Pearlstein, Al Held, George Sugarman, Ronald Bladen, and Mark di Suvero. Katz and Pearlstein were members of the Tanager Gallery when I managed it from 1956 to 1959. Held, Sugarman, and Bladen belonged to the Brata Gallery, and di Suvero, to the March Gallery, both venues across Tenth Street from the Tanager. Why did I single out these six? Simply, because their work gripped me more than that of their fellow artists. I also sensed that it would live past the decade—and grow in the estimation of the art world. It did, like little else from Tenth Street.

I found my six pals attractive because they behaved just as artists ought to. They were self-assured, ambitious, and competitive, aiming to create original works that would knock everything else off the wall. There was nothing modest about them, to say the least. They were all singularly independent in their thinking and unafraid to jettison received opinion.

Since I had written early reviews, articles, catalog introductions, and monographs about these artists, I have often been told that my own art-critical efforts were helpful in establishing their reputations. But it was the quality of their work that was chiefly responsible for its success. And furthermore, I do not think that I had the art-world clout to be a "kingmaker," as Clement Greenberg later had. Nor was it my intention to forge reputations. I was just writing about what moved me, but perhaps I was naive about the effect of my criticism.

Towards the end of the fifties, Katz, soon followed by Pearlstein, Held, and Bladen, began to react against gesture painting, the orthodox Tenth Street manner. I was of mixed mind about the direction they were taking, since it meant turning away from the art that first affected me deeply and to which I remained committed. However, my friends claimed—tentatively at first and then with growing conviction—that gesture painting had become outworn and academic. The old guys are still lively, they said, but their followers are boring, and enough is enough. I had to agree about the newcomers, but what of the existential "truths" embodied in gesture painting that were so meaningful to me? Katz raised *both* eyebrows, and Pearlstein retorted that there were other "truths" that were fresher and more

challenging, namely, a "new realism" that would revitalize figurative painting. Held and Bladen countered my objections by asserting that gesture painting was in "crisis." Abstract art needed regeneration; a "new abstraction" was required.

Katz, Pearlstein, Held, and Bladen began to replace the hot, dirty, direct-from-the-self look with a cool, clean, distanced-from-the-self look. Each in his own way suppressed the ambiguous atmosphere of gesture painting and opted for clearly articulated images. I witnessed all of the steps in each artist's stylistic development. I was also strongly influenced by our conversations at the time. They ushered me into the 1960s.

Katz and Pearlstein challenged me to take a critical look at the slap-dash imagery of second-generation figurative gesture painting. What were the figures doing there? Were they anything other than tokens in what was essentially abstract painting? And wasn't there just too much brushy painting around? Didn't it all look "Dead-on-Arrival," as Katz quipped? I had to admit, reluctantly, that they had a point. But, I asked, what was the alternative? They said that the need today was to respect the human subject by representing it as it appears. Then, I asked, how can you avoid being backward-looking and academic? Their painting soon persuaded me that they had—Katz, by creating a new modernist realism, and Pearlstein, by making the subjects more factual than ever before in painting.

In his tough-minded way, Katz posed the questions facing figurative artists: What would make figurative painting *contemporary*? What if you didn't want an unfinished open surface, like that of Cézanne or de Kooning, and preferred a finished closed surface, like Manet's or Matisse's? What then? Could you make a realist painting in a nontraditional large scale? What did the subject contribute to the expression of the painting? What if the image was factual? How could ideas culled from abstract art be used in figurative painting? How could realist art compete with abstraction?

In being literal, Katz and Pearlstein inaugurated what came to be labeled "the new realism." It soon became evident to me that the other major representational "isms" in the sixties, namely pop art and photorealism, were equally factual. This specificity made all three tendencies peculiarly *of* the decade. That also applied to abstract art that was literal. Its seminal painter, Frank Stella, spoke for many of his fellow artists, later dubbed the minimalists, when he scorned "people who want to retain the old values in painting—the humanist values that they always find on the canvas. . . . My painting is based on the fact that only what can be seen there *is* there. . . . What you see is what you see."

Figurative art as a whole was suspect in the 1950s. It was rarely considered the equal of major abstract painting. Heroes of the New York school, such as de Kooning, Pollock, Kline, and Hofmann, had painted figurative pictures, but their

reputations were based largely on their abstractions. Although gestural figuration was acceptable, specific representation was not. In the 1960s, the die-hard advocates of gestural figuration, who still made up a large and vocal group in the New York art world, continued to slight the new realism. They bad-mouthed Katz's and Pearlstein's work as retrograde and simplistic. The supporters of stained color-field and hard-edge painting, while rejecting gesture painting, also ran down the new realism as old-hat. As early as 1954, Clement Greenberg, the impresario of stained color-field abstraction, announced that all of figurative art was passé. "In fact, it seems as though, today, the image and the object can be put back into art only by *pastiche* or parody—as though anything the artist attempts in the way of such a restoration results inevitably in the second-hand."

The supporters of pop art were no more sympathetic to the work of Katz and Pearlstein. If in its literalism the new realism seemed related to the work of Andy Warhol and Roy Lichtenstein, the differences were more pronounced than any similarities. Alert to consumer culture, pop artists copied advertisements, comic strips, and the like. Compared to these subjects, the actual people, landscapes, and objects portrayed by Katz and Pearlstein seemed old-fashioned. Indeed, pop art eclipsed the new realism because it looked new at a time when novelty was prized; socially relevant because of the pervasive influence of the mass media on contemporary life; aesthetically pertinent because its clearly defined, unmodulated forms resembled those of the new abstraction; and avant-garde because it muscled into high art the subject matter and techniques associated with commercial art. Moreover, pop art seemed scandalous, and it riveted art-world attention, engaging both those who reviled it for celebrating vulgar kitsch and those who praised it for its insights into consumer society. Photorealism, which emerged somewhat later than the new realism and pop art, also seemed peculiarly relevant because it used painting to replicate photography, which had become ubiquitous in modern life.

Compared to pop art and photorealism, the new realism did seem passé. In actuality it was not, of course, but in the face of sustained carping, Katz and Pearlstein felt embattled. That did not deter them. They rejected the idea of copying commercial images, on the one hand, and on the other, as perceptual painters, they spurned photo-based representation because it viewed reality through the lens of a camera instead of the eye. As they saw it, the camera was a crude and imperfect *machine* that distorted visual reality, whereas the eye was an *organ* of such extraordinary complexity and sophistication as to make it infinitely superior to the camera as a tool of perception. Because the eye is a scanning organism, perpetually adding information, Katz's and Pearlstein's figures look animate, unlike the frozen images recorded by a camera.

Katz and Pearlstein did not take the attacks on their work lying down. Loud

and clear, they proclaimed their devotion to the *tradition* of Western *painting* as well as their aspiration to revitalize it. They pointed out that their subjects were those of a Courbet or Manet and not copied from commercial art or photographs. More important, they affirmed what Linda Nochlin said were the virtues of nineteenth-century realism, namely, truth to appearances, contemporaneity, directness, and authenticity. Moreover, like their predecessors, the new realists painted with brush by hand, unlike the pop artists who used mechanical means such as stencils and silkscreens, and the photorealists who airbrushed their images. Above all, Katz and Pearlstein sought to emulate the artistry of earlier master painters.

Whether they were painted forty years ago or yesterday, Katz's pictures do not look old. Neither does Alex himself. In his seventies, he continues to have the physique of a model, and occasionally appears in fashion magazine photographs. When Alex makes up his mind about any issue, he asserts his opinions in one-liners so forcefully that it is difficult to disagree, even when one wants to. He is occasionally overbearing, but most of the time he is fun to be with. I have learned a lot from Alex. A hard-nosed antiromanticist, he deflated my existential sentiments at every opportunity.

What was Alex's contribution to contemporary art? In the early 1960s, he was a primary innovator of the new realism. And he was the first to adapt to figurative painting the huge size and internal scale associated with abstract expressionism and hard-edge and stained color-field abstraction.

Alex developed his style in an organic way, from canvas to canvas, making intuitive choices but verging toward specific representation and expression through color. He increasingly eliminated smudged and scumbled brushwork because it got in the way of his rendering the details of what he saw, an ear or hair, for example, and because it dulled the effect of color, preventing it from being fully felt both visually and emotionally. Reducing modeling to heighten color caused Alex's pictures to flatten and the images to look somewhat abstract and modernist. That presented him with a problem, namely, how to reconcile the flattening of his images with the creation of a convincing illusion of volume and depth. His solution was to suggest a sense of space through the interaction of planes of color. As Alex put it in 1957: "If I stretch the surface taut and also get space into it; get the weight of my subjects and keep the surface fluid; get the instant of light; and get it all right, it's going to be a good painting."

At the same time that Alex's pictures took on a modernist "look," he began to focus on portraiture, the most specific kind of representation. His style then issued from a desire, deeply rooted in his psyche, to fuse disparate pictorial com-

ponents—that is, literalist portraiture—on the one hand, and on the other, modernist flatness and expression through color—at their extremes. Thus, he was able to break out of the confines of the then commonplace gesture painting into a new realism. In so doing, he changed my perception—and the art world's—of what figurative painting could be.

To be taken seriously, a New York school painter was expected to employ open, fatty brushwork, which emphasized the expressiveness of pigment. In his desire for specific representation, Alex curbed brushiness, which put him at odds with the reigning gesture painters. Moreover, his reduction of painterly activity made his pictures look "cool." At a time when "heated" painting was prized, Alex's pictures were thought to be unfeeling and inexpressive. They were not, of course, but, as he said, in order to "stress objectivity, a certain impersonality creeps in. Objectivity and impersonality are words that link naturally."

Some of Alex's public comments further alienated him from the gesture painters. He was the first Tenth Street artist I knew to publicly lampoon abstract-expressionist rhetoric. For example, while participating on a panel titled "The Accidental in Art" at The Club at the beginning of 1957, when gesture painting was riding high, he said: "To me the only accidental days are good painting days and bad painting days. If you drop paint on canvas, you know what it will do. Where's the accident?" So much for the highfalutin claims made for chance in art. As for the commonly held belief that violent painting conveyed violent emotions, Alex scoffed, "It's hot handling and cold feeling."

It took a lot of guts to suppress gesture painting and make derogatory comments about it. And Alex was punished for his independence by being dismissed or patronized by most of his fellow artists. It built up in him an aggressive I'll-show-you attitude that fueled his ambition, goading him ceaselessly to extend his painting in daring new directions. Indeed, no other painter of his generation has had his range in subject matter, paint handling, or composition. Alex never forgot or forgave his early rejection, even when in time, he became an art star, one of the most successful and feted painters in the Western world.

Alex's work is multidimensional, and in my monographs on him I have dealt with its varied aspects. However, I did not sufficiently indicate what set Alex apart from his fellow realists. At the risk of oversimplification, it is his awareness of what is fresh and stale in life and art. He possesses a kind of fashion-mindedness that makes him a dandy in Baudelaire's definition, namely, as a sharp observer of society and its culture, especially attuned to what makes them contemporary. As Alex said as early as 1961: "I would like my paintings to be brand-new . . . and terrific."

I once asked Alex to account for his flair in predicting what was trendy and what was not. He said that he had had the knack as far back as he could remember. He became fashion conscious in high school, choosing to wear a zoot suit

because it was "away from tradition, away from constraints." His first teacher at Cooper Union, Robert Gwathmey, used to analyze different styles and declare what was dead and alive in each. Alex seldom agreed with Gwathmey's opinions, but he was taken with his approach. Soon after his graduation in 1949, he rejected as stale the work of his teacher and other "humanist" figurative artists who were deriding abstract expressionist painting as merely formalist. Sensing where lively art was being made, Alex joined the New York school.

I first became aware of Alex's ability to forecast emerging tendencies in 1957. He and the other members of the Tanager Gallery proposed to arrange a series of shows and publish a book that would reveal artists' opinions in contrast to those of curators and critics. They would select the liveliest artists of the time and try to classify them in new ways. The group met regularly for weeks, discussing the categories and voting on which artists would be in or out. It was my job to tally the votes. More often than not, the result of a ballot was eight or nine to one, the one being Alex. At first, I looked skeptically at his unorthodox opinions, which struck me as perverse, but I quickly noted that they anticipated fashionable art-world opinion. As late as the 1990s, he still had the gift of distinguishing the used-up from the viable, and he cued me into the work of John Currin, Elizabeth Peyton, and other young figurative artists before they became trendy.

In retrospect, I am awed by Alex's repeated discernment of "the brand-new." As early as 1956, his growing preoccupation with color led him to look for inspiration to Rothko as the heir of Matisse and Avery, while most of his fellow artists were in thrall to de Kooning as the successor to Picasso and Soutine. That was before the school of de Kooning was eclipsed by the stained color-field abstraction of Louis, Noland, and Olitski and the hard-edge abstraction of Kelly and Held, young artists also in debt to Matisse, Rothko, and Newman. Stained color-field and hard-edge painting would soon be hailed in the art world as the avant-garde abstract trend. In its clear articulation of color and form, Alex's work was related to that of Held and Kelly. Indeed, his style could be fittingly labeled "hard-edge realism."

Like his abstract colleagues, Alex painted increasingly big pictures and cropped his figures to make them loom even larger, in order to make his images project more strongly—and aggressively. In this, his work was related to the cut-off "letters" being painted by Held, who was his friend and upstairs neighbor. Alex's ambition was to have his pictures compete in visual impact, muscle, and grandeur with the best of the new abstraction. But he also had an eye to contemporary mass media, such as large-scale billboards and wide-screen movies, anticipating soon-to-become-chic pop art.

Alex's sitters generally have been his wife and son, as well as artist, poet, dancer, and critic friends—including me. Alex was, and still is, devoted to modern dance

and contemporary poetry. It was largely because of him—accompanying him—that I got in the habit of attending poetry readings and avant-garde dance performances. In the fifties, Alex's models were not yet fashionable, but they would soon be. David Antin called us "secret celebrities" because we were "well enough known for most people at all familiar with the art world to know that [we] are known, though not always well enough known to know who [we] are." Alex chose us because we were willing models, stimulating and sympathetic to him, and we made up his milieu. In painting us, he revealed the mood of the art world in the 1950s: It was small, poor, and of necessity, bohemian. Responding to public hostility, we turned in on ourselves and formed our own community. Alex caught our mood in the wedding portrait he painted of Lucy and me in 1958. We huddle in the center of an expanse of white—because of affection and for comfort, but also for mutual support. The pigment is a bit smudged, not unclean, like the run-down lofts and apartments in which we could afford to live while striving to make them elegant. Alex documented our poverty, but he also caught our pride, soberly confident in our creative power. He turned our down-at-the-heels, but not dirty-ankle, appearance into a high style. As Dave Hickey has written, Alex rescued figurative painting from the throes of private expression and restored it to the social realm.

For our wedding portrait, Alex stretched a five-foot-square canvas, larger than any he had attempted previously. As we stood around, he asked us to just "pose," and without thinking we put our arms around each other and pressed together. He said: "Hold it." Alex painted us nestled against a white field. Because of its Rothkoesque atmosphere, its size, and the spareness of the image, our double-portrait turned out to be one of his seminal pictures.

After the *Wedding Portrait*, I sat for Alex twice more. From 1967 to 1970, he made thirty-eight more or less lifesize head-and-shoulder cutouts of art-world friends, which he then set on a tabletop so that they called to mind people at a party. Each one had a face and a back of the head except mine; it had two backs of the head. Years later I asked Alex why, but he couldn't remember. Once, having coffee with Alex, I kidded him by asking why he always portrayed his friends in their everyday clothes and social situations. Why not paint them in moments of glory? He asked: "What was your moment?" I had to think and I replied: "Well, you know, I was once a Marine." A few weeks later Alex invited me to his studio. He had obtained somewhere a Marine Corps blue dress jacket and hat and asked me to change into them. I protested: "Alex, this is an enlisted man's uniform. I was an officer." He barked like a drill sergeant: "Put 'em on and pose." Alex made some quick oil sketches—he gave me two—and painted a 51- by 81-inch picture of my head. He later presented it to me as a gift. Lucy and I lugged it home from his studio, but it was too large and aggressive to hang in our apartment, so we brought

it back. I later joshed Alex by saying that he gave us that particular picture not only because I was its subject but in order to knock out everything else on our walls. He laughed. It was true.

In the 1960s, Alex's subjects were still friends of his, many the same ones he had painted in the previous decade. But we looked different. No longer the disheveled bohemians of the Eisenhower fifties, in the affluent Kennedy years we had become stylish, looking sleeker, trimmer, smarter (our hair coiffed to look unkempt), and grander; we had achieved a certain success in the world. In contrast to the inward-looking bohemians of the 1950s, sixties dandies were outer-directed. Cool and reserved, at ease and assured, many were at home in the world of high fashion. Alex also began to portray us in groups, at parties, dinners, picnics, and other social events and rituals.

The settings in Alex's pictures are always clean, bright, and pleasant; there is no grime or any sign of the assorted miseries that we know the sitters must experience. As John Russell remarked, "No one has ever looked vicious, nasty, hung-over, left out of the party or bored." Hilton Kramer found this "a shocking notion—an artist in love with surfaces . . . and eager to stake his work on his affectionate attachment to the here and now. So little that we value in modern art has prepared us for such inspired insouciance." Or, for such emotional reticence. Alex has said: "I prefer cool painters like Manet." He added that "detachment was what I liked in bebop, Stan Getz, John Ashbery, Paul Taylor." Alex's sitters are cool in their self-projection and so are his representations of them. The cool is conveyed by the smoothness of the painting, the flatness of the pared-down images, and the large size of the formats, all of which distance the subjects.

The trendiness of Alex's sitters reflected our affluent society's growing fascination with fashion. His own interest in fashion is personified in his self-portraits: in the transition from the rough, guileless *Self-Portrait (Cigarette)* (1957) and *Self-Portrait* (1960), to the street-smart, wary but confident *Passing* (1962–63), to the suave, man-of-the-world *Self-Portrait with Sunglasses* (1969). In *Green Jacket* (1989), Alex strikes a pose between a Renaissance nobleman and a basketball star. His stylish garb becomes a kind of extension of himself, defining both his personal style and his stylishness.

Alex's and America's growing fashion-consciousness was exemplified by Jacqueline Kennedy in her role as First Lady. She was both clothes- and culture-minded, without sacrificing either seriousness or glamour. We were also charmed by her husband's "cool," which emerged in sharp relief to Nixon's "hot" during their television debates and contributed greatly to his election victory.

Alex's wife, Ada, has been his favorite model. He has portrayed her well over one hundred times, and he has transformed her into the First Lady of the Art World. Beginning in the 1960s, cultural figures became famous and, as a result, the subjects

of paintings. Willem de Kooning painted Marilyn, Alex painted Ada, and Andy Warhol followed with more of Marilyn as well as Liz, Jacqueline, and others. Such has Ada's celebrity become that when she and Alex attended an opening of Alex's work in Florida, they overheard a woman asking her companion: "Is that the artist over there?" The companion replied: "It must be, he's standing next to Ada."

Although representation is central to Alex's style, it is style itself that is paramount in his work. Indeed, he insists that style is its content. As he sees it, style dictates what stays in or is kept out of a picture. And style differentiates the work of artists. Put another way, Alex's primary content is the Katzness of Katz.

Alex also thought of his style as "high style," a term he borrowed from the vocabulary of fashion. Because of his interest in fashion, he has preferred to paint clothes and has rarely painted the nude. Fashion was long denigrated by the art world as kitschy, commercial, and frivolous, but Alex always kicked up his heels at taboos. As Robert Storr observed, he chose to scrutinize "the superficialities of fashion . . . for truth-telling signs of the times."

How are high style in art and high fashion related? Both inform us about the up-to-date look of things and manners, what the trend-setters wear at parties, benefits, the beach, or other leisure activities. High style in art and high fashion both have to be cool. Neither can be sweaty. So the contours in Alex's paintings are clean, their facture, smooth; everything is on the surface, the scale is big, the gesture, dashing. In sum, if a high style embraces what is in vogue in life and art, then Alex aspires to be what Baudelaire called an "aristocrat of taste."

Alex also applied the term "high style" to the work of past artists. He once told me that Rubens' painting in its time was the newest thing in Europe—"like a 1960s Cadillac." Rubens, Watteau, or Boucher, compared to, say, Chardin, were high style, because their work attracted the fashion- and art-conscious elite of its time, nobles then, dandies and clothes designers later. I hasten to add that Alex knows the difference between fashion and art. The one is ephemeral and ever-changing; the other is essentially shaped by an artist's vision and aspires to time-lessness. Fashion self-destructs whereas art that has any validity doesn't.

Alex's references to fashion illustration related his work to that of the pop artists Warhol and Lichtenstein, despite their use of the mechanical techniques of commercial art and his, of the traditional craft of painting. From the 1970s on, he and they (along with David Hockney) have been the most celebrated figurative artists of their generation. Why have these artists become global superstars? Because their work typifies the post-World War II consumer society. I don't mean this to be derogatory. After all, the consumer society is *our* society. Alex is its master painter—even more so than Hockney. He is its Sargent, I would venture to say its Watteau, and that is an extraordinary achievement.

In appearance and manner, Philip Pearlstein is the opposite of Alex. Short and round, he is gentle and reticent, but just as tough-minded. When I first met Philip at the Tanager Gallery in 1955, he was studying for a Master of Arts degree at New York University's Institute of Fine Arts. His thesis was on Francis Picabia and Marcel Duchamp—years before they became fashionable. For me, Philip became a primary source of art historical information and opinion. He talked about old and new art, much of which he collected, with remarkable insight. Since I knew little about past art, his soft-spoken comments were very useful.

Philip was adept at conceptualizing his artistic intentions and articulating them clearly. In 1957, he participated on a Club panel whose topic was "The Artist's Involvement with Nature." He spoke about the gestural pictures of imaginary rocky mountains near the sea that he was then painting—the first of his works that I saw.

Why do I paint rocks, pebbles and such? They enable me to find a variety of more interesting forms, ideas, and structures than I could dream up by myself. But I look for ideas in nature that conform to the painting ideas I have. Still, I don't place too much value on subject matter. My lack of involvement with it enables me to concentrate on the painting. And my painting ideas come as much from art as from nature, for example, Southern Sung painting, Watteau, Cézanne, de Kooning, and Kline.

I am not consciously concerned with expressing moods or subjective states or ideas about nature. The expressionist element in my work has much more to do with the struggle I have with paint than with any external feelings.

However, Philip was already questioning the expressionist look of his painting:

Last summer, I went to Maine and decided to work directly from nature. I decided to record as much detail as I could in my drawings, and when I went back to painting in New York, to render them as accurately as I could. I hoped to bring intensity and imagination to my illustrations and a sense of importance, to say nothing of unique style and aesthetic qualities.

I was struck not only by the clarity of Philip's statement and the lack of high-flown rhetoric but by its coolness, a coolness akin to Alex's. Breast-beating was the going style in 1957, and it took courage for Philip to openly reveal his dispassion.

I would drop in to Philip's studio occasionally to see what he was painting. On one visit in 1958, I found him in a dejected mood. It had been his practice to play Mozart's *Magic Flute* while working, but his recording had worn out, and he could not afford to buy another. I asked: "How much is it?" "Fifteen dollars." That's a lot,

I thought, but I could probably scrape it together. Seeing a small piece of canvas I said: "Philip, paint me one of your rocks, and I'll buy you the Mozart." A month later, he showed up with the picture, a superb landscape that he must have worked endlessly on, and I bought him his *Magic Flute.*

What led Philip to create a new realism? He recalled that Landes Lewitin pointed to his specific drawing and brushy painting and noted that they were at odds. He advised Philip to move toward greater realism. Moreover, Philip said, when he began to teach at Pratt in 1959, he tried to explain one-point, two-point, and three-point Renaissance perspective to a class. "I got tangled up in all my chalk marks. Finally, I gave up. Suddenly, it seemed that to be a realist painter [was] the most challenging, sophisticated, and interesting thing to do."

Philip's intellectual bent, which prompted him to study art history at New York University, led him to conceptualize his move toward representation. He asked, What does it mean to record what I see? How can it best be accomplished? Where is it taking me? He also began to speculate about the situation of figurative painting in the United States. It seemed enervated to him, and he wondered how it could be revitalized. Through his research on Picabia and Duchamp, Philip came to believe that art was about ideas and "not just being a craftsman, and emotional." Before figurative painting could be renewed, it would have to be formulated as an idea, an idea as rigorous and intellectually challenging as the rationales for the best contemporary abstraction, with which it would have to compete for attention.

To justify his factual approach, Philip published two articles, one titled "Figure Paintings Today Are Not Made in Heaven," and the other, "Whose Painting Is It Anyway?". He maintained that to paint realistically, he would have to rid his art of "two tyrannies." The first was pictorial flatness, which denied the bulk of the body. This put Philip at odds with modernist picture-making, in which illusionism was taboo. The second tyranny was "the roving point of view," which was the way the line of modern painters from Cézanne to de Kooning aspired to see. Suggestive of multi-levels of human experience, it led artists to segment anatomies, overlap contours, and interpenetrate forms so that they appeared to be complex, ambiguous, and in constant flux. As he said: "The artist looking becomes the subject of a painting rather than the subject itself." Philip's urge to depict only what he could observe troubled him. In 1961, he wrote that his move to realism struck him as mad, for "as artists we are too ambitious and conscious of many levels of meaning. The description of the surface of things seems unworthy."

Nevertheless, in the early 1960s, Philip began to paint, as he said, "the naked figure, conceived as a self-contained entity possessed of its own dignity, existing in an inhabitable space, viewed from a single vantage point." In order to render his

subjects more accurately, Philip stripped away the overlay of gestural brushwork and "hardened" his painting. It became closed and finished rather than open and unfinished. His modeling grew smoother and his contours more exact. Philip's steps toward a new realism followed Alex's and were also related to Held's moves toward hard-edge abstraction. Philip recalled that his conversations with his two friends abetted his moves. However, unlike Alex, Philip focused on the nude, the central subject matter of Western painting. But how could Philip make this figure new and not merely a rehash of used-up figurative styles? This question caused Philip, art-history-minded as he was, to look to the past for answers.

In conversations Philip and I had in the early sixties, often looking at the picture he happened to be painting, he reviewed earlier realist styles. None, he said, were truly literal. Even the naturalism of Courbet was tinged with romanticism. Moreover, further moves toward realism had been aborted by photography and impressionism. Much as Monet and Renoir aimed to paint what they saw, they dematerialized their subjects, flattened pictorial space into a screen of light, and verged toward an abstract art. The post-impressionists, each in his own way, advanced even further toward abstraction, van Gogh in an expressionist vein, Gauguin and Seurat in a symbolist manner, and even Cézanne, because of the liberties he took with nature on behalf of pictorial structure. Courbet's realism had been relegated to the dustbin of history by modernists. Philip proposed to rehabilitate it, but he would go beyond Courbet toward representation and try to be truly perceptual. Philip would paint from the model and record what he saw coolly and painstakingly, avoiding any and all interpretation.

However, as Philip said: "I cannot duplicate exactly what I see. There are always optical and psychological distortions. I do come up with something about the sitters by being true to appearances." Did this make Philip a "humanist"? Not in the traditional sense. As he declared: "I don't like any psychological, erotic, literary, narrative crap. I am interested in the subjects as art. They are really nothing more than models in the studio." Philip's thinking paralleled that of Ad Reinhardt, a fellow graduate student at NYU, but Reinhardt did not accept Philip's figuration and once twitted him: "You'll be responsible for their souls."

Philip was pro-people in his respect for the human body. He wrote that he saved it from the "tormented, agonized condition given it by the expressionistic artists and the cubist dissectors and distorters of the figure, and at the other extreme I have rescued it from the pornographers, and their easy exploitation of the figure for its sexual implications." Essentially, Philip approached the human figure as Duchamp, that ultimate realist, had viewed the ready-made, or as Andy Warhol would regard the Brillo box.

Warhol had been an undergraduate with Philip at Carnegie Tech, and they came to New York City together to find jobs as commercial artists. Their teacher,

Balcomb Greene, found them an apartment, and both quickly got jobs. Warhol was an immediate success, and he worked steadily at fashion illustration. Philip tried to paint on the side. He remarked that commercial art was very factual and that it may have contributed both to his new realism and Warhol's pop art. Philip's and Warhol's friendship cooled after Warhol was turned down for a show at the Tanager Gallery because the members thought his imagery was too homosexual.

The sharper Philip's focus became, the more distasteful he found the brushy "soft edges" in gesture painting. He now equated what he termed "comfortable pillows of gray mist" with "soft sentimentality." He also rejected abstract expressionism's seemingly anxious improvisation that left the scars of the brush-in-action in completed pictures. There were, however, curious carryovers from gesture painting in Philip's work and thinking. As he said in 1976: "I feel more related to de Kooning and Kline than to the Soyer brothers." Kline's big and aggressive black-and-white swaths inspired Philip's configurations of torsos and limbs. Just as Kline cut off his abstract shapes to make them more immediate, so Philip cropped his figures, making them appear larger than they are, drawing them to the surface, and causing them to thrust out at the viewer confrontationally—as Katz had.

Philip spoke of his reservations about venturing into a new realism in a calm voice, as matter-of-fact as his painting. But, as I recall, the way in which his work evolved made him extremely apprehensive at the time, and with good reason. The art world was not prepared to accept his or Katz's perceptual realism. Pearlstein and Katz had to contend with pop art and photorealism, particularly photorealism, because it was closest to perceptual representation in appearance. Specifying the difference between photorealism and his new realism, Philip said: "I really see more than a camera does, and it takes me more time. . . . If I look at a knee for an hour, I get conscious of every little ripple and detail." He remarked elsewhere: "In rendering a photograph, the figure is given beforehand. There is no challenge of putting it together. A figure painted from life has a presence that could not be achieved without the model." However, Philip remained fascinated by photography to the extent that he took a great many photographs of a work in progress. He used the photographs to see how his eye differed from a lens and a painting from a photograph.

If Philip knew exactly what he wanted to represent, his process nonetheless was endless. Posing interminably, his models would get bored and therefore look bored. Critics began to write that the content of his pictures was boredom or depression. Paul Brach once asked Philip: "How come all of your subjects look as if they just had sex and it didn't go so well?" That troubled Philip, and he thought that if he had a friend pose, his or her image might look somewhat animated. He asked me to sit for him, and I agreed. Sixteen sessions of three hours each—even

listening to the *Magic Flute*—and I ended up looking bored. But that was just how I appeared, not as Philip "interpreted" me.

The new realists had to contend with the hostility not only of the supporters of pop art and photorealism but also of Greenberg, whose formalist rhetoric had enormous clout. Greenberg railed against figuration. He had, however, once included Philip in an important *Emerging Talent* show, but because he misread Philip's picture as nonobjective. When Greenberg discovered that the work was figurative, he tried to coax Philip into becoming an abstract painter.

Philip rejected the new abstraction, pop, and photorealist art when their art-world appeal was at its greatest. Their supporters emphatically attacked the new realism as retrogressive and academic. Why did anyone bother to take notice of it at all? In other words, when Philip chose to ignore fashionable sixties styles, why was his perceptual realism not brushed off? It couldn't be disregarded, because it partook of the "cool" sensibility of the 1960s, just as new abstraction, pop, and photorealist art did. Consequently, Philip's painting forced itself into the aesthetic discourse of the time. It may also be that Philip's specific realism had social relevance. He thought so. "Perhaps it is significant that I developed my attitude during the period of political upheaval in the United States in the 1960s, when the terms 'seeing it as it is,' and 'saying it like it is,' become radical expressions."

Above all, Philip strove to maintain a balance between painting that functioned descriptively and, painting that functioned in its own right, expressively. Having it both ways was vital to him, because he wanted to transcend *realistic* illustration—"the mere rendering of enough detail to make the thing read convincingly"—and aspired to *realist* painting which "implies more than it shows." Flaubert once commented that the goal of realist literature was "to write the *mediocre* beautifully." Substitute painting for writing, and that was Philip's achievement.

If Pearlstein and Katz were prodding me to question painterly figuration, Al Held, Ronald Bladen, and George Sugarman were battering my ideas about the continuing viability of gestural abstraction. I was getting a double whammy.

Al Held was burly both in his physical appearance and in his conversation. Presented with an idea, he would grasp its jugular and not let go. He was utterly honest and relentless in discussion, often becoming overbearing—although he thought of himself as passive. Once, at a meeting of the Visual Arts Overview Committee of the National Endowment for the Arts (of which I was the chair), Frank Hodsoll, the head of the NEA, walked in, looked around, and said: "This committee needs more artists. I want independent-minded ones. Make some recom-

mendations." After he left, Chuck Close suggested Al. I said: "He is one of my closest friends, but as a member of this committee, he would be unbearable." Close countered: "But he certainly is independent. He was my professor at Yale, you know. He came to my opening at the Bykert Gallery in 1970. I went up to him and thanked him for coming. He scanned the paintings on the wall and said, 'Don't hang this shit on me.'" I said to Close: "Have you listened to what you just said?"

Although Al never went to college, he was appointed to an associate professorship at Yale (where he taught from 1962 to 1980). Katz recalled that when the offer came, Al, in a panic, came to him for advice. Al said: "Those kids are the smartest in America, and I never even finished high school." Katz responded: "Don't worry, Al. These Yalies are punks and you, you're a real gangster." And he was. As a teacher, Al was sometimes abrasive, and students who couldn't take his battering-ram talk avoided him. He relished dialogue and after class would continue talking as long as his students' energy would allow, something the other professors seldom did. Former students of his, such as Judy Pfaff and William Conlon, found his caring supportive and his confrontational criticism useful, and they remained lifelong friends. So have I, although during our forty-years-plus of arguing, after many sessions, I left in a frustrated fury. So did Al, he has admitted to me.

I met Al in 1955 on Tenth Street. He had recently come to New York and was a member of the Brata Gallery, which was across the street from the Tanager. He was painting fields of pigment-laden gestures, all-over and fluid, like Pollock's abstractions, yet structured, like de Kooning's. Al's canvases were aggressive, seeming to project into the space of the viewer, physically as well as figuratively, like earth-colored tidal waves of impasto. I was impressed by them, and we became friends.

Al told me about his return to New York from Paris, where he had lived from 1949 to 1953.

> I looked up Rothko. He was gracious and spent an entire afternoon showing me his paintings and talking. As we parted, I asked whether I could visit him again. He said: "No, build your own world with your own contemporaries. That's the healthy way." I felt rejected, but he did me a favor. We became friendly later, in the sixties.
>
> There were terrific painters in New York—Rothko and Pollock and de Kooning. Everybody else not with us was just absolutely out.
>
> Rothko was a no-hands magician. I was more deeply moved by his work than de Kooning's, but I was more intrigued by the malleability of de Kooning's visual language.

Al became particularly close to two other members of the Brata Gallery:

Sugarman, whom he first met in Paris, and Bladen, whom he had gotten to know during a sojourn in California. Al also became friendly with Katz—they would live in the same buildings for decades—and Pearlstein. (I found it curious that during his stay in Paris, Al had turned to abstraction by painting images of stones. Pearlstein too depicted rocks on the way to literal representation. Neither could have known the works of the other.)

In 1959, when the *New American Painting* show returned from its European tour and was on view at the Museum of Modern Art, Al recalled: "I looked hard at the works and was disappointed. I was put off by the mustiness of the painting. I vowed to get rid of that dusty haziness that clouded their surfaces, that atmosphere of 'otherthingness,' and try for something more concrete." (At much the same time, Pearlstein also felt the need to squeeze the vague atmosphere out of his figurative pictures.) Moreover, Al had become bored with the glut of gesture painting exhibited in New York galleries.

Increasingly dissatisfied with his own pigment paintings, Al reviewed them with a critical eye. By temperament, he was attracted to the heft of thick paint and liked how it felt to move it, but he was equally drawn to design. He had been composing his forms loosely along vertical and horizontal axes in order to "give the gestures structure," recalling the way Cézanne had made something solid out of impressionism. Now, Al began to think that his true artistic bent was toward clarity—a kind of classicizing urge. The compositions of his pigment paintings were buried beneath thick layers of paint. To unearth them, he had to cut away the troweled and smeared slabs of paint.

Al's pigment paintings were bothersome to him for another reason. As the impasto dried, it formed a hard skin beneath which pockets of liquid paint remained. These pools would occasionally shift, altering the composition. Every day, he would come anxiously into his studio or even a gallery during one of his exhibitions, unsure as to what a picture would look like. I once kidded him about the changeability of his work, pointing to Jackson Pollock's comment that his poured pictures had a life of their own, presumably independent of him. Al's pictures were painting themselves. He didn't think my joking was funny. Al consulted chemists in order to find a way to harden the pigment and eventually succeeded.

Confronting the crisis in his gesture painting, Al said: "There has to be another way of making art." In 1960, Sam Francis generously lent him his large light-filled studio. Al wrapped its sixteen-foot-high walls with ten-foot-high sheets of butcher paper. In a surge of energy, he proceeded to cover the surface freehand with roughly rectangular, triangular, and curvilinear configurations in flat colors reminiscent of Matisse's *Jazz*, but much louder. Al said of the change in his work: "I revolutionized myself." When he was finished with these paper works, he removed

them from the wall, folded them up, stored them in an unused silo on his farm, and forgot about them. (I did not even know of their existence when I was writing my book on Al's painting.) Years later he retrieved them. Titled the *Taxi* series, they now rank among his finest works.

In these quasi-geometric abstractions, the direct process of painting is still evident; that is, the forms are composed of visible brushstrokes. Al soon suppressed these painterly gestures, absorbing them into clearly defined forms of unmodulated colors. Al had arrived at hard-edge painting. The color-forms—not the painterly gestures—now bore the burden of content. Al aspired to invest each with an individual "personality," as if each were a real being. That is, he aimed to transform the geometric forms, which are by nature generalized—indeed, the most generalized of shapes—into specific forms that were weighty and muscular (like Al himself). Hence, the paintings remained expressionist in spirit. Years later, when Al saw Malevich's black square and discovered that it was askew, he recognized that Malevich had anticipated what he had wanted to do. In his desire for specificity, Al then made every component of his abstractions different in form and color, varying geometric shapes with fragments of letters. To further dissociate the color-forms, he placed them side by side so that they would not interweave.

Al treasured one transitional picture, key in the change from his pigment paintings to hard-edge abstraction. When his works began to sell, he was afraid that some collector might make him an offer that he could not refuse. I very bigheartedly volunteered to borrow it and hang it on my wall so that he would not be tempted to part with it. There the painting has stayed. Al would probably have liked it back but as the years went by it became more and more Lucy's and mine. With Al's permission, it'll end up as a gift to the Museum of Modern Art.

As Al's work was changing, so was that of George Sugarman and Ronald Bladen, along the same lines as his. They became a threesome, making frequent visits to each others' studios. Their perpetual conversations (which I often sat in on or had reported to me by one or the other) goaded them to make fresh moves in art—and caused me to revise my ideas. Their friendship was useful, because as Al said: "It is vital to make contact with those who share your views."

In 1965, I curated a show titled *Concrete Expressionism*, that included all three. I knew that they were entirely too individualistic to run as a pack. Nonetheless, with Greenberg's coterie in mind, I hoped that the artists I selected (and perhaps a few more, such as Sylvia Stone and Tom Doyle) would support each other's work and occasionally act in concert—with me as their critic. Using the pretext that a discussion would help me write the catalog of the show, I called a meeting of them at the beginning of 1965 and made my proposal. The artists simply wouldn't play. Sugarman told me bluntly to stick to criticism.

Like Al, Bladen and Sugarman were motivated by a "will to clarity." Bladen reacted against his gesture paintings and constructed wood reliefs, each composed of a cleanly cut letter-like form, akin to Al's. In a related manner, Sugarman smoothed out the rough volumes of his earlier laminated wood constructions and painted each component a different unmodulated color. The three artists rejected "cubist" composition (as they labeled it), based on relating and repeating more or less similar forms. Sugarman said: "What bothered me about cubism was its confinement. I wanted to open it up, to pull it apart, to reach out. Besides, it had gotten boring; everybody was doing it." Sugarman and Al experimented with an unprecedented kind of structure in which forms were unrelated, that is, each was shaped to exist in its own self-contained space. They also strung the dissociated forms out in extended space, which was an innovational organizing principle. To further avoid the customary manner of composing, they even imposed "rules" on themselves, for example, never to repeat a shape or color in the same work, somewhat like what Arnold Schoenberg had done with his twelve-tone scale. In another more minimal but equally noncubist manner, Bladen would build only a single, simple form in each of his works.

Nonetheless, the three artists remained temperamentally tied to gesture painting because they were suspicious of things that came easy—in one shot. They had to grope for a form, to worry and sweat it through, to be sure that it evolved from what Kandinsky called "inner necessity." In Al's case, I wrote that his hard-edge paintings were expressionist in feeling but not in appearance. Facing this contradiction and wanting to have it both ways, I labeled Al's work "concrete expressionism."

In painting his hard-edge abstractions, Al decided that for the forms to dissociate, their edges had to be sharp and their colors flat. At the same time, he wanted the forms to be weighty, but could only achieve that through contour drawing and the interaction of color (just as Katz had). Finding the exact edges created agonizing problems for Al, and I recall his shifting them by fractions of inches back and forth for weeks on end (and in one picture, for months). In the quest for weightiness, Al hung his canvases close to the floor, to suggest that they were being acted on by gravity. To keep their placement from looking eccentric, he used outsize canvases. Having hardened the edges and flattened the color, Al found rough surfaces out of place. He was reluctant to sacrifice the painterly coating that added to the weight of his forms, but the signs of process, no matter how slight, became superfluous. In the end, he suppressed them.

By 1967, Al felt increasingly limited by the simplicity of his images and suffocated by their flatness. He felt the need for complexity, and to achieve it, he tunneled into the picture space—but avoided atmospheric effects. In so doing, Al vio-

lated the fundamental modernist taboo against illusionism, but as a painter he saw no other way to create space (just as his friend Pearlstein had in his new realist vein). Painting black bands on white grounds, Al formed open cubic, cylindrical, and triangular volumes and pieced them together as if they were masonry. Yet, they keep coming apart, de-constructing and re-constructing, as if in perpetual flux. Al said about this move in a new direction: "I was drunk on the thrill of it. . . . You don't get that kind of sensation very often in your life. . . . the sense of elation."

In 1969, Al's work grew even more complex as he began to interweave the open geometric volumes. His aim was to incorporate multiple events simultaneously in the same space. What did this signify exactly? In repeated discussions, Al and I concluded that images perceived in a ramifying variety of often contradictory ways are metaphors for the constant change, diversity, indeterminacy, and paradox inherent in contemporary reality. As he once said to me: "I'm not an expressionist. I don't want to get something *out* of me but instead a truth out there *into* me."

There are parallels between Al's thinking and Frank Stella's in that they both desired greater complexity and more space in their painting. Stella said that abstract painting had become as flat and reductive as it could be. In order to make it vital again, Stella's remedy was to construct increasingly complex, painted reliefs—that is, to project his "painting" physically into the room. Al agreed with Stella's analysis of the plight of abstract art, but he chose to find solutions within two-dimensional painting. Moreover, the viewpoints of both artists were very different. Stella justified his development on formalist grounds, and Al, in his desire to express contemporary reality. Al utterly rejected Stella's solution to move painting into relief construction. In 1979, I met Stella at his show at the Castelli Gallery. His "painting" then extended a half-dozen feet into the room. "Is it sculpture yet, Frank?" I asked. "No, I've just advanced the picture plane another two feet." I mentioned this to Al, who was annoyed by Stella's rejoinder. "His work *is* sculpture, not painting. The problem for painters is to create pictorial space within the parameters of two-dimensional painting. His solution is a cop-out."

As he explored illusionistic depth, Al became increasingly alienated from modernist art, whose defining attribute was flatness. His paintings no longer seemed to belong, and he turned against it—all of it, from impressionism down to the present—with growing distaste. That led him to search for kindred spirits in the history of art, and he found them in the early and high Renaissance. Evaluating Renaissance art, culture, and life, Al was led to speculate about the differences between the sixteenth century, the twentieth century, and what the future of humankind might—or should—be. He began to experience visionary stirrings, and to think that his illusionistic abstractions might convey intimations of a brave new world.

Did anyone else have some such vision? Mondrian perhaps? But Mondrian's fixed geometry and the message it conveyed were no longer believable. Marx and Freud were of no use. Neither were current social practices or Al's own psyche; they only informed him of what was finished or ought to be finished. Al found inspiration in the Christian humanism of Renaissance old masters and their vision of a heavenly paradise, particularly after he spent six months in Rome in 1981. He kept the humanist and futuristic vision, and dropped the Christian component.

Al attached himself to the tradition of Western art but, as a twentieth-century artist, he updated it. His vision led him to modernize Renaissance painting, or more specifically, its two main space-making devices: modeling and perspective. Instead of shading with light and dark, he constructed depth with planes of flat color that resembled structural beams, but weightless. Renaissance artists used perspectival systems to construct a fixed space. Juggling these systems, Al built structures which deconstructed and pulled apart every which way to create the sense of discontinuity, multiplicity, ambiguity, and paradox. Nothing was fixed. However, each component was clearly defined, a specificity (a key word for Al) lacking in abstract expressionist painting. Unlike his earlier hard-edge painting, Al's imagery now defied gravity. To enhance the illusionism, he removed the "scar tissue" of the process, even more than in the black-and-white pictures, often using an electric floor scraper to shave them clean (to my horror), but after he understood what the image would be. The signs of Al's hand totally disappeared, to my regret, for he had a fine hand. Visiting Al's studio once, I encountered a picture in progress. It was painted so beautifully that I begged him to keep it as it was. He told me that I was not the first to tell him to stop. The next time I visited, I saw the finished picture. Al sensed my disappointment and said that he had saved the "unfinished" version.

Al's need for a forward-looking vision was rooted in his boyhood and adolescent experience. I was keenly aware of his aspirations because we both came from the same background. That is, our parents were working-class immigrants who embraced Marxism and Yiddish culture. Dedicated to working for a better future, they possessed an optimistic world view. They prized learning and the arts as preparation for a higher stage of culture that socialism was supposed to usher in. Al too accepted Marxism and, as an art student, chose to paint in a social realist manner. He soon abandoned it, however, as well as the political ideology that underpinned it, but not his hope of creating an optimistic, socially relevant abstract art.

Rejecting social realism as cliché-ridden and false to contemporary experience, Al chose modernism. But there is a bond between Marxism and modernism; a progressive impulse underlies both: One aspires to make things new and better in life; the other, to make new and better things in art. Both Marxism and mod-

ernism, moreover, reject bourgeois society and culture. To Marxists, capitalism is inhuman, to modernists, it spawns a mass culture, which is inauthentic at best, commercial kitsch at worst.

I think, too, that both Marxism and modernism instilled in Al an epic vision of the artist that he never gave up. As Irving Howe commented: "Marxism advances a profoundly dramatic view of human experience.... We were always on the rim of heroism; the mockery we might suffer today would turn to glory tomorrow.... The moment of transfiguration would come, if only we held firm to our sense of destiny." Modernism presented an equally dramatic view of artistic experience. In our war against middle-brow culture, we were the avant-garde—in military terms—out in front where it was loneliest and riskiest. Ridiculed and alienated, we too were convinced of the rightness of our course. Al had come to believe that his spatially ambiguous painting expressed not only a new but a (the) *true* vision of reality to which our time had given rise. Consequently, what came before, namely flat and fixed modernist painting, all of it, was outmoded. Much as he had once esteemed it, he now scorned it. Moreover, Al thought that, with only a few exceptions, his contemporaries did not understand his aspirations, and he spurned them all. He had retained one of his youthful attitudes, namely the rejection of any deviation from his cause. In Al's case, that meant any art since the Renaissance other than his.

I have talked—or, more accurately, argued—about art with Al more than I have with any other artist (almost a half-century's worth). Much of our disputation was the result of our differing opinions about the destiny of humankind; he remained optimistic and I have become increasingly pessimistic. Moreover, we carried on a quarter-century-long argument about the history and fate of modernism and its adherents. I kept making the point that presumptions of modernist painting, such as flatness, were transcended by its expressiveness. The one could be denied while accepting the other. The two should not be conflated.

What has Al's enterprise been for the last two decades? To put it bluntly: the aggrandizing of his vision. He has been driven to construct pictures of such complexity and size as to beggar the imagination. The sheer relentlessness and obsessiveness of his enterprise can be off-putting, even to some of his supporters, but the brilliance of its results is impressive. His refusal to relax is proof of his belief in the validity of his message: He will paint it ever larger. However, Al was often depressed about the art world's lack of understanding of his work. I would try to reassure him by reminding him of the leading art critics and curators that admire his work, that it is genuinely original, that at present there is little art-world interest in constructive art, but should (when) in the future the need arise for it, his work will emerge as a major and masterful progenitor. I continue to believe that.

George Sugarman was burly, like Held. They were both loud and aggressive debaters, and it was difficult to get a word in when they were head to head, which they often were. If George's thinking paralleled Held's in some respect, his intentions were different. George was a remarkably inventive formalist—in the tradition of Alexander Calder, whom he greatly admired. As he said: "Abstract art has had a long, autonomous existence, long enough for us to attempt to give it its own abstract content." He wanted to continue "the modern tradition of extending our inquiries into form and space . . . opening possibilities, not closing them. The search must be for a language specific to sculpture, one not dependent on architecture, engineering, psychology, etc." More specifically, George considered his artistic enterprise to be the posing of questions concerning form and color in space. Among the questions he asked, in his own words: "What would happen if: I put sculpture on the floor; I put it on the ceiling; I got rid of the pedestal or integrated it; I covered whole walls with sculpture; I separated the parts of sculpture and made them diverse; I used color; I extended its relationship into space in all directions; I combined elements of painting and sculpture."

In the mid-fifties, George reacted against fussy welded construction, then the sculptural counterpart of gesture painting. I had been an advocate of Ibram Lassaw, Herbert Ferber, David Hare, Seymour Lipton, and Theodore Roszak, and continued to admire their work, although not that of their followers, whose kind of "drawing in space" increasingly looked worn out. In contrast, George's bulky sculptures looked fresh. He constructed them by laminating chunks of found wood, and by carving, sawing, power sanding, and further lamination, he built a prodigious variety of geometric and organic, open and closed shapes. He then joined these improvised volumes into constructions in space. By 1960, he started to place contrasting shapes one next to the other so that each of his strung-out sculptures seemed to be made up of many sculptures. To further separate and individuate the components, George painted each a different, solid acrylic color with the aim of enhancing the shape and projecting the color fully in three dimensions. No modern sculptor before him used color so daringly.

In the sixties, George turned from wood lamination to metal construction. One reason was that he could work more quickly and easily in metal than in wood and consequently give his inventiveness freer rein. He had become increasingly interested in public art, and metal was a better medium than wood, since it would withstand all weathers out of doors. My interest in public art led me to follow George's sculptures closely. Whenever I could, I helped him secure commissions, for example, a work for a Philadelphia public school. Philadelphia had a law requiring that one percent of all public building costs be spent on art. The city launched a massive program of school construction and hundreds of thousands

of dollars were available for art. I was the consultant for the Board of Education art committee charged with choosing the works. We had a crisis when two bond issues for education were rejected by the voters. Textbooks and school lunches were cut back. Under the circumstances, we could not justify spending huge sums for art so we stopped meeting. Frustrated by our situation, Elizabeth Greenfield (Petrie), the chair of the committee, decided to commission a work privately. On my recommendation, she had George create a piece for an elementary school named after her husband.

I helped George a second time in 1976 when he came to me for advice about a problem that had arisen with a sculpture commissioned by the General Services Administration for a federal courthouse and office building in Baltimore. George proposed a colorful bower-like piece into which people could enter, sit, eat their lunches, and otherwise relax. The administrators at the GSA were so delighted with the model that they immediately sent George a check for one-third of its cost. He then received a phone call to delay fabrication. The federal judges objected; they claimed to be terrified that criminals and terrorists would hide in the work and shoot at them and that their secretaries would be dragged into it and raped. George met with them several times but could not allay their fears. The GSA told George to back away, to take the down payment they had sent him and run. He refused—for the sake of public art in general and, in particular, for his piece, whose open structure he equated with America's openness and optimism. The judges wrote letters to the *Baltimore Sun*. Journalists then contacted George for his comments, and a public controversy ensued.

I advised George not to lose his temper, although the situation certainly merited it, but to move with cool deliberation, one step at a time. He marshaled his forces, set up a committee, and recruited leading art professional and public figures to write letters to the Baltimore and Washington newspapers on behalf of his piece. The judges struck back. They wrote to the newspapers that they had consulted with the local police, the state police, the FBI, and the Secret Service and were informed that a bomb could be secreted in the sculpture. The judges' paranoia made them look silly. At a public meeting to resolve the issue, most of the local people who attended spoke in favor of the work. George was deeply touched. The decision was to build. The GSA asked George to wait a month or two until the judges simmered down. He was then given the go-ahead. The piece was built and became a popular public meeting place.

---

Ronald Bladen had the demeanor of a "pure" artist. He was tall, thin, and gangling, one shoulder slightly deformed, and a little stooped. Somewhat gaunt, he looked like a saint in a Renaissance painting on the verge of being martyred. He was

friendly, soft-spoken, and never pushed himself. However, as Held recalled: "Ronnie was a man with a fantastic will. . . . but he did not impose it on other people. If he decided to do something for whatever reason, he did it and stuck to it."

Ronnie was utterly committed to the pursuit of "new visual poetry," as he said, without even a hint of irony or pessimism. I considered him *the* romantic mini-malist. In time, though, I have come to think that his monumental works are icons, mystical rather than romantic. Why mystical? Simply, because they look inscrutable and awesome. They emanate an otherworldly aura, although they don't refer to any existing religious signs or symbols.

In 1955, Ronnie was introduced to Al by the choreographer Yvonne Rainer. He was taken with Al's "incredible force and vitality," as he said: "I have known no one else to whom I have felt as close or from whom I have gotten as much in terms of ideas and excitement. No one else. But it can only happen once. You can only be young once." They would remain life-long friends. Influenced by Al, Ronnie adopt-ed abstraction and used heavy pigment from which he had squeezed out the oil—to create lyrical abstract landscapes. Ronnie's imagery is related to that of Clyfford Still, but as I later wrote, whereas Still's are awesome and forbidding, "Bladen's are intimate and inviting. [He] builds up certain of his forms so that they protrude two or three or sometimes even four inches, turning the pictures into bas-reliefs. [These] impasto shapes . . . look like outcroppings in the sea seen from a high cliff, calling to mind Vancouver Island, where Bladen was born and grew up, or Big Sur, where he participated in the society of anarchopacifist poets and artists." I went on to say that "Bladen's 'islands' are painted with a painter's touch, but they are also sculptural." As he said, these pictures "brought me off the wall"—into actual space.

Ronnie came to New York in 1956. He continued painting his "pigment" pic-tures and exhibited them at the Brata Gallery on Tenth Street in 1958. They were admired by those of us who closely followed the shows downtown, although reviews in the art media were thumbnail and noncommittal—forty-eight words in *Art News* and fifty-eight words in *Arts*.

In 1961, Ronnie became fascinated by the shadows cast by the built-up paint. This led him to make reliefs by pasting rectangular strips of papers whose ends were folded outward. I "owned" one of these collages for about an hour. In 1972, my five-year-old daughter, Cathy, and I were walking down Greene Street in Soho when I glanced at what looked like a relief by Ronnie on a heap of garbage. It was, and I retrieved it and immediately phoned him. He was over in twenty minutes, visibly shaken, I imagined, because he knew to whom he had given the work. He asked for it back. "It's mine. I found it," pouted Cathy. Ronnie promised her a drawing instead, and she reluctantly accepted. He kept his word. (Most likely he destroyed the relief, since it was not to be found in his studio after his death.)

In 1961, to project his works even further into actual space than the paper

reliefs, Ronnie began to construct wall reliefs from wood, each composed of a large planklike fragment of a geometric figure (an L or an inverted C). He painted each of these forms a single color and suspended it in front of a rectangle of a contrasting color. His intention, one that he shared with Held, was to project his forms forcefully into the viewer's space.

Ronnie told me that he changed his forms from organic to geometric because he wanted to "eliminate nature ... rivers and trees ... that kind of poetry" in order "to come closer to a purer type of abstraction, in other words, to push abstract art a little bit further, but not to lose the poetry."

In 1966, Ronnie exhibited *Three Elements* in the *Primary Stuctures* show at the Jewish Museum. Composed of a row of three free-standing, nine-foot-high, rhomboid-like monoliths, each was tilted so as to appear precariously balanced, and painted black, with the outer diagonal side sheathed in aluminum. This piece made the art world look up. Mark di Suvero said that *Primary Structures* was "the keystone show of the 1960s and had introduced a new generation of sculptors." He singled out Ronnie's work as "the one great piece in the show. It expands our idea of scale and changes our knowledge of space. It is radiant." Mark was right. *Three Elements* had an astonishing presence, at once grand and enigmatic, that, as Alex Katz quipped, "assassinated" its neighbors. Ronnie told me: "At first I made two forms. My eye demanded a third, since I wanted to create a sense of rhythm and of procession in time. And I wanted the three units to charge the space between them, turning them into live spaces, so that there are five volumes. I desired something in the grand manner since I'm still romantic."

The three rhomboids were influenced by Donald Judd and Robert Morris. I asked Ronnie why he had moved his work in their direction. He responded: "Minimal forms are very definite. And they enable artists to explore volume, which is very exciting at this time, when so much of sculpture tends to be open construction in space and ambiguous." It was through my discussions with Ronnie that I became sympathetic to minimal sculpture. At the time, I also got to know Morris and Judd and learned from them what they were trying to achieve.

Ronnie, however, was not wholly accepting of Judd's sculpture. He found it too "industrial and too blunt an object" for his taste. However, he gave Judd the benefit of the doubt. "He is really involved with matter-of-factness, and he's deleted beauty or poetry or whatever you wish to call it. I think he's doing what he's set out to do; I think it's very successful." Ronnie preferred Morris's works to Judd's, because of their "poetics, their magic." He particularly admired his piece in the *Primary Structures* show because it was "light despite its mass" and because "the light reflected from the planes so beautifully." He concluded that Morris's geometry was close in mood to Rothko's—and so was his. But Ronnie was differ-

ent from Judd and Morris. Their cubic volumes are contained and static whereas Ronnie's off-axis monoliths are dynamic and expansive. Where their primary structures "occupy" space passively, his "conquers" it.

Ronnie had the *Three Elements* in mind when he commented that he wanted his sculpture "to reach that area of excitement belonging to natural phenomena such as a gigantic wave poised before it makes its fall. . . . The drama is best described as awesome or breathtaking." Mass and size contribute to the monumentality of *Three Elements*, but this quality also issues from scale, which causes the volumes to appear larger than they are. The difference between size and scale was clarified to Ronnie—and Held—by a stone Olmec head that was set down in the plaza of the Seagram Building in the summer of 1965, as Ronnie began *Three Elements*. It was a large sculpture, nine feet tall (the height of Ronnie's piece), but size alone could not account for the way it made the surrounding skyscrapers look cardboard-thin. When I first saw the Olmec head I thought of Ronnie, and I asked Philip Leider to reproduce an illustration of it in my article on Ronnie in *Artforum*. Leider ran the Olmec head on the cover.

In my survey of sixties art, I wrote, "The diagonal of the giant volumes [of *Three Elements*] is reminiscent of a human gesture, at once epic and grand, like the backward lean of Rodin's *Balzac*, and vulnerable, suggesting falling or bowing. They can also be viewed as a grand procession—anthropomorphic menhirs on the move."

Ronnie's sculptures did not exhibit the signs of artistic making, but each of the simple forms that he built had an elaborate infrastructure which he then concealed. Some of his pieces took a year to finish. Held and Sugarman would kid him by pointing out that the belabored interior frameworks were not only invisible but also structurally unnecessary, but Ronnie continued making them. He was very stubborn on this point. Although Held teased his friend, he accepted his mystical approach to materials and work. So did I. It seemed to me that Ronnie believed that icons required devoted and contemplative, if secret, labor. The spirituality in his icons had to be earned. Why did he hide the evidence of his mystical streak? Perhaps out of reticence.

The need to change styles occurred several times in Ronnie's art-making. As he said in a conversation we had in 1966, it enabled him "to keep myself alive and regenerate myself. But you also respond to changes that take place around you. I want very much to be alive right now. I have a certain amount of vitality that's not going to be wasted in dragging a dead horse all the time." I interjected: "You were among the first to make minimal art." "Yes," he responded, "and it may have already been done to death."

Every new piece that Ronnie showed made the art world pay attention. In each of them he seemed to take a new spatial idea—such as a unitary mass, a vol-

ume in extended space, sculpture as field, or as line—and develop it in a spectac-
ular fashion. In the *Black Triangle* (1966), he inverted a triangular volume 9 feet 4
inches high, 10 feet long, and 13 feet across the top. Balancing it on its edge, he
overturned the usual expectations of how the sculpture ought to sit. Indeed, the
form calls as much attention to the space it activates as to its massiveness. *Black
Triangle* is monumental, but in its seeming precariousness, even more than in
*Three Elements*, it subverts monumentality. Afraid that it might topple, viewers
keep their distance. Richard Serra would later make much of this fear. In *Black
Lightning* (1981), a 24-foot-high zig-zag line points upward—to the ineffable sub-
lime, like an upward finger in Christian art—a trajectory that is breathtaking.

Corinne Robins asked Ronnie how he felt about being an artist. He responded:

> It's the only identity I have as a person. I wouldn't know how to exist other-
> wise. It's the only dignity I have. I think art is very grim and very difficult. It
> can also be joyful, but I'll never forget when some little old lady came up to
> me when I was fifteen or sixteen, looked at my paintings and said: "What
> fun!" I just about died. The years go by, each new crisis occurs with its own
> character and language. You continue to do your work, and you realize that
> [every contentious issue] after a few years ceases to be an issue or danger in
> terms of doing your own art. It falls away, and you continue to do the kind of
> work you can produce.

I delivered one of the eulogies at the memorial for Ronnie after his death. I
concluded: "Ronnie's dedication to art was pure—there is no better word for it—
and it inspired us all. . . . I'll never forget my last visit to him in intensive care.
Knowing that the end was near, he still monitored the completion of his last
work, giving instructions to Connie Reyes (Ronnie's companion), Bill Jensen, and
his assistant, Larry Dyab."

Ronnie's "purity" attracted Mark di Suvero and the group of his friends who
founded the Park Place Gallery. Ronnie was an exemplar to them. They would
meet on Sundays in a "free" jazz session, in which anyone who wanted to partici-
pate brought any kind of instrument and joined in. I bought a second-hand bugle,
and happily played along with Ronnie on saxophone—he was a fine musician—
and several dozen more, including di Suvero, Philip Wofford, Forrest Myers, John
Chamberlain, and sometimes John Coltrane. A number of Ronnie's friends played
jazz at his funeral.

After Ronnie died, Bill Jensen devoted considerable time helping Connie
Reyes keep Ronnie's work from deteriorating and his reputation alive. It was an
admirable act of generosity by one artist on behalf of another. With considerable
difficulty, they preserved the sculpture and found a European collector and

patron, Egidio Marzona, who purchased the body of work and promoted it with love. I said to Held: "Ronnie would have thought that this was too commercial. If he were alive, he would have found some way to queer the deal."

---

I first met Mark di Suvero because a New York City housing law stipulated that apartments had to be painted every three years. In 1959, our landlord gave Lucy and me seventy-five dollars to have it done. He said: "Take it or leave it, and if you don't like it, sue me." We looked around for an artist who might need the work and found out about Mark. I was impressed by his show of sculptures of hands at the March Gallery on Tenth Street and wanted to meet him. He had no phone, but we finally located him and set a date. Upon arriving, he turned on our record player full blast. He painted the walls for the next three days while we argued about art, shouting at each other over the din of the music. He borrowed half our records (returning the exact number—but different records—a year later). That was the beginning of our friendship.

I was bowled over by Mark's junk constructions when they were first shown. I hailed him in a review in *Art International* as "one of the liveliest young talents— he is twenty-seven years old—to appear on the New York art scene." In my romantic style of the time I went on to say:

> His room-size sculptures at the Green Gallery—"Barrell" is 16 feet long—are constructed from the guts of demolished buildings: beams, at times a foot thick, steel cables, chains and rope. The blackened and cracked wood surfaces, studded with rusted nails, screws and bolts, and hacked with an ax, retain the roughness of the wrecked state in which they were found. The timbers are joined to form aggressive jutting angles that further emphasize the image of brute strength. The power and rawness of these pieces relate them to Abstract Expressionist painting. Di Suvero's monumental works—sculpture turned into architecture—insist on being seen in social terms. They become a cry of vengeance on the part of detritus that refuses to be relegated to the rubbish heap, a metaphor for the displaced artist, the last individualist.

Mark's studio-living space was in the Fulton Fish Market near the East River. The nineteenth-century building was an urban ruin slated for demolition. It was condemned, and living in it was against the law. To keep inspectors away, Mark boarded up the door with massive planks of wood, but it took only a finger's pressure to swing it open. His loft was four flights up, on the top floor. Its elevation was 24 feet, and Mark had built a small platform for sleeping 16 feet off the floor. Waking up in the morning, he looked down on huge constructions in progress. The space would make a perfect subject for a contemporary Piranesi. There was

an opening next to the bed that led to a higher platform, suspended another four flights up, which Mark could sun himself on or use as a launching pad to climb over the roofs. He could look east to the East River docks, west to Wall Street, and, shimmying up a pitched roof, north to the Brooklyn Bridge. Mark liked the irony of himself lying in the sun contemplating Wall Street. He could also observe the gulls—and was inspired by them. They made him think of different spaces, the air that cushioned their flight as more solid than other air.

In 1960, Mark almost died after his body was crushed while he was working on top of an elevator in a loft building. I visited him in the hospital. He was told by his doctors that he would never walk, much less work, again. Yet within months, Mark went back to work in a wheelchair—he gave me a small metal construction that he had welded in his lap—and in time he willed himself to walk. Mindful of his courageous effort to overcome his disability, and familiar with photographs of the artist at work in a red hard hat atop a crane or one of his epic constructions, art writers have often presented him as a romantic hero. Indeed, Mark *looks* romantic. He has piercing blue eyes, a flowing mane of reddish blond hair, and a grizzled beard. The label "romantic" has taken on connotations of the exotic and come to imply posturing, a kind of behavior of which Mark is incapable. Rather than romantic in the current sense of the word, he is existential, in that he made himself what he is. In the face of death, he chose life, and he chooses to live it and embody it in his art exultantly. He is the only person I know who makes me ashamed of my pessimism.

Mark's broad smile captivated just about everyone he met—people from all walks of life—and he treated them all alike. Lucy and I came to Paris in 1975 to see his show at the Tuileries. We could only get there on the last day, and Mark and his crew were beginning to disassemble the sculpture. He invited us to lunch at a nearby café along with a dozen or so other people, including a baroness, a director of a museum, a few French and American friends, and his crew of Algerian workers. Despite class differences, it felt like a family dinner. The French waiters were visibly upset because of the Algerians, but a few sharp words from the baroness made them behave. Mark's dealer, Dick Bellamy, was supposed to join us but didn't arrive. When we left, we found him asleep on a pushcart in the street outside the restaurant.

Mark did not charm everyone, certainly not reactionary prigs. In 1989, the Sculpture Center decided to honor him at its annual fund-raising dinner, and Mark agreed. The celebration was at the Union League, one of the oldest and stuffiest of rich men's clubs. Mark showed up a little late in his habitual red sweater and accompanied by a paraplegic friend whom he had met during his long stay in the hospital. Entering the club, he encountered one of its functionaries. One look at the tieless Mark and his disabled friend, and there was no way

they were going to get into *his* space—guest of honor be damned. He had recognized Mark as his inborn enemy and maliciously struck his petty blow. Several hundred people were waiting for Mark. In deference to the Sculpture Center, they stayed on and made the best of it, but I left as soon as I heard what had happened, after a nasty exchange with one of the guests, a distinguished writer for *The New Yorker* who ought to have known better: "Who does that di Suvero think he is? Not wearing a tie!" Figuring that Mark had gone to the Cafe Loup, a favorite eatery of his on Thirteenth Street, I joined him there for dinner. Mark was his smiling self, but underneath his good humor, he was furious at that uptight bluenose.

From the middle 1960s on, I wanted to write a book on Mark, but he put me off again and again. He had an idea, carried over from his associations with the abstract expressionists, that as an artist you had to be dead to have a book, or if you had one while you were still alive, you were dead, that is—as an artist. Either way, a book meant death. In 1993, I asked him once more, expecting that he would say no, but he agreed. When I asked why now? he answered: "I just turned sixty."

In my book on Mark I wrote:

On the wall of his Petaluma, California, studio, di Suvero has a quotation from George Bernard Shaw that reads in part: "I am of the opinion that my life belongs to the whole community, and as long as I live it is my privilege to do for it whatever I can." As di Suvero himself said, "art is a gift which we give to others." And creating it has been an intrinsic part of a wide range of activities on behalf of the public.

For example, in 1975, Mark and Anita Contini founded the not-for-profit Athena Foundation, whose mission was to provide artists with working space and grants to create large-scale works in a noncompetitive communal setting, and to bring art to the community at large by founding a sculpture park. Mark asked me to be on the board, and I was delighted to serve. Adjacent to his studio in Long Island City, with a beautiful view over the water to Manhattan's skyscraper horizon, were four and a half acres of rubble owned by New York City. Mark rented this "garbage-land," as he called it, and hired unemployed neighborhood youths to clear it. The upshot was the Socrates Sculpture Park.

The Athena Foundation's main problem was to hold on to the land. From the first, we feared that the prime riverside land uncovered by Mark would tempt greedy real estate developers, and it did. I was told that at one point, a big-gun made an offer we thought the city could not refuse: the construction of a $100 million complex of luxury apartments and a marina. To the credit of our city officials, they refused and opted for art over profit. In the end, Mark won, and New York turned Socrates into a permanent city park—and took it out of the clutches of the real estate moguls. I believe that my participation on the Athena board was

one of my most important public services, but I really don't know exactly what I contributed to help build the park. Mark thought it was significant, and that made me proud.

As the final paragraph of my monograph on Mark, I wrote: "There is a largeness, a generosity of spirit in both his artistic aspiration and social imagination that can only be characterized as Whitmanesque. Whitman also comes to mind because, like his poetry, di Suvero's sculpture is deeply rooted in the American experience—in our democratic ideals and civic-mindedness and in our industrial civilization and the art that exemplifies it." Was I being too laudatory? I don't think so. Mark is the greatest sculptor of his generation, and the most public-spirited. As a person, an artist, and a citizen, he stands head and shoulders above anyone else I know in the art world (with the possible exception of Chuck Close).

---

I would like to try to distill the sensibility of each of my pals at the risk of being simplistic. Katz was the grand master of the brand-new; Pearlstein, the history-minded new realist; Held, the visionary; Sugarman, the inventive formalist; Bladen, the mystical minimalist; and di Suvero, the romantic hero.

*Left: The original Cedar Street Tavern, 24 University Place (now demolished), October 2, 1959.*

*Below: Ruth Kligman, Franz Kline, and Willem de Kooning in front of the Sidney Janis Gallery, May 4, 1959.*

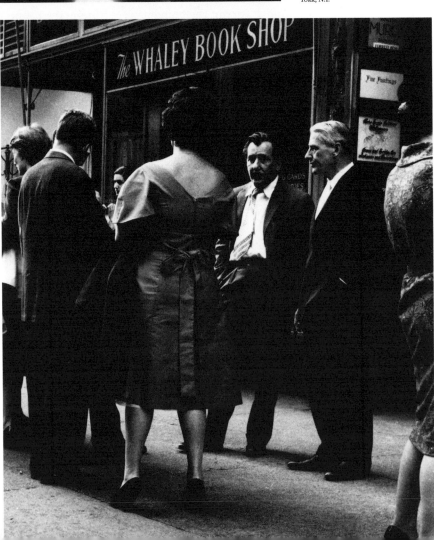

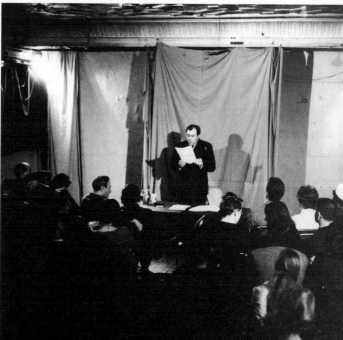

*Above: Irving Sandler and Elaine de Kooning at the Herman Cherry exhibition at the Poindexter Gallery, May 18, 1959.*

*Right: David Sylvester, reading his Giacometti essay at The Club, March 18, 1960.*

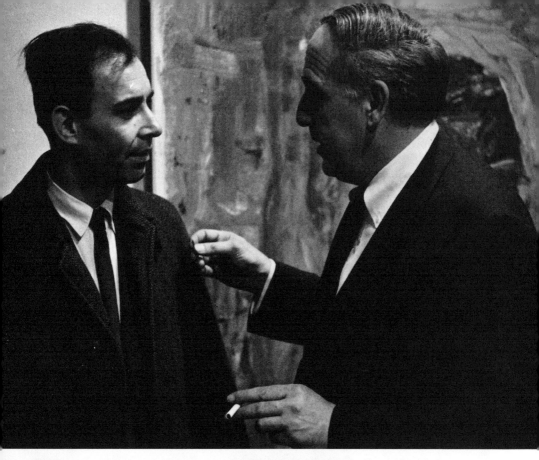

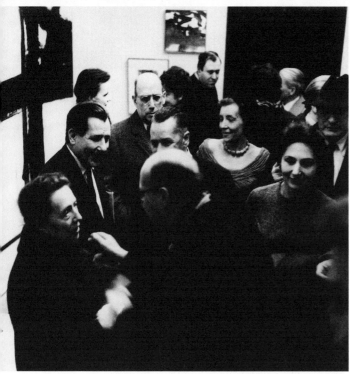

*Above: Irving Sandler (left) and
Philip Guston (right) in front of
Painter II (1959-60), 1960,
New York.*

PHOTO BY RUDY BURCKHARDT, ESTATE OF
RUDY BURCKHARDT ©, COURTESY TIBOR DE
NAGY GALLERY, NEW YORK, N.Y., LICENSED
BY VAGA, NEW YORK, N.Y.

*Left: Franz Kline (left center) at
his opening at the Sidney Janis
Gallery, March 7, 1960; To his
right Harriet Janis, William
Baziotes (center), Robert
Goldwater, Louise Bourgeois
(center), Ethel Baziotes (right),
Mark Rothko (in hat), David
Sylvester (rear left), and Willem
de Kooning (far right).*

PHOTOGRAPH © BY FRED W. MCDARRAH,
NEW YORK, N.Y.

*Right: Mark Rothko, New York, 1960.*

*Below: Ad Reinhardt in his Broadway studio, New York, April 1, 1961.*

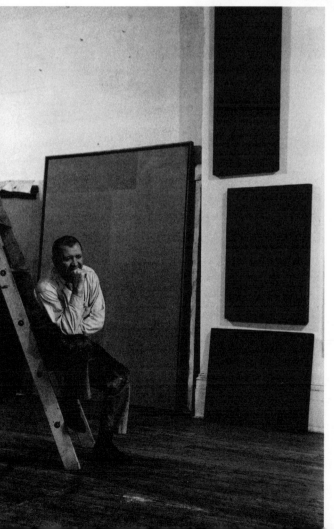

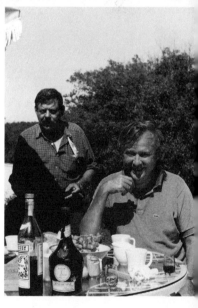

*Above: David Smith (left) and Robert Motherwell (right) at Smith's property in Bolton Landing, circa 1962.*

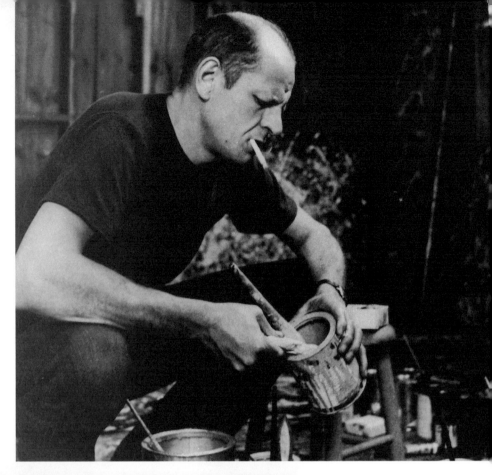

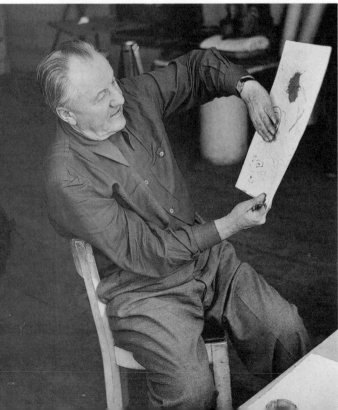

*Above: Jackson Pollock in his studio, Springs, New York, 1950.*

PHOTO BY RUDY BURCKHARDT, ESTATE OF RUDY BURCKHARDT ©, LICENSED BY VAGA, NEW YORK, N.Y.

*Left: Hans Hofmann, 1950,*

PHOTO BY RUDY BURCKHARDT, ESTATE OF RUDY BURCKHARDT, ©. LICENSED BY VAGA, NEW YORK, N.Y.

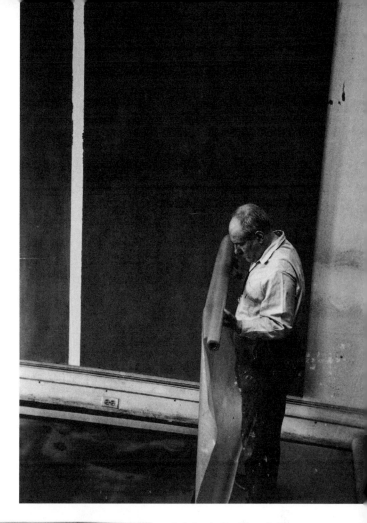

*Right: Barnett Newman in his Front Street loft, April 21, 1961.*

PHOTO © BY FRED W, McDARRAH, NEW YORK, N.Y.

*Left: Landes Lewitin at the Rose Fried Gallery, March 24, 1959.*

PHOTO © BY FRED W. McDARRAH, NEW YORK, N.Y.

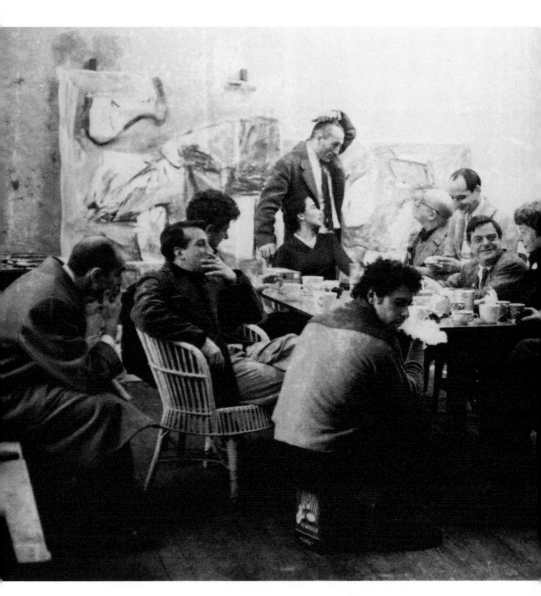

*Above: Milton Resnick's Tenth Street studio, 1956. Clockwise from far left, Irving Sandler, James Rosati, George Spaventa, Pat Passlof, Milton Resnick (standing), Earl Kerkam, Angelo Ippolito, Ludwig Sander, Elaine de Kooning, and Al Kotin.*

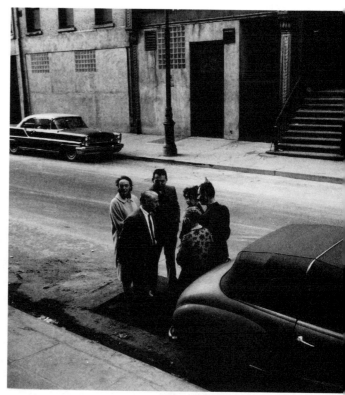

*Above: Willem de Kooning on
Tenth Street, April 5, 1959 with
(left to right) Ellen Rapee, David
Slivka, Rose Slivka, Irving
Sandler, and Lucy Sandler.*

PHOTO © BY FRED W. MCDARRAH, NEW
YORK, N.Y.

*Above: Philip Pearlstein in his
studio, 1990s, New York.*

PHOTO BY JACK MITCHELL, © PHILIP
PEARLSTEIN, COURTESY ROBERT MILLER
GALLERY, NEW YORK, N.Y.

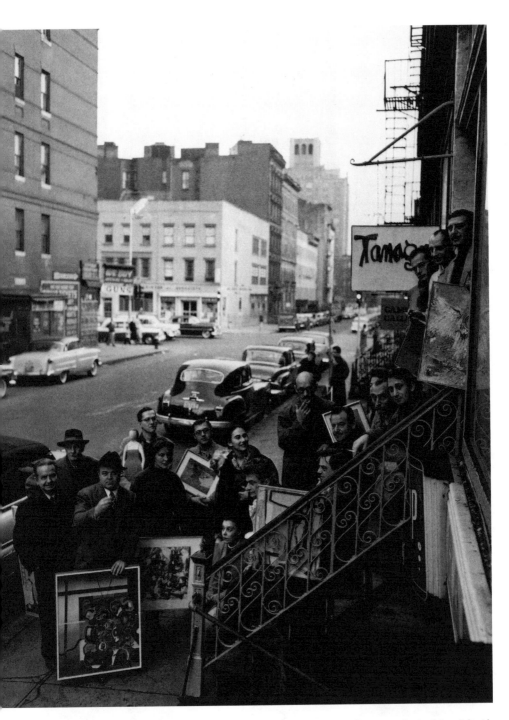

*Above: Artists bringing work to the Tanager Gallery on Tenth Street. Standing on top of stairs, left to right, Al Kotin, Angelo Ippolito, Charles Cajori; sitting on stairs top to bottom, James Rosati, Milton Resnick, Gabriel Kohn, Ludwig Sander (in profile), George Spaventa, Linda Lindeberg; standing from left to right, Martin Craig (on stairs), Pat Passlof, unknown, William King (in rear), Vita Petersen, Steven Wheeler, unknown (in rear), and Alfred Jensen.*

PHOTO BY JAMES BURKE, COURTESY © TIMEPIX, NEW YORK, N.Y.

*Above: Josef Albers, New York,
1950.*

*Right: Alex Katz in his studio,
New York, 1961.*

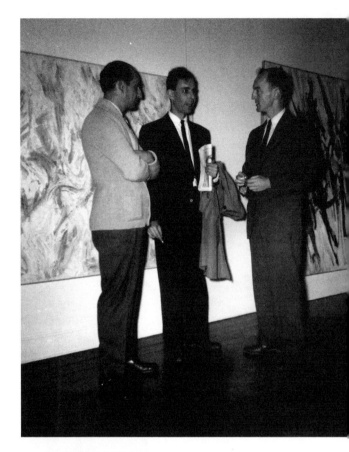

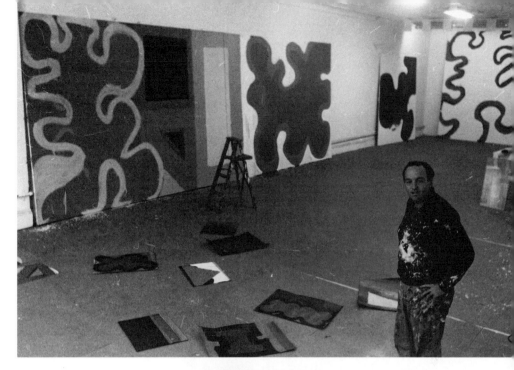

*Above: Al Held in his studio, New York, 1964.*

*Above: "Irving Sandler and His Friends": left to right: Robert Berlind, Robert Storr, Mark di Suvero, Alex Katz, and Judy Pfaff (not in picture), at Artists Space, New York. Panel in honor of Irving Sandler, sponsored by the American Section of the International Art Critics, Association, May 6, 1999.*

*Left: Ronald Bladen with Riff in his 21st Street studio, New York, N.Y.*

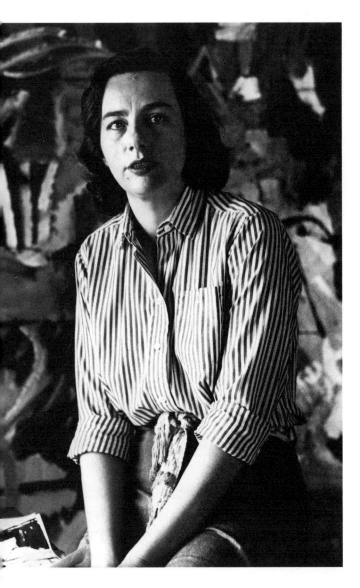

*Left: Grace Hartigan in her studio on Essex Street and Hester Street, 1957.*

*Right: Harold Rosenberg, Bridgehampton, New York, July 19, 1975.*

*Left: Clement and Jenny Greenberg at the Poindexter Gallery, New York, 1960.*

*Right: Joan Mitchell in her studio, New York, N.Y., 1957.*

*Above: Willem de Kooning, talking to Thomas B. Hess, Aristodimos Kaldis (in center) at the Milton Resnick show, Howard Wise Gallery, February 19, 1960.*

PHOTO © BY FRED W. MCDARRAH, NEW YORK, N.Y.

*Right: Meyer Schapiro, New York, October 4, 1959.*

PHOTO © BY FRED W. MCDARRAH, NEW YORK, N.Y.

*Left: Left to right, Chuck Close, Irving Sandler, and Philip Pearlstein at a meeting of the Artists Advisory Committee, Marie Walsh Sharpe Art Foundation, 1990s.*

*Below: Left to right: Jasper Johns, Bill Giles, Robert Rauschenberg, Merce Cunningham, John Cage and Anna Moreska at Dillon's Bar on University Place, November 10, 1959.*

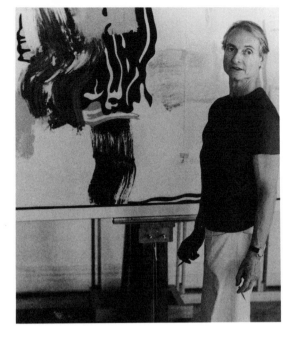

*Right: Roy Lichtenstein with*
*Painting with* Silver Frame *in*
*his studio on 29th Street, New*
*York City, 1984*

© ESTATE OF ROY LICHTENSTEIN.
PHOTOGRAPH BY ROBERT MCKEEVER.

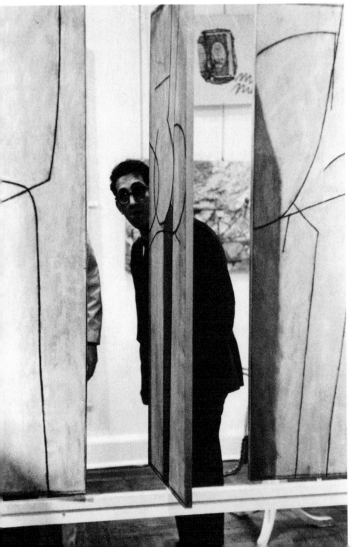

*Left: Frank Stella at the Martha*
*Jackson Gallery, September 28,*
*1960.*

PHOTO © BY FRED W. MCDARRAH, NEW
YORK, N.Y.

# Art Criticism: Critics at War

**IF HARVARD-BRED WASPS** controlled the Museum of Modern Art, ghetto-bred, heterosexual Jews (the sons of immigrants) dominated writing about avant-garde art in the late 1940s and 1950s. The more prominent were Greenberg, Rosenberg, Hess, Schapiro, and Goldwater. The intellectual credentials of the Jewish art critics were as impressive as those of the Harvard men. Greenberg, Rosenberg, and Schapiro wrote for prestigious highbrow journals. Schapiro and Goldwater were university professors of art history, and Hess was a Yale graduate who had written the earliest book featuring the abstract expressionists. As managing editor of *Art News*, Hess made it the "family" magazine of the New York school.

Perhaps there was a parallel between being homosexual and being Jewish. Both groups were outsiders in American society who faced discrimination. Was that why they embraced an alien, non-mainstream culture, namely, modernism? Greenberg, Rosenberg, and Schapiro proselytized not only for the modernist arts but for Marxism, of a Trotskyist, anti-Stalinist variant. (That, of course, ruled out any idea of spying for the Soviets.) Trotskyism, unlike Stalinism, allowed for the coexistence of modernism and Marxism by proclaiming the autonomy of art. The Jews championed abstract expressionism earlier and more wholeheartedly than the WASP museum men. They guessed right, and that gave them a taste-making edge.

Why did the Jews favor abstract expressionism and, above all, the gesture painters? Because the gesture painters were in search of their individual artistic identities. Issues of identity had long been of central significance to Jews, as a religious and ethnic minority in an often hostile gentile world. It was not accidental that of the eight prominent gesture painters, five were either Jewish (Guston, Resnick, and Tworkov) or immigrants (Hofmann and de Kooning), or both (Guston, Resnick and Tworkov). Other gesture painters—Pollock, Tomlin, and Kline—were neither Jews nor immigrants. However, Pollock and Kline were of lower-class origin, just like the Jewish artists. It is significant that the color-field painters Newman, Rothko, and Still did not appeal nearly as much to the Jewish critics (with the exception of Greenberg), even though Newman and Rothko were Jewish. Of the three, Rothko was most appreciated. Newman was considered too simplistic, at least at first, and Still, too aggressive and nationalistic.

The relations between the MoMA WASPs and the Jewish critics were generally amicable, but they mixed socially only on occasion. Anti-Semitism probably played a role, open in the case of Philip Johnson, but mostly subtle or institutional. Class differences also kept the two groups apart. That is, the Jewish critics lacked the social graces, smart talk, and whatever else might have made them welcome in rich and fashionable WASP society. Their political radicalism, which was often combative, further discouraged invitation to upper-crust salons.

There was, however, one contentious issue between the museum men and the art critics. The abstract expressionists—and their supporters—believed that Barr was late and lukewarm in his recognition of their work, and to a degree that was so. Differences in sensibility between MoMA's WASPs and Jewish critics may explain why. The moralist, pro-high-art, and anti-kitsch stance of a Rosenberg or Greenberg seemed at odds with Barr's and Johnson's often "campish" taste, regard for popular culture, embrace of chichi surrealism, and admiration for Rauschenberg and Johns, and, in the sixties, pop art. Why the difference? Rosenberg and Greenberg had entertained a vision of a brave new socialist world—with high seriousness. When they turned from Marxism to modernism, they retained the same serious attitude. The MoMA coterie, as aspiring cultural aristocrats, was intent on avoiding middle-class tastes and values, and would entertain any idea of art that the bourgeoisie found repulsive or shocking or incomprehensible. Hence, they would accept art that was low, like folk art or outsider art, or was witty, outré, or exercised a *nostalgie de la boue.*

Harold Rosenberg and Clement Greenberg were both champions of the New York school, but their views were mutually antagonistic. One-time friends—Clem had sat at Harold's feet—they came to despise one another and were vocal about it. Nonetheless, they had much in common. Both were sons of Jewish eastern European immigrants. They had been Marxists and were steadfast modernists—members of a tiny group of Trotskyist intellectuals, including William Phillips, Irving Howe, William Barrett, Philip Rahv, Dwight Macdonald, and Mary McCarthy. During the 1930s, this down-at-the-heels, highbrow coterie distinguished themselves as contributors to *Partisan Review.* As the Cold War intensified, they gained renown and influence as knowing and polemically adept anti-Communists. They became even more celebrated as modern culture became increasingly fashionable. Sophisticated politically and culturally, they played a growing role in American intellectual and cultural life.

The Marxist polemics of these *Partisan Review* contributors did not interest me, but as their cultural heir, I wondered about the role my background played in my artistic pursuits and taste. Had I, and Jewish intellectuals like me, been influenced by the Jewish tradition of study and reverence for scholarship? I had been.

Moreover, our working-class roots made us yearn for a socialist and cosmopolitan society in which poverty and racism would be eradicated along with social hierarchies based on birth instead of accomplishment. We also embraced modernism because we were outsiders. And we believed that social and cultural transformation went hand in hand.

For most of us, socialism turned out to be a delusion. What remained were the modernist arts. They were attractive because they defined themselves, in part, through their opposition to the established arts. Modernism offered us an open field. Ironically, our untraditional or radical anti-establishment criticism would eventually enable us to move from the margins of culture to the center—and to win fame and fortune. For many of us, however, the success that counted was recognition in the world of the arts. Social or monetary reward was a secondary consideration, at best a byproduct of our cultural endeavors. It certainly was for me. I did not expect it, nor did the avant-garde artists, poets, composers, and dancers I knew. I felt privileged to be a critic who was accepted in my avant-garde milieu. Indeed, I and my friends were suspicious of success, equating it with selling out, though many of us did succeed.

Both Harold and Clem transferred their social revolutionary yearnings into the support of radical painting. However, they transposed Marxist dogma into aesthetic terms in different ways. Assuming a formalist stance, Clem applied the Marxist concept of historical determinism to the development of modern painting. Harold, a romanticist at heart, applied the Marxist idea of praxis or action—with an existentialist twist—to the individual artist's act of painting. Clem focused on painting as "pure" painting; Harold, on the creative process as self-search and self-identification.

Both detested "kitsch," which they considered the pseudo-culture of American capitalism and Soviet Communism. Mass culture was bad enough, but even worse was debased "high" art, which was palatable but made no demands on the artist or viewer. Moreover, both denounced "trivial" mass and middle-brow culture as the enemy of "serious" high art and regarded this opposition as crucial in the discourse of modernism. Clem pitted the "highness" of art against the "lowness" of mass and middle-brow culture. As he viewed it, kitsch had become so pervasive that artists could avoid contamination only if they placed their art beyond its reach by entrenching it in abstraction and thus guaranteeing its integrity. Harold, on the other hand, stressed the "authenticity" of genuine art—that is, art that honestly exemplified an artist's existential being—which he opposed to inauthentic mass and middle-brow culture. In order to avoid the influence of the latter, artists had to undertake an interior migration.

For both Harold and Clem, art was either avant-garde (good) or academic (bad), but they admired different sets of advanced artists. Clem favored the

allover or field abstraction of "uptown" artists Jackson Pollock, Clyfford Still, Barnett Newman, and Mark Rothko; Harold, the gesture painting of "downtown" artists Willem de Kooning, Franz Kline, and Philip Guston.

Schooled in the political squabbles of the 1930s, the soapbox counterparts of the class struggle, Harold and Clem waged war on behalf of their theories and heroes. Their stance was tough-guy; they were absolutely cocksure in their pronouncements, particularly Clem, who would arrogantly and condescendingly shrug off any contrary opinions as beneath serious consideration. He and Harold were pugnacious debaters.

In the early 1960s, I was at a party with Harold and Clem at the apartment of collectors Ethel and Robert Scull, and I had the opportunity to compare them at close hand. Since they kept their distance from each other, I shuttled from one to the other, keeping track of their monologues. Harold stood in the center of the room and orated expansively to a captivated group around him. Clem, a head shorter than Harold, leaned against the wall in the other room. He had a reputation as a fighter, and, looking as if he might throw a punch at any provocation, talked to one or two guests tersely, jabbing out his words in clipped sentences.

For me, Harold was the most relevant art writer in the 1950s. He was prominent both as the art theoretician of the "downtown" avant-garde and in the flesh. Towering to a height of six-feet-plus-plus, his massive and ungainly frame was topped by a commanding head, whose dominant features were thick eyebrows and a mustache. When seated, his extended club foot was a stumbling block for all in his vicinity. Harold's physique added weight to his rhetoric, which, delivered in an incongruous high-pitched voice, was both spellbinding and penetrating. He was close to the de Koonings and Thomas Hess. The quartet of a celebrated intellectual, a revered avant-garde painter, his quick-witted and art-world-savvy wife, and the managing editor of *Art News* constituted a formidable art-world power base. However, Harold was not the promoter Clem would become— that is, he did not "establish" artists. He did throw an annual "birthday" party at which invited artists brought gifts—a drawing or small painting. The invitation list was closely watched to see who was in or out. I was invited for several years after 1958—until my attitude toward the New York school became suspect, and "friends" told Harold to drop me.

Harold's key article, "The American Action Painters", was published in 1952 and gave rise to more controversy than any other single essay on abstract expressionism. He wrote: "At a certain moment the canvas began to appear to one American painter after another as an arena in which to act—rather than as a space in which to reproduce, re-design, analyze or 'express' an object, actual or imagined. What was to go on the canvas was not a picture but an event. . . . The

big moment came when it was decided to paint . . . just to PAINT." As I interpreted Harold's idea, the action painter would begin a picture with "nothingness." Then, in a kind of improvisational dialogue with the painting, he or she would paint—the brush dictated by what Vasily Kandinsky termed "inner necessity"—until no other stroke was required, and the picture would be "finished." Harold went on to say that what gave action painting its meaning was "the way the artist organizes his emotional and intellectual energy as if he were in a living situation." In the end, the painter "might find reflected the true image of his identity."

As Harold viewed it, the action painters, faced with the unceasing problem of making choices in the direct process of painting, were in a constant state of anxiety—in what Auden termed the "Age of Anxiety." Harold was strongly influenced by existentialism, as were most of my friends and myself. We were impressed by its emphasis on angst and alienation; it seemed very suited to the temper of the times.

Asserting that the existential experience of painting was the exclusive mainspring of action painting, Harold claimed that the artists had discarded "form, color, composition, drawing" as well as references to past art. Therefore, action painting was an unprecedented departure from past and existing styles. Harold stated this emphatically, thus distancing his conception of action painting as far as he could from formalist and art-historical analysis, which was identified with Clem and Alfred Barr.

Harold obviously had Clem in mind—and Pollock, whom Clem championed. He denigrated them without mentioning their names, but everyone knew whom he meant. Clem was Harold's model for "The critic who goes on judging in terms of schools, styles, [and] form." Clem then was the kind of historian, as Adam Gopnik remarked, who denied the disruptive power of modern art by sedating its anxiety with the tranquilizer of historical continuity. Clem had worried that Pollock's poured paintings might lapse into decoration or be perceived that way. Picking up on this fear, Harold sneered at artists who made "*easy* painting[s] . . . unearned masterpieces" and "apocalyptic wallpaper."

I found Harold's conception of the *content* of action painting compelling, as did many of my friends. They too claimed to value existential action and to revile artistic performance. Painting meant more to them than mere picture-making; its purpose was emotional discovery. Nevertheless, they scoffed at Harold's notions about how action painters actually worked. They pointed out that it was impossible to begin a canvas with "nothingness" and to shut out their knowledge or memories of past art. Nor would they discard formal values. Moreover, as Clem pointed out, there *was* a tradition of painterly painting, stretching back through Soutine and early Kandinsky, van Gogh, Delacroix, Rubens, Titian, and others.

Action painters were extending this tradition, and although they transformed it into original and personal styles, their pictures were created (and recognized by their audience) with reference to previous painterly painting.

My artist friends and I also took Harold to task for considering action paintings primarily as "events," pointing out that what artists painted on their canvases were *pictures*. Mary McCarthy spoke for us when she quipped, you can't hang an event on the wall. We would not accept Harold's refusal to deal with quality in action painting, "how to tell a good one from a bad one." Harold did set up criteria for judgment, among them "authenticity" and "seriousness," but such qualities, even if sensed in a work, could not be checked against the painting. Besides, many of us thought that Harold refused to make value judgments because he really did not *see* art and lacked the taste to make fine distinctions. We respected him as an exceptional intellectual and raconteur but not as an "eye."

As the fifties progressed, Harold's rhetoric grew less and less persuasive. Action painting had become an established style, the greater part of it little more than decoration. Harold's formulation turned into parody. Once, at The Club, when the nth artist, dripping angst, said, "I don't know what I'm doing," one wit called out, "After twenty years." The audience laughed, uneasily; the wit touched a nerve.

Then there was a memorable encounter with a former world heavyweight prize-fighting champion, Ezzard Charles, who was brought to an artists' party by Elaine de Kooning. She was painting athletes then and attended their practice sessions and games to observe them. Beautiful and charming as she was, she would pick up world-class sports figures and escort them to artists' venues, where we would goggle-eye them. At this particular party, Herman Cherry tried to explain to Charles that action painting was akin to boxing. Dwarfed by the towering fighter, Cherry sparred around Charles, punching air. Charles listened very intently and said, "I think I understand what you are saying, but the canvas doesn't hit back, does it?"

———

Clement Greenberg was not as highly regarded by my circle of friends in the 1950s as Harold and Thomas Hess. For example, in 1957 Philip Guston put Clem down as "a mixture of unlearned art historian, semi-Marxist, and box-score keeper." In *It Is*, the in-house journal of the downtown avant-garde, Phillip Pavia deliberately slighted Clem by commenting that Harold and Hess were "the two critics in the United States who brought thinking back to art criticism." We recognized Clem as an early champion of Pollock, but Pollock was not very highly esteemed in my downtown circle, in which de Kooning was the reigning painter. Moreover, Clem did not write much after 1955. His job as a salaried advisor to the French and Company Gallery was suspect in those purer days and hurt his reputation. Then,

in 1961, his much revised essays were published in a book titled *Art and Culture*. With its appearance, a growing number of artists and art professionals began to look to him for guidance, and he quickly outstripped Harold in influence and prestige.

I never liked Clem, but I was always cordial to him and he to me. He wrote a letter of recommendation for a travel grant that sent me to Europe in 1960. In the following year, after I had published a favorable review of Kenneth Noland's painting, I was invited to a party at Ken's studio. I had a hunch that I was being vetted for membership in the formalist coterie. I did not pass muster. In 1965, I took Clem's pet stained-color-field painters to task in my *Concrete Expressionism* catalog. He never forgave me—and often twitted me about it—but he remained civil. He had a reputation of being a bully who abused even his closest associates, but he treated me with respect. He never asked me to make the pilgrimage to his apartment, but we often encountered each other at openings, at his frequent lectures, which I made a point of attending, and at other art-world events.

Like most critics in the 1960s, I read Clem closely, and wrestled with his ideas, notably that "the purely . . . abstract qualities of the work of art are the only ones that count." I did not agree, but I was persuaded to pay closer attention to the formal components of artworks. Most art professionals accepted that Clem's formalist aesthetics constituted a rigorously unified whole. As late as 1998, Arthur Danto, a philosopher who ought to know one, placed Clem "among the century's great philosophers of art, greater than Gombrich and Schapiro, equal to Vasari." Why? Because Clem had devised a total theory of modernism, ending "with the view that the essence of painting is flatness." But as I chewed over Clem's essays, they seemed flawed by irreconcilable contradictions.

Clem formulated three major premises. The first was a theory of the historical development of modernist or avant-garde or mainstream art (the terms were used interchangeably). According to Clem, what made any art modernist was its quest for "purity," and it achieved this by separating itself from every other art. In the case of painting, it had to "confine itself to the disposition pure and simple of color and line, and not intrigue us by associations with things we can experience more authentically elsewhere." Hence, painting had to be purged of such impurities as "literary" subject matter. Because painting was identified primarily by its flatness, the artist was obliged to be above all panel-conscious and squeeze out illusionistic space. He once did say that at a time when illusions of every kind are being destroyed, illusionism in art must also be renounced, but he rarely wrote more about art's social context.

As Clem viewed it, the purification of the medium was an ongoing process, or more accurately, a historic progression. Following its own internal imperatives, modernist art was a succession of styles, evolving and dying as if predestined, each

of which inevitably moved art closer to its essence. Clem claimed that his interpretation of modernist art history was objective. He was merely reporting what actually had happened. Although he denied it, his narrative was influenced both by his taste and by the Marxist conception of historical determinism. The idea of inexorable progress was vital to Clem because he shrewdly realized that his appetites and opinions would be more persuasive if they were buttressed by History.

Toward what had modernist art progressed? What was the "mainstream," as Clem saw it? In 1944, he announced, "Abstract art today is the only stream that flows toward an ocean." Anointed by history, it opened up to the future. Conversely, figurative art was banished to the dustbin of history. Consequently, Clem hailed abstract expressionism generally—and Pollock in particular—as *the* modernist painting (and in sculpture, David Smith). In 1955, he singled out the color-field painting of Clyfford Still, Mark Rothko, and Barnett Newman. At the end of the 1950s, he championed the stained color-field painting of Morris Louis and Kenneth Noland, and somewhat later, Jules Olitski (and in sculpture, Anthony Caro, as Smith's heir), the four comprising the last of his wholehearted endorsements.

I found Clem's reading of the history of modern art curiously unbalanced. He paid little attention to fauvism, expressionism, constructivism, dadaism, and surrealism. Indeed, as Robert Goldwater observed, Clem was "fixated on Cubism" and viewed "the whole development of the New York School [as] somehow reduced to a battle for freedom from Cubist composition." Clem may have downplayed surrealism, but the abstract expressionists did not. They "were engaged in 'telling the truth' and they talked a great deal about it." Clem never forgave Goldwater for his review and bad-mouthed him whenever he could.

Just as Clem misjudged the role of surrealism, so he mistook the role of impressionism. He claimed that the abstract expressionists knew Monet's late lilypads, but it is extremely unlikely that they had seen them. What Clem attributed to impressionism was actually the issue of surrealist automatism. He got much else of abstract expressionism wrong. He turned a blind eye to the sexual dynamics of Gorky; the mythical content of Gottlieb, Rothko, Pollock, Still, and Newman; the urban rawness and anxiety of de Kooning and Kline; and even the art-nouveau references in his treasured Morris Louis's color-fields.

Clem's second theoretical premise was that the primary function of art criticism was judging quality. He allowed that quality was not a formal "fact," since there were no demonstrable criteria for telling good from bad, and quality was to be found in the art of any style. Aesthetic experience was immediate and involuntary; an instant glance was sufficient. The recognition of quality—the "conviction" that a work had it—depended on individual taste or an "eye" for art. However, this second premise seemed to conflict with the first. If assessing quali-

ty depended entirely on "subjective" taste, then Clem's "objective" master narrative was of no use. Clem tried to get around this contradiction in his aesthetics by asserting that formalist art turned out to be the best, or so his "empirical" reading revealed. Thus, he used the dual *authority* of his intepretation of art history and his personal taste or "eye" to validate each other. Nice stratagem. In too much of his writing, Clem assumed the role of an all-knowing arbiter of taste, pontificating about good and bad instead of dealing with visual particulars.

Clem's third supposition was that when avant-garde styles become academic, new styles emerge from their ruins. Modernist artists were perpetually confronted with formal problems that they were obliged to solve, in the process of which, others presented themselves. This was Clem's most useful idea, one more fully developed by Michael Fried.

During the early and middle 1940s, Clem favored cubist painting because it was the flattest and most abstract of all tendencies in art. Thinking that it had reached a formal dead end, he grudgingly began to accept surrealism as a positive force, because its "reliance upon the unconscious and the accidental" aided the artists in "surrendering, as he needs to, to his medium." However, surrealism entailed a "swing back towards 'poetry' and 'imagination,' the signs of which are a return to elements of representation, smudged contour lines and the third dimension." This gave rise to another discrepancy in Clem's aesthetics. A backward step was irreconcilable with his theory of historical progress.

In the end, I found it impossible to integrate logically Clem's historically deterministic theory of the progressive purification of the medium (which was very questionable in itself) *and* his idea that painting could advance through retrogressive moves, *and* his conception of the role of quality, which was purely subjective (although he later revised this tenet, claiming quality could be objective). Clem's attempts to cobble the three axioms of his aesthetics together made his thinking even less persuasive. In any case, I was preoccupied with the meaning of art, and I could not accept his exclusively formalist analysis. In my view, if art has any human significance, it reaches beyond formal matters to an artist's vision and emotions. The persuasiveness (or conviction) with which vision and emotion are embodied in a work is responsible for its quality, whatever that is, since there are no criteria to determine it. However, in picking apart Clem's aesthetics, I came to understand his appeal. His followers could choose among his assumptions, accept one and ignore the other two, or shift from one to the other when it seemed convenient to do so.

How to account for Clem's own shifts and turns? I came to believe that he was motivated by his peculiar aesthetic appetite. We all bring to art our baggage of appetites, predilections, desires, beliefs, loves, hates, and what have you. They affect how we experience the content of art—and its quality. In Clem's case, in 1947, he

called for "the development of a bland, large, balanced, Apollonian art in which . . . an intense detachment informs all. Only such an art . . . can adequately answer contemporary life [and relieve those] frustrations that ensue from living at the present moment in the history of Western civilization." What Clem was calling for then, and continued to call for, was a pleasurable, decorative art in which anxiety was suppressed.

Clem's appetite for the decorative caused him to question even his beloved Pollock's painting for "its Gothic-ness, its paranoia and resentment [which] narrow it; large though it may be in ambition—large enough to contain inconsistencies, ugliness, blind spots and monotonous passages—it nevertheless lacks breadth." Clem prized Hans Hofmann's painting, as he said to me, because its scope surpassed that of all of the other new American painters. But Hofmann was *the* hedonist among the pioneer abstract expressionists. No wonder Clem discovered in stained color-field painting the unabashed decoration that best suited his temperament.

Clem's approach, despite his claim to tough-minded objectivity, was essentially sensual and sentimental. For him and his followers, art and its history provided a kind of sanctuary into which one could escape from the dark side of life. It was this avoidance of reality, not its alleged formal rigor, that was the source of its attraction. I could not overlook modern life's underbelly. My modernism was exemplified by Kafka's and Beckett's harrowing characters, Primo Levi's doomed victims, and in the visual arts, the tradition of dadaism's iconoclasm, surrealism's irrationalism, and especially, abstract expressionism's tragic sense of life, personified by Pollock, de Kooning, Kline, Rothko, and Guston (and more recently, by the perverse and absurdist pathos of Cindy Sherman, Bruce Nauman, and Mike Kelly).

Clem had a right to his appetites, and to extending them into an aesthetic. He could even claim that only the art he esteemed was the bona fide modernist art, if he could get away with it. And he did, far more than he should have. What I rejected was Clem's use of his formalist theory to validate *his* personal taste. It was clear to me that his predisposition for decoration blinkered his "eye." I would not accept that the artists Clem championed were better than the artists he considered beneath contempt. Above all, I objected to his using his taste, bolstered by his ideology, as a weapon to denigrate art he did not like for reasons other than its presumed lack of quality. In 1987, he said, "I think that the best painter alive right now is Jules Olitski. . . . Noland is still a great painter. . . . I think Wyeth is way better than most of the avant-garde stars of this time. Better than Rauschenberg. Better now than Jasper Johns." That was an art-political ploy to wipe out the competition— and simply unworthy. It didn't do Noland, presumably out of favor, much good to become second-best. When Clem made such statements, he gave connoisseurship a bad name.

What made art criticism exciting in the 1960s was the verbal war between Harold and Clem. I was close to the firing line, since I kept in touch with both combatants. In a conversation above the jazz decibels at the Five Spot in 1958, Clem sneered that Harold denied the seriousness of the new painting and betrayed it by rejecting formal values and the role of tradition, thus putting painting outside of art's realm. This allowed hostile critics to dismiss it as non-art or to brand it as anti-art. I responded that they would anyway.

In 1962, Clem wrote an article titled "How Art Writing Earns Its Bad Name," in which he continued to abuse Harold, going so far as to call him a comedian. According to Clem, the writing of Harold and his followers had been corrupted by "perversions and abortions of discourse: pseudo-description, pseudo-narrative, pseudo-exposition, pseudo-history, pseudo-philosophy, pseudo-psychology, and—worst of all—pseudo-poetry. . . . The pity, however, is not in the words; it is in the fact that the art itself had been made to look silly." Not really. Silly words are silly, and Harold's writing was anything but silly.

Since I was interested in relating art to history, politics, philosophy, and psychology—indeed, to any subject that might shed light on the art, it came as no surprise that Clem scolded me. He was particularly annoyed because I treated the idea of action painting seriously and therefore perpetuated it.

Harold rebutted Clem's attacks in a 1963 article (without mentioning his name). He wrote:

> . . . formal criticism has consistently buried the emotional, moral, social or metaphysical content of modern art under blueprints of "achievements" in handling line, color, and form. Perhaps advancing Gauguin's idea of color or Cézanne's means of construction was what Picasso was 'about' in painting "Demoiselles." I doubt, though, that anyone but an art historian would find it "stirring" on that account. "What forces our interest," Picasso has said, "is Cézanne's anxiety"—that's Cézanne's lesson; the torments of van Gogh—that is the actual drama of the man. The rest is sham.

Harold did weigh into Clem by name in another article of 1963, titled "The Premises of Action Painting." Referring to Clem's job at French and Company, he called him "an advisor on masterpieces, current and future," an "old salesman . . . purveying goods to the bewildered." In the following year, Harold continued to rebuke Clem in an article published in *Art in America*. Its title, "After Next, What?", twitted Clem's essay "After Abstract Expressionism." Harold denounced "prophets" who "[consigned] to the critical rubbish heap any art that fail[ed] to take" the path they predicted.

The war of words between Harold and Clem was focused not only on ideas but

also on the artists they championed. Harold was in de Kooning's corner, and Clem, in Pollock's. The two painters considered themselves competitors and fueled the art-critical rivalry, but they respected each other (as Harold and Clem did not). Bill told Angelo Ippolito that when he first saw Jackson's painting he thought it was bad. Then he went to his own studio and looked at his own paintings and thought they were awful. Grace Hartigan said to me that in 1948, soon after seeing Jackson's painting, she visited him and asked if he would recommend artists that he admired. He answered: "Only Bill." When she asked the same question of Bill, he said: "Jackson."

However, Jackson mocked Bill as "a French painter," implying that he was old-hat. Bill taunted Jackson on his "Americanism"—that is, his play-acting as artistic cowboy. At a panel at The Club in 1956, the first I arranged, titled "Homage to Jackson Pollock," Bill called the recently deceased Jackson "the icebreaker." This has been interpreted by later historians to be complimentary—an acknowledgment of Jackson's priority and influence. Clem did not think so. Sitting next to Bill, he challenged him angrily. "Do you mean that Pollock's primary role was to usher in presumably greater artists?" he asked. "Was he supposed to be an icebreaker for mediocrities like you?" Clem may have been right about Bill's intention. When Barnett Newman looked ceilingward and intoned, "Jackson Pollock lives," Bill retorted, his Dutch accent thickening: "Vat do you mean, lifs? I vas dere. Dey dug the hole in the ground, put him in, and trew dirt down dere." The next time I met Clem, he said that he had been so upset by the so-called memorial that he would never go back to The Club again. The panel was meant to praise Jackson; instead, it buried him.

Bill would also spoof his rivalry with Jackson. Michael Goldberg recalled standing with Bill and Kline watching a huge boulder being lowered on Jackson's grave in East Hampton. Bill turned to Kline and said, "You see that stone? The rock Elaine is going to put on my grave will make it look like a pebble."

In their rivalry, Jackson had an edge in that he was undeniably an innovator. He had even been featured in *Life* magazine, becoming something of a household name. Bill, on the other hand, had an advantage in that his painting offered young painters fresher possibilities. As Joseph Kosuth once said, "When you faked a Pollock, it looked like a fake Pollock; when you faked a de Kooning, it looked like a great painting."

Bill could talk—and Jackson couldn't. Bill's talk was direct and his insights into art were incisive. He was personable, most of the time, although he was a bad drunk, but Jackson was worse and rarely appeared sober in public. Bill was available to downtown artists—on Tenth Street where he lived and worked, at The Club, and at the Cedar Street Tavern—unlike Jackson, who lived in East Hampton. Helen Frankenthaler, who was close to Clem, reported that in the

fifties, "Jackson had no following except for myself, Friedel Dzubas, and a few more. We were just interested in his paintings. Jackson never gave us a life, but de Kooning gave a whole group of young artists a bohemian life. It was never de Kooningites and Pollockites. You were a de Kooningite or you weren't." Indeed, young painters who considered themselves the heirs of abstract expressionism formed an informal de Kooning fan club.

Clem and his toadies bashed Bill and what Clem termed the "school of de Kooning" or "Tenth Street Painting" at every opportunity. The tactic used to topple Bill from his pedestal was to overstate his ties to cubism and to dismiss him as outmoded. In a conversation with me in 1958, Clem said that in comparison to Jackson—and Newman—Bill was backward-looking while creating the illusion of being forward-looking.

As a backbiter, Harold was Clem's equal. In a nasty review of Bryan Robertson's book on Jackson, Harold aimed all his venom at the author but, in the process, insulted the artist. He ignored Jackson's paintings and lit into the man. "Pollock fits snugly into the semi-comic legend of the 'ring-tailed roarer' of the American frontier. [His] whackdoodle was . . . stimulated and a bit modified by Western movies. He wore the high boots, the blue jeans and the 'neckercher'; he crouched on his heels and pulled up blades of grass as he talked; he liked to go to saloons and play at bustin' up the joint." Pollock was, in a word, a hayseed, presumably compared to Bill. Harold also took pot shots at Clem in his review, claiming that his role consisted not "merely in promoting Pollock's reputation [but] for better or worse [affecting] his work itself, shoring up the artist's arbitrariness with his own and pressing him onward."

All the mudslinging between Harold and Clem was unworthy, but such were the art wars at the time.

In the mid-1950s, Clem "discovered" Morris Louis and Kenneth Noland in Washington, D.C., and arranged for their stained color-field paintings to be shown in New York, in the case of Louis, at the French and Company Gallery, of which Clem was a paid advisor. Clem also made a strong case for them in the articles "Louis and Noland" (1960), and "After Abstract Expressionism" (1962). They had, Clem said, adopted the watercolor technique of staining thinned pigment, and thus had rendered color more visual or optical than ever before. Clem allowed that Newman, Rothko, and Still pointed the way, but then declared that Louis and Noland advanced beyond their predecessors. Had Clem discovered the true successors to the pioneer abstract expressionists? Not in my book, but the art world took him very seriously.

Clem's successful advocacy of Louis and Noland, and then of Jules Olitski and Anthony Caro, got him the reputation of being a "kingmaker." This attracted

artists. So did his formalist dogma and the implication that the entire history of Western art funneled through the artists who accepted his dictation or, more specifically, painted according to his specifications. Clem convinced artists that their primary function was to become an instrument of formalist aesthetics or modernist art history. In the name of high art, they were required to work in styles he prescribed. He actually went into artists' studios and "advised" them how to paint. He justified his entry into the creative process of artists by claiming that his intervention was a sign of his passionate conviction, which required him to tell the artist exactly how he felt and thought.

I was willing to grant that artists might find Clem's theories useful, but the idea that he told artists how to "improve" their pictures, editing them, as it were, and telling them what to paint next, appalled me. What bothered me most was that Clem demanded that painters accept his ideas *before* painting. "Right" ideas made for "good" painting and "wrong" ideas made for "bad" painting, much as he denied that. Who decided "right" from "wrong"? Clem, of course. Consequently, he painted by proxy. Susan Crile told me that the problem with Clem was not only that he advised his followers how to paint, but that he built a dependence of artists on him. He was intellectually and emotionally powerful and projected the voice of truth that was hard to resist. He had to be in control and would bully and intimidate artists. Those who courted his favor had to do his bidding. There was no middle ground.

Most Greenbergers were afraid of Clem, on the one hand, and on the other, relied on his "eye." Indeed, they painted their pictures for *him*. When Clem liked what he saw in the studio, he recommended that the artist do more. His disapproval caused an artist to abandon the direction he had taken. Clem's groupies were turned into his brushes. How demeaning! I must admit, however— Greenbergers did paint some wonderful paintings. I think especially of Morris Louis's *Saraband*, now in the collection of the Guggenheim Museum.

Clem was also heeded by dealers and collectors. He would pander to the rich, assuring them that what counted in art was taste; everything else was incidental. Anyone could have an "eye" and one either had it or didn't, and if one did, nothing else was needed, certainly not knowledge. Flush ignoramuses were flattered, and they were persuaded that they had taste—if they bought the artists Clem recommended, of course.

Clem himself was in "business." He accepted "gifts" from artists he promoted (who allowed him to make his own choices) and then put them on the market. He felt it was his due. (Such merchandising would later become a common practice, but at the time a critic's profiteering off art was frowned on.) I never knew how many works Clem had acquired until after his death, and I was shocked at the number. Money was obviously important to him. Robert Goldwater reported

that Clem said to him, "'If I had been more serious about my own painting, I would be . . .' Clem stopped and waited for me to finish the sentence. I said, 'great.' 'No, 'rich,'" Clem replied. At the College Art Association Annual Meeting in 1973, with the Vietnam War on everyone's mind, I invited a broad array of artists and art professionals to deliver five-minute statements on art and politics. More than one hundred agreed. Clem declined because there was no payment involved.

Clem's formalist approach appealed not only to artists but to art professionals as well. Among them were critics Darby Bannard, Michael Fried, Rosalind Krauss, Barbara Rose, and William Rubin, and curators Kenworth Moffett and E. A. Carmean. Graduates of elite universities, such as Harvard, Princeton, and Columbia, they had intellectual cachet. Schooled in academic art history, they were attracted to formalist criticism and the post-abstract expressionist painting that it seemed to interpret best. Clem persuaded them that his opinions were empirical, implying "scientific"—or, at least, visually demonstrable—compared to the existentialist and romantic criticism of the 1950s. His formal analysis and conception of modernist art history as an inexorable progression of styles did seem more objective than subjective.

Thus, Clem appealed to history and science, the twentieth century's two most powerful myths, as Jacques Ellul identified them. Indeed, history became the judge of good and evil, or—in the case of art—good and bad. Clem's "eye" did seem to be on the side of history, and that was a large part of his charisma—and influence. He conveyed the impression of owning the history of modern art. Indeed, his art-critical followers were so convinced that modernist styles progressed as inevitable links in a stylistic chain that they believed he could predict the next link, that he was, in a word, "prophetic."

Conceiving of formalist art as the legitimate continuation of the historic mainstream of high modernist art, young history-minded critics could be both proper academics and on the cutting edge of art. They put their extensive academic training in the service of the formalist art of their own generation. It became a cause, a crusade. They were so sure about the significance of formalist art that they wrote about it as if no other art existed. Their mission was to gain recognition for Louis, Noland, Olitski, and Frank Stella (their one deviation from Clem's A-list). Though few in number, the painters they promoted were, after all, the heirs of Manet, Monet, and their modernist successors. The course of Western painting and its continuing vitality—indeed, its fate—depended on them. This was a claim far more grandiose than claims made for the authentic self-expression of abstract expressionist painting. In the process of proselytizing, formalist critics, nose in the air, showed off their "good" taste. They also academicized art criticism, by analyzing formal minutiae at great length, bolstering their analyses and opinions with weighty footnotes (citing mostly Clem and each other), and

favoring a dense language—all of which they believed to be signs of seriousness. It made for unfeeling and tedious prose.

Greenberg's art-critical followers aped their mentor's arrogance shamelessly. After all, they had the academic credentials, the word from above, and the model of thuggish discourse. The most cocksure was William Rubin (although his arrogance predated his connection to Clem). In 1967, on the recommendation of Alfred Barr, he succeeded him as the Museum of Modern Art's Director of Painting and Sculpture, arguably the most powerful taste-making position in the international art world.

In 1960, Rubin hailed Clem as "the dean of post-war critics" and parroted his contention that the de Kooning-Kline influence was a losing proposition. He seconded Clem's "preference for the direction pointed by Still and Newman [which] showed extraordinary prophetic [that word again] insight in terms of where younger painters of quality find themselves today." Of these artists, Rubin singled out Morris Louis. I agreed that Louis was a fine painter, but I was taken aback when in 1969 Rubin revised art history by including Louis in a show of *The New American Painting and Sculpture: The First Generation.* In fact, Louis became known in New York as a painter only in 1954, and clearly belonged to the second generation, along with Helen Frankenthaler, who had influenced him decisively, Joan Mitchell, Grace Hartigan, and other artists whose styles matured after 1950.

I admired major shows that Rubin curated: dada and surrealism, Cézanne's late painting, a Picasso retrospective, and retrospectives of younger artists Frank Stella and Anthony Caro, as well as significant works he acquired for MoMA's permanent collection. I had only disdain, however, for his neglect of newer art, that is, post-Johns, Louis, and Stella.

Disagree in any way with Rubin, and the bully in him reared its proverbial ugly head. I was the object of one of his rages. He had written two important articles on various Jungian overinterpretations of the work of Jackson Pollock, who had been in Jungian analysis. As I read Rubin's text, it occurred to me that he had overlooked John Graham's seminal contribution to Pollock's thinking. Curious, I reread Graham's book, *System and Dialectics of Art,* in which he dealt with Jung, and his essay linking Picasso and so-called primitive art in the *Magazine of Art,* both of 1937. One illustration that accompanied the essay text was of an Eskimo mask, and it suddenly struck me that it resembled a few of Pollock's images, notably *Birth,* which I had looked at dozens of times at the Tate Gallery and had long considered one of Pollock's "breakthrough" paintings. Pleased with my discovery, I acquired photographs and sent them to *Art in America* with a letter to the editor, Elizabeth Baker, which she published.

My letter read in part: "I am as unsympathetic toward iconographical binges,

Jungian or other, as William Rubin is, and I agree with him that Pollock was more inspired by what he saw of primitive and modern art than by what he read. However, there was writing that I believe was crucial to Pollock's artistic development and overlooked by Rubin in his two articles—that of John Graham, which relates primitive art, Picasso's painting, and Jung-inspired ideas." I concluded that Graham had strongly influenced Pollock, who was a close friend.

Rubin then published a rude rejoinder. "Professor Sandler's letter . . . is essentially a lengthy non-sequitur masquerading as criticism. . . . As Graham's writing was irrelevant to my argument, I hardly 'ignored' it. . . . Nor is Graham's writing of any pertinence—and this, of course, is the main point—in evaluating the complicated iconographic schemes proposed by Pollock's recent critics." So much for my innocent desire to provide another, and in my opinion very relevant, view of Pollock's imagery.

The next time Rubin and I met, I greeted him cordially and made no reference to his written temper tantrum, and he seemed relieved. It is my belief that when he cooled off and presumably looked calmly at the illustrations that accompanied my letter, he had a revelation. *Birth* now seemed to him, as it had to me, seminal in Pollock's development, and the Eskimo mask the catalyst. In 1984, when Rubin curated *"Primitivism" in 20th Century Art* at the Museum of Modern Art, he found the Eskimo mask and exhibited it with the Pollock. At the opening of the show, he came over and said that he had thought that he had discovered the relationship between the two works, but Kirk Varnedoe had told him that I was the one who had made the find and that Varnedoe had dealt with it in his essay.

Clem's insistence on the objectivity of his art-historical narrative led to a confrontation between us. It started in 1979 at a conference of the International Art Critics Association in Dublin. We were at a reception hosted by the Lord Mayor soon after I had discovered Irish whiskey. The Lord Mayor had evidently discovered it well before me, and in our mutual drunkenness he and I hit it off famously. Clem saw me, made a beeline to me, and said, "You just wrote that I championed Louis, Noland, Olitski, and Caro. I never champion anyone. I just describe. What you did was in bad faith." In Clem's vocabulary, "bad faith" was a major no-no. We went out to dinner, and I was stuck with the bill—as penance, I assumed.

We met again a few months later at a conference in Buenos Aires. There were only a few participants from the United States there, so Clem came to my lecture. I made sure I said that he championed Louis, etc. Later that night, we met in the hotel lobby. Clem said, "Sandler, you did it again." I reponded, "O.K. Clem, shoot-out time. Do you really believe that if, of the dozens of significant artists in New York, you choose to talk only about four, I can't view that as championship? And do you think that you are so lacking in art-world power that when you do that I can't consider it as advocacy?" Clem retorted, "My daughter Sarah took a course

in contemporary art in college and said that the only thing worth reading was your book." I said, "O.K. Clem, you win!"

Who won the art-critical war? Clem prevailed over Harold because Harold's writing struck young critics in the 1960s as excessively romantic. When existentialism went out of fashion, so did Harold. As Josef Albers said to him, (or so I was told), "Angst is dead!" Moreover, Harold's thinking was complex and ranged over a variety of intellectual disciplines. In contrast, Clem seemed to have a master narrative that was simple, clear, seemingly verifiable, and primarily art historical. As philosopher William Barrett pointed out, "Formalist theories of any kind . . . seem to promise some kind of rigor and exactness. They seem to give one something definite and precise to talk about, in comparision with which the realities of the spirit look vague and insubstantial." Thus, Clem's formalism and what Robert Storr termed his "'cult of quality' and the mystique of the 'eye'" eclipsed the examination of the social, psychological, metaphysical, and existential context of art. Finally, there was a perception that Harold lacked an eye; this worked against him and in favor of Clem. If memory holds, Philip Guston drew a caricature of Harold that portrayed him with one cyclops eye and a patch over it.

Perhaps the most important reason for Harold's decline in the sixties was that his criticism seemed applicable primarily to gesture painting of the 1950s, which had gone out of art-world favor. Clem's formalist writing conformed more to 1960s art. Even artists, such as the minimal sculptors, who denigrated Clem's roster of stained color-field painters, adopted his rhetoric. Consequently, Clem's aesthetics seemed to *supplant* Harold's. However, if in the end Clem won because his criticism continued to command attention, the reputations of painters he championed—Noland and Olitski—soon slumped, just as those of Rauschenberg, Johns, and Stella soared.

Was Harold's eclipse fair? I don't think so, even given all of the shortcomings of his thinking, notably, the outlandish idea that formal considerations don't count. Issues that Harold raised about the extra-aesthetic context of abstract expressionism during the hot and cold wars, and the crisis mentality they generated, are relevant. Harold understood that at a time of increasing pressure to conform, the abstract expressionists boldly broke the binds of past and existing styles and asserted their individuality. Clem stood opposed to such romantic notions, and much as he admired the painting, he sought to trap it in history—and in the end to domesticate it. So did I, in a way, but I tried to retain the sense of crisis in the new American painting that Harold recognized and Clem wanted to ignore.

Recently, young historians have been finding Harold's ideas more interesting than Clem's interpretation—and given the destruction of the World Trade Center Towers, I believe that this interest will grow. In retrospect, Clem's formalist

approach appears to have been a flight from the self and the artist's experience, as well as the alienation and anxiety that continue to inform contemporary life. In my view, Harold's neglect and Clem's undue influence distorted the interpretation of abstract expressionism. Indeed, the painting cannot be properly understood without Harold's account.

Both Harold and Clem hated pop art, minimalism, and postminimalism. They also rejected postmodernist art. They tried to combat it, but fewer and fewer artists and art professionals who emerged after 1965 paid any attention to their opinions in this matter. In response, Harold lost interest. It was reported to me that when a student asked him what he thought of modernism, he responded: "It happened a long time ago." "Well, what about postmodernism?" He said: "I don't care." What a sad ending. Clem did become the revered whipping boy of postmodernist critics, but he accepted no artist wholeheartedly after Olitski and Caro.

Meyer Schapiro was a friend of the first-generation abstract expressionists and a guru figure to the second—and to me. Whenever he lectured, we would fill the front rows of the auditorium, so greatly did we revere him. The power of Meyer's mind was without equal, at least in my world. The scope of his knowledge was staggering, encompassing mathematics and physics, economics and politics, the classics, perceptual psychology and psychoanalysis, Hebrew studies, and philosophy. He had an unshakable belief in art, its essential value in human affairs, and its magnificence. Dealing with a work of art, he probed at one and the same time his own subjective response and the singular creative impulses and psychological motivations of the artist. He also situated the work in broad art-historical, historical, social, and philosophical contexts, and submitted it to an incisive formal analysis. He had the imagination, erudition, and insight to negotiate among the diverse pulls of these various approaches. Meyer never lapsed into system building but remained open to new possibilities, to inconsistencies that pedants repressed—hence his love of grotesque marginalia in medieval manuscripts. He supported his multidimensional scholarship with an encyclopedic array of art-historical, sociological, metaphysical, and other information. Moreover, as a speaker, he was hypnotic and inspiring. Two or three minutes into a lecture, he would seem to levitate six inches off the floor.

My friends and I were touched that a scholar of Meyer's stature was supportive of young avant-garde artists. Allan Kaprow recalled that in those days there was nothing more thrilling than to hear him give a critique whether it was of one's own work or anyone else's.

What I found most useful about Meyer's thinking was his ability to make ideas about art concrete. For example, Rosenberg was unable to relate his conception of action painting to actual pictures. Meyer did. He wrote:

The consciousness of the personal and spontaneous . . . stimulated the artist to invent devices of handling, processing, surfacing, which confer to the utmost degree the aspect of the freely made. Hence the importance of the mark, the stroke, the brush, the drip, the quality of the substance of the paint itself, and the surface of the canvas as a texture and field of operation—all signs of the artist's active presence. . . . The impulse . . . becomes tangible and definite on the surface of a canvas through the painted mark. We see, as it were, the track of emotion, its obstruction, persistence or extinction.

The spontaneous (or improvisational, the word I prefer) was not all, for, as Meyer continued, the "elements of so-called chance or accident [are] submitted to critical control by the artist who is alert to the rightness and wrongness of the elements delivered spontaneously, and accepts or rejects them." Having situated gesture painting in the artist's subjective being, as it were, Meyer extended the personal into the social. He wrote that "art in modern society requires for its life the artist's spontaneity." Gesture painting provided an antidote to the stifling mass culture that was proliferating in a conformist America in the grips of what President Eisenhower termed "the military-industrial complex."

I attended every lecture given by Meyer that I could. He always gave me new ideas to mull over. For example, in a talk at Brooklyn College in 1965, he speculated about the relation between philosophy and art—that is, between a discursive verbal mode and a concrete visual one. He asked, on the one hand, if an artistic style could be a kind of knowlege that set forth a philosophy or world view. On the other hand, could philosophy be an expressive experience like art? Meyer demonstrated that they could.

I witnessed a dramatic example of Meyer's erudition at a week-long conference on Cézanne during his major retrospective at the Museum of Modern Art in 1977. The participants were limited to art historians and other art professionals with a particular interest in Cézanne. At the end of each talk, a woman would rise from the audience and ask about the influence of the philosopher Hermann von Helmholz's theory of color vision on Cézanne. Her insistence made her a kind of scapegoat, and speaker after speaker dismissively mocked her. Meyer showed up only to give his talk, the last of the conference. Although allotted thirty minutes, he delivered an hour-long lecture without notes about the metaphysical thinking of Cézanne's time and how it paralleled his painting. It was a breathtaking performance. When he finished, the Helmholz person again was on her feet. Meyer

responded, Yes, of course Helmholz! But how would Cézanne have known of Helmholz? Well, we know what newspaper Cézanne read, and we know that it published three articles on Helmholz while Cézanne was in Aix, etc. Many red faces among the other speakers. Ted Reff asked the last question. Turning to Meyer, he said that a quarter of a century had elapsed since his seminal book on Cézanne had appeared. Now, with all the subsequent scholarship, much of it delivered at the present conference, would Professor Schapiro change anything? Meyer thought for a while and responded, "No."

I may have inadvertently insulted Meyer once. He had participated on a panel on Mondrian at the Guggenheim Museum. He juxtaposed slides of a Mondrian and a Bonnard, and showed how the composition of the Mondrian paralleled the window frame in the Bonnard. Another speaker, Barbara Rose, related Mondrian to impressionism. In the question and answer period, I addressed Rose and declared that it was an affront to Mondrian to compare his neoplasticism with impression- ism, a style that seemed utterly opposed to his. Then it occurred to me that Meyer could suppose that my fault-finding of Rose could also have been leveled at him. I glanced at him, and his flushed face revealed that he had taken it that way.

I should add that I never had any use for the art historians' predilections for scavenging through their memory banks of art and coupling artists because details in their works looked alike. The it-looks-like approach can yield imagina- tive and brilliant insights, as in the case of Meyer and Robert Rosenblum, but I found it lacking in conceptual rigor.

Meyer was very accessible to young art historians and artists, perhaps too unstinting with his time, since his generosity—and perfectionism—curbed his scholarly output, which was of smaller quantity than a scholar of his gifts would have been expected to produce. While working on a book on Alfred Barr, I phoned Meyer and asked if I could interview him, hoping that he had forgiven me. His friendly tone indicated that he had, but he begged off, saying that he wanted to spend his remaining days—he was then eighty years old—on his own work. I responded that I fully understood. Then he interjected, "But how can I say no to Alfred? How much time will you need?" "An hour." Three hours into our interview we were still talking—and not only about Barr. Meyer told anecdotes, one about attacks made on him in public by Communists who, in private, shame- facedly requested letters of recommendation, about his feelings of Jewishness and socialism, and much more. I asked about Serge Guilbaut's thesis that the abstract expressionists were cold warriors. He said, "It's nonsense!" I felt guilty about taking so much of his time but was too captivated to leave until he indi- cated that our interview was over.

What Meyer wrote of Diderot applied equally well to his own relations with artists: "[Diderot] is so intensely concerned with artists not simply because he

loves their paintings or sculptures. The artist is for him an example par excellence of the free man. As a producer he works from inner necessity; art is his life and in his work he appears as his own master, creating from impulse but guided by an ideal of truth, and correcting himself for the perfection of the result and not from fear of others.... In his warmth and spontaneity the artist is a model of the natural, productive, self-fulfilling man.... Through this freedom and full individuality he serves others, including a future mankind." If I had the choice to be someone else, it would be Meyer.

———

Like Meyer, Robert Goldwater was a distinguished professor of art history, a champion of the New York school, and close to many avant-garde artists. I never studied with Robert, but he was one of my mentors. I would meet him often, and we would talk. He usually stood smiling and at ease, but said nothing unless someone began a conversation with him or asked him a question. I would broach an idea with which I was grappling. He would dice it every which way, but the bit I ended up with was usable. Robert was a dialectical thinker. He would set up opposing theses and whipsaw back and forth. For example, was abstract expressionism the upshot of the romantic-surrealist tradition, which focused on the vision of the individual artist, or of the classical-cubist tradition, which prized the well-formed picture? How could the desire for immediacy be reconciled with an artist's sense of history? What was the relation of the self to the public; art-as-protest to the desire for acceptance; and individuality to the awareness of stylistic affinities with other artworks?

Robert encouraged me to study art history. He said that it provides a perspective that art criticism needs by revealing the difference between the present and the past. He looked askance at formalist criticism because it minimized the importance of what the work expresses, and consequently, missed its point. He cautioned me to be careful of artists' statements about their intentions and particularly about the dates that they attached to their works. Robert had strong reservations about "eulogistic criticism." He recognized that it was necessary when avant-garde artists were fighting for acceptance. But in the case of the New York school, by the end of the 1950s, the need was not for raves but for "a careful if reverent analysis of what is seen." That was his own practice. For example, he pointed out that Franz Kline, who was often considered the prototypical action painter, was actually quite the opposite. "His action is only in his drawings. His paintings are close renderings of his sketches. You might consider him an action draftsman."

I ran Rosenberg's conception of action painting past Robert. He said that he understood its attractiveness. "It suggests existential engagement and improvisation. Instead of being a contemplator, the artist becomes a doer (which Americans

like).” The problem is, he said, that “Rosenberg’s notion makes being an artist more important than what the artist produces. That’s a progressive school attitude. Our sympathy for action painting is used to excuse formal deficiencies? We must look at the result of painting not its process. Bad painting is bad painting. Good artists are in control of their medium and know when they have achieved what they intend. Look at the work, not what you’ve read of Sartre or Rosenberg.”

Robert challenged current received ideas about abstract expressionist intentions, notably, that the painters were “engaged in internal combat [in] an atmosphere of crisis. But if one allows the art—rather than the artist—to speak for itself, it is evident that one of the principal attractions of the New York school has been its great sensuous appeal. With certain exceptions (of whom de Kooning is the most obvious), this is a lyric, not an epic, art.” “Why lyric?” I asked. Robert answered: “The artists enjoyed painting their pictures, and we ought to respond to that.” I disagreed: “Not the great ones, like de Kooning, Rothko, or Pollock. I view their work as tragic.” He responded: “Not Pollock. He may have been a tragic person but he painted lyric pictures.”

Robert was married to Louise Bourgeois. During the period that I was closest to him, she was very much Mrs. Goldwater. When Lucy and I were invited to dinner, she cooked, served, and kept in the background. However, at one point late in the evening, she would invite us to the cellar where she worked and show us the most astonishing sculptures. I recall most vividly the hanging plaster and latex “lair” pieces.

The central narrative in Louise’s work was her father’s betrayal of her mother by having an affair with a live-in tutor. If Louise distrusted men generally, she must have excluded Robert. I cannot imagine a more loyal and trustworthy man, but I was never sure of her attitude. When I dedicated an essay on Rothko to Robert, I was worried about whether she would approve. The next time I saw her—at a reception—she made straight for me and offered her thanks.

---

In 1957, I began to publish monthly reviews in *Art News* and to work closely with its managing editor, Thomas Hess. Although I considered Tom a mentor, we were never close. He invited me to his stylish apartment on Beekman Place twice but rarely came to my occasional parties. I felt that his upper-middle-class sense of himself precluded casual intimacy with me. He was always friendly and we spoke often, but on his part, it was mainly in urbane one-liners. His conversation often had a sardonic edge as did his editing. When a gallery showed the work of a preteen artist, Tom assigned the review to his preteen son. When in 1954 *Art News* ran a painting by Hofmann on its cover, a reader wrote in that his grandchildren could do it better. Tom responded: “May they keep up the good work.”

I once previewed a show of Nora Jaffe's abstract paintings at the Stable Gallery. The images were biomorphic and sexual. I remarked to Eleanor Ward, the dealer, that the work was very erotic. She said: "What do you mean?" Viewing the paintings anew, she gasped: "Oh, my God." She canceled the show without informing me, but my review appeared in *Art News*. (Jaffe later forgave me for my ill-timed comment.) When I next encountered Ward in the gallery, she invited me into her apartment, which was on the floor below, reached by a circular ladder. Apologizing for the mixup, she offered me a bottle of scotch. I said: "I can't accept this," but she insisted. Ward was a large woman and was standing between me and the ladder. The only way I was going to escape was to take the whiskey. Safely outside, I wondered what to do. Well, if baseball players reported improprieties to their commissioner. Tom was my commissioner. So I ambled over to *Art News*, walked into his office, plunked the bottle on his desk, and announced: "I've been bribed." He smiled wryly: "Great, let's have a drink."

Tom joined *Art News* in 1946 and became managing editor in 1950. He was considerably younger than Greenberg and Rosenberg, but like them, was an early advocate of abstract expressionism. Yale-bred, he was trained in the discipline of art history and was more academic in his thinking than the older critics. He was also less dogmatic and more cosmopolitan and ironic in his outlook. Tom and Rosenberg were both champions of de Kooning, although their points of view differed. Tom was pro art history; Rosenberg, anti. Tom stressed de Kooning's ties to tradition; Rosenberg ignored them.

In his book on abstract expressionism and its roots in past art, Tom underscored his regard for art history. Alive to the sources of contemporary art, he valued both old art and new. Like Alfred Barr, he considered avant-garde art both a legitimate continuation of the art that preceded it and a radical departure. However, he was suspicious of the more nontraditional abstract expressionists: Pollock, Still, and Newman (about whom he later changed his mind). His admiration of de Kooning led him to favor painterly painters—both figurative and abstract—ranging from Joan Mitchell to Larry Rivers, who, like him, were history-minded.

Tom used his position at *Art News* to promote the New York school. I was in total agreement with his enterprise. We also favored the same artists, at least in my early years as a critic. Indeed, I was considered Tom's follower, although I was not aware of it at the time. I recall meeting Adja Yunkers at a party. Prepared to be respectful of an older and distinguished (though minor) artist who was married to Dore Ashton, a fellow critic, I was shocked when the first thing he said to me with a nasty smirk was: "Oh, so you are one of Hess's messenger boys." Why would he say that? Years later, I read a memo from Rosalind Constable to the executives of Time-Life, which reported that I was a disciple of Tom's. I asked my wife, Lucy, whether this had been her perception of me at the time. She answered: "Of

course."

However, Tom and I did not always agree. In 1959, we curated a large group show of "younger" painters for the Art Rental Gallery in Washington, D.C. I prepared a long list of possible artists, including Mitchell, Rivers, and Rauschenberg. I was surprised at the ones Tom asked to be excluded, among whom were Frankenthaler, Hartigan, Johns, Held, and Pearlstein. I did get Tom to change his mind on Frankenthaler, Hartigan, and Pearlstein, but not Johns and Held.

As a partisan of the New York school, Tom believed that it had replaced the school of Paris as the vital center of international avant-garde art, and that would be the underlying premise of his art writing. He asked: "What made Paris the center of global art for a glorious century prior to World War II?" He answered by setting up a polarity between "Paris art" and "French art." Paris art was advanced and international; French art was retarded and provincial. The Paris artist "treats history as something that belongs to him, picking and choosing from it. [He is] tortured by and forever conscious of his self-imposed limitations." In contrast, the French artist is "charmed by his limitations." He "accepts history with humility. . . and cheerfully carries his dead father on his back all his life—to borrow Apollinaire's metaphor." Tom concluded that after World War II, art in Paris had become French art. New York had replaced Paris *as the center of "Paris" art.*

Tom believed that the French would not acknowledge the hegemony of New York, so they had to be reminded repeatedly. As late as 1961, Tom chided Paris. "The artists and writers [there] are in a battle, a mock-riot to prove: 1) New York never happened. 2) New York stole all its ideas from Paris anyhow. 3) New York has imposed itself here and there, like in Rome, by sneaky chauvinism. 4) New York had something around 1950; now it's pooped."

In a talk at the Guggenheim Museum, Tom continued his polemic against the school of Paris. He said that it had fallen apart because its artists had become pastry cooks and cosmeticians, lapsing into elegance and tastefulness. Why? Because instead of fighting the bourgeois as they once had, they had joined it. As I listened to this at the time, it occurred to me that the New York school was also rapidly becoming embourgeoisified. What then?

Tom later tackled this issue when it became clear that abstract expressionism had been eclipsed by new tendencies and had gone into decline. He formulated a new polemic to explain the reason why. The cause was the machinations of an "avant-garde audience," spawned by the affluent society. The new-rich collectors supported trendy novelty art and neglected genuine art. Many artists were complicit, even Dubuffet (not surprisingly, Tom would single out a Frenchman), who seemed to be a lone wolf even while running with the pack; Hess dubbed him a "pet saboteur." But many of Tom's favorite artists (and mine) were fraternizing with the "avant-garde audience," sitting beside their pictures in collectors' parlors

chewing on canapés. Did that make them pastry cooks and cosmeticians? Tom continued to deny that they were. But they had become, or could become, what Allan Kaprow termed "men of the world."

As market-savvy as anyone, Tom knew that Kaprow was right, much as he didn't like it. We all knew it. Tom himself was rich and as bourgeois as anyone I knew. Artist friends of mine had become wealthy, and others were envious. Art professionals were presented with new opportunities. I myself was hired to teach at New York University and was catapulted into the middle class. Many of us wondered whether this new affluence had affected our perception of art and the art world.

---

Tom's anti-school of Paris stance—and mine—was rebutted not by a Frenchman, but by an English painter-critic, Patrick Heron, whose frequent London letters were published in *Arts* magazine from 1956 to 1958. Ironically, he promoted French modernism in the guise of an early champion of the new American painting (an exaggerated claim he would proudly repeat over and over). It is true that when in 1956 a roomful of abstract expressionist works was first shown in London's Tate Gallery, Heron's response was favorable, but, as an avid advocate of the school of Paris, he was ambivalent. If he "was instantly elated by the size, energy, originality, economy, and inventive daring of many of the paintings," on the one hand, on the other, he found fault with their "creative emptiness" and with "an absence of relish in the *matière* as an end in itself, an absence of worked-up paint quality such as one never misses in the French [and] a lack of resonance in their color."

By 1958, Heron was thinking that abstract expressionism had run its course. He would repeatedly reaffirm his support of the beautifully painted picture identified with the school of Paris and, he hoped, with his own canvases. Of the Americans, he most admired Motherwell, "because [his painting] is nearer to the French. . . . Motherwell has in a sense a more civilized (forgive the expression) touch than all the others," and so on. Heron's high opinion of the "superbly manipulated surface texture" of Parisian painting made it difficult for him to accept the rawness of abstract expressionist painting. He seemed to think that "finish" and sensuous "touch" were something the New Yorkers could not achieve rather than something they did not want.

Of the Americans, Heron was troubled most by Rothko, whom he considered his main rival as a painter. In 1956, he wrote that Rothko was "probably a more important *explorer*" than Motherwell, but "his paintings were deficient." Over the next three decades, Heron would put down Rothko's painting for lacking "a sensuous subtlety of tone color, a subtle asymmetry of shape, a varied tempo of working," as he wrote in 1958. Indeed, the American became the Englishman's bête noire. As late as 1989, Heron berated Rothko as "a 'one-idea' artist" whose work

"led him nowhere, except to the dealers and suicide." This was an unworthy and self-serving ploy to wipe out the competition. He then went on to compare Rothko to Matisse, contrasting the limited and depressing palette of the American with the work of the Frenchman, who "displays *infinite* invention every time he picks up a new canvas." Heron did not realize that Matisse (like himself) was a hedonist and that Rothko was a tragedian. I once asked Heron: "Why Matisse versus Rothko? Why not Matisse *and* Rothko?" He turned away.

I became friendly with Heron in 1962, when he visited New York. I arranged for him to speak at The Club. His talk was highly formalist—a rare approach at the time. He scolded American action painting for being too harsh and "disorganized" and made an appeal for "order, nuance and subtlety." Lester Johnson challenged Heron, saying: "It would be more honest in our time to paint disorganized pictures, which would constitute a new kind of organization." Heron asked: "Are we sliding into a position where there is no bad painting?" Johnson replied: "There is bad painting and different painting."

After 1965, Heron attacked New York painting furiously because of what he alleged to be American cultural imperialism. In the winter of 1971, he published an article titled "Two Cultures" in *Studio International*. It was the opening shot in a prolonged campaign on behalf of British art, which he felt was being eclipsed and marginalized unfairly by American art. He demanded, in overheated rhetoric, that the British art world stand up against "a gang of American art promoters whose Madison Avenue techniques of publicity, whose ruthless cultural chauvinism and whose positively Wall Street financial resources combine to form a gigantic steamroller."

A number of Heron's accusations rang true. American painting had pushed British painting out of the picture. British art deserved better, particularly from British critics, many of whom had obsequiously joined an American bandwagon. New York artists hogged the walls of London museums and galleries, and the reputations of many were overinflated. There was no doubt in my mind that the best of American painting was better than that of Britain. However, I did sympathize with Heron's frustration, and I agreed that British museums should support British artists more than they had.

Heron was so extreme in his attack that he got a reputation, even in England, of being a chauvinist and something of a crank. In 1974, he published three lengthy articles in *The Arts Guardian* in which he maintained that the history of post-World War II art had been distorted by American brainwashing. The English had done it first and had shown the way to the Americans. Heron claimed that "colour stripe painting was not initiated by Morris Louis but by myself," and that Peter Lanyon "enormously" influenced de Kooning—and besides, was a far superior artist. Heron would also claim that with the exception of Pollock, the abstract

expressionists "developed their known styles in a matter of months. It looks as though someone had said around 1948 in New York, 'make it big! make it flat! make it empty!' And hey presto: . . . by 1950 the change was complete, and Abstract Expressionism was there; a whole group; indeed, a school." Heron concluded that New York "had come to the end of the line," but its cultural colonization still had to be resisted.

Although Heron had pegged me as an American culprit, he invited Lucy and me to visit him one summer in the mid 1970s. His house was aptly named Eagle's Nest. Situated on top of a hill some 400 feet above cliffs that plunged another 400 feet to the ocean, it provided some of the most stunning vistas in Cornwall. For the four days we stayed with him, we argued most of the time. He insisted that he had influenced Greenberg. I countered that Greenberg learned his color principles from Hans Hofmann and did not need Heron's instruction. (I later sent Heron my essay on Hofmann.) I don't think I convinced him. Nor would he accept that New York artists rarely gave English artists a second thought. Though cordial, he was the most stubborn man I ever met. I'm not sure he heard anything I said but if he did, he was unshakable in his own opinions.

Heron's obstinacy may have been bred in his English bones. He pointed to an unused field behind his house and recounted that warplanes from the aircraft carrier *Ark Royal* had swooped down over Heron's place and simulated bombing the field. His protests to the Admiralty were to no avail. Then the field went up for sale; Heron immediately bought it, and turned it over to English Heritage. That stopped the warplanes. Months later, at a reception, Heron was introduced to an admiral who said, "Heron? Heron? Are you the Heron who made us move the *Ark Royal* four-hundred miles so we could continue our maneuvers?" Do anti-establishment nonconformists in the establishment exist anywhere else but Britain?

---

Tom Hess admired poets and engaged a number as *Art News* critics, notably Frank O'Hara and James Schuyler. Tom and the poets took to each other because they were cultured and cosmopolitan. The poets liked avant-garde art and the New York school artists because the artists attended their readings, and they befriended them. As writers, it was natural for them to become art critics. My favorite was Frank.

I admired Frank's poems because of their artistry and, as his friend John Ashbery wrote shortly after he died, because they "are all about him and the people who wheel through his consciousness, and they seek no further justification. 'This is me and I'm poetry—baby,' seems to be their message. . . . Such a program is absolutely new in poetry. . . . Here everything 'belongs': unrefined autobiographical fragments, names of movie stars and operas, obscene interjections, quotations from letters." Ashbery likened O'Hara to Pollock because both demonstrated "that

the act of creation and the finished creation are the same.... The work of both is in the form of a heroic question: can art do this? Is this really happening?... Frank O'Hara was the first modern poet to realize that the question was there, waiting to be asked, and he formulated it in terms of the highest beauty."

The painting most akin to Frank's "autobiographical monologues," as Bill Berkson called them, was Larry Rivers' smorgasbord of heterogeneous images culled from his personal experience. It is not surprising that poet and painter were the closest of friends, so close that Frank posed naked (with his boots on) for Rivers in one of his most notorious portraits.

Frank's love of contemporary painting led him to adopt a public role in the New York art world, not only as a critic but as a curator for the Museum of Modern Art as well. In private he assumed the role of the friend of artists. Frank had the ability to pay attention to someone he liked so intensely that the favored one could only feel like his best friend. As Rivers said in his eulogy at Frank's graveside, he had the abundance of passion to have had dozens of close attachments. (He had been killed in 1966 in a freak accident, run over by a car on Fire Island where traffic was forbidden.) Frank's attention was of vital significance to artists; it literally sustained them.

Frank was witty and often bitchy, his bitchiness adding bite to his wit. Yet, with respect to the artists and art professionals he was attracted to, he was uncommonly generous. Early in my career, he tried to help me along—that is, not just talked about it but really tried, without saying anything to me. In 1966, shortly before his death, he asked if I would co-curate a retrospective of the painting of Bradley Walker Tomlin at the Museum of Modern Art. I was delighted and touched by his offer.

Frank was catholic in his taste, embracing artists as diverse as his friends Rivers, Joan Mitchell, Michael Goldberg, Grace Hartigan, Norman Bluhm, Elaine de Kooning, and Jane Freilicher, as well as Willem de Kooning, Pollock, Motherwell, Robert de Niro (the actor's father), Robert Rauschenberg, and Andy Warhol. He favored both abstract and figurative art, but in the middle fifties, he was particularly drawn to painterly realism. In an article titled "Nature and the New Painting" (1954), he wrote that figurative artists who took their cues from de Kooning's *Women* rebelled against Clement Greenberg's dictum branding all figurative painting as backward-looking, derivative, and second rate. In rebuttal, Frank condemned Greenberg's high-handed pronouncement as "narrow" and idea-ridden. I, the enemy of all ideologues, wholeheartedly agreed.

---

I learned how to write while the art critic for the *New York Post.* Trained as an academic, I developed my ideas step by step, building up to a conclusion. My editor

took my first article, and without really looking at it, scissored the last paragraph and pasted it at the top. "Put your main idea up front. That'll keep people reading on," he said. "Besides, if they are short of space in the editing room, they'll cut you from the end." Then my editor changed every French-derived word, such as any word that ended in "-ion," to its Anglo-Saxon counterpart, and made every passive verb active. He would cross out "inhibit" and pencil in "curb." "Yeah," he would say: "Now it has punch." Years later, I wrote the first draft of my history of abstract expressionism in New York tabloid style. The publisher insisted that I use bigger words to make it sound more academic.

At the *Post* I was free to write as I pleased. At $25 an article, my editor was in no position to dictate, and he didn't care enough to want to. He had never been to a commercial gallery, but inspired by a review of mine, he went to the Guggenheim Museum. His report was: "Never again." I was pressured only once, in 1964, when I chided the New York legislature in Albany, controlled by the Democratic Party, for dragging its feet in passing a law permitting artists to live in their lofts. My editor received a note from the publisher—she was never referred to by name, only by a glance upward—the gist of which was: Keep your damned art critic out of politics.

In my first article, in September 1961, I took aim at John Canaday, the senior critic of *The New York Times*, as the exemplar of "critics who yearn for the death of abstract art [and therefore are unable] to treat it or its tradition seriously. Basing their criticism on notions of what art should be, these critics avoid considering actual works of art, how they evolved and why." I concluded that Canaday was "reduced to assassinating the character of Abstract Expressionists, calling them— and the museum curators, critics, educators and collectors who admire their canvases—'charlatans' and 'freaks.'"

I promoted New York school painting and sculpture at every opportunity. The following month, I hailed a large survey of paintings *American Abstract Expressionists and Imagists,* at the Guggenheim Museum, observing that "the display, in its multiplicity, should do away with ideas that Abstract Expressionism is a uniform style or that these artists have painted themselves in a corner and will presumably be incapable of further developing their art—a claim a certain leading newspaper critic has been making for years." I also promoted second-generation artists, but not those I branded as "the superficial parodists, the 'craftsmen' who have little more to offer than their facility, and the pastiche artists adept at camouflaging conventional content with a 'new look.'"

I received letters from readers at the *Post*, several of which I treasured. In 1962, Stuart Davis sent in a postcard, which thanked me for my review and concluded that he likes a man with the right attitude. Most of the mail was negative. Artists eclipsed (justifiably) by abstract expressionism protested to my editor. Frederic

Taubes, infuriated by my laudatory review of de Kooning's show in 1962, casti-
gated my writing as senseless drivel masquerading as art criticism. A notarized
note declared that I disgusted its sender. My favorite letter was from a
"Commander Whitehead" (a well-known character in a soft drink advertise-
ment); it read: "Congratulations on your exciting reviews in the *New York Post*. In
this corrupt and decadent world it is gratifying to find a person who has the
honor and integrity to stand by his friends no matter what kind of shit they are
producing." I was sure that the letter was written by a "friend" of mine, but I could
never figure out who.

From the middle sixties on, I continued to follow current art closely and to write
about it. I also curated shows in museums and galleries, but I devoted more and
more time and energy to writing a history of abstract expressionism and subse-
quent movements. It seemed scandalous to me that more than two decades after
abstract expressionism's inception no comprehensive treatment of its pioneers
existed. Had these artists been Parisian, a dozen books would have appeared hail-
ing them as jewels in the diadem of French culture. I figured that I, as a trained
historian, should undertake it. It would also be my homage to the painting and,
hopefully, a contribution to art history.

But first, I would have to organize the random art-historical information I had
acquired. I was given the opportunity in 1958. The week the fall semester at Pratt
Institute was to start, I received a phone call from the dean who informed me that
the assigned professor had suddenly dropped out. Would I teach the course on
the history of modern art? I managed to stay a week ahead of my class by cram-
ming. By the end of the semester I had greatly increased my knowledge of mod-
ern art, and learned that I liked teaching and that I was appreciated by my stu-
dents. Internal politics at Pratt prevented me from being rehired, but I soon
received a call from New York University's Adult Education Department and was
asked to teach a field trips course. My students and I would visit New York muse-
ums and galleries every week. Those taking the course for credit would have to
write a paper a week on an assigned artist or theme. I enjoyed this course, and I
taught it at NYU and later at the State University of New York at Purchase until
2001—that is, for the remainder of my teaching career.

My field trips course led to my appointment as an instructor in NYU's
Department of Art Education. There, I taught modern and contemporary art until
1970. I also enrolled in a doctoral program, since a Ph.D. was necessary for pro-
motion in academe. It seemed to me that I would continue teaching, if only to
support my art criticism. For my dissertation, I would write a history of abstract
expressionism.

In 1964, I received a Guggenheim Fellowship. My deans at the university

crowed about the great honor bestowed on me that redounded to NYU. However, when my advisor learned that my Guggenheim project was to be on the same subject as my doctoral thesis, he turned up a rule decreeing that I had to change the topic, presumably because outside nonacademic pressures might be brought to bear on me. I could never fathom what they might be. In order to be promoted and gain tenure, I was required to complete a doctoral dissertation within six years, but I could not undertake any new topic because I was committed to survey abstract expressionism first. Thus, ironically, winning a Guggenheim set back my academic career some eight years.

In the spring of 1971, still minus a Ph.D., I was asked to leave the university. The deans said they were sorry. After all, as my chair Howard Conant told me, I had been working for many years at a level which far exceeded my rank and salary. Once I received my doctorate, they hoped they could rehire me—and even jump me two ranks to an associate professor.

The year before my "resignation" from NYU, I had begun to teach part-time at State University of New York at Purchase (now Purchase College). I continued to work on a dissertation that would become my next book, *The New York School*, but I did not announce it officially to the outside world until the doctorate was conferred.

In the process of pursuing a Ph.D. I grew to hate the system of graduate education, which struck me as the last bastion of medieval authoritarianism in the Western world. By this I mean that a graduate advisor has a student completely in his or her power. The professor can destroy a student's career without recourse—and in many cases do so without remorse. I know from my own experience that more academics than their institutions would admit are "certifiable" but, given their tenure, they can't be fired.

Take my own case. In the school of education at NYU, a graduate student is required to submit a full dissertation outline that generally takes him or her a year to complete. An anonymous professor is supposed to read it, evaluate it, and make suggestions to the student. No one fails, but a lukewarm recommendation to proceed is a sign to the student to quit. I received a halfhearted approval. The professor's comments were so irrelevant and asinine that it was clear to me that my outline had not really been read—scanned perhaps, but not read. Furious, I stormed into the dean's office and demanded that he read my outline and evaluate the outside reader's comments. A few days later, I received a letter from the dean upgrading my evaluation. I would not let the matter rest and again accosted the dean. I told him that I could meet with him because I was a faculty member, and a distinguished one at that, but what of a lowly graduate student who had spent a year working on an outline only to have some irresponsible creep toss it off? What about that? The dean mumbled some apology. When I was on the

board of the College Art Association, I tried to raise the issue of academic fascism, but my fat-cat associates would not listen.

I received my Ph.D. from NYU in 1976. I was still an instructor at SUNY Purchase, even though I had a book published and much more. With my degree I was quickly jumped to a full professor with tenure—such is the power of the doctorate in academe. I never forgave NYU. When I was later asked to return as a full professor, I declined, and I subsequently refused to serve on a dean's advisory committee. Lucy, however, taught art history at NYU both in the undergraduate department of the College of Arts and Sciences, of which she was the chair for fifteen years, and on the graduate level at the Institute of Fine Arts.

The loveliest Ph.D. perk occurred when Philip Pearlstein wrote me a letter dated October 24, 1976, which read: "I promise to make a portrait drawing of Lucy Sandler, in profile, in front of their living room window (viewed from inside) (Lucy also inside) with the N.Y. harbor in the background, sometime during the year 1977. To honor Irving on his elevation to Ph.D." The work consists of a print based on a watercolor he had made earlier of lower Manhattan from our window. It took him thirteen Sunday mornings to finish the image. My daughter, Cathy, then aged ten, stood beside him counting windows to make sure he didn't miss any. Philip then painted a portrait of Lucy, cut it out, and floated it in front of the print. He also asked Lucy and me to pose naked. I was willing, but she refused.

Beginning in 1970, I taught the history of modern and contemporary art at SUNY Purchase for almost three decades. It was an excellent department, made up of professional artists who had credible exhibition records but were not stars. In most cases, they were conscientious instructors. Art history at Purchase was originally assigned to the Division of Visual Arts. However, at a time when the division was ineffectively led, the Humanities Division ripped off art history, but I remained in Visual Arts. I was repeatedly asked to shift from Visual Arts to Humanities, but I refused. I wanted to be with artists, not academicians, most of whom I found mediocre and boring. More important, I could help my artist colleagues in the art world—and at Purchase, particularly after I received my Ph.D. The terminal degree for artists was the M.F.A., which was not much of a weapon in academic infighting. Besides, my artist colleagues were too busy making art to play college politics. But too many humanities professors at Purchase seemed to spend more time at intrigue than at scholarship, and they were adept at it; the differential in our pay scales was proof of their skill. My doctorate carried as much weight as that of my colleagues, and my publication record was better than most. At one point, I was asked by the president to meet with the head academic honchos to discuss transferring me from Visual Art to Humanities. I listened quietly to the reasons for having a unified

board of art-historical study and said: "O.K., shift me, if that's what you want. But then, like so many of our colleagues, I'll sit on my fat tenure and become dead wood." That ended any talk of moving me.

I gave teaching my all and enjoyed it, particularly the interaction with art students. It also provided me with the most efficient way of supporting my art criticism and history, efficient because I was enabled, indeed encouraged, to write.

---

I began work on *The Triumph of American Painting: A History of Abstract Expressionism* with two aims in mind. One, I would be inclusive rather than exclusive. In an epigraph at the beginning of the introduction, I quoted Albert Camus's *Notebooks 1942–1951*: "I have the loftiest idea, and the most passionate one, of art. Much too lofty to agree to subject it to anything. Much too passionate to want to divorce it from anything."

My second aim was to treat abstract expressionism with "'the sympathy of a man who stands in the midst and sees like one within, not like one without, like a native, not like an alien,' to cite Woodrow Wilson's conception of the historian's role."

Consequently, revealing the aims and beliefs of the artists was of prime importance, because it illuminated the actual evolution of their styles. I was acutely aware of the pathetic fallacy, that what artists said about their work was not necessarily what it expressed and that there were other meanings of which the artists were unaware that merited consideration. However, an artist's remarks, "no matter how private, can be true revelations and can be checked against the evidence on the picture surface, verified, as it were, or at least made comprehensible.... The ultimate test, however, is the work itself. It must convince one that it embodies the meanings that the artist (or anyone else) attributes to it, else any discourse concerning content is irrelevant."

When I began my survey, there was relatively little published on the new American painting. Consequently, I had to dig up the facts myself, and to do so I went to the artists, jotting down their comments (in that pre-tape-recorder era). In the process, I met most of the major abstract expressionists and many more of the minor ones.

My work then, at its source, was an oral history. This approach is now under attack because memory, even collective memory, is often faulty. It can be selective, biased, and self-serving; conflate events; slant the facts to fit new needs; or get them flat-out wrong. It quickly occurred to me that the stories that artists told were conflicting, full of discrepancies and inconsistencies. Trying to sort them out made me think of the Japanese film *Rashomon*, in which every character had a different interpretation of the same event. As I proceeded, it became increasingly

clear to me that my interpretation depended on which artists I considered signif-icant. That determined the weight I gave to the artists' narratives. As is the case with all historians, I not only chronicled the history but also to a degree invent-ed it. However, I did not want to depend solely on my own taste and opinions. I solved the problem by establishing a consensus of the artists and art profession-als I interviewed—and respected.

My desire to formulate criteria other than my own led Greenberg to write me a letter soon after the *Triumph* was published. He wrote: "My one main criticism is that you didn't mix enough *criticism* with the description & narration & expli-cation. No artist—like no public figure—should be taken at his own word. In the end you do yourself a disservice by that acceptance, however much it wards off what's called controversy. You have your own opinions: why not express them?" I responded: "Reading about what a critic thinks is good or bad bores me. What I care about are ideas or insights that open up ways for me to see and think. And I believe that it was this in your writing that made it important, not your taste.... One more thing, you can write and that counts for a great deal."

Although I downplayed my likes and dislikes in my surveys, I kept chewing over the question of what makes one work more expressive or better than another. What makes it *matter*? What was it in Kline's *Chief* that gripped me? What makes me think that it is of superior aesthetic quality? Why do I think that de Kooning, Pollock, Guston, and Rothko are better artists than Byron Browne or Henry Botkin? Why does the art world agree with me more or less? Does their recognition have to do with formal attributes? Is artist x's repetition of angles better than artist y's? Am I the only art historian who feels like throt-tling the nth lecturer who does the angles bit for the nth time? Does expressive-ness depend on aesthetic quality, as Clem would say? Is de Kooning as good a painter as or a better painter than Picasso? What does this mean? When de Kooning deflected Picasso's cubism, why did he do it? Was he out to "beat" Picasso? At what? The more I have thought about it, the more persuaded I am that de Kooning had other things to express—that is, an attitude, outlook, feel-ing, or mood about his experience in his historic moment that felt more real to him and to us than Picasso's painting did. And he did so with such specificity and profundity that it continues to engage later audiences.

After my survey was completed, my publisher called and said, "The Book of the Month Club wants to offer some 10,000 books to its membership but wants a livelier title than "'A History of Abstract Expressionism.'" My editor suggested "The Triumph of American Painting." I thought, triumph means victory, but over what? Paris? That kind of triumphalism was not to my liking. I asked: "Why stop at triumph, why not apotheosis?" My publisher replied: "That's not funny. Read your contract. The choice of title is ours." Well, I thought, triumph also meant

celebration, and "*Triumph*" it was. After the book appeared, Harry Abrams invited me to lunch. He took me to a good restaurant—at the next table was Otto Preminger—so he must have wanted something. At one point, Harry asked: "Why didn't you give Abrams the book?" I replied: "What's so important about it?" He said: "Oh, it's not what you wrote, it's the title, a stroke of genius."

While I was working on the *Triumph*, I never thought that I was establishing a pantheon, but as the book became popular it was soon clear that I had. I hated the idea, but I had no further say in the matter. Nonetheless, I was taken aback when Carter Ratcliff referred to me as "the New York School's recording angel" in an article on the art establishment in 1978.

When I decided to survey abstract expressionism, I thought that the history I should have been writing was that of the second generation, my generation. However, I recognized that the *Triumph* needed to be written first. After it was completed, I began to survey abstract expressionism's successor, which resulted in *The New York School: The Painters & Sculptors of the Fifties*. I knew most of its members, and many were friends. Aside from the fifties styles that continued gesture painting, I dealt with distinctive new tendencies, among them the Cage-inspired work of Rauschenberg, Johns, Kaprow, and other makers of assemblage, environments, and happenings; the hard-edge abstraction of Kelly and Held; the stained color-field painting of Louis and Noland; and other styles of new abstraction, such as those of Parker and Stella; as well as the figurative painting of Katz and Pearlstein, which would usher in a "new realism." I thought I had covered all the bases fairly, but Carl Andre told me: "Your book is primarily about Rauschenberg and Johns." In retrospect, I believe he was essentially right.

By the time I finished *The New York School*, it occurred to me that writing histories, generation by generation, had become my forte, and I ought to make it my life work. Hence, I began a survey, titled *American Art of the 1960s*. By then the New York school had become so established that it no longer needed defending. Moreover, I had begun to wonder why I had been embattled in the first place. I would now question all blinkered standard-bearers. Hence, I became increasingly impatient with all true believers enlisted in the cause of formalism or neo-Marxist social commentary or any other "ism." Indeed, I pitched in an opposite extreme; I became open to every and any tendency in art, or at least I tried to understand them all. As the 1960s progressed, I became an ever more passionate anti-ideologue. Openness was congenial to me, rooted in my being, as it were. I had come to look upon my "self," whatever that might be, as an arena of shifting, and often conflicting, impulses and attitudes—before it became an axiom of fashionable critical theory in the 1970s and 1980s. My many-sided sense of self caused me to respond to multiple tendencies in art. I also grew skeptical of claims that art had gone into decline or had even died—after abstract expressionism or color-

field abstraction or minimalism or whatever one's last passion in art was. As I saw it, art was constantly changing, but the best continued to be as vital as ever.

My next survey was titled *Art of the Postmodern Era: From the Late 1960s to the Early 1990s*. Writing it, I no longer felt the need to know personally all of the some 150 artists I dealt with—and given the number, it was not feasible. I befriended many, but it was sufficient to follow closely shows of new artists in galleries and museums, read the proliferating articles, catalog introductions, and monographs, and attend the frequent lectures and panels. This history was my most varied, since pluralism had become the situation of contemporary art. I decided that *Art of the Postmodern Era* would be my final survey. It was time to turn over this enterprise to young critic-historians. But contemporary art continued to engage me, and I continued to follow it closely in galleries and studios—and to keep writing about it in reviews, articles, catalog introductions, and monographs.

# The New Academy:
## Joan Mitchell, Raymond Parker, Grace Hartigan

I lived through the 1950s at the epicenter of the New York school. I was a partisan of gesture painting, unreserved in my admiration of first-generation artists such as de Kooning, Kline, and Guston. I also had a high opinion of younger artists, notably Helen Frankenthaler, Michael Goldberg, Grace Hartigan, Al Held, Alfred Leslie, and Joan Mitchell, but I did not consider them the equals of their elders. Increasingly, I also questioned the painting of the growing legion of followers. By 1958 it had become clear to me that gesture painting had become an established style and, if not yet a new academy, then well on its way to becoming one. Indeed, 1958 was a turning point in American vanguard art. Yet, I was hesitant to make my feelings public, at least until the early 1960s, fearful that my doubts might harm artists whose work I prized. I would hold negative judgments to myself until I was certain that it was no longer necessary to close ranks in the face of hostile art-world and public opinion.

Perhaps I'm not stating my partisanship strongly enough. Until 1958, I was a true believer. As I viewed it, gesture painting could still yield original styles, or at least individual or personal ones, or put artists in a better position of achieving such styles. The works of Mitchell, Hartigan, Leslie, and Goldberg called to mind de Kooning, to be sure, but they didn't look alike; nor did they resemble those of Frankenthaler or Held. Still, I was nagged by the question: How really different were they all? Had I been looking at trees and not seeing the forest? Had a set of living premises become a dead dogma?

Of the younger abstract gesture painters, I most admired Joan Mitchell. In 1956, I asked Thomas Hess if I could write an article on her for *Art News*—the first for both Joan and me—and he said to go ahead. It was to be one in a long-standing series on artists in the process of creating a work. For a beginner, it was a good essay to write because it dealt with an artist's intention, which could be determined by following the step-by-step progress of a work while talking to the artist. My conversations with Joan were very drunken. She could hold her liquor, but I couldn't hold mine. I took notes scrupulously only to discover the next day that just the first few pages were legible; the remainder was scribble-scrabble.

In many ways, Joan typified her generation. She recognized that she was a fol-

lower, a member of the New York school, but she also believed that she could create a personal style—and she did. She readily acknowledged her debt to her artistic elders, and accepted de Kooning and Kline as her mentors. Was she an action painter? "No, I spend too much time looking, which stops action." Was Pollock an influence? "Not much. I am too traditional." But did she consider herself avant-garde? "An avant-garde is by definition dated. Manifestos are obituaries. The moment something is clarified, it's dead. There is no one valid way to paint. Newness and originality as such have nothing to do with painting. I don't paint to be avant-garde or to be in history. I would like to be in the history books, but I don't set out to be."

When I asked Joan what it was about de Kooning's and Kline's painting that gripped her, she replied its "crudeness and accuracy." Seeing their work made her abandon the "tasty French pictures" she had been painting. Furthermore, de Kooning's and Kline's canvases had a "New York look." Could she specify what it was? She answered by contrasting her work to "spacey" California painting. "I am always conscious of four walls in the city—I live on the fourth floor of an East Side tenement—and I am up against the wall looking for a view. California space is panoramic. If I was out there, I'd probably find four walls. I am an urban person." Joan grew up in Chicago, near Lake Michigan, whose storms made a indelible impression on her as a girl. In her work in the fifties, as she painted, she tried to recall her memories of city and water and the intense feelings they gave rise to. A favorite image was an amalgam of bridges and trees: man-made architecture and nature.

In 1956, Joan's self-characterization as a second-generation abstract expressionist artist was acceptable in my circle. As a young, avant-garde, and ambitious painter, what else could she be? However, this view soon troubled me. I acknowledged that Joan's painting was "felt" and in its lyrical references to nature, a fresh departure, but it did not compare in range and depth of feeling with that of de Kooning, Kline, and Guston. What was it, then, that made the difference? There was nothing wrong in working in a tradition if an artist extended it in an individual way, which Mitchell had, but the tradition was originated by Pollock, de Kooning, and others of their generation. Innovation *counted*.

In the picture Joan began for my article, a 90-by-80-inch canvas, she quickly brushed a horizontal central image that to her suggested a bridge. A few weeks later, she phoned to tell me that she "lost" *Bridge*, as she titled it, and guessed that the article would have to be abandoned. I said: "No, begin another, and I'll be able to contrast the failed picture with the new one—that is, if you can complete it. In that way I'll be able to specify just what you believe makes for a successful painting." I later asked her what was wrong with *Bridge*. She replied that it lacked "intensity" and "accuracy."

Joan started another canvas of roughly the same size as *Bridge*. She said that the subject was her memory of a beloved dog she once owned who jumped into

the water in East Hampton on a pleasant, sunny day. She laid down a large splash of yellow, which she whitened as she remembered a hurricane that swept over Long Island that summer in which several of her paintings had been destroyed. It ended up being titled *George Swimming at Barnes Hole But It Got Too Cold.* It turned out to be one of Joan's finest works.

What to do with the aborted *Bridge*? Joan decided to junk it. I happened to visit her at the moment she began to rip it apart, and I begged her to stop. Just then, Michael Goldberg dropped in, and the two of us persuaded her to save it. A few weeks later, Joan phoned and said: "I have to leave for Paris and don't want *that* picture in the studio when I return. If you're here within a half hour, it's yours; if not, out." I was there. I then had the canvas stretched and hung it in our living room; it replaced one entire wall. A year later, Joan came to visit, studied *Bridge* very closely, and announced that she could complete it and wanted it back. I told her to start another one. *Bridge* remained with me. In time, Joan accepted it as a finished work.

*Bridge* had a further history. *George* was acquired by the Albright-Knox Art Gallery. Robert Buck, its director, asked that we bequeath *Bridge* to his museum as the companion piece to *George,* and Lucy and I agreed. Then, Buck left the Albright-Knox to become director of the Brooklyn Museum. He announced to us: "The picture goes to Brooklyn, of course." I responded: "Why? Just because you moved, why should the picture move?" He said: "That's not the reason." "Well, what is it?" "Both you and Lucy were born in Brooklyn." I had to think for a moment to remember that I was. It was more than we could resist; *Bridge* would follow Buck to Brooklyn. Shortly before Joan died, we met her at her opening at the Robert Miller Gallery. Even before she said hello, she greeted us with: "Ya sold it, didn't ya?" We were so appalled that the next day we phoned the Brooklyn Museum and gave them the picture, keeping a life interest in it.

Joan and my other artist friends aspired to paint honestly. They claimed to want to tell it like it was, no matter what. Their pictures did look raw and crude, a look we believed signified the struggle to reveal emotion—no matter how unseemly—truthfully. Call a picture "beautiful," "handsome," "elegant," or worst of all, "tasteful" or "decorative," and you were looking for a punch in the nose. "Telling-it-like-it-is in art" was often carried over into life—often over the edge of boorishness. Joan was notoriously disagreeable, and she was aware of her reputation. When she knew she was going to die, she imagined that if there was a memorial, a close friend of hers would most certainly be invited to speak. She told her friend to ask those who attended to take a moment of silence in order to forgive her for one terrible thing she had inflicted on each of them. Her friend did. Looking about, I saw people figuratively counting one, two, three . . .

Joan was not alone in her unpleasantness. Many of her fellow artists were as surly as she was; it was a kind of collective lifestyle. They desired to avoid the good manners of the hated middle class. Excessive drinking contributed to their nastiness. Paranoia was another cause. It was impossible to tell why one artist should receive recognition and another, not. It was easy for the losers—and everyone seemed to feel that he or she was a loser in some respect—to believe that there was an art-world conspiracy against them. In fact, paranoia and alcohol were the occupational diseases of the art world, and they made artists bad-tempered.

If being rude, at its best, had to do with being honest, at its worst, it was a pretentious ploy to put down others. The snobs carried on like alienated geniuses, proclaiming that in their studios they were alone, existentially naked, and anxiously confronting the void as they sought for an authentic image. Sacrificing all for their art entitled them to arrogantly patronize non-artists—presumably philistine enemies—as well as most other artists, who supposedly had not suffered enough and/or allegedly "sold out." Brian O'Doherty branded these artists "a young breed of tough guys who thought their certificates of inheritance had been stamped by Pollock and Kline and de Kooning and that the future was theirs by divine right." I put up with obnoxiousness as well as I could because I needed the artists' help in writing my history. Grace Hartigan did apologize for being horrible to me at one of her openings in 1978, adding that I, as an artists' friend, knew how such events brought on temporary insanity. I was grateful for her comment.

I must admit that I was intimidated by my artist acquaintances. I did not envy any of them as artists and certainly not as people, but I felt that my position as critic was subservient to theirs. Even when I became confident in my own achievement, I could never emulate their arrogance, even if I wanted to, which I did not. However, some of the hubris of my artist friends seemed to rub off on me. I once participated on a radio program with Stuyvesant van Veen, a former president of Artists' Equity. We went out for a drink afterwards and at one point he turned to me and said bitterly: "I've been on juries with youse guys. There's always one conservative, one man in the middle, that's me, and one of youse guys. The conservative and I bend over backward to consider seriously the art of youse guys, but you won't even acknowledge that we too make art." I had to admit that I was one of the "youse guys" he was referring to.

Joan's nastiness did not lessen with age, but her painting became increasingly lyrical, particularly after 1967 when she spent more and more time in France—in the countryside where Monet painted. Joan may have preferred France because in the heyday of pop and minimal art, she found the New York art world hostile. Or, as her work grew lyrical, she may have found the French regard for the beautifully painted picture more to her liking, reversing the first generation's rejection of the school of Paris. Moreover, Joan now looked for inspiration to Hans Hofmann,

the hedonistic odd-man-out of abstract expressionism who continued to pro-claim the superiority of French painting.

————

The attitude of Joan, Goldberg, Held, Hartigan, and Frankenthaler was different from that of their mentors, and the difference became increasingly significant to me as the fifties progressed. The older artists were innovators, not followers, pio-neers, not colonizers. Their paintings, at least the ones that moved me the most, seemed scarred by anxiety from the psychic wounds inflicted by World War II, its Cold War aftermath, the revelations of the Holocaust, and the threat of nuclear devastation. In other words, when the older artists painted their most meaning-ful work, they were in the grip of a "crisis" mentality. They were the kind of artists that Renato Poggioli had in mind when in *The Theory of the Avant-Garde* he wrote that "dominated by a sense of imminent catastrophe [they strove] to transform the catastrophe into a miracle." These "victim-heroes" embraced "sacrifice and consecration [with] hyperbolic passion, a bow bent toward the impossible, a par-adoxical and positive form of spiritual defeatism."

The second generation was not as troubled by the crisis mentality as the first. The anxiety that pervaded life in the forties dissipated in the fifties (even for first-generation artists). World War II had receded into the past. And despite the con-tinuing threat of nuclear devastation and the Korean War, the Cold War had cooled. Moreover, the United States was becoming a prosperous consumer socie-ty, and life was better than ever. In any case, American artists seemed to have come to terms with angst, and besides, were beginning to partake of the bur-geoning affluence. As a result, the younger artists used the formal innovations of their elders but turned to art history and visual reality for subjects.

As if responding to the changed social situation, the work of the younger artists was easy-going and appealing, certainly compared to that of their heroes. Even at its rawest, it still looked mannered. That troubled me. Were these heirs of abstract expressionism deficient? Or was their painting just too unlike that of the older generation to compare?

A few younger artists denied that anything had changed. As Grace Hartigan said in 1958 at a Club panel titled "What We Don't Have to Do Anymore," "Painters of ten years ago are still painting and their work today has a tremendous vitality. If a condition exists that makes their painting vital, it exists for us as well." Alfred Leslie claimed to see no difference between himself and the older artists. He never forgave me for making that distinction in my surveys. We once participated on a panel together. As we climbed onto the stage, he told me, as moderator, to ask him whether he was a second-generation artist. When I did, he attacked me vehemently for even raising such a stupid question. He insisted that

he was a contemporary of de Kooning. Al Held, another panelist, came to my defense. I just sat back and smiled inwardly at being set up. But there was a difference between Leslie and de Kooning, and Leslie knew it.

My artist friends on Tenth Street recognized that the generations were different. They asked why, and what it meant. In 1957, Angelo Ippolito acknowledged that the older painters opened up a vast realm within whose boundaries his generation could find room to work, avoid copying, and manage to be personal. However, he also warned: "We are in danger of becoming a new academy."

There was indeed that danger, as the art world was populated by third, fourth, and fifth waves of gesture painters. Young artists in escalating numbers, not only in New York but throughout America, were adopting gesture painting. I was of mixed mind as to whether this was good or not. On the one hand, their very number struck me as a validation of the tendency, proof of its significance and potential. I assumed that we had embraced the art of de Kooning, Kline, and Guston not merely because it was avant-garde but because it was true to our experience. We believed that our search was for what we felt was genuine and real in ourselves. Our struggle for authentic being was important because it was occurring at a time when the efficacy of a person's individual actions appeared to count for less and less. Humankind was in crisis—and gesture painting was addressing that crisis. As the sense of crisis waned, the work of Mitchell, Hartigan, and Frankenthaler understandably became more relaxed and agreeable, but their myriad followers were often lax and smarmy—and predictable. As Ippolito commented: "Action painting has gone on long enough to lose its risk. We know too well what can come out of it." More specifically, Paul Brach said: "When de Kooning drew a line, he hoped it would work. When a follower made a line, he knew he would erase it."

The very number of followers indicated that gesture painting was becoming a dead end. Most of them were clearly mediocrities, deficient in intelligence and ambition, churning out hand-painted illustrations of illustrations in *Art News* and *It Is*. To be sure, they recognized that copying de Kooning was livelier than copying Ben Shahn. Apart from that, they were servile mimics who fabricated pictures in someone else's manner, with minor deviations, or who mixed the styles of others, contriving a measure of "originality." Mastery had all too often become empty bravura. In the end, copying de Kooning was no less academic than copying Shahn.

The younger artists in the New York school had their reasons for continuing to work in established styles at the risk of appearing derivative or eclectic. They claimed that their painting was a "consolidation" of the innovations of the pioneer abstract expressionists—that is, it aspired to be "good." As John Ferren commented as early as 1955: "Consolidation is a conquest.... Abstract Expressionism has become more refined and relaxed, fewer nerves and more gray matter back of the eyes. In a word, better painted." Ferren concluded: "It could become an acade-

my but it hasn't. It is a movement and it knows it. It does not think it is a school because it has no one technique." But was this development of gesture painting healthy or an academic betrayal?

As artists embraced the idea of consolidation, the value of spontaneity and out-and-out improvisation was questioned. In the spring of 1955, the issue was debated at a Club panel on "Sculptural Influences on Sculpture." Sidney Geist asserted: "For me, sculpture is a conscious act." Ibram Lassaw countered: "I have an opposite point of view. I accept what doesn't come consciously, but we work on all levels. If I don't like it, I willfully change it. My muse helps me." Geist reiterated: "I make a sculptural statement and accident is not part of it. I once made a piece which broke in firing and looked better than the way I had made it. I had to destroy it." Lassaw responded: "Was your pride more important than the piece?"

Again, in the winter of 1957, the topic was "The Accidental in Art." Friedel Dzubas declared: "I believe in purpose and this precludes accidents." Geist agreed: "To trust in the accidental is a sign of intellectual and moral laxness. It is to proclaim the final beauty of driftwood. The artist as human driftwood who thinks that because I found it, it's good, is just as uninteresting." John Ferren challenged Geist: "What do you mean by moral laxity: the accident itself, the leaving of it, or the reliance on it?" "All of these," responded Geist: "They add up to the so-called happy accident. When it happens in the street, it is unhappy, but on canvas, it is always happy. When a bucket of paint falls on your head, it is unhappy, but when it falls on the canvas, it is happy." A voice from the audience: "If a donkey plays a flute and makes noises, is it music or just accidental?" Harry Holtzman quipped: "The donkey is a jackass." Ferren concluded: "We rationally used the irrational for purposes of revolt ten years ago. Is it still useful today?"

I met Nicholas Marsicano soon after, and in recalling the panel, he lamented the "loss" of accident. "Ten years ago we didn't want to make a painting out of reason or existing values. Therefore, we painted with abandon, spontaneously. We did a painting in one sweep." He then added: "The drip today is as much a technique of painting as impressionism was. The old kind of accident-making is now a conscious method. I wish to God I knew what the accidental was today so that I could use it. We've got to paint with our left hands."

Artists engaged in consolidation also reevaluated the role of subject matter. They now claimed that a "return to nature" was a viable option. Frank O'Hara became their champion. A Club panel in the winter of 1955 was devoted to his essay "Nature and the New Painting." From the start the question was the relation of nature to abstraction, and the more the panelists tried to spell this out, the more muddled the issue became. Reinhardt said: "All painting is abstract because it's constructed, including that of Constable and Courbet. They always talked about naturalism. I wonder what they meant." Kline picked up on Reinhardt's

comment: "Corot today looks like a naturalistic painter, but in his day, they told him nature didn't look like that." De Kooning then said: "Words and labels are very confusing. We need definitions. I'm not an abstract expressionist, but I express myself." There were audible rumblings and gasps from the audience at de Kooning's denial of a label that was applied to him more than any other painter. Reinhardt then asserted: "Painting should be about painting, not grass and trees or psychology." Wolf Kahn spoke up from the audience: "O'Hara wants to make us reconsider the subject. Abstract artists aren't interested in an old woman's legs, but Larry Rivers is." Reinhardt challenged O'Hara: "Is it valid to use subjects as keys into the painting?" O'Hara responded: "A painting can look like something." "It must transcend," retorted Reinhardt. O'Hara concluded: "A painting that looks like something can transcend. It just refers to life."

At a Club panel in the winter of 1956, Kyle Morris asked (once more), "What is the role of nature in painting?" William Kienbusch replied: "In the nineteenth century all painters painted outside and used umbrellas as shields from the sun. Americans today don't use umbrellas." Morris quipped: "What about Rauschenberg [who affixed an umbrella to one of his combine-paintings]?" A voice from the audience: "Gorky worked right from nature. The straight observation of nature may be very important now in order to paint inner reality." Angelo Ippolito interjected: "You don't need to get sunstroke to know about the power of the sun." Kienbusch disagreed: "You have to see the lily pond." "Or jump into one," retorted Ippolito: "There are many ways of struggling with nature."

Invited back to The Club in the spring of 1957 to deal with "The Artist's Involvement with Nature," William Kienbusch joshed:

> I'll begin with some jokes about Whistler. A woman came up to Whistler and told him that a painting of his looked just like a scene she saw on the Thames. He answered: "Ah Madame, nature is creeping up on me." A student once said to Whistler: "I paint what I see." Whistler said: "Wait till you see what you've painted." Picasso said: "I must evacuate the color green."

Again, in 1958, at still another Club panel, John Ferren looked out at the audience and asked: "Does anyone actually worry about this question?" A chorus of yesses.

At a Club panel at the beginning of 1958 on the changed situation of the New York school, Lester Johnson summed up the general attitude of young artists at the time: "We are indebted to artists who ten years ago revealed to us a new freedom. The old guys showed us new ways to paint. Now we are free to paint what we never could before." That included nature, art history—or variations on the styles of their elders.

My friends who studied with Hans Hofmann also spoke favorably of consolidation. Wolf Kahn recalled that Hofmann's teaching was based on two main ideas. The first was "that there is a mainstream that stretches from Cimabue to abstract expressionism and that there is a formal logic that governs all masterpieces past *and* present—a kind of formal common denominator which guarantees [their] quality." Kahn went on to say that he and his fellow students became art-book hounds, hunting for an underlying structure of all great paintings. This art-history mindset led them to become conservative. They appreciated Gorky and de Kooning because of their ties to the past but dismissed the more radical Still, Pollock, and Rothko. Hofmann's second idea was that there was such a thing as "good" painting, even "an ideal of a perfect picture" toward which students ought to be constantly striving. Consequently, the primary question was: Did a painting "work"? Thomas Hess characterized the Hofmann school as "an academy" but added, "in the best sense of that term."

A number of my critic acquaintances advocated consolidation too. Hess was the most vocal. He even praised an "aesthetic incest" on the part of younger artists because, by stealing from each other, painters quickly pushed an idea to all possible mutations. "This orients the individual to his basic talent, because he knows that alone remains his." But what if the product of his or her basic talent resembled that of a lot of other painters? In time that would trouble Hess.

Dore Ashton was equally positive in her justification of consolidation. She wrote that an international style of slap-dash abstract expressionism was being proclaimed as advanced art. Denying that claim, she proposed that "the real *avant garde* today consists of those who have acknowledged the victories and lessons of the 20th-century revolution and who calmly develop in a progressive, but defined line." Ashton was critical of the eclecticism and derivativeness of many young artists, of their cultivation of "elegant manners at the expense of magnificent dreams." She commended "talented pros," concerned "with such old fashioned considerations as quality of paint, durability of technique, and possibilities of subtlety within painting." I found Ashton's roster of craftsmanlike painters problematic. In 1958, she acclaimed her husband, Adja Yunkers, as well as Philip Guston, Esteban Vicente, Jack Tworkov, and Theodoros Stamos as "lyricists." She quoted Yunkers, who declared that he was "against spontaneity" and that "it is beauty and the profoundly considered that matters." But Guston was not a "lyricist," in his and my opinion, and her other pros did not compare with Guston, de Kooning, and Kline.

Besides, what was craft? I never forgot an early encounter with Henry Botkin, a johnny-come-lately action painter. He compared de Kooning's painting to his own mediocre rip-offs unfavorably because de Kooning's lacked "craft." I was not

sure what Botkin meant by "craft," but I knew that I was not interested in whatever he had in mind.

What did I believe? I entertained the idea of consolidation but with growing dissatisfaction—and a sense of loss. Wandering through the Tenth Street cooperatives became a boring chore. I wanted to make distinctions between one of the myriad gesture paintings and another, but I found myself not caring most of the time. Moreover, my closest artist friends—Held, Katz, Pearlstein, Sugarman, and Bladen—ridiculed consolidation as academic.

Although I was a member of the de Kooning camp, as the "manager" of the Tanager Gallery I was also in the midst of artists who were unsympathetic to his school although they admired him as a master. In 1957, they sensed a certain dullness in New York art—and wondered why. They asked whether the New York school had become a new academy and decided to assess the situation. The question, as they framed it, was: Given all the art that was being produced, what was vital and how might it be categorized? They decided to use their findings to arrange a series of exhibitions, each centered on a group of related artists, and to publish a book addressing the situation of current art.

All this required winnowing and classifying some 200 artists, a task that proved so complex that it took two months of frequent meetings to complete. Although the sessions were intense, they were also playful. Those in regular attendence were Charles Cajori, Lois Dodd, Sidney Geist, Sally Hazelet, Angelo Ippolito, Ben Isquith, Alex Katz, Philip Pearlstein, Raymond Rocklin, and myself as a notetaker and tabulator. They decided to avoid existing labels, such as abstract expressionism, abstract impressionism, and action painting, which, they claimed, were the outworn inventions of critics. Now, as artists, they would formulate fresh categories that would reflect artist opinion. It was not easy.

At one meeting of the Tanager members, it was suggested that artists might be grouped according to their intentions, processes, and products. Six subdivisions were proposed: One, the artist as craftsperson, producing a thing. Two, the artist as dreamer-out-there-among-the-nightingales, the work an evocation of his or her vision. Three, the artist as myth-maker, the work a search for private symbols. Four, the artist as hero, trapped in the painting or sculpture, the work a record of the struggle to escape. Five, the artist as shaman, lost in a trance, the work an incantation of the sublime. And six, the artist as scholar, the work an embodiment of his or her theory.

Another evening was spent trying to classify art under the headings of symbol, paint mechanics, personal mythology, explicit subject ("nature observed"), and implicit subject ("nature departed"). Pearlstein's categories were body, paint, sign, place, and thing. Isquith's list consisted of Sturm und Drang (Franz Kline,

Willem de Kooning); Now You See It, Now You Don't (Ad Reinhardt, himself); Ah! Wilderness (Pearlstein, Fairfield Porter); The Light Never Seen on Land or Sea (Philip Guston, Ippolito); Bellevue Psychiatric Hospital (Joseph Cornell); Erotica (Balcomb Greene, Louise Bourgeois, Marisol); and Radiation (Mark Rothko).

The book we worked on long and hard was not published. The Tanager members rejected Elaine de Kooning, and her husband refused to participate. Given his prestige, that was enough to bury the project. They thought that this might happen but decided to risk failure rather than compromise the integrity of the process. These meetings were critical to me. I learned who made up the New York school, or at least, the limits of its membership and its different constituencies.

In 1953, a number of New York school artists, motivated by a growing sense of group consciousness, curated an exhibition titled the *New York Artists Annual* at the Stable Gallery. The show inaugurated a series of yearly shows which came to be known as the Stable Annuals. The first group consisted of some ninety participants. Because it was organized by artists, it reflected peer opinion—and that's what made it count. Wolf Kahn recalled: "If you were in, you were *in.*" Anyone who heard about the first show and brought a work was included. By the third annual, so many artists wanted to participate that a committee of twenty-five artists was appointed to do the choosing. By 1956, the Stable Annuals, as Thomas Hess observed, had undergone "the historical change of fossilization." The jury, confronted by a multitude of newcomers on the scene, decided that rather than deal with them, it would pick only the "best" artists. The outcome was a group that was familiar to everyone. Many participants accused it of designating a new academy, and their voices prevailed. The Stable Annuals were terminated in 1957.

In 1958, the magazine *It Is* appeared. It was the brainchild of sculptor Phillip Pavia, who ran The Club from its beginning until 1955. An advocate of abstract art, Pavia meant for *It Is* to promote it, although he occasionally smuggled in an essay or an illustration of a work by a figurative artist. His coverage was broad, but he favored "the boys," as he called them—that is, the circle of de Kooning, the habitués of The Club and the Cedar Street Tavern, and the artists on Tenth Street. The magazine mapped out who was in and who was out and, according to the amount of space given to illustrations and statements, who was who and who was not. The New York school now had its own in-house journal to promote itself.

Most of the contributors to *It Is* were painters and sculptors who tended to write about their artistic intentions. I enjoyed reading their statements even though many were baffling, to say the least, as were a series of editorial-like articles written by Pavia. Much as I tried, I never could fathom what he meant. Neither, it seemed, could many artists and critics I knew.

Pavia was a close friend of mine. He and Landes Lewitin had sponsored me for membership in The Club, and I helped him on the early issues of *It Is*. After he retired from running The Club, he decided to write its history, which appeared in 1996. In 1965, I published an article on The Club in *Artforum*, and Pavia was enraged. I had infringed on his turf, and he went on the warpath. He made mutual friends choose between him and me, and many chose him. I was hurt. Had I not run The Club for six years—as long as he had—and wasn't I therefore entitled to write about it? Had I not been a standard-bearer of the New York school? Had I not preferred de Kooning to Pollock? I had been innocent enough to believe that I was one of the younger "boys." True, I also admired post-abstract expressionist art, such as that of Al Held, whom Pavia put down as a "Swiss" painter, whatever that meant.

What caused Pavia's venom? I pulled my file on him and understood. Pavia was embattled and needed enemies. As he viewed it, even the art galleries of the avant-garde were at war. The antagonists were the Parsons and Kootz artists, on the one hand, and on the other, the Egan artists. Pavia stood with Egan. He hated Greenberg because, as he said, he was on the side of Parsons and Kootz and promoted painters like Rothko, a Parsons artist, who "made watercolors out of Mondrian."

What was Hess's position on my alleged "treachery"? Pavia put him on the spot, and he sheepishly took his side but without cutting me off. When I asked Hess what he thought of my Club article, he said that I had gotten a few facts wrong, and he changed the topic. Hess was also ambivalent about Held. He was sufficiently impressed by his painting to allow me in 1964 to write an article about him for *Art News*, but instead of publishing a reproduction of his work from a color transparency (as was the customary practice), Hess economized by printing color onto a black-and-white photograph—and then only the orange and not the green. My support of Held was an indication to the gesture-painting establishment that I was deviating from the party line. Was that in part responsible for Pavia's enmity? Had the custodians of the New York school become so inflexible? At any rate, Pavia's feud was for me the last straw. I stopped caring whether I was in the good graces of Pavia or "the boys." (After abstract expressionism went into decline, I would encounter former friends who would respond reluctantly to my greeting with hatred in their eyes. Because I had ceased fighting the good fight, I had betrayed them.)

In 1958 the market for abstract-expressionist painting began an astounding upswing. In this respect, the "situation" had changed. What triggered it was the sale the year before of Pollock's *Autumn Rhythm* to the Metropolitan Museum for $30,000 (present value: upwards of $20 million)—a price beyond the imagination of anyone I knew. It was reported that de Kooning's paintings were beginning to

sell for about $9,000, Rothko's $6,000, and Kline's $4,000—staggering prices at the time. Also to our astonishment, much of the buying was by Europeans.

Many of my artist friends were also achieving success. They no longer had to renew their vows of poverty. A few found this disconcerting, or claimed to have. Charles Cajori and Angelo Ippolito bemoaned the change, charging that the acceptance of avant-garde art by the "enemy" perverted it. But most of my acquaintances accepted success as their due and became money-conscious as never before. Gossip about galleries raiding galleries and artists playing musical chairs became frequent topics of conversation—all too frequent, in my opinion. In a letter to *Art News* in January 1959, dealer John Myers deplored the artists' "wild scramble for new galleries. . . . What is the basis of this drift to big money?" I didn't like it either. Was I being pure or innocent? Of course, but I am still nostalgic for "the good old days" when we lived on dreams.

In 1957, the question of whether gesture painting had become academic began to be hotly debated privately in artists' studios and the Cedar Street Tavern. For example, Friedel Dzubas said bitterly: "Too many painters take Bill de Kooning's handwriting and sling their own undigested and immature hash into it. The upshot is a facile, empty, mechanical echo. Bill deserves better. The New York school is in a rut—academic, stagnant—falling back on what has already been established and doing that which is safe." In 1958, Herman Cherry lamented what he called "aesthetic opportunism. Now you can become something in the art world by copying the right guy and having a little talent." He went on to disparage "Love-lorn Artists," who crave affection, and the "Emily Posts of Painting," the good mannerists.

In 1958, I decided to bring the artists' private conversations on the new academy out into the open at The Club. I framed the issue as a question: What had changed from the late 1940s to the late 1950s? To begin, I asked Alfred Barr, Thomas Hess, and Harold Rosenberg to address the question at a panel titled "Has the Situation Changed?" Their discussion reverberated throughout art venues as no other Club session had before or would again. Rosenberg began by asking: "Has a certain way of painting become acceptable as a style? Is this mood of acceptance antithetical to the mood in which the new painting began? Has what set out as desperate jabs in the dark become an established style?" Barr continued Rosenberg's questioning: "Is the younger generation rebellious or is it basking in the light of half a dozen leaders? Are Tenth Street artists living on the energies of the painters of the forties or early fifties? Is this a good or a bad thing? Or is it just inevitable? Should there have been a rebellion by 1958?" Then Barr threw down the gauntlet: "I looked forward to a rebellion, but I don't see it. Am I blind or does it exist? Are painters continuing a style when they should be bucking it?"

Hess countered Barr: "I don't see why an artist in 1958 has to rebel against a work in 1950. This may be imposing a pattern of rebellion that doesn't necessarily apply. A painter like Rivers who paints differently may not want to make a gesture of rebellion." Rosenberg seconded Hess: "Assuming that a breakthrough has taken place, are artists not justified in following it until something new comes along? Nothing new has. Perhaps the breakthrough opened a wide range of possibilities that young artists could develop in new ways. If so, revolution is not necessary."

Then Rosenberg switched gears: "It is wrong for artists to believe that they can learn to do what's already been done and make a career of it. That is never creative." Barr picked up on Rosenberg's remark: "It may be that the vein is rich enough that it may take a whole generation to mine. It may take more time for boredom to set in. But working veins that have already been opened yields only minor discoveries. I hope that I am wrong, that something new is happening. Temperamentally I'd like to see some rejection by artists in their twenties of artists in their forties and fifties. What we value most in the last hundred years was achieved in rejection and reform."

Rosenberg interjected: "There's a third possibility: consolidation in order to make a decisive statement. And a fourth possibility: criticism. If you are going to get a fundamental change, it is through criticism. I can't accept the idea that it's now been ten years of abstract art, so let's go back to the figure or landscape. De Kooning, Gorky, Pollock made a criticism of past art, an often conscious criticism, out of their necessities. They just couldn't do what had been done. Such genuine criticism is missing today. De Kooning said it pertinently at The Club when it was on Broadway. We can no longer work on the basis of ideals in which we no longer believe, those of Mondrian, for example. Criticism must be revived." Turning to Rosenberg, Barr said: "It is interesting that you point to de Kooning's dissatisfaction with the past—and with his own paintings. This is not apparent among his juniors, and this is rather sad. De Kooning painted for a decade before 1948 in a mood of dissatisfaction. Then he had an extraordinary show. The pictures he painted for four years became key works in the movement. Yet, de Kooning turned away from abstraction and so did Pollock." Rosenberg broke in: "De Kooning's style didn't change. The elements were the same, and he thought so, but he carried them into greater realms of difficulty. He didn't go back to anything more established. The *Women* presented him with almost insurmountable difficulties. The first of these paintings took him a year and a half to complete."

Hess said: "I think there is a danger in oversimplifying the problem by bunching together the painters. There is no collective, no name." Barr interjected: "There are several names . . ." Hess continued: "The names are always hedged. You came up with the name abstract expressionism." Barr looked dejected: "I just revived it, and I'm not particularly proud of that. The art worlds of Britain, France,

and Germany believe that there is an American school which they are trying to emulate. When we use the name abstract expressionism we falsify for convenience and in order to present a heritage. This is the method of art history." Hess said: "Yes, artists who work in one direction are opposed to artists working in another direction. It's de Kooning versus Pollock. There is great disagreement in ideas." Rosenberg added: "I agree, but I also agree with Barr that there should be new developments."

Michael Goldberg rose from the audience and protested angrily: "You guys are acting like grave diggers—digging your own graves. You are stuck with your original revolution. The revolution is going on, and you can't recognize it." Hess nodded: "I agree with Mike. The initial movement was one of artists opposed to and different from one another, except socially. Its continuation has been vital." Sculptor Sidney Gordin stood and declared: "The trouble with revolution is that it has become too fashionable, an academy of revolution. I'm surprised that a respectable head of a respectable museum calls for revolution." In defense of Barr, Hess said: "Revolution has been respectable since the French Revolution."

Collector Ben Heller called out: "Why is no other name than de Kooning mentioned? Don't younger artists relate to any other painters?" Applause. Hess countered: "We discussed Pollock." Loud murmurs of disapproval from the audience. Heller then attacked *Art News* for its emphasis on de Kooning. More applause.

Then painter Ludwig Sander said good-naturedly: "The older painters have been changing since ten years ago. There is nothing to revolt against because the leaders have been revolting against themselves. It's an atypical historical period." Hess said: "I agree."

Sitting quietly in the back of the room, Allan Kaprow, who had begun to make environments and would soon become famous for happenings, took the floor and challenged the audience: "I am convinced that painting is a bore. So is music, literature, etc., etc. What doesn't bore me is the total destruction of ideas that have any discipline. Instead of painting, move your arms; instead of music, make noise. I'm giving up painting and all of the arts by doing everything and anything." Someone in the audience shouted: "You sound like Billy Graham," and there was a general hubbub. From within the bastion of abstract expressionism, Kaprow had broadcast John Cage's call for a new art that would break down barriers between art and life.

Leaving The Club that night, I thought that what was clear from the panel discussion was that "the situation" had changed. And that change had become widely accepted in the art world.

Clement Greenberg waged war on gesture painting. As early as 1956, he announced at The Club that "Tenth Street painting" or "de Kooning style painting"

had become "timid, handsome, second generation . . . in a bad way." Or, as he reviewed it in 1964, "Abstract Expressionism was, and is, a certain style of art, and like other styles of art, having had its ups, it had its downs. Having produced art of major importance, it turned into a school, then into a manner, and finally into a set of mannerisms. Its leaders attracted imitators, many of them, and then some of these leaders took to imitating themselves."

In 1958, with the changed "situation" of abstract expressionism in mind, I compiled a series of statements by artists under the heading, "Is Today's Artist With or Against the Past?" which appeared in *Art News*. The following year I dealt directly with the topic of "What is the New Academy?" by organizing a series of panels at The Club. When I announced the title, I was chided by Jack Tworkov for even raising the issue. "We are finally being recognized abroad, so don't rock the boat with talk about academicism." I was not impressed and asked Tom Hess if I could put together a series of artists' statements for *Art News* on the question, and he agreed.

As the moderator of one of the panels, Raymond Parker asked the following questions: "Is what is being called a new academy perhaps a new tradition? What is the difference? Is academicism to be defined as imitation, that is, following rules or rehashing settled questions? Is there anything wrong with painting what is already known? Or varying old themes? Is originality important as a goal or is it a result? Can an artist create an academy of *his* own work?"

Parker then offered his definition of an academy. "It begins when a group comes to value an idea to the point where it seems so true that it is beyond argument. Insisting that they have the truth, its members become moralists and then preachers who try to sell the idea and then to impose it on other artists. At this point, the academy becomes the target of its natural enemy—the next academy." Parker continued: "The impulse toward the academic is good in its beginnings because it originates in belief, conviction, and faith. It goes bad when it strangles individual freedom. The worst aspect of academies is that once ideas are formulated, inferior people with superior attitudes try to impose them on others. Mediocrities take over." Parker concluded that the New York school was not yet an academy, but he then claimed that growing pressures to conform were being exerted by the de Kooning coterie at The Club, *Art News*, and *It Is*. Looking around the room, I saw glances of surprise at Parker's audacity but also nods of approval.

Another panel in 1959, titled "What is the New Academy?" directly confronted the issue. Emmanuel Navaretta began by saying: "To avoid being labeled academic, an artist friend of mine forced himself to experiment. Then, because his work changed, he got beaten on the head by critics, dealers, and even his friends." Herman Cherry interposed: "But artists who paint the same way for more than a year are

condemned for being in a rut." Navaretta agreed: "The artist can't win. I suggested to my friend that he do what he does best. He said: 'Why can't I experiment?'"

Cherry then said: "There is a difference between tradition and academy. We all work in a tradition. When a dogma is created it leads to an academy." Parker added: "All artists are influenced. They have seen enough art to have an idea of what they want to do. Each has singled out his or her tradition. Imitative art is not always bad. Young artists have a right to do as their elders do." Painter Peter Stander called out from the audience: "Tradition holds your pants up. Academy is what you put in your pocket." Frank O'Hara asked: "Can there be an academy in this century when there are no established values?" Ludwig Sander concluded the discussion: "I want to inject an eerie note. From 1859 to 1863, the National Academy was on the corner of Tenth Street and Fourth Avenue [which then was The Club's location]."

In 1959, I asked a group of artists to write statements to be published in *Art News* on the question, "What Is the New Academy?" Opinions were split. David Hare wrote: "If academy means artists working with other artists' feet in their cheeks, we have it.... If an academy is a group of loiterers, littering history with their action, we have it." Cherry disagreed. He ridiculed the "thieves in art" but added bluntly that there is no new academy or the possibility of one. "Time has to stand still before an academy can be formed, and the whole history of art in the last sixty years proves, if nothing else, that it is in a state of flux. At no time in the history of art has there been such a scorched earth policy."

Jack Tworkov agreed with Cherry and offered the most cogent defense of abstract expressionism: "If you grant the possibility that painting can be non-representational and non-geometric, and still be expressive, that is, reflective of experience, insight and awareness, then the birth of such painting is one of the greatest cultural events ever and not at all subject to sudden obsolescence." Tworkov concluded that "Abstract expressionism as an idea ... has no rules, no specific character, attitude or face.... As such, it is ... non-academic if you realize that, given the idea, everything else in a picture still remains to be done—you cannot predict in advance what its look ought to be."

However, I had become convinced that a new academy had come into being. What left no doubt in my mind was a catalog introduction to a show of the painting of Nicolas Carone in 1961, written by the philosopher William Barrett:

> Carone speaks the same language as de Kooning. Derivations in the New York School cease to be important at this point. [The] really important thing [is] that the painters ... are in the grip of a common language that wants to speak, has to speak, will speak through them all whether they like it or not. Here for the first time is an American Style, a collective expression larger than an individual painter....

Naturally, the painters speak this language with different accents, even different dialects. The individual accent does not matter so long as the painter ... really speaks the language....

What does this language mean? I don't know.

Barrett praised Carone's painting, which I also admired, and his text sounded good on first reading. A closer reading disturbed me, however. If the artists were in the grip of some extrapersonal force, was that force not beyond questioning, and was uncritical acceptance not the primary condition of an academy? In days gone by, artists were considered the paintbrushes of God or the zeitgeist or the rules of the academy. Now they had become paintbrushes of "a common language." Was it not the same difference? Barrett claimed that "the painter risks everything," but how could this be in a style everyone already knew by heart? What bothered me most was the idea that gesture painting had become "a collective expression larger than any individual painting."

Collective expression? I was touched by a comment that Milton Resnick made at The Club in 1961 around the time Barrett's catalog appeared. Lamenting his alienation, Resnick said, "We felt that the future was open ten years ago. We felt that art was made somewhere else, in France, and that made us light-headed. We couldn't explain ourselves—why we were artists—and nobody asked. This question remains unanswered. Nevertheless, we now have a grading system and arguments about who did what first. That makes me feel alienated. So does the idea that art that was started ten years ago could be imitated by others for money or career. How can art be true if it is used by the state and Time/Life?"

Looking back on Barrett's introduction some four decades later, I now think that he may have had a point. The abstract expressionists did, at least, agree on what they did not want to paint any more. To that extent, their ideas were collective. Moreover, if a Pollock, Still, or de Kooning each had been the only artist to innovate the painting he did, it would not have made much, if any, impression. As a group, they were able to command attention for their painting.

As the issue of the new academy was being debated at The Club, a new generation of artists was rejecting abstract expressionism and shunned The Club. Because these newcomers were receiving growing art-world attention, Club members felt the need to confront their painting. A major exhibition titled *American Abstract Expressionists and Imagists* at the Guggenheim Museum in 1961 brought the issue to a head. As I viewed it (and I was not alone), "abstract expressionist" painting seemed enervated. In contrast, "the imagist tendency" exemplified by Barnett Newman and younger painters such as Frank Stella, Ellsworth Kelly, Al Held, and Morris Louis made a far stronger showing.

I arranged two panels at The Club titled "The Guggenheim Image." At one, painter Jon Schueler said disapprovingly: "The new imagist work is marked by coldness, arrogance, calculation, and elegance." Paul Brach declared: "That's marvelous. There wasn't enough of that in the past. I liked the Newman painting. The imagist tendency offers possibilities to my generation that the école de Kooning doesn't." Nicholas Marsicano interjected: "Has Newman changed or have you?" Brach responded: "I changed. I didn't know how good Newman was." I understood Brach's attitude and enthusiasm. The Newman picture in the *American Abstract Expressionists and Imagists* survey was a standout. It made Newman an artist to be reckoned with.

With gesture painting seemingly stale and used up, new imagist painting, notably the minimalist abstraction of Frank Stella, the stained color-field painting of Morris Louis and Kenneth Noland, and the hard-edge painting of Ellsworth Kelly and Al Held, did seem fresh and viable. So did assemblage, notably the combine-paintings of Robert Rauschenberg and the flags and targets of Jasper Johns. These new tendencies found support from art professionals who earlier promoted abstract expressionism, notably Alfred Barr, Clement Greenberg, Dorothy Miller, William Seitz, and Leo Castelli, although they did not always agree.

The new art was also championed in *Artforum*. Under the editorship of its founder, Philip Leider, it replaced *Art News* as the most relevant art magazine because it featured the artists who came to prominence in the sixties. I once asked Leider why it took the lead. He replied: "My colleagues and I were very conscious of the artists of our generation. Tom Hess's *Art News* was losing contact with what was happening. He had allegiances to too many third-rate New York school painters, and he was put off by the new artists who were tough and had nasty and obnoxious insulting things to say about abstract expressionism. Not the older artists, whom they admired, but their followers." What did these new artists share? As Leider saw it:

> It would seem surprising if, after a movement as earth-shaking as abstract expressionism, some ideas would not seem to take the form of a reaction. Thus, a hatred of the superfluous, a drive toward compression, a precision of execution ... an impeccability of surface, and, still in reaction, a new distance between artist and work of art [achieved], above all, by the precise, enclosed nature of the work of art, [a] quality of distance, coldness, austerity.

Leider went on to say that the new artists felt "that anything less than the most compressed statement is fat, sloppy and boring." Most important: "The young artists supported by *Artforum* were better than those featured in *Art News*. It was *my* time and stopped being Tom's.

Gesture painting did have a viable extension in the junk assemblages of two young artists, John Chamberlain and Mark di Suvero. In the 1950s, I believed that the welded constructions of their elders, Herbert Ferber, David Hare, Ibram Lassaw, Seymour Lipton, and Theodore Roszak, were the rightful sculptural counterparts of abstract expressionism since the older artists used the welding torch as a brush, creating surfaces that were bubbled, fretted, and pitted. They were, in a word, "painterly." Nonetheless, though admirable, they turned out not to be in the class of di Suvero and Chamberlain. The sculptures of the older artists were relatively small and evoked biomorphic processes, which was already an overworked surrealist theme. Moreover, they were too ambiguous and fussy to have the power and immediacy of the strongest gestural painting. In contrast, di Suvero's bulky wood beams and Chamberlain's crumpled fenders and the charged spaces they created were fitting, three-dimensional analogues of the energy-packed paint swaths in the pictures of de Kooning and Kline.

Although gesture painting had become outworn and had gone out of fashion, a few leading artists, for example, Joan Mitchell, stayed the course, though her reputation was temporarily eclipsed. Helen Frankenthaler had a new lease on life as the primary influence on stained color-field abstraction. After testing a number of styles, Michael Goldberg circled back to gesture painting. Alfred Leslie took an opposite tack, embracing realism somewhere in between Philip Pearlstein's perceptual representation and photorealism. Other gesture painters, Al Held, Grace Hartigan, and Raymond Parker, ventured in new directions, directions that engaged me most.

As a person, Raymond Parker was laid-back and soft-spoken. In art matters he was keenly analytical. Around 1957, he became "disenchanted with the push and pull" of gestural drawing with the brush. He was already disposed to color, having decided not to use black. Could more be done with color? Ray asked: "If you want color to have meaning, why not color all by itself? Is it possible? Can there be a color without a shape?" He recalled that an older painter, Rollin Crampton, visited his loft and "holding up fingers and thumbs framed two strokes out of my ambitious hundreds, and said: 'Wouldn't this make a beautiful painting?'" Ray decided that it would. "I unrolled blank canvas, tacking it to the wall bigger than needed. No format. Stretchers, size, and shape were made later only.... From staring at that blank canvas a color would come. I spread the pigment slowly to fullness.... The simple paintings of 1958 were made then with the thought that cutting out everything but pigment on ground would let color tell the whole story." Ray had dispensed with drawing, modeling, and assertive textures—pictorial elements that he felt "contaminated" color and detracted from its inherent expressive force.

Spreading a few colors on unstretched canvas enabled Ray to immerse himself

in these colors, thinking and feeling from within them, enabling each of them, with reference to the others, to become ample visually and emotionally. He told me of a cadmium purple that "grew" for five days until he had had enough of that color. When was enough enough? "There is a very fine line between a couple of spots and an image that has presence and is moving." The areas were oval and oblong, "simple" so that as "shapes" they would be "unassuming." The "drawing" was where the spreading colors stopped, but that "edge" was "crucial." Ray recognized that if a painter started with a stretched canvas, the framing edges that constituted a kind of drawing decisively shaped anything the artist painted. Therefore, he would "find" the borders of the picture as his final decision.

Ray's pictures may look simple, but they are not. As he said, "For a color to have presence, to be convincing and real, doesn't result only from its specific hue, or from the effect of adjacent colors, but instead comes from some combination of all the aspects of pigment on ground. Beyond the different inherent qualities of pigment, besides hue, value, texture, etc., there are the questions of their weight, light, density, glow, radiation, transparency, illumination."

As for the content of his abstractions, Ray said that he wanted "to let color tell the whole story. I found images that floated, rested heavily, hung, nudged, bumped, touched, hovered in vast voids of separation, were many, were few, isolated, single, alone." Ray's thinly painted areas of color are suspended in the picture space like chromatic clouds, and yet they are palpable and loom large, monumental. Thus, Ray made color, that most optically intangible pictorial element, something massive, like a two-dimensional Stonehenge.

Grace Hartigan was smart and tough—a woman had to be hard to survive in the macho milieu of the New York school—and she never changed. For instance, as a participant in one of three panels on the interaction of American and English art since World War II which I moderated at the Tate Gallery in 1987, Grace began her remarks by saying that in the fifties, as far as she and her fellow artists were concerned, there was no such thing as English art, eliciting a shocked gasp from the audience.

Like Parker, Grace resolved the crisis in gesture painting in an individual manner. She made a name for herself in the mid-1950s as a figurative gesture painter who looked to downtown Manhattan for subjects, such as shop windows, pushcarts, and the like. Then, from 1957 to 1965, she painted abstractions that called to mind landscapes.

As gesture painting was eclipsed by pop art and the new abstraction, Grace became increasingly alienated from the New York art world. She said that the stimulating discourse about art that engaged her generation was replaced by a careerist chatter about showing, selling, and making-it. In 1959, Grace moved to

Baltimore. Fearful that isolation might make her bitter, she maintained close contact with Philip Guston, George McNeil, and other artists she admired, and the graduate students she began to teach, on whom she made exacting demands for which they adored her.

Grace's abstract "landscapes" troubled her because they were too reminiscent of de Kooning. Consequently, she searched for new subjects that spoke of her experience, just as city scenes had. "My unconscious seems to operate best when I am looking at images". In the early seventies she appropriated illustrations in children's coloring books, the kind that amused her as a girl—images that were implanted in her own (and society's) psyche. She became a pop artist of sorts, but she improvised her new subject matter in freely brushed, thick-lined shapes of thin color—that is, in a gestural manner she loved but that the popsters hated. The "infantile" subjects, references to popular culture, and "sloppy" painting were initially shocking, at least to a number of my art-world friends, but that didn't deter Grace.

Like her abstract expressionist friends, Grace detested pop art primarily because of the "cool" way in which it was painted. However, in the middle fifties, she had chosen as her subjects window displays and other urban themes. Consequently, in 1992, her painting was included in a show titled *Hand-Painted Pop: American Art in Transition: 1955–62* and was heralded as a precursor of pop art. I phoned Grace and asked how she felt about her new-found celebrity. She replied that the choice was between being a second-generation artist of a movement she loved or an originator of a movement she hated. I asked, What will you do? She laughed and replied, I think I'll run with it.

Old-fashioned gesture painting did have one improbable revival with the discovery of Harold Shapinsky. I first heard of him in 1985 when I received a phone call from Lawrence Weschler. He told me that he was writing an article for *The New Yorker* on a "first generation" abstract expressionist named Harold Shapinsky. Had I heard of him? I had not. Weschler then said neither had anyone else he had spoken to, but he had been advised that if I hadn't, then nobody would have. Could Weschler interview me?

When we met he told me an astonishing story about this unknown painter. Akumal Ramachander, a thirty-five-year-old Indian school teacher, whose primary knowledge of art was acquired in chasing butterflies, had met Shapinsky's son at a party in Chicago and learned that his father was an artist. Visiting the elder Shapinsky in New York, Ramachander was so taken with his work that he decided to make its recognition his career—his Karma. He was convinced that when art historians at long last saw Shapinsky's painting they would be forced to rewrite their tomes on abstract expressionism. At first, Ramachander took the

painter's slides around to New York galleries and was rejected. Then, he decided to try his luck in London. In December 1984, he walked into the Tate Gallery in London and asked to see Ronald Alley, the Keeper of the Modern Collection. Ramachander had no appointment, but Alley agreed. Impressed by the slides, Alley suggested that he take the work to the Mayor Gallery, which offered Shapinsky a show. It sold out.

The story was so incredible that I was afraid that it might lead Weschler to ridicule Shapinsky, but he assured me it was not his intention. I told Weschler that the saga delighted me because many art-world people had a fantasy that somewhere in America there was a genius painting alone and in obscurity in a barn (it was never an loft, apartment, house, or garret) and then, late in life, was "discovered." Shapinsky's arrival would make the dream come true and would hold out promise for other unrecognized artists. That is, until I saw the transparencies of Shapinsky's work. I said sadly, these are de Kooning knock-offs. But, Weschler informed me, Shapinsky said that he had not seen de Kooning's work.

I then looked at the artist's resume and pointed out that he was born in 1925, just as I was, and thus was not a pioneer abstract expressionist but a follower who had studied at the avant-garde Subjects of the Artist School with Motherwell and Rothko. He could not have avoided de Kooning's painting unless he was completely out of it. In fact, he was one of more than 200 younger artists in the New York school. Moreover, he had exhibited his work but off the beaten track—for example, at St. Mark's Church, a few blocks away from the Tenth Street cooperatives—so it was unlikely that his work was seen by many, if any, art professionals.

Looking over my shoulder at the transparencies, Lucy asked about the size of the pictures and was told that they were each about a foot square—and all but one were painted on paper. She said they're "cabinet de Koonings." Weschler remarked that they were so small because Shapinky could not afford to work larger. I said that it was not surprising that no Tenth Street gallery, much less an uptown venue, would agree to show them, certainly no dealer who knew the works of such painters as Mitchell, Goldberg, Hartigan, Leslie, and other second-generation artists inspired by de Kooning. In the case of the Tanager Gallery, its members had viewed so much of school-of-de-Kooning painting that they had reacted against it and wouldn't show any more. Moreover, like Shapinsky, most artists were poor and yet managed to paint "big" pictures if they needed to. Poverty was no excuse. What held Shapinksy back? A lack of ambition or confidence, some private inhibition? The Shapinsky chronicle was riveting but made no sense. However, to Shapinsky's credit, he believed enough in what he was painting to spend some thirty-five years at it—and he did it quite well.

I later found out that Ramachander enlisted Tariq Ali, a Pakistani acquaintance,

in Shapinsky's cause. Ali, a contributor to the BBC and a well-known leftist intellectual, saw a chance to bash the United States. In rapturous articles in *Time Out* and *The Illustrated Weekly of India,* he hyped the idea that Americans, particularly "the sharks of the New York art world," were so crass that they were unable to recognize a genius who was "a contemporary of Pollock, Rothko and de Kooning." It was scandalous that no New York gallery would exhibit him. However, "Akumal's discovery has been a body-blow to the giants of New York art. He has lifted one of the great painters of our century from under their noses and transported him to Europe."

Salman Rushdie, a friend of Tariq Ali, agreed. "The story of the belated 'discovery' of Harold Shapinsky must surely be one of the most extraordinary in the history of modern art. It is hard enough to believe that a painter of the first rank, who is now attracting lavish praise from every corner of the European art establishment, could have languished so long in Manhattan, the undisputed capital of the art world, without gaining any sort of real recognition." Tariq Ali arranged an hour-long BBC television program on Shapinsky, narrated by Rushdie, which was aired June 2, 1985. The BBC blurb proclaimed: "After centuries of Western art historians and archaeologists uncovering the treasures of the East, Akumal managed to reverse the process."

I met our Indian impresario soon after his triumph. He literally pounced on me and, producing a long list of names with mine somewhere on it, announced that he was just about to phone me. I knew he wouldn't—what did he need me for?—and he didn't. After the success of the Mayor Gallery show, Shapinsky made plans to move to England. He thankfully offered Ramachander a percentage of all future sales. Shapinsky was forgotten almost as quickly as he was "discovered." Wechsler's article in *The New Yorker* was delightful. We are still waiting for an unheard-of genius to come forth from his (never her) barn.

Despite the growing evidence that the consolidators had become the new academicians, they still thought of themselves as avant-garde, or at least, embattled. That was because the New York school came under vicious attack by John Canaday of *The New York Times* and Emily Genauer of the *New York Herald Tribune.* As late as 1964, the mogul Huntington Hartford published an advertisement in six New York newspapers, including a full-page ad in the *Times,* attacking abstract painting. He also promoted his taste in art by spending $9,000,000 to build a new Gallery of Modern Art, a Venetian-type palazzo designed by Edward Durrell Stone, in midtown Manhattan. Hartford preached that "the purpose of great art is a moral one" and that "the old lesson which Beauty has taught for so many years, the lesson of goodness and kindness and strength . . . has caused poets to identify it with truth." He decried "the diseases which infect the world of paint-

ing today—of obscurity, confusion, immorality, violence." Great art which teaches ethics has to be "easily understood." What was Hartford's taste? *Newsweek* reported: "His favorite book is 'Gone with the Wind.' 'As far as I'm concerned it is the great American novel. . . .' His favorite poet is Laurence Hope, female Victorian author of the 'Indian Love Lyrics.' In music 'Mozart has been overestimated by the scholars. From a humanistic standpoint, Tchaikovsky is greater.'" As for art, he loved Salvador Dali and Pavel Tchelitchew, the subject of the museum's first retrospective—perverse choices given Hartford's upbeat humanist rhetoric.

With Canaday, Genauer, and Hartford in mind, artists could believe that if the philistines hate us, we must still be avant-garde. Canaday was the avant-garde's most formidable enemy. In September 1959, he was appointed chief art critic of *The New York Times*, the most influential art-critical taste-making position in the United States. His power was further enhanced when he immediately launched a campaign, more like a vendetta, against abstract expressionism. He accused the painters of being frauds, and as a skillful journalist, he stirred up controversy while ingratiating himself with a sizeable public already convinced that the new American painting was fakery. However, the vilified artists and their art-professional supporters struck back in a letter to the *Times*. We felt genuinely outraged that avant-garde art was once again being mugged; the philistines we thought we had beaten were on the rampage again.

Angry myself, I had no choice but to defend the New York school, despite my growing concerns about its having become a new academy. In a talk at The Club in 1959, I lashed out at Canaday for his sneaky acceptance of a few leading abstract expressionists who painted figures, such as de Kooning, in order to more effectually stigmatize the younger artists as "the freaks, the charlatans and the misled who surround a handful of serious and talented men," a rather generous comment for Canaday. These phonies, he wrote, gave rise to "a situation built on fraud at worst and gullibility at best [which] has produced a school of such 'prolix mediocrity' . . . that the 'grossly imitative' . . . drives out the good."

I also attacked Hilton Kramer, then the editor of *Arts* magazine, for claiming that abstract expressionism had become "a fixed position, a vested interest, a tradition as rigid as any other." I challenged Kramer to specify what that tradition was, and whose: de Kooning's? Newman's? Guston's? Moreover, how fixed was the painting of de Kooning, Kline, Motherwell, and Gottlieb, which recently had undergone considerable change? I rebuked Kramer for bad-mouthing writers who tried to interpret abstract expressionism sympathetically. He wrote that they "have either taken refuge in phony poetics or given themselves over to the most vulgar 'explanations.'" He singled out Hess's incisive book on de Kooning, which he termed "garbage." I concluded my talk by quoting Rosenberg: "If there is anything the humanist resents more than the contentless art of our epoch, it is

any statement about this art which explicates its content. . . . The humanist seeks the destruction of modern art, not a better understanding of it."

In January 1960, I took the lead in organizing a protest against Canaday's character assassination of us. I teamed up with John Ferren, and we invited a group of distinguished art-world figures to meet at his home. We were surprised (but should not have been) at the number that showed up. They were as angry as we were. At the meeting, Robert Goldwater said that *The New York Times* had to take a stand against a revolutionary art, but added: "It's disgraceful for a critic to approach art with the idea that artists are a bunch of crooks." Rosenberg said that the *Times* had no right to wage a philistine Kulturkampf against an art movement, and must be exposed.

The participants decided to send a letter to the *Times* denouncing Canaday. De Kooning and Newman, with me as a kind of secretary, were designated to frame the letter. The three of us arranged to meet at my apartment. When we met, de Kooning and Newman began reminiscing about the old days and got so caught up in conversation that the letter never got written. I don't know who wrote the final letter, most likely Hess and Rosenberg, but Newman may have helped.

The preamble to the letter denounced Canaday's "consistent practice of going beyond discussion of exhibitions to impute to living artists en masse as well as to critics, collectors, and scholars of present-day American art, dishonorable motives, those of cheats, greedy lackeys or senseless dupes." The letter quoted scurrilous excerpts from Canaday's articles and concluded that they comprised the writing "not of a critic but an agitator." There followed a list of forty-nine signatories included artists Stuart Davis, Adolph Gottlieb, Hans Hofmann, Robert Motherwell, and David Smith; art historians James Ackerman, Robert Rosenblum, and Meyer Schapiro; composer John Cage; poets Edwin Denby and Stanley Kunitz; and philosopher William Barrett. The letter was published on February 26, 1961.

I was also the instigator of another letter sent to the *Times* on February 10, 1961, but not published. Drafted by myself and Howard Conant, chairman of the Department of Art Education of New York University and signed by sixteen professors, it protested Canaday's claim that "brainwashing . . . goes on in universities and museums." We termed it "a libelous shocking lie in a format which the reader might interpret as an established fact of truth." In a reply to this letter, Arthur Hays Sulzberger attacked us for demanding that Canaday be fired and asked what our reaction would be if sixteen of his colleagues petitioned NYU to dismiss one of its professors. We had no intention of having Canaday fired or curtailing freedom of speech. Canaday apparently did. He had Dore Ashton, a *Times* colleague who was sympathetic to abstract expressionism, ousted. The members of the American Section of the International Art Critics Association (IACA) were so

angered by Canaday's dismissal of Ashton that they resurrected their moribund association in order to censure him.

The forty-nine of us who signed the letter to the *Times* recognized that our protest would help Canaday more than it would hurt him, and we were right. He would later publish a book of his articles titled *The Embattled Critic*, using our letter as the pretext for his title. Canaday's defenders, whose letters supported him by a ratio of 12 to 1—we expected the ratio to be even higher—turned our objection to his slander into an attack on his freedom of speech. We were dubbed "a lynch mob," a "scalping party" engaged in a "gang attack," and the like.

After the publication of our letter, Canaday's reputation went into an eclipse. His name cropped up in art-world conversation about the same number of times Emily Genauer's did— hardly ever. As if in response, Canaday curbed his own obituaries of abstract-expressionist painting, assigning most reviews of it to his underlings.

The entire controversy had its ironies. Canaday's position at the *Times* was never in jeopardy, and he knew it. And by 1961, abstract expressionism had become recognized nationally and internationally. We were now the establishment. If there was ever a sign that the new American painting ceased to be radical, the list of names attached to our protest letter was the proof. But such comments as "Young painters . . . should be cut down in battalions," made us feel the old alienation stir in our veins, and to believe we were besieged again, although we knew better.

Around 1962, Canaday invited me to lunch. He had decided that the *Times* needed broader coverage and that I might be the critic to provide it, even though in all of the reviews I wrote for the *Post*, I only agreed with him once, on Gaston Lachaise's sculpture, which neither of us much liked. We met at Sardi's restaurant, a theater district institution. Discussing art, we both realized that after each comment, one of us said, "You can't mean that," or "Do you really believe that?" Knowing that Canaday wrote mystery novels under the pseudonym Matthew Head, I switched the conversation to that subject. He told me proudly that he had received a fan letter from Erwin Panofsky. Canaday also remarked that writing art criticism was not very interesting to him. He would rather review plays or restaurants, but his bosses would not let him. Canaday did not offer me a job on the *Times*.

I met Canaday once more, this time at a panel at the annual meeting of the College Art Association. It consisted of artists who lived in states that stretched from Virginia to Texas. Dubbing themselves the Southern Rim, they had set up a network with the aim of fostering a genuine regional art. The panelists had invited Canaday—as a former Southerner he was a "good old boy"—as window dressing. The Southern Rim artists performed with energy, wit, and above all, humor, rare at academic conferences. During the question and answer session, Robert

Pincus-Witten scolded the Southerners for their lack of sophistication and theoretical grounding. I stood and defended the panelists. Canaday looked shocked and pointed at me and said: "But he's the enemy."

Gesture painting declined primarily because of a glut of followers. An avant-garde that turns into a mass movement becomes a parody of itself. When the art world became convinced of that, The Club and the artist-run galleries on Tenth Street faded. The most gifted downtown artists moved to commercial galleries uptown. The cooperatives ended up being farm teams to the majors—jumping-off points for relatively few artists and dead-ends for the rest. Skimmed of the best artists, the art that remained to be seen downtown was too banal to continue to claim art-world attention. The Club became tiresome. Any fresh idea that was broached was shouted or mumbled down. The atmosphere became so hostile that it was uncomfortable to be there. Young avant-garde artists venturing in new directions avoided The Club. They also refused to show on Tenth Street. Art professionals, who in the past were not always welcome in downtown venues, stopped coming.

A dozen or so excellent artists who had matured on Tenth Street, notably Bladen, di Suvero, Held, Katz, Yayoi Kusama, Pearlstein, and Sugarman, found the experience valuable. In this sense, the downtown scene was beneficial, but in the end, Tenth Street became "a community of mediocrity and failure." It certainly was no longer *important* to exhibit there. Harold Rosenberg had predicted that the bulldozer would demolish Tenth Street; I believed that "inertia" would precede the dumpster. My Tenth Street spell was over.

There was another reason for the decline of gesture painting, one that went with the money. Accompanying the emergence of a new art was a new affluent audience for avant-garde art. The influx of money gave rise to a change in attitude and the economic condition of artists and art professionals. With the rapid growth of the art market beginning in 1958, the abstract expressionist image of the artist as an impoverished, alienated outsider suffering in the cause of art rapidly lost credibility. Artists had already noted the change—and a few lamented it. At a Club panel in the winter of 1957, the conversation turned to the difference between the art world of the past and the present. John Ferren asked: "What was so good about the good old days?" Herman Cherry replied: "We starved, and that was good. In the WPA days, we made just enough money." Ibram Lassaw added: "And we were just young enough." Cherry nodded sadly: "The togetherness we had is missing today. Now there are stratas. We wonder where we belong—and who we are."

By 1964, it was clear that the economic situation of artists had radically changed. Allan Kaprow published an article titled "Should the Artist Be a Man of the World?" His answer was an emphatic yes. The Pollockian image of the heroic

yet pathetic, rebellious, drunken visionary had been replaced by the Warholian image of the artist as socially adept celebrity and businessman. Neither image could account for the "genius" of Pollock or Warhol, but it did explain their lifestyles.

In his article, Kaprow wrote, "If the artist was in hell in 1946, now he is in business." The best vanguard artists are rich, just like the middle-class collectors they now socialize with and cultivate. With this new bond between middle-class artist and collector in mind, Kaprow went on to say that artists should create middle-class art that would please their clients. He concluded that artists could either choose to be men of the world or victims, and those that did not "make it" after a reasonable time ought to think of quitting.

Thomas Hess, who published Kaprow's article in *Art News*, attacked it in an editorial. He was particularly disturbed by Kaprow's comment that avant-garde artists should keep their middle-class collectors in mind while making their aesthetic decisions. Hess asked, wouldn't artists become alienated from their true beings or visions? And just as bad, weren't "serious artists . . . being pushed off the stage [in] favor of chic art-gimmicks" and being distracted from their work? Wasn't the avant-garde artist supposed to be "aggressively indifferent [to] middlebrow, middle-class society?" Kaprow countered by asking how artists could be alienated from their true being if that being was bourgeois.

In one respect, Tom was closer to the truth of artists' practice than Kaprow was. The most innovative, exceptional—and in most cases, celebrated—artists (yes, bourgeois or newly bourgeois) of the sixties pursued their own visions and did not respond to external pressures, certainly not to the changing tastes of their audience. They did not follow aesthetic fashions; they anticipated them, and their work bears this out. Actually, Kaprow's characterization applied not to the innovators but to their followers, the band wagoners. He did not distinguish between the two. Yet, even the innovators, particularly the innovators, had become successful beyond the most extravagant imagining of the fifties avant-garde. The sale of Pollock's *Autumn Rhythm* to the Metropolitan Museum in 1957 was the start of it. The situation had indeed changed.

# Post-Gesture Painting: Out of the 1950s:
## Robert Rauschenberg, Jasper Johns,
## John Cage, Marcel Duchamp

By 1958, it appeared to many artists and art professionals that, as gesture painting was becoming an academy, new tendencies were emerging, notably assemblage and stained color-field painting. As early as 1953, Richard Stankiewicz made sculpture from junk. His work would be labeled (or rather mislabeled) neo-dada, the new anti-art (later dubbed assemblage). Stankiewicz was soon joined by Robert Rauschenberg and Jasper Johns, whose advocate was John Cage and whose dealer was Leo Castelli. Stained color-field painting had been introduced in 1952 by Helen Frankenthaler and was championed by Clement Greenberg. In 1953, he shepherded Morris Louis and Kenneth Noland to Frankenthaler's studio and converted them to her way of painting.

Cage's life-as-art rhetoric and Greenberg's art-as-art aesthetic were antagonistic. For the next decade and a half, their partisans waged an art-critical war—often in mouth-to-mouth combat. Castelli and Greenberg became leading figures in competing networks of artists and art-professional standard-bearers promoting and marketing their favored artists.

When Stankiewicz first exhibited his welded junk constructions, the New York art world was scandalized. Never before had an artist exposed cast-off metal so nakedly with so little redeeming aesthetic quality—or so it appeared to many at first. They were aware that Kurt Schwitters, an original dada, composed works from detritus, but he integrated his found materials into the formal fabric of his collages. In contrast, Stankiewicz risked making rubbishy objects stand—that is, he declared their particular origin seemingly at the expense of their formal role. Compared to him, Schwitters seemed decorous. It was for this reason that Stankiewicz, Rauschenberg, and Johns were commonly thought of as neo-dadas, the new anti-artists.

Assemblage, and somewhat later, the environments and happenings of Allan Kaprow, Claes Oldenburg, Jim Dine, and Red Grooms, intrigued me from the first time I saw them. On the occasion of the first major survey of the *New Media* at the Martha Jackson Gallery in 1960, I wrote an article titled "Ash Can Revisited." I was still using the name neo-dada, which I claimed "has stuck, and until a better label takes hold, it will have to do." I wrote that "The Neo-Dadas look upon the city as

their landscape—dump would be more accurate. The junk materials that they use suggest urban forms and images, metaphors for both the poverty and the richness of city life, its terror and anxiety as well as its particular spectacle and rhythm." Consequently, "these artists have evolved a variant of American-scene art without having been influenced in any specific way by past realist styles."

I went on to say that neo-dada appropriated from dada some of its iconoclastic spirit—its rejection of all preconceptions about what art ought to be. However, unlike the dadas who carried on an organized insulting of modern civilization and who used art as part of their shock treatment, the neo-dadas are accepting of their condition and are primarily interested in expressing a heightened sensitivity to it. That the label neo-dada was generally applied to assemblage indicates widespread art-world resistance, even in avant-garde circles. I still wonder why the use of rusty scrap metal outraged so many in the New York school. Wasn't art supposed to be modernist precisely because it challenged conventional taste?

The so-called neo-dadas disliked the name and tried to refute it. In a conversation with me in the late 1950s, Stankiewicz said: "The label implies a desire to redo dada. Neither I, nor Rauschenberg or Johns, care to do that. Our works are too formal. I use found objects because they fit into the composition I desire and because they can be expressive." In fact, he stressed, perhaps overly stressed, the formal nature of his construction. In 1960, Rauschenberg remarked: "Dada was something very exciting. One can feel a hunger for it, but we really don't hold their kind of chips. Things are easier now."

The misnomer neo-dada remained in general use until 1961, when it was replaced by the more descriptive and neutral name, assemblage, the title of a major survey at the Museum of Modern Art. It had taken some eight years for junk sculpture to be widely accepted as *serious* art—even in the geographic center of the international avant-garde.

Except for a small smile that he occasionally flashed, the well-mannered, soft-spoken, and somewhat severe Richard Stankiewicz was the most improbable iconoclast. Furthermore, nothing about him hinted at his lavish fantasy. I visited his workplace in the middle 1950. He took me through an office in which everything was spotlessly clean and meticulously in place, into a studio whose floor was covered with heaps of filthy found metal. The contrast said a lot about the man and his sculpture. He valued both freedom—his manner of assemblage was improvisational—and "disciplined construction," not only in his art but in his life.

In his conversation, Richard, a former Hofmann student, not only repudiated dada but also made constant references to art and its history. He said: "The modern artists I most admire are Dubuffet, Giacometti, Moore—his reclining fig-

ures—Calder, and David Smith. I first saw Smith's constructions while I was still a painter, and I was astonished. He did things that were never done before. He taught me what was possible in sculpture, although I did not consciously imitate him. He gave me permission to do what I am doing now—that is, it was all right to do so." Richard also said: "I liked Chamberlain from the first but not as much as Smith. Chamberlain looks too much like a sculptural demonstration of action painting. I don't like that, but I can't say why. I also admired Rauschenberg's combines and Nevelson's works—not the individual pieces but the walls; they are extremely beautiful."

Richard's adoption of junk materials occurred suddenly in 1951 while he was trying to convert his yard into a garden. He had "excavated a great number of rusty metal objects which seemed so beautiful by themselves" that he "set them aside as objects to look at . . . and of course it was only a short step of the imagination to combine various of these things together to make compositions from them." The next step was to teach himself to weld, and he quickly did, using a *Ten Easy Steps to Welding* manual. Richard said to me: "I prefer to use the real thing rather than its representation. You might call it 'realism.' The function an object originally had isn't important; I create my own images."

The junk metal that Richard salvaged provided him with a large and evocative vocabulary for sculpture. Machine parts suggested human and biomorphic references. Holes called to mind eyes; extending pipes, limbs or grass. He loved such visual puns and analogies. Richard conjured up personages and creatures that were always imaginative and fanciful, sometimes menacing, but more often witty or ironic and funny. Indeed, his humor compounded his problem of being taken seriously. Despite the precedents of Klee, Miró, and Calder, humor in art was still suspect. In fact, it remains so today.

Richard was a Polish-American and proud of both his ethnic roots and the United States. When he felt that as an American he had been slighted by his own government, he got mad. In 1962, the Moderna Museet in Stockholm mounted an exhibition of 118 works by himself, Jasper Johns, Alfred Leslie, and Robert Rauschenberg. King Gustav attended the opening of the exhibition, but the American ambassador did not. Hurt, Richard wrote letters to President John F. Kennedy and the State Department protesting what he considered an insult to the artists and to his country. Addressing Kennedy, Richard referred to the President's devotion to the arts and then recounted his experience in Sweden. He concluded that having achieved a certain position in the arts he thought he had earned at least some civility from American civil servants, particularly because of the shame he felt in having to explain to the Swedes why no one from the embassy had attended. When Richard told me what had happened in Stockholm, I too got angry and wrote an article in the *New York Post* chiding our embassy in Sweden.

Why did Richard's reputation go into an eclipse? Its decline was caused by the figurative references and surrealist overtones in his sculpture. I consider him the most underrated artist of his generation.

---

I met Robert Rauschenberg occasionally at the Cedar Street Tavern. I was attracted to him because of his winning, if a touch nervous, smile, and also because he seemed easy-going in a rangy American way. In 1958, I invited Bob to participate on a Club panel. He began his talk by recalling the notorious all-white canvases he exhibited in 1951. "I did white paintings that had nothing on them except my inadequacy. It is hard to paint nothing. Painting is an object, a whole object, that isn't just waiting for someone to express anything. It is finished before it is painted. It is convincing in the racks. I limited myself to the outside dimensions. The white paintings are probably more beautiful than anything else I have done." George Ortman, another panelist, interjected: "It was only because I didn't have a pencil that I didn't draw on your blank canvases." Bob replied: "People had pencils, but they didn't use them. But on my present combine-paintings, they draw with ballpoint pens."

However, the "white" paintings were not blank. Neither was their counterpart in music, namely, John Cage's composition of four minutes and thirty-three seconds of silence, which was not soundless, since there was always sound where it was performed. Both painter and composer called attention to what nature or life "created" in their work, in Bob's case, a fly alighting on the canvas, perhaps, or a speck of dust, or shadows cast by viewers. As the light changed, so did the white. On a dull day, or as the room darkened, the canvas took on an apparitional aura—and ghost images would continue to fascinate Bob. Thus the "white" pictures exemplified Cage's conception that art and life ought to merge. However, he acknowledged Bob's priority: "To whom it may concern: the white paintings came first; my silent piece came later."

Bob's allover "white" pictures were composed of multiple rectangular canvases and hence could be related to Barnett Newman's color-fields. Thinking that the vertical separations between the sections were derived from his "zips," Newman commented: "These young punks think it's easy." The geometric aspect of Bob's canvases called to mind Josef Albers's paintings. Albers, whom Bob considered "the most important teacher I ever had," is rarely mentioned as an influence on Bob, certainly not like Cage. Albers would seem to be the opposite of Cage, and in many ways he was. Yet there were affinities. Both composer and painter distrusted self-assertion and the expression of angst. They believed that the function of art was to "open eyes," as Albers said on his first day at Black Mountain College. Both focused on ordinary materials. Cage believed that any

thing in itself was art, and Albers required that students pay attention to the specific properties of materials.

In a defining gesture of his career, Bob tried to rub out abstract expressionism. In 1953, he asked de Kooning, the painter who had most profoundly impressed him, for a drawing and told him that he meant to erase it. After much thought, de Kooning gave him a good one. Bob said that he worked hard to obliterate the image but did not quite succeed. The trace of the de Kooning remained. Nonetheless, Bob's destructive gesture was one reason, perhaps the main one, that it and his subsequent assemblages, indeed all assemblages, were labeled neo-dada.

The erased drawing had a three-fold purpose. It was Bob's way of figuratively getting de Kooning off his back. It reduced gesture painting to the bare surface on which life could act, and it retained the hint of the original drawing—another ghost image. The erased de Kooning was also something of an art-world insider joke. I relished it along with Bob's other double-entendres. In one assemblage, *Winter Pool* (1959), he introduced a real ladder, which could be taken as a send-up of Pollock's desire to get physically into his painting, an idea which New York school artists had bandied about until it became a cliché.

In a review of Bob's show I wrote: "He transmutes ugly objects found in city streets into something elegant and full of verve, diabolic wit, and delight." When we next met, Bob thanked me for my review but objected to my use of the word "ugly." "My things are beautiful," he said.

I took Bob seriously, but it did not surprise me that many knowledgeable art-world insiders did not. In 1956, Leo Steinberg commented: "On the merry work of Robert Rauschenberg the kindest comment I can make is that some of my friends, whose (other) judgments I respect, think it is not out of place in an art exhibition. Presumably these 'combines' of elaborate whimsy, glue and chic will steal the show. Eulenspiegel is abroad again, and one must be patient."

Two trustees of the Jewish Museum, where Bob had a retrospective in 1963, stood baffled amid Bob's assemblages. Searching for something to say, one commented: "Well, at least Rauschenberg is a nice Jewish boy." Overhearing her comment, Alan Solomon, the director of the museum, called out: "But Rauschenberg is not Jewish." The other, eyes cast heavenward, murmured: "Thank God."

Bob's mission was to make-it-new and to challenge habits of perception, the way we look at works of art, what we expect of them, and what their limits are. I was able to observe him at work in mid-March 1967, when John Gibson and I invited him to participate in *Three Events* at the Loeb Student Center of New York University. Bob put on a performance, titled *Outskirts*, that incorporated film and dance and took place in the space of a theater, above and under a stage, and outdoors. The audience entered a dark, empty auditorium and encountered a line of

performers with their heads poked through a white sheet swaying and threading through the audience—like a boat through water—followed by a movie projectionist with a camera. On the bobbing sheet, Bob projected his film titled *Canoe*, and thus turned the sheet into a movie screen. At the far end of the auditorium, dancers in cagelike compartments beneath and in front of the stage were performing. Then, with the banging of a drum, a procession of dancers, two on their bellies, and two balancing a blue neon tube, traversed the space. Seen through a window was a film projected onto the roof of the Catholic chapel next door. At first, an NYU bureaucrat vetoed the proposal for the projection, but he relented when I got the permission of the priest, who thought it was a lively way to use his church. Participating in all of these activities was a stellar cast of characters that included Trisha Brown, Lucinda Childs, Alex Hay, Deborah Hay, Yvonne Rainer, and other friends of Rauschenberg in the Judson Dance Theater. *Outskirts* challenged the notion that the visual arts were supposed to be still and silent, purely spatial and not temporal. The piece was daring because it combined the visual arts, the physical "theater," dance, and film media in unexpected ways. It was also magical.

Bob and Jasper Johns were often paired because they appropriated or represented real objects, but they used them differently. For Bob, found objects were signifiers of "life." For Jasper, images and recreations of readymades were ideas. Bob was primarily Cagean; Jasper, Duchampian.

I first met Jasper at the Stable Gallery in 1955 or 1956. It was at the opening of the artist-selected annual. Jasper was not invited to exhibit, but Bob incorporated into his own combine-painting a *Flag* by Jasper (which was later stolen).

Jasper was an enigma to me. He didn't talk much, but when he did, it was cryptically or with sardonic humor. I ran into him once during his show at the Castelli Gallery in 1984. In one of his pictures, *Racing Thoughts* (1983), he had painted a trompe l'oeil nail stuck into the surface. Recalling a similar image in a famous analytic cubist painting by Braque at the Guggenheim Museum, I said: "Ah, Braque's nail." "Not really," said Jasper, smiling: "I was sitting at the table of my printmaker in Paris with nothing to do. There was a sheet of paper nailed to the table, and I began to doodle the nail. The director of the Louisiana Museum walked in and, looking over my shoulder, said: 'Ah, Braque's nail,' and I knew I had a good thing."

I was stunned when I first saw Jasper's green *Target* in a show of younger New York school artists at the Jewish Museum in 1957. The picture created a "buzz" in the art world, prompting Thomas Hess to reproduce another painting of a target on the cover of *Art News*, (January 1958) although he panned it in an article in a later issue. Most of my friends downtown assumed that an artist who depicted such banal subjects as flags and targets could only intend to sabotage "Art." The

relation of these subjects to Duchamp's readymades reinforced that belief. I disagreed. Jasper's work was different, a difference he pointed up in bronze sculptures of beer cans and a coffee container filled with brushes and painted to resemble the objects in their original state. Using traditional materials of art, such as encaustic and bronze, Jasper created commercial objects, lavishing care and craft in the process, thus transforming Duchamp's presumed anti-art into art.

I was also impressed by the artistry with which Jasper used his encaustic medium. After all, encaustic is a melted wax medium that has to be worked with slowly, and Jasper obviously used it painstakingly and with tenderness. However, his painting looked as if it was freely brushed and as such, subverted what I and my friends believed to be the ethic of gesture painting, namely, that an image had to be *found* in the anxious process of painting; it could not be *made*. With an eye to the brushwork of Guston and de Kooning, Jasper obviously crafted the surfaces of his painting—and beautifully at that. (Bob took a similar tack in his two versions of *Factum*, 1957, in which he seemed to duplicate a gesture painting.) Jasper's clever subversion of gesture painting both intrigued and troubled me (as did Bob's).

I was fascinated most by Jasper's perceptual eye-twisting. In the case of *Flag*, how was it to be viewed? As the real thing? As a representation of the flag? Its sign? Or symbol? As a painting? And what of the shrouded *Flags*? In a review in *Art News* at the beginning of 1960, I wrote that in *Flag* Jasper tried to make the invisible—that is, the commonplace thing that is so familiar that we no longer bother to look at it, visible—and in the ghostly version, to make it invisible again. In other pictures, the stenciled names of colors were overlaid with areas of colors. In *False Start*, a blue 'RED,' for example, is painted on orange. What did the viewer actually *see*: the colors or their names? I concluded that these images were "wonderfully impossible."

I was so taken with Jasper's color/name pictures that I coveted one. When I discovered that he had produced a print of the image which was selling for $100, I phoned him and asked if I could buy one on time—the price was steep for me in 1961. He agreed, and after I picked it up in his studio and asked how I would pay for it, he said that he wanted to give it to me. It hangs in the bedroom next to a Stella print and across from a de Kooning lithograph and a Reinhardt black painting. The wedding portrait by Katz is on a third wall.

---

Cage's ideas not only influenced Bob and Jasper but also inspired other young artists who, in 1957, took a course he taught at the New School. Among the students who attended were Allan Kaprow, George Brecht, Al Hanson, Dick Higgins, and Jackson MacLow. Cage posed the following questions: "How can we break

down barriers between life and art?" and "As artists, where do we go from here?" His answer, "Toward theater." Cage himself had arranged the first such event at Black Mountain College in 1952. Cage's students took up his challenge. Kaprow, soon to be joined by Jim Dine, Red Grooms, Claes Oldenburg, and Robert Whitman, went on the create environments and happenings. Higgins and MacLow, in concert with Yoko Ono and Nam June Paik, formed fluxus and also staged performances.

But what were John Cage's ideas? I learned of them piecemeal in the 1950s. I saw John only occasionally, on his rare visits to The Club or the Cedar Street Tavern or at openings. He was always friendly, though I only found out after his death that he admired my writing. I attended most of his concerts, only dutifully because his music did not engage me. John was an advocate of Zen Buddhism and spoke several times at The Club about it. I asked him after one talk what he thought of Martin Buber. He answered with a smile that he preferred his mysticism genteel. He didn't say gentle, but if he had, he would have aptly characterized himself. No one in my art world was more pleasingly soft-spoken or had better manners.

John has not been treated as an art critic and/or theoretician, but I came to consider him one, arguably the most influential critic/theoretician of the second half of the twentieth century. To put it directly, he formulated a cogent aesthetic, which was opposed to Reinhardt's and Greenberg's purism, on the one hand, and on the other, to Rosenberg's existentialism. Moreover, John championed a different roster of artists, notably Robert Rauschenberg and Jasper Johns and their progeny.

As John Cage viewed it, the function of "art" was to break down all barriers between art and life. In this, he was inspired by Marcel Duchamp's readymades and his use of chance. Not only was Duchamp John's mentor, but he was also his friend. John rejected any hierarchy of sounds in music, or of materials, forms, and colors in the visual arts. Each element, as it occurred, was to exist only for itself, allowed to come into its own "rather than being exploited to express sentiments or ideas of order." Consequently, any sound or material, by itself or in any combination, whether intended or not, *is* art. Noise is music and so is silence, which Cage denied could even exist, since in nature sound is always to be found.

John's seminal work, titled *4'33"*, exemplified his life-as-art aesthetics. In its first performance, David Tudor walked onto a stage, sat down at a piano, opened it, sat there for four minutes and thirty-three seconds, occasionally opening and closing the piano, then closed it, got up, and walked off the stage. But there were sounds in the hall, of chairs creaking, people shuffling programs and coughing, the scuffling shoes of people leaving and their angry mutterings, airplane, traffic, and insect noises, and so on. As I noted, the artistic counterpart of *4'33"* was the series of blank canvases Rauschenberg exhibited in 1951.

John maintained that in his *4'33"* and in Rauschenberg's white paintings, "life" was making the "art," and that was their "message." "I would like to think that the sounds people do hear in a concert could make them more aware of the sounds they hear in the street, or out in the country, or anywhere they may be." Thus, instead of Rosenberg's "angst" and Greenberg's "art history," John substituted "mindfulness" and "enjoyment"—of one's everyday life.

Wanting to know more of John's aesthetics, I interviewed him in the spring of 1966. We met in my apartment on Tenth Street off Avenue A. Upon entering, John looked admiringly at a 1954 drawing that Philip Guston had given me. He began by saying that in the 1930s he was most interested in geometric abstraction. Then, he went on, he met Mark Tobey.

> Tobey had a great effect on my way of seeing, which is to say, my involvement with painting, or my involvement with life even. I remember in particular a walk with Tobey that would normally take no more than forty-five minutes but on this occasion must have taken several hours, because he was constantly stopping and pointing out things to see—opening my eyes, in other words. This, if I understand it at all, has been the function of twentieth-century art: to open our eyes.
>
> I don't remember the exact date of it, whether it was in the late forties or early fifties, but there was an exhibition of Tobey's work at the Willard Gallery which included the first example of white writing. I liked one so much that I began buying it on the installment plan. It was completely, so to speak, abstract. It had no symbolic references. It was a canvas that had been utterly painted. But it was not geometric, which brought about a change in my way of seeing.
>
> When I left the Willard Gallery, I was standing at a corner on Madison Avenue, and I noticed that the experience of looking at the pavement was the same as the experience of looking at the Tobey.... Now this involvement with Tobey naturally opened my eyes to abstract expressionism, not to its intentions but to its appearance.
>
> What you have in the case of Tobey and in the case of the pavement and in the case of much abstract expressionism is a surface which in no sense has a center of interest, so that it is truly distinguished from most art, occidental and oriental, that we know of. The individual is able to look at first one part and then another and insofar as he can, to experience the whole. But the whole is such a whole that it doesn't look as if the frame frames it. It looks as if it could have continued beyond the frame. It is, in other words, if we were not speaking of painting but of music, a work which has no beginning, middle, or ending, or any center of interest.

That made me think of Jackson Pollock, and I asked John whether he was friendly with him.

Well, I tried to avoid him, because he was generally drunk and unpleasant to encounter. I remember seeing him on the same side of the street I was on, and I would cross over to the other side. Now and then, I would be unable to avoid him. We would meet, and he always complained that I didn't like his work enough, and I didn't. I first saw one at Peggy Guggenheim's apartment uptown. She had a hallway downstairs in which there was this enormous mural. The image seemed to be taken from the human figure, and that immediately made my interest diminish. Then came along these things that you would think I would like, namely the allover dripped canvases.

I looked surprised and, noticing that, John continued:

But I was familiar with Tobey, and Pollock's work looked easy in relation to Tobey's work, which looked far more complex. It was easy to see that Pollock had taken five or six cans of paint and more or less mechanically "dripped." He never troubled to vary the color, so the color didn't interest me. Whereas if you looked at a Tobey, you could see that each stroke has a slightly different white. And if you look at your daily life, you see that it hasn't been dripped from a can either.

I interjected, "What about the intensity, the excitement?"

Oh, none of these aspects interested me. They're precisely the things about abstract expressionism which didn't interest me. I wanted to change my way of seeing, not my way of feeling. I'm perfectly happy about my feelings. I want to bring them, if anything, to some kind of tranquility. I don't want to disturb my feelings, and above all, I don't want somebody else to disturb my feelings. I don't spend my life being pushed around by a bunch of artists.

Again, thinking of Pollock, I asked John whether in a talk he gave at The Club in 1949 on sand painting, he had alluded to Pollock who had been inspired by Indian sand painting. He answered, "No, I was promoting the notion of impermanent art, [and Pollock's] work had a permanence. I was fighting at that point the notion of art itself as something which we preserve."

I asked John why he was not sympathetic to the abstract expressionists' aims.

I never agreed with their intentions. For instance, it was clear in the late forties that the work of Bill de Kooning was of extreme interest. I recall a painting of his, a black-and-white one which had no center of interest and which had been impressed with some newsprint. It had been exhibited for a while at

the entrance of the Whitney Museum when it was still on Eighth Street. This painting was one of the most glorious paintings I have ever seen. It was introductory to the very life that I was living.

At this time, I began to write a series of very short pieces by making notations calligraphically on very fine paper. I gave these musical scores as gifts to friends. I wanted to give one to Bill de Kooning. He and his wife, Elaine, used to come to the musical evenings I gave at my apartment down at Grand Street. The idea was that he would give me in return a drawing of his. A meeting took place at which the exchange was to take place. It was late one evening when he had a studio on Fourth Avenue. I gave him immediately my manuscript, and we sat down and in the darkness had a conversation and later he showed me a few drawings, and he could tell that I didn't particularly like them. So I never received a drawing. He said, "We are different. You don't want to be an artist, whereas I want to be a great artist." Now it was this aspect of wanting to be an artist—that is to say, wanting to be someone who had something to say, who wanted, through his work, to appear really great—that I had no interest in, and that separated me from even those people who were close friends, and whose work I could use but not in the way they intended.

I said, "Just as you had no use for the intentions of the abstract expressionists, so they had no use for yours. And yet, they constituted most of your audience." John responded, "Oh yes. Every experimental musician in the twentieth century has had to rely on painters."

John then recalled the influence of Zen Buddhism on his life and thinking: "In the middle forties, through personal circumstances that ended in my divorce, I required help. That could have come from psychoanalysis, as was usual, but it didn't. Instead I got involved with oriental philosophy and that performed for me the function that psychoanalysis might have performed. Zen is characterized by an insistence on an utterly realistic approach, and one which ends in humor." John added with a smile that abstract expressionism lacked a smile.

I remember hearing Rosenberg say, at an exhibition of pop and op art, where is the suffering? I continually have made it clear in my discussions of art that I prefer laughter to tears. How did I come to that view? I came to it partly through the recognition that if art was going to be of any use, it was going to be of use not with reference to itself, but with reference to the people who used it, and that they would use it not in relation to art itself, but in relation to their daily lives, that their daily lives would be better if they were concerned with enjoyment rather than misery.

With John's early regard for geometric abstraction in mind, I asked about Josef Albers, who had invited him to teach at Black Mountain College in 1948 and

again in 1952. "We were very close. Albers liked my work, which was involved with structure through most of the forties." I asked, "What did Albers think of your use of chance?"

> He was not able to accept my involvement either with chance or with inde-terminacy—to such an extent that our friendship has been broken.
>
> I have spent my life denying the importance of relationships and intro-ducing situations where I could not have foreseen a relationship. Now this happened at Black Mountain where I gave people the possibility of perform-ing, I admit, within compartments which I had arrived at through chance operations. By compartments I mean periods of time in the total period dur-ing which they were free to do whatever they wished or to do nothing. They mostly chose to do something. I had no knowledge of what they were going to do. I had a vague notion of where they were going to do it. I knew that M. C. Richards and Charles Olson would climb a ladder which was at a particular point. I had less knowledge of what Merce [Cunningham] and the dancers would do because they would move around. The thing had not been rehearsed. It had simply been planned, in fact that very day before lunch, and it was performed before dinner. We all simply got together and did these things at once. And if we did bring about patterns, they were patterns which we had not measured, and furthermore which we didn't wish to emphasize. We simply wished to permit them to exist.
>
> I don't wish to impose my feelings on other people. Therefore, the use of chance operations and indeterminacy, the nonerection of patterns, of either ideas or feelings on my part.

John met Rauschenberg while Rauschenberg was still a student. Subsequently, he admired his allover black and then white paintings. "As Bob's work became more and more representational, my eyes were opened by him to representation-al things. He made it possible for me to see . . . a Coca-Cola bottle, for heaven's sake." I said: "There is a relation between that idea and your incorporating radios in your work." He responded: "Right. All of that goes together, and it brings back with great impact the work of Marcel Duchamp." I added: "Back to his ready-mades. And then Johns shows his targets and flags."

John said,

> I was not able to see Johns' work immediately. I had difficulties with it. In fact, they are among the difficulties I most cherish. They too have obliged me to change. For instance, you can look at a Johns work without paying any atten-tion to its subject, and so enjoy it in the same way you would enjoy abstract expressionism or Tobey or anything that was nonrepresentational. But if you

accept it as a flag or a target, your mind has to change. It has changed the nature of art criticism, and more potently than the work of Bob Rauschenberg. And it has made reemphatic, it seems to me, the work of Duchamp.

I added, "And it leads to art which uses common objects, that of Warhol, Lichtenstein, Oldenburg." John said, "My gratitude extends to them. I'm far more interested in what's being done now than I am in the best things that were done formerly. I feel much more at home in an area that completely lacks discussion of quality and which completely involves us in changing our minds, increasing our awareness, and satisfying our curiosity." Once as we talked, I pointed out to John a potential contradiction in what he was saying. His response was to accuse me of "linear thinking."

After our conversation, John and I went to an Italian restaurant on Avenue A for supper. In the middle of our meal, he asked if I played chess. I told him that I did but had not for many years. He then challenged me to a game and, reaching into an inner pocket of his jacket, produced a portable chess set. He was an inept player and must have spotted my shocked looks at his dumb moves. After I won, John said sadly that he was not very good at chess. He then remarked that the only time that Duchamp, who was a chess master, ever lost his temper was during a game. He shouted, "How could you be so stupid?" But Duchamp probably knew why John could never get the hang of chess. To blame was his lack of "linear thinking," that is, of being able to plan with a goal in sight.

---

Until I encountered Cage's ideas, the mass-produced objects exhibited by Duchamp and dubbed readymades by him had meant anti-art to me, little more. I was aware of Duchamp's historic role, that he had achieved notoriety in the Armory Show of 1913 and the Society of Independents show of 1917, for which he had submitted a urinal he had titled *Fountain.* And I had read Robert Motherwell's *The Dada Painters and Poets,* published in 1951. However, artists and art professionals that I admired dismissed Duchamp as a failed artist who had abandoned painting and turned against it because he was a mediocre painter. I agreed. I didn't give readymades much thought, until Richard Stankiewicz, Rauschenberg, and Jasper Johns began to incorporate them into their work in the middle 1950s. It was then that I began to take seriously Cage's interpretation of Duchamp's readymades. My conception was far different than John's all's-well-with-the-world view, however. Duchamp's objects struck me as nihilistic, profoundly nihilistic.

I occasionally glimpsed Duchamp through a window at the Cookery on University Place and Eighth Street. Remarkably handsome at age 74 (in 1961), he

looked like an artist-prince, even when having lunch at a downscale eatery. After I had been introduced to him, we would occasionally chat at chance meetings near his apartment on East Tenth Street, a three-minute walk from where I lived. I also interviewed him twice in the early 1960s, on the Casper Citron radio show and at his home.

I asked Duchamp whether he had intended his penciled mustache and goatee on a reproduction of the *Mona Lisa*, along with a printed obscenity beneath her image, to be an anti-art gesture. He denied that it was. I then asked whether he had the original work would he have defaced it. He said, absolutely not; his graffiti was not intended to be destructive. He then commented that in looking back he suspected that he had added the male appendages to the *Mona Lisa* because he thought that she was a man, alluding to Leonardo's homosexuality. I found that remark even more subversive than his defacing the image.

In retrospect, it seems to me that I was shocked by Duchamp's remark because I was heterosexual. So was he, even though he had a female alter-ego he named Rrose Selavy. The sexual dynamics get even more complex. Did Duchamp's printed obscenity indicate a desire to get into the angelic Mona Lisa's pants? Or was it scorn? As a heterosexual, had he "assisted" a readymade of a woman's portrait by Leonardo, a homosexual, by attaching male hair to it, because he thought the Mona Lisa was a man, possibly Leonardo himself—or maybe Duchamp—in drag? And Duchamp was the guru to Cage, Merce Cunningham, Rauschenberg, and Johns, who were all alleged to be homosexuals. How to negotiate all this?

Some time later, at a show of Duchamp's work, I saw an inept, obviously amateur copy of the Mona Lisa, acquired by Max Ernst, and after some arm twisting, given to Duchamp. Duchamp had then scratched a mustache and goatee on the copy. Ah ha, I thought, if he mutilated the copy, would he not have defaced the original? Close up, I saw that Duchamp, using a fine brush, had lightly painted hairs on the surface of the picture with pigment that could easily have been removed without damaging the work. What an extraordinarily complex mind!

I wondered whether the impact of World War I had provoked Duchamp to vandalize and defame the Mona Lisa, as an icon of European art. He stayed out of the fighting but his brother, the sculptor Raymond Duchamp-Villon, died of typhoid contracted in the trenches. Duchamp must have sensed that the war created an irrevocable rupture in Western culture. Weren't his iconoclastic, indeed nihilistic, anti-art gestures aimed at subverting a civilization that had led to the unspeakable slaughter? Through his work, Duchamp obviously wanted to engage in a creative dialogue with Leonardo, as a Renaissance master, out of respect for his genius. Or did he also want to topple the exemplary artist-scientist-humanist from his pedestal? Duchamp admired the work of Alfred Jarry, the mod-

ernist cynic, I assume because he was the underbelly of the humanist paragon. In the end, I knew that Duchamp's motives were so convoluted that I would never unravel his love-hate relationship to Leonardo.

Detractors of Duchamp—Roger Shattuck, for example—as late as 1997, denounced him as an aesthetic con man, prankster, trickster, or charlatan, and scolded those who took him seriously as gullible dupes. Shattuck should have been ashamed of himself for his cheap shots. Whatever Duchamp was, the question that remains to be answered is why he achieved the iconic stature that he did in the eyes of innumerable artists, historians, critics, and art theoreticians, whose seriousness and intellectual credentials are no less impressive than Shattuck's. In large measure, it was because of his influence on artists, such as Rauschenberg, who used detritus to break down barriers between life and art; Johns, who created everyday objects with traditional art materials; Warhol and Koons, who glorified commodities; Joseph Kosuth, who, recognizing that Duchamp had added a new idea to a commonplace thing, conceived of a purely conceptual art; Sherrie Levine, who made remades of readymades; Barbara Kruger, who "altered" advertisments for feminist purposes; and innumerable artists who use rubbishy, found materials to make "pathetic" or "abject" art, which aimed to expose our wretched era.

In 1970, I wrote in a notebook that the Duchampian aesthetic would triumph if *ideas* and *readymades* became even more central in art than artistic making. They have. At the millennium, if the number of Duchamp's disciples is any criterion, it appears as though he won out over Picasso and Matisse as *the* premier artist of the twentieth century.

The question of Duchamp's role in modern art came up at a formal dinner in honor of Sir Ernst Gombrich at New York University to which I was invited as Lucy's husband. I was seated across from him. He began our conversation by saying that he felt a deep sense of "shame" when told that art historians took Duchamp seriously. That's a direct challenge, I thought. Do I take him on or let it pass? It looked as though it was going to be a tedious evening. I responded: "Interesting you should say so, Sir Ernst, because I just spent two hours teaching Duchamp to my class." And the sparring began.

Gombrich put me in the position of justifying Duchamp, and I took two tacks. One was that World War I created an unbridgeable rift in Western civilization. In reaction to the bloodbath, much of modernist art had emerged. Humanism was rendered obsolete. Gombrich refused to accept that the war had been anything other than one of many horrors in Western civilization—nothing special. It occurred to me that he was using Duchamp as a scapegoat to justify his across-the-board dislike of modern art. I then pressed him to reveal whether he admired any twentieth-cen-

tury artist. He allowed a fondness for Klee. I had him cornered, and asked: "Why equate modern art with Duchamp? Why not Klee?" and, "What about Mondrian?" Gombrich acknowledged Mondrian but added: "Compared to Botticelli?" I responded: "If there was a living artist who painted as skillfully as Botticelli had, would you accept him?" He thought for some time and said: "Probably not."

I thought to myself, even you, the exemplary humanist, have your doubts about the continuing relevance to artists of the masterworks of Western art, and you lived through more of this dreadful century than I did. This was brought home to me years later when I met Gombrich at the ninetieth birthday party of Lotte Horowitz, the widow of the founder of Phaidon Press and the mother of Lucy's publisher, Elly Miller. Again, he recognized me and in an affable way recounted our "argument" in New York. At one point, Mrs. Horovitz came over and began to reminisce with Gombrich. She recalled that she had been at the funeral of Emperor Franz Josef in 1916. "Were you?" he said, "Where were *you* standing?"

---

The major promoter of the artists who were inspired by the Duchamp-Cage aesthetic, and of their followers, was Leo Castelli. He was a small and dapper man with the slightly bowed bearing of an aristocratic courtier. He was always cordial but not familiar—not with me at any rate. I was not part of Leo's inner circle. I imagine that he expected more deference than I gave him. Or at least, that I would ask for his guidance in what I wrote. I never did, but that did not deter him from being very helpful in providing me with information and photographs.

Most recent art historians believe that Greenberg was the most influential critic-impresario of the half-century following World War II. They are mistaken. It was Leo Castelli. Like Cage, he was not considered an art critic or historian. His conception of the development of avant-garde art was not recorded in articles or books but was manifest in his choice of artists. (His views did appear in articles by others—for example, Alan Solomon.) Leo's interpretation of new art since the middle fifties provided a sense of a logical and necessary evolution from one generation to the next or, more important, a sense of history being made. Implicit in his selection was a genealogy: Johns begat Stella, Lichtenstein, and Warhol; Rauschenberg begat Rosenquist; Stella begat Judd, Andre, and Morris, who begat Serra, and so forth. This lineage from Rauschenberg and Johns though pop and minimal art into postminimal art became the mainline in contemporary art. Leo's "history" was understood by the art world as an aesthetic counter to that of Greenberg. Leo's taste has turned out to be far superior to that of his formalist rival. The stained color-field painters and construction sculptors promoted by Greenberg are in decline, but those Leo championed are still in the art-world's eye, and they deserve to be.

As I noted, Allan Kaprow was inspired by Cage's demand that the visual arts approach theater, and he became the standard-bearer of environments and "happenings", as he dubbed them. I met him around 1957, when I reviewed his early painted collages and sculptures. I was stunned by their "immediacy and authority." Reminiscent of New York slums, the work was harsher and more frenetic than that of his contemporaries, but it remained in the ambit of New York school painting. What it ushered in, however, was radically different. In the spring of the following year, Allan produced his first environment, and in the fall, he published a manifesto-like article titled "The Legacy of Jackson Pollock." Since Pollock's death in 1956, he wrote, "the 'Act of Painting,' the new space, personal marks that build its own form and meaning, the endless tangle, the great scale, the new materials, etc., are by now clichés of college art departments. The innovations are accepted. They are becoming part of textbooks."

With art on Tenth Street in mind, Allan insisted, "The greatest problem facing the artists today is boredom, boredom with themselves and in their work." What then were artists to do? Break the art habit as an addict breaks the junk habit. Abandon painting in order to "become preoccupied with and even dazzled by the space and objects of our everyday life.... Not satisfied with the *suggestion* through paint of our other senses, we shall utilize the specific substances of sight, sound, movements, people, odors, touch." Allan had taken Cage's aesthetic to its extreme.

Allan's article on Pollock irked me. He was trashing what I stood for. In a letter to *Art News*, I wrote that Kaprow's "idea that an artist has to go past Pollock is offensive; it seems to have more to do with racing than with art. And if, indeed, these pictures reach out into life, why say that artists must abandon painting?"

Much as I disagreed with Allan's ideas, they were radical, and I had to know more about them. Keenly intellectual and middle class, Allan neither looked nor sounded like the iconoclastic artist he was. In 1963, I felt that the time was ripe to introduce his thinking to the public at large that read the *New York Post*. In my interview, Allan acknowleged the influence of Harold Rosenberg's article on action painting but added that he had separated out the action from the painting. He said that "the 'action' part in action painting ... contributed to my work." But, I asked him, wouldn't the emphasis on process deny the product and result in non-art or dadaist anti-art? He responded, "Dada was extremely important, for rather than being simply anarchistic, it was at heart, liberating. I see its anti-art position as nothing more than a healthy hatred for clichés and smug aesthetics.... Yet specifically, I cannot count it as a major influence on my art, either in attitude, subject matter or method."

I may have been ambivalent about Allan's aesthetics, but I enjoyed the environments and happenings they spawned. I recall most vividly *Yard* of 1961 in

which Allan dumped a mountain of old tires in the yard of the Martha Jackson Gallery over which we scrambled happily. I also think back on *The Words*, a 1962 environment which consisted of a roomful mélange of words painted and collaged on the walls, and three-dimensional constructions sitting on the floor and hanging from the ceiling. The *mise-en-scène* enveloped the viewer, calling to mind the mesh of words—newspaper, magazine, radio, TV, etc.—that clutter up our lives. It was a hyper slice of reality.

In 1962, I was the instigator of one of Allan's most ambitious happenings. A real estate developer wanted to turn the disused Mills Hotel (designed by Sanford White) on Bleecker Street into an apartment building and thought that it would help to incorporate within it an art center of sorts. He got in touch with me and asked for my help. I invited a group of artists to meet with him, but his crass money-mindedness made us suspicious of his intentions. As a kind of test, I asked that the magnificent nine-story-high courtyard be offered to Allan to create a happening, and the developer reluctantly agreed. Here's what happened from my notes:

A three-story mountain composed of tar and rock; newspaper on floor; unnerving humming sounds get louder and louder until they fill vault; animal and mechanical sounds; tinfoil flutters down like snow; four spotlights illuminate space; tin cans rattling attached to a go-cart pushed slowly through the audience, forcing people to move out of the way; two workmen carrying cartons of brooms shove their way through audience in a trancelike way, sweeping newspapers very slowly; the workmen hand out brooms to audience and ask for help sweeping; newspapers are piled on mountain; man with bicycle ringing bell drives through audience; then a period of silence, followed by loud noises and booming sounds, as mountain erupts like a volcano, belching balls of tarpaper; voices start calling from windows, apartment noise, breaking plates; mattresses put on mountain; hanging tire starts swinging knocking things down; girl in nightgown with transistor radio wanders as a sleepwalker humming, slowly climbs ladder; two press photographers come in and take photographs, bulbs flashing; the piercing sound of an electric saw; clouds of smoke flow out of windows and fill the vault; tarpaper like black soot is thrown through the smoke; loud whine of ship distress signal; an inverted mountain is lowered until it kisses top of mountain below; finis.

The way in which the audience was shuttled from place to place in the *Courtyard Happening* was aggressive, but the spectators responded agreeably. Allan generally meant for his works to be benign, but at least one I saw in April 1963 did not turn out that way. In *Push and Pull: A Furniture Comedy for Hans Hofmann*, an homage to his teacher, Allan asked the audience to push and pull objects in two rooms and add some of their own if they so pleased. In his scenario he wrote,

"Anyone can find or make one or more rooms of any shape, size, proportion and color. Then furnish them perhaps, maybe paint some things or everything./ Everyone else can come in and, if the room(s) are furnished, they also can arrange them, accommodating themselves as they see fit./ Each day things will change." Was this happening meant to be spectator-friendly? Of course, but what occurred was the art-world counterpart of road rage. The viewers/participants, all of them intelligent and art-conscious, demolished the rooms in a kind of frenzy of destruction. I stood with Allan observing the mayhem, neither of us able to account for it. I recall saying to Allan, "You once said that you did not want to ill-treat the public. But did you ever expect them to behave toward a work of yours this way?"

———————

Cage-inspired artists were not all of one mind. Their aesthetic (and personal) differences came to the fore during a panel titled "Patriotism and the American Home" at The Club in the spring of 1958. In response to Kaprow's proselytizing, I invited him, Rauschenberg, Stankiewicz, and George Ortman to participate. Frederick Kiesler was the moderator. I no longer remember why I chose him. He may have asked, and I could not refuse since he was a historic figure, an innovative architect, an installation artist, and a highly visible figure in the New York art world. He also had a reputation as a wit. When Gorky was introduced to him as the greatest painter in America, Kiesler responded: "North or South America?"

In his opening remarks, Kiesler made a pitch for Johns, which was shocking because at The Club, promoting artists was taboo. Kiesler declared that Johns's humility and love separated him from the artists on the panel. "His targets and American flags are so simple and yet so hypnotic." Rauschenberg asked whether Kiesler wasn't being too romantic. Someone from the floor called out: "Do we really care whether or not a painter has humility, Kiesler? Are you trying to found a monastic order? If a man really had humility, he wouldn't paint at all." Kiesler responded: "That's too much humility." Stankiewicz interjected: "Or too much arrogance."

From the start, Rauschenberg was hostile to Kaprow. It surfaced after Kaprow's professions of love, that is, of a giving of self to some external situation or object. Addressing Kaprow, Rauschenberg said: "You talk too much about love. What counts is literalness and objectivity. As I work I make divisions that are not very interesting, like dividing a picture down the center in order to have as little to do with composition as I possibly can. I don't care to use green to make the red look redder or to direct the observer's attention. The observer can find his or her own focus. The approach to a picture can even be negative. When you don't know what to do, you find out what not to do and do something else." Kaprow coun-

tered: "But critics say your work is well formed and use this point as a justification for what they otherwise think is a questionable art."

Rauschenberg picked up a Dixie cup and said to Kaprow: "You can see this Dixie cup, feel it, but not understand it. . . . It is not in the nature of a Dixie cup to be understood, and I am not being facetious." Kaprow asserted: "I object to the idea of indifference. I cannot find anything meaningful until I have paid attention to it or it has forced me to." Rauschenberg responded: "Indifference is an impossibility for Western man. I recognize that I am attracted and repelled by certain things, but I want to establish a more neutral situation." Kaprow asked: "Does that mean a more harmonious situation?" Rauschenberg shrugged: "Do you mean love again? Painting has nothing to do with love and hate unless you want other people to get into the same frame of mind you were in. Making art is really yourself playing with yourself. Things ought to be allowed to exist and not be turned into symbols."

George Ortman, whose art was symbolic, looked up. "A thing has more meaning than just being itself." Rauschenberg countered: "There is nothing that we know about an egg that is more awesome than the egg." Ortman asked: "Is your *Bed* a symbol?" Rauschenberg answered: "When you see a bed in a bedroom, it's a place to rest. I don't think anyone ever thought you couldn't lie on a bed until I put it on the wall and smeared paint all over it."

Rauschenberg ended the discussion by reading a series of questions, among them: "Is it possible to ask a question without knowing the answer? Can a work be considered art before its meaning has been agreed upon? Once agreed upon, what is the function of the work? Can a painting ever be more or less than a fact? Is emotion based on anything other than previous literary information? What is a photograph? As a statement, is a question more explicit than an explanation? Can things be anything other than what they appear to be? Is it possible to make something that has no meaning? If not, what meanings are valid ones? Cross two fingers on your left hand if you are right-handed. What do you think about?"

Allan Kaprow introduced me to Claes Oldenburg around 1959. Claes was a large man, somewhat impassive but friendly, and well spoken. I immediately liked him. He referred to himself as a city artist. "The street is a marvelous artistic image," he told me. "As a spatial idea, it is at once open and closed; everything is in motion, signs go out, windows go in; things hang in the sky, like wires and clothes, or jut up, like lamp poles." Claes thought of the city as anonymous. "People can do most anything in it. Its 'nature' is destructive, but it can be humanized, as kids do when they scrawl graffiti on tenement walls." (He said this some fifteen years before graffiti writers covered New York with their spray-painted

tags). Claes's broader aim was to assess American society: "I take its incoherences, tremendous desire, rejection, and loneliness very seriously."

In a review of Claes's environment titled *The Street* (1960), I wrote that the figures he pieced together from burlap, corrugated cardboard, and newspaper edged in black as if charred were funny, tender, and grim, and called to mind "the human wrecks that inhabit downtown New York." They symbolized "the American dream ... unfulfilled in the anonymity of city life." I was especially interested in "the drawing that distinguishes these pieces. Line is direct and rough, in keeping with the content, but it is also precise and animate." Claes said that he had been impressed by "Kline's and de Kooning's use of line, the way they keep it alive. It is very exciting to me, especially Kline's drawing. But when I came to New York, they were already old masters. Their painting moved me, but it was already museum art. I wished to do more. I hated the four edges of the canvas." Such was Claes's distaste for museum art that in response to a laudatory review I wrote in *The New York Post* in 1961, he thanked me, then shrugged and said, "But it was too historical."

Claes invented a pistol-like object he called a raygun. He and Jim Dine concocted *Raygun*, a series of artworks and events, whose slogan was "Annihilate—Illuminate." They organized "Ray Gun Specs," which consisted of six performances at the Judson Church in 1960. The participants were Claes, Dine, Al Hanson, Kaprow, Dick Higgins, and Robert Whitman. Claes's performace was titled "Snap Shots from the City." As I recall it, he stood on some kind of parapet high above the audience and recited in Swedish. He also handed out mimeographed sheets of paper with crude cartoons.

I asked Claes whether it bothered him that his environments and happenings were ephemeral. He said, "Permanency doesn't interest me much yet. But my paper works are as permanent as most works of art in the past." However, the transient nature of his work soon annoyed Claes, and he began to translate the props of his happenings into permanent objects. The move was a natural one. Speaking from the floor at The Club in 1961, he said, "My theater is a theater of objects."

In 1960, he invited me to his studio and showed me the first of his painted plaster sculptures of American flags. I immediately thought of Jasper Johns' flags, but almost as quickly it occurred to me that the rough-and-ready, high-spirited manner in which Claes handled the plaster set them apart. He created a multitude of common objects in polychromed plaster, which in 1961 he assembled in *The Store*, which was just that, a store on the Lower East Side that on first glance looked like any neighborhood bodega, but whose commodities on closer viewing were exuberant sculptures. Though it was not easily accessible, the art world trekked to see Claes's environment. His subsequent pieces were often composed of soft materials, an innovative departure from traditional sculpture made from

hard materials. Yielding, visceral, and vulnerable, and suggestive of bodily functions, they opened up a new direction in sculpture.

In the early days of assemblage, environments, and happenings, the art world tended to treat their makers as a kind of collective. Claes soon resented being pigeonholed with other artists. When, in 1960, I invited him to participate on a Club panel, he declined, saying that he wanted to be treated as an individual and not as a member of any group. Claes had a point. He was often linked to Jim Dine. He differentiated his work from that of his friend. "Dine expresses American home life; my work stands outside the house." When pop art emerged in 1962, Claes's work was often related to it. He denied the connection to Warhol and Lichtenstein. As he said: "I am inspired by found objects, such as Coke bottles and shoes, but I never use them as such. I find materials, but I want my forms to be entirely my own."

In 1964, I encountered Claes in the Sidney Janis Gallery. Glancing in the wastepaper basket, I saw a vacuum-packed piece of a raygun that I immediately recognized as his. I fished it out and asked him what it was. He said it was a damaged piece of an edition of one hundred. I asked if I could have it. He said yes, took it from me, wrote "Reject" on it, and initialed it. He later destroyed the edition, so the rejected *Reject*, as it is now titled, assumes a special function in his body of work, or rather, non-work.

Claes's works in public places—the huge baseball bat, glove, and shuttlecocks—were monuments commemorating consumer society. In 1973, I went to Sweden and visited the Vasa Museum, which housed a great battleship that was launched in 1628, sailed a few hundred yards into the bay, and sank. In 1961, after centuries of trying, the Swedes finally succeeded in raising the Vasa and eventually ensconced it in a museum. When I next met Claes, I told him that I finally understood his useless monuments; they were part of the Vasa trauma. He did not think it funny.

———

The most sensational happening of all that I attended was Jim Dine's *The Smiling Workman*, one of the six performances at the Judson Church in 1960. It conveyed frustration at its most melodramatic. In it, Jim "acted" as an artist. With a spotlight on him, he approached an empty canvas and a table with three jars of paint and two brushes on it. As he recalled:

> I was all in red with a big, black mouth: all my face and head were red [and Jim's head was large and rotund], and I had a red smock on, down to the floor. I painted "I love what I'm doing" in orange and blue. When I got to "what I'm doing," it was going very fast, and I picked up one of the jars and drank the paint, and then I poured the other two jars of paint over my head, quickly, and dove, physically, through the canvas. The light went off. It was like a thirty-second moment of intensity.

Jim forgot to mention the unearthly sound he hummed throughout the performance. As I remember it, the last word he painted was "Help."

———

I attended fluxus performances from their beginning in 1962. Unlike most happenings they tended to be short single events, musical rather than visual, and aimed to demythologize the artist. The fluxus artist, so the movement's manifesto announced, "forgoes distinctions between art and non-art, forgoes artists' indispensability, exclusiveness, individuality, ambition, forgoes all pretention towards a significance, variety, inspiration, skill, complexity, profundity, greatness, institutional and commodity value. [Fluxus] is a fusion of Spike Jones, Dada, games, Vaudeville, Cage, and Duchamp."

The exemplary fluxus event was Nam June Paik's dragging a violin along the street and then exhibiting the mangled remains in an art gallery. In my favorite fluxus opus, a line of musicians in black tie toting their instruments enter the stage single file. The conductor appears and after bowing to the audience, faces the performers. On a wave of his baton, they turn, march toward the nearest wall, and take positions alongside it. Then, on another flick of the baton, in unison they bump their heads against the wall. One bump, and finis.

Nam June Paik was my favorite fluxus artist. His music always had a visual component. As he said, "Eighty percent of my information comes through the eyes, twelve percent through the ears." The innovator of video art, he will be one of the few artists of his generation whose contribution will outlive our time. I was in awe of Paik's genius and would have been even more reverential had he not been so funny. He said that he decided to become a musician after hearing a concert by Stockhausen because he thought he could write music as bad as his. I was once on a panel with him at New York University. He delivered a hilarious lecture on the history of the use of light in art. After each outlandish assertion, he turned to me and said: "Isn't that right, professor?" Putting on my most solemn academic face, I nodded and annouced: "Indubitably, Mr. Paik."

In 1958, Paik met Cage, who aroused his interest in Zen Buddhism, but the young artist seemed to be less taken with Zen's contemplative aspects than with its use of physical force and shock tactics as a stimulus to enlightenment. When Paik spent three days at a monastery in Japan, the head monk struck him repeatedly with a long stick. In *Hommage à John Cage* (1959), Paik "fixed" a piano so that it toppled over (figuratively killing the "father" he loved). In *Étude for Pianoforte* (1960), he jumped off the stage, attacked Cage with a large pair of scissors and castrated his necktie, poured shampoo over his head—and that of David Tudor—elbowed his way aggressively through the crowded audience and out of the hall, and then phoned to announce that the performance was at an end. In *One for Violin*

(1962), Paik slowly raised the instrument over his head and then brought it down with a crash on a table in front of him. As a founding member of fluxus, Paik continued to stage violent events, prompting Kaprow to call him a "cultural terrorist."

In 1962, Paik begun to use television as his primary medium, experimenting both with the sets as materials for sculpture and with their electronic transmissions. At this time, he rejected violence and embraced Cage as the prophet of "joy and revolution." His work began to partake of the benign side of the counterculture—that is, its penchant for Zen Buddhism, iconoclastic humor, and eroticism. Paik employed Cage's aesthetics to justify his use of television. If, as Cage reasoned, everyday life and art ought to be fused, and if new technologies were central to contemporary life, then they and art should be merged. The purpose of art was to sensitize the public to the radical changes taking place in life. Indeed, in a catalog of a Paik exhibition, Cage predicted that "someday artists will work with capacitors, resistors, and semiconductors as they work today with brushes, violins, & junk."

At first, Paik manipulated the innards of TV sets, distorting the pictures to create new and unprecedented images. "I buy thirteen secondhand sets in 1962. I didn't have any preconceived idea. Nobody had put two frequencies into one place, so I do that, horizontal and vertical, and this absolutely new thing comes out." Paik's show of these sets in Wuppertal, Germany, in 1963, was the genesis of video art.

Paik settled in New York in 1964 and met cellist Charlotte Moorman, who became a close collaborator. Inspired by the zaftig Moorman, Paik introduced sex into his concerts with humor and irreverence. In *Cello Sonata No. 1 for Adults Only* (1965), Moorman played phrases of a Bach cello sonata. On finishing a phrase, she removed a piece of her clothes. She ended up on the floor, completely naked, playing her cello, mounted above her. *Opera Sextronique* (1967) resulted in the arrest of Paik and Moorman on the charge of indecent exposure. After a notorious trial, she was convicted and received a suspended sentence. In *TV Bra for Living Sculpture* (1969), Moorman wore a brassiere made of two three-inch television sets and played cello compositions by Paik and other composers. As the tones changed so did the images on the tubes. Paik said that he aimed "to humanize technology." He never made his goal clearer than in *TV Bra*.

In *Waiting for Commercials* (1971), Paik had Moorman and a pianist play classical music but only a few bars at a time, and interspersed them with commercial breaks. In such works, Paik sought to create a countercultural television that would expose commercial television as a mass-cultural machine that fuels the commodity-crazed spectacle of consumer society and pacifies the public with mind-drugging pap. As Paik said, "My job is to see how the establishment is working and to look for little holes where I can get my fingers in and tear away walls. And also, try not to get too corrupt." The last line in a 1966 work of Paik was his voice announcing, "Please follow instructions. Turn off your television set."

Paik was once asked whether he was a Zen Buddhist. He replied, "No, I used it as a joke. I needed a title to justify a broken TV." Just what a Zen devotee would say. Yet, he obviously had Zen in mind in such pieces as *Simple, Zen for Head* (1961), *Zen for Film* (1965), and *As Boring as Possible* (1966). Epitomizing Paik's Zen outlook is *TV Buddha* (1974), my favorite piece. In it, a traditional sculpture of a sitting Buddha views his own image on a closed-circuit television screen. The Buddha sculpture from a bygone age contemplates the Boobtube Buddha of the modern age, but the image does not change. The paragon of serenity, it transcends time. Paradoxically, in the spirit of fluxus iconoclasm and humor, Paik mocked spirituality and at the same time embraced the religious icon. On the one hand, the Buddha appears as a media star and couch potato in a kind of Buddha sitcom. On the other hand, it represents the Divine looking at the Divine—without interference. Instantaneous holy feedback. God using electronic media to contemplate Himself. The luminous TV image is the perfect medium for contemplating pure contemplation. In a work related to *TV Buddha, Zen for TV* (1963–75), a single, centered, vertical line—the beatific vision of Barnett Newman—replaces the Buddha on the television screen. Barney Buddha, friend of Cage Buddha, meets Paik Buddha.

If Paik's works were commercials, what would he be selling? Spirituality in a materialistic world.

Paik was a precursor of Cage-inspired technological artworks that began to proliferate in the middle 1960s. Billy Klüver, an engineer who had emigrated from Sweden, Robert Rauschenberg, Robert Whitman, a happenings-maker, and a group of friends organized *9 Evenings: Theater and Engineering*, a series of events at the Twenty-fifth Street Armory (the site of the Armory show of 1913). The participating artists, among them Cage and Rauschenberg, collaborated with more than thirty engineers from Bell Telephone Laboratories, who were enlisted by Klüver.

I attended all of the events, but the ones that remain in my mind's eye are Rauschenberg's and Cage's. The first half of Rauschenberg's consisted of an actual tennis match in which the sounds of balls striking rackets were amplified. In the second part, what seemed to be hundreds of people were doing some kind of shuffle or dance in the center of the cavernous space to the amplified sounds of the tennis match. Rauschenberg had the lights dimmed and then turned off. The participants could only be seen in the pitch blackness on large TV screens. The media image provided the only view of the actual space, and signified the replacement of "reality" by the media.

I also enjoyed Cage's electronic composition. My brother, an engineer, came with me to the performance. As it progressed a team of engineers was busily adjusting the equipment. My brother began to anticipate their moves, whisper-

ing, "Stage left, now stage center," and so on. "What are you doing, Neal?" I asked. "Oh, you're hearing the music. I'm listening for broken circuits, and the guys up there are hearing what I am and are trying to fix them."

The *9 Evenings* led to the formation of the organization Experiments in Art and Technology (EAT), whose mission was to build bridges between the disparate worlds of artists and engineers and to make the newest technologies available to artists. I attended the first meeting of the group. All the participants were enthusiastic. I was amused by the worries the artists voiced over the copyright of their ideas and the indifference of the engineers to the issue. I thought then that Kaprow was right. Artists had become men of the world, solicitous of their creative and commercial rights. By 1968, EAT had some 3,000 members in thirty groups throughout the world.

In the summer of 1971, Rauschenberg, Whitman, and Klüver teamed up with Pontus Hultén, the Director of the Moderna Museet in Stockholm, to raise funds with which to assemble a collection of contemporary American art to be given to the museum. The Swedish Ministry of Education provided $100,000, which turned out to be about one-seventh of the value of the works acquired.

Hultén was enamored of New York art, one of the very few European museum professionals who was. He organized pathfinding shows that featured Cage-inspired art, assemblage, pop art, and kinetic art. As early as 1961, he became interested in art that utilized new technologies. These, he came to believe, totally dominated contemporary life and evolved independently of the needs, desires, and aspirations of people. Consequently, science had eclipsed art, but art could provide science with a human face. It made sense then for Hultén to join with Klüver and the members of EAT, whom he asked to select the works for his museum.

In the fall of 1973, I was invited to the opening of the *New York Collection* in Stockholm. A planeful of art-world luminaries was flown to Sweden. The festivities began in transit. The menu of our meal was designed by Red Grooms; he signed mine, and I still have it. As guests we were lavishly entertained. A high point was a tour of the Royal Palace guided by Princess Christina. At first we were guests of the Ministry of Culture. Then, Nancy Hanks, the head of the National Endowment for the Arts, appeared. Suddenly, the Ministry of State became our host, and the dinners became even more gourmet. Why the switch? We were not told, but I thought that it may have been that, because of the Vietnam War, Sweden had severed relations with the United States. Hanks, who was skilled in diplomacy, was assigned to use the art fete in Stockholm as a cover to try to patch things up.

At one reception a beautiful woman took a liking to me. She turned out to be a leading Swedish tragic actress. Brian O'Doherty said go for it, but Barbara Novak said, think of your wife. When my new-found friend's husband also became interested in me, I ceased to be tempted.

The show at the Moderna Museet was excellent. The standout was Rauschenberg's notorious *Monogram*, which featured a stuffed goat encircled by a tire.

Like Cage, most fluxus artists were anarchic but apolitical. The outstanding exception was the German Joseph Beuys. Richard Demarco introduced me to him at the Edinburgh College of Art in 1970. I was fascinated by Beuys's trademark uniform—a felt hat (atop his sallow, hollow-cheeked face), an apple-green fisherman's vest, jeans, heavy shoes, and knapsack. I knew of Beuys's influence on recent European art and understood why Demarco kowtowed to him, but his reverence seemed excessive. I was not prepared to accept this former World War II Stuka pilot as our new leader. I was prepared to listen, however, and what I heard was a mishmash of Marxism, anarchism, syndicalism, etc., etc. However, he gave a terrific performance. I attended two more lectures by Beuys, one in 1974 at the Cooper Union in New York, and the other at London's Victoria and Albert Museum in 1983. I also spent an afternoon chatting with him in his hotel room in New York. I did not change my opinion about his politics, but his art was another matter. His retrospective at the Guggenheim Museum was stunning. What Beuys had first used as props for his "actions" were revealed as imposing sculptures.

---

I never quite figured out where to fit a half-dozen or so social-protest artists within the New York school who, in the late 1950s, formed the NO! group, although they were heavily influenced by Rauschenberg's combine-paintings. Led by Boris Lurie and Sam Goodman, its members pieced together junk collages that were explicitly political, sexual, and scatalogical. NO! works were stylistically familiar, however. Composed from ripped-up posters, news photos of corpses, and porno photos, much bondage, anything to make-it-ugly, they were brazenly perverse and nihilistic. There was also nothing subtle about the titles of NO! shows, such as *Vulgar* and *Doom*, both at the March Gallery, across Tenth Street from the Tanager.

Lurie and Goodman were dour and difficult, Lurie, understandably, since he was a Nazi death-camp survivor. Goodman had a reputation of sorts as a painter. His canvases, which looked like seismographs of muscular activity in diarrheic colors, attracted Clement Greenberg, who selected them for a show at the French and Company Gallery. He quickly canceled the exhibition when he figured out that Goodman's smearing was not "high" formalist art but rather, a fecal parody of action painting. Many snickers at the Cedar Street Tavern.

Goodman and Lurie invited me to write about their work, but I begged off because it looked too derivative on the one hand, and on the other, too obvious.

Thomas Hess was interested, however, to my surprise. In 1962, he wrote, "Sam Goodman and Boris Lurie are true Social Realists. . . . They comment on the disgrace of society with the refugee materials of society itself—fugitive materials for fugitives of our great disorders."

Seymour Krim, a spokesman for the Beat poets, wrote the introduction of a *NO!* show in 1963. He lauded the show for "letting escape all the smelly gases that cause constipation in [contemporary] psychological and even artistic life." In response to a "mass society such as ours [we] need art that screams, roars, vomits, rages, goes mad, murders, rapes, commits every obscene act. [The] bulk of the work in this show is an appropriately brutal attempt to cope with a brutish environment." After more heated prose about "our squawking American nightmare," "unedited strips of the contemporary id," and "a bad pot-dream, paranoid and cruelly absurd," Krim concluded, "How right and necessary for us all!" *No! Sculpture Show* (1964) was the group's climactic and most scatological show. It consisted of plaster works that looked just like piles of shit in every size and degree of squishiness.

NO! art has been forgotten because, as Brian O'Doherty summed it up in 1971, "It is extremely difficult to produce a kind of art that histories will pass over in silence, that the art magazines will dismiss, that will embarrass collectors and be offensive to most other artists. [NO! art] succeeded in achieving this large negative." In retrospect, however, NO! art was ahead of its time. It anticipated later perverse and abject art that reflected our miserable twentieth century, and particularly the Vietnam War era.

---

At an opposite pole from Cage-inspired art was stained color-field and hard-edge abstraction. By the beginning of the 1960s, it was clear that the liveliest avant-garde abstract painting was "post-gestural." It was featured in two group shows: *Toward a New Abstraction*, curated by Alan Solomon at the Jewish Museum in 1963 and, a year later, *Post-Painterly Abstraction*, assembled by Clement Greenberg at the Los Angeles County Museum. Both shows included stained color-field painters Louis and Noland as well as hard-edge painters Kelly and Held. There were similarities in all their pictures, notably, simplicity and clarity, lack of surface incident, a generally large scale, an avoidance of cubist composition, and a concern with the emotional vibrations that expanses of color can generate. More interesting to me than the similarities were the dissimilarities, primarily the difference between the optical field of stained color in the canvases of Louis and Noland, and the tactile color-shapes in the pictures of Held and Kelly—that is, color-field against color-form.

Greenberg championed Louis, Noland, and Olitski. I too admired certain of

their pictures. I was put off, however, by Greenberg's rejection of any tendency other than stained color-field painting and the elaborate art-critical rationale he wove about what was essentially an eye-pleasing decorative style. I objected even more to his followers' amplification of his ideas with inflated glosses of their own, bolstered by lengthy footnotes.

As the artists Greenberg supported and his formalist approach commanded growing art-world attention in the 1960s, it seemed to me that Held was relatively neglected. I decided to try to right the balance between stained color-field abstraction and Held's "concrete expressionism," as I called it. Not the catchiest of labels, to say the least, but it was weighty like his painting. Consequently, in 1965, I curated a show with that title at the Loeb Student Center of New York University. It consisted of Held and the two sculptors related to him—Ronald Bladen and George Sugarman—as well as painter Knox Martin and sculptor David Weinrib, although they were peripheral to my thinking.

As I viewed it, concrete expressionist abstraction continued gesture painting's sweaty groping for images but in a new form. In Held's case, he also reacted against the restless ambiguity, intricacy, and look of spontaneity conveyed by the open, gestural forms. Instead, he painted quasigeometric compositions in unmodulated colors.

The *Concrete Expressionism* show was well received. The most glowing review was by Nicolas Calas in *The Village Voice*. He called it "the most exhilarating group show of the season. . . . Sandler's analysis of the exhibited work is not to be missed. . . . On stepping out of the building and facing once again the suffocating narrowness of the Fifth Avenue perspective, New York looks as old as Jerusalem."

The art-world attention given to concrete expressionism was short-lived. Perhaps the main reason for its demise was that the rationale that I and the artists—notably Held—used was too "conservative" in that it acknowledged a relationship to gesture painting. The rhetoric favored by Stella, the pop artists, the stained color-field painters, and the minimalists rejected any such kinship, which made their stance seem "radical" and new—thus, acceptable to neophiliacs.

---

Beginning in 1961, Lucy and I began to visit London frequently and after 1967, to spend every summer there. She needed to use English libraries for her research on fourteenth-century illuminated manuscripts. Most of the materials I required for my writing were to be found in the libraries of the Victoria and Albert Museum and the Tate Gallery. I preferred New York to London, but I had no choice. I was in a reverse Ruth scenario; whither she goeth, I goeth.

In the summer of 1961, upon arriving in London, I telephoned the critic Lawrence Alloway and asked for the names and phone numbers of interesting

English artists whose work I was not familiar with—that is, who were newer than the abstract-landscape painters who lived in Cornwall or were identified with them. He provided a list of about twenty artists, most of whom had participated in a show labeled *Situation* the previous fall and who were planning a second show. I visited all of them and was invited to dinner with most. The notes I took of our conversations are the primary record of this critical moment in English art history. The leading painter was William Turnbull. Other members were Robin Denny, Bernard and Harold Cohen, John Plumb, and John Hoyland. The art-critical spokesman was Alloway, who was a champion of the New York school and provided the English art world with first-hand information about it.

In an attempt to enter the international avant-garde, the "situation" painters looked to New York and not to Paris. They admired what they knew of paintings by de Kooning, Guston, and Kline but were interested more in Newman (above all), Rothko, and Still of the older artists, and of the younger, Raymond Parker and Ellsworth Kelly, artists they considered the vanguard of American painting. I was surprised to learn that they formed their opinion of Newman after having seen only six paintings, four in *The New American Painting* exhibition, and slides Alloway had brought back from New York. In their appreciation of Newman, they were in advance of the artists in my circle (but not that of Greenberg and his coterie). Conversations with William Turnbull helped persuade me about the signficance of Newman's painting.

Although the artists worked in a variety of styles, they shared certain attitudes. They all dismissed Cornwall painting (Patrick Heron was a favorite butt), which they believed was derivative of the old-hat French painting on the one hand and on the other, was too reminiscent of landscape (action-y landscape), which they denigrated as "British," meaning parochial. Ben Nicholson, Victor Pasmore, and "latter-day constructivists" were also dismissed as outmoded. The organizing committee of the first *Situation* show decided that all works selected should be abstract and not less than 30 feet square. What stimulated the English artists most in American color-field painting was the sensation of simple expanses of color and the large scale. The size enhanced the emotional and visual effect of color, particularly because the paintings were meant to be exhibited in small rooms. The "big picture" presented in this way set up an environmental "situation" and prompted a new kind of "personal" relationship between the spectator and the work. The desire to work large motivated the English painters to band together. London galleries were reluctant to exhibit outsize canvases, particularly by little-known artists. The situation painters believed that as a group they could better break down gallery resistance.

In 1961, I wondered whether the London group might become a minor satellite of the New York school. However, they knew little about American art; not

many works were available, and only a few of the artists had been to America. Thus, a seeming disadvantage could be viewed as a strength. I later found that all the artists were singularly independent and shared a fear not only of being derivative of American art but of each other, of group togetherness, as Turnbull put it. They need not have been apprehensive, because the work was very varied. Nonetheless, concerned that their work would become ingrown, the artists decided that the second *Situation* show would be the last. Indeed, the group fell apart; within a year most of its members were not speaking to each other. I recall telling several of them that if a group of artists as talented as the Londoners had emerged in New York, they would have been like gangbusters in the international art world. But American artists tended to be expansive and generous to colleagues they respected, their idea being that the pie was big and was getting bigger, whereas the English believed the pie would not grow and, if anyone got more, the others would get less.

Alloway also recommended that I visit artists who were not in the situation group. One such was Gwyther Irwin. His studio was far from the center of London, and we arranged for him to pick me up in his car. On the way, Irwin became visibly agitated. I wondered if I had said anything to upset him but could think of nothing. Finally, he asked whether he could turn on the radio. What he needed was the cricket test match score. Then he was fine. It occurred to me that if much of the non-art talk at the Cedar Street Tavern centered on baseball and boxing, the counterpart in London was cricket. In many respects, American and English artists were different, but not when it came to sports—and a passionate dedication to art.

While in London in the early 1960s, I encountered artists in two other coteries. One, consisting of Kenneth Martin, Anthony Hill, John Ernest, and Mary Martin (who died before I could meet her), were known as the constructivists. Another circle included Michael Kidner, Malcolm Hughes, and Jean Spencer, who dubbed themselves systems artists.

The three groups disapproved of gesture painting, whether identified with New York or Paris, but disagreed with each other on other issues. The situationists thought of themselves as traditional painters who had extended American hard-edge and color-field abstraction, whereas the constructivists and systemists continued the practice of the Russian constructivists, Dutch de Stijl, and German Bauhaus associates. However, the systemists differed from the constructivists in that they based their work on mathematical formulas, as did their mentors, Max Bill and Richard Lhose. Hence, they were sympathetic to American minimal art, notably that of Carl Andre.

There was an ongoing discussion in situationist, constructivist, and systemist

circles of Charles Biederman's "structurist" painting and writing. His large tome was prominently displayed in many studios or houses I visited. This surprised me because the name Biederman was new to me, although he was an American living in Red Wing, Minnesota, which I had also never heard of. Biederman constructed polychromed aluminum reliefs from rectangular elements, which he viewed as neither painting nor sculpture. Although they were abstract, they were based on what he considered the method and structure of nature as well as ideas culled from the paintings of Monet and Cézanne. Although the British systemists and the American minimalists shared certain ideas, Biederman's thinking was not one of them. I wondered why, but could come to no conclusion.

The differences between the situationists and constructivists were spelled out at a panel on the integration of art and architecture at London's Institute of Contemporary Arts. (Had systemists been invited to participate, they would have sided with the constructivists.) Kenneth Martin, as the constructivist elder, announced that integration was desirable. Hill said that when he was given a certain space in which to work, he could either leave it alone, create an artwork in it, or do something in between. He preferred to "edit" the entire space with the industrial materials he normally worked with. Ernest added that he began where the architecture left off, putting finishing touches on it.

Speaking on behalf of the situationists, Turnbull rejected what he termed the constructivist ideology of creating ideal spaces in which people live in perfect harmony. Plumb added that there was a contradiction between embellishing a site and creating a work of art, and it was the latter that engaged him. Bernard Cohen agreed, stating that he wanted to assert his own artistic identity. This comment was seconded by Turnbull and Plumb.

In 1979, Kidner, Hughes, and I drove from London to the University of Norwich to visit Alistair Grieve, a teacher there, and to see the collection of modern art at the school. On the road we talked about arranging a show of international systemic and constructive art. We brought Grieve and the critic-historian Stephen Bann, a professor at the University of Kent, into our planning. Then we made a proposal to Andrew Dempsey of the British Arts Council. He agreed to the show and formed a committee to make the selection. I was included as the American advisor.

From the first, our deliberations were a shambles—meeting after meeting with no resolution on any issue; members resigning and new ones appearing unannounced; members fighting bullheadedly for opinions at one session which they opposed just as stubbornly at the next; bitter arguments, many of a personal nature, after which all of us would go to the nearest pub for a friendly pint.

It was soon clear to me that there were two conflicting agendas: one was to focus on English hard-core constructive and systemic artists and their interna-

tional associates, and the other was to introduce peripheral artists if they were internationally trendy. The hard-core committee members began to squabble among themselves and quit one after another, leaving me and Bann to wage a losing battle for their cause. I later demanded that Dempsey recommend me for a knighthood for my efforts on behalf of British art. With our artist allies gone, the field was left to Norman Dilworth, who was the most skillful infighter I ever encountered, alternatively wearing down any opposition by interminable jabber and scheming behind our backs. Even he could not get the committee to agree on much. In the end, it was suddenly announced by the Arts Council powers that the show would be curated exclusively by the German artist Gerhard von Graevenitz, a friend of Dilworth. I never figured how that was engineered, but I was appalled at the denial of Queen and Country. Von Graevenitz did make a point of visiting me in New York, presumably to get my approval of his choices, but we met in a noisy bar and the information he gave me was, what I could hear of it, so scanty that I ended up with little idea of what he was about.

Von Graevenitz's show, titled *Pier + Ocean*, was mounted at London's Hayward Gallery in 1980. It was disappointing, to say the least, more about art-world fashion than aesthetic rigor. Bann wrote a negative review in *Art Monthly*. In a nasty letter, von Graevenitz attacked the magazine for inviting Bann to write (which it did not). Von Graevenitz claimed that his own conception of the show had "nothing to do with constructivism or constructive art." In a lengthy defense of Bann published in *Art Monthly*, I pointed out that a third of the 56 artists von Graevenitz included were on the original list that Bann presented to our Arts Council committee, a list I helped to draw up, and would have made, in themselves, a compelling exhibition. *Pier + Ocean* was a lost opportunity to show constructive art in all of its variety. Equally unfortunate, it forestalled another museum show on the theme for some time to come.

Back in the United States, by the end of the 1950s, assemblage, environments, and happenings, as well as stained color-field and hard-edge abstraction, had deflected avant-garde art in directions different from established abstract expressionism. These new tendencies would, in the following decade, usher in even more novel developments, such as pop art and minimal abstraction.

# Into the 1960s:
## Frank Stella, Barnett Newman, Robert Smithson, Andy Warhol, Roy Lichtenstein

The death blow to academic gesture painting was struck by Frank Stella, at age twenty-three, in the prestigious *16 Americans* show at the Museum of Modern Art at the end of 1959. The deadly stroke was a roomful of his abstractions composed of symmetrical, concentric configurations of black stripes. Much as I was a neophiliac, this was one body of work that I would not accept (at least initially). To put it bluntly, I was enraged. His black-stripe canvases struck me as so reduced—to absurdity, I believed—as to appear nihilistic.

It was not only Frank's paintings that infuriated me, but also what he—and sympathetic writers—said about them. While participating on a panel at New York University in 1960, he remarked that he found few creative ideas in current art; there were not even any good gimmicks. He then said that it was enough for him to have an interesting idea; he would be happy if someone else, or a machine, made his pictures according to his specifications. What interested him most was the idea and not the process of painting. He couldn't understand why it was bad for an artist who had a good idea to just execute it or have someone else do it—to be an executive artist, as it were, just as Alexander Liberman was in some of his work. Frank added that Liberman was a good painter when he didn't paint his own pictures. Frank also said that his conception of a painting was one in which only paint and nothing of himself was used. He implied that his idea was to paint a picture that referred only to itself. The idea was both the pretext for making art and its content. Nothing else counted.

Frank concluded that he did not know whether or not he was an artist. It occurred to me only later that what he meant was that his art did not look the way art was supposed to look. At the time, however, I took him at his word. If the black-stripe paintings were art, then everything that I believed to be art was not—and vice versa. I attended Frank's talk at NYU with Robert Goldwater, who was just as outraged as I was. When we left the lecture hall, he turned to me and said: "That man's not an artist. He's a juvenile delinquent."

In the most vicious review I ever wrote, published in *Art International* at the end of 1960, I compared Frank to Ad Reinhardt, commenting that both use "geometry and monochromatic 'colour,'" but where Reinhardt is engrossed with purity in art and paints monotonous pictures because he feels that art should be diffi-

cult, aloof, for the museums and hence, dead, Stella seems interested in monoto-ny for its own sake, as an attitude to life and art. His pictures are illustrations of boredom. The inner glow that illuminates Reinhardt's works becomes a mechan-ical surface shine in Stella's," and so on. The only thing I can say on behalf of my review was that it was one of the first to take Frank seriously, even though I iden-tified him as the enemy. I should have been more open to his painting because it looked *new*, and I was, after all, a critic identified with the avant-garde.

Frank did not hold my hostile critique against me, and when I asked to interview him on the radio in 1962, he agreed. With my 1960 review in mind, I asked him to compare his work to that of Reinhardt, whom I knew he admired. (When Frank could afford it, he bought one of Reinhardt's black paintings.) Frank said that he wanted to make direct paintings, paintings you could see all at once, whereas Reinhardt wanted the opposite—that is, paintings at a very low pitch. I then asked Frank whether he thought his work was boring. He replied that it was boring to make but shouldn't be boring to look at. He then quoted John Cage that if something looks boring after two minutes, look at it for four; if it's still boring, try it for eight, then sixteen. At one point it will become very interesting. Besides, Frank added, his pictures could be seen quickly, and if one was bored, one could just walk away.

In time I would change my mind about Frank's minimal abstractions and con-sider them to be seminal in sixties avant-garde art. In fact, I introduced my survey of the art of that decade by announcing that it was Frank who ushered in a brand-new sensibility in American art.

In 1970, Frank again shocked the art world. Having been the innovator of mini-malism, he jettisoned it, indeed, he did a 180-degree turn from it. In a review of his new collages and reliefs in *Art in America*, I wrote that he had abandoned the "nonrelational" aesthetic, which yielded an allover pattern of modular units, and instead embraced an extreme relational design that called to mind cubism, a ref-erence that he long sought to avoid. Moreover, because of allusions to art deco, these works touched slyly on pop art.

The change in Frank's work intrigued me. Was it a signal that color-field and hard-edge painting were used up? I raised that question in a review in *Art in America*:

> Stella's collages and reliefs (along with Al Held's black-and-white paintings of the last few years) bring into focus what I consider the important question con-cerning abstract art now: what is the potential of a relational aesthetic? At a time when there is a glut of field abstractions ("color," "lyrical," etc.) and when painting looks tired and ... appears open to other approaches, Stella introduces a fresh relational style that values pictorial construction rather than the open-ness of "impressionist" fields. Indeed, it strikes me that the viability of abstract

art in the immediate future at least depends on the resumption of such a "cubist" impulse.

Frank then extended his "painting" into the room and embellished the protruding components with a garish overlay of "expressionist" brushwork. Some works, projecting several feet, looked more like polychromed relief sculpture than painting.

Stella advanced a rationale for his new work in a stunning talk at an annual meeting of the College Art Association in 1982. He said that abstract painting had achieved the literal flatness to which it aspired in the pictures of Malevich and Mondrian, and in his own black-stripe abstractions, and, consequently, had come up against a blank wall. Abstract painting now needed space in which to expand and to breathe; it needed "working space," as he named a book he subsequently wrote. Abstract art had become impoverished, when compared to figurative art of the past. As Stella put it dramatically, "Consider the human form: skin, bones, and flesh. Consider the poor paintings: surface, structure, and pigment. The first gives the ingredients of human figuration. The second gives us the ingredients of abstract figuration. Blended together, these ingredients have yielded great paintings. Question is: can we get along with half of the recipe?" If abstract painting was to be revitalized, if it was to be as rich and full as the figurative art of the past, it would have to become volumetric, like Caravaggio's paintings or Picasso's figurative pictures of the 1920s, but not through the creation of illusionistic space. Instead, abstract painting would have to come off the wall into actual space. Frank invoked the names of Caravaggio and Picasso on behalf of a formalist rhetoric and ignored the historical, psychological, social, and cultural dimensions of their work.

As Frank spoke about the need for painting to venture into the actual third dimension, he turned to George Sugarman, who was seated behind him, and said that Sugarman had gotten there first. That was a generous admission. Listening to Frank's talk, I thought: It's an update of his formalist aesthetic. I was at once impressed by his analysis and shocked and amused at his presumption to speak for abstract art as a whole while self-serving his own art.

---

Frank was a subject of frequent discussions that I had with Michael Fried, Stella's former classmate at Princeton and a close friend. I got to know Michael well in the summer of 1971, when we both worked at the library of London's Victoria and Albert Museum and had lunch together nearly every day. I found Michael companionable. We knew that our aesthetic positions were far apart and agreed never to raise our voices. I would calmly say to a comment by Michael: "You can't really believe that." Or he would say: "Al Held is beneath contempt."

Michael told me that he, Stella, and Darby Bannard, another classmate, were

impressed by Greenberg's Gauss seminar in 1959. He added that they "despised every word that Rosenberg ever wrote." Michael wrote to Greenberg and received in return a postcard inviting him to visit. Michael was too shy, but after a second invitation, he accepted. They did not become close, however, and after 1966, Michael rarely saw Greenberg.

Next to Greenberg, Michael was the leading champion of formalism. As the sixties progressed, he became its standard-bearer in an acrimonious art-critical war of formalism against minimalism, whose primary protagonist was Robert Morris. The battlegrounds were the pages of *Artforum.* The dispute was over whether formalist painting or minimalist sculpture was the latest legitimate stage of modernism. Both camps claimed that the art they advocated had confined itself to what was unique in its medium and had purged everything that was extrinsic to that medium, particularly any element identified with another art. Each camp imperiously proclaimed that it was *the* authentic avant-garde.

Morris maintained that the mission of modernist art was to progress toward making the work of art into a physical object. Painting had gone as far as it could go in that direction and therefore had become a dead-end. The "next move" was into sculpture, and minimal sculpture at that, since of all contemporary styles it was the most object-like. In a much-debated article of 1967 titled "Art and Objecthood," Michael attacked minimal sculpture for having become so much a literal object that it impoverished art on the one hand, and on the other, set up relationships with its surroundings. Consequently, the work became a kind of stage-set and the viewer, a kind of actor. In contrast, formalist works of art were dependent only on internal relationships; each was autonomous and immediately *present* in its entirety. Michael concluded that "theatricality" was the enemy of art and had to be defeated. The argument often focused on Frank's black-stripe abstractions, Fried claiming them for formalism, and Morris, for minimalism.

Michael lost the war. Minimal art won out because its claim to be avant-garde was more persuasive than that of the formalists. Seemingly empty and boring, simple-looking sculpture looked more advanced than color-field abstraction—that is, more difficult, even iconoclastic, and more an affront to conventional taste, like non-art. In another sense, minimalism too lost out because it spawned postminimalist styles that subverted objecthood and called it into question. The issue in art had become the very viability of art-as-object.

Michael and I also argued about the role of the critic in the artist's studio. Should critics help artists decide what to create? Michael said that he did not hesitate to enter into the art-making process. He said that Darby Bannard was the first painter to whom he said: Why don't you do such and such? Michael's training was in creative writing courses in which merciless critiques were encouraged to make the writing better. He carried that mentality into the studio. He assumed, as Greenberg

had, that he was required to respond completely and critically to the art. "The idea," he said, "was to produce good works of art." I interjected: "No, inspired works of art. Can a critic really contribute to that?" Fried went on to say that art is made by groping, and critics can be of use. "They have an active role to play." I strongly disagreed.

---

It would take me time to recognize Frank's paintings as art. Reinhardt's regard for the young artist helped. So did my somewhat belated appreciation of Barnett Newman's painting. Barney was a first-generation abstract expressionist, but during the fifties, he was patronized in downtown circles. He began to paint seriously only in 1945, which was rather late. For much of the 1940s, he was perceived in the art world as an art writer and a spokesman for avant-garde artists. He wrote brochures and catalog introductions to shows of Adolph Gottlieb (1944) and Theodoros Stamos and Herbert Ferber (both in 1947), and to exhibitions of pre-Columbian art and Northwest Coast Indian art, which he curated in 1944 and 1946 respectively.

Barney had his first one-person show in 1950. In his review, Hess referred to his abstractions as exercises; he could not even bring himself to call them pictures, much less paintings. My friends and I agreed. In November 1958, Nicolas Calas gave a speech at The Club in which he dealt at length with Barney's work. He later told me proudly that he was the first speaker at The Club to defend Barney. He was. Our attitude to Barney's abstraction began to change around 1959, when he had a show at the French and Company Gallery. Then, in 1961, a single picture of his in the *Abstract Expressionists and Imagists* show at the Guggenheim Museum, the unforgettable *Onement #6*, opened my eyes wide—and those of many of my contemporaries. It literally riveted our attention, and also that of younger generations. In time, even champions of de Kooning and former belittlers of Barney changed their minds, notably Rosenberg, who wrote a major monograph, and Hess, who curated Barney's retrospective at the Museum of Modern Art and summed up his life's work in a book-sized catalog.

In person, Barney resembled a good uncle—portly, with a friendly smile, and spoke to one as if bestowing gifts. However, watch out if you ever said anything without scorn about Ad Reinhardt or in any way "misinterpreted" Barney's history. In my review of the Guggenheim show in the *New York Post*, I wrote: "Standing out among the proportionately large number of exceptional paintings [is] Newman's expansive blue field—animated by a light vertical band—that imprints itself indelibly on the mind's eye." I soon received a note from him saying that he had been moved by my review but berating me for distorting history, and concluding that I, as a friend, was more dangerous than John Canaday of *The New York Times*, who was the enemy. After reading and rereading my review, I could never fathom how I had distorted art history. Barney's poison-pen letter did

not change my newly acquired admiration of his work, however. In 1961, I castigated the Carnegie International jurors for omitting his work, denouncing their rejection as "inexcusable" and "scandalous." I was delighted when Barney put up $500 for a prize for the best artist who was *not* in the Carnegie show.

Prior to the Guggenheim show I had already begun to interview Barney in preparation for my book on abstract expressionism. In the course of several conversations, we became friends. Barney spoke about his appreciation of Pissarro and Monet and his dislike of Cézanne and, particularly, Cézanne's champion Roger Fry. Alluding to the bulk of Cézanne's apples, Barney said: "I objected to his cannon balls. Compared to the impressionist idea of an even surface with no edges, Cézanne's weighty images are counterrevolutionary. But his watercolors really come off. Pissarro and Monet have been overlooked, but they changed painting." Barney added that Picasso did not interest him, but Matisse, as a colorist, did.

Barney also said: "My hat goes off to the impressionists because they moved into a new subject matter. They insisted that their subjects be chosen from secular life but claimed that they were as important as any crucifixion. This was a stupendous step." Barney claimed that he was the first abstract expressionist to recognize impressionism. It is true that he did praise Monet as early as 1948, but he did so because of the ugliness of Monet's brushwork, not the field composition of his late paintings of *Lilypads*. Besides, there were no late Monets to be seen in the United States, nor were there reproductions, as far as my own research could determine. (Barney's friend Stamos remarked that talk of impressionism began in 1952 with Philip Guston's show at the Peridot Gallery.)

Recalling the early days of the new American painting, Barney said: "I was sitting with Gottlieb in Union Square right after Pearl Harbor. I said that painting was finished. Adolph was more optimistic. It was he who first broached the idea that we needed a new subject matter." Mythmaking, as their colleague Rothko termed it, began then. Barney said that a surrealist show organized by Howard Putzel at the New School in 1941 was "memorable.... Best at the time. We *respected* the surrealists but disagreed with their Marxist and Freudian approaches. Our orientation was more mythic. Gottlieb and I looked to primitive art. Our interest was in breaking out of art history as we knew it."

In a talk at Studio 35 in 1949, Barney did not deal with contemporary art. Instead, he recounted a recent visit to the Indian mounds in Ohio. His main point was that at the mounds there was nothing to see. You had to feel it, and if you did, then all else was unimportant. What he experienced there he characterized as "the sublime," by which I think he meant the feeling of awe that possesses one before Niagara Falls or the Grand Canyon. Finding semi-abstract mythmaking too limited, Barney turned to nonobjective painting to suggest the sublime, as did Clyfford Still and Mark Rothko. As Barney said, "In our search for the sublime, we

had to reject the mock-heroic, voluptuous, and superficial realism. In our search for an American tradition, we had to assume an anti-European stance."

At that time, Barney began to paint allover fields of a single color punctuated by a few vertical bands of other colors. Many of Barney's colleagues would not accept his abstraction as art. His rejoinder to them was to ask rhetorically: "When is something not a work of art? As I see it, what is crucial is the intent—and desire—of the artist."

In the early 1960s, Barney participated at a symposium at Brandeis University with Philip Guston, Thomas Hess, Sam Hunter, Harold Rosenberg, and William Seitz. Unfazed by this formidable array, Barney took the limelight. He said, "One paints in relation to oneself and not as an avant-gardist. I paint so that I will have something to look at [laughter]. People here seem to think that art is some kind of historic process. It is not. Art is a series of historical miracles. It either happens or it doesn't. It isn't a continuum of activity." Barney also said, "Aesthetics is for the artists what ornithology is for the birds," to great laughter.

After a lecture by Barney at the New York Studio School, a student asked him what he thought of pop art. Looking ceilingward Barney replied: "I thought our discourse was with Michelangelo."

During Barney's show of the *Stations of the Cross* at the Guggenheim Museum in 1966, the curator arranged a public conversation between Barney and Thomas Hess. Barney asked William Rubin whether he would attend. Rubin replied with a question: Was Barney going to talk about that same old sublime stuff? Referring to Rubin's admiration of Meyer Schapiro, Barney asked Rubin how he could accept Schapiro's wide-ranging interpretations (for example, that a change in scale could denote the decline of a civilization) but not his own.

In their dialogue, Hess asked Barney: "Why the title, *Stations of the Cross*? I always thought that you were a staunch atheist." Barney replied: "I don't have to be a believer. I have strong feelings about this subject. Michelangelo wasn't tested by the Pope about his religious beliefs." Hess added: "The subject has struck some as corny and an affront." "John Canaday would have been affronted no matter what I did," Barney answered. "I was always involved with what a painting says, its subject matter. In the *Stations*, I was interested in passion, the cry of Christ to God. I ignored the anecdote." "Why the exclusion of color?" Hess asked. "Tragedy demands black, white, and gray. I couldn't paint a green passion, but I did try to make raw canvas come into color. That was my color problem—to get the quality of color without the use of color. A painter should try to paint the impossible."

Was Barney's painting religious? In his catalog essay on Barney, Hess wrote at some length about the influence of the Kabbala. I had my doubts about this inter-

pretation, since in our extensive conversations, Barney did not mention the Kabbala once, or if memory holds, anything mystical. Later, Barney's wife, Annalee, told David Sylvester that Hess exaggerated Barney's interest in the Kabbala. She added that Hess, an utterly assimilated Jew, had become troubled about his religious roots and was studying the old mystical texts. Barney, she said, was comfortable in his Judaism.

Barney's paintings could be interpreted as "spiritual." In 1967, Thomas Mathews, then a Jesuit priest, in a lecture at the International Congress on Religion, Architecture, and the Visual Arts before an audience of about a thousand religious figures and makers of religious artifacts and art, dramatically made the claim. He declared to the shock of those in attendence that conventional religious symbols and the art that incorporated them were no longer capable of contributing to religious experience. Instead, he said, churches and synagogues ought to commission contemporary artists, such as Newman, Rothko, and Still. However, Barney did not use the word "spiritual" in our conversations.

Perhaps Barney's abstractions were political. In 1962, he said, "Almost fifteen years ago Harold Rosenberg challenged me to explain what one of my paintings could possibly mean to the world. My answer was that if he and others could read it properly it would mean the end of all state capitalism and totalitarianism. That answer still goes." (Spoken like a good anarchist, which Barney was, if indeed he meant it seriously, and I think he did.) Frank Stella told me that during the São Paulo Biennale in 1964, he heard Barney repeat that claim when he was accosted by a group of Brazilian artists who demanded to know what his abstractions meant.

I considered myself Barney's friend. Lucy and I had exchanged a number of dinners with him and Annalee. I remember once, at their home, Barney and me kneeling in front of a print, and Barney quizzing me about the way in which the vertical band or "zip" functioned spatially. Was it on the picture plane itself, or was it a shape that sat in front of or behind the picture plane? He said that if it appeared to be a separable form, he would destroy the work.

Sadly, our friendship did not last. Barney's break with me came in 1967, shortly after I had published an article on Ad Reinhardt. Ad had been Barney's close friend, but after he had included Barney in one of his cartoons lampooning the art world, Barney sued him for libel. They became archenemies. Barney and I met at a party that William Rubin gave in his apartment. Barney took me aside and, at great length, objected to my even writing about the likes of Reinhardt. Barney sneered: "Reinhardt ticks off the four corners of his pictures, enclosing the space. That's academic." Barney was particularly incensed because in the article I compared his pictures with Reinhardt's. He asserted that even coupling their names demeaned him. He never spoke to me again. When we found ourselves together

on social occasions, he would talk to Lucy and Annalee would talk to me, but as far as Barney was concerned, I was a kind of absence.

I was surprised that Annalee went on talking to me. She was the model artist's wife. Such was her devotion to Barney that she had total recall of everything he ever said—or so it seemed—and echoed it in her own conversation—that is, in the rare moments when she spoke. She supported her husband on her school teacher's wages, took care of him, and as many of their friends reported, kept his glass full of vodka. A young artist once asked Barney how he survived in the lean years when he wasn't selling anything. He replied: "I grit my teeth and put Annalee out to work." At Annalee's memorial, Carol Mancusi-Ungaro recounted a story that Annalee told her. Barney asked his wife to destroy one of his pictures. He died before she could but, in keeping with his wish, she found the canvas, resisted a powerful urge to save it, and scissored it into pieces, feeling wretched as she did. That night she had a panic nightmare in which she cut up Barney. She then dug up the pieces, meticulously stitched them together, and restretched the canvas. Thus, she felt true to Barney—and to herself.

Barney was hostile to geometric abstraction that was featured in American Abstract Artists shows of the 1930s, and its architectural counterpart, the International Style. He later had his chance to do hand-to-hand combat, as it were, with the geometric enemy when his *Broken Obelisk* was placed in the plaza of the Seagram Building, literally on the turf of Mies van der Rohe. It was David versus Goliath, and if David didn't exactly slay the giant, he held his own. The lower component of Barney's sculpture is a pyramid, itself a direct challenge to the International Style's ubiquitous cube (and Mondrian's rectangle). Yet, the pyramid also alludes to the Egyptian pyramid, an ancient structure that is also stable and meant to be eternal. The upper element is a rectangular column, one end of which is a pyramid whose inverted point is poised precariously on the tip of the lower pyramid. The other end looks as if it was broken off. The balancing act introduces a sense of vulnerability, and its jagged edge, a humanizing element that challenges the immutable perfection that Mies and Mondrian strived for. Barney also used color as a polemical weapon. The rust color echoes Mies's copper, but the eroding surface of cor-ten steel undermines aspirations to perfection.

Barney's abstraction was admired by the minimalists Donald Judd, Carl Andre, and Robert Morris. He also became a kind of mentor to them. However, it was Stella's black-stripe painting that showed the way to their sculpture. Consisting of elementary cubic volumes, minimal works looked simplistic in that they did not refer to anything apart from their own dumb existence. That made them seem rad-

ical, certainly when compared to the welded construction of David Smith and Mark di Suvero, sculpture that I loved. Having learned from my premature put-down of Stella's black-stripe paintings, I held off from making value judgments. I soon was cued into the new sculpture by my friend Ronnie Bladen and through meetings and discussions with Carl Andre, Donald Judd, and Robert Morris.

Don Judd was a dour person. He looked like he might be an ideologue and moralist—and he was. He was possessed of an utter conviction in the rightness of the art he was making and in his ideas. No one in his generation was as publicly self-assured. When Don was able to build a repository for his work, he situated it in the Texas boondocks. People who wanted to see it had to be committed enough to make the long trek.

In conversations I had with Don in the middle 1960s, he claimed that the sensibility of avant-garde art in the United States had changed. As a hard-bitten Americanist, he declared that Humanism with a capital H, or anthropomorphism, as he put it, that is, the idea of a man-centered universe, was a European idea—and passé. So was the reading of human sentiments into things. "Think Baskin," Don said with a look of disgust: "Then, think Stella." Stella's black-stripe painting was not only new but better than old styles and had superseded them. Don wrote: "The absence of illusionistic space in Stella . . . makes Abstract Expressionism seem now an inadequate style, makes it appear a compromise with representational art and its meaning. [Stella's] canvas is on stretchers four inches deep so that the shapes become reliefs—which is [his] innovation." Thus, Don said, Stella pointed the way to the next move in avant-garde art, namely into sculpture based on the physicality of materials and their actual colors.

In a panel discussion on "Primary Stuctures" at the Jewish Museum in 1967, Don spoke of his dislike of diverse but related forms because of their references to the human body and its parts. "I like work that doesn't allude to other things and is a specific thing in itself. . . . If you have a rectangle of a certain size and a certain surface and material and it has the quality you want, then it's sufficiently interesting, and you don't have to work it into some other context to make it interesting. It's certainly not impersonal, anonymous, and all that sort of stuff. My work has expressive qualities." Di Suvero, a fellow panelist, attacked Don because "he doesn't do the work. Therefore, he's not an artist. Artistic making is necessary." Don protested that "one technique is as good as another. I use the one that suits me."

Don required specificity not only in his sculpture but also in his voluminous art criticism. Most of his writing was factual description in flat-footed prose that was distinctive as a style and a refreshing respite from overly subjective and poetic rhetoric.

The label Don used for the new sculpture was "specific object." Robert Morris preferred "unitary object," but it was much the same thing. Bob arrived at his mini-

mal—and, as he saw it, "revolutionary"—sculpture in the middle sixties. He posed the problem of how to combine the artist's body-in-action prized in the 1950s with the 1960s desire for literal "objecthood." His solution was to try to reveal the process of making an object in the finished work. His inability to do so in painting led him to sculpture. My favorite work of his was a box with the tape recording of its construction—hammering sounds and the like—secreted within it. In a subsequent work, Bob exhibited two identical rectangular volumes, one standing, the other lying on the floor, to suggest the process of movement from one position to the other. The individual elements became his first minimal objects.

Bob said that he wanted his unitary objects to be indivisible and immediately graspable, like "gestalts." "My things are inert. Forms are not pitted against each other. You don't relate to them kinesthetically. But they are not boring." He preferred the forms to be a matte gray because it was a neutral color. Compared to white, however, it was allusive, as Bob himself acknowledged. I thought that its enigmatic aura seemed to exemplify the artist himself, since I found him inscrutable. Both in his conversation, sculpture, and extensive formalist writing, he gave little of himself away.

Bob's writing was more theoretical than Judd's but equally formalist and specific. In his introductory statement at a panel I moderated in 1966, he read a long series of adjectives commonly used in art criticism in order to make the modifiers appear ridiculous. It quickly occurred to me that most or all of the words came from my writing, and from my embarrassed look, the audience also knew. But his point was well taken, at least by me, and I began to look critically at my descriptive terms.

Bob later employed industrial felt that drooped down the wall and over the floor. He concocted an elaborate formal rationalization for his switch, namely, that in order for material to express its physicality it ought to be permitted to take its own form. As I saw it, he chose the material because in its final form it shifted every time it was shown, which took up an earlier desire to reveal process. Nevertheless, hopping from one style to another was one of Bob's strategies. He even created a series of wallworks whose subject was the slaughter of Jews in Nazi death camps. I was bothered by these quick, chameleon-like switches—one jump behind the innovators and one jump ahead of art-world trendiness.

Carl Andre was shortish and stoutish, bearded and generally dressed in a signature blue denim suit. He reminded me of portraits of Karl Marx. Since Carl was a materialist both in his politics and in his art, Karl was very much on Carl's mind. More rigorous than the other minimal sculptors, his metal plates arranged in checkerboard arrangements on the floor asserted their physicality. Hugging the floor like a rug, and inviting the viewer to walk on them, they also subverted what viewers expected of sculpture.

Carl once met with a class of mine. A student challeged him. "Why can't I go to Canal Street, buy some metal plates, and make this piece of yours?" Carl answered: "Why bother? I've already done it. Why not use your imagination and make something of your own?"

Another student asked, "What's the difference between an artist and an art student?" Carl replied: "An artist is someone who thinks he or she is an artist. An art student thinks he or she is an art student."

In 1966, the Jewish Museum mounted a show titled *Primary Structures*, the first major show of minimal art, which riveted art-world attention. So did two important panels—one that I arranged and moderated at New York University on November 17, and another that I attended at Yale University's School of Art on December 14.

At the NYU panel, I proposed that we define content as the meaning that inheres in form. Then I wondered how we might distinguish the diverse meanings built into the rectangles of works by Mondrian, Malevich, Albers, Tworkov, Rothko, Reinhardt, Stella, Morris, and Held. I also asked: "Can we talk about Mondrian without talking about spirituality? That was his intention." Robert Morris responded: "I don't care what Mondrian intended or what he said. What do you mean by spiritual when you confront a work of art? Where is it in the Mondrian? You have to identify it." I countered: "You seem to think that sculpture should reduce itself to elements intrinsic to itself only—to its irreducible limits." Morris agreed. I continued: "Why is this of such importance to you? Why must sculpture do this?" Morris explained: "It has to do with my development as a sculptor in response to past sculpture and what I see as possible for sculpture now."

Jack Tworkov turned to Morris and protested: "Your 'as possible now' excludes certain forms." "Yes, things get used up," Morris answered. "Seeing something is obviously a very complex situation. I think we can dispense with the idea of the spiritual, but I don't think we can dispense with the idea of seeing something in its historical context. Things are meaningful in terms of how they differ from past things." Tworkov again objected to Morris's attempt to limit art and added: "The presence of the artist in the work is fundamental to the idea of the work. That presence distinguishes it from any other kind of work. Artistic making is the means through which the significant thing about the work is achieved." Still addressing Morris, Tworkov said: "Painters working now are embarrassed by the handwriting of the artist. I remember Frank Stella coming to Yale and saying that he was against handwriting. He would like to eliminate it, perhaps quite correctly as a reaction against too much handwriting in recent painting." "Handwriting is all right," Morris said, "but I prefer typing."

Among the comments that struck me at the Yale panel was Robert Smithson's assertion that "Painting is pretty much dead, like mosaics. Most of our works are based on ideas and are preplanned, then sent out to be fabricated. They are just art. The artist is the artist, the art is the art, and the artist is not in the art." Sol LeWitt said: "I like to conceive things without knowing what they look like—that is, with a kind of blindness. What interests me is the difference between conception and perception. You *know* that my jungle gym is all made of right angles, but you rarely *see* them. The mind informs the eye and the eye destroys what the mind knows. But the message continues to be the conception." Smithson interjected: "I like the idea of seeing with your mind." Jack Tworkov, in the audience, challenged the panelists: "What are your kicks? And what kicks do you want the spectator to get?" Smithson replied: "Everyone has feelings. So does the artist. But I don't have an emotion and run to the drawing board to put it down. My problems are aesthetic."

There was one important disagreement among the panelists. Judd said to Smithson: "You don't speak for me." I discovered later that Smithson, who greatly admired Judd, was hurt by this rejection.

---

Robert Smithson may have fancied himself a spokesman of minimalism, but much as his work was derived from it, it was also very different. Indeed, Smithson might be considered an early postminimalist, since he was among the first to venture into earth art and conceptual art. Moreover, toward the end of the 1960s, Smithson, as a postminimalist, became the primary antagonist of Michael Fried's formalism. I found Smithson's ideas more compelling than Michael's, partly because they were iconoclastic.

Smithson was tall and gangly. He looked somewhat scruffy, had unruly hair and a pimply face, and wore glasses. He would have made a persuasive revolutionary intellectual in a Hollywood movie. Bob was known to be unkind both to his friends and to his enemies, but he was always cordial to me, in part because, as a critic for *Art News*, I reviewed his first show of extragavant expressionist pictures favorably. The centerpiece was a bizarre crucifixion. Bob would soon turn 180 degrees from that painting to a reductivist extreme.

The two motivating drives in Bob's life and work were his rejection of his Catholic upbringing, on the one hand, and on the other, a vision of "the celestial playgrounds of the suburbs" and New Jersey's badlands, where he was born and raised. Both led him to formulate an anticlerical, science-fiction vision of entropy as the fate of the universe. His rhetoric was at times zany, but always brilliant and passionate.

Bob rejected Catholicism but never seemed to get it out of his system. Instead of man-made-in-the-image-of-immortal-God (which he coupled with man-made-

art-for-the-ages) he substituted a nihilistic image of a decaying universe in which humankind and all else would be atomized. His outlook was cosmic, just like that of the holy Bible, but all that he promised was a cosmic hell. Bob's construct was playful but informed by an ardent seriousness.

Bob once gave me a one-page typescript of a "poem," titled "The Lamentations of the Paroxysmal Artist." It read in part:

Let this Paroxysmal Vision be delivered to the Church of Used Blood, the Church of Defunct Immortality, the Church of Abnormal Shapes, the Church of Audio-Visual Aids, and the Church of Smart Money.

Unamen . . . unamen, I tell you. . . .

Creeping Jesus with twisted gonads and ice-cream eyes spit at me last night about 9:25.

Good-by Mary. It was nice knowing you. Give my best to Dad. . . .

Pass out the Word of Ashes—

For the One True Holy Virgin Catholick Church.

Blast off

Glory! Glory! Glory!

Bingo. Bingo.

I B M

In the middle of the poem, Bob digressed to write specifically about painting, coupling painting with Catholic doctrine.

Bring on the paint buckets! Bravo! for paint. It smells good. Like money. When Easter comes, I'll paint a bunny-rabbit with big ears and a white behind. Bravo!

My mouth is full of thick paint. It's dripping down my chin in long purple drips. I cannot tell at what speed it is traveling.

Degod me! The faster the better. Spare my dying puddle. Unamen.

Bob's funny (and serious) side is exemplified by his 1967 essay, "A Tour of the Monuments of Passaic, New Jersey." Among the sites in the wasteland of his youth that thrilled him were a parking lot and a sandbox.

Looking at a photograph of Robert Morris driving a forklift, Bob said, "You know, Morris is still interested in craft."

In 1966, Barbara Rose and I asked Bob to contribute a statement to a series we were compiling on the sensibility of the sixties. He sent in a ten-page tract, answering each of our questions with ten bitter one-liners. For example, in response to whether there was a sensibility of the 1960s, he wrote that there were ten:

1. The sensibility of momentary paralysis.
2. The sensibility of inauthentic boredom.

3. The sensibility of Habit.
4. The sensibility of monotonous and wholesale plagiarism.
5. The sensibility of involuntary memory.
6. The sensibility of stupifying adjustments and readjustments.
7. The sensibility of the dynamics of banality.
8. The sensibility of frozen time.
9. The sensibility of neither tomorrow or yesterday,
10. The sensibility of stale thoughts.

Rose, who disliked Bob, vetoed its publication in *Art in America*, allegedly because it was too long. His statement appeared in his collective writings.

Toward the end of his life, Bob began to use his art to improve the environment. His projects and proposals were provocative, but I preferred the "demonic Smithson," as did Peter Schjeldahl, because, as he wrote, "cultural despair . . . has proved more durable than . . . cultural hopes."

---

I later asked Brian O'Doherty, who was close to the minimal artists from 1965 to 1968, about the inner dynamics of the group. He said that the grid was an obsession of theirs, and they often talked about serial composition. They admired Reinhardt, Stella, Ruth Vollmar, Barnett Newman, and, guardedly, Tony Smith. The minimalists had no use for action painting, color-field painting, and pop art. They all attacked the *Responsive Eye* show, which featured op art, and had no sympathy for European systemic artists. The minimalists hated Greenberg, particularly his I-own-art-history stance, but they took him and his disciple Michael Fried very seriously. Smithson, above all, felt that he had to repudiate Fried's formalism. He and his acquaintances admired the ideas of Ludwig Wittgenstein, George Kubler, Samuel Beckett, and Roland Barthes ("The Death of the Author") and ignored biography and psychology. Freud was a joke. The minimalists had their differences, of course. For instance, Smithson's espousal of entropy was rejected by Judd.

Although Greenbergian formalists were in retreat, they still sallied forth to counterattack. In 1966, at one of five Critics Colloquium panels titled "Is Easel Painting Dead?", Darby Bannard responded to an attack on painting by Judd by stating simply that so long as painters painted excellent pictures, the tradition of painting remained alive. The proof of its vitality was the new work of Kenneth Noland, Helen Frankenthaler, Frank Stella, Jules Olitski, Roy Lichtenstein, Larry Poons, etc.

Judd responded: "Both Stella and Poons have a certain modular order that I like which, unlike their painting itself, is radical and new. In other words, I may like the order but feel sorry that it's in painting."

I was in neither the formalist nor the minimalist camp, so I did not have to choose. I admired the work of Judd, Andre, Bladen, and Tony Smith, on the one hand, and that of Louis, on the other. I was fascinated by the polemics and even more so by the passion with which the partisans argued questions such as: What makes an object more of an object than some other object. I assumed that if intelligent critics, such as Fried or Morris, found the issues significant, then I ought to pay attention. In retrospect, they seem inconsequential. But were they? After all, they contributed to the creation of important paintings and sculptures.

When I first encountered the pop art of Warhol and Lichtenstein in 1962 I was cool to it, or rather, cool to its cool. I wrote a negative review of the first major group show, the *New Realists* at the Sidney Janis Gallery, the show that put pop art (as new realism was soon to be labeled) on the map, as it were. Many of my friends gave me hell for even considering pop art. When I protested that my review was unfavorable, they countered by insisting that to write about it at all, even with hostility, abetted the enemy of high and true art. But I had begun to rethink pop and minimal art and, in time, accepted both tendencies. I recognized that they aimed to call attention to the art as *object*, whether consumer-derived or abstract. That is, as I began to understand the relevance of these literalist styles, their meanings in my life and in American life, I looked at them with new eyes.

It was Alfred Barr who prepared the ground for the establishment of pop art. He introduced the screening of Hollywood movies and the exhibition of commercial design into the Museum of Modern Art's programs. He then embraced Jasper Johns's painting when it was first shown in 1958, because it combined both his populist and elitist avant-garde passions. Johns' work also looked new—that is, it diverged from abstract expressionism, which in Barr's eyes had become academic. Pop art, as the continuation of Johns' work, was made to order for Barr.

Andy Warhol always associated me with Philip Pearlstein, his classmate at Carnegie Tech, with whom he traveled to New York and for a time shared an apartment. Whenever Andy and I met and he thought it was safe to drop his public persona, he would ask after Philip, his wife Dorothy, and other artists he knew before he became "Andy Warhol."

I visited Andy at his "factory" several times. Henry Geldzahler was present at one of these meetings, and whenever I asked Andy a question Henry answered it. That was part of Andy's act—or his art, since he was as much a performance artist as a painter. He became so adept at playing "Andy Warhol" that his art and "life" appeared to be seamless.

Andy comes to my mind almost every day because I own a Brillo box, which,

encased in Plexiglas, sits on the floor of our living room. It's not Andy's silk-screened wood construction, but the real thing, the actual cardboard carton, which happened to be designed by the abstract expressionist painter James Harvey, who made commercial art to earn a living. Andy apparently didn't know about Harvey when, in the spring of 1964, he had a carpenter make 120 wooden boxes on which he silkscreened the Brillo logo. In 1965, he exhibited these works at the Stable Gallery with a price tag of $300 each. The Graham Gallery, which represented Harvey, issued a press release complaining that Harvey had to support his "high art" by designing the packages of lowly commodities, and this upstart Andy Warhol had ripped off Harvey and was making big bucks on his design.

I encountered Harvey a few days later and kidded him about the heavy-handedness of the press release. He said sheepishly that he had not been consulted by the gallery. Then I said: "You know what should have been done. While Andy was hawking his constructions at the Stable Gallery, your gallery should have been selling signed 'originals' for ten cents each." A few weeks later I received a signed Brillo carton in the mail. Andy found out about my box and immediately phoned Harvey and offered a trade. I don't know whether Harvey agreed, but in any case, before the exchange could take place, Harvey died of cancer. He was thirty-four.

My Harvey-Warhol box would at times appear in a dream, most likely because it was often the last thing I saw before going to bed. On December 29, 1999, my last remembered dream of the millennium, the image of Brillo, like an oracle, revealed to me the key to Andy's art, or so I thought when I woke up. I knew that Andy's sculpture was a radical gloss on art because it did not transform or interpret its model as art traditionally had. But in my dream, Andy's Brillo box had a halo. When I awoke, I remembered my dream and thought that with inscrutable wizardry, Andy had turned the commodity into an icon. The appropriated carton became so precious that it did not need transformation. It was sufficient just to present it. Andy's enterprise was commodity worship, and as such, was a social and religious statement. No wonder he amassed a cornucopia of products in addition to portraying them. For him, shopping was a kind of ritual and paying for things was a kind of praying. Andy was indeed the high priest of the burgeoning consumer society. His veneration of the commodity separated him from Duchamp, who was indifferent to what his readymades represented, and from Jeff Koons, who like Andy made them into icons but also jazzed them up, turning them into hyper-kitsch.

I told my dream to Lucy. She asked: Why Brillo? Why Campbell's soup? Her answer: It has to do with his mama, the devout, hard-working, immigrant mama, who kept the house clean and fed him lunch. His venerated mama, I added, was the source of his Catholic practice. Warhol had transferred some of his religious passion from Jesus to Mammon.

When I first saw Warhol's paintings, they appalled me. They had to be kitsch, which was bad enough, but what was worse, they were masquerading as high art and thus were a threat to abstract expressionism. However, in time, I recognized their relevance. Andy gave us consumerism straight, or so it seemed. But emanating from his portraits of supermarket goodies and celebrities was the smell of death. Some of his pictures—the skulls, for example—were too obvious. The indirect ones of female superstars—like the Jackies (Donald Droll gave me one, which hangs in our entrance hall)—are truly moving. Peter Schjeldahl observed that Jackie, Marilyn, and Liz were, for Andy, "epiphanies of a new democratic religion in which certain people are mysteriously singled out to soar and suffer for us all." Liz, painted while recovering from surgery; Jackie, painted shortly after her husband was assassinated, and Marilyn, shortly before her suicide—the evocation of glamour and death.

———

Andy, with his flamboyant shock of fake hair and his pallor, stood out in any crowd. Not so Roy Lichtenstein, who was delicate, reserved, self-effacing, and proper, except for a small tuft of hair kept in place with a rubber band at the nape of his neck—countercultural but neatly coiffed. Roy's move into pop art was not as abrupt as often thought. He had earlier painted gentle parodies of American historical events and the modernist styles in which he had rendered them—and had achieved some art-world recognition. But Roy's replication of comic strips was shocking, both in subject matter and in their seeming lack of transformation. On the other hand, his paintings were traditional because he often chose comics that dealt with hallowed art-historical subjects, such as war and love. Moreover, unlike Warhol, he insisted on recomposing the images he appropriated.

How did Roy come to paint comic strip frames? There have been several different stories. My favorite was told to me by Allan Kaprow, his friend and colleague. One day, Roy's son came home from grade school in a depressed mood. After some coaxing, he told Roy that his teacher had asked the children to show-and-tell something having to do with their daddy's work. The boy would have to present to the class one of the abstractions that Roy was painting then and would become the laughing-stock of the school. Sensitive to his son's problem, Roy painted a Mickey Mouse, and the boy became a hero. It felt good to Roy as well, so he kept at it.

As this anecdote reveals, Roy was a kind man. He also had a strong sense of right and wrong. In the early 1970s, I monitored a National Endowment for the Arts panel which awarded grants to painters. At the end of the jurying, loyalty oaths were distributed for the participants to sign so that they could be paid their honorariums. It was just pro forma, but Roy refused.

In 1989, the Endowment gave Artists Space $10,000 to mount a show of works

by artists in memory of their friends who had died of AIDS. Then, fearing that the theme was too controversial and might offend reactionary congressmen, the Endowment canceled the grant. In the mail the next day, we received a $10,000 check from Roy. We used it in our fight to have our grant reinstated—and won.

Pop art ushered in the go-go sixties, which was chronicled by Tom Wolfe in his best essays. Its exemplar was Andy, who became a superstar. The art world became increasingly fashionable. Why did this occur? As the 1950s progressed, there was an enormous growth of public and media interest in the new art. This had its roots in the hundreds of thousands of World War II veterans who, subsidized by the GI Bill, were able to go to college and were often required to take a course in art history or a studio discipline. Moreover, there was a radical change in American society. Two revolutions occurred: one in production, with the advent of computerized automation, and the second in mass communications. The upshot was an affluent society defined by an abundance of commodities produced by the new computer technology and fueled by the newly prevalent mass media, notably, television. Americans now had the education and the wherewithal to buy an oil painting or an original print instead of the ubiquitous van Gogh sunflowers, which hung in just about every kitchen of my boyhood. Then, beginning in 1958, the art market boomed. In tandem, the number of museums and art centers mushroomed across the nation. Recognizing a public demand for information, the media began to provide it. Gone were the days when mass magazines such as *Time* could label Pollock "Jack the Dripper" and de Kooning "Willem the Walloper."

As I remarked, the sale of Pollock's *Autumn Rhythm* in 1957 to the Metropolitan Museum for $30,000 became front-page news—and stunned the art world. That was followed in 1958–59 by the success of the *New American Painting* show that toured Europe and, on its return, went on view at the Museum of Modern Art. MoMA then exhibited *16 Americans*, which put its stamp of approval on the new art of the 1960s as the successor of abstract expressionism.

*Newsweek* reported, "Naturally enough, pop has turned up most insistently in those places where what's new is what sells—the world of art, television, fashion, and advertising." As pop art achieved popular notoriety, art became fashionable, and a number of artists became celebrities—and wealthy ones at that.

The patrons of these new artist-celebrities became celebrities in their own right—feted by the hair-dryer magazines. They also became role models for many others in the hinterlands. Robert Scull, an early collector of pop art, recalled the fashionable art scene in the 1960s. "The clothes, vinyl, movies, fads. [It] was so new it took our breath away. The high luster of it was the way we were living; the parties we were giving; the good times; ... breaking the old mores, traditions; and

living was swinging." Museum and gallery openings, auctions at which each new record bid was applauded, and art-world parties, benefit dinners, and dances became the playpens of the "with it" wealthy and trendy, who used these events to parade their Armanis and Givenchys. In their wake, the media created an aura of glamour about art and those involved in it. The art world became the place where "what's happening" was "at."

At the center of the fun-and-games were Robert and Ethel Scull, who were acquaintances of mine. I must admit that I was tickled by them because they were vulgar, knew it, and didn't give a damn. Bob was a self-made taxi-fleet mogul. I met him before he became a celebrity. He used to frequent the galleries on Tenth Street, consulting with me and others he met there—getting an art education, I supposed. Scull was trying to paint at the time. He once invited me to his home on Long Island and showed me some of his abstract pictures—all black and heavily pigmented, the paint still wet beneath a drying skin, or so I found out when one exploded as he moved it, spewing paint; luckily, it missed me. He soon gave up painting. The pinnacle of the Sculls' social success, I was told, came at a party attended by President Lyndon Johnson's wife. Ethel walked over, sat down next to Lady Bird as if she were her best friend, and engaged her in conversation. I never checked the facts, but knowing the Sculls, the story was probably true.

I dipped in and out of the fashionable social scene, enjoying it from the margins, but too busy with writing my history of abstract expressionism to waste a great deal of time partying. Nevertheless, the conflation of art, fashion, and money troubled me. This was not the art world I grew up in. I must admit that I enjoyed the partying, but in the back of my mind I kept asking myself, what were these chic, new rich collectors responding to in art, or rather, what were they using it for? Hip life-style? Status? Social climbing? Entertainment? *Nostalgie de la boue*? Titillation? Investment? Were they responding to what moved me? Was I impressed by their money? Was I bothered that, because of their money, more and more of them were invited to serve on boards of museums and other art institutions? Did they deserve their taste-making power in shaping the art-world consensus about what art was significant and of quality at any moment? Yes, I was bothered. The motives of the new collectors often did not serve the ends of art. The tawdry depths were plumbed in 2000 with an exhibition of clothes designed by Armani at the Guggenheim Museum, accompanied by a catalog of hernia-inducing bulk—in the wake of an alleged massive handout by the "schmatte" empire to the museum. Were such venal and shameful spectacles to become common in the new millennium? Most likely.

As I watched the growing art-world power of the monied trustees and the museum directors with whom they were in cahoots, the more I examined the mecha-

nisms whereby artists succeeded or failed. Taste-making is done by a small "establishment" of certain artists, dealers, collectors, art editors, critics, museum directors, curators, and trustees, who create a consensus about what is significant, timely, and good or bad art. There were shifts in taste-making power within this select group. For example, in the 1950s, artist opinion held sway. Critics assumed increasing importance in the 1960s. Power shifted to dealers in the 1970s and to collectors in the following decade.

Most taste makers knew one another, if only casually. However, beginning in the 1960s, the consensus began to look more like a system, but it was too loose to be a cabal since the interaction of its participants remained informal. When accused of acting in concert, we strongly denied it, but we understood that we networked and knew what art was being promoted and why. Still, we believed that each of us exerted his or her individual taste and acted out of conviction, as I believe I did. Most of the artists supported by the art world deserved the recogniton they received, in my opinion.

Looking back to the sixties, it seems that there were three major centers of taste-making power, namely, circles around the kingmakers Greenberg and Castelli, and a group of minimalists, a number of whom were represented by Castelli. Was I a power broker myself? For a moment in the middle sixties, I tried to promote Al Held, George Sugarman, and Ronald Bladen as a group, which I labeled the "Concrete Expressionists." My opinions were respected in the art world, but I created no network of dealers, collectors, critics, or curators. I also supported Katz and Pearlstein but no other realists, hence I was not in the figurative camp that was developing. I admired most of the artists supported by Greenberg or Castelli, but I was a devotee of neither. I attacked Greenberg in my writing, for which he never forgave me, but he remained cordial. Castelli made subtle recommendations for my criticism in the *New York Post*, which I did not follow. He became standoffish but continued to be civil and, in social situations, friendly.

In 1970, Henry Geldzahler curated *New York Painting and Sculpture: 1940 to 1970* at the Metropolitan Museum of Art, which consisted of 408 works by 43 artists, and filled 35 galleries—the largest and most prestigious show of its kind. I considered Geldzahler a friend, but it did not surprise me that he did not include Held, Sugarman, or Bladen, on the one hand, or on the other, Katz or Pearlstein. In his selection, Geldzahler spelled out the then-fashionable 1960s establishment consensus. The Castelli Gallery was represented by pre-pop artists Jasper Johns and Robert Rauschenberg; pop artists Roy Lichtenstein, James Rosenquist, and Andy Warhol; minimalists Donald Judd, Robert Morris, and Frank Stella; colorfield painter Larry Poons; and construction sculptor John Chamberlain. From the André Emmerich and Lawrence Rubin galleries, Geldzahler chose stained colorfield painters Helen Frankenthaler, Morris Louis, Kenneth Noland, and Jules Olitski, and from the Janis Gallery, Ellsworth Kelly, Claes Oldenburg, and George

Segal. The semi-outsiders were Mark di Suvero and Dan Flavin and the real out-sider was Gabe Kohn (although he had had a show at the Castelli Gallery in 1959). With the exception of Frankenthaler, there were no second-generation abstract expressionists included. Apart from Kohn and di Suvero, there were no artists who had shows in a Tenth Street cooperative. It is significant that of the 20 younger artists selected by Geldzaher, 15 were in the Castelli, Emmerich, and Janis galleries, two more were associated with either Greenberg or Castelli—leav-ing only di Suvero, Flavin, and Kohn, who after the show closed was banished to (undeserved) anonymity. It is noteworthy, too, that three of the five critics Geldzahler asked to write catalog introductions were Greenberg, Rubin, and Fried; the other two were Robert Rosenblum and, in a nod to the enemy camp, Harold Rosenberg.

———

In January 1965, I published an article in *Art in America* titled "The New Cool Art." It was the first attempt to define a common sensibility shared by Frank Stella, Donald Judd, Roy Lichtenstein, Andy Warhol, and Larry Poons. I wrote that for the abstract expressionists the act of painting is crucial. In contrast, for the cool artists, process is unimportant; they think up ideas that require little or no cre-ative transformation. "The upshot of this approach has been an art so dead-pan, so devoid of signs of emotion, that I have called it cool-art." I concluded that the cool artists would be to the 1960s what the abstract expressionists had been to the 1940s and 1950s.

I had come to admire the work of the cool artists I singled out in my article, but not wholeheartedly. I declared that in its impassive and impersonal coolness, it was inferior to the passionate and romantic painting of the abstract expres-sionists. I still believe this. I recognized, even in 1965, that it no longer made sense to make such comparisons. Yet, I did it because I was reacting against the "end-lessly parroted pronouncements that Abstract Expressionism is dead, and only that art which rejects its values is *avant-garde*." I now find my comments distaste-ful—and should have then, and I never engaged in this kind of polemic again.

For a time it seemed as if the label "cool art" would stick to the new painting and sculpture. In her report on the state of art to Time-Life executives in 1965, Rosalind Constable wrote that "Irving Sandler, the first to pinpoint the character-istics of this new art, calls it 'Cool-Art.' . . . Cool art seems currently to be the pre-ferred term, but none of them should be construed as critical."

———

In 1967, over lunch, Barbara Rose and I lamented that the number of artists in New York had grown so, that it was impossible to keep track of even the best of them. If we couldn't talk to them face to face, we might poll them by mail. We pro-

posed to send a questionnaire to some hundred artists we respected. Thirty-five responded, some with our prodding. We had their answers published in *Art in America* under the heading "The Sensibility of the Sixties."

Representative samples of comments on the sensibility of the sixties included that of Lichtenstein, who claimed that the signs of sixties art were "the impersonality [of] factory surfaces [and] predetermined end-product." Gene Davis added: "Coolness, passivity and emotional detachment seem to be in the air. Pop, op, hard-edge, minimal art and color painting share it to some degree." Larry Rivers quipped: "Miss Jones . . . take a painting." Allan Kaprow wrote: "The last half-dozen years has been a period of cool detachment [and] irony. [A] quasi- technological sensibility [existed] that excluded hand-work and individualized personality. [A] 'cool' outlook." Ed Ruda concluded: "Stay cool. Burn slow. Live long."

Rivers asked: "Is there an avant-garde?" and answered: "Is there anything else? . . . What is more glamorous or *Glamour* magazine more in search of? Name an artist below thirty who hopes for anything else than some place in this aesthetic Vatican." Dan Flavin disagreed: "The term 'avant-garde' ought to be restored to the French army. . . . It does not apply to any American art I know." Alex Katz concluded that the "word avant-garde has become so beat up by unimaginative writers and sales promotion people that it has lost its romance and become sentimental."

Davis remarked that "The condition of the artist, economically, at least, seems to be on the upswing. There are few starving Gauguins around today unless they are dedicated masochists. There are fellowships and grants as well as teaching jobs at colleges and universities. An affluent society is buying art wholeheartedly, if somewhat blindly. Federal funds are being earmarked for art." Paul Brach agreed: "Things have changed. There are more artists, more collectors, more dealers, more critics, more money, more action!" However, Brach concluded: "It is still lonely in the studio."

It is significant that Rose and I did our survey in 1967, just before the Vietnam War escalated. It was at this juncture that the sensibility of the sixties changed drastically. Overtaken by history, our compilation pertains only to the sensiblity from roughly 1959 to 1967, but it turned out to be an accurate summary of artists' thinking at the time.

# The Trauma of Vietnam and its Aftermath

## THE VIETNAM WAR

The Vietnam War cast a pall over my life and that of my friends. Reading about the war in *The New York Times* every morning filled me with loathing and despair. Watching television at night was even more depressing. The news made my own work seem trivial and bred demoralization and anomie. I never forgave President Lyndon Johnson. The hawks were despicable, but those antiwar demonstrators who embraced the Vietcong were no better. I was a reluctant antiwar activist, preferring to nurse my anger in private rather than vent it in public protests. I could not put out of my mind that my marines—the kind of men that I had served with for three and a half years during World War II—were on the front lines. But to "Kill for Peace," as the slogan went, made me sick, literally physically sick.

The interminable war exerted an irresistible and overwhelming pressure on artists in all of the arts, and they devoted more and more of their time and energies to antiwar activities. In February 1967, about 600 New York artists put on a week-long Angry Arts protest that featured some 40 events, including a "collage of indignation," performances, films, dance recitals, poetry readings, and music concerts that drew 50,000 spectators, myself among them. Most political art—lots of blood red, mawkish smashed dolls, ugly caricatures, gory montages of newspaper and magazine illustrations featuring mangled bodies—was meant to be shocking but looked hackneyed, bad and boring. Antiwar sentiment was also the catalyst of major art, notably, Peter Saul's mordant caricatures and Leon Golub's gladiators in combat. The perpetual-party mentality of the earlier sixties ended abruptly. Symbolizing the change, inadvertently, was the near-fatal shooting of Andy Warhol in 1968.

The Vietnam War grew increasingly ferocious in 1968. The Tet offensive and the My Lai massacre stunned the nation and raised the political temperature to boiling point at home and abroad. That same year saw the assassinations of Robert Kennedy and Martin Luther King, and President Johnson's decision not to seek reelection. Moreover, 1968 was the year of a huge antiwar protest at the Pentagon and the student uprisings in Europe and in our own universities, notably, Columbia. There were massive demonstrations in Chicago during the Democratic Party convention to nominate a presidental candidate. In the streets outside, police clubbed crowds of demonstrators, who chanted for the benefit of the omnipresent television cameras:

"The whole world is watching." Inside, the delegates nominated Hubert Humphrey, who had earlier proclaimed that the war was a wonderful adventure. The Republicans selected Richard M. Nixon as their candidate, and he was elected.

In 1969, radical artists organized the Art Workers Coalition (AWC). I often attended its meetings. The Coalition's aims, apart from protesting the war, were varied. Among them were the creation of an art community; improving the living conditions of artists on the whole and, specifically, of women, African-Americans, and Puerto Ricans; creating neighborhood art centers in ghettoes; and revolutionizing capitalist society. But the AWC's primary mission was to restructure the Museum of Modern Art and museums generally, or at least, to change their functions. The rationale for this goal was that the System was monolithic and that those who supported the war controlled the museums for their own class interests. Strike at one, and you strike at the other. Since MoMA discriminated against African-Americans and women, it could be a rallying point for antiracist and antisexist as well as antiwar forces. The museum made a good target because it was highly visible and vulnerable. It was also within the art world, and sixties radicals believed that action for social change ought to begin in one's backyard, as it were. The Art Workers issued thirteen demands, among them, that a wing of MoMA, under the direction of black and Puerto Rican artists, be devoted to exhibiting black and Puerto Rican artists; that another section be devoted to showing artists who weren't represented by galleries; that rotating committees of artists be allowed to curate shows; that artists be paid a rental fee for the exhibition of their work; and that artists be consulted by museum personnel.

MoMA was extremely wary in its dealing with the Art Workers. Its administrators were afraid that if they treated the AWC cavalierly, they might increase sympathy for it. Of greater concern was the possibility that if the Art Workers became too frustrated, they might act violently, possibly damaging or destroying works of art. Threats of this nature were made, and one Coalition member did spray paint on *Guernica*. (Ironically, he later became a successful dealer who exhibited graffiti art, among other work.)

On April 10, 1969, I attended a public meeting of the AWC at the School of Visual Art. Some 250 artists were present and 50 made statements. Various topics were broached, but transforming the Museum of Modern Art dominated the discussion. I recall Gregory Battcock's outrageous demand that the museum's director, Bates Lowry, be tried before a "people's tribunal" for "his role in the worldwide imperialist conspiracy." I was an acquaintance of Bates—Lucy had worked with him on editing the *Art Bulletin*—and to think of this mild-mannered art historian as some cold-war baddie was too amusing to be shocking, but then, I had become accustomed to such excessive rhetoric on the part of young radicals. Yet, I was shocked by their demand that the Modern sell its early masterpieces and

use the proceeds to finance the exhibition and purchase of current works of art or give the money to the poor.

I also attended the meeting the Art Workers arranged with members of MoMA's staff on November 25, 1969. It was chaired by Carl Andre of the AWC. Arthur Drexler, the museum's spokesman, said that the staff would strongly oppose any change in MoMA's basic mission, that is, to combine at full strength the functions of a *kunstmuseum* and a *kunsthalle*. "That is why the museum was founded and has flourished. Our purpose is to make the museum better at what it does. If you want a new framework, start your own institution." Art Workers then demanded AWC participation in policy-making on the trustee level. Drexler responded that he could not speak for the trustees but invited the Coalition to work with the staff in shaping its operations. The Art Workers gave in but under protest and only as a wedge to the real power. Those attending the meeting agreed to take direct antiwar action by publishing, under the joint auspices of the Modern and the AWC, a poster condemning the massacre of Vietnamese civilians at My Lai. The museum trustees later overruled the staff, and the Coalition produced the poster in its own name. The photograph of slaughtered children turned out to be one of the most persuasive of antiwar images. However, nothing much came out of the collaboration between the Art Workers and MoMA's staff.

On May 18, 1970, after the invasion of Cambodia and the killing of four students at Kent State University, a large public meeting was held at New York University. The some 2,000 participants decided to organize an Artists' Strike Against Sexism, Racism, Repression, and War, whose purpose it was to close down all New York museums and galleries for one day, beginning with the Metropolitan Museum. Three hundred demonstrators showed up at the museum, but this was the last major antiwar protest in the art world.

As the war wound down and continuous antiwar agitation exhausted protestors, the Art Workers Coalition fell apart. Responsible also was the uncomradely behavior of the comrades. Ideologues began to test their associates on the correctness of their positions and aesthetics. Was it enough to oppose the war, or was it necessary to call for the overthrow of capitalism? Was painting abstract pictures a betrayal of the working class? Radicals of all persuasions began to infiltrate the Coalition and try to twist it on behalf of their own political agendas. For example, in 1970 a meeting of the Art Workers was called to deal with the arrest of Jon Hendricks, Jean Toche, and Faith Ringgold for organizing a show in which the American flag was desecrated. Featured was a panel composed of critic Dore Ashton, dealers Howard Wise and Richard Feigen, Elizabeth Shaw (representing John Hightower, Director of the Museum of Modern Art), and Allon Schoener from the New York State Council on the Arts. Many in attendance seemed to care more about abusing the panel, and demanding proof of their radical creden-

tialsmobilizing the art world in defense of their comrades. It was shameful.

One's attire could even be suspect. At one meeting, at which I was wearing a tie, some wild-eyed paranoid pointed a finger at me and demanded to know whether I was an FBI agent. Friends jumped to my defense. I started to tell him that if I were one, I would be dressed like he was, except my jeans would not be quite so filthy, but gave up in disgust.

Some artists were accused of careerism. Because of the invasion of Cambodia, Robert Morris shut down his show at the Whitney Museum two weeks before its scheduled close. His action was derided by some antiwar protestors, who claimed that he should have done so earlier. The next day there were posters on SoHo walls with Morris's photo and the caption "Prince of Peace."

In the end, aside from whatever the AWC contributed to ending the war, it did succeed in calling attention to art-world discrimination against women, African-American, and Puerto Rican artists. The Coalition also caused museums, galleries, and art magazines to rethink their various functions.

In 1973, I organized an open hearing on the topic of "Politics and Current Art" at the annual meeting of the College Art Association. I invited about 70 artists and 30 art professionals to participate with written and verbal five-minute statements. Three dozen artists, critics, and curators agreed to take part.

A few asserted that the primary issue was the "class struggle." As Carl Andre remarked: "Nowhere is this more apparent than in the art world." Artists produce works of art, but their disposition is in the hands of the owning class. Andre concluded that it was the "historic duty" of artists to unite with other producers to overthrow this exploitive system. However, Cindy Nemser attacked "Carl Andre, Robert Morris and Donald Judd [who] have ranted and raved against the reprehensible actions of their patrons but, all the while, have continued to accept the favors of the people they claim to despise." She called for artists to resurrect social realism and to "use their special skills to incorporate political commentaries into an art which is comprehensible and humanistic—an art that has the capacity to stir up the populace and inspire it to act."

While claiming that "*all* art is political," Leon Golub disagreed with Nemser. He pointed to dissident artists in Soviet Russia who resisted the politicization of art and concluded that "Political art is not restricted to propaganda or literal descriptions of the class struggle." Rudolph Baranik added: "All art worth its salt is created by a private sensibility [but one that can be shaped by] a genuine political conviction." In a phone conversation (the transcript of which I read at the session), Harold Rosenberg introduced an existentialist note: "An artist who is passionately interested in politics is constantly tempted to forsake art. . . . It is this intense conflict which is the only basis for a serious political art."

Feminists turned the discourse to the problems of women. Nancy Spero said: "I, as a woman artist, have felt alienated, with little expectation of participating in the 'art world' at any level." If she tried and wanted to succeed, she would be "forced to imitate male chauvinist aggression," and she resented it. Joan Semmel appealed to women to struggle against museums and colleges that discriminate against women. However, May Stevens cautioned that feminism, though "a vital issue . . . is not the only issue, nor the limit of woman's concerns." There was still the war. Moreover, women were not the only "others" in American society.

Artists who desired to separate their roles as citizens in the public sphere from that of artists in their studios spoke up. Benny Andrews declared that artists should act politically as citizens, but their art should be evaluated from "the standpoint of aesthetics" and not from anyone's "social, moral or political beliefs." Finally, there were artists who refused to consider the issue. As George Segal said: "I'm sick of politics."

The trauma of Vietnam initiated a new generation of artists into the imagination of disaster. Antiwar feeling paralleled a change in avant-garde art. It grew increasingly ironic, even perverse—as if in the throes of a cultural convulsion or malaise. An early sign was the change in avant-garde art from minimalism to postminimalism. The postminalists rejected art-as-object-for-the-ages and created works that were increasingly ephemeral. They partook of the avant-gardist make-it-new mentality that marked sixties art. Many were also counterculturalist. Disgusted by the treatment of art as a commodity, they tried to produce art so outrageous that it was unsalable. How else could one account for Robert Morris's "process" pieces composed of perishable piles of felt or of dirt, grease, and metal odds and ends, or his "sculpture" made of steam, Robert Smithson's entropic earthworks, Eva Hesse's absurdist eccentric abstractions, Bruce Nauman's perverse sculptures and videos, Vito Acconci's sadomasochistic performances, Richard Serra's menacing sculptures, Chris Burden's self-destructive acts, Gordon Matta-Clark's wrecked "anarchitecture," John Baldessari's conceptual art, which consisted only of verbal statements, or Robert Barry's and Douglas Huebler's documentation-as-art of invisible phenomena?

The most shocking example of countercultural malaise that I witnessed was Raphael Ortiz's proposal to kill two chickens in an event at the Judson Church in 1968; he relented at the last moment. Alfred Barr provided cachet for Ortiz by acquiring one of his works for the Museum of Modern Art—a smashed mattress—and even helped the artist put it in his car and lug it into the museum. Barr's interest in violence was not new to him. In 1960, he commissioned Tinguely to build a huge contraption in MoMA's garden that self-destructed—a little too obviously, in my opinion, since The End was by fire, which firemen were

summoned to extinguish. Barr recognized that "anti-art" had a long tradition with roots in dada and thus merited the museum's sponsorship. During the Vietnam War, however, countercultural works took on a new political urgency and grew in number. Radical artists and critics reasoned that if enough anticommercial works of art were produced, the art market would collapse. It did not, of course, and postminimalist works were soon recognized by the "establishment" and became collectors' items, such was the resourcefulness of the neophiliac acquisitors who were happy to pay handsomely for inaccessible earthworks, photodocumentation, and even typewritten proposals. Ironically, many countercultural artists became wealthy celebrities.

If artists were goaded by an alienated and radicalized response to American life in the late 1960s, they were also inspired by the idea that individuals should be free to "do their own thing," a popular catchphrase at the time. The artists were weaned on avant-garde art and were therefore willing to try anything no matter how irrational, anarchic, absurdist, or perverse. Indeed, these negative qualities were prized, if only because they were unconventional, unrestrained, and immoderate, and consequently hated and feared by the middle class. But there was a positive side to postminimalism: the artist's direct, free—and potentially elating—involvement with his or her materials and with actual space, that is, with art-making as an unalienated activity without market or media pressures.

The best postminimal art was only implicitly political. It did not impart any specific message, but it did partake of the dark mood of American life. Extreme and eccentric art generated more of the same until there was a cross-referential density that no longer appeared extreme and eccentric but if not exactly moderate, then at least "normal." As the period receded into history, art that looked countercultural, even irredeemably perverse, appeared increasingly formal and aestheticized. Such is the fate of all radical art.

Some three decades after the war ended, perverse and absurdist art continues to command art-world attention—witness the scatalogical performances of Paul McCarthy. Indeed, so ingrained has the counterculture become that in 1994 a *New York Times* editorial proclaimed that "Only a few periods in American history have seen such a rich fulfillment of the informing ideals of personal freedom and creativity that lie at the heart of the American intellectual tradition.... The counterculture, in sum, produced a renewal of the Thoreauvian ideal of the clear, defiant voice of the dissenting citizen." The editorial concluded that despite its excesses, the counterculture "was about exposing hypocrisy, whether personal or political, and standing up to irrational authority."

The Vietnam War called into question assumptions and values we had tacitly accepted. Like the newly politicized artists, I was caught up in the quest for "rele-

vance." In 1968, I began to experiment with new ways of teaching art history in my courses at New York University. I relied increasingly on the participation of my students, literally asking them what they would like to be taught. News of my courses reached the dean at Pratt Institute. Disgusted with the war in Vietnam and caught up in the counterculture, art students at Pratt tried to burn down the school. The dean hadn't a clue as to what the students wanted. Perhaps my free-wheeling approach might provide answers, and I was invited to teach two painting seminars. I began each class with, "Well, what shall we talk about today?" More often than not, I became a kind of moderator of a group discussion. At the end of the semester, I asked the students to evaluate the courses. The consensus was that they enjoyed them and that they learned a great deal, but they should have given me greater opportunity to teach. However, I never again stood in front of a class and pontificated.

In 1970, as President of the American section of the International Art Critics Association, I decided to convene a conference on art and education in order to provide cachet for art critics who wanted to teach in colleges and universities but lacked academic credentials. In collaboration with Jerome Hausman and David Ecker, professors of art education at NYU, I organized a two-day meeting at the Guggenheim Museum. It began on the day after Cambodia was bombed, and as a result, was almost canceled in protest.

In my talk I asked: How can we make our teaching of art history more relevant? My answer was: Begin with the art of today and create a history for it. The past is not immutable; it is constantly changing, according to the desires and needs of later generations. I said that art history traditionally is taught more or less as an orderly progression of artistic traditions—humanist traditions—from generation to generation, each generation adding its gloss while considering those traditions valuable and pertinent to its time. I pointed out that in the modern era changes in art—as in life—were revolutionary rather than evolutionary. The breaking point was the bloodbath of World War I. That gave rise to an extreme dislocation of past and present. History could no longer be treated as a continuous flow.

I went on to claim that today's students, radicalized by Vietnam, no longer considered the humanist tradition pertinent, not in a world they perceived as fragmented, random, even orderless and meaningless. Consequently, in the name of relevance, they were demanding that all accepted values be exposed and subjected to genuine challenge. As I viewed it, this called for a new approach to the teaching of art history. I rejected the imposition of a predetermined chronology of Western art and predetermined notions concerning the significance of styles and artists, and extending these notions into the present. Instead, I proposed to stand chronology on its head—that is, to teach art history by beginning with the study of contemporary art and the conflicting issues deemed important now.

They would become the points of departure for reviewing the past, allowing the living present to provide access to the vast realm of the past—and in the process to revitalize the past, conferring on it a significance that it otherwise no longer seemed to possess. I concluded: "Let current needs and problems regenerate those aspects of the past which illuminate and enrich the present."

I then addressed the issue of teaching art history to art students. My aim was to bring art history and studio disciplines closer together. Addressing a student's work, the class discussed the problems that it posed, its expressive content and formal means, its relation to contemporary styles, its antecedents in art history, its aesthetic quality, and the justifications for value judgments. In this process, an attempt was made to characterize the unique artistic identity of the student's work. The following week, I came prepared to lecture on the work's history, focusing on the developments in current art pertinent to it. I then opened up my presentation for class discussion, not the least of which was a critique of my approach. As an additional requirement, I asked the student to investigate an aspect of his or her own art history and present a paper to the class for further discussion. What my method provided was a sense of immediacy and relevance, and often the revelation of fresh and exciting insights.

As formalism and minimalism waned in the late sixties, it occurred to me that pervasive changes were occurring in the visual arts. As early as 1969, in the catalog to a *Critic's Choice* exhibition that I curated, I tried to characterize this change. I wrote that in recent years one avant-garde artistic style after another monopolized the attention of the art-conscious public. Value in art was thus made to depend on novelty. I then announced that this point of view was outdated. I granted that it was still possible to make original art, but that it could no longer believably be thought of as avant-garde. The reason was that in the "past half-century art has reached so many limits. Frontiers may remain, but the artists who discover them cannot be considered avant-garde since the impulse to press to the limits has been established as a tradition." Indeed, it had become commonplace.

"A limit in art," as I defined it, "is reached when an artist's work comes as close as possible to being non-art. This art does not go over the boundary because artists, critics, historians, museum curators, and a sizeable segment of the art-conscious audience treat every artist's work as art." As examples of art on the edge of non-art, I gave, among others, Duchamp's readymades and Kaprow's happenings, which were scarcely indistinguishable from our everyday environment and which tended to resemble theater more than painting or sculpture. I went on to say that "In the last two or three years, a number of artists have systematically demolished every notion of what art should be—to the extent that they have eliminated what may be the irreducible conventions in art—the requirements

that it be an object and visible. Some are . . . filling galleries and other spaces with ordinary 'formless' substances that do not seem to add up to an object. Others merely think up ideas that need not result in anything visible."

There was another reason that the avant-garde ceased to exist. In the past, it had been in advance of the audience for art. Yet now, I said, "there exists a large and growing public that no longer responds in anger to the novel, and when not eager for it is at least permissive." I concluded that the art-conscious public "may have to change some of its expectations. It may have to stop considering novelty in art as a primary value. Rather it may have to attach greater importance . . . to the expressiveness and uniqueness with which artists mix visual ideas. . . . The audience for art objects may have to become open as never before to multiple tendencies in art, [since proclaiming] one direction as the 'right' one has lost credibility." I had made a plea for pluralism in art and had anticipated "the postmodern condition."

In my book *Art of the Postmodern Era*, I considered postminimal art the opening phase of postmodern art. I also tried to define what postmodernism was, a difficult if not impossible task, since there was considerable disagreement among critics and historians as to what the term meant. However, it was clear that if it had any meaning, it entailed a rejection of modernism. But which or whose modernism? There were two primary ways to think about modernism and postmodernism. The first was art-historical, treating postmodernism as a bundle of styles superseding modernist ones. The other was sociological, positing a radical change from an industrial society that generated a modernist art to a postindustrial society that gave rise to a postmodernist art.

In many ways the two approaches were contradictory, but both tended to equate modernism with Greenberg's formalism. I thought that with the emergence of postminimalism, the Greenbergian assumptions underlying both formalist painting and minimal sculpture would become irrelevant. I was mistaken. Postmodernist critics singled out Greenberg's aesthetic and treated it as the modernist paradigm. In some measure, they were justified in doing so since his dogma was the dominant art-critical theory in the 1960s. Because it was narrow and simple, it made an easy target. Indeed, when the art-critical tide turned against modernism in the 1970s, Greenberg's reputation only grew, for he became the foil— the esteemed foil—of postmodernist art theorists. They ignored interpretations that rooted modernism in dadaism, constructivism, and surrealism—interpretations that stressed social or psychological concerns—and instead, accepted Greenberg's definition of modernism as the operative one.

Postmodernist critics focused on Greenberg's belief that the aesthetic realm was self-sufficient, transcending class, race, and gender. Its source, he said, was essential human nature. It followed that high art was international, universal,

and transcendent. If the Greenbergian aesthetic was to be challenged, a new post-modernist paradigm for considering and evaluating art would have to be formu-lated, and one was. If the generative term of Greenberg's modernist paradigm was "autonomy," its competing term was "relevance," which was attained by con-fronting social issues or expressing the zeitgeist. Modernists demanded that art rise above worldly concerns; postmodernists required it to engage its specific social context. Instead of stressing the purely visual, postmodernists focused on timely subjects. If the party cry of modernism was "make it new," the postmod-ernist catchphrase seemed to be "make it old." The young artists recycled images and forms from past and existing art as well as the mass media. Indeed, appropri-ation, as the practice came to be known, was the primary postmodernist practice.

Postmodernism called for a different sensibility from modernism, a different attitude toward formal elements and subject matter, and different criteria for judgment. Modernists believed that a work's content inhered in its form. Subject matter was incidental. Postmodernists emphasized subject matter and disregard-ed the form-content synthesis. These different ways of seeing made it difficult for modernists and postmodernists to talk to each other. They were simply speaking different languages. I was reared as a modernist, but with the advent of postmod-ernism, I tried to bridge both ways of seeing.

The critic, Lucy Lippard cued me in on the postmininal styles that crowded one another in the late 1960s. I liked her as a person, although I should have held a grudge against her. The first time we met, she said that my existential criticism was of great use to her, because it showed her exactly what she did not want to do. But she said it without hostility, and I understood why. She was merely reporting that art criticism had changed. I admired Lucy because she stayed close to the most exciting artists in the 1960s and part of the 1970s. Much as she was an enthu-siast, she questioned every aesthetic position, fearlessly following her own incli-nation.

Around 1964, Lucy joined a group of artists who lived in and around the Bowery in downtown Manhattan. These Bowery Boys, as they came to be called, included Sol LeWitt, Dan Flavin, Robert Ryman (whom she married), Robert and Sylvia Mangold, and Eva Hesse. Lucy championed minimalism but cooled to it, because it became established and lacked a sensuous dimension. Consequently, in 1966, she embraced what she labeled *Eccentric Abstraction*, the title of a show she curated. Ushering in postminimal art, it was one of the most significant shows of the decade. Eccentric abstraction was a kind of sexy, exotic, or funky minimalism. Its central artist was Eva Hesse, who retained minimalism's modular or serial grid and literalist treatment of materials while giving free rein to psychological pres-sures and bodily functions.

Lucy's growing politicization in opposition to the Vietnam War led her to become a leader of the Art Workers Coalition. It also prompted her to champion newly emerging conceptual art, and she became its in-house critic and one-person international clearinghouse. The introduction of verbal ideas into the visual arts lent itself to social commentary. Because conceptual art was anti-object, it was also viewed as a countermove to sixties commodity fetishism. Indeed, much of the acclaimed art that followed conceptual art in the 1970s and 1980s was explicitly social or political.

When the AWC's political energies waned, newly organized feminist groups emerged from within it. At first Lucy was embarrassed by the women's movement, but she was slowly drawn in and became one of its most persuasive spokespersons. She promoted what was called "essentialist feminism," as did first-generation feminist friends of mine, Miriam Schapiro and Nancy Spero, my student Hannah Wilke, and acquaintances Carolee Schneemann, Joyce Kozloff, and Cynthia Carlson. Conceived in consciousness-raising sessions, essentialist feminism's central premise was that the nature of women was inherently different from that of men. In order to express what was intrinsically female, feminist artists cultivated a personalist, introspective, and antiformalist art. They focused on such subjects as the vagina, menstruation, pregnancy, and body language. Imagery tended to be symmetrical and was often termed "central core," "central cavity," or "vaginal iconography," prompting Lucy to title her germinal book of feminist essays, *From the Center* (1974). As she later summed it up, with Judy Chicago's work in mind: "Women's bodies, for better or worse, are still the core of much feminist art, entangled as they are with our exploitation on the economic, domestic, and media fronts, central as they are to our campaigns for reproductive rights and against discriminatory 'protective' laws." As a feminist, Lucy's art writing changed. As she said: "I had always been the avantist of the avant-garde. Then, all of a sudden, I was going back and looking at anything. I didn't care what it was, as long as it was by a woman... and I found I liked a lot of things."

Feminists sought not only to celebrate female attributes but also to counter the repressive social mechanisms that held women back. Above all, they struggled to improve the situation of women artists and achieve recognition for them in a male-dominated art world. The primary butt was the Whitney Museum—with justification. For example, of the 143 participants in its 1971 annual exhibition, only 8 were women. The curators claimed that their decisions were dictated solely by aesthetic quality, but the lopsided ratio of women artists to men made that claim ridiculous. Among their demonstrations and pranks, feminists deposited Tampax and raw eggs throughout the museum. My favorite caper was a fake press release issued in the name of the Whitney announcing that it had

agreed to all feminist demands, most notably, that 50 percent of artists in future annuals would be women. The release looked so authentic that it was widely reported by news agencies. There was talk of legal action, but no one was able to identify the perpetrators. I suspected Lucy.

Second-generation feminist artists, in contrast to the first, believed that male-dominated social mechanisms were responsible for the discrimination against women and undertook to "deconstruct" them. Following these feminists, socially conscious artists commented not only on sexism, but on racism, homophobia, and ecological devastation. They responded with growing concern to the power of the mass media in a burgeoning consumer society. Yet, the new political art differed from earlier social protest art because it was on the cutting edge rather than being retrogressive and because it proposed to stimulate thought rather than parrot slogans.

Art that "deconstructed" social ills more often than not employed photography and other mechanical media. Consequently, photography, long considered a minor art by the art world, achieved growing recognition in the 1980s. It was also promoted as the exemplary postmodernist art. At the same time, there was an international "renaissance" of painting, some of it political, most not. Painting, often dismissed as dead, seemed more alive than ever. In this situation, the advocates of mechanical media, on the one hand, and on the other, the supporters of traditional media, were at constant loggerheads. Indeed, their competing claims dominated art-world polemics in the 1980s.

The major proponent of photography and postmodernist art theory was Rosalind Krauss. As a person, she was often nasty. Critics who did not agree with her were dismissed as stupid and worse. In a special issue of her journal, titled "Art World Follies, 1981," and "dedicated to knaves and fools, with an emphasis on the latter," she declared that "foolishness has become the medium through which almost every transaction in the art world is conducted." Although Krauss was cordial to me, I guessed I was one of the fools. Yet, it was somewhat comforting to know that I was in a large company of just about everyone who was not a contributor to the journal, *October*, which she, Annette Michelson, and Jeremy Gilbert-Rolfe founded in 1976. *October* was named in celebration of the Russian Revolution and Sergei Eisenstein's film memorializing the Bolshevik takeover. The journal's editors would have liked to be on the barricades, but they recognized that they were "members of a middle-class intelligentsia with no illusion of a revolutionary mission." Their chosen constituency was not the masses but their leftist colleagues in academe.

Krauss and her colleagues used art theory to gain art-world power, and they were expert at playing art and academic politics. Krauss had been a disciple of

Greenberg but later categorically rejected his formalist theory. However, she had learned from him how to acquire tastemaking power: Assume an identifiable aesthetic position with a few identifiable premises, repeat them again and again, and apply them to a relatively few privileged artists. At the same time, identify an opposing aesthetic—modernism, in Krauss's case—and attack it vehemently or dismiss it contemptuously. I resented Krauss's twisted conversion of art discourse into an instrument of intimidation and exclusion. While serving on panels with her, I learned never to rephrase anything she said because you would always get it wrong, of course, and get verbally pummelled in return.

In place of old-hat formalism, Krauss embraced the newly fashionable theories of Roland Barthes and Jacques Derrida in particular, but also those of Michel Foucault, Jean Baudrillard, Jacques Lacan, and other French intellectuals. Instead of paying close attention to what was *within* the frame of a work of art, as Greenberg insisted, the new art theorists looked *beyond* the frame to the social, political, and economic context within which art supposedly came into being and whose interests it presumably served. Particular attention was paid to class and gender as shapers of art. What counted above all was not how the art was formed but what it represented. Art theorists analyzed the content of art from the often conflicting perspectives of Marxism, feminism, history (rather than art history), sociology, psychoanalysis, semiology, and linguistics. But they all agreed that art was essentially about representation, not formal issues.

Krauss proposed to demystify modernist claims of originality, uniqueness, authenticity, autonomy, transcendence, and aesthetic quality. She used Derrida's method of deconstruction, which, to put it simply, meant selecting an alleged key, primary or "privileged" term and pitting it against a secondary or "marginal" term with the aim of inverting—or decentering—the terms. The purpose was to prove that the marginal term was more significant, or at least, to establish an unstable relationship between the two terms.

For example, Krauss took what she professed to be the key term of modernism, namely originality, and opposed it to its "repressed" term, that is, copying, and inverted them, declaring that copying was more to the point of modernist practice. However, appropriation was also central to postmodernism, but it was used differently from modernism, so she argued, because postmodernist piracy aimed to deconstruct modernist notions of originality. All established assumptions could be inverted. With regard to the visual in art, the verbal could be elevated over it, thus providing a rationale for conceptual art. Duration-in-time could be "privileged" over the moment-of-vision, thereby establishing a rationale for "theatrical" happenings and performances. If painting, an art identified with originality, was considered the premier art, and photography, as an art of mechanical reproduction, was relegated to a cultural limbo, Krauss inverted

them, moving the marginal into the center.

Indeed, Krauss decreed that painting was outworn and had to be jettisoned. She and her co-editor, Annette Michelson, declared that it had been "consigned to deserved oblivion in the sixties." They would not brook new painters who were emerging "paint spattered from their studios," touting "the cleansing properties of linseed and turpentine." Painting, as *October* contributor Douglas Crimp bluntly put it, was "pure idiocy."

Painting was *October*'s bête noire because it epitomized originality, subjectivity, uniqueness, and authenticity. Moreover, it was esoteric, elitist, and appealed to bourgeois appetites. Most distressing, painting seemed to be on the rise, as young artists such as Eric Fischl, Elizabeth Murray, Susan Rothenberg, David Salle, Julian Schnabel, and Sean Scully commanded growing art-world attention.

I was a spectator of a dramatic skirmish in the war between photography and painting. It took place in 1981—at a panel discussion at Julian Schnabel's studio. Theorist Craig Owens and Sherrie Levine, who took photographs of photographs and was *October*'s favorite artist, confronted so-called neo-expressionist painters Schnabel and Salle. Owens began by asserting that "the next move" in contemporary art was to deconstruct postindustrial or information society. With Levine in mind, he said: "The artist no longer makes an object, but rather is involved in the transfer and processing of information. This aspect accounts for the absolutely central role of photography in Post-Modernism—photos that were always excluded from the Modernist hierarchy." As a means of production, painting was technologically "academic" and "moribund," and attempts to revive it were futile. Salle countered that what he ironically called his "production" "is as much about the resonance of information [as Levine's.] What you're describing, Craig, is pure Conceptual Art, which is extremely academic." Owens responded: "I'm arguing for an art that is culturally relevant"—as if Salle's wasn't.

I did not accept *October*'s war on painting. It seemed pointless to have to choose between mediums. I was moved by painting as an art based on the interaction of eye, mind, and hand, in which the surface was built up brushmark by brushmark, each requiring choice. Painting could evoke feelings and thoughts that no other art could. It was an option for artists who wanted to use it. But so was photography, and Cindy Sherman's and Barbara Kruger's use of it was compelling. I also admired the environments of Ilya Kabakov and Christian Boltanski, the video of Mary Lucier and Bill Viola, and the performances of Laurie Anderson and Eric Bogosian, to mention just a few non painting artists.

I admired most of the artists Krauss did, but I utterly rejected her thinking. I was able to state my opposition strongly, if fairly, in *Art of the Postmodern Era*. I attacked the hypocrisy of art theorists who denied the existence of genius and rejected the conception of the artist-as-genius while touting the art-theorist-as-

genius. I found this self-serving to be disreputable. I was put off by the practice of Krauss and other *October* contributors of promoting artists who were theoretically "correct," particularly those who seemed to have formulated their art with *October*'s dogmas in mind or, if not quite that, internalized the journal's opinions and assimilated them into their own art-making. I also faulted art theorists for drawing attention away from art to the discourse about it—and the murkiness of the langauge, which struck me as a kind of speaking in art-theoretical tongues. Their motive was to appear profound, but the upshot tended to be shoddy thinking and an insensitivity to language. It was all too common for the rhetoric in *October* to have lost all reference to the art it purported to illuminate.

Krauss and Lippard were the left-wing adversaries of Hilton Kramer, the editor of *The New Criterion*, who was an implacable anti-Communist and pro-American neoconservative. Hilton and I were also antagonists of sorts. He had replaced Canaday as the chief art critic of the *Times* and continued his predecessor's hostility to abstract expressionism. Face-to-face with Hilton, he appeared well mannered and soft-spoken, but sit him down at a word processor and he would often begin, figuratively, to froth at the mouth.

Hilton and I saw each other off and on and spent a memorable evening together in 1961, during my trip to Wolfsburg to review a modern French painting show, which I have mentioned earlier. Its sponsor, the Volkswagen Company, had planned a boat tour on the Rhine, but Hilton and I decided to visit the museum in Hamburg instead. At night, we wandered through the Rieperbahn, then the premier red-light district in the world. What was happening openly on the streets—prostitutes in all states of undress, much leather—left little to the imagination. I was surprised by their hostility. But then, I supposed that was what the customers wanted; after all, they were paying for it. Hilton and I ended up in a bierstube talking about art.

*October* made Hilton see red. In fact, he opposed everything the counterculture stood for. As a lonely voice in the desert of art-world leftism, he was perpetually embattled. However, Hilton was the cultural spokesman of neoconservatism and thus, a political power to be reckoned with, most notably at the National Endowment for the Arts and right-wing think tanks.

Aesthetically, Hilton was an unregenerate champion of "classic" modernism, in despair over its decline. In a no-holds-barred fashion, he condemned the introduction of any semblance of "low" popular culture into "high" art. Rauschenberg was never forgiven for his perfidy. In the name of the established modernist canon, Hilton rejected postmodernist art history and art criticism in all of its guises—poststructuralist, deconstructionist, feminist, gay, and multicultural—which he held reponsible for the sorry state of American culture. He singled out John Cage, John

Ashbery, Donald Barthelme, Philip Johnson (in his postmodern period), and Andy Warhol as the betrayers of the "high purposes and moral grandeur of modernism."

Hilton stood for quality in art and for the practice of connoisseurship in art criticism and history. He did not indicate what his criteria were, but he nonetheless used the assertion of quality to condemn art he didn't like, and his writing was primarily a list of woes. However, Hilton's jeremiads were against most everything the art world found interesting. He would attack rather than entertain new art, ideas, and approaches. This disturbed my art-world colleagues on the whole, but not me. I was perversely amused by Hilton's diatribes. They made my blood run hot, like in the good old days, and I could fantasize that I was avant-garde again—knowing, of course, that an avant-garde no longer existed.

Hilton did make me question many art-world assumptions. In my survey of postmodern art, I asked: "Was [the] art, no matter how perverse, established by the art-world consensus the true expression of its ... time? Or was it a nihilist assault on more than twenty-five centuries of Western civilization in the name of marginalized 'others'—women, gays, people of color, and other minorities? If one valued civilization, were the barbarians at the gate? Or had the world, succumbing to rampant tribalism and nationalism, ethnic cleansing, population explosion, and ecological devastation, degenerated into barbarism?" The confrontation between art critics on the right and those on the left over the countercultural legacy of the Vietnam War continues to this day.

By the beginning of the 1990s, postmodernist polemics were played out, and the artists supported by the *October* group were established. However, the journal did succeed in deconstructing master narratives, notably the idea of an ever-progressing mainstream. Indeed, American art as a whole was increasingly perceived as a delta, each tributary receiving more or less its fair share of art-world attention, although certain artists stood out in each. The choice of style, image (whether figurative or abstract), medium (whether painting, sculpture, video, or performance), whatever, all became viable options. Artists were free to move in any direction they desired. American art entered a period of total pluralism—and it seems as if it will remain in this condition for some time to come.

# The Sweeper-Up After Artists

In the 1960s, I found myself spending more and more of my time and energy writing a history of abstract expressionism, particularly after being awarded a Guggenheim Fellowship in 1964. That book, *The Triumph of American Painting*, would be followed by three more which surveyed the art that came later, an enterprise that occupied me for the next three decades. Moreover, having enjoyed running the Tanager Gallery from 1956 to 1959 and The Club from 1956 to 1962, I began a life-long participation in art-world organizations, causes, and activities. Indeed, I treated my attendance at meetings, panels, and lectures as recreation, although every now and then I thought that I must be strange, even sick, to get my kicks this way. But I enjoyed being with the artists and art professionals on the committees and acquiring information through listening and socializing— and that was what counted to me.

---

In 1962, with abstract expressionism's eclipse by new tendencies and the demise of both The Club and the Tanager Gallery, my first art world, small though it was, began to fall apart. Its last sign of life was a huge party of artists and a smattering of critics and curators that I organized in celebration of New Year's Eve, 1964. Sylvia Stone offered her loft, and I collected monies from some fifty art-world friends and acquaintances, $10 tops or what they could afford. With a total of $497 (there was a $8.99 surplus) I bought liquor and food, rented a jukebox, hired my brother-in-law as doorman, and sent out invitations. Some 200 people came, virtually the entire New York school. The party was a blast. A few persons were denied entry—the beat poet Gregory Corso, who was drunk and nasty, and a prestigious uptown dealer who sought to invite himself and a rich out-of-town client. The party ended about 4 A.M. and was a much-talked-about success. Later that morning as we were cleaning up, Saul Steinberg called and said that his friend had lost an earring. He asked if we could look for it, and he came over to help search. We found it. My party turned out to be the last major social event of my art world.

I continued to follow current art closely and wrote occasional essays in magazines and catalogs. In 1966, I became increasingly frustrated by what I felt was the art world's lack of discussion of problematic issues in current art, that is, the kind of discussions I had arranged at The Club. I also sensed that I was not alone in my dissatisfaction. My feeling was generated partly by nostalgia for the good old days at The Club, the Cedar Street Tavern, and the Tenth Street cooperative galleries. I was determined to do something about it. I didn't have the time to do it alone, so I asked Barbara Rose to collaborate with me. We thought it might be interesting to ask five critics, including ourselves, each to organize a panel on a topic of particular interest to him or her. The other critics we invited were Max Kozloff, Annette Michelson, and Sidney Tillim. As a faculty member at New York University, I booked the auditorium at its student center.

I thought that the participants should be paid, if only a pittance, but where would the money come from? We planned to charge a small admission fee, but that would not be enough. Luckily, I ran into art patron Vera List on a Madison Avenue bus (of all places) and outlined our plan for the symposia and asked if she would fund it. "How much?" she asked. Without knowing exactly why, I said: "Well, three thousand dollars should do it." She said: "Mail me a proposal, and please keep it short, just a few lines." I did, and about a week later, a received a $1,000 check in a tatty envelope, the kind you send thank-you notes in.

The cast of panelists was stellar, to say the least. It included Donald Judd, Robert Rauschenberg, Robert Morris, Roy Lichtenstein, Leon Golub, and Robert Smithson. Barbara and I were astonished at the number of people that showed up, approximately 800 to 1,200 for each panel. We knew there was a need for art talk, but not the extent of the need. Our five panels were also a financial success. We charged $1.00 admission, and after paying the panelists $100 each, we were left with a surplus of $1,000. NYU let me put it aside for future programs.

I used that money later, at the beginning of 1971, to defray the costs of a series of performances, videotapes, and films by artists who used their bodies as their medium. Organized by dealer John Gibson and me, these events, which we titled *Body*, included Vito Acconci, Dan Graham, Dennis Oppenheim, Bruce Nauman, Richard Serra, and Michael Snow. *Body* turned out to be a pioneering venture.

During the 1950s, most of my friends in the New York school were not interested in public art, since commissions were rarely in the offing. Furthermore, the artists' sense of alienation curbed speculation in this direction. However, my curiosity as to whether art could be socially useful led me to entertain the idea of placing works of art in urban settings. I recognized that the organic collaboration

of an architect and an artist from a building's inception was the ideal procedure, but this rarely happened. Architects insisted on designing a building as a total work, down to the smallest detail. It was only later that art was added as a kind of cosmetic, if the architect would allow it, and many would not. Because art was considered incidental, it was thereby degraded. There had to be another, more imaginative and serious approach. In an early note to myself, I wrote: "Think the city." Why? Because it would allow an artist the freedom to choose a location best suited to his or her art and create a work for it. Moreover, in dealing with the formal problems the site presented, the artist might consider the people who lived there. This might generate a new content—and perhaps change the outlook of the inhabitants.

In 1967, I asked Doris Freedman, New York City's Commissioner of Parks, if I could curate a show of works outdoors. She agreed, and we mounted the first show of its kind in New York. I borrowed the works of twenty-seven artists, including Stephen Antonakos, Alexander Calder, Mark di Suvero, Louise Nevelson, Barnett Newman, Isamu Noguchi, Claes Oldenburg, Tony Rosenthal, David Smith, Tony Smith, and Richard Stankiewicz, and sited them throughout Manhattan. The show, titled *Sculpture in the Environment*, was favorably received. Newspaper coverage, even that of the tabloids, was friendly, thanking us for showing museum art on city streets. One of the works on view, Rosenthal's huge black cube, is still in place across from the Cooper Union and is now an East Village landmark.

*Sculpture in the Environment* revealed the potential of a public art. In 1973, it led Brian O'Doherty, then the Program Director of Visual Arts at the National Endowment for the Arts, to ask me to write a position paper on the NEA's Works of Art in Public Places program, justifying its existence and formulating its guidelines. I began by stating that by supporting public art the NEA would affirm America's humanity. I went on to say that a democratic society could best achieve a valid public art not by governmental dictation to artists, as has been and is the practice of totalitarian regimes, but by making it possible for a variety of artists (and American art is distinguished by its pluralism), each according to his or her individual vision, to create works for public places, in the conviction that together their works will embody the highest aspirations of American society. The program was approved and turned out to be a great success; it provided commissions for some 300 artists.

The *Sculpture in the Environment* show also led to my appointment to Mayor John V. Lindsay's Fine Arts Advisory Committee. Given the problems he faced during his tenure from 1966 through 1973—racial unrest, strikes, economic and fiscal crises—art-related issues were of little consequence. Yet, Lindsay did what he

could. He inaugurated concerts, festivals, and events in city parks, many of them vest-pocket parks he created. I was only one of many advisors on the committee so there was not much I could do. However, I did make one valuable contribution: Because of the success of my show, the committee decided to sponsor works of art in public places. It was proposed that they be sited in Central Park. I objected to turning Frederick Law Olmsted's masterwork into an outdoor gallery and recommended instead that the works be placed in city spaces where people live and work. I won. When Louise Nevelson donated a large sculpture to the city with the proviso that it be placed on Park Avenue, I suggested that it not be located in the moneyed midtown section but rather that it be put on a rise overlooking Harlem, and it was.

It soon occurred to me that a work of public art did not have to be a monumental sculpture, like the Nevelson, or a wall-size relief or mural. A grant could be used to endow a continuing series of temporary works or events, such as happenings, and intermedia and light shows. Public art could also consist of inexpensive photographs and prints. In 1972, Artists Space, a not-for-profit gallery I co-founded, asked for and received a grant from the New York State Council on the Arts to have Hans Namuth produce a portfolio of his photographs of artists. We circulated it without cost to not-for-profit institutions throughout the state. Simply push-pinned to a wall, the photographs constituted an exhibition. It was a lovely idea, and it worked.

In 1983, I had another opportunity to experiment with this novel form of public art. Murray Zimiles, a colleague at SUNY Purchase, thought up the idea, which he named "The Atelier Project," and I was delighted to help him. He got eleven donors, to contribute $9,000 each. Sixteen artists were each paid $2,000 to come to our campus and create a print. Among the participants were Lee Bontecou, Leon Golub, Reuben Nakian, Philip Pearlstein, Judy Pfaff, and William Tucker. (Nakian required rather unorthodox print-making aids—a "medicinal" bottle of Bombay Gin and the presence of female students—to inspire his *Leda and the Swan*.) The portfolios of prints were given to the donors and to museums, galleries, libraries, or art departments of the sixty-four campuses of State University of New York as well as LaGuardia High School. Meant for exhibition and/or study purposes, the prints were transformed into works of public art. This was the most innovative aspect of The Atelier Project.

———

By the end of the 1960s, the American section of the International Art Critics Association (IACA) had become moribund. Its forty-eight members had lost their enthusiasm but refused to admit anyone new because, in their opinion, none was

"distinguished" enough. In 1969, George Heard Hamilton resigned the presidency. When no one else would serve, I volunteered, thinking that interesting things might be done. I was elected by a vote of 14 to 0. "Not exactly a plurality," Hamilton remarked in a letter to the membership, "but a landslide compared to the response to my appeal for dues."

As president, my biggest fear was that everyone would quit. Therefore, I made no attempt to collect dues and would not accept resignations, despite the protest of Fairfield Porter, who wanted out because he no longer wrote criticism. I was sure that the international body would object to our not paying the monies we owed them, but there were no complaints. Apparently the French, who dominated IACA, did not want any competition from us. I must admit that I was indifferent to the international organization. But I was interested in the American section, and I organized a number of activities. I arranged for us to meet with African-American artists to discuss the problems they faced. (I recall most vividly our insensitivity to their situation.) We also met with the Art Workers Coalition during the time of its intense agitation against the policies of the Museum of Modern Art.

I also wondered whether the American section could serve as a trade union of sorts. I called a meeting to set minimum fees for our reviews and articles, but no one seemed to know how to go about it. Finally, I said that before we could discuss wages, we had to know what each of us was being paid. Silence. Bourgeois under the skin, our aesthetic radicals refused to own up, fearful of losing face, I guess. The only exception was Gene Swenson who said that he was being paid a dime a word. Lawrence Alloway, in one of his nastier moments, blurted: "You're not worth it." He later apologized, but his remark signaled the end of our venture into unionism.

The high point of my presidential tenure was a two-day conference on "Art Criticism and Art Education" held at the Guggenheim Museum in May 1970. The conference was funded by a grant from the New York State Council on the Arts and organized by myself and Professors Jerome Hausman and David Ecker of New York University. Our intention was to establish academic cachet for art critics who supported themselves by college teaching but didn't have impressive academic credentials. However, the proceedings turned out to be a freewheeling critique of art criticism's function in an America waging a war in Vietnam. Among the speakers were Lawrence Alloway and Hilton Kramer on "Elitist vs. Popular Criticism"; Robert Rosenblum and myself on "The Teaching of Contemporary Art"; Max Kozloff and Brian O'Doherty on "The Teaching of Art Criticism"; and H. W. Janson on "Prospects for Art Criticism in Art Education." The proceedings were published by New York University and are both pertinent today and a revealing commentary on that awful time.

By 1973 I had tired of the presidency of the American section but I couldn't

find anyone to replace me who was acceptable to the membership. In 1975, I decided that, old fogeys and by-laws be damned, I would transfuse new blood into the organization by inviting all the working art critics I could think of to join. The next meeting I called was well attended; about fifty critics came. I resigned, and Rosalind Krauss was elected president by one vote over Gregory Battcock. I have a canceled check for $250, made out to her, which was then our entire treasury. Eventually, the new membership of the American section revitalized it. I returned to the board of the American section in 1998, at which time we had 400 members and $20,000 in the treasury. Our own Kim Levin was elected president of the international organization, which indicated how the role of American art critics had changed in the last three decades.

---

One of my most rewarding and productive administrative projects was the founding of the not-for-profit gallery Artists Space. In 1972, I was asked by Trudie Grace, the director of the Visual Arts Projects Program of the New York State Council on the Arts, to administer a program that sent artist-speakers to colleges, many of which were short of monies for extracurricular activities. Working closely with Trudie in the office of NYSCA, I was able to decipher its operations. Both of us became increasingly sensitive to an inadvertent inequity in the Council's funding policy as mandated by state legislation, namely, that only not-for-profit institutions could receive grants. This met the needs of dancers, actors, and other performers who, because of the nature of their work, founded companies. It also suited film- and video-makers, who banded together in order to share the high cost of their equipment. But visual artists rarely set up organizations; they worked privately in their own studios. The Council did provide funds for individual grants, but that was hardly enough. Painters and sculptors deserved more since they had turned the city into the world capital of art.

Trudie and I raised the issue within the Council. Its higher-ups responded sympathetically and asked us to formulate projects that would be of general use to artists. We then invited small groups of artists of diverse ages, aesthetics, and positions within the art world to talk with us in order to identify the needs of artists and to design programs to meet them. The artists we called together agreed that a distressing problem facing many excellent New York artists was the lack of venues in which to exhibit their work. The existing galleries were not able or willing to offer shows to the large number of artists who merited them. Moreover, there was a great deal of "non-commercial" art, much of it "anti-commercial"—that is, conceptual, anti-form, etc.—that private galleries did not show.

At first, Trudie and I thought that artists who were not associated with commercial and cooperative galleries—"unaffiliated artists," as we called them—

might be awarded grants to mount shows in their own studios. We quickly reject-
ed this approach because the privacy that most artists required would be violat-
ed, because artists' lofts were often out of the way, and because studio shows
would not possess the authority to attract a significant public. Even those gallery-
goers most sympathetic to unrecognized artists would not have the time to visit
many dispersed lofts. It soon became evident to us that a permanent exhibition
space in an accessible art-world location was needed.

It all made good sense, but we were fearful that NYSCA would balk at being
closely identified with a program of such high visibility. What if the gallery
exhibited a pornographer, racist, or political subversive? Nonetheless, we pre-
sented the plan for a new gallery and half a dozen other projects and assumed our
job was done. The heads of the Council accepted our proposals but informed us
that the Council's mandate was to fund arts groups, not to administer their pro-
grams. We were then asked to incorporate ourselves as a not-for-profit organiza-
tion and, with a substantial grant from NYSCA, put into effect the projects we
devised. Trudie and I asked Jerome Hausman and David Ecker, colleagues of mine
at New York University, to join us in forming the Committee for the Visual Arts
(later changed to Artists Space). Trudie left the Council to become the
Committee's executive director, and I became a part-time employee for the first
year and the president of its board of directors.

In the spring of 1973, Trudie single-handedly found a spacious, well-lit loft on
Wooster Street near Houston Street in the heart of Soho. During the summer, she
had the floor-to-ceiling junk removed and the space fixed up so that three one-
person shows could be mounted simultaneously. The result of her efforts was one
of the handsomest galleries in New York City. We named it simply Artists Space.

I must admit that I was reluctant to devote my energies as an agent for
NYSCA, but the money was there and someone had to spend it. Better me than
some bureaucrat who was ignorant of what artists really needed. My problem
was determining how to use my cachet with NYSCA and my organizational skills
without becoming a cultural czar or apparatchik. My answer was to place policy
making in the hands of artists. Trudie and I decided that at least half of Artists
Space's board members would be artists. That would make us different from typ-
ical arts organizations that are controlled by non-artist bureaucrats. We also rec-
ognized the need for tough-minded administration. Indeed, Artists Space suc-
ceeded largely because it was able to couple the imagination of artists when they
face the problems of their own community with the skill of a staff adept at mick-
ey-mouse bookkeeping and writing the elaborate and stringent grant proposals
demanded by public and private funding organizations.

We decided that because of their great number in New York, we would have
to screen the unaffiliated artists who wanted shows. After lengthy discussions,

we concluded that each artist to be shown would be selected by a relatively well-known or established artist on a one-to-one basis. This procedure had the advantage of turning over decision-making powers to artists; of being public, because the names of the selectors would be announced; and of avoiding the compromises and tedium of a committee process. If the art-conscious public on the whole would not go out of its way to visit an unknown artist's show, it might, if only out of curiosity, wish to see what new work a known artist believed to be significant, particularly if the venue was easy to reach.

We also agreed that each selector would have only a single choice and that an unaffiliated artist would be shown only once. Thus, no person or group could dominate the gallery. Moreover, the element of unpredictability and surprise would be guaranteed. We also decided that the gallery would pay for the costs of the exhibition, such as transportation of works, printing and mailing announcements, and advertising. If anything was sold, all of the proceeds would go to the artist. We would fund our operations in ways other than collecting commissions from those we were meant to serve.

I chose the initial roster of selectors, making sure that all aesthetic positions were represented. While the gallery was being prepared, the selectors made their choices. A number were ready to show immediately, and Artists Space opened in the early fall. Among the first year's selectors were Vito Acconci, Romare Bearden, Peter Campus, Chuck Close, Nancy Graves, Donald Judd, Sol LeWitt, Philip Pearlstein, Dorothea Rockburne, Lucas Samaras, Richard Serra, and Jackie Winsor.

The response to Artists Space by the art world was enthusiastic. Even the commercial dealers welcomed us, recognizing that we were fulfilling a need that they would not. To make Artists Space more useful to the art community, we made the space available after hours to performing artists, poets, multi-media artists, film and video artists, and art-advocacy groups from within the art world. In our first three years, we averaged two or three nighttime events a week. We also arranged panel discussions and lectures on issues of interest to our constituency.

We soon faced two problems. Who was to choose the selectors? I had initially, because we needed them quickly, but why me when there was no longer any necessity for haste? We solved the problem by drawing up a list of names of some 650 artists, most of whom were represented by New York galleries. Then we mailed the list to all the named artists, inviting them to vote for the ten artists they believed would make the best selectors, excepting those who had already served in this capacity. More than 400 artists returned the ballots. The large number was a tribute to the role that Artists Space was already playing. The artists who led the tally became the selectors for the following two years. Among them were Louise Bourgeois, Christo, Red Grooms, Al Held, Brice Marden, Robert Ryman, and Richard Tuttle.

Our second problem was how to take into account unrecognized artists so far underground that even our selectors did not know of them. Our solution was to set up a file of unaffiliated artists in which any New York State artist could be included by simply submitting slides and, preferably, a short biography. The file was used in a variety of ways. Selectors were urged to consult it. Groups of artists who had been given one-person shows at Artists Space were asked to choose group shows from the file. Also, all of the artists who were in the file were invited to serve as a jury-of-the-whole—the first time, to my knowledge, that such a method was used to select a show. All who were interested, and most were, assembled to view all of the slides and selected a dozen of their peers by voting for those they favored. The file was also made available to curators, critics, dealers, collectors, heads of college art departments, indeed, anyone who wanted to see it. In 1995, in recognition of my contribution to Artists Space, the file was named after me.

Trudie Grace and I thought that Artists Space, along with other not-for-profit organizations, such as 112 Greene, the Clocktower, and the Kitchen, might initiate an art-support system alternative to the commercial galleries. However, much as we tried, we did not succeed in selling art. Since we exhibited artists only once, we could not represent them as private galleries could. Dealers invited many of the artists we showed to join their galleries, and the artists did. We became a feeder for these galleries—a kind of farm team for the majors. We did launch dozens of soon-to-be-famous artists, and a first show at Artists Space quickly became an important career move.

Artists Space became the model for a number of other alternative spaces among the some 300 that were soon founded. Indeed, many artists and art professionals visited us to learn how we did it. For example, we were directly responsible for the formation of Sculpture Space in Utica, New York. As one of the programs at Artists Space, I had the idea of sending artists to live and work for periods of time in communities throughout New York State, a variation of the artist-in-residence programs in colleges and universities. We would identify a city or town that had a facility artists could use and match it with an artist. We would provide a stipend and the community would host the artist. In turn, the artist would interact with the local people and leave a work behind.

We made arrangements with the Kirkland Art Center in Clinton and selected Richard Friedberg as the visiting artist in the summer of 1974. The project was a great success, so much so that the powers at the State Council for the Arts decided to take it away from us and have it administered by others. We urged them not to, saying that our vision and energy were necessary for its success, but to no avail. They coopted it, and nothing more was heard of it.

The Friedberg residency had unexpected and propitious developments, how-

ever. He and John von Bergen, the director of the Kirkland Art Center, arranged with the Utica Steam Engine and Boiler Works to make working space and machinery available to twenty artists a year at a moderate cost. In 1978, Sculpture Space was incorporated as a nonprofit organization and is still in existence.

In 1976, Artists Space hired Helene Winer as its executive director. She believed that our program of artists-choose-artists had ceased to be interesting to the art world. She proposed that we maintain the practice of giving unaffiliated artists individual shows but that we also curate thematic shows of new art not readily accommodated by commercial galleries, and support the work with adequate documentation. The shows would be curated by the staff, invited artists, and art professionals. I resisted this new policy, and questioned Winer's right to choose the shows. Indeed, my animus became so strong that my agitation threatened the very existence of Artists Space. Recognizing this, I backed off. In retrospect, it is clear that Winer was right, and I was wrong. The artist-choose-artists approach had run its course. She gave Artists Space a new life.

In 1979, Artists Space faced a crisis that almost destroyed it. Donald Newman, one of the exhibiting artists, titled a show of abstract charcoal pictures *The Nigger Drawings*. Newman said that he chose the title as a comment on the status of unrecognized artists like himself in the art world. His detractors said it was a sensationalist attempt to attract attention. In retrospect, I think that it was a misguided gesture, particularly because the artist was white, and we at Artists Space should have made a concerted effort to stop it. But the staff did not, naively thinking that the racist taunt had become a broadly used adjective that no longer referred specifically or even pejoratively to African-Americans—that is, it had become deracialized. Helene Winer pointed out that it was African-Americans "who perpetuated the use of that term," and if they could use it, why not whites? Moreover, Artists Space refused to curb the artist's freedom, the hatred of censorship seeming to outweigh the racist implications of the title. However, one group of art-world leftists, who had not had a viable political cause since the end of the Vietnam War, now rose up in righteous fury (although not until two weeks after the show opened). The letters came fast and furious—many cc'd to the New York State Council on the Arts, the primary funding source of Artists Space—and they ranged from sincere outrage to knee-jerk political correctness. Suddenly, instead of being a "funky downtown gallery," as Ragland Watkins, an Artists Space staff member, commented, "we're considered a prestigious art institution."

One letter to the *Village Voice* condemned a "typical ... social practice in the art world [whereby] racism appears in chic packages." By "believing that *in an art context* racism isn't racism, it's art [the art world] perpetuates racist attitudes without

consciously acknowledging it. Thus, the art world fully reinforces the overt and conscious expression of fascism it would claim to abhor." "Typical social practice"? "Fascism"? I couldn't believe what I was reading. Among the signers of the letter were Carl Andre, Rudolph Baranik, Leon Golub, Sol LeWitt, and Lucy Lippard, all former leaders of the Art Workers Coalition. It was not one of their better moments. Some letters called for firing the staff for insensitivity. Other letters demanded cutting off of state and federal funds to Artists Space; a few from directors of arts organizations implied that the monies ought to be given to them. Donald's show also gave self-serving neo-Marxists a new cause, and they condemned it as a sinister trial balloon whose message was that the pervasive racism in the art world is acceptable. In a flight of hyperbole, Carol Duncan remarked: "If I killed someone in a gallery, it wouldn't be murder, it would be art."

A quickly formed Emergency Coalition Against Racism in the Arts claimed that Artists Space introduced into the art world a new kind of racism, "brutality chic," and demanded that it atone for its insult by showing more black artists. The controversy was soon exported to England by Rudolph Baranik who, in a "Note from New York," found even more to bemoan. In pretentious new left rhetoric, Baranik claimed that in its defense, Artists Space had "started to mobilize support within the culture of fashionable ennui, the modish New Right, the punk and brutality chic circles." Baranik had upped the ante on "brutality chic." It was now transformed into an art-world conspiracy. As Janet Koenig (which was a new name to me) put it: "In brutality chic social pathologies masquerade as new found virtues. Racism, sexism, poverty, social violence and repression emerge in glamorized form. Brutality chic is the cultural front of today's backlash." She was seconded by Alan Wallach, "The message [of Newman's drawings] to the art world is racism equates fashion and good taste." I could not imagine who Baranik, Koenig, and Wallach had in mind—certainly not anyone I knew.

Artists Space was defended by Laurie Anderson, Rosalind Krauss, Craig Owens, Douglas Crimp, Roberta Smith, and Stephen Koch who, in a letter, condemned racism but accused the Coalition of "exploiting this sensitive issue as a means of attracting attention." Moreover, the signers deplored the Coalition's attempts "to use government funding agencies as organs of censorship, their prolonged harassment of an extremely valuable and ethical arts organization, and their insensitivity to the complexities of both esthetics and politics." Owens attacked the real motives of the Coalition, which were "to cut off their funding! fire the director! censor the artist! Is it not ironic that those 'liberals' who in the sixties, when government support of the arts was hotly debated, warned against the danger of censorship, turn out to be precisely those who attempt to use the governmental agency as an instrument of repression?"

Helene Winer apologized for "this one event of misjudgment and insensitivity."

"It was not anticipated nor intended that the use of an acknowledged provocative term in this situation would be interpreted as a racist gesture. Artists Space made a commitment to the artist and his work and, as in other instances, respected his right to present the work unedited. Artists Space and the artist acknowledge that greater and different considerations should have been given to the title in this case. We made an error in assuming that this word could be legitimately used in an art context. In fact, it appears that to many its use is categorically unacceptable." The staff and board concluded that in the future, Artists Space would be more socially conscious and accountable.

Jim Reinish, Program Associate of the Visual Art Services of NYSCA, took an even-handed position in support of Artists Space, writing that its staff did not want to engage in censorship but that democracy had gone a bit too far this time. However, Artists Space barely survived what should have been treated as a naive or thoughtless error.

Newman's show was not the only controversy that confronted Artists Space. In the fall of 1989, Susan Wyatt, its director, asked photographer Nan Goldin to curate a show of works intended as a collective memorial to friends who died of AIDS. The show, titled *Witnesses: Against Our Vanishing*, received a $10,000 grant from the NEA. Wyatt was fearful that the topic, the works on view (several of nude males), and an essay in the catalog by David Wojnarowicz attacking Senators Jesse Helms and Al D'Amato, Congressman William Dannemeyer, and John Cardinal O'Connor might create problems for the NEA and forewarned it. At first the Endowment's chairman, John Frohnmayer, fearful of Senator Helms, tried to get Artists Space to return the grant voluntarily. When we refused, he canceled the grant. His reasons were that the Senate, prompted by Senator Helms, outlawed support of "obscenity" and that "a large portion of the [*Witnesses*] content was political rather than artistic in nature."

Not in Goldin's opinion: "I have asked each artist to select work that represents their personal responses to AIDS. . . . The focus of the responses vary: out of loss come memory pieces, tributes to friends and lovers who have died; out of anger come explorations of the political cause and effects of the disease. Some work concentrates on the continuum of daily life, relationships and sexuality under the shadow of AIDS, others on the physicality of the disease. . . . And some respond with work pertaining to death and the reclamation of the spirit."

In an editorial, *The New York Times* asked: "Are these images obscene? All that is shocking about an art show that focuses on AIDS . . . is the cruelty of the illness it reflects."

Within days after the cancelation, Artists Space received five unsolicited $10,000 contributions. Among the donors were Roy Lichtenstein, the Art Dealers

Association, and the Pace Gallery. Another thousand came from assorted individuals, including one of $10. PEN also condemned Frohnmayer's actions. Leonard Bernstein refused to go to the White House to receive a National Medal of Arts, embarrassing the President. What began as a low-keyed, elegiac show became an object of national concern. Susan Wyatt waged an inspired campaign on behalf of artistic freedom, compelling Frohnmayer to take notice. He accepted her invitation to meet with thirty-four artists at Artists Space. Their anger stunned him. It became clear to him that he had to choose between the art world and Senator Helms, and that as the chairman of the NEA, he could not afford to lose the support of his art constituency. On November 15, the day before the opening of *Witnesses*, Frohnmayer visited Artists Space again, and on the following day, on the advice of four members of his Art Council, issued a statement that he would release the grant "for the exhibition only," meaning, not for the catalog. *The New York Times* twitted Frohnmayer for his "fumble" but lauded him for climbing out of the hole he had dug.

In 1974, I was invited by the Baroness Minda de Gunzburg (née Bronfman), an heiress of the Seagram fortune, to be an advisor to a foundation she had formed called The Association for the Support and Diffusion of Art, or ASDA, and to organize art-related activities in Paris, New York, London, and Montreal. The other advisors were Maurice Tuchman of the Los Angeles County Museum, Michael Compton of the Tate Gallery, and painter Avigdor Arikha.

At an early meeting we discussed the Parisian art world, which still thought of itself as the center of international art but had actually become a backwater, out of touch with the liveliest artists and art-critical issues of the last quarter-century. We decided to remedy this situation by arranging a series of lectures in Paris in 1976 by leading non-French art world figures. Among the speakers we invited were John Golding, Clement Greenberg, Thomas Hess, Lucy Lippard, Linda Nochlin, and Robert Rosenblum. We were surprised by the success of our lectures; the audiences for each numbered around 1,000 persons.

At the beginning of 1978, the director of the Neuberger Museum at State University of New York at Purchase resigned, and an interim director was needed. President Michael Hammond asked me to fill the position. I agreed because I believed that the museum was critical to the college, and I could keep it on track. Besides, I thought it might be interesting to substitute administration for teaching for a while.

My primary mission as director would be to instruct the college and wider

community about the mission of the museum in order to enable the search committee to choose the best available new director. The issues were complicated. The Neuberger had four roles. Just under the size of the Whitney and designed by Philip Johnson, it was meant to be a national museum. It had to be the gallery of Purchase College, and it could not avoid serving as the art center for Westchester and surrounding counties. A forty-five minute car ride from Manhattan, it had a role to play in the art world there. How could it meet all of these challenges, some of them contradictory? For example, should the museum exhibit the work of faculty members who were fine teachers but indifferent artists, and/or students, high school teachers, amateurs, and other members of community arts organizations? If it showed local artists, the museum might serve the college and the community, but would that hurt its national profile?

In order to define the problems and to identify the kind of director who might best solve them, I organized a day-long conference aimed at educating the fifteen-person search committee, but I also invited college and art-conscious community leaders. As speakers, I chose Robert Buck, the director of the Albright-Knox Art Gallery; Thomas Leavitt, the director of the Herbert Johnson Museum of Art at Cornell University; Alan Shestack, the director of the Yale University Art Gallery, and Brian O'Doherty, the Program Director of Visual Arts of the National Endowment for the Arts.

The three museum men dealt with the multiple functions of their institutions as acquisitor, guardian, conservator, exhibitor, and educator. They agreed that the museum should foster and encourage the creation of current art, lest it become a "cemetery of culture." As a college museum, it had to assert its independence and prevent art history and studio departments from meddling in its affairs and turning it into a showcase for the faculty. Brian O'Doherty was delayed by NEA matters and came late. The blue jeans and work boots he wore raised eyebrows. He announced that the era of the museum was over. Aesthetic quality was a repressive idea. Asserting that the most vital art events were taking place in artists' spaces, he recommended that the museum commission artists to work at the Neuberger. To finance these projects, it should sell its permanent collection. The university museum should promote "risk." O'Doherty's comments were as shocking as his dress. Two decades later, Roy Neuberger, the museum's chief benefactor, would still shudder when O'Doherty's name came up.

It seemed to me that the museum could best serve the college by creating a national reputation for itself. After all, Purchase was SUNY's art campus, and the museum was the first building constructed—and I considered this indicative of the college's mission. My purpose, then, was to mount shows that would attract New York and national attention.

My first priority was to sort out staff problems I inherited. The museum had

become something of a snake pit, with the staff constantly squabbling. Aware of this feuding, the college's personnel officer decided that I needed his help. He began scheming with my people behind *my* back. I smelled a rat. Taking him aside, I told him that if he continued to mess with my staff, I would personally kick his bureaucratic ass. Nothing more was heard of him. My most difficult moment as director occurred during the installation of the Mary Frank show. I agreed to include 120 works, much too many, but I was too inexperienced to know that. We really should have accepted one-third less because, as clay sculptures, they were so fragile. The installation became so nerve-wracking that on some pretext the curator and other staff members walked out in the middle, and I was left to install it with student help. The show was a magnificent one. Much to my relief, none of the sculptures were damaged. On the whole, I managed the staff relatively well; I attributed this to my stint as a Marine Corps officer as well as my sense of humor and tough skin (although my annual medical examination that spring indicated increasing stress).

Throughout my tenure, the volunteers and the Friends of the Museum (who constituted a kind of museum board) provided useful advice and were wonderfully dedicated and supportive. I thought that fundraising would be the most difficult problem I would face. I was wrong. It quickly occurred to me that I was considered a distinguished professor, respected in the art world for my scholarship and activities on behalf of the artists' community. Potential donors looked up to me. All I had to do was outline a need clearly and simply ask for money—and miracle of miracles, they gave it to me.

Not all wealthy potential patrons were generous. At least one tried to rip off the museum. I discovered in my storeroom a considerable number of works owned by a private collector. I knew that it was common for museums to provide services for donors, but this person had given the museum nothing. I phoned him and suggested that it was time to offer us some of his works. After dragging his heels, he agreed, but only as long-time loans. I told him that that was not sufficient, we wanted gifts. Again he dragged his heels. I then found out that he had brought employees of Parke-Bernet and collectors to our storeroom with the intent of auctioning and selling works. I got furious; we were a public institution, not his place of business. It was costing us money and staff time to warehouse his stock. I would be damned if I was going to have our space used for private dealing. I sent him an ultimatum demanding that he remove his work from my museum and that he notify me immediately about arrangements. No response. I sent him another letter informing him that I was prepared to call the Attorney General and take legal action if no removal date was set. The next day I began to receive phone calls from prominent local citizens close to the museum, who demanded to know how I could treat one of their own in this unseemly fashion.

My proletarian roots kicked in; no money-grubbing bourgeois was going to push me around. I explained the situation to my callers and told them: "Either he moves his work out or I move it out, at his expense," and he did.

I found working as a museum director fascinating. As I reported to *The New York Times*, I enjoyed organizing exhibitions, dealing with staff, students, artists, and the public, and even fundraising and mickey-mouse administration. The entire day was full of challenging chores. But at the end of the day, I would look back with a hollow feeling. What had I accomplished? I had written nothing. When President Hammond asked me to stay on as permanent director, I was tempted, but after some agonizing, I refused. It was clear to me that my passion was to write about art. At a dinner party, Thomas Messer, the director of the Guggenheim Museum, mistakenly pressed me to tell him why I had taken the Neuberger position. After I had convinced him that I didn't want it, he seemed relieved. He said that if I were young and immature, he could understand my accepting a museum directorship. But given my experience of the art world, if I had accepted the position, I had to be crazy.

When the search committee was slow in coming to a decision on a new direc- tor, I urged them on by saying that I was leaving for London at the end of the semes- ter—regardless of whether a director was in place. For dramatic emphasis, I flour- ished my plane ticket. "See," I said, "the date on it is June first." The president of the Friends, Milton Rosenthal, the CEO of Englehardt, laughed and said: "I tear one of those up every other day." I left before the new director was decided upon.

What intrigued me most about my directorship was my association with Roy Neuberger, who was most supportive. I first met Roy in 1979, when he was eighty- two years old. I couldn't have guessed his age, such was his energy. Short and round, he did not look like the founder of a brokerage house which, when he was ninety, had 49 partners, 600 employees, and managed $25 billion. How Roy made money mystified me. Someone gave the museum some stock, which we asked Roy to sell for us. Months passed, and no sale. Then, the stock jumped suddenly and fell just as quickly, but at its height, Roy had unloaded it. "How did you know?" I asked. He smiled.

Roy was one of those rare collectors who was driven to buy art because of his love of it. What made him even more exceptional was his decision to acquire the art of living Americans, at a time when informed opinion generally accepted that significant contemporary art was made only in France. Neuberger not only col- lected for his own pleasure, edification, and self-definition, but also to help American artists, and to educate the American public, and especially, students, generously lending works to shows and donating them to college and university galleries. He has given the museum at SUNY Purchase more than 500 works, the largest single gift in the history of SUNY. In appreciation, the museum bears his

name. Roy and I became friendly. He was very impressed with the all-day confer-ence I organized and repeatedly praised me. He didn't mix in museum affairs, except to urge me to show neglected artists that he had collected, but he did not complain when I didn't.

---

In 1979, I was asked by Andrew Forge, the dean of the School of Art at Yale University, and Alan Shestack, the director of the Yale Art Gallery, to curate a show of prominent graduates. I decided to select 20 of some 800 former students from 1950 to 1970. Among them were Jennifer Bartlett, Chuck Close, Rackstraw Downes, Janet Fish, Nancy Graves, Eva Hesse, Robert and Sylvia Plimack Mangold, Brice Marden, and Richard Serra.

Forge planned to use the show at the museum to launch a fund-raising cam-paign. The idea seemed sound, but he did not take into account the self-admira-tion of Yale alumni. I ended up making some 780 enemies; as late as a decade later I would get dirty looks from people I'd never met. I did not have the heart to ask Forge how the campaign went.

---

In 1980, I was appointed as a trustee of the Mark Rothko Foundation. This came about as a result of the most notorious court case in the annals of the American art world. In his will, Rothko named as the executors of his estate three of his friends: Morton Levine, an anthropology professor, Theodoros Stamos, an abstract expressionist painter, and Bernard Reis, his accountant. Reis drew up the will, which left most of the works to the Mark Rothko Foundation and omit-ted mention of his daughter and son. At one point, the trustees of the Foundation decided that Rothko meant for the works to be sold and the pro-ceeds given to needy, older artists. They selected the Marlborough Gallery to do the selling. This surprised no one; Reis was employed by Marlborough, and the gallery shrewdly decided to represent Stamos, which put him under contract and under thumb. Within weeks of Rothko's death, the Foundation sold 100 paintings to the Marlborough Gallery at bargain prices and consigned to it 698 other works. The result of this step was to enrich Frank Lloyd, the gallery owner, and his cohorts.

Rumors of questionable dealing soon spread throughout the art world, and Herbert Ferber, the trustee for Rothko's children, blew the whistle. The upshot was a notorious court case, in which I was almost made a participant. At a dinner party given by Isabelle and Jerome Hyman I encountered Edward Ross, who was the attorney for Rothko's children. When he found out that I was an "expert" on the artist, he backed me into a corner and began to grill me, and then asked our

host for paper, not just any paper, but a yellow legal pad, in order to take notes. Ross told me that Peter Selz testified—at a hefty fee—that Rothko used cheap art materials, implying that he did not care much for his work. Not according to what I knew, I told Ross. He said that he would call me to testify. I told him not to bother. No matter what I said, Marlborough's lawyer would ask whether I was a friend of Rothko, and I would have to answer that I was just an acquaintance. What about Selz? He was a friend. That would be the end of any effect my testimony might have. I was not summoned.

Judge Millard Midonick, who presided over the case, decreed that five-ninths of the estate would go to the Foundation and the remainder to Rothko's children. The judge also punished the bad guys but only lightly. Stamos's house was taken away from him, but he retained a life interest in it. His career was in a shambles, partly because of his role as executor but mainly because his painting was second-rate. The Marlborough Gallery was kicked out of the Art Dealers Association. The judge also dismissed the Foundation's board and appointed new trustees of impeccable reputation; among them were Donald Blinken, Dorothy Miller, Gifford Phillips, Emily Rauh Pulitzer, and Jack Tworkov.

When Tworkov retired from the board, I was appointed to replace him. The continual problem we faced was deciding what to do with some 160 paintings from Rothko's mature period, 200 earlier "surrealist" works, and 690 miscellaneous items, including drawings, sketchbooks, and small studies. I suggested that we meet with leading art professionals and solicit their advice. The board agreed, and I invited museum directors Robert Buck (Albright-Knox Art Gallery), Martin Friedman (Walker Art Center), Henry Hopkins (San Francisco Art Museum), and Sherman Lee (Cleveland Art Museum). I also invited Arne Glimcher, the owner of the Pace Gallery, which represented the Rothko's estate, Professor Richard Turner, Director of New York University's Institute of Fine Arts, and Brian O'Doherty of the National Endowment for the Arts and a friend of Rothko's. We informed them that a number of Rothko's acquaintances believed that it was his intention upon his death to have his works sold and the proceeds to be spent helping older artists in need. However, there was nothing in his will to indicate this. If he said it, did he really mean it, or was it just cocktail party conversation? We were thinking that what Rothko really would have wanted was to use the works we received to promote the public appreciation of his art. What should we do? Lend or donate works to quality institutions? Organize exhibitions ourselves? Maintain a study resource for scholars? Our options were completely open.

I learned a great deal from our meetings. I always thought that when an artist died, supply was shut off, and consequently, the prices for his or her work would rise. The fewer works for sale, the higher the prices. Not so, said Arne Glimcher.

Market activity increases monetary value—major exhibitions, conspicuous prices, important collections. The higher the visibility, the higher the prices.

The interviewees told us that our foundation should be a model for other estates and that we ought to publicize our proceedings and decisions. We kept this very much in mind. The interviewees agreed that our primary function ought to be to preserve the works and place them in groups of three to ten in important museum collections in prominent cities, such as New York, Chicago, Los Angeles, and Paris—museums that had shown a commitment to Rothko's work or to contemporary American art. We knew that Rothko would have liked his works installed where they would make a strong impact, as they did at the Phillips Gallery in Washington or the Tate in London. The interviewees warned us against dealing Rothko's paintings out like playing cards; giving only one to an institution would be a bad policy. We were also advised to require museums to agree to certain conditions—above all, that pictures in ensembles be placed on view often and that the museum agree to restore works that needed it—but that we should also be flexible. It was further recommended that we organize one or two traveling shows.

In the end, we decided not to sell any works. We favored museums that had shown an interest in Rothko's painting while he was alive, and gave them clumps of his work. We also did this because many of Rothko's works in our possession were not of the highest quality and were only useful for study purposes. We wondered whether we could use our major pieces to protect the lesser ones. When the National Gallery of Art offered to create a study center and to become a clearinghouse for other museums, we readily accepted and gave it the bulk of the Foundation's pictures. We also made provisions for a catalogue raisonné, which was eventually executed by David Anfam and published under the auspices of the National Gallery. Moreover, money was provided for a book on Rothko's works in New York museums, an affirmation of his idea that he wanted his works considered in groups.

In 1981, we opened a state-of-the-art warehouse and study center to house our holdings. It needed a manager, and D. Roger Anthony was retained to do the job. Our interviewees had commented that the preservation and conservation of Rothko's paintings should be a primary concern of ours, and that, in the process of taking care of our own, we might foster the development of conservation in general. We were indeed aware that much of Rothko's work was disintegrating and that a great deal of restoration was necessary. Consequently, we hired Dana Cranmer as conservator. To undertake, encourage, and facilitate scholarship, we appointed Bonnie Clearwater as curator. As a critic-historian, a particular concern of mine was developing an archive on Rothko's life and art. I recommended to the Board that it fund a series of interviews with Rothko's friends and associates under the auspices of the Archives of American Art. I added that this should

be done as quickly as possible since we were racing with the Grim Reaper. The trustees agreed.

When the Foundation decided to dissolve, it still had approximately $250,000 in its account and five-ninths ownership of Stamos's house (after he died). What should we do with these assets? With the recommendations of some of Rothko's friends in mind, we resolved to use the funds to aid neglected and needy older artists, whose achievements had been ignored because of "the whims of fashion," as Brian O'Doherty said. I suggested that the left-over money be given to Artists Space to arrange shows of the works of overlooked older artists whose work merited such recognition. The Board agreed. The idea of exhibiting the works of our worthy elders was a common one in the art world, but the question of how to avoid the "loser" image soon arose—and that finished that. Artists Space solved the problem by showing the older artists with young unknowns, but gave them special catalogs. It worked, and for a period of time we made older neglected artists fashionable, so much so that other institutions, e.g., P.S. 1, organized geriatric exhibitions.

But what of the five-ninths of Stamos's house? What should we do with that? One trustee said: "Give it to a museum." Another said: "No museum would accept it, not with the artist's life interest in it." I said: "Why not give it to Artists Space?" It was agreed. Years later, Stamos died, and by then, the gift was forgotten by everyone but me. Our share turned out to be $800,000, which made Artists Space the only solvent alternative space I knew of in America. I was told later that the Attorney General questioned whether it was legal for a trustee on one not-for-profit organization to transfer its assets to another not-for-profit organization of which he was also a trustee. Was there a conflict of interest? The matter was dropped when it was revealed that I was not being paid by either.

One last note. Frank Lloyd was ordered by Judge Midonick to sponsor gallery visits by schoolchildren. He had the gall to name the program after himself. This so infuriated Donald Blinken that he protested to the judge, who made Lloyd replace his name with Rothko's.

––––––

In 1982, I was invited by Frank Hodsoll, the new chairman of the National Endowment for the Arts, to a think tank in Los Angeles. I joined some four dozen artists and art professionals around a large horseshoe-shaped table. None of us represented what one panelist called "the cookie and pattern constituency," to which another added "quiche and kitsch." We were each allotted three to five minutes to make a statement.

Hodsoll had gotten word to me that the Republican adminstration wanted to fund artistic "quality" but had no a clue as to how to identify or define it. He said

that this was a key issue facing the NEA, and he wanted me to deal with it. At the think tank, I said that it was difficult to ascertain aesthetic quality because there are no demonstrable criteria. We all aspire to it, but we cannot show that a work possesses it. There is nothing specific to which we can point. I then said that there was one feasible approach, at least with respect to contemporary art. At every moment there exists a loose consensus concerning what is the best in art, a consensus of those who care most about art and are most knowledgeable about it. The consensus consists primarily of artists, but also museum directors, curators, and trustees; art editors, critics, and historians; and dealers and collectors—most of whom listen closely to artists. Consequently, anyone who desires to determine quality in recent art, above and beyond one's personal taste, must gauge this consensus. It is the only reasonable "objective" guide we have. I concluded that this is precisely what the NEA did through its structure of peer panels, whereby leading practitioners in each discipline made the selection—painters chose painters, sculptors chose sculptors, and so on. Any other method would involve a tacit admission that persons other than artists know better about art and its quality. Thus, the NEA had already devised the best method of assuring the selection of the finest contemporary artists for its awards and commissions. I strongly urged that these procedures not be changed. If the machine works, don't fix it.

My talk apparently so impressed Hodsoll that he appointed me chairman of the Overview Committee of the Visual Arts. I was soon embroiled in a struggle over the fate of the Art Critics' Fellowships program. The neoconservatives attempted to eliminate the grants, but I soon recognized that their real agenda was the termination of the NEA. Art critics made good targets. They were not artists, and, as art professionals, had none of the prestige or institutional support of curators. In 1983, the NEA convened a two-day Visual Arts Criticism Seminar at its headquarters in Washington, which I chaired. Among the issues discussed were the differences between elitist and populist art criticism as well as the various functions of art criticism, among them, education, aid in the creation of art, the judge of quality, self-aggrandizement, reputation making, self-articulation, publicity and commercial promotion, the public advocate of the arts, audience and market development, and the criticism of criticism. Given the contribution of critics to the field of art, the participants concluded that the grants should continue.

Then Hilton Kramer, who had participated in the seminar, attacked our recommendation in an editorial in the *New Criterion*, and I knew the program was in jeopardy. The influence of Kramer within the NEA was pernicious. As the leading cultural spokesman for neoconservatism, his voice was powerful. His power was augmented by that of Samuel Lipman, the publisher of the *New Criterion*, who sat

on the National Council, and bully that he was, threw his considerable weight around. At one meeting of the Council to which I was invited, there was a *New Criterion* at the seat of every member. I was asked to give a two-minute report on the growth of the number of artists in the United States, the need for regional art centers, and alternative methods of exhibiting art. One minute into my talk, Lipman glared at me and blurted out: "Who invited this guy?" I sat down.

I spoke to a number of participants in the Art Criticism Seminar, and in a letter (January 6, 1985) to Benny Andrews, the head of the Visual Arts Division, I reported that we condemned Kramer's "breach of confidentiality and its potential danger to NEA procedures [and his] biased representation of what actually happened at the seminar, our discussion and recommendations."

I kept insisting to the Endowment's higher-ups that art criticism was vital to the well-being of American art because it informed the public about (often difficult) contemporary art. Yet critics were poorly paid, if at all, and scarcely recognized. They needed the NEA's support and encouragement, but its administrators weren't listening; they had received their agenda from Lipman and Kramer.

I then called a meeting at my apartment on May 1, 1985. Present were Elizabeth Baker of *Art in America*, Michael Brenson of *The New York Times*, Kay Larson of *New York*, Kim Levin of *The Village Voice*, Ingrid Sischy of *Artforum*, and Robert Storr. We wrote a letter to Hodsoll and the National Council members, and, at my suggestion, launched a nationwide campaign to save the critics' grants. Each of us would phone ten leading artists and art professionals and encourage them to send letters or mailograms to Hodsoll and to call on others to do likewise.

Letters flowed into Washington, but our efforts had no effect. The NEA's fellowships for art criticism were suspended in 1985 but came up for discussion at the National Council on the Arts. A voice in the wilderness, Raymond Learsy, asked that the suspension of the program be revoked. He fought hard for us, but was outgunned by Lipman and his supporters on the Council. Lipman's argument was that if the NEA was supporting art, it should not be supporting the public discussion of the art. Nor should it be subsidizing critics because the recipients might be critical of the Endowment's own activities. If there is any sense in this, I never could figure it out. I concluded that he had to invent some argument to kill the critics' grants. Finally, word came to me that our cause was lost and that anymore agitation on my part would lead to my dismissal from the Policy Committee. My days at the NEA were numbered.

In the wake of the controversies over the exhibition of Robert Mapplethorpe's and Andres Serrano's allegedly pornographic photographs, Kramer saw his chance to strike at what was most useful to living artists in the NEA, namely, the peer panel process. Kramer asserted that too many "dubious" NEA grants were going to radical artists because the panels that chose them were packed with their

comrades. The idea that fine artists knew best what fine art was, was an elitist idea, an idea that one thought Kramer as a champion of high art would endorse. But no, he asserted that the NEA must cease to be "a lobbying agency for special interest groups"—i.e., fine artists—and must "be accountable to the American people as a whole." What Kramer really had in mind was that the NEA, which he viewed "as a kind of licensing agent for social rebellion masquerading as artistic innovation," "should get out of the business of passing judgment on new art altogether." Instead, the NEA should support "the great institutions of art [to] make it, yes, more conservative." It was shameful that Kramer's dead hand weighed so heavily on living American art.

In the 1990s, the NEA became the butt of congressional abuse. The likes of Senator Jesse Helms condemned artists as irresponsible pornographers and what have you, and demanded that no government funds go to artists, period. Under threat, the NEA cut back on programs that might have created controversy, particularly grants to individual artists. I deplored this development. For the first quarter-century of the NEA's existence—through the presidencies of Kennedy, Johnson, Nixon, Ford, Carter, and Reagan—it provided artists with individual grants via peer panels. This, to me, was the most remarkable and innovative of the Endowment's programs. No more. I was also troubled because the United States became the butt of ridicule as the only major nation in the West that supported the arts in a stingy manner, and in whose highest legislative bodies artists were derided. Equally dispiriting was the damage done to American cultural life.

---

In November 1986, I was asked to appear before Senator Edward M. Kennedy's committee on copyright. I came prepared to lobby for the artists' right to copyright and to sue for the destruction and alteration of their work. I recalled that at a social gathering of a group of lawyers from a distinguished New York law firm, the topic of art and the law came up. I told of a case concerning a painting that won a prize in an exhibition. The owner, as well as the painter, claimed the prize money. I then asked who should have received it. The lawyers unanimously opted for the owner. After all, the picture was his property. Even after I pointed out that the prize was being awarded for the creation of the work, a few of the lawyers still held out for the collector. After all, he had the acumen to buy it.

Having made the point about the way in which ownership is prized in America, I went on to say that the artist and the public also had rights to a work of art. It is not just a piece of property, like a chair or a table, to do with as its owner would. It ought to possess the status of a dog or a cat, at least. We have laws prohibiting cruelty to animals. We ought to have laws prohibiting cruelty to art. I concluded by saying that an artist ought to have a residual right to his or her

work and that it was high time that federal law acknowledged that right.

Rosalind Krauss took an opposite tack, arguing for the right of art critics and historians to reproduce works of art without restriction. Critics' freedom of expression had to be safeguarded. Moreover, art-critical and historical publication would be curtailed. Krauss lost the case. I now believe that she was right. Short-sighted artists, and particularly their money-grubbing heirs, charged exorbitant prices to publish reproductions. Knowing that writers would have to cut back the number of illustrations, they still preferred cash in hand to the publicity that the publication of the work would bring about. Artists have also demanded to read and censor writers' texts before granting permission to publish illustrations. Museums, public as well as private, have viewed reproduction fees as a source of fund-raising, and many have become rapacious. One museum I approached demanded $200 for a black and white photo. I had to eliminate ten illustrations of works in its collection since that would have eaten up one-third of my budget for reproductions. The director protested that the publishers ought to pay, but I think he knew full well that they would not, given the relatively small readership of most serious art books and the cost of production. Museums that exploit scholarship ought to be ashamed of themselves. Kennedy's legislation badly hurt art critics and historians, and I regret the role I played

---

In 1985, Marie Walsh Sharpe, who had been a Gibson Girl, died at age ninety five. She played the stock market and dabbled in real estate. Having been successful at both, she left an estate of some $10,000,000. Her will stipulated that the money go toward the education of gifted high school students and to the aid of visual artists. She appointed Charles Hemmingsen and Joyce Robinson as her executors. After paying off a few relatives who suddenly appeared—laughing cousins, as they are known in the legal profession—Robinson and Hemmingsen set out to faithfully execute the will and established the Marie Walsh Sharpe Art Foundation.

Joyce set up two programs. One was an annual Summer Seminar during which high school juniors could work with professional artists. The other provided K-12 teachers with studios and living space during their summer vacation. But how should professional artists be assisted? Joyce asked Philip Pearlstein and Chuck Close. They suggested that she ask artists what their needs were. How was she to go about doing this? They told her to see me. I said that Philip, Chuck, and I would organize an all-day conference of visual artists known to be active in the affairs of artists. I made only one demand: that the proceedings be edited and published in order to be of use to other foundations.

On November 16, 1988, twenty-six artists of varied ages and reputations who worked in diverse styles met in Pearlstein's studio. Among them were Cynthia

Carlson, Close, Rafael Ferrer, Janet Fish, Elizabeth Murray, Pearlstein, Peter Plagens, Joel Shapiro, Harriet Shorr, Wayne Thiebaud, and Elyn Zimmerman. As the chairman, I introduced the meeting by saying: "It is my conviction, based on experience, that artists know best what the problems of artists are and can most imaginatively and effectively solve them. Also, all of you recall when and how outside help counted most in your own careers, and we would like to know about your experiences." I went on to say that the assembled artists would have to consider "the issue of priorities. How would you channel limited funds so that they would do the most good, that is, to use Buckminster Fuller's term, 'synergize resources'? Who gets funding and how, and who decides?"

Among the issues discussed were grant-giving in all of its aspects, the role of artists on foundation boards, health and housing, and the special problems of women and minority artists. Our proceedings were taped, edited, and published as *Roundtable Discussion on the Needs of Visual Artists*. The handbook made foundations, traditionally run by bureaucrats, sit up. Growing numbers began to include artists on their boards.

Joyce asked that Pearlstein, Close, and I set up an Artists Advisory Committee for the Sharpe Foundation. Reviewing the contributions of the participants in the Roundtable, we chose Carlson, Fish, Shorr, and Robert Storr, and later added Lorna Simpson. The committee devised three programs. The first was the Visual Artists Information Hotline. Begun in the fall of 1990, in cooperation with the American Council for the Arts, 1-800-ARTIST-HELP proposed to provide answers to any problem an artist had. During its first five years, it responded to calls from approximately 20,000 artists. Having established the Hotline, the Artists Advisory Committee suggested that another agency be found to administer it so that money could be freed up to fund other innovative programs that the Committee might devise. In fact, the Hotline was so successful that in 1996, it was transferred to the New York Foundation for the Arts and was funded by a consortium of fifteen foundations and private funders.

The Committee then confronted the artists' growing problem of finding affordable studios in New York. In 1991, we developed the Space Program (which we hoped other foundations would use as a model). Joyce found a large space in downtown Manhattan and had it subdivided into fourteen ample studios which were made available to artists free on a round-the-clock basis for up to a year. The participants were chosen by a rotating jury of artists from the roughly 800 applicants each year.

Then, in 2000, after eight successful years, the rent of the space jumped to a figure that the Sharpe Foundation could no longer afford. We tried to raise new funds but fell short of what we needed. *Art in America* published a short report of our plight, and an anonymous donor suddenly materialized and wrote a check for

$200,000 so that the program could continue for another three years. This was just the beginning of his largess. Visiting the studios, he decided that it would be nice if each of the participating artists that year received $10,000, and he wrote a check on the spot. Then, he provided the wherewithal to mount a show of all 163 artists, to publish a book-size catalog on their work, and to fund a lavish dinner in their honor. This took place in May 2002. The opening of the show attracted thousands of artists and their friends and turned out to be a major art-world event of the year. In organizing this show, we were amazed that of the 163 artists who were granted studios, two had died, and only one had stopped making art, choosing motherhood instead. Our juries had really chosen well. The one condition that our donor imposed was that he remain anonymous. I still don't know who he is.

Having established the Space Program, the Committee discussed the growing concern on the part of artists (particularly baby-boomers, who were now in their fifties) about what would happen to the acres of objects they had created after they died. As Harriet Shorr put it, "Dead artists leave two bodies, their own, and a body of work." To consider this issue, in April 1997 we convened a two-day conference of artists, lawyers, accountants, museum personnel, dealers, and others in the arts. Our mission was to walk artists through the problems of estate planning. Aware that the legal problems of artists' estates were in many respects different from other estates, we asked Barbara Hoffman to arrange for members of the Art Law Committee of the New York Bar Association, which she chaired, to deal with legal issues, but in language artists would understand. Our money was tight, but Harvey S. Shipley Miller, the trustee of the Judith Rothchild Foundation, generously offered to help fund our project. The upshot was *A Visual Artists Guide to Estate Planning.*

Then, in 2001, we decided that the art world had so changed since we held our first conference on the problems facing artists that it was time to do another. We invited thirty-two artists to meet at Artists Space. The publication of the proceedings, *On the Needs of Visual Artists: A Roundtable 2001*, appeared in the fall of 2002.

We New Yorkers were astonished that natives of Colorado, particularly religious and political conservatives, would listen to us, outré artists and liberals to boot—but Joyce Robinson and Charles Hemmingsen did. We marveled at their dedication in realizing the programs we suggested. They inspired us on the Artist Advisory Committee to do whatever we could to help them. The recent Roundtable has provided us with useful ideas for future programs.

---

What did my efforts on behalf of the art community mean to me personally? Philip Roth wrote of one of his characters in *American Pastoral:* "What was astonishing to him was how people seemed to ... turn into the sort of people they would once have felt sorry for." I knew exactly what Roth was talking about, and I determined never to let it happen to me.

# EPILOGUE

UNDERLYING MY ART

Underlying my art criticism and art history was a personal attitude. It amazes me that I have lived though the Great Depression, Stalinism, the gulags, Nazism, the Japanese rape of Nanking, the Holocaust, Pearl Harbor, World War II, Hiroshima and Nagasaki, the Cold War, the Korean War, the threat of atomic disaster, the Vietnam War, ethnic slaughter in Bosnia, Rwanda, and Kosovo, population explosion, starving millions whose deaths were avoidable, ecological devastation, and the destruction of the World Trade Center Towers—one damn thing after another! Raymond Aron once remarked that "Civilization is a thin membrane which a shock can easily tear open, and barbarism will surge through the rift." It has done so repeatedly in our savage century.

If the past has been awful, the future looks as if it will be even more wretched. An Indian acquaintance joked that in his country, whose population has passed the billion mark and whose poverty beggars the imagination, the difference between a pessimist and an optimist is that the pessimist says, things cannot get worse; the optimist responds, they will.

Where is meaning to be found? Is human nature inherently inhuman? Is barbarism our true condition? Are the likes of Auschwitz and Hiroshima to recur perpetually? When Gandhi was asked what he thought of Western civilization, he said it would be a good idea. (Not that Indian civilization has been any better.) Perhaps civilization is an impossible idea—and war, genocide, and dictatorship are our fate.

I have become increasingly pessimistic about the destiny of humanity. Existentialism was the fashionable "philosophy" after World War II, and it spoke to me—and, shorn of politics, it still does. So did artists such as Mark Rothko, Alberto Giacometti, and Samuel Beckett, who embraced a tragic view of life. They despaired, but not sufficiently to prevent them from creating a tragic art—in the case of Beckett, one with an ironic or comedic edge which lightens its hopelessness. I read Beckett's *Watt* in the middle 1950s, as did many of my artist friends, and recognized him as the true visionary poet of the twentieth century. No writer exposed our harrowing hell on earth, felt to the core of his being, with as much urgency and humor—and in such affecting prose. The absurdity of going on and the need to go on interminably even though humankind was incorrigible and life

was a cosmic joke. As Murphy's first line read: "The sun shone, having no alternative, on nothing new."

I often recoil from works of art that are perverse, absurdist, abject, or pathetic or that deal candidly with violence, torture, and despotic power—the performance artist Paul McCarthy comes to mind. But then, I turn back and look again, since when they are persuasive, they exemplify our post-Holocaust and post-Hiroshima experience and make of it something aesthetic, at once gripping and revealing. The content can be distasteful, even disgusting, but in order for an artist to have created it, he or she must have felt that the experience was worth expressing and possessed the conviction to do so. No matter how negative or even nihilistic the outlook, it requires optimism of sorts to construct a compelling form for it. Indeed, if absurdist art has any drama—I think of artist Bruce Nauman—it is in the tension between the pessimism, despair, or nihilism of its vision, on the one hand, and on the other, the optimism of its realization. Flaubert tried to write (as Courbet tried to paint) the mediocre beautifully. Is it also possible to make perversity or cruelty "beautiful"?

But I also find myself responding to art that aspires to express the old humanist verities—virtue, hope, faith, and beauty—art like that of Mark di Suvero or Al Held. Indeed, I cannot help being stirred by all art past or present that is heroic and optimistic, that transcends mundane existence and becomes self-transcendent. Some can even evoke the sublime. Since I have no faith in utopia and God, works that engender privileged moments, aesthetic epiphanies, will have to serve as substitutes.

If I believe that there is little hope for the future and that it will be a replay of the miserable past and present, how can I not lapse into apocalyptic despair or nihilism—or even contemplate suicide? I guess that part of me won't accept this melancholy vision. As for suicide, one wit quipped, there is no future in it. Except for a wretched period after the collapse of my early marriage, I have been temperamentally unable to be miserable for more than a few moments. I am occasionally and momentarily overcome by grief that seems to flit in and out of consciousness, but I am rarely depressed.

How to reconcile my negative outlook on the world and my positive one on my own life? Simply by separating the two. I believe that everyday life is self-sufficient and I am grateful for it, even though I know that it is ultimately meaningless. As Czeslaw Milosz has written: "To get up in the morning and go to work, to be bound to people by the ties of love, friendship, or opposition—and all the time to realize that it was only meanwhile and make-believe." A sense of humor helps. At times I doubt that life is really meaningless. It is ultimately too mysterious. May it not have some transcendent purpose? I cannot accept any dogma, religious or other, that purports to define it or offers a vision of a glorious future. And

I have no answers. But it is enough to be conscious of being alive—the wonder of it—and of the existence of the world. It makes sense to live in the prosaic present—with compassion and humor. And I discovered that meaningful work makes life less meaningless. I even wanted to change the world for the better, if only in a minor way, trying to help improve the condition of the visual arts and artists in America (and occasionally even abroad). And I did try.

As I complete this memoir in 2002 at age seventy-seven, my writing continues to absorb me. It has been my privilege to live the life of art and to work on behalf of art in the belief that it was worth living for—and was wonderfully stimulating as well. I've rarely been sick, and my health remains good. I've been happy in my marriage, and I assume that Lucy has been as well. Our daughter seems happy too and is successful in her career and marriage, and has given us a grandson. To sum it up, I have found a great deal to enjoy in my life. It has been interesting, or almost never boring, and, as I look back, it seems to me that with an element of luck, I negotiated it well, or rather, I avoided or shielded myself against most of the potential misfortunes that I could anticipate. "Negotiate" is the operative word.

To negotiate—to avoid extremes—is a bourgeois concept if there ever was one. Indeed, my way of living has been conventional. I sometimes wonder how my middle-class existence (at least, in the second half of my life) has shaped my mentality. Has it manifested itself in my taste for high culture? But at the same time, I have been attracted to the counterculture, though in art, not in life.

I do hope that I'll continue to be content at age eighty, if I live that long. But I think of death more and more. It's unavoidable, as friends die, and one's breath shortens and prostate enlarges. The world news never seems to get better, and it becomes monotonous too. Do I really care whether this or that politician gets elected or about who killed whom? Yes, but it is hard not to scorn all of humanity. And what of the God of love who will kill me—and everybody else? Will I look at the inch of my entries in a library card catalog or its internet equivalent with the same pleasure as I do now? Will posterity care? Will I continue to care about posterity? Or will I ask, as Groucho Marx did, what did posterity ever do for me?

# Sources

Many of the passages quoted in this memoir were jotted down in longhand. To reconstruct other conversations in this memoir I have relied on notes and audio tapes I made in the course of interviews or while attending lectures and panels. In a few cases I have relied only on my memory to reconstruct conversations and events. My original notes and audio tapes are now held in the Getty Archives. For sources not found in the list below, please refer to the notes that follow the list of sources.

INDIVIDUAL ARTISTS
ALBERS, Josef: Radio conversation. Early 1960s.
ANDRE, Carl: Conversation. September 23, 1978; Audio tape: March 9, 1982.
ANDREWS, Benny: Conversation. 1975.
AVERY, Milton: Conversation. undated.

BABER, Alice: Conversations (2): circa January 12, 1958 (group); March 28, 1958 (group).
BARTLETT, Jennifer: Audio tape. November 24, 1979 (3).
BAZIOTES, William: Conversation. May 28, 1958.
BLADEN, Ronald: Conversations (2). December 26, 1965; undated 1966.
BLUHM, Norman: Conversations (4): August 28, 1957; August 29, 1957 (group); August 30, 1957; September 10, 1960.
BRACH, Paul: Conversations (7): March 11, 1957 (group); June 3, 1957 (group); October 18, 1957; December 15, 1958; one in the late 1950s; May 5, 1962; April 12, 1966; Audio tape: November 20, 1976.
BRIGGS, Ernest: Conversation. Late 1950s.
BROOKS, James: Conversation. Fall 1962.
BULTMAN, Fritz: Conversation. Late 1950s or 1960s; January 6, 1968.
BURLIN, Paul: Conversation. 1960-61.
BUSA, Peter: Conversation. May 25, 1966.

CAJORI, Charles: Conversations (4): January 14, 1957; February 17, 1957; April 16, 1957; undated 1957.
CARONE, Nicholas: Conversation. June 18, 1958.
CHERRY, Herman: Conversations (3): June 3, 1957 (group); January 10, 1958; March 12, 1958.
CLOSE, Chuck: Audio tapes (4): November 30, 1979; May 7, 1981 (3 tapes).
CORVIELLO, Peter: Conversation. Summer 1961.
CRILE, Susan: Conversation. August 6, 1972.

DE KOONING, Elaine: Conversations (12): 6 in October 1956; January 22, 1958; May 21, 1958; two undated from late 1950s; November 2, 1965; undated.
DE KOONING, Willem: Conversations (4): April 25, 1957; January 10, 1958; February 19, 1958; June 16, 1959.
DENNY, Robin: Conversation. Summer 1961.
DILLER, Burgoyne: Conversations (2): June 30, 1959; early July 1959.
DINE, Jim: Conversation. Early 1960s.
DI SUVERO, Mark: Conversation. June 27, 1962: Audio tapes (3); November 5, 1985 (2); December 30, 1989.
DOWDEN, Ray: Conversation. June 3, 1957 (group).
DOWNES, Rackstraw: Audio tapes (2): February 1980; circa 1980.
DZUBAS, Friedel: Conversations (3): two on April 26, 1957; June 5, 1957.

ERNST, Jimmy: Conversations (2): 1960s.

FERBER, Herbert: Conversation. Late 1950s.
FERREN, John: Conversation. Circa May 21, 1958.
FISH, Janet: Audio tape. May 6, 1980 (2).
FORGE, Andrew: Audio tape. April 1980.
FRANKENTHALER, Helen: Conversation. May 24, 1973; Audio tape: May 24, 1973.
FRIEDBERG, Richard: Audio tapes. December 17,1978 (2); May 22, 1980.
FROMBOLUTI, Sideo: Conversation. March 21, 1958 (group).

GOLDBERG, Michael: Conversation. April 23, 1969.
GOLUB, Leon: Audio tape. October 28, 1994.
GORDIN, Sidney: Conversation. January 12, circa 1958 (group).
GOTTLIEB, Adolph: Conversations (2): mid-August 1957; August 15, 1957.
GRAVES, Nancy: Conversation. Undated; Audio tapes (2): 1979; circa 1980.
GREENE, Balcomb: Conversations (3): July 20, 1959; two undated.
GUSTON, Philip: Conversations (10): March 11, 1957 (group); April 1, 1957; June 3, 1957 (group); May 9, 1957; May 17, 1957; June 16, 1957; September 13, 1957; September 17, 1957; March 24, 1958; June 12, 1958; January 27, 1959.

HARE, David: Conversation. Late 1950s.
HARTIGAN, Grace: Conversation. January 14, 1974; Audio tapes (2): January 14, 1974, April 10, 1988.
HELD, Al: Conversation. September 19, 1976; Audio tapes (22): December 6, 1971; September, 12, 1976; October 29, 1978 (2); December 23, 1979; September 13, 1980; January 2, 1980 (2); April 17, 1980; December 24, 1981; January 29, 1983; February 13, 1983; March 1983 (2); March 5, 1983; March 6, 1983 (2); May 2, 1983; May 28, 1973; May 30, 1983; September 4, 1983; October 18, 1987.
HENDLER, Ray: Conversation. March 21, 1958 (group).
HILL, Anthony: Audio tape. Undated.
HOLTY, Carl: Conversations (2): June 10, 1965; January 2, 1967.
HOLTZMAN, Harry: Conversations (4): one in July 1958, October 12, 1958; two circa 1958.
HOPKINS, Budd: Conversation. March 21, 1958.
HOYLAND, John: Conversation. Summer 1961; Audio tape. July 16, 1980.
HUGHES, Malcolm: Conversation. August 1974; Audio tape. August 3, 1977 (2).

IPPOLITO, Angelo: Conversations (5): January 10, 1957; April 22, 1957; June 24, 1957; June 25, 1957; July 27, 1957.

JENSEN, Alfred: Conversation. March 21, 1957; Audio tape: no date.
JUDD, Donald: Audio tape: April 1987.

KAHN, Wolf: Conversation. March 6, 1969.
KALDIS, Aristodemos: Conversations (2): June 3, 1957 (group); August 14, 1957.
KANOWITZ, Howard: Audio tape. March 21, 1969.
KANTOR, Morris: Conversation. June 3, 1957 (group).
KAPROW, Allan: Conversation: undated; Audio tape: February 16, 1975.
KATZ, Alex: Conversations (6): February 4, 1957; February 18, 1957; September 17, 1974; 2 undated; March, 1959; November 6, 1970; Audio tapes (12): September 17, 1974 (2); February 20, 1976 (2); March 3, 1976; May 15, 1977; May 27, 1977; January 11, 1977; January 21, 1980 (3); April 24, 1996.
KIDNER, Michael: Audio tape: June 6, 1990.
KLINE, Franz: Conversations (2): March 11, 1957 (group); March 24, 1958.
KOHN, Gabriel: Conversations (2): circa 1957.
KRASNER, Lee: Conversation. July 8, 1958.

LASSAW, Ibram: Conversations (2): April 4, 1958; April 20, 1958.
LESLIE, Alfred: Conversation. Late 1950s.
LEWITIN, Landes: Conversations (10): March 24, 1957 (group); January 8, 1957; March 20, 1957; May 2, 1957; June 6, 1957 (group); August 26, 1957; August 29, 1957; August 29, 1957 (group); September 1, 1957; February 15, 1958.

LeWITT, Sol: Conversation. Mid 1960s; Audio tape: February 9, 1983 (2).
LUND, David: Conversations (2): Circa January 12, 1958 (group); 1958 (group).

McNEIL, George: Conversations (5): July 29, 1957; August 11, 1957; April 23, 1959; June 8, 1959; November 1959; Audio tape: November 14, 1990.
MANGOLD, Robert: Audio tape. Late 1970s or 1980s (2).
MANGOLD, Sylvia: Audio tape. April 2, 1980.
MARDEN, Brice: Audio tape. 1979.
MARSICANO, Nicholas: Conversations (5): March 14, 1957; March 24, 1957 (group); June 3, 1957 (group); March 7, 1958; March 30, 1958 (group).
MATTER, Mercedes: Conversations (2): June 3, 1957 (group); June 22, 1959.
MITCHELL, Joan: Conversations (7): January, 1956; February 18, 1957; February 20, 1957; February 27, 1957; March 14, 1957; March 21, 1957; undated.
MORRIS, Robert: January 30, 1966
MOTHERWELL, Robert: Conversations (8): July 13, 1957; July 16, 1957; July 22, 1957; August 8, 1957; August 16, 1957; April 26, 1960; September 24, 1965, November 4, 1965.

NEWMAN, Barnett: Conversations (2): Late 1950s; May 1962. 2 undated phone conversations.
NOLAND, Kenneth: Conversation. April 16, 1962.

OLDENBURG, Claes: Conversation. 1959.
ORTMAN, George: Conversation. March 17, 1957.
OSSORIO, Alfonso: Conversation. Late 1950s.

PACE, Steven: Conversation. June 3, 1957 (group).
PARKER, Raymond: Conversations (5): February 12, 1958; March 19, 1958; March 28, 1958 (group); June 1959; February 1961.
PASSLOF, Pat: Conversation. April 30, 1957.
PAVIA, Phillip: Conversations (3): late 1950s; January 19, 1957; October 16, 1965.
PEARLSTEIN, Philip: Conversation. February 10, 1957. Audio tapes (5): September 15, 1975; December 19, 1976; December 26, 1976; January 16, 1977; January 24, 1993.
PLUMB, John: Conversation. Summer 1961.
POLLOCK, Jackson: Conversation. March 1, 1972.

RESNICK, Milton: Conversations (14): January 7, 1957; January 10, 1957; March 24, 1957 (group); April 23, 1957; April 30, 1957; June 6, 1957; June 6, 1957 (group); July 20, 1957; January 30, 1958; March 2, 1958; March 7, 1958, undated, late 1950s; January 2, 1961; April 1965.
ROSATI, James: Conversation. Circa 1957.
ROTHKO, Mark: Conversations (5): September 22, 1960; 1964; December 1966; 2 undated.

SANDER, Ludwig: Conversations (3): 2 in late 1950s; April 22, 1957.
SCHAPIRO, Miriam: Audio tape: April 1990.
SCHNEEMANN, Carolee: Audio tape. Circa 1992.
SCHUELER, Jon: Conversation. late 1959.
SERRA, Richard: Audio tape. February 12, 1980 (2).
SLIVKA, David & Rose: Conversation. March 30, 1958 (group).
SMITH, David: Conversation. Early 1960s.
SMITH, Tony: Conversations (2): January 9, 1958; December 28, 1966.
SMITHSON, Robert: Audio tape: March 3, 1982.
SPAVENTA, George: Conversation. June 3, 1957 (group).
STAMOS, Theodoros: Taped conversation (undated)
STANKIEWICZ, Richard: Conversations (2): late 1950s; 1958 (group).
STEFANELLI, Joseph: Conversations (2): February 1957; May 2, 1957.
STELLA, Frank: Taped radio conversation. October 29, 1962.
STORR, Robert: Audio tape: May 4, 1989 (3).
STROUD, Peter: Conversation. Summer 1961.

SUGARMAN, George: Audio tapes (2): February 12, 1981; December 6, 1981.

TURNBULL, William: Conversation. Summer 1961.
TWORKOV, Jack: Conversations (6): August 11, 1957; August 15, 1957; 4 others, late 1950s.

VICENTE, Esteban: Conversations (3): January 21, 1957; February 21, 1957; May 9, 1957.

WOODRUFF, Hale: Conversation. November 4, 1965.

YAMIN, Alice: Conversation. 1950s.

ART CRITICS & ART PROFESSIONALS
ALLOWAY, Lawrence: Conversation. Summer 1961.

BARR, Margaret Scolari: Audio tapes. May 19, 1983 (2); May 26, 1983.
BAZIOTES, Ethel: Conversation. Circa 1965.

CAGE, John: Audio tape
CALAS, Nicolas: Conversation. Early 1960s.
CASTELLI, Leo: Conversations (2): February 23, 1957; undated (late 1950s or early 1960s); Audio tapes (2): December 2, 1978; December 21, 1978.

FRIED, Michael: Conversation: December 26, 1981; Audio tapes (2): December 26, 1980; December 26, 1980 (2)

GREENBERG, Clement: Conversations (2): January 13, 1958; September 15, 1959; Audio tape: undated.

HESS, Thomas: Conversation. Circa 1962.
HITCHCOCK, Henry-Russell: Audio tape. November 20, 1984 (2).

JOHNSON, Philip: Audio tape: January 1985.

KOZLOFF, Max: Audio tape. October 22, 1980 (3).
KRAUSS, Rosalind: Audio tape: September 26, 1980.

LEIDER, Philip: Conversation. February 27, 1981; Audio tape: February 27, 1981.
LIPPARD, Lucy: Conversation. October 30, 1980; Audio tape: October 30, 1980.

NAVARETTA, E. A.: Conversation. Late 1950s.
NEUBERGER, Roy: Audio tapes (8): March 3, 1992; March 31, 1992; May 12, 1992 (2); November 25, 1992 (2); December 12, 1992; December 29, 1992.
O'DOHERTY, Brian: Conversations (3): March 9, 1981; April 11, 1981; undated; Audio tape: April 17, 1981 (3).
PLAGENS, Peter: Audio tapes (2): January 19, 1990 (2); October 16, 1990 (2).

ROSE, Barbara: Audio tape: April, 1983. (N/A)
ROSENBERG, Harold: Conversation. 1956 or 1957.

SCHAPIRO, Meyer: Conversations (2): November 26, 1984; undated.

WINER, Helene: Conversation. 1980s; Audio tape. Circa 1992 (2).

# Endnotes

## PREFACE

P. 7.   "a kind of Boswell": George McCue, "New York Critic on 'Pop' Painting," *St. Louis Sunday Post Dispatch*, March 3, 1963, p. 5.

P. 7.   "the balayeur des artistes": Frank O'Hara, "Adieu to Norman,/Bonjour to Joan and Jean-Paul," from *The Collected Poems of Frank O'Hara* (New York: Alfred A. Knopf, 1971), © by Maureen Granville-Smith.

P. 8.   "moments of being": Virginia Woolf, "A Sketch of the Past," *Moments of Being: Unpublished Autobiographical Writings of Virginia Woolf* (Sussex: The University Press, 1976), p. 71.

## 1. STUMBLING UPON A VOCATION

P. 11.   "those who": Isaiah Berlin, *Personal Impressions* (London: Hogarth Press, 1981), p. xxiii.

P. 13.   "the public extension": Irving Sandler, Statement, Tanager Gallery (New York: Tanager Gallery, 1959), n.p.

P. 14.   "One need never": Frank O'Hara, "Meditations in an Emergency," from *The Collected Poems of Frank O'Hara* (New York: Alfred A. Knopf, 1971), © by Maureen Granville-Smith.

P. 15.   Years later: Irving Sandler, "Provincetown in the Fifties: A Memoir," *The Sun Gallery* (Provincetown: Mass.: Provincetown Art Association and Museum, 1981), pp, 5-8.

P. 19.   "Here is": Czeslaw Milosz, "A Pact," trans. Czeslaw Milosz and Robert Haas, *The New Yorker*, June 1, 1998, p. 40.

P. 20.   "One must live": Gustave Flaubert, "to Louise Colet, 1853," in Francis Steegmuller, ed. and trans., *The Selected Letters of Gustave Flaubert* (New York: Farrar, Straus & Cudahy, 1953), p. 161.

## 2. THE ART WORLD IN THE 1950s

Material in this chapter, much revised, appeared in Irving Sandler, "The Club: How the artists of the New York School found their first audience–themselves," in *Artforum*, September 1965, pp. 27-31.

P. 21.   "the dream": Frank O'Hara, "A Memoir," in Sam Hunter, *Larry Rivers* (New York: Harry N. Abrams, 1969), pp. 51-52.

P. 22.   "Then there was": O'Hara, "A Memoir," pp. 51-52.

P. 23.   "What really matters": Morton Feldman, "Frank O'Hara: Lost Times and Future Hopes," *Art in America*, March-April 1972, p. 51.

P. 23.   "Somehow we all": Joel Oppenheimer, "Good-bye to Big John," *The Village Voice*, October 3, 1977, p. 8.

P. 26.   "a spontaneous": "The Subjects of the Artist: A New Art School," Catalog for 1948-49, printed page.

P. 27.   "These meetings": Robert Goodnough, ed., Introduction, "Artists' Sessions at Studio 35 (1950)" *Modern Artists in America* (New York: Wittenborn Schultz, 1951), p. 9.

P. 28.   "choice of jurors": The letter was reprinted in Weldon Kees, "Art," *The Nation*, June 3, 1950, p. 557. The Irascible 18 were William Baziotes, James Brooks, Fritz Bultman, Jimmy Ernst, Adolph Gottlieb, Hans Hofmann, Weldon Kees, Willem de Kooning, Robert Motherwell, Barnett Newman, Jackson Pollock, Richard Pousette-Dart, Ad Reinhardt, Mark Rothko, Theodoros Stamos, Hedda Sterne, Clyfford Still, and Bradley Walker Tomlin.

P. 29.   "the most acceptable": Goodnough, ed., "Artists' Sessions at Studio 35," pp. 17, 22.

P. 29.   "the continuing validity": James S. Plaut, Frederick S. Wight, René d'Harnoncourt, Alfred H. Barr, Jr., Andrew C. Ritchie, Hermon More, and Lloyd Goodrich, "A Statement on Modern Art," by the Institute of Contemporary Art, Boston; the Museum of Modern Art, New York; and the Whitney Museum of American Art, New York, March 1950, n.p.

P. 29.   A significant: The abstract expressionists also received growing recognition from the Museum of Modern Art in such shows as *Abstract Painting and Sculpture in America*, 1951, and *Fifteen Americans*, 1952. In 1950, *Art News*, whose managing editor was Thomas B. Hess, began to publish articles on the New York school and in the following year, his seminal book, *Abstract Painting:Background and American Phase* (New York: Viking Press, 1951), was published.

P. 31.   "these highly individualistic": P. G. Pavia, "The Unwanted Title: Abstract Expressionism," *It Is* 5, Spring 1960, p. 9.

P. 33.   "I think": Goodnough, ed., "Artists' Sessions at Studio 35," p. 10.

P. 33.   "The Unwanted Title": Pavia, "The Unwanted Title . . .," p. 8.

P. 34.   "The proceedings": Robert Goldwater, "Everyone knew what everyone else meant," *It Is* 4, Autumn 1959, p. 35.

P. 34.   "The consciousness": See Robert Goldwater, "Reflections on the New York School," *Quadrum* VIII, 1960.

P. 34–35.   "Since the artist": Goldwater, "Reflections on the New York School," p. 30.

P. 35.   "The Club is": Jack Tworkov, "Four Excerpts from a Journal," *It Is* 4. Autumn 1959, p. 12.

P. 36.   "The club was": Larry Rivers, *What Did I Do?* (New York: Harper Collins, 1992), pp. 280-284.

P. 37.   "Here it is": John Gruen, *The Party's Over Now* (New York: Viking Press, 1972), p. 215.

P. 44.   "staid, conservative": G. L., "10th St.: Main Street of the Art World," *Esquire*, September 1959, pp. 110-111.

## 3. MY PANTHEON

P. 46.   "a sense of": William Barrett, *Irrational Man* (New York: Anchor Books; Doubleday, 1958), p. 31.

P. 46.   "The Greek": See Irving Sandler, "Conversations with de Kooning", *Art Journal*, Fall 1989, pp. 216-17.

P. 46.   "Nobody owes": Conversations with Alice Yamin in New York, middle 1950s.

P. 47.   "That's different": Morton Feldman, in B. H. Friedman, ed, *Give My Regards to Eighth Street: Collected Writings of Morton Feldman* (Cambridge, Mass.: Exact Change, 2000), p. 53.

P. 47.   "a painter is great": Peter Plagens, panel at the Metropolitan Museum of Art, October 15, 1997.

P. 47.   "on paintings": Harold Rosenberg, *The Anxious Object* (Chicago and London: University of Chicago Press, 1964), p. 111.

P. 47.   "way of living": Willem de Kooning, "What Abstract Art Means to Me," *Museum of Modern Art Bulletin*, Spring 1951, p. 7.

P. 48.   "Bill structured": Wayne Thiebaud, panel at the Metropolitan Museum of Art, October 15, 1997.

P. 48.   "always thinking": Willem de Kooning, in William C. Seitz, *Abstract Expressionist Painting in America* (Ph.D. dissertation, Princeton University, 1955), pp. 319-20.

P. 48.   "torn-meat abstractions": Peter Plagens, panel at the Metropolitan Museum of Art, October 15, 1997.

P. 48.   "Byrd without": Feldman, in Friedman ed., *Give My Regards to Eighth Street*, p. 17.

P. 49.   "You could learn": Robert Storr, panel at the Metropolitan Museum of Art, October 15, 1997.

P. 49.   "he didn't worry": Robert Rauschenberg, Statement, *Art Journal*, Fall 1989, p. 232.

P. 49.   "Bill was": Wayne Thiebaud, panel at the Metropolitan Museum of Art, October 15, 1997.

P. 49.   "Bill was very": Elaine de Kooning, in *The Spirit of Abstract Expressionism: Selected Writing*, edited by Rose Slivka (New York: George Braziller, 1993), p. 228.

P. 49.   I often: The dates of my de Kooning interviews are April 25, 1957, and June 16, 1959. Excerpts appear in Sandler, "Conversations with de Kooning," pp. 216-217. The quotes here are from these interviews.

P. 51.   "It was early": Peter Schjeldahl, "Blue Stroke: Willem de Kooning 1904-1997," *The Village Voice*, April 8, 1997, p. 93.

P. 53.   "I lost it": See Irving Sandler, "Willem de Kooning: 1904-1997," *Art in America*, May 1997, p. 29.

P. 54.   "It's a certain": Sarah Boxer, ed., "Word for Word/Willem de Kooning," *The New York Times*, March 23, 1997, section 4, p. 7.

P. 55.   "[She] knew": Frank O'Hara, "A Memoir," in Sam Hunter, *Larry Rivers* (New York: Harry N. Abrams, 1971), p. 52.

P. 56.   "I remain uneasy": Irving Sandler, "Reviews: New York: Willem de Kooning," *Artforum*, Summer 1978, p. 64.

P. 57.   "Old man's painting": Robert Storr, panel at the Metropolitan Museum of Art, October 15, 1997.

P. 57.   When Elizabeth Baker: See Sandler, "Willem de Kooning," p. 29.

P. 57.   "He liked beer": Harry F. Gaugh, "Franz Kline's Romantic Abstraction," *Artforum*, Summer 1975, p. 28.

P. 58.   From 1948: Conversations with Alice Yamin in New York, middle 1950s, and April Kingsley, undated.

P. 59.   "the bulk": Elaine de Kooning, "Two Americans in Action: Franz Kline/Mark Rothko," *Art News Annual*, No. 27, Part II, November 1957. p. 179.

P. 59.   "Hell, half": Frank O'Hara, "Franz Kline Talking," *Evergreen Review*, Autumn 1958, reprinted in Frank O'Hara, *Standing Still and Walking in New York* (Bolinas, Calif.: Grey Fox Press, 1975), p. 94.

P. 59.   "To think": Seldon Rodman, *Conversations with Artists* (New York: Devin-Adair, 1957), p. 109.

P. 59.   Indeed, only:  Frank O'Hara, "Franz Kline Talking."

P. 60.   "Hell they don't": David Sylvester, "Franz Kline 1910-1962: An Interview with David Sylvester, *Living Arts* 1 (London), 1963, p. 10.

P. 62.   Such were art-world: Irving Sandler, "Guston: A Long Voyage Home," *Art News*, December 1959, pp. 36-39, 64-65.

P. 62.   "I do not think": Philip Guston, "Faith, Hope and Possibility", *Art News Annual*, no. I, October 1965, pp. 102-3, 152-53.

P. 62.   "no matter how perverse": Philip Guston, lecture on "The Muse of Painting" at the University of Minnesota, 1954; handwritten notes.

P. 62.   "I must live": Guston, "The Muse of Painting," n.p.

P. 62.   "the moment and": Philip Guston, Statement, *Nature in Abstraction*, Whitney Museum of American Art, 1958.

P. 62.   "With a so-so": Guston, "The Muse of Painting," n.p.

P. 64.   "significant resemblances": Irving Sandler, "Guston: A Long Voyage Home," pp. 37-38.

P. 65.   "'Gustonesque' now": Peter Schjeldahl, *The 7 Days Columns: 1988-1990* (Great Barrington, Mass.: The Figures, 1990), p. 51.

P. 66.   "Only that subject": Adolph Gottlieb and Mark Rothko (in collaboration with Barnett Newman), "Letter to the Editor," *The New York Times*, June 13 1943, section 2, p. 9.

P. 68.   "There are no": Nietzsche, notebook fragment, cited in John Sallis, *Crossings: Nietzsche and the Space of Tragedy* (Chicago: University of Chicago Press, 1991), p. 37.

P. 68.   When Greenberg: Clement Greenberg, "American-Type Painting," *Art and Culture* (Boston: Beacon Press, 1961), p. 225. This comment does not appear in Greenberg's original article, "'American-type' Painting" (*Partisan Review*, Spring 1955).

P. 68.   "I curse God": Katharine Kuh, handwritten notes of an interview with Mark Rothko c. 1961, in Katherine Kuh Papers, Archives of American Art, New York, reel 2226, frame 1333.

P. 70.   If he were alive: The material on Reinhardt, much revised, is culled from Irving Sandler, "Ad Reinhardt: The Purist Blacklash," *Artforum*, December 1966.

P. 71.   "What's wrong": "Report from the Club," *Scrap* 8, June 14, 1962, p. 5. Reinhardt was referring to Larry Rivers' portrait of Frank O'Hara.

P. 72.   "To be right": Frank O'Hara, "Franz Kline Talking," *Evergreen Review*, Autumn 1958, reprinted in Donald Allen, ed., *Frank O'Hara: Standing Still and Walking in New York* (Bolinas, Calif.: Grey Fox Press, 1975), p. 94.

P. 72.   "I am nature": Ad Reinhardt, "44 Titles for Articles for Artists under 45," *It Is* 1, Spring 1958, pp. 22-23.

P. 72.   "There is no such thing": Ad Reinhardt, "Documents of Modern Art . . . " *Pax*, number 13, 1960, n.p.

P. 72.   "If any paint": Elaine de Kooning, "Pure Paints a Picture," *Art News*, Summer 1957, pp. 57, 86-87.

P. 73.   "pin-up boys": Elaine de Kooning, "A Cahier Leaf," *It Is* 1, Spring 1958, p. 19

P. 73.   "When one excludes": See P.G. Pavia and Irving Sandler, eds., "The Philadelphia Panel," *It Is* 5, Spring 1960, pp. 34-38.

P. 74.   "color symbolism": Margit Rowell, *Ad Reinhardt and Color* (New York: Solomon R. Guggenheim Museum, 1980), p. 24.

P. 75.   As Ad saw it: I think Lucy R. Lippard said this first.

P. 75.   "Kootz-and-Janis Kids": Reinhardt titled his talk at The Club on March 29, 1960, "The Kootz-and-Janis Kids, Momaism (Mus. of Mod. Art) & Pop-abstraction." Extra 1,000 slides.

P. 77.   "He can't play": Frank Stella, "On Reinhardt," *Straight*, vol. 1. no.1, n.p.

P. 78.   "blacksmith artist": Irving Sandler, *Mark di Suvero at Storm King Art Center* (New York: Harry N. Abrams, 1995), p. 24.

P. 78.   In 1998: Irving Sandler, "A Memoir," The Fields of David Smith (Mountainville, New York: Thames & Hudson, 1999).

P. 79.   "The metal itself": David Smith, "The New Sculpture," ed. in Garnett McCoy, a paper given at a symposium on "The New Sculpture" at the Museum of Modern Art, February 21, 1952. ed., David Smith(New York: Praeger, 1973), p. 84.

P. 80.   I covered: I[rving]. H. S[andler]., "Reviews and Previews: David Smith." Art News, September 1959, p. 9.

P. 80.   "I polished": Thomas B. Hess, "An Interview with David Smith, June, 1964" (New York: Marlborough-Gerson Gallery, October 1964), n.p.

P. 80.   "My sculpture": David Sylvester, "David Smith: Interviewed by David Sylvester," *Living Arts* 3, April 1964, p. 5.

P. 80.   "I've been painting": Hess, "An Interview with David Smith," n.p.

P. 81.   "the unspoiled": S[andler]. "Reviews and Previews: David Smith," p. 9.

P. 81.   "a new man": Quoted in Harold Rosenberg, *Tradition of the New* (New York: Horizon Press, 1959), p. 13.

P. 81.   It was as if: See Leo Marx, *The Machine in the Garden: Technology and the Pastoral Ideal in America* (London, Oxford, New York: Oxford University Press, 1964).

P. 82.   "when artists think": Debbi Snook, "Bringing the Sculpture to the Mountain," *Times Union* (Albany, N. Y.), Sunday, July 29, 1979, p. 1.

P. 82.   Or as John Ashbery: John Ashbery, "Art: Telling It on the Mountain," *New York*, August 27, 1979, p. 83.

P. 82.   We also published: Irving Sandler, Introduction, *Prospect Mountain Sculpture Show: An Homage to David Smith* (Lake George, N. Y.: Lake George Art Project, Inc., 1979). The catalog also included a Foreword by Beth T. Rowe and "Reminiscences" by Dorothy De hner.

P. 82.   "stimulated an interest": David Sylvester, transcript of a tape-recorded interview with David Smith, June 16, 1964, in McCoy, ed., David Smith, p. 169.

P. 83.   "for the first": Sylvester, "David Smith: Interviewed ...," p. 5.

P. 83.   "work of these": Ashbery, "Art: Telling It on the Mountain," p. 84.

P. 84.   "The secret": In David Smith papers, Archives of American Art.

## 4. MORE FIRST GENERATION ARTISTS WHO INSPIRED ME

P. 85.   "Long live": Hans Hofmann, lecture, July 3, 1949. In Rosalind Browne, "Art World Eyes Forum 49 Program of Abstract Work and Discussions," *Provincetown Advocate*, July 7, 1949.

P. 86.   "His charisma": Irving Sandler, "Hans Hofmann: The Pedagogical Master," *Art in America*, May 1973, p. 52.

P. 87.   "They see": Thomas B. Hess, "Hans Hofmann: The Last Optimist," *The New York Times*, Sunday, February 27 1966, section 2, p. 24.

P. 87.   "appears to be": Jack Kroll, "Old Man Crazy About Painting," *Newsweek*, September 16, 1963, p. 88.

P. 87.   "One would be": William Seitz, *Hans Hofmann*, (New York: Museum of Modern Art, 1963), p. 7.

P. 87.   "No wonder": Hess, "Hans Hofmann: The Last Optimist."

P. 87.   For example, Frank: Frank Stella, "The Artist of the Century," *American Heritage*, November 1999, pp. 14,17.

P. 89.   "his living room": Mark Rothko, "Commemorative Essay," delivered at the New York Society for Ethical Culture, January 7, 1965.

P. 92.   "the baby-faced killer": Conversation with John Ferren in New York, 1958.

P. 92.   "with Joseph Cornell": Robert Motherwell, in *Bradley Walker Tomlin* (New York: Whitney Museum of American Art, 1957), p. 11.

P. 92.   So was Bob's: Motherwell, *Bradley Walker Tomlin*, pp. 11-12.

P. 92. and in 1978: See Terence Maloon, "Robert Motherwell: An Interview," *Artscribe*, April 1978, pp. 17-21.

P. 95. "And the artist today": Ti-Grace Sharpless, *Clyfford Still* (Philadelphia, Pa.: Institute of Contemporary Art, University of Pennsylvania, 1963,) n.p.

P. 96. "Still feels": "Clyfford Still," *Magazine of Art*, No. 3, March 1948, p. 96.

P. 97. "the first painting": "Interview with Emile de Antonio," John P. O'Neill, ed., in *Barnett Newman: Selected Writings and Interviews.* (New York: Alfred A. Knopf, 1990), The dates of Newman's paintings are suspect, as are Still's, except that Still's were exhibited and reproduced with a greater frequency than Newman's. Karen Wilken, in "Abstract Expressionism Revisited," *The New Criterion*, February 1991, p. 32, wrote that Newman was "reported to have painted, after the fact, a series of 'missing-link' pictures to fill a gap of several years in his working life."

P. 97. The picture is composed: *Tiger's Eye*, October 15, 1949.

P. 98. He later painted: Gottlieb, an old friend of Newman's, reported that his chronology was "fraudulent. Newman began to sketch around 1945 but didn't really paint until 1948. He painted his first one-man show in a year."

P. 102. "brains hamper": John Ferren, Statement, "Is There a New Academy?" *Art News*, September 1959, p. 58.

P. 102. "controlled and intellectual": I[rving]. H. S[andler]., "John Ferren," *Art News*, November 1958, p. 14.

P. 108. "a cult of bewilderment": Boston's Institute of Modern Art's statement was issued on February 17, 1948. On March 21, Boston's Modern Artists Group called a protest meeting and some 300 people attended and called for the Institute to retract its statement. Then Paul Burlin in New York proposed to continue the attack and invited a group of artists who met at Stuart Davis's studio. The group arranged a meeting at the Museum of Modern Art on May 6, 1948.

5. ART CRITICISM: APPRENTICE YEARS

P. 112. "what was new": Linda Nochlin, "The Necessity of Criticism," convocation address, American section, International Art Critics Association, conference at the Solomon R. Guggenheim Museum, New York City, February 15, 1983; handwritten notes.

P. 112. "The world is fond": Honore de Balzac, *Cousin Bette*, translated by Kathleen Raine, introduction by Francine Prose (New York: Modern Library, 2002), p. 214.

P. 114. "mere textural novelty": Statement, *Reality* 1, Spring 1953, p. 1.

P. 114. "belongs among": I[rving]. S[andler]., "Reviews and Previews: George Morrison," *Art News*, February 1957, p. 10.

P. 114. "The bold action": I[rving]. S[andler]., "Reviews and Previews: Gerhard Schneider," *Art News*, March 1957, p. 58.

P. 114. "one of America's": I[rving]. S[andler]., "Reviews and Previews: Joan Mitchell," *Art News*, March 1957, p. 32.

P. 117. What meaning do they find: Irving Sandler, "The People's Car Drives Art to the People," *Art News*, Summer 1961, pp. 42, 59-60.

P. 118. "Your pen": *Paragon: A Comparison of the Arts by Leonardo da Vinci*, edited and translated by Irma A. Richter (Oxford, England: Oxford University Press, 1959), quoted in E.H. Gombrich, "Portrait of the Artist as a Paradox," *The New York Review*, January 20, 2000, p. 8.

P. 121. "the truly traditional": Irving Sandler, notes of an interview with Lewitin for statement "Is the artist for or against the past?" in *Art News*, Summer and September 1958.

P. 123. Lewitin gave me: Theodore L. Shaw, *Art at a Price: A New Approach to Aesthetics* (New York: Richard R. Smith, 1942), p. 31.

P. 123. "a perfectly realized": Hilton Kramer, "Art Critics as Artists? Better Keep Your Day Jobs, Boys," *The New York Observer*, April 17, 1995, p. 19.

P. 125. "Modern art": Alfred H. Barr, Jr., *Introduction to Paintings from the Museum of Modern Art* (New York: Museum of Modern Art, 1956), n.p.

P. 125. "To rebel": B. H. Friedman, *Give My Regards to Broadway: Collected Writings of Morton Feldman* (Cambridge, Mass.: Exact Change, 2000), p. 22.

P. 125. Younger gay: In Barr's circle, a group of younger Harvard graduates interested in modern art founded the Harvard Society for Contemporary Art. Among them were Edward M. M. Warburg and Lincoln Kirstein, who went on to found the School of American Ballet in 1934 and brought Georges Balanchine to America; MoMA's librarian, Iris Barry; Agnes Rindge; John McAndrew; A. Everett "Chick" Austin. Walker Evans was brought into the Barr circle by Kirstein, who was his passionate promoter. These friends met at the house of Kirk and Constance Agnew and the Agnew Gallery, at the Julian Levy Gallery, and occasionally at the Pierre Matisse Gallery.

P. 126. "culture depended": Alfred H. Barr, Jr., "Museum," *Charm*, November 1929, p. 15.

P. 127. "a sinister effect": W. McNeil Lowry, "Profiles: Conversations with Kirstein--II," *The New Yorker*, December 22, 1986, p. 55.

P. 127. "Modern art": W. McNeil Lowry, "Profiles: Conversations with Lincoln Kirstein, Part 1" *The New Yorker*, December 15, 1986, p. 57.

P. 127. "they're not educated": Lowry, "Profiles: Conversations with Lincoln Kirstein, Part 1," p. 61.

P. 127. Barr was his mentor: Franze Schulze, in *Philip Johnson: Life and Work* (New York: Alfred A. Knopf, 1994), p. 47, wrote: "Philip's personal history, together with the fact that Barr was a bachelor at the time they met, are enough to arouse the suspicion that a sexual magnetism was also at work between them. There is no known evidence that it ever existed, either overtly or covertly. In fact, Philip, who in his mature years discussed his various liaisons with disarming and often sardonicfrankness, spoke of Barr as he spoke of no one else, with a memorably guile-less affection. Heclaimed he was never moved to touch Barr, who, reverently or no, less than a year after their meeting married a woman to whom he appears to have been true his entire life and who in her own right became one of Philip's closest friends and companions."

P. 128. "a stirring spectacle": See Schulze, *Philip Johnson*, pp. 129, 151-155.

P. 128. "Every young man": Calvin Tomkins, "Profiles: Forms Under Light," *The New Yorker*, May 23, 1977, p. 46.

P. 128. "most influential architect": Diana Ketcham, "'I am a whore': Philip Johnson at Eighty," *The New Criterion*, December 1986, p. 58.

P. 129. When Blunt's cover: John Bayley, "The Double Life," *The New York Review of Books*, May 29, 1997, pp. 17-18.

## 6. MY PALS IN THE 1950S

P. 132. "people who want": Bruce Glaser, interviewer, and Lucy R. Lippard, ed., "Questions to Stella and Judd," *Art News*, September 1966, p. 58.

P. 133. "In fact": Clement Greenberg, "Abstract and Representational," *Art Digest*, November 1, 1954, p. 7.

P. 134. Whether they were painted: Material on Alex Katz, much revised, is culled from Irving

Sandler, *Alex Katz* (New York: Harry N. Abrams, 1979), *Alex Katz 1957-1959* (New York: Robert Miller Gallery, 1981), and *Alex Katz: A Retrospective* (New York: Harry N. Abrams, 1998).

P. 135.  "I would like": Alex Katz, "Brand-new and Terrific," *Scrap* 5, February 23, 1961.

P. 137.  "secret celebrities": David Antin, "Alex Katz and the Tactics of Representation," in Irving Sandler and Bill Berkson, eds., *Alex Katz* (New York: Frederick A. Praeger, 1971), p. 16.

P. 137.  As David Hickey: See David Hickey, "Those Cool American Blondes," in *Alex Katz Under the Stars: Landscapes 1951-1995* (Baltimore: Baltimore Museum of Art, 1996), p. 45.

P. 138.  "No one has ever": John Russell, "Alex Katz," in *Alex Katz: The Cooper Union Collection* (New York: Cooper Union, 1994), n.p.

P. 138.  "a shocking notion": Hilton Kramer, "Quite a Lot to Look Art," *The New York Times*, November 28, 1971, p. 21.

P. 139.  Willem de Kooning painted: See Jed Perl, "Pop Theater," *Yale Review*, January 1995, pp. 41, 43.

P. 139.  Put another way: See Sanford Schwartz, "Alex Katz So Far," *Art International*, December 1973, p. 58.

P. 139.  "the superficialities": Robert Storr, "The Rules of the Game," in *Alex Katz: American Landscape* (Baden-Baden: Staatliche Kunsthalle, 1995) p. 29.

P. 140.  In appearance: The following text on Pearlstein, much revised, is culled from Irving Sandler, "Philip Pearlstein and the New Realism," in *Philip Pearlstein: A Retrospective* (New York: Alpine Fine Arts Collection, 1983).

P. 141.  "as artists": Philip Pearlstein, "Figure Paintings Today Are Not Made in Heaven," *Art News*, Summer 1962, p. 39.

P. 141.   "the naked figure": Pearlstein, "Figure Paintings Today ...," p. 39.

P. 142.  "tormented, agonized": Philip Pearlstein, "A Statement," in *Philip Pearlstein: Zeichnungen und Aquarelle: Die Drucksgraphic* (Berlin-Dahlem: Staatliche Museum, 1972), p. 15.

P. 143.  "I really see": Linda Nochlin, "The Art of Philip Pearlstein: Realism Is Alive and Well in Georgia, Kansas, and Poughkeepsie," *Philip Pearlstein* (Athens, Ga.: Georgia Museum of Art, University of Georgia, 1970), n.p.

P. 144.  "Perhaps it is": Pearlstein, "A Statement," p. 15.

P. 144.  Substitute painting: See Charles Rosen and Henri Zerner, "What Is, and Is Not, Realism?" *The New York Review of Books*, February 18, 1982, p. 25.

P. 144.  Al Held was: Much of the following text on Held, much revised, is culled from Irving Sandler, *Al Held* (New York: Hudson Hills, 1985) and *Al Held 1959-1961* (New York: Robert Miller Gallery, 1980).

P. 147.   In 1965: Irving Sandler, *Concrete Expressionism* (New York: Loeb Student Center, New York University, 1965), n.p.

P. 149.  "I was drunk": Paul Cummings, interview with Al Held, New York, November 19, 1975; transcript in the Archives of American Art, p. 184.

P. 151.  "Marxism advances": Irving Howe, *A Margin of Hope: An Intellectual Autobiography* (New York: Harcourt Brace Jovanovich, 1982), p 53.

P. 152.  George Sugarman was: The material on George Sugarman, much revised, is culled from Irving Sandler, *George Sugarman* (Omaha, Neb.: Joselyn Art Museum, 1981).

P. 152.  "Abstract art": Barbara Rose and Irving Sandler, "The Sensibility of the Sixties," *Art in America*, January-February 1967, p. 51.

P. 153.  Ronald Bladen had: The Material on Ronald Bladen, much revised, is culled from Irving

Sandler, "Ronald Bladen," *Artforum*, December 1966.

P 154. "Ronnie was a man": Douglas Dreishpoon, telephone interview with Al Held, November 2, 1995, in *Ronald Bladen Drawings and Sculptural Models* (Greensboro, N.C.: Weatherspoon Art Gallery, University of North Carolina, 1995), p. 43.

P. 154. "Bladen's are intimate": Irving Sandler, *Ronald Bladen* (New York: Joan Washburn Gallery, 1989), n.p.

P. 155. "the keystone show": Symposium on "Primary Structures" at the Jewish Museum, May 2, 1966, with Kynaston McShine, Barbara Rose, Robert Morris, Donald Judd, and Mark di Suvero.

P. 156. Where their primary: See Lucy Lippard, "As Painting Is to Sculpture: A Changing Ratio," *American Sculpture of the Sixties* (Los Angeles: Los Angeles County Museum of Art, 1967), pp. 31-34.

P. 156. "to reach that area": Barbara Rose, "ABC Art," Art in America, October-November 1965, p. 63.

P. 157. "It's the only": Corinne Robins, "The Artist Speaks: Ronald Bladen," *Art in America*, September 1969, p. 81.

P. 158. "I first met": Passages from the following text on Mark di Suvero, much revised, are culled from Irving Sandler, *Mark di Suvero at Storm King Art Center* (New York: Harry N. Abrams, 1996).

P. 158. "one of the liveliest": Irving Hershel Sandler, "New York Letter," *Art International*, December 31, 1960, p. 24.

## 7. ART CRITICISM: CRITICS AT WAR

P. 182. "At a certain moment": Harold Rosenberg, "The American Action Painters," *Art News*, December 1952, pp. 22-23, 48.

P. 183. "Form, color": Rosenberg, "The American Action Painters," p. 23.

P. 183. "The critic": Rosenberg, "The American Action Painters," p. 23.

P. 183. "easy painting[s]": Rosenberg, "The American Action Painters," p. 49.

P. 184. "how to tell": Harold Rosenberg, "Critic Within the Act," *Art News*, October 1960, p. 26.

P. 184. "the two critics": P. G. Pavia, "Editor's Notes," *It Is* 3, Winter-Spring 1959, p. 80.

P. 185. "the purely … abstract": Clement Greenberg, "Toward a Newer Laocoon," *Partisan Review*, July-August 1940, p. 305.

P. 185. "among the century's": Arthur Danto, "Us and Clem," *Artforum*, March 1998, p. 14.

P. 185. "confine itself": Clement Greenberg, "Abstract Art," *The Nation*, April 15, 1944, p. 451.

P. 186. "fixated on Cubism": Robert Goldwater, "Art and Criticism," *Partisan Review*, May-June 1961, pp. 690-694.

P. 187. "reliance upon": Clement Greenberg, "Surrealist Painting," *The Nation*, August 12, 1944, p. 193.

P. 188. "the development": Clement Greenberg, "The Present Prospects …," *Horizon*, October 1947, p. 27.

P. 188. "its Gothic-ness": Greenberg, "The Present Prospects …," p. 26.

P. 188. "I think": Clement Greenberg, *Art News*, September 1987, p. 16.

P. 189. "perversions and abortions": Clement Greenberg, "How Art Criticism Earns Its Bad Name," *Second Coming*, March 1962, p. 71.

P. 189. "formal criticism": Harold Rosenberg, "The Art Galleries: The New as Value," *The New Yorker*, September 7, 1963, p. 41.

P. 189. "The Premises": Harold Rosenberg, "The Premises of Action Painting, Encounter, May 1963. p. 4.

P. 189. "After Next": Harold Rosenberg, "After Next, What?" *Art in America*, April 1964, p. 64.

P. 190. "When you faked": Panel on "Painting and Photography" at Artists Talk on Art, April 27, 1983, with Craig Owen, Joseph Kosuth, Barbara Kruger, Sarah Charlesworth, Jack Goldstein, Mark Tansey, and Robert Maplethorpe.

P. 191. "Pollock fits snugly": Harold Rosenberg, "The Search for Jackson Pollock," *Art News*, February 1961, pp. 35, 58-59.

P. 191. Clem allowed: Clement Greenberg, Lecture at the Solomon R. Guggenheim Museum, October 29, 1961.

P. 192. I never knew: More than 150 works in Greenberg's collection were acquired by the Portland Museum.

P. 193. Thus, Clem appealed: Jacques Ellul, "Modern Mythologies," *Diogenes*, Fall 1958, p. 28.

P. 194-95 "I am as unsympathetic": Irving Sandler, Letter to the Editor, *Art in America*, October 1980, p. 57.

P. 195 "Professor Sandler's": William Rubin, "William Rubin Replies," *Art in America*, October 1980, pp. 65-67.

P. 196. "Formalist theories": William Barrett, "The Painters' Club," *Commentary*, January 1982, p. 49.

P. 196. "cult of 'quality'": Robert Storr, "No Joy in Mudville: Greenberg's Modernism Then and Now," in Kirk Varnedoe and Adam Gopnik, eds., *Modern Art and Popular Culture: Readings in High & Low!* (New York: Museum of Modern Art, 1990), p. 180.

P. 197. "In those days": Allan Kaprow, interviewed by Dorothy Seckler, New York, September 10, 1968, p. 17. Transcript in Archives of American Art, New York.

P. 198. "The consciousness": Meyer Schapiro, "The Liberating Quality of Avant-Garde Art," *Art News*, Summer 1957, pp. 38-40.

P. 198. "art in modern": Meyer Schapiro, "Diderot on the Artist and Society," *Theory and Philosophy of Art: Style, Artist, and Society* (New York: George Braziller, 1994) p. 204.

P. 199-200 "[Diderot] is": Schapiro, "Diderot and the Artist and Society," p. 207.

P. 201. "engaged in internal": Robert Goldwater, typescript for an unpublished book by the Tanager Gallery; later reprinted as Robert Goldwater, "Reflections on the New York School," *Quadrum* 8, 1960, pp. 17-36.

P. 203. "What made Paris": Hess, "The Cigarbox of Napoleon III: Some Notes on the Battle between French Art and Paris Art," whereabouts unknown.

P. 203. "The artists and writers": Thomas B. Hess, "The Battle of Paris, strip-tease and Trotsky: Some Non-Scenic Travel Notes," *It Is* 5, Spring 1960, p. 30.

P. 204. "elated by the size": Patrick Heron, "The Americans at the Tate Gallery," *Arts Magazine*, March 1956, p. 16.

P. 204. "By 1958": Patrick Heron, "London Letter," *Arts Magazine*, January 1958, p. 18.

P. 205. "displays infinite invention": Patrick Heron, "Can Mark Rothko's Work Survive?" *Modern Painters*, Summer 1989. pp. 37, 39.

P. 205. It was the opening shot: Patrick Heron, "Two Cultures," *Studio International*, December 1970, pp. 240-48.

P. 205. "colour-stripe painting": Patrick Heron, "The British Influence on New York, Part 3," *Arts Guardian*, October 12, 1974, pp. 8-9.

P. 206. "developed their known": Patrick Heron, "The British Influence on New York, Part 2, "*Arts Guardian*, "The British Influence on New York, Part 3," pp. 8-9.

P. 206. "had come to the end": Heron, "The British Influence on New York, Part 3," pp. 8-9.

P. 206–07. "that the act": John Ashbery, "Writers & Issues: Frank O'Hara's Question," *New York Herald Tribune* (Book Week), September 25, 1966, p. 6.

P. 208. "critics who yearn": Irving Sandler, "In the Galleries," *New York Post*, September 24, 1961, p. 12.

P. 208. "the display": Irving Sandler, "In the Art Galleries," *New York Post*, October 29, 1961, p. 12.

P. 208. "the superficial parodists": Irving Sandler, "In the Art Galleries," *New York Post*, December 24, 1961, p. 12.

P. 211. "I promise": Philip Pearlstein, letter to Irving Sandler, October 24, 1976.

P. 212. "no matter how private": Irving Sandler, *The Triumph of American Painting: A History of Abstract Expressionism* (New York: Frederick A. Praeger Publishers, 1970), p. 2.

P. 213. "My one main criticism": Clement Greenberg, postcard to Irving Sandler, April 5, 1971. © Janice van Horne for the Clement Greenberg Estate.

P. 213. "Reading about": Thinking back, I'm not sure I mailed my letter to Greenberg.

P. 214. "the New York School's": Carter Ratcliff, "The New York Art Establishment," *New York Magazine*, November 27, 1978, p. 63.

## 8. THE NEW ACADEMY

P. 217. "In 1956": See Irving Sandler, "Joan Mitchell Paints a Picture," *Art News*, October 1957.

P. 220. "a young breed": Brian O'Doherty, "Master of a Movement Manqué," *Arts Magazine*, April 1966, p. 28.

P. 221. "dominated by": Renato Poggioli, *The Theory of the Avant-Garde* (Cambridge, Mass.: Belnap Press/Harvard University Press, 1968), pp. 66-67.

P. 222. "Consolidation is": John Ferren, "Stable State of Mind," *Art News*, May 1955, pp. 22-23, 64.

P. 224. "Or jump into one": The panel was titled "What Are the Valid Motivations for the Artist Today: Spiritual, Ethical, Technical, Traditional?" and took place at The Club on February 24, 1956.

P. 225. Consequently, the primary: Wolf Kahn, notes of a lecture "On the Hofmann School" at the College Art Association annual meeting in New York on January 1973 and in a lecture at the New York Studio School on January 10, 1990.

P. 225. "elegant manners": Dore Ashton, "What is 'avant-garde'?" *Arts Digest*, September 15, 1955, p. 8; "Art," *Arts and Architecture*, September 1956, p. 4; and "Art," *Arts and Architecture*, February 1956, p. 10.

P. 225. "against spontaneity": Dore Ashton, "Some Lyricists in the New York School," *Art News and Review* (London), November 22, 1958, pp. 3, 8.

P. 228. In 1965: Irving Sandler, "The Club," *Artforum*, September 1965.

P. 229. "wild scramble": John Meyers, "Letters to the Editor," *Art News*, January 1959, p. 6.

P. 232. "Abstract Expressionism": Clement Greenberg, Introduction, Post Painterly Abstraction (Los Angeles: Los Angeles County Museum of Art, 1964), n.p.

P. 233. "If you grant": Jack Tworkov, Statement, in "Is There A New Academy?" Art News, September 1959, p. 38.

P. 233–34. "a collective expression": William Barrett, *Nicolas Carone* (New York: Staempfli Gallery, 1961), n.p.

P. 235. "It would seem": Philip Leider, "The Cool School," *Artforum*, Summer 1964, p. 47.

P. 238. "My unconscious": Grace Hartigan, talk titled "The Education of an Artist," Xerox copy, undated, p. 2.

P. 240. "Akumal's discovery": Tariq Ali, "The Painter and the Pest," *Time Out*, May 23-29, 1985, p. 34, and "The Making of a Modern Art Master," *The Illustrated Weekly of India*, June 2, 1985, p. 41.

P. 240. "The story": Salman Rushdie, "Magnificent Obsession," *Observer Magazine*, May 26, 1985, p. 11.

P. 240. "the purpose": "Art: One Man's Taste," *Time*, March 27, 1964, p. 62.

P. 241. "His favorite book": "Art: Hartford Modern: What's in a Name?" *Newsweek*, March 23, 1964, p. 65.

P. 241. "a fixed position": Hilton Kramer, "Month in Review," *Arts Magazine*, September 1959, p. 58.

P. 241–42. "If there is anything": Harold Rosenberg, "Extremist Art: Community Criticism," reprinted in The *Tradition of the New* (New York: Horizon Press, 1959), pp. 42-43.

P. 242–43. "The members of": Canaday was accused of "having treated a fellow critic in a manner unbecoming the profession of criticism, violating her dignity as a critic and infringing basic principles of freedom of criticism by his accusations, demands and threats, aimed at forcing compliance with his own views and methods in matters of judgment."

P. 245. "If the artist was in hell": Allan Kaprow, "Should the Artist Be a Man of the World?" *Art News*, October 1964, pp. 34-37, 58-59.

P. 245. Kaprow countered: Allan Kaprow, *Art News*, October, November 1964.

## 9. POST-GESTURE PAINTING: OUT OF THE 1950s

P. 247. On the occasion: Irving Sandler, "Ash Can Revisited, A New York Letter," *Art International*, October 25, 1960, pp. 28-30.

P. 249. When Richard told: Irving Sandler, "In the Art Galleries," *New York Post*, September 9, 1962, p. 12.

P. 250. "To whom it may concern": *John Cage, Silence: Lectures and Writings* (Cambridge, Mass.: M.I.T. Press, 1967), p. 98.

P. 250. "the most important": Martin Duberman, *Black Mountain: An Exploration in Community* (New York: E. P. Dutton, 1972), p. 71.

P. 251. "He transmutes": Irving Sandler, "In the Art Galleries," *New York Post*, November 26, 1961, p. 12.

P. 251. "On the merry": Leo Steinberg, "Month in Review," *Arts Magazine*, January 1956, pp. 46-47.

P. 253–54. "How can we break": Cage, *4'33"* p. 12.

P. 261. Detractors of: *New York Review*, March 27, 1997.

P. 263. "immediacy and": I[rving]. H. S[andler]., *Art News*, January 1957, p. 10.

P. 263. "the 'Act of Painting'": Allan Kaprow, "The Legacy of Jackson Pollock," *Art News*, October 1958, p. 26.

P. 263. "idea that an artist": Irving Sandler, "Editor's Letters," *Art News*, December 1958, p. 6.

P. 263. "the 'action' part": Irving Sandler, "In the Art Galleries," *New York Post* magazine, June 16, 1963, p. 14.

P. 267. "The drawing that distinguishes": I[rving]. H. S[andler]., "Reviews and Previews: Claes Oldenburg," *Art News*, Summer 1960, p. 16. See also Sandler, "Ash Can Revisited."

P. 270. "cultural terrorist': The quotes on Paik, unless otherwise cited, come from Calvin Tomkins, *The*

*Bride and the Bachelors* (New York: Viking 1965), p. 137, and *The Scene: Reports on Post-Modern Art* (New York: Viking, 1976), pp. 196, 198, 205, 216, 219, 226.

P. 270 "She ended up": William L. O'Neill, Coming Apart: An Informal History of America in the 1960s (New York: Quadrangle Books, 1977), p. 251.

P. 271. "No, I used it": Nam June Paik, talk at the Whitney Museum, January 10: 1990; Sandler's handwritten notes.

P. 274. "Sam Goodman": Thomas B. Hess, Introduction, *B. Lurie, S Goodman*, (Milan: Gallerie Schwarz, 1962), n.p.

p. 274. Seymour Krim: The NO! Show at the Gertrude Stein Gallery, October 8-November 2, 1963. The artists in the NO! Show were Lurie, who curated it, Sam Goodman, Rocco Armento, Stanley Fisher, Esther Gilman, Gloria Graves, Allan Kaprow, Kusama, J.-J. Lebel, Michelle Stuart, and Richard Tyler.

P. 274. "letting escape": Seymour Krim, Introduction, No! Show (New York: Gertrude Stein Gallery, 1963), announcement sheet, n.p.

P. 274. "It is extremely": Quoted in John Strausbaugh, "Lost Art," *NY Press*, February 9-15, 1994, p. 12.

P. 275. "the most exhilarating": Nicolas Calas, "Art Journal," *The Village Voice*, April 22, 1965, p. 5.

P. 276. I visited all: The artists I interviewed were Gillian Ayres, Bernard Cohen, Harold Cohen, Peter Corviello, Robin Denny, Gordon House, John Hoyland, Gwyther Irwin, Henry Mundy, John Plumb, Peter Stroud, William Turnbull, Marc Vaux, Brian Young, Anthony Caro and John Latham.

P. 276. The organizing committee: The first Situation show was organized by a committee consisting of Lawrence Alloway, Robin Denny, Bernard Cohen, Gordon House, Henry Mundy, Hugh Shaw, and William Turnbull. They selected Gillian Ayres, Harold Cohen, Peter Corviello, John Epstein, Peter Hobbs, William Green, John Hoyland, Gwyther Irwin, Robert Law, John Plumb, Ralph Rumney, Richard Smith, Peter Stroud, Marc Vaux, and Brian Young.

P. 279. Equally unfortunate: See Irving Sandler, Correspondence, *Art Monthly* 39, September 1980, pp. 22-23.

10. INTO THE 1960S

P. 281. Frank concluded: Frank Stella, lecture, "Art 1960," at New York University, April 21, 1960; handwritten notes.

P. 281. "geometry and monochromatic": Irving Sandler, "The New York Letter," *Art International*, December 1960, p. 25.

P. 282–83. "Stella's collages": Irving Sandler, "Frank Stella," *Art in America*, January 1972, p. 33.

P. 284. The "next move": Robert Morris, "Notes on Sculpture, Part 2," *Artforum*, October 1966, pp. 20-23.

P. 284. "theatricality" was the enemy: Michael Fried, "Art and Objecthood," *Artforum*, Summer 1967, pp. 15, 19-20.

P. 285. "Standing out": Irving Sandler, "In the Art Galleries," *New York Post*, October 29, 1961, p. 12.

P. 286. It is true: Barnett Newman, "The Ideas of Art: 60 Opinions on What is Sublime in Art." *Tiger's Eye*, December 15, 1948. p. 52.

P. 287. During Barney's show: "Hess and Newman: A Conversation," the Solomon R. Guggenheim Museum, May 1, 1966; handwritten notes.

P. 288. Barney, she said: Carol Mancusi-Ungaro, at the Memorial for Annalee Newman at the Metropolitan Museum of Art, New York, January 29, 2001; handwritten notes.

P. 288. Instead, he said, churches: Thomas Matthews, lecture at the International Congress on Religion, Architecture, and the Visual Arts, August 30, 1967; typescript.

P. 290. As a hard-bitten: Panel on "Is Easel Painting Dead?" at Loeb Student Center, New York University, November 10, 1966, with Barbara Rose, moderator, Darby Bannard, Donald Judd, Larry Poons, and Robert Rauschenberg; handwritten notes.

P. 290. "The absence of": D[onald]. J[udd]., "In the Galleries: Frank Stella," *Arts Magazine*, September 1962, p. 51.

P. 290. "one technique is": Symposium on "Primary Structures" at the Jewish Museum, May 2, 1966, with Kynaston McShine, Barbara Rose, Robert Morris, Donald Judd, and Mark di Suvero.

P. 291. But his point: Panel on "The Content of Abstract Art," in the Critics' Colloquim at the Loeb Student Center, New York University, November 17, 1966; handwritten notes.

P. 292. So did two important: The participants of the panel at NYU, part of the Critics Colloquium titled "The Content of Abstract Art," were Stephen Greene, Robert Morris, Robert Murray, and Jack Tworkov. The Yale panel was titled "The Unitary Object," and the participants were Donald Judd, Sol LeWitt, Robert Morris, and Robert Smithson.

P. 294. "Let this Paroxysmal": Robert Smithson, "The Lamentations of the Paroxysmal Artist," one-page typescript handout, undated. © Nancy Holt for the Robert Smithson Estate.

P. 294. "A Tour of the Monuments": Robert Smithson, "The Monuments of Passaic," *Artforum*, December 1967, pp. 48-51.

P. 294–95. "The Sensibility": Robert Smithson, "Response to a Questionnaire from Irving Sandler," in Jack Flam, ed., *Robert Smithson: The Collected Writings*, (Los Angeles: University of California Press, 1996), p. 329.

P. 295. "demonic Smithson": Peter Schjeldahl, "Monuments of a Metaphysical Dandy," *The Village Voice Literary Supplement*, June 1982, p. 8.

P. 295. The proof of its vitality: Panel, "Is Easel Painting Dead?".

P. 295. "Both Stella": "Is Easel Painting Dead?".

P. 298. "epiphanies of": Peter Schjeldahl, "Barbarians at the Gate," *The New Yorker*, May 15, 2000, p. 104.

P. 298. Liz, painted: See Jerry Saltz, "Swish Myth," *The Village Voice*, May 16, 2000, p. 83.

P. 299. "Naturally enough": "The Story of Pop," *Newsweek*, April 25, 1966, p. 56.

P. 299. "The clothes, vinyl": Robert Scull, interviewed by Paul Cummings, New York, June 15-28, 1972, Transcript in the Archives of American Art, p. 19.

P. 303. We had their answers: Barbara Rose and Irving Sandler, "The Sensibility of the Sixties," *Art in America*, January-February 1967, pp. 44-57.

## 11. THE TRAUMA OF VIETNAM AND ITS AFTERMATH

P. 306. "people's tribunal": Battcock's remarks were reported in *Open Hearing*, Art Workers Coalition, New York, 1969, p. 8.

P. 309. How else could one account: See also Barbara Rose, "Problems of Criticism VI: The Politics of Art, Part III, " *Artforum*, May 1969, pp. 46-48.

P. 310. "Only a few periods": "In Praise of the Counterculture," an editorial, *The New York Times*, December 11, 1994, section E, p. 14.

P. 312. "Let current needs": Irving Sandler, "The Teaching of Contemporary Art," *Conference on Art Criticism and Art Education* (New York: New York University, 1970), pp. 41-45.

P. 312. As early as 1969: Irving Sandler, "Critics' Choice," *Critics' Choice* (New York: New York State Council on the Arts and State University of New York, 1969), n.p.

P. 313. In my book: Irving Sandler, *Art of the Postmodern Era: From the Late 1960s to the Early 1990s* (New York: Icon Editions, 1996).

P. 315. Imagery tended to be: Lucy R. Lippard, *From the Center: Feminist Essays on Women's Art* (New York: E. P. Dutton, 1974).

P. 315. "Women's bodies": Lucy R. Lippard, "Judy Chicago's 'Dinner Party,'" *Art in America*, April 1980, p. 118.

P. 315. "I had always been": Kate Horsfield, "On Art and Artists: Lucy Lippard," *Profile* vol. 1, no. 3 (Chicago: Video Data Bank, School of the Art Institute of Chicago, May 1981), p. 13.

P. 316. The journal's editors: Annette Michelson, "The Prospect Before Us," *October* 16, Spring 1981, p. 119.

P. 318. "consigned to": Rosalind Krauss and Annette Michelson, "Editorial," *October* 10, Fall 1979, pp. 3-4.

P. 318. Painting, as October contributor: Douglas Crimp, "The End of Painting," *October* 16, Spring 1981, pp. 85-86.

P. 318. "The artist no longer": "Post-Modernism," *Real Life*, Summer 1981, pp. 8-10.

P. 320. "Was [the] art": Sandler, *Art of the Postmodern Era*, p. 368.

## 12. THE SWEEPER-UP AFTER ARTISTS

P. 322. It included: The first panel, titled "Is Easel Painting Exhausted?" moderated by Rose, consisted of Darby Bannard, Donald Judd, Larry Poons, and Robert Rauschenberg. My panel, which followed, was titled "The Content of Abstract Art Today" and was composed of Robert Morris, Robert Murray, Stephen Greene, and Jack Tworkov. Tillem's panel, which consisted of Howard Conant, Eugene Goossen, Sidney Geist, and Mercedes Matter, dealt with "Art Students and the Future of the Avant-Garde." The fourth panel, whose topic was "The Meaning of the Formal Statement," was moderated by Annette Michelson and consisted of Roy Lichtenstein, William Rubin, and Frank Stella. The participants in the final session, titled "Current Art and the American Place," were moderator Kozloff, William Agee, Leon Golub, Ivan Karp, and Robert Smithson.

P. 323. One of the works: Irving Sandler, *Sculpture in the Environment* (New York: New York City Administration of Recreation and Cultural Affairs, 1967), n.p.

P. 325. The proceedings: *Conference on Art Criticism and Art Education* (New York: New York University, 1970).

P. 330. Helene Winer pointed: Richard Goldstein, "Artbeat: The Politics of Culture: The Romance of Racism," *The Village Voice*, April 2, 1979, p. 43.

P. 330. "funky downtown": Eileen Blair, "Arts: Pure Art or 'Brutality Chic': Artists Space Accused of Racism over Exhibit Title," *The Villager*, April 26, 1979, p. 15.

P. 330. "typical . . . social practice": "Letters: Art and Language Divorced," *The Village Voice*, April 9, 1979, p. 6.

P. 331. "If I killed": In Blair, "Arts: Pure Art or 'Brutality Chic,'" p. 15.

P. 331. "The message": Rudolph Baranik, "The Nigger Drawings: A Note from New York," *Art Monthly*, No. 29, 1979, pp. 27-28.

P. 331. "exploiting this": Grace Glueck, "'Racism' Protest Slated Over Title of Art Show," *The New York Times*, circa April 27-28, 1979, p. 15.

P. 331. "to cut off": Craig Owens, "Black and White," *Skyline*, April 1979, p. 16.

P. 332. "I have asked": Nan Goldin, "In the Valley of the Shadow," *Witnesses Against Our Vanishing*

(New York: Artists Space, 1989), p. 5.

P. 332. "Are these images": "Mr. Frohnmayer's Fumble," editorial, *The New York Times*, November 17, 1989, section A, p. 38.

P. 333. *The New York Times* twitted: "Mr. Frohnmayer's Fumble."

P. 333. Among the lecturers: The ASDA speakers were William Rubin (on Jackson Pollock), Robert Rosenblum (on Pop Art), John Golding (on Matisse), and Werner Hofmann (on Duchamp). These speakers were followed in 1977 by Francis Haskell (on modern art in the nineteenth century), Werner Hofmann (on Art Nouveau), Clement Greenberg and Lucy Lippard (both on the avant-garde). Other speakers were Thomas B. Hess (on Abstract Expressionism), Barbara Rose (on Jasper Johns), Leo Steinberg (on content and form), and Linda Nochlin (on American realism since 1960).

P. 336. I left before: The new director was Suzanne Delehanty.

P. 336. What intrigued me: Irving Sandler, *Roy R. Neuberger: Patron of the Arts* (Purchase, N.Y.: Neuberger Museum of Art, State University of New York, 1993).

P. 337. In 1979: See Irving Sandler, "The School of Art at Yale: 1950-1970: Collective Reminiscences of Twenty Distinguished Alumni," *Twenty Artists: Yale School of Art 1950-1970* (New Haven: Yale University Art Gallery, 1981).

P. 339–40. The trustees agreed: Among the participants were Dore Ashton, Sally Avery, Elaine and Willem de Kooning, Herber Ferber, Esther Gottlieb, Katherine Kuh, Jacob Kainen, Jacob Kufeld, Dorothy Miller, Robert Motherwell, Annalee Newman, Betty Parsons, Rita Reinhardt, Hedda Sterne, and Joseph Solomon.

P. 343. "the great institutions": Hilton Kramer, "Notes & Comments: April 1992," *The New Criterion*, April 1992, pp. 1-3.

P. 346. "What was astonishing": Philip Roth, *American Pastoral* (Boston and New York: Houghton Mifflin, 1997), p. 329.

EPILOGUE

P. 347. "Civilization is a thin": Quoted in David Gress, "Raymond Aron, Philospoher of Liberal Democracy," *The New Criterion*, June 1990, p. 25.

P. 348. "The sun shone": Samuel Beckett, *Murphy* (New York: Grove Press, 1938), p. 1.

P. 348. "To get up in the morning": Czeslaw Milosz, "Subjects to Let," *The New York Review of Books*, May 15, 1997, p. 16.

# Acknowledgments

I wish to express my gratitude to the many artists, critics, curators, and others in the art world whose friendship has meant more than I can say. This memoir is as much about them as about me.

Above all, very special thanks are due to Peter Warner of Thames & Hudson, for his enthusiastic support and his skillful shaping and editing of my memoir; and to his assistant, Raoul Calleja, for his help in all phases of its production; and to Veronica Johnson for her thoughtful copyediting.

I would also like to thank Amber Fogel, Rachel Elizabeth Belmont, and Deanne Shashoua for their help in preparing the text. I am grateful to Fred McDarrah, Yvonne Jacquette and Jacob Burckhardt for the Rudy Burckhardt Estate, Robert Panzer of VAGA, Peter Stevens and Susan Cooke for the David Smith Estate, Eric Brown and Andrew Arnot of the Tibor de Nagy Gallery, Carol and George Silver for the Walt Silver Estate, Connie Reyes for the Ronald Bladen Estate, Lisa Mordhorst of Spacetime C.C., Amy Young of the Robert Miller Gallery, Jim Yohe of the Amringer & Yohe Fine Art Gallery, Jack Cowart and Clare Bell for the Roy Lichtenstein Foundation, and Douglas Dreishpoon, Joyce Robinson, Phyllis Tuchman, and Robert Warshaw for their help in acquiring photographs. I would also like to thank Maureen Granville-Smith, Anna and Rita Reinhardt, Janice Van Horne for the Clement Greenberg Estate, and Nancy Holt for the Robert Smithson Estate for allowing me to publish quotes from letters and/or poems.

I am deeply grateful to the corporation of Yaddo for the residencies, the Getty Research Institute for housing my archive, Isabelle and Jerry Hyman, Elly and Harvey Miller, DeeDee and Joseph Levine, Nina and Michael Sundell, Jane and Gilbert Edelson, Candace Wait, Krzysztof Ciezkowski, Mitchell C. Benson, James M. McKiernan, and Robert Berlind for their support and valuable advice, and to Maxine Groffsky and Susan Ralston for their initial efforts on behalf of this book.

Finally, I dedicate this memoir to my wife, Lucy, who shared these memories with me, my daughter Catherine, who lived through many of them, her husband, Tom Bussey, and my brand new grandson Jackson.

# Index